TIRELLI 50

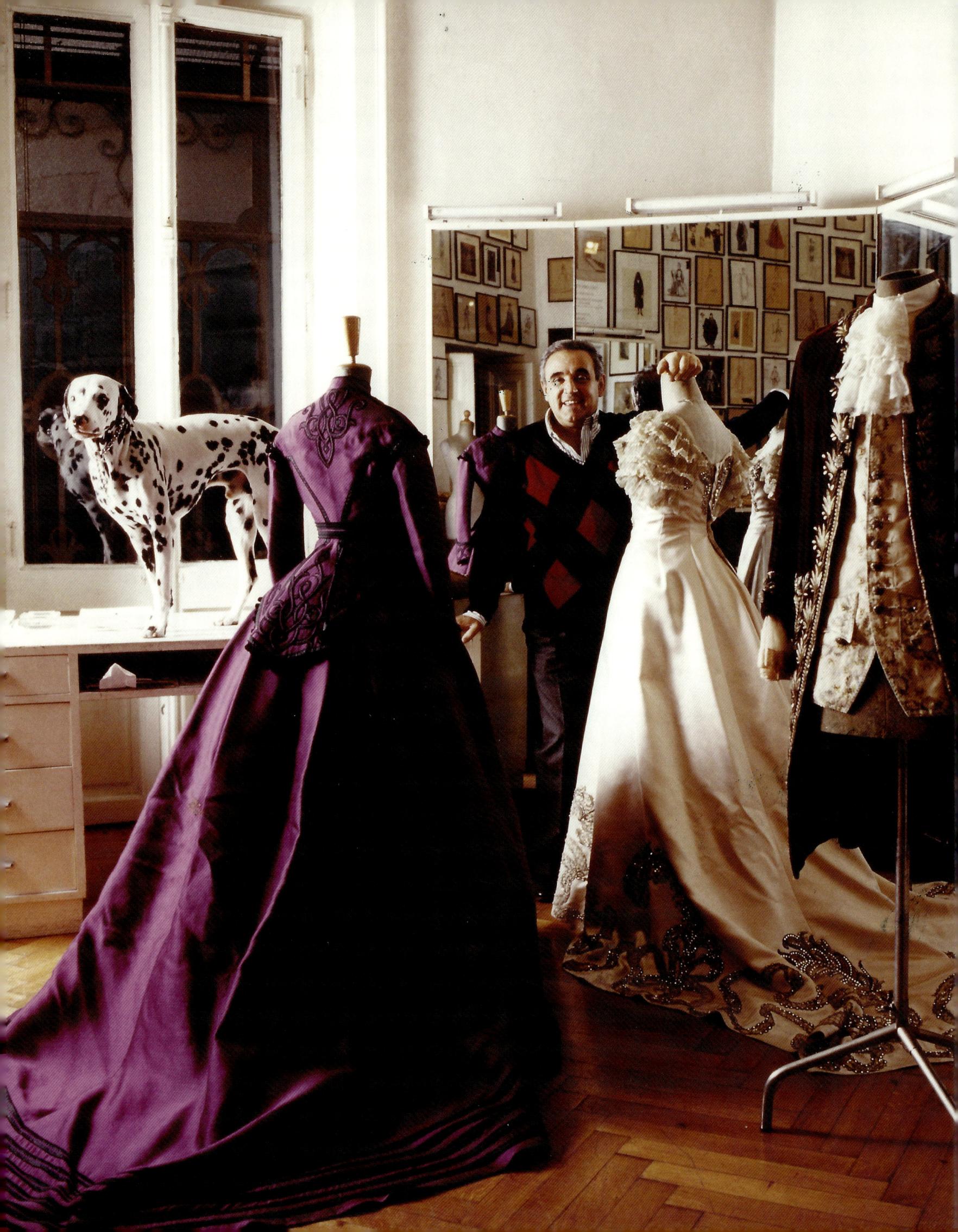

TIRELLI 50

The Wardrobe of Dreams

Edited by Masolino d'Amico, Silvia d'Amico, Caterina d'Amico and Dino Trappetti

SKIRA

Cover
Graphic rendering of a photo
by Fiorenzo Niccoli

Page 4
Umberto Tirelli in the fitting room of the
atelier on Via Pompeo Magno in Rome
with his Dalmatian Dindo, 1983
Photo by Cristina Ghergo

Design
Marcello Francone

Editorial Coordination
Emma Cavazzini

Editing
Catherine Connery

Layout
Serena Parini

Translations
Susan Ann White, Felicity Lutz
and Sergio Knipe for *Scriptum*, Rome

First published in Italy in 2015 by
Skira Editore S.p.A.
Palazzo Casati Stampa
via Torino 61
20123 Milano
Italy
www.skira.net

Printed and bound in Italy. First edition

ISBN: 978-88-572-2688-0

Distributed in USA, Canada, Central & South
America by Rizzoli International Publications,
Inc., 300 Park Avenue South, New York,
NY 10010, USA.
Distributed elsewhere in the world by
Thames and Hudson Ltd., 181A High
Holborn, London WC1V 7QX, United
Kingdom.

TIRELLI 50

The Wardrobe of Dreams

Interviews with costume designers by
Silvia d'Amico

Appendices by
Caterina d'Amico

Image research and coordination
Alessandro Trappetti

*The photos of the Sartoria
and the donations are by*
Fiorenzo Niccoli

Mannequin dressing
Mina Bavaro
Flora Brancatella
Valentina Fucci
Petra Gruden
Tiziana Recupero
Lucia Votoni

Administrative coordinator
Luigi Morena

Organizational coordinator
Laura Nobile

Secretary
Daniela Bartoli

Assistance
Laura Lo Surdo

A particular thank-you to
Alain Elkann

Special thanks to
Sergio Ballo
Flora Brancatella
Milena Canonero
Massimo Cantini Parrini
Franco Carretti
Carlo Diappi
Claudie Gastine
Pasquale Grossi
Alessandro Lai
Fiorella Mariani
Maurizio Millenotti
Lucia Mirisola
Ursula Patzak
Gabriella Pescucci
Pier Luigi Pizzi
Carlo Poggioli
Alberto Spiazzi
Mariano Tufano
Piero Tosi

Thanks also to
Colleen Atwood
Hugo de Ana
Stefano De Nardis
Nicoletta Ercole
Massimo Gasparon
Stefano Poda
Sandy Powell
Penny Rose
Ann Roth

*A heartfelt thank-you to all the
staff at Sartoria Tirelli for their
valuable, loyal and constant
collaboration over these fifty years.*

*We are most grateful to Piero Tosi,
Pier Luigi Pizzi and Gabriella
Pescucci for their kind suggestions
and Massimo Cantini Parrini for
his expert advice.*

*We sincerely thank the Fondazione
Tirelli Trappetti for making
available its collection of sketches,
designs, preparatory drawings
and other material useful for the
historical reconstruction of the
Sartoria Tirelli.*

*We would also like to thank
the theatres, institutions and
photographers who have made
their archives accessible, especially:*
Archivio Fotografico della
Cineteca Nazionale – Centro
Sperimentale di Cinematografia,
Rome
Archivio Liliana Cavani, Rome
Archivio Storico del Teatro
La Fenice, Venice
Archivio Zeffirelli, Rome
Cineteca di Bologna
Fondazione Istituto Gramsci,
Rome
Fondazione Teatro del Maggio
Musicale Fiorentino – Archivio
Fotografico Allestimento Scenico,
Florence
Fondazione Teatro dell'Opera
di Roma – Archivio Storico
Piccolo Teatro di Milano
Rossini Opera Festival, Pesaro
Teatro di San Carlo – Archivio
Storico del Teatro di San Carlo,
Naples
Teatro Regio, Turin

Roberto Angelotti
Philippe Antonello
David Appleby
Graziano Arici
Fabrizio and Sandro Borni
Emanuele Cattozzo
Carlo Cofano

Michele Crosera
Greta De Lazzaris
Cristina Di Paolo Antonio
Simone Donati / TerraProject
Jack English
Romolo Eucalitto
Corrado Falsini
Cristina Ghergo
Alessandra Giannese
Silvia Lelli
Pino Le Pera / Nuovo Teatro
Claude MacBurnie
Antonio Maraldi
Joan Marcus
Roberto Masotti
Fiorenzo Niccoli
Stefano Poda
Alberto Ramella
Luciano Romano
Paul Ronald
Mark E. Smith
Studio Tornasole
Alfredo Tabocchini
Maurizio Torti
Pietro Vertamy – OnOff Picture

01 Distribution
Buena Vista
Cecchi Gori Distribuzione
Columbia Tristar
CTV / Showtime
Gravier Productions – Inc. 2014
Istituto Luce
Lux Vide
MEDUSA FILM S.p.A.
Miramax Films
Moviemax
Penta Distribuzione
Rai – Ufficio Stampa
Skorpion Entertainment
Summit Entertainment – LLC
UIP
Walt Disney Pictures
Warner Bros Italia

*A special thank-you
to Tommaso Le Pera
and Studio Amati Bacciardi.*

Contents

Masolino d'Amico

THE FOUNDER

Thirty-three years ago, the founder of the Tirelli company dictated a short memoir of his private and professional life to a journalist friend, Guido Vergani. This account is filled with anecdotes about the founder's relationships with the many, often remarkable, individuals he had come in contact with through his work. A rather lengthy passage from that valuable little book (*Vestire i sogni – Il lavoro, la vita, i segreti di un sarto teatrale*, Milan: Feltrinelli, 1981) offers a vivid echo of the extroverted personality of Tirelli – who was fond of using words such as passion, enthusiasm, love and delirium in relation to his profession – as well as lucidly summing up his views on the career he had chosen and his rightful pride in his achievements:

On 30 November 1964, I set up my own business. Just before *The Leopard*, my work relationship with Safas had started deteriorating and falling apart. For two years, however, I couldn't get myself to make a break. Safas had been my professional cradle: it was by slaving away there that I had become "Tirelli". Day after day, I had found myself loaded with responsibilities, charged with the kind of decision-making powers which the good old Maggioni sisters had hitherto kept firmly under their control: contracts, the organization of work, the management of the tailoring business, costume fittings. I was the bosses' "alter ego", but with no official position, although my meagre salary was of course given a boost. Mine was effectively a central role, yet at the same time it was vague and ambiguous contractually.

This situation could well have continued in the atmosphere of deep, loving partnership that had emerged; I felt I was somewhat more than a simple employee. I was bound to the elderly sisters not just by gratitude, but by a combined feeling of filial affection and protectiveness. Things worsened, however, after the passing of the baroness, when the desperate Gita Roux started deserting the company and Safas's heirs stepped in to take her place. Outsiders to the tailoring world, they knew nothing of costumes and had a very different outlook from mine – from ours. We just didn't connect, didn't click: it was a matter of incompatible characters and instincts.

I could have left immediately. My friends had noticed my unease and were pressuring me to set up my own tailoring business. Had I done so, Visconti would immediately have entrusted me with all the costumes for the common folk in *The Leopard*, Romolo Valli and Giorgio De Lullo would have given me plenty of work. I loyally discussed the matter with Gita Roux. She said: "Forget it! You will never leave us, you will join us as a partner". It was Christmas 1961. The next three years were a constant shilly-shallying. The heirs were leading me on: one month it seemed as though they would give me 20% of the shares, the next they would offer me a cut of the profits, and the month after that, they would say nothing at all and play the waiting game.

We were not making any headway and I was tired. I was stuck in an uncertain situation that was draining my enthusiasm. One day, in the late summer of 1964, I was staying at Castel Gandolfo as a guest of Dino Zanardo and Mariella Lotti. They brought up the question that was tormenting me. Dino said: "Listen. How many

million lire do you need to set up your own tailoring business?" I had been racking my brains making estimates for months and months. "Three or four", I answered. "You mean thirty or forty?" "No, three or four million would be enough." "Here are five. You'll pay me back whenever you can. Actually, since I'm sick of seeing you so gloomy and of listening to your whining, I'll even give you the premises you need. I've inherited an apartment in Via Tevere. Take it for six months. Let's forget about the rent for now. You only need to pay for the phone – I'll take care of the electricity bills."

Other friends helped Umberto financially: Ida Cavalli, a cousin of Luchino Visconti; Bice Brichetto, a friend of Umberto's from his days in Milan; Ignazio Nicolai, then Distribution Director at Rank Film, who lived in the historic apartment building in Via dei Due Macelli with Umberto, Mauro Bolognini and Franco Zeffirelli (among other tenants); and Dino Trappetti, who converted his loan into shares when the business became a limited liability company, joining it as a partner.

The Sartoria Artigiana Tirelli was born from this surge of friendship and generosity. Such things are a rare event in a man's life. In my case, they happened again and again, making my recurrent claim that much of my professional success has been nourished by the friends surrounding me more than a mere platitude and show of modesty. On my part, I contributed my work skills, earnestness, enthusiasm, and full appreciation of life. I have never been plagued by ambition, by the anxiety to achieve, to make a career, to "hit the big time". I have never set myself any goals to be met at all costs. I have never forced the hand of destiny. I have only slaved away – and continue to do so. Backed by that cheque, given my frayed relationship with Safas and the support of so many friends and potential clients, I made up my mind. I spoke to Gita Roux. There were no problems. "I'll be leaving soon and you have the right to follow your own path", she said. It was not easy to say goodbye, since I was very fond of that dear old lady: a feeling that had grown over the years of working together, filled with enthusiasm, obstinate perfectionism and huge successes.

My departure provoked a kind of diaspora. I was followed by Marisa Duscio, Gilda Silvestri, Ginetta Amodio and Anna Silvestri – my beloved Anna who, though young, already had ten years' experience in tailoring, and who gave me so much encouragement and love when I was starting out on my own. Anna is a real scissors wiz, a great cutter, a true artist and a real woman. Maria Consalvo, with her magic hands and natural talent, joined us from another tailoring shop. Born into the craft, Maria had worked for Caramba, which for a theatre costume-maker means more than a degree from the Scuola Normale Superiore di Pisa would mean for a mathematician. Maria brought a young man with her, Luigi Russo. He had been a tailor in his hometown and had then found a job at a tailoring shop in Rome. Maria claimed that he had what it took to become a great cutter. Maria was to be trusted: she was a brilliant theatre costume-maker, with flair and a lot of experience. Luigi has been working with me ever since. He is an outstanding cutter and one of the pillars of our company. He is a very special person, a wonderful father of five who has ensured a place at university for his children through his hard work with the scissors; yet at the same time he has the heart, soul and candour of a boy. On 30 November 1964 I embarked on my adventure: two sewing machines; five employees for the tailoring shop; a milliner, Elsa Codognato; a secretary, Gianna Trappetti, who was to prove irreplaceable; a driver and warehouseman, Gregorio Simili; and finally Alviero Spingardi, my guide through the bureaucracy maze, and Ventura, a trade-unionist who helped the employer Tirelli to become a frank and honest "boss". In a magazine I found an article that Luigi Einaudi had written about the entrepreneurial spirit. I framed it and it became the first thing to hang on the wall in Via Tevere.

Seventeen years have gone by since then. Some have been very tough. It is not that we didn't have enough work, but actually I had started by incurring a debt since I had to set up a stock of materials, textiles and authentic costumes we could hire out. So, once I paid the social security contributions punctually (one of my fixations as an employer), once I had put aside the money for severance pay and made the necessary investments to ensure some growth, the yearly profits were minimal. For years I allowed myself no private treats at all – no car or paintings. All the earnings I reinvested in the business I believed in.

Gradually, Sartoria Tirelli grew more experienced, healthy, robust and resilient to unforeseen developments, ups and downs in the cinema world, and recurrent credit crunches. If I have made it, I am aware that I largely owe this to the people who, in that distant November of 1964, followed me on my adventure, running the same risks as I did, pouring blood, sweat and tears into the business. I owe it to my colleagues' love for the profession and their great warmth. The "quality" of my tailoring reflects the quality of my assistants. That initial band of seamstresses and cutters has become a troupe, armed with scissors, needles and chalks, still constituting the backbone of the Tirelli company, my second family (and I have no fear of using clichés in speaking in terms of family, as entrepreneurs always do, because mine is truly a tight-knit and mutually supportive family).

Over the years, some members of the team have left us to pursue more independent paths – with much success. Many of my assistants have left the tailoring shop and office to cater to the needs of their husbands and kids. The Tirelli company has been a real matchmaker: it has brought a lot of people luck and paved the way to the altar even for a number of

A trip to Tuscany, 1958: among others, Umberto Tirelli, Alfredo Bianchini, Marcel Escoffier, Franco Zeffirelli, Paolo Poli and Aldo Trionfo; left, in the foreground, Anna Anni

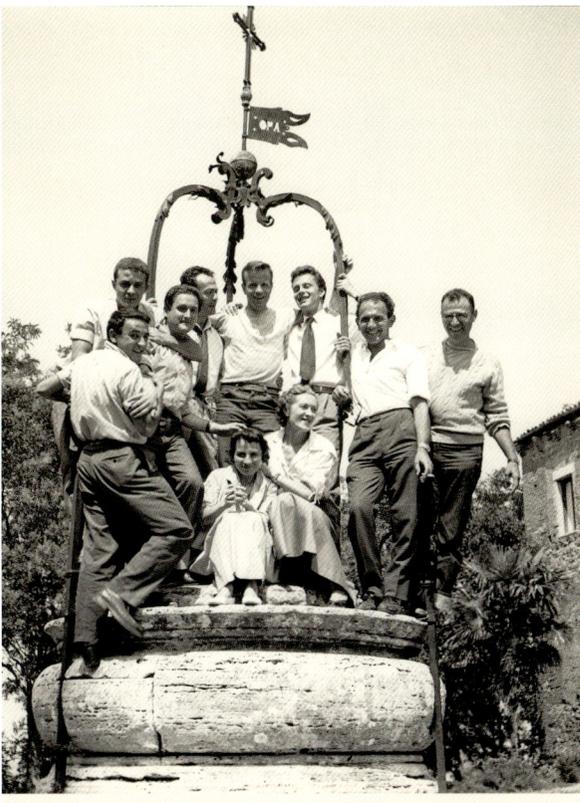

Anna Maria Guarnieri, Anna Magnani and Franco Zeffirelli during a rehearsal for *The She-wolf*, 1965. The photo is dedicated to Umberto Tirelli by Franco Zeffirelli

confirmed spinsters. It has witnessed the birth of no less than forty children – and I am godfather to nearly all of them.

Some employees have turned to different careers or keeping house; new ones have arrived. With heroic endurance, Emilia Severoni oversees my nine warehouses filled with authentic period costumes and my all-consuming passion for fashion archaeology. She is a very straightforward and iron-willed woman and her generosity is contagious. Renzo Lucci manages rentals with a veritable business flair. Jose Fasoli, a very talented milliner, runs the hat sector. Giorgio D'Alberti, a shy blond boy when he first showed up as a replacement for our driver, is now my right-hand for the whole opera sector. Sweet yet stubborn, he is like a son to me. Bruno Pieroni, a leather wiz, is responsible for all the leather goods as well as military headgear and accoutrements. Luigi Morena, professor Cardoni and Pietro Elia manage the whole shebang rigorously and efficiently. Then there is the tempestuous Azucena Antonucci, an excellent external seamstress; Anna Rita Ciccione, our petite yet highly efficient secretary; and Assunta, Marianna and Mariangela, the three guardian angels of my life and home.

In professional terms, who or what is the Umberto Tirelli who at the age of 36 set up his own business? What had I become in those nine years at Safas? This is not a rhetorical question as far as we don't limit the answer to the label "theatre tailor". Actually, I was – and still am – both something more and something less than a tailor, if by this we mean someone who cuts and sews. Now and then I will lend a hand and do some cutting or sewing. But I avoid it as much as I can, since I have inherited from Gita Roux the professional commandment "Ofelé, ofelé, a ciascun il sò mesté" [Each to his own craft]. I think I know everything there is to know about cutting cloth on the bias and on the straight and the choice of the best method for each fabric. I know how they used to cut an *inquartata* in the eighteenth century, I have done my research and collected antique manuals, I have been a zealous, curious and enthusiastic apprentice. As such, I got to join some amazing tailoring companies: Finzi, with three old seamstresses from the Caramba school; Safas, whose rigorous cutting made it a kind of university – a goldmine where each day I would pocket a nugget.

Because I enjoyed their company, but also to speed up my apprenticeship, I used to spend time with the jewellery wiz Giuliano Fratti and with Nicola Zecca, a brilliant, legendary tailor with his own take on French fashion. I learned a lot from both of them. Zecca showed me how moving a quarter of a centimetre dart two and a half millimetres can fix a dress and lend it a distinctive shape. The art of tailoring also involves miniature interventions.

In other words, I've mastered the theory but do not resort to the scissors and needle; I willingly leave those to people who may be less familiar with the theory, less knowledgeable than myself, but who possess the dexterity – unmatched professional and practical know-how. To each his own. But after nine years at Safas, which was mine? More than a theatre tailor, I was – and am – a costumier, a support for costume designers, a mediator between the sketch and the craftsman who will bring it to life using scissors, a needle and a piece of fabric, an organizer of ideas, which must find the right material and technique in order to come alive.

This is the craft I learned at Gita Roux's school. It may be that when I first joined Safas, I was already harbouring the thought of becoming a costume designer. However, I

have never been able to draw more than a rough sketch. Had I shared the outlook of today's generation – and this is not just a grumble from a middle-aged man either, but the reality I experience every day – I would have given it a try. Nowadays very young people join a tailoring shop and have a casual, slapdash approach. Not to speak of the many costume designers whose only credentials are the fact that they are related to the producer of the film – cousins of his wife, sisters of his son-in-law, and so on. I am speaking of bright young people; they may have attended a good art school and know how to use a pencil, but they see sketching as a redundant task, a big hassle. A small show might feature their name and they'll see themselves as full-fledged costume designers, ignoring – or conveniently dismissing – the fact that being a good costume designer, just like being a good engineer, is the result of hard work and apprenticeship. So, no drawings, no sketches. "Who needs them?" they say, given that Tosi and Visconti have shown that the essence is often grasped through the use of authentic costumes, and Sartoria Tirelli has whole warehouses packed with period clothes. Nowadays, roughly 80% of performances resort to this reuse: a designer will show up, open our wardrobes and find ninety of the hundred costumes he needs ready for use. This is a convenient short-cut, but without having first made some sketches, without having defined the look of the show through some serious drawing, it may prove nothing but an illusion with catastrophic effects in terms of the final aesthetic result. Besides, Tosi, a pioneer in the use of authentic period clothing on stage, does not conceive this as some kind of short-cut at all; on the contrary, in his view it involves research, culture, ideas to be refined and carefully pondered through the use of hundreds of meticulous, thorough sketches. There is also much modesty in choosing to use a period costume after having made the effort of drawing five or six with the aim of ensuring a painstaking historical reconstruction, on the grounds that the original costume is more streamlined, more "polished", and that its braids and buttons are impossible to reproduce, even when copied to perfection.

I couldn't draw and was working with costume designers who were so amazing and committed to their work that I felt little inclination to try and get away with a slack job. Especially back then, I didn't have a specific theatrical background that would allow me to identify a character and come up with a tailor-made costume for him, or choose one colour over another. I abandoned my dream with few regrets. What made up for these shortcomings was the fact that I had a good enough eye to know how to fix a costume in the cutting phase, on a mannequin, or during the fitting. And I nourished this talent by learning the theory. I had specialist knowledge of fashion – and have expanded it since. I had extensive experience with fabrics. At Safas I realized that by combining this theoretical knowledge and practical know-how with my innate feeling for the craft, and by delving deeper and deeper into the field, I could secure a rare and vital profession for myself.

Aside from Gita Roux, who was my mentor, back then there were no costumiers, no makers of stage costumes capable of providing valuable support to costume designers, not only at the stage when a costume is about to emerge from its sketch, but also at the planning stage. There were no tailors who could work alongside the costume designers in such a way as to provide full backing for the creation of life-like or fanciful sketches, even influencing his choices by providing this or that material.

Umberto Tirelli, with the help of young Antonia, has Claudia Cardinale try on a costume designed by Piero Tosi for *The Leopard*, 1962
Photo by Giovanni Battista Poletto

Piero Tosi, Silvana Mangano and Umberto Tirelli during the preparations for *Death in Venice*, 1970

Here is a very recent example: *Lady of the Camellias*, Mauro Bolognini's latest film. It was a tough job, even in terms of research, since neither Tosi nor I (although we had always been providing costumes for all periods) had ever dealt with the 1840s: the exacerbation of Romanticism in fashion through overemphasis on refinement – a rejection of Empire-style simplicity and of Louis Philippe's pomp. Having ruled out the possibility of resorting to authentic costumes, which was not an option for that period or fashion, Piero envisaged the use of light taffeta and started drawing some sketches based on this idea. Taffeta as airy as the one he had in mind, however, is unavailable in Italy. At Leuco, a town near Caserta, there is an artisan workshop that still manufactures it, but its prices are prohibitive for any film production: 200,000 lire a metre. Piero was at his wits' end. His sketches called for that taffeta. I reassured him that I would find the lightest taffeta of all at a fair price. Sure enough, I found some in Germany. This is an example – one out of many – of crucial collaboration even before the tailoring stage.

In my apprenticeship years under Gita Roux's wing, I realized that between the figure of the tailor, with his scissors, needle and thread, and that of the costume designer there was a gulf that needed to be bridged with professionalism. I realized that was my job, and one destined to become increasingly crucial: the job of the costume-maker and fashion archaeologist.

Fashion archaeologist. It might come across as a pretentious definition, but I believe it is the one that best describes my love for collecting period costumes and authentic accessories: buttons, buckles, ribbons, plumes, braids, aigrettes, sashes, dalmatics, trimmings, gloves, hats, bustiers and handbags.

Coincidences, convergences or what – to use a literary expression – we might refer to as "elective affinities" play an important role in life. No doubt, Visconti, Tosi and Gita Roux helped me appreciate the value of authentic things, instilling in me the idea of "second-hand" clothing through their example. For anyone following Gino Carlo Sensani's teaching, searching for period costumes that could be used on stage was an inevitable, natural process. There is nothing more intrinsically theatrical than to reuse real items by retrieving them from attics or old forgotten wardrobes and bringing them back to life on stage.

When I first got a place at Safas, Visconti and Tosi were just starting to go wild over that discovery, which struck me as a Columbus' egg but required a lot of effort in terms of research. It was like feeling your way in the dark since, especially in Italy, that was still year zero. To tell the truth, at the public level we have yet to move beyond that stage, considering that although tailors have been responsible for one of the few assets on Italy's balance sheet for the last few decades, there is still not a single fashion museum in the country. Visconti

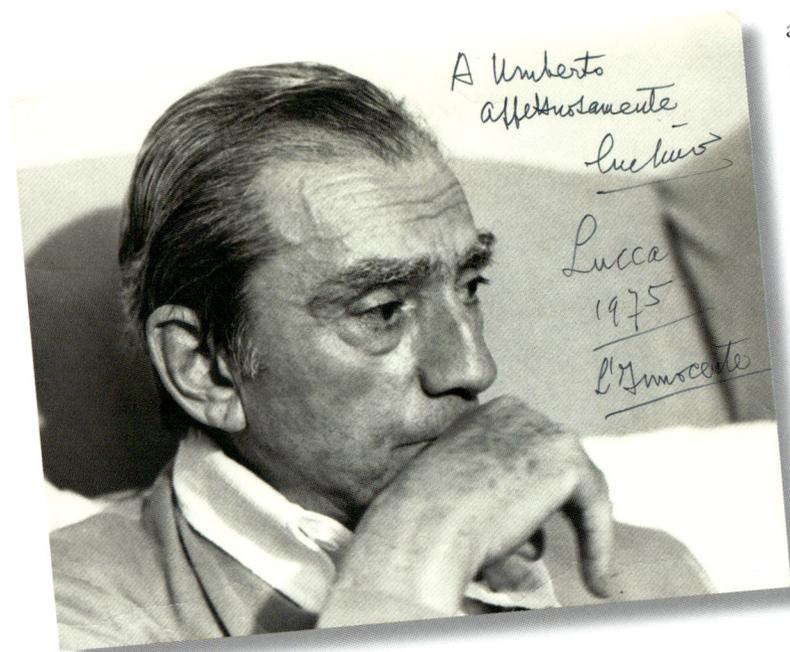

Luchino Visconti during the shooting of his last film, *The Innocent*, 1975. The photo is dedicated to Umberto Tirelli

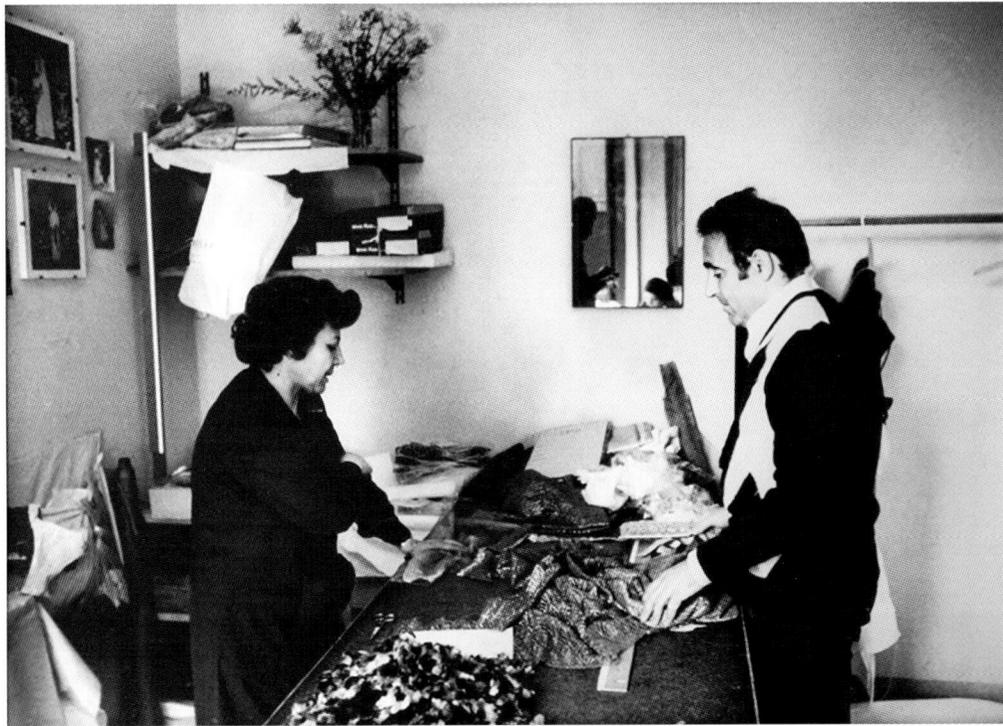

and Tosi were wild with excitement and they got me involved in ferreting out costumes. They saw me as a beginner who was even more enthusiastic than the pioneers themselves, as a catechumen who outstripped the apostles in the knack for finding sources of authentic costumes, scouting attics and decrepit old chests. It was then that I discovered my innate love of fashion relics, of a past whose traces lie piled up in people's attics. In fact, I realized that if fate had led me to make this leap into the world of theatre, it was precisely because of my previously unacknowledged passion: afternoons spent exploring the chests of the Bigi family at Gualtieri and pulling out old drapery, remnants of outmoded fabrics and unsold suits from the 1920s; or rummaging through the Guarienti family's attics at Villa Malaspina Torello and finding the grandmother's moth-eaten evening dress, which I could use for the leading actress of our somewhat irreverent amateur theatre evenings as evacuees. Besides, even my debut at Finzi's had been marked by a sort of obsession for those vast, enormous wardrobes packed with costumes that had been hired out countless times – wardrobes steeped in the history of dressing up.

In other words, I was highly vulnerable to authentic period clothing. And the disease I contracted is one I have never got rid of: acquisition fever, the pleasure of discovering an eighteenth-century dress in some abandoned chest or a 1927 Vionnet lying in the wardrobe of a Roman princess. The end result was nine warehouses filled with anywhere between ten and fifteen thousand period costumes. Most of them cover the century between 1870 and 1968: flamboyant crinolines by Worth, the leading tailor of European courts and of the actresses Sarah Bernhardt and Eleonora Duse; evening dresses by Balenciaga, Dior and Jacques Fath; Italian fashions by Gandini, Zecca, Ventura, Biki, Marucelli, Fabiani, Forquet, Schubert, Galitzine, and especially Roberto Capucci, whom I regard as the only great tailor we have today.

For all the ups and downs it has experienced over the years, my "museum" traces the history of four centuries of fashion (and I am using inverted commas partly out of modesty and partly because all the items are obviously stored in wardrobes, in warehouses). It brings traces of this history to life: the fifteenth, sixteenth and seventeenth centuries; the drastic rebellion of the French Revolution, when women ditched their

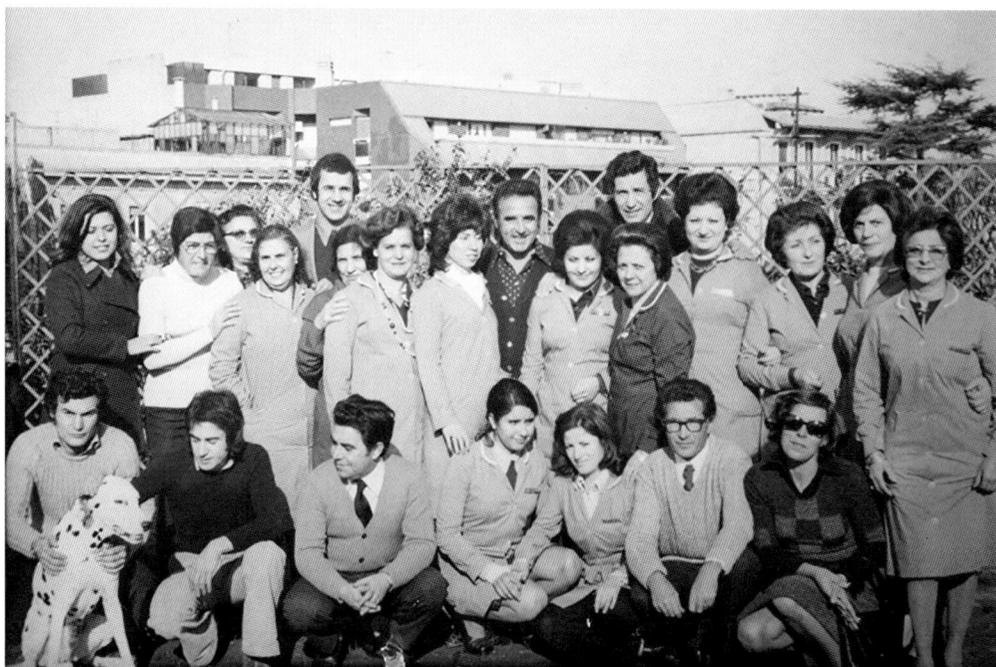

Group photo of the Sartoria staff on the terrace of the Via Settembrini premises, Rome, late 1970s; in the centre, Umberto Tirelli

wigs, hoops, corsets and satin, covering their bare flesh with white batiste blouses; the first Empire; the comeback of the corset; Romanticism, with its frills, satin, birds, flowers and velvet; the empty pomp of Louis Philippe and the triumph of vulgarity during the Second Empire, with its riot of crinolines, diadems, ringlets and trains.

The "museum" is better supplied – with no ups and downs – for the period starting from the last glimmers of the age of Napoleon III, when Eugénie de Montijo and the Countess of Castiglione would vie with one another for the fanciest skirts and underskirts – extending at the back through huge hoops – with Worth diabolically doing his best to promote the use of crinolines. Two wardrobes illustrate the revolutionary turning point of 1880, when Worth made a clean slate of the past and the tradition he had been following in order to help the Empress of Austria, a loyal and most generous client of his.

Elizabeth was to be crowned Queen of Hungary, and turned to Worth for advice on what gown to wear. She had passed the forty mark, and it showed on her face; however, by following a regime of lemons, gymnastics and horse-riding, she had kept a youthful figure. Worth realized that he needed to make the most of that wonderfully slender body – an unusual choice for those years. This led to the creation of Elizabeth's legendary pink dress, laced with pearls and edged with white marabou: a figure-hugging design, a tight-fitting skirt with a small *coulisse* at the back and a really long *tournure*. The same years also saw the introduction of long white gloves of *chevreau glacé*, as Elizabeth was obsessed by the ugly hands she had inherited from the Bavarian royal line, and her arms showed the ravages of time. The new style took on, sweeping crinolines into the attic, and endured for over a decade, with a few changes: in 1886 it grew richer, more complicated; in the 1890s it regained its simplicity; in the 1900s it became more lissom and graceful.

Countless other wardrobes illustrate the revolution brought about by Poiret in 1911. While expecting his female clients to watch their weight, the portly Poiret – a man who had a remarkable weakness for fine dining – hardly practised what he preached, advocating the banning of corsets, freedom of movement, shortened skirts. My nine warehouses progressively offer tangible testimonies of Chanel's talent; the 1920s of the Callot sisters, Paquin, and Moulineux; Madame Vionnet's bias styles, which lightly wrapped the material around the female body; the 1930s of Schiaparelli and her

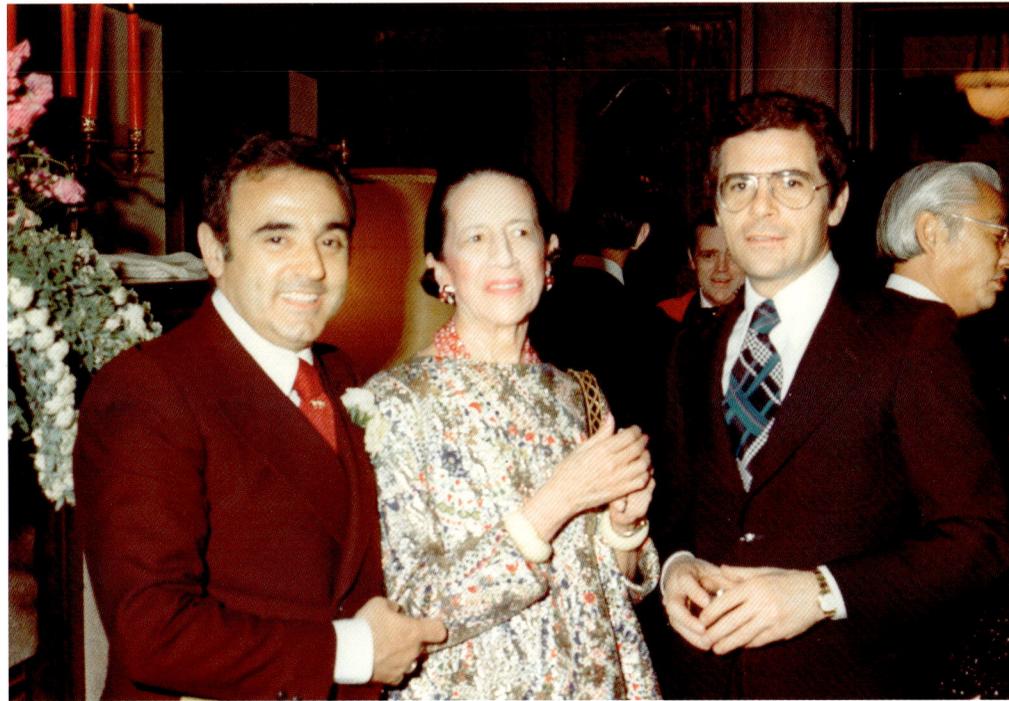

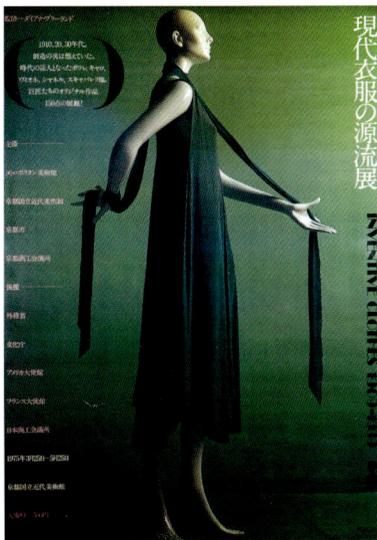

Poster of the *Inventive Clothes* exhibition, Kyoto, 1975

Gallenga was more of a textile designer than a dressmaker. As the latter, she only ever created three or four prototypes, which were then repeated over time with a few alterations. However, these were all items of outstanding taste: chiffon tunics, at home dresses, cloaks and the softest velvet jackets. Her secret lay in the fabrics used, mostly chiffon and silk velvet; her main colours were sparkling light blue, black, magenta and blood red; the patterns were either gold or silver. Vying with Fortuny, Gallenga had actually invented and patented a method for printing in gold or silver on all kinds of fabric. The innovation, I was told, lay in the binding agent they used.

I found a few other Gallenga items in the Gazzoni sisters' treasure trove. This became a real fixation for me, an actual obsession. Then one day, I got a call: "Gallenga speaking. I have a large stock of things that belonged to my mother. Would you be interested?" I struggled to hide my enthusiasm, as business etiquette and tactics required. I immediately called a taxi and sped off to Via Ludovisi, to the furniture shop which Gallenga's son, who was an architect, had opened exactly where her atelier had stood – as I learned later. At the back of the shop were large Art Nouveau wardrobes filled with outstanding pieces. The collection consisted in fifty-odd items, including cloaks, evening dresses and scarves; a few lampshades and piano-covers; a large range of velvets and chiffons with perfectly preserved weaves and colours; the patent for the new printing system; and 7,000 wooden blocks. Some of these were hand-sculpted, others machine-cut, and they came in all sizes (from one centimetre to 10 × 10 centimetres) with a stunning range of patterns (Roman, Byzantine and Renaissance, inspired by the paving of Siena Cathedral, Art Nouveau and Art Deco). I fell head over heels. I felt love-sick. Gallenga's son, however, did not take advantage of me. He could have exploited my unrestrained enthusiasm, but he didn't. I didn't have the money to buy everything and told him so. He gave me the option to pay a little at a time. But it was still too big a commitment for me. I had just finished a good film, *The Conformist*; in fact, an excellent one in terms of artistic rendering as well as the contract it had brought us. Much to my administrators' amazement, I chose to invest all our profits to purchase at least the dresses from this perfectly preserved collection. Gallenga agreed to sell me that part of it and assured me that I could reserve the option to purchase the rest as well.

A sketch by Umberto Tirelli

it's not linen. Come and see". I rush there and find dozens and dozens of clothes from the years 1905–10 in the trunks.

In the early years of this hunt for period costumes, I would also resort to classified ads. I would use them as an archaeologist might use prospecting instruments: "I buy 1930s tailored clothing"; "Wanted: officer uniforms from the Libyan War". Now I no longer need ads. People who wish to clear out their wardrobes and sell their grandfather's Caraceni, or aunt's Dior, know that Tirelli means business.

I have met amazing people: old admirals moving house who open up wardrobes packed with uniforms, a real life story; impoverished *grandes dames* well past their prime who sell me a Balmain, reminiscing about a soirée made unforgettable by that dress; daughters who want to get rid of their mothers' clothes, not without a touch of embarrassment. I have made some truly unique discoveries, including rather awkward ones, since wardrobes often reveal unspeakable private secrets…

I have never got over my feverish buying and this archaeology has become a crucial part of my job, the very hallmark of my company. For sixteen years I have been raking in authentic "pieces" and have no intention of stopping. Each day I buy something – and not just dresses, but also accessories, costume jewellery, fabrics and other period items. By now I have developed a kind of radar for the authentic clothing that may lie behind the most nondescript shop windows. I am a back-of-the-shop mouse. I fly off to Milan when I learn that a shop specializing in plumes is closing, and find a range of old feathers. I run off to Siena before an old hat shop shuts down and return to Rome with a couple of thousand top hats, bowler hats, Gibus hats, panamas and homburgs. I go back to Milan and pick up miles of satin and silk from Sassi the "sketcher". Sassi was closing down and allowed me to pay him in instalments over many years. Often I need neither radar nor informers because people will get in touch with me of their own accord, knowing that in the whole world there is only one loon who is likely to swoon over a single nineteenth-century button.

In the Via del Tritone area there used to be a haberdashery, the most elegant and traditional one in Rome. When I was working at Safas and was in charge of materials, I had never visited the shop because it was too expensive, but was itching to do so. One day I got a phone call: it was the owner of the store. He was 65, his mother 90. "We've decided to retire, Mr Tirelli. We're selling everything, and someone mentioned your name." Half an hour later, I was there. It was a real heaven filled with items from 1907 onwards: laces, fringes, buttons, buckles, scarves, garters, braids, ribbons, cabochons, cords. I bought everything, including the chests of drawers in the warehouse, paying bit by bit. This is my most recent block purchase.

Another phone call, eight years ago, introduced me to the Gallenga paradise, possibly my most thrilling archaeological discovery. Over time, through classified ads, I had purchased two cloaks and three or four dresses in gold and silver patterned silk. I thought they were by Fortuny, the legendary textile designer of the 1920s and 1930s. Actually, those finds were labelled Gallenga. After all, Fortuny's textiles were mostly interior design fabrics, whereas these "pieces" I had chanced upon were less ostentatious, less theatrical and more couturier-like. I was fascinated by that signature, that style. After a little research in the library and a word with old Roman fashionistas, I knew all there was to know in order to solve the Gallenga mystery, which was only a mystery because of my ignorance: from the aftermath of 1918 to the eve of the Second World War in 1940, "Madame Gallenga" had been running her business in New York, at the Paris Ritz and in Rome, designing clothes for the hyper-snobbish, hyper-sophisticated customers of Chanel, Vionnet and Paquin.

Balthus, Romolo Valli and Umberto Tirelli
at the opening of an exhibition at Villa Medici,
Rome, mid-1970s

The clothes I used to find in Gazzoni's warehouses did not look like rags at all. That's where 60% of my finest "pieces" come from, including some evening and day dresses owned by Queen Margherita, Queen Elena and Maria José. Concetta Gazzoni began her career as a seamstress. Towards the end of the nineteenth century, she had a breakthrough: she started purchasing second-hand dresses from the *grandes dames* of the Roman aristocracy – nobles by birth or income. She would make them as good as new and sell them to middle-class or lower-middle-class ladies. These could hardly be regarded as second-hand dresses: for the Borghese or Colonna princesses and for the stars of Roman society – those who used to swoon over the young "Duke Minimum" Gabriele d'Annunzio – it would have been quite unthinkable to wear and show off the same designer creation, be it an evening dress or fox-hunting outfit, more than once or twice.

This seamstress near Santa Maria Maggiore was doing good business, but her "suppliers" would change their wardrobe faster than her customers would make their purchases, so the clothes kept piling up. Considering that Concetta Gazzoni had spent the years between 1890 and 1946 rifling wardrobes, it is easy to imagine the masses of clothes she had collected: five flats crammed with fashion items by designers ranging from Worth to Balenciaga.

As for me, I had stumbled upon this collection almost by chance and it was a real joy. The place run by that bright old lady and her two nieces, Assunta and Giovanna, soon became my second home. Each month, once I had done the costumier accounts, I would rush off to them and pick something from the pile, depending on how much cash I had. I have been "mining" those deposits for the past sixteen years. Concetta Gazzoni has passed away, as have her nieces Assunta and Giovanna, yet the mine is not yet exhausted. Now and then I get a phone call from Gazzoni's heirs, really civilized people: "Tirelli, you were right. We finally opened those two trunks. No,

A gouache by Balthus for Tirelli

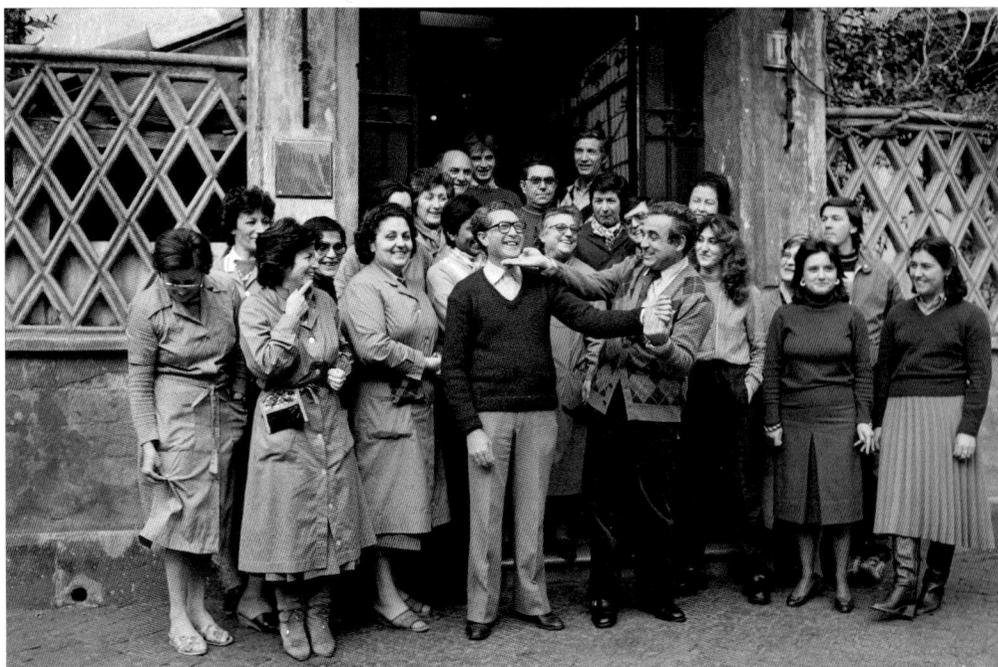

partnership with Dalí and Cocteau; Balenciaga's "architectures"; the "new look" of the post-war period, with Dior's return to the corset and the *guepière* – almost to the eighteenth century, with satin, white tulle and *points d'esprit*; and the late Chanel, with her Italian period.

The "museum" covers the centuries until 1968, which marked the end of fashion as a cultural phenomenon. Nowadays it all amounts to copying: there may be some intelligence behind it – certainly, there is financial acumen – but the kind of inventiveness and feelings that would take root in culture and renew it now belonged to the near and distant past.

Nine warehouses, 15,000 authentic pieces: I am the only person in the world to have invested his money, time and hard work in this fashion archaeology. As soon as I had opened my costume-making workshop, I started buying things and "excavating" attics, searching for "rags" in junk shops, basements and storerooms. Of the five million that I had obtained as a loan to set up my own business, one was immediately invested in period costumes. I spent years counting my money down to the last penny to see if any could be put aside for this kind of investment. I would call my accountant every evening: so much for the rent, so much for the electricity and phone bills, wages, social security contributions and fabric suppliers. I would do my accounts and any extra would be spent on authentic clothing.

For years, even if I had managed to put five or six hundred thousand lire aside, I would never dream of changing my car, or going on holiday to some exotic location. Marché aux Puces. I have spent countless weekends rummaging through piles of old clothes. And what wonders I have found! Poiret, Chanel, laces and embroideries by the Callots or Schiaparelli, jumbled on the floor among filthy old trousers and tattered tracksuits. I would be joined on my archaeological expeditions by Lila de Nobili, Pier Luigi Pizzi and Jean-Marie Simon, a costume and set designer who has made a successful switch to directing. We would set off at daybreak in order to have the first choice: filled with anxiety, we would get up at an ungodly hour, and quite pointlessly so – since no one paid any attention to those mounds of second-hand clothes. The second-hand dealers – I will never forget Madame Tricorne's stunned expression – would react with amazement whenever we turned down a bargain Gallé vase, asking instead the price of what looked like an old rag.

I returned the following year: I had saved a little money and brought home the textiles. All that remained now were the printing blocks and the patent: the biggest expense. Gallenga was unusually considerate. My enthusiasm had won him over: "Look, Tirelli, I won't sell them to anyone else. I'll wait until you're able to make the purchase". I was able to make it, in instalments, two years later. My accountants had already told me I was crazy, and this time they really drove the point home. But I felt confident and was ultimately proved right.

Gallenga's blocks and printing system (I even tracked down the German company that supplied her purpurin and silver dust; destroyed during the war, it has now reopened and streamlined its production) enabled me to create the costumes for some of the most successful productions in my career and to consolidate work relationships and creative partnerships with costume designers. I made Gallenga's art available to them – they had already caught a glimpse of it through certain operas, films such as *The Iron Crown* (1941) and the accounts of those who had experienced the fashion of the 1920s and 1930s. I made Gallenga's art available, and the result was visually striking costumes and sets. Let me give a few examples. I remember two versions of *Simon Boccanegra* in Chicago (1974, with Pizzi as set and costume designer and De Lullo as director) and at La Scala (1978, with Frigerio as set and costume designer and Strehler as director): while very different, they both featured Gallenga's work, since I had the 7,000 printing blocks and their visual rendering varies significantly depending on whether one prints on a shiny or opaque surface, on velvet, chiffon or a cheap fabric. Frigerio used Gallenga's work for the London Royal Ballet's *Romeo and Juliet* choreographed by Nureyev. The Gallenga-Pirandello alliance proved a real success, not least thanks to Pier Luigi Pizzi's stunning sets featuring Gallenga prints for *All for the Best* (1975). I'm indebted to Gallenga for the possibility to create really sumptuous designs for shows with shoestring budgets, ones which actually were only rich in "rags" – as in the case of Ronconi and Pizzi's *Orlando Furioso* television film. The Tirelli-Gallenga brand has carved a niche for itself even in the fashion field (for Gallenga this was a comeback, whereas for me it is the only sortie I have ever made

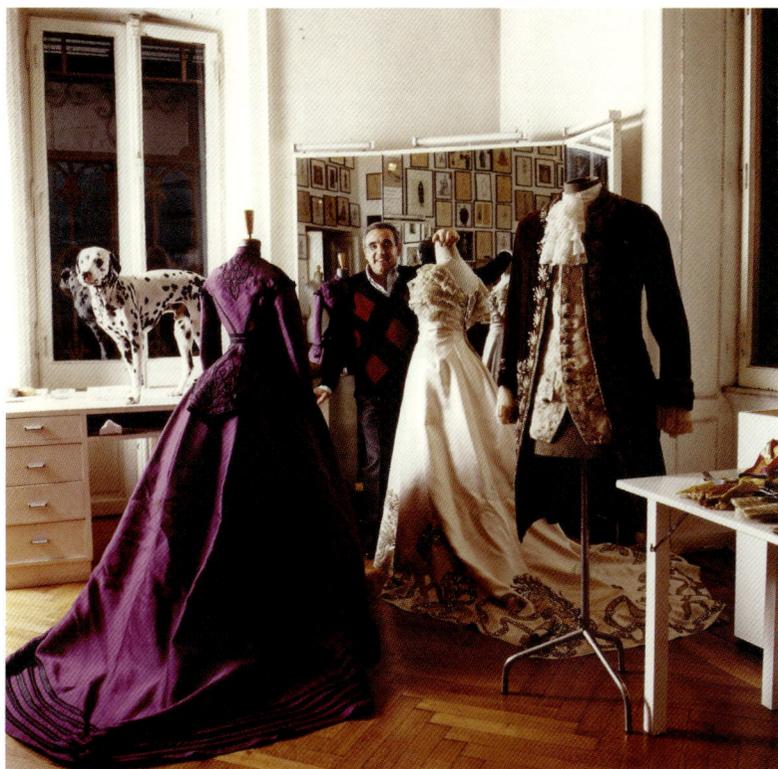

Umberto Tirelli in the fitting room of the atelier on Via Pompeo Magno in Rome with his Dalmatian Dindo, 1983
Photo by Cristina Ghergo

beyond the field of theatre costumes). My Fendi friends, those clever she-devils, often visit my warehouses, rummaging through my archaeological "finds" in search of inspiration: a handbag, a hat, a suitcase, a coat. One day, they discovered Gallenga's cloaks, the original fabrics, the printing blocks. Amazed, they suggested we print some velvet for evening handbags. For the past three years, under Fendi's aegis, the Tirelli-Gallenga duo has been working quite well, finding a good market.

This is only one of the many positive consequences of my frenetic passion for fashion archaeology – a real monomania. Mine is a kind of collecting that is actually applied to work: first of all as a study of cutting, solutions and fabrics from real life; then, when required, as the historical reconstruction of costumes to the height of perfection; and finally, as the use of many authentic clothes in theatre or cinema. Clearly, not all items can be hired out. While eighteenth-century men's clothing can withstand use on stage, it would be sheer folly to hire out super-delicate women's costumes: it would mean

ruining magnificent silks. However, even these unique finds can be put to good use: they can be photographed or filmed close-up.

Mine is a passionate pursuit applied to work – not a form of speculation. The balance is always in the red, apart from my material assets. For although I am the one who really creates the market, since I am practically the sole purchaser, I have never taken advantage of the situation to "shake down" second-hand dealers, old seamstresses, *grandes dames* fallen on hard times, people wishing to clear out their family wardrobes and decrepit, retired generals who wish to earn something by begrudgingly parting with old uniforms from their war days in Libya or the Carso.

How did Umberto Tirelli succeed in becoming the founder of a costume-making company? As noted above, in the momentous year of 1964 he was 36, since he was born on 28 May 1928 at Gualtieri. This town, half way between Reggio Emilia and Parma, is in the province of the former city but, from a cultural perspective, rather closely dependent upon the latter – at least as far as the young Umberto was concerned. He had been christened with the name of the heroic aviator Umberto Nobile, who in those days had been reported missing during his famous expedition to the North Pole. Our Umberto was the youngest of four siblings; one of his sisters passed away at a very young age. His parents were strongly attached to the land. Umberto's father, who met an untimely death during a bombing raid in 1944, traded in corn and ran a winery, although in the early 1930s he had left everything to emigrate to Argentina on his own. His wife got by opening a pork butcher's shop and a transport café. When his father returned a few years later and reopened his business, the family was able to live comfortably again. It is not easy to see in Tirelli's background the seeds of an international career in show business. Indeed, although at one stage Umberto broke away from his parents to try his luck elsewhere, not only did he never sever the umbilical cord connecting him to the milieu in which he had been born and raised, but always took great pride in his enduring relationship with his home-town and its citizens. When he sought to understand the origins of his vocation for art and the theatre, his mind would usually turn to the books that in his youth had made up for his lack of interest in conventional schooling, as well as to his early fascination with music in general and especially opera, which was very popular locally. Most of all, perhaps, Tirelli connected this with his attraction to the high life, which in those post-war years – in the provinces as much as in big cities – consisted in endless parties and private entertainments, including many masked balls. Another native of Gualtieri who still owned a house there and spent a lot of time in the town was Luigi Bigi, one of Milan's leading couturiers. It was through the lively parties he gave that Umberto discovered his talent for wielding the scissors and using colourful offcuts to create fanciful, improvised costumes for himself and many friends of his age.

Giorgio Sarassi, who was also from Gualtieri and had made it big in Milan by specializing in haute-couture fabrics with Bigi's support, found Umberto his first job. At the age of 24, Umberto had been a lazy student and was now eager to get to work. He was hired as a shop assistant in a knitwear boutique in Via Montenapoleone. A few months later he was managing an upholstery wholesale store; then, after an even shorter stint in another knitwear shop, early in 1953 he was hired by Sartoria d'Arte Finzi: Costumi per Teatro, also in Milan. This long-standing costumier had just been purchased by a couple of friends of Umberto's, Pia Rame and Carlo Mezzadri. In the past it had not really operated as a costume-making business at all. To quote Tirelli:

Finzi had done very well by hiring out party outfits and carnival costumes. This is what ensured the company's revenue even when Rame-Mezzadri ran it, only with

increasingly narrow profit margins – despite the fact that masked and carnival balls seemed to be making a comeback in the post-war period.

It was the carnival of 1953 that made me realize that was my world. Customers would come and go. They would ask us to turn them into Julius Caesar, Verdi's Aida, Empress Sissi, or Puccini's Mimì. I would persuade beauties to put on a hump and young lads who styled themselves after the Sun King to show up at the ball as Nijinsky's faun. In my hands, Camilla Cederna became Christina of Sweden…

Soon, however, the enterprising new Finzi management found a way to latch onto the theatre boom, which Milan was experiencing in those years through the relaunch of La Scala, and which was not limited to Giorgio Strehler's early golden years at the Piccolo Teatro. Then there was television, which was about to burst onto the scene. The young Umberto realized that he had found an ideal milieu.

I owe a great deal to Pia and Carlo, especially my love for the challenges that theatre presents, even when approached with the utmost professionalism. We would bend over backwards, we would improvise. We would win a contract for *The Merry Widow*, for example. We would study the sketches drawn by Maurizio Monteverde, who had just embarked on his career, and would get busy; but we would have so much work on our hands that a week away from the deadline hardly a quarter of the costumes would be ready. So we would rush to Remigio Paone's warehouse, rent what we could find, and adjust and adapt the costumes to suit our needs – a stitch here, a trimming there. We would then hire everything out again to the studios in Corso Sempione, bringing home a little profit. In other words, we were always racing against time, always working under pressure, yet always cheerfully: a really crucial apprenticeship for an aspiring costumier.

Umberto Tirelli took a major step after a couple of years of this hectic yet stimulating work when, in October 1955, he left Milan and moved to Rome. Here – with the backing of leading set and costume designers of his generation, like Danilo Donati, Piero Tosi and Franco Zeffirelli – he was taken on by Safas belonging to the two Maggioni sisters, Baroness Emma Cappabava and Mrs Gita Roux.

In 1942–43, when the war was at its height, the two sisters had taken over Safas, which had been opened a few years earlier and had chiefly "served" the cinema world and, within it, Gino Carlo Sensani and his cultural revolution in the field of costumes. In the post-war period, with the resurgence of the theatre and cinema, the tailoring shop had broadened its horizons: as an economist would put it, it had taken off. The jewels in its crown, under the Maggioni sisters' management, were Chekhov's *Three Sisters* and *Senso*, two of the masterpieces signed by costume designers Marcel Escoffier and Piero Tosi – and of course by Luchino Visconti, who adored the two "old ladies" and would spend hours in their spacious studio-cum-salon, scrutinizing their work from a black velvet armchair.

The two sisters were remarkable women. The baroness would take care of the contracts and management, Gita Roux was responsible for the workshop. By altering, mending and juxtaposing the right colours, she would turn an old rag into a costume with that certain "je ne sais quoi" that is the secret of success.

In his memoirs, Umberto Tirelli clearly points to the three crucial elements in his training as a costume-maker that really influenced the way he shaped his own business. One of these elements, which has already been mentioned, is his almost obsessive quest for truth, verging on a virtually manic form of collecting. This is what ultimately turned his collection of authentic

Piero Tosi, Maria Callas and Umberto Tirelli in the tailoring shop during the preparations for *Medea*, 1968

clothes and accessories into something truly unique and unprecedented. The second element is Tirelli's rigour in crafting period costumes, a rigour based on the understanding and exact reproduction of old techniques. The third element, the crux of his own creativity, is Tirelli's feeling for how to render costumes: in his view, they not only had to "be" original but also needed to "look" it. Another page of his invaluable memoirs may provide a better idea of what often lies behind a stage costume.

We made her try on the costumes. I pinned, tightened and shortened them. Piero Tosi, the costume designer, was very apprehensive. A great silence reigned. Maria Callas looked at herself in the mirror and said: "Now, I am Medea". Tosi couldn't believe his ears. In the tailoring shop, while we were working on the costumes, he had repeated again and again: "Just think of when Maria arrives and we get her to wear these rags. She probably imagines she will be playing Medea dressed in satin and we are giving her some grandmother's cast-offs!".

These truly were rags – a deliberate choice. The idea was Tosi's, who had been entrusted with the costumes for *Medea* by Pier Paolo Pasolini. There was the risk of resorting to the usual tunics, the usual Greek stereotypes – the well-worn cliché. Providing a historical reconstruction of the clothes of the period was quite impossible: we had nothing to support us, no models. Authenticity could perhaps only spring from the fabric and the way it was worked. But which fabric? Those grandmother's cast-offs, that cheap fabric of the sort upholsterers use for the underneath of sofas. Grandmother's cast-offs and hospital gauzes, kilometres of which were purchased from healthcare suppliers. No one had ever used such poor material for a costume. We were the first to do so and, since then, grandmother's cast-offs have made a triumphant debut in fashion – not theatre fashion, but that of leading couturiers and prêt-à-porter.

This would have remained a half-baked idea, however, had the stratagem of employing this material not fully developed through the way it was treated. We reverted to ancient, primordial methods. We set up a makeshift dye-works in the tailoring shop. Even before *Medea*, we had touched-up a few colours using Superiride products. But we had only done so with offcuts, ribbons and laces. It was now a matter of dyeing hundreds of metres of fabric; and we did so also by using natural dyes: lemon rind and chamomile for some yellows; nettle for some greens. We did away with irons in favour of hand-pleating. We wet the grandmother's cast-offs, pulled them taut, did some running stitches to make the gathering, then left them to dry in the sun: this would make the plissé permanent. Nowadays it is a popular technique in the fashion world. Tosi and I pioneered it. We even brought the sewing machines in our tailoring shop to a halt. In the costumes for *Medea* there is not a single stitch that has not been done by hand.

After dictating these memoirs, Umberto Tirelli remained at the helm of his innovative company for a decade of further successes. However, his health started to deteriorate a couple of years before his death, at the age of 62, on 26 December 1990. As prudent on the practical level as he was impulsive and inventive on the artistic one, Tirelli had thought of his succession and especially of the future of his business well in advance. One of the steps he took was to turn it into a limited company: in his will he nominated his partner Dino Trappetti as the majority shareholder, parcelling out the other shares among trusted employees and external collaborators – particularly those costume designers who over the years had most contributed to the development and prestige of the business. A further change in the name of the company

occurred in 2010 with the establishment of the Fondazione Tirelli Trappetti, which inherited the collection of original costumes and sketches. Today the company has around twenty employees, including cutters, tailors, assistants, warehousemen and office staff. The collection of period clothing has continued to expand, and since 2007 the contents of the various store-rooms have been brought together in a huge 5,000 sqm warehouse at Formello, near Rome. Stored here on display – meaning, on racks rather than in boxes as used to be the case – are over 5,000 authentic costumes and over 170,000 costumes crafted by the tailoring company, arranged chronologically according to decade and social class, and all available for hire.

Umberto Tirelli's book of memoirs, which I have extensively drawn upon, is the best way to bring his voice and personality back to life. Here Umberto paints a faithful picture of himself, without understating his voracious appetite for life and its delights: he had been an insatiable seeker of strong emotions, both aesthetic – ever since he became an assiduous galleryite of La Scala – and concrete ones, such as those he got from the fine view afforded by the Capri villa he had purchased with his sweat and toil, or indeed the ravioli and Lambrusco wine of his native land, which he and his family had continued to produce and enjoy. He never sought to conceal his thirst for life, friendship and merrymaking; in fact, he openly proclaimed it to the world. When favourably – or, more rarely, unfavourably – struck by something, lowering his voice was the last of his concerns.

Although he does not state it in his memoirs, Umberto Tirelli was also extremely generous – impulsively so, with no further motives. I first met him in the 1950s, as a friend of friends who were then studying acting at the Academy of Dramatic Art (which he himself had considered attending). I met him countless times over the following years, but if I were to conjure up a specific memory of him, it would be an evening in 1961. We had just seen the première of *Romeo and Juliet* at the Old Vic in London, directed by Franco Zeffirelli, who had only recently entered the field of drama and had just made his debut in England by staging none other than Shakespeare. Umberto, who at the time was sharing a large apartment on Via dei Due Macelli in Rome with Zeffirelli and Mauro Bolognini, had come to support his friend, along with a small group of other people. After the show, we ended up in some dimly lit pub where everyone seemed to be talking in whispers: they didn't look like the supporters of a winning team. The atmosphere was ambiguous. The audience at the theatre seemed to have enjoyed the performance, yet no one was willing to speak his mind. The triumph only came a few days later, on Sunday, when a rave review appeared in *The Observer*, signed by the leading theatre critic Kenneth Tynan. We Italians formed a group and talked among ourselves. The English actors boozed away, discussing other things, as English actors usually do. Sitting on her own, with a rather sulky look on her face, was the actress who had played the part of Juliet, a certain Judi Dench. Who knows, perhaps she wasn't quite happy with her performance, or perhaps this was only her particular way of releasing the tension of her debut with that strange foreign director who had introduced so many bold innovations. In any case, she was not being made a particular fuss of. Out of shyness or awkwardness, none of us made any effort to speak to her; besides, she herself did not seem too eager to strike up a conversation. The very moment he saw her, however, Umberto dashed over to her, bombarding her with compliments in his broken English in an attempt to express his admiration. Seeing that the actress remained aloof – possibly embarrassed at the sight of that hothead – and no longer knowing what to do to make himself understood, Umberto rummaged in his pockets and took out a small jewel that had belonged to his mother (it might have been a brooch, ring or necklace), a talisman he never went without, and gave it to her, obliging her to accept the gift. Then, leaving her puzzled and somewhat dazed, Umberto rejoined our small band of *suiveurs*. "I absolutely had to give her something", he said. "But I had nothing more valuable on me".

Dino Trappetti

THE STORY CONTINUES...

I could never have imagined how a visit to the costumier Safas to try on costumes in June 1960 would change my life.

When I was around 17 I had joined an amateur dramatic society in the post-office employees club-house in Rome, on Piazza San Macuto, where I was introduced by a friend of my family who had a passion for the theatre, just like me.

The director made me read a piece, said I had a good voice and an acceptable presence and that they actually needed a "young actor".

That experience was very useful indeed, it made me "grow up": they taught me to smoke (I had never smoked, it wasn't allowed at home), to move, to pitch my voice. My debut was a classic "Dinner is served": as a waiter in a white jacket, I carried a tray with glasses and served drinks and so on.

Then I began to play roles. I had the nerve to tackle Noël Coward, Pirandello, d'Annunzio, Tennessee Williams; and I was happy, I was nourishing my passion for the theatre. I had seen some plays put on by the Compagnia dei Giovani (including *The Diary of Anne Frank*) and had been enchanted by Anna Maria Guarnieri and Romolo Valli; I had the part of Peter, who was then played by Luca Ronconi (unthinkable).

But I couldn't study drama because my father had set me on the road to technology (quite rightly, as he saw it); the era of television was just beginning, but I didn't understand a thing.

My natural inclination towards history, culture, music and the theatre had not been taken into account at all. I adored dancing and learned steps from the television or films; I organized parties at home and moved all the furniture; my friends called me "Rudy", Rudolph Valentino.

With great difficulty I managed to get a diploma in telecommunications and found a job immediately. At 18 I was employed by an important company; to my father's joy and to my grief.

I went to university and enrolled in the Faculty of Electronic Engineering, but I was very slow. I was working and in the evening I would go to the amateur dramatic society, where Andrea Camilleri had been the director before I arrived – then he had gone on to work at the RAI – and where there had been actors who later became famous, such as Gabriele Ferzetti.

My ambition was not so much to become an actor as to work in the theatre and fate was good to me. We were rehearsing Goldoni's *La locandiera* (*The Mistress of the Inn*) in which I was to play the Count of Albafiorita. Until then when we needed costumes we went to small inexpensive costumiers, but for Goldoni the director decided that we had to make an effort and go somewhere that had a name, and that is how I happened to find myself at the famous Safas on Via Margutta that supplied the costumes for the stars of films by Visconti, Castellani, Bolognini and Zurlini.

Umberto Tirelli was the manager and he greeted us very kindly and called an assistant saying "Let's find some eighteenth-century costumes for these lads, who are

staging *La locandiera*"; then he added, "Of course we can't give them the Visconti-Tosi ones, they need a more classical eighteenth-century style". In fact, a few years earlier, in 1952, Safas had made the costumes for a memorable production of *La locandiera* with Rina Morelli, Paolo Stoppa, Marcello Mastroianni and Giorgio De Lullo, directed by Luchino Visconti, with sets and costumes designed by Piero Tosi.

Then Tirelli came to see the play, paid us compliments, subsequently invited the whole company to dinner and said we could come back to Safas for future shows and he would give us a big discount.

We became friends. It was 1960, I was 20, Umberto was 30, and at that time we certainly felt the age difference; but he was very nice, amusing and cultured.

I was going out with a lovely girl and during my military service in the navy we wrote to each other every day; when I finished we began to talk about getting married. I was very worried, I was discovering a new world, I had so many ideas, marriage scared me and we broke up.

I felt freer and my friendship with Umberto became closer.

He invited me to dinner with his friends who were Romolo Valli, Giorgio De Lullo, Elsa Albani, Anna Maria Guarnieri, the whole cast of *The Diary of Anne Frank*, my dream.

I realized I needed to broaden my culture to be at their level and I began to read everything: Pirandello, Goldoni, Chekhov, Shakespeare, and even Strindberg, Ibsen and the Americans Tennessee Williams, Arthur Miller and Edward Albee. I devoured them rapidly and began to feel more confident. I had been more familiar with the cinema since my boyhood.

Then I got to know Zeffirelli, Bolognini and Lucia Bosè, with whom I became firm friends and still am today, and one evening Umberto got Luchino Visconti to invite me to dinner. He was very kind, gave me a warm welcome and even called me "Dinino", which he continued to do later whenever I worked with him.

Romolo Valli was very curious about my passion for the theatre. He came to see me act – we were performing *Weekend* by Noël Coward – and after the show he wanted to come backstage. My fellow actors were extremely excited and he was very friendly to all of us. Then we went out to dinner and he explained how difficult it was to pursue an acting career and what a lot of sacrifices you had to make. I would have to leave my job and go to the Academy of Dramatic Art, which would stir up a storm in the family. He didn't exactly advise me against it, since he recognized some of my good qualities, but neither did he give me much encouragement. I'm still grateful to him for making me face reality.

However, I didn't want to go on working in industry, I didn't like the routine and I gave in my notice.

My father excommunicated me, my mother tried to act as a go-between and I left home, since I had the chance of working with an architect, who was looking for an assistant-cum-driver; so I set out on an adventure involving journeys and building sites, which I far preferred to technology.

That lasted two years. I was still close friends with Umberto Tirelli and when I was in Rome I stayed at his place.

Meanwhile, in 1964 Tirelli began his own adventure by starting up his business. I was hoping he would ask me to help him, but he didn't. He asked some friends to help him and I myself lent him two million lire, my severance pay, and he opened "his" tailoring shop with two seamstresses, a female cutter, a male cutter and two sewing machines. He asked my sister Gianna who had studied business administration to act as his secretary; a friend, Dino Zanardo, lent him an apartment on Via Tevere but six months later he was already looking for larger premises, another two sewing machines and two more seamstresses.

In the meantime, I was unemployed since the architect I was working for had received the offer of a job in Brazil: Brasilia, the future capital, was coming into being and there was a demand for good architects. I couldn't go with him, but Umberto was very supportive, though he didn't ask me to help him.

I knew that his tailoring business was doing well, though he had to make huge sacrifices. Fortunately his clients were the best costume designers and directors of the moment, and often to make a good impression he generously gave them low estimates so he didn't make much, but he said he was "building up the stock". And he was right: this was the very beginning of what would be one of the largest costume "gold reserves".

At the start of 1965, a very dear friend of mine, Fiorella Mariani, Roberto Rossellini's niece, who was the director of the set designing

Franco Zeffirelli during rehearsals of *Romeo and Juliet* at the Old Vic in London, 1960; in the background, John Stride who played Romeo. The photograph is dedicated to Dino Trappetti

Dino Trappetti, Anita Bartolucci,
Gianna Giachetti and Giorgio De Lullo
during rehearsals of *Three Sisters*, 1980
Photo by Tommaso Le Pera

workshop at the Festival of Two Worlds in Spoleto, wanted to help me by offering me a job in the workshop (I was so cocky I said I could do everything, even carpentry – anyway I'd learn). But when she took me to the Festival offices in Rome they told her there were no openings, all they were looking for was an errand boy, so I offered my services.

I had my own car and they reimbursed the petrol, so I began to deliver parcels and correspondence, stick on stamps, etc.

The offices moved to Spoleto and I went to, they couldn't pay my daily expenses but luckily I had family there. One day I was in the office when a phone call came in from Gian Carlo Menotti: he had to go to Perugia and needed a car with a driver. As all the drivers were busy I offered to take him and picked him up at his house in Piazza del Duomo.

During the trip he wanted to know all about me, where I came from… When we arrived in Perugia we went to some antique shops, as Menotti was looking for furniture and other objects to decorate his terrace giving onto Piazza del Duomo, and I took the liberty to suggest a few things, relying on my past experience. He approved of them, we loaded everything into the car and on the return journey he asked me: "Why are you an errand boy?" I answered that I needed a job, that's what they had offered me and I'd accepted.

In silence we arrived in Spoleto, he asked me to unload what he had bought and take it out onto the terrace, then he called the Festival offices right there and then and said: "Dino will be working for me now, so look for another errand boy".

Yet again fate had given a sign.

I arranged the things he had purchased on his terrace, then he asked me to decorate some rooms for an exhibition of Umbrian products (ceramic ware, rugs, etc.); he also asked me to be responsible for staging a large exhibition of contemporary landscapes to be held in Palazzo Collicola. I saw the photos of the works that he had ordered from the States and was galvanized: new works by Lichtenstein, Rauschenberg, Warhol and Jasper Johns, never seen in Italy. Through painter friends of mine in Rome I found some Italian landscapes by Cagli, Guttuso, Clerici, Funi, Vittorini and others. The show was a huge success and very generously Menotti attributed it all to me. I had become famous overnight!

Menotti wanted me to become a permanent member of the Festival staff and I told him I would like to work in the public relations office.

Romolo Valli came to the Festival, saw me at work and was pleased to notice that, thanks to a combination of good luck and will power, I had found the right road to working in the theatre.

He asked me to work as a factotum in his prestigious company (fate continued to smile on me) and in September 1965 I started to work with the Compagnia dei Giovani and soon became secretary, driver, press officer, prompter – in other words, their factotum. It was just what I wanted.

My friendship with Umberto was going from strength to strength, there was affection and a wonderful trust. Things were taking off, he was setting up a limited company and asked me if I wanted him to pay back my loan with interest or if I wanted to be a partner in the company. Naturally I accepted the second proposal!

He had rented a small four-storey building at 17, Via Settembrini and kept the top floor for himself; the apartment was vast and he invited me to move into two rooms. I did so and stopped being a nomad. That's how we began to lay the foundations of a partnership that lasted a lifetime.

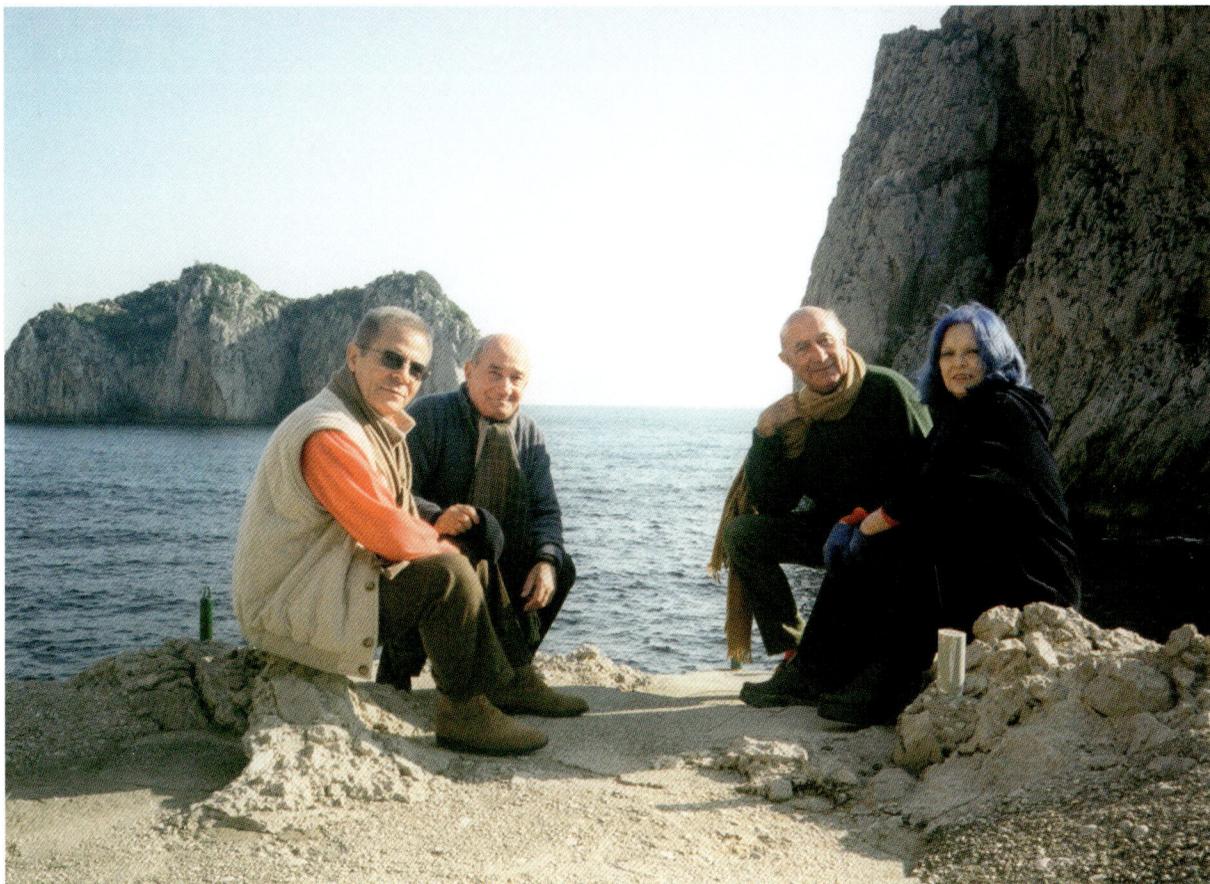

Dino Trappetti, Piero Pinto, Beppe Modenese and Lucia Bosè at the Faraglioni on Capri, where Umberto Tirelli's ashes were scattered

"The Milanese cutlets are ready, kids", Umberto announced to my children in his rather loud voice, in the house "Il Canile" on Capri that he shared with Dino Trappetti and which years earlier he had bought with Lucia Bosè and Esa De Simone. We were there on holiday and Umberto, always dressed in a red linen shirt, white trousers and Moroccan babouches, spoilt children, adults and friends alike by giving them all kinds of goodies. He and Dino had invented their own special cuisine, which was a bit Emilian, a bit Milanese and a bit Neapolitan: pezzogna all'acqua pazza (local fish cooked in white wine, tomatoes and a little water), Milanese cutlets (fried veal cutlets in bread crumbs), tortelli di zucca (pumpkin ravioli) and potato gâteau. Umberto was constantly giving us presents, little gifts. When we left Capri with the kids on a trip through Italy – Naples, Rome, Florence, Venice – he gave each of my children a chocolate and cream cake in the shape of the Faraglioni, the famous Capri sea stacks. The cakes were packaged and they accompanied us the whole trip gradually melting in the summer heat. He divided his time between Rome and Capri, but also Paris where he had many friends.
Umberto was happy in Paris. His costumes where on show in the Louvre

in a display designed by Piero Tosi; he and Dino would stay at the Meurice and would invite us for fish meals at Le Duc. And when he was invited at home to dinner, his arrival with Dino was always announced by bunches of flowers.

On the occasion of his sixtieth birthday, Umberto threw a memorable party, a mix of work, entertainment and talent just like his whole lifestyle. He had strong opinions, a strong character, a strong voice and strong feelings, but he was a good man full of enthusiasm. Certainly mediocrity, lack of taste, talent and intelligence horrified him. He was sociable, jolly, surrounded by friends of both sexes; to him the legendary world of cinema and opera was a natural calling not a job. Tiredness did not exist, work was a serious commitment. But also a pleasure.

His feelings were private. Umberto was a loner in his own way. Faithfulness in friendship was a religion and even though, thanks to his charm and magnetic personality, he had become the friend of film and opera celebrities including Lucia Bosè, Ingrid Bergman, Maria Callas and Raina Kabaivanska, had dressed Hollywood and opera stars, had dined

with Balthus, Moravia and Pasolini, and in Paris had frequented the Rothschilds and the Weillers, he never forgot his friends from Parma, where he had gone to school – his most famous fellow students included Francesca Sanvitale, born in Milan but originally from Parma, Enrico Medioli and Romolo Valli.
A few years later I happened to be passing through Rome with my kids during the festive season. I called Dino to have some news and he answered: "Umberto has just passed away!" We went to the Sartoria on Via Pompeo Magno. Umberto was there, among his many costumes, in the Sartoria he had established with friends like Gabriella, Piero, Pier Luigi …
We were so very sad, we would never again hear that unique voice of his calling "Dino!".

Alain Elkann

Umberto's untimely death, on 26 December 1990, left us all devastated. He was only 62.

It seemed that his vitality, his energy and his will to live would never cease. Despite the fact that the idea of death had never crossed his mind, he had written a precise and detailed will a few years earlier, in 1986. His testament, a masterpiece of generosity, was commented on at length since it surprised everyone, me above all, because, though I was the main beneficiary, I had never been informed. He left me, already a partner, the majority of shares in Tirelli Costumi S.p.A. and made some of his main collaborators and costume designers, who had contributed to the growth of the business, partners by leaving them shares in the company. What he particularly insisted on was the continuity of his "business". Probably the idea was not to leave me as the sole director, since I knew nothing about tailoring as I had never been concerned with it; I think he believed above all in my loyalty.

For a moment I thought of giving up and leaving everything in the hands of the experts; I didn't know where to begin to manage Tirelli Costumi S.p.A., but the friends Umberto had made "responsible" supported me: "Umberto wanted continuity so we must go on. We'll help you".

So I left the work I shared with Simona Barabesi, who had always been my colleague. There were difficult moments, better moments, and great, marvellous emotional moments, as when Gabriella Pescucci won the Academy Award for Best Costume Design for *The Age of Innocence* costumes, in 1994, the first big project undertaken after Umberto's death. Gabriella had worked tirelessly and unstintingly between Rome and New York, and during her absences from Rome Flora Brancatella had seamlessly carried on the work she had planned; the Award crowned an extraordinary creative achievement.

Then Ann Roth arrived for *The English Patient* directed by Anthony Minghella and won the first Academy Award for Best Costume Design of her prestigious career in 1997.

Those who thought that after Umberto passed away Tirelli Costumi S.p.A. would collapse were fortunately proved wrong.

At the beginning of 2000, we began to think of attempting to realize what had been Umberto's dream: finding a space big enough to hold all the material made and

Dino Trappetti and Mario Natale in Spoleto, July 1970

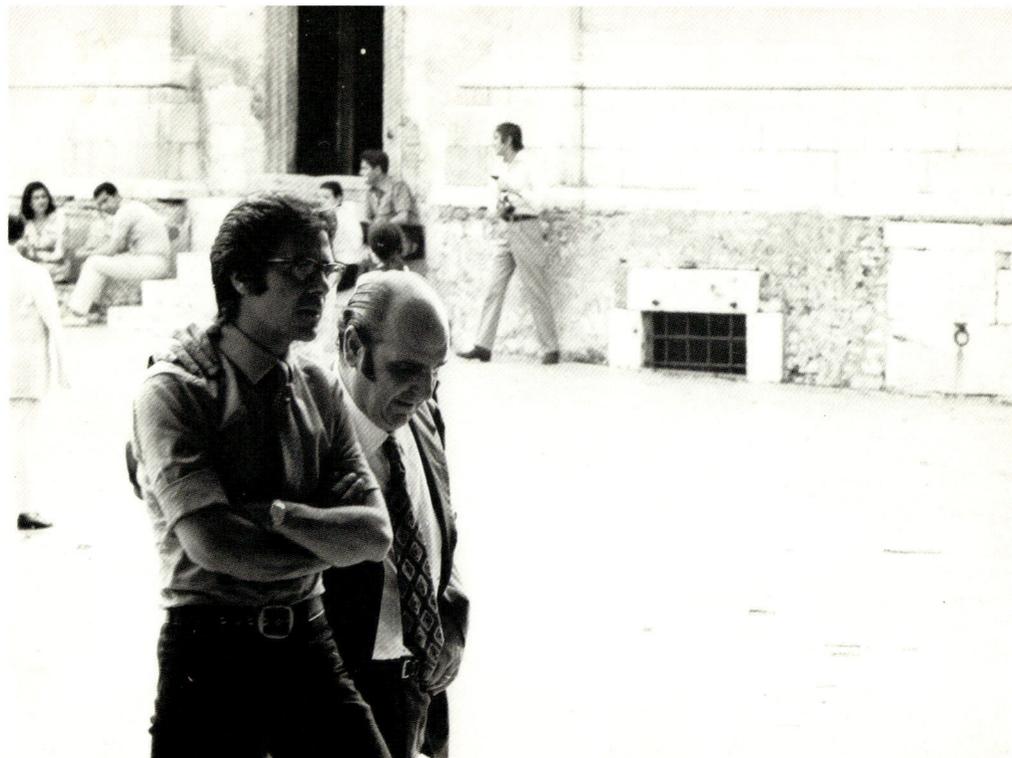

collected over the years, which was in seven warehouses on the outskirts of Rome that had now become dilapidated. It was difficult to make out the costumes, which were crammed into spaces that had become too small; just trying to take them out would ruin them and entail immense restoration work. So we began our search for the right place with the valuable, indispensable help and enthusiasm of Luigi Morena, who had been Managing Director of Tirelli Costumi S.p.A. since 1968.

In 2007 the Formello complex came into being, which has solved all our storage problems – though it's already beginning to be too small! I'm very proud of it; it's a researcher's dream, a place where you can find everything – or nearly everything.

Gabriella did an extraordinary job cataloguing and organizing the spaces, helped by those I call the "angels of Formello": Valentino, Antonio, Fausto and Alessandro. Luca painstakingly and intelligently organizes the work in the restoration workshop and the formfitting of the costumes before they leave, aided by the expert Tina, "the mistress of formfitting", with Francesca, Kingsley and other helpers who take it in turns as required.

I am sure that Umberto would also have been proud; after twenty-four years everything is continuing, with staff he himself chose.

Every day when I arrive at work, in the first room on the left, I see Luigi Morena at his desk; he has been managing Tirelli Costumi S.p.A. conscientiously, shrewdly and passionately for forty-five years; dear Simona, his secretary, is unfortunately no longer in the same room as fate has taken her from us all too soon, but Daniela has replaced her and has been a valuable point of reference for the last fifteen years. Further on there is the office of Carmela whom Umberto chose as our accountant and who is as precise and strict as anyone could wish. Then comes the large fitting room, where some of

the greatest stars of stage, screen and opera have tried on costumes: from Maria Callas to Sophia Loren, Marcello Mastroianni, Anthony Hopkins, Romolo Valli, Giorgio Albertazzi, Raina Kabaivanska, Katia Ricciarelli, Anna Caterina Antonacci, Gina Lollobrigida, Virna Lisi, Monica Vitti, Helen Mirren; Geoffrey Rush, Matt Damon, Heath Ledger, Alessandro Gassman, Raoul Bova, Massimo Ghini, Massimo Ranieri, Mariangela Melato. The list is endless, right up to Salma Hayek and Vincent Cassel, among the most recent, for Matteo Garrone's latest film with costumes designed by Massimo Cantini Parrini, and Joseph Fiennes for a film with costumes by Maurizio Millenotti.

When the fitting room is free Flora Brancatella uses it. She is a costume designer and occasionally organizes the work of the big productions, where setting up the workshops demands great practice and experience. Flora has chosen to liaise between the set and the costumiers, and with her exceptional organizational talent is a valuable support to Laura who is in the room opposite. In her role as general coordinator Laura, who started out as a lawyer, later devoted herself to Tirelli (by the way she is my niece) and soon, by keenly applying herself, succeeded in mastering a profession she had never studied for.

I occupy Umberto's office that has remained just as he arranged it. A few years ago it was dismantled and transferred to Via Farnese, in a moment when we thought of leaving the Via Pompeo Magno premises; fortunately the decision was revoked and the office was reinstalled just as it was.

Now I come to the "women's" corridor, where there is the workshop for female costumes. At the cutting table I find Antonia who in 1962 – as we can see from the photos – was already holding the box of pins for Tirelli while Claudia Cardinale was being fitted for the costumes for *The Leopard*. For a time Anna wanted to try cutting in the workshops organized on set. So after the great Anna the table was occupied by Enrica, then Dina and finally Antonia came back, after gaining an extraordinary amount of experience on set. We grew up together, so to speak, and she is the only member of staff I use the familiar form "tu" with.

Then there is the faithful and capable Pamela, who alternates between one table and another; Rosana who arrived later, but is already very efficient; and Paoletta, whom we continue to call Paoletta though she's grown up in the meantime.

Now we go down to the "men's" workshop, where for years Luigi dressed the greatest actors in the world. Luigi dressed actors almost without ever meeting them; he understood everything from their measurements, even if they couldn't come for a fitting. If you asked him who Daniel Day-Lewis was – for whom he made the whole wardrobe for *The Age of Innocence* without ever having seen him – he didn't know; and yet Gabriella Pescucci used to say that there was never any need for alterations.

Luigi was followed by Roberto, who luckily did not make us regret the fact that Luigi had gone; he is respected by all the costume designers. Milena Canonero won't trust anyone else, and I myself sometimes pester him to adjust my clothes. He has an infallible eye: he comes from a great school, but he also has an extraordinary natural talent.

Beside him, though only occasionally, there is Maria, putting together what Roberto cuts – naturally under his guidance – and Luciana, whose work is of a high standard.

I miss the legendary Signora Maria very much, she was a great seamstress, the oldest of all: she was the first to follow Umberto when he decided to set up his own business, and she virtually organized his first workshop. She hasn't been able to work for several years now because of a serious problem with her eyes, but she was the best

Group photograph in front of the entrance to the Sartoria on Via Pompeo Magno, 2014; in the centre, Dino Trappetti; behind him on the right, Piero Tosi

seamstress that Umberto and I have ever had. She didn't do any cutting, but she could have done; she made fantastic lingerie. I miss Franca too, the best maker of trousers we have ever had. To make up for this, the men's workshop has gained the valuable work of Giorgio, who as an external tailor is the best at putting together what Roberto cuts.

On the same floor as this workshop there are two rooms that, before we acquired the Formello complex, were used for storing costumes that were about to be sent out or had just returned, and which Flora's magic touch has transformed into rooms for costume designers and a workshop, where Rosaria is to be found. She supervises "special" costume designers and workshops, with that special discretion and competence acquired in the Sartoria Tirelli.

It comforts me to think that all this could continue for a long time, and perhaps even expand (the potential is there), also thanks to the Fondazione Tirelli Trappetti that I have recently established, because I am certain that we will go on working with the passion and the quality that have always distinguished Sartoria Tirelli.

I would like to close this panorama of the staff of the Sartoria with two great protagonists of our history: Emilia, a factotum who was the symbol of the company, an unassuming, intelligent, generous woman who was willing to do anything and had no timetable; and Mariangela, our invaluable housekeeper, who looked after the house and the business with the same passion, love and perfectionism. She organized the lunches for the "company's parties" for eighty to a hundred guests alone; she had a very affectionate relationship with all the staff and all of us still miss her.

Silvia d'Amico

PERIOD AND MADHOUSE

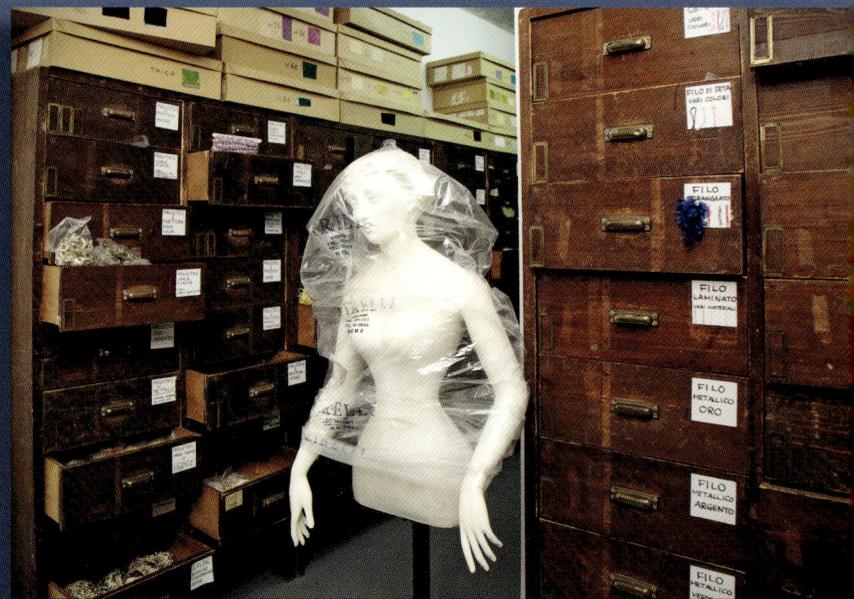

It is impossible to recount in detail the story of a company like Tirelli Costumi, which has seen not dozens but hundreds of leading directors, costume designers and actors of their day pass through its rooms, and has turned out hundreds of thousands of costumes as well as signing nearly two thousand theatre, film and TV productions.

From whatever standpoint you consider their vast quality output, you lose your bearings and do not know where to start. Hence the only way to fully render the idea of Tirelli and the philosophy of this singular monument to craftsmanship seemed to be to rely on needle, thread and scissors myself, seek help from the many costume designers who have worked, and still work, at the costumier, and use the "cut and paste" method to at least enable us to relive the unique atmosphere. My apologies to those – so many – who, due to my shyness or their commitments, have not been able to contribute to this fond reconstruction of the Tirelli world.

In the beginning there was Lila de Nobili.

This great lady – reserved and modest to a fault but an absolute artist – had, in my opinion, an extremely important influence on what would be the Tirelli company's definitive character. The fact is that Umberto Tirelli fell in love with the world that would later be his when he saw the legendary *Traviata* by Visconti in Milan, on which de Nobili had collaborated as costume designer. But there is another telling episode that occurred in 1954, when Tirelli was still working at the Finzi tailoring shop in Milan. He never tired of recounting the story and it lay at the heart of the extraordinary and discerning perfectionism that would become a hallmark of the company. Let's hear it from Tirelli himself:

> … and this tailoring shop where I was working, Finzi, was given a small job. [The tailoring shop did not feel like accepting the responsibility of doing all the costumes for *Come le foglie* by Giacosa, which Visconti was staging in Milan, but had accepted a smaller commission.] Not much, just the costumes for the painter, the coachman and the maid, nothing important… So I met de Nobili, who said: "This topcoat is fine [it was the coat for the painter] but if you bring me a bowl with some water in it, preferably hot, and some bleach, I'll sort out the colour because it's too bold the way it is". It was a tartan fabric. We brought the bowl – they were made of thin steel sheet then – with some hot water and bleach: one bottle, two bottles, more, more, more. She took the topcoat, threw it in, took off her shoes and stockings and proceeded to "tread" the coat right in front of us, while we said to ourselves: "Who on earth is this woman?". She took the coat out: "Hang it up like this, don't iron it, it'll be perfect, you'll see". In fact, it became de Nobili's painting.

It was a revelation: a garment is not perfect unless it has a story, a past. This was a lesson that Tirelli would never forget. Like the one he learnt from his passion and quest for

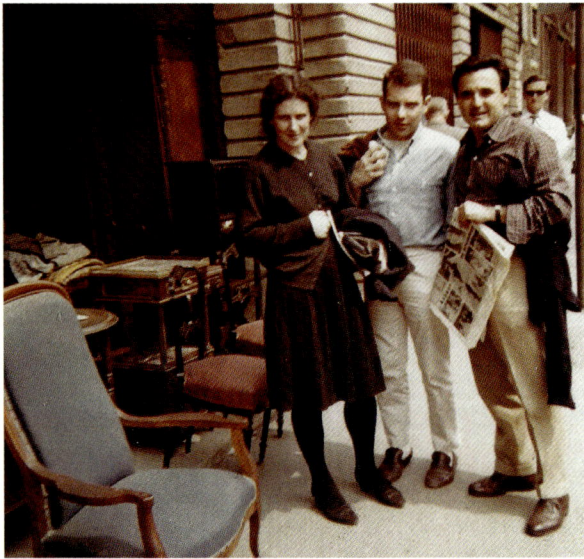

Lila de Nobili, Jean-Marie Simon and Umberto Tirelli at the Marché aux Puces in Paris, 1961

the "authentic" – another of the characteristics that have made Tirelli Costumi great, and one we can also trace to de Nobili. She was certainly the Virgil who guided Tirelli through the twists and turns of the Marché aux Puces in Paris in search of mop caps, corsets and remnants as well as old clothes and hats. Items that were not necessarily just to be reused or given a new lease of life, but also deconstructed and studied in order to be able to reproduce the particular cut or stitching to perfection and thus enable the costumes made by the Sartoria to evoke the period in question. But I will let other people, much better qualified than myself, speak more eloquently and at length about this.

Fiorella Mariani for example, costume and set designer, director and author, who at that time was de Nobili's invaluable assistant. She met Umberto Tirelli shortly afterwards, at Safas in Rome:

When I arrived at Safas for Lila's *L'Arlesiana* (1958) everything was perfect, everything was wonderful. There was Piero Tosi who had to do the witches for Luchino Visconti's *Macbeth*, which was to open the first Festival of Two Worlds in Spoleto. I had to give him a hand as well.
"Bleach and redye", he said to me. "These witches are perfect, but now destroy them for me".
Actually, they were great witches, but now they had to be dirtied, torn and burnt. So my first job at Safas was to destroy a costume.
But then I did a lot of others, for example those for *The Organizer* by Monicelli, with Piero once again. Well, I saw the film again and realized I had never really understood how important the "aging" is. Those costumes were fantastic, dammit, and I had "destroyed" them myself. For two, maybe three months I had been rubbing the elbows, lapels and waistcoats, and stuffing crumpled up wet paper into the pockets to ruin their shape. I had been ruining them. This was a very important lesson: afterwards, Tirelli would always apply this rule. Indeed, he perfected it. He brought alive the costumes he made and transformed them into "real clothes" instead of costumes. And all of us who have worked at Sartoria Tirelli remember the steaming vats of dye and the aging: real witches' stuff.

Backed by all the experience he had gained in the nine years managing the Safas tailoring shop that had always enjoyed an excellent reputation – a period crowned by the huge task, performed personally and in the field, of doing the costumes for *The Leopard* – in 1964 Umberto Tirelli was ready to take the big step, to realize his dream of setting up his own costumier business, structured and run according to his own rules, and managed completely by him. As we have seen, he received practical support from his generous friends; but another "glue" – even stronger, if that is possible – consolidated the foundations of his ambitious business: the esteem that Tirelli himself had won in the professional sphere: the leading costume designers of the period greatly appreciated his work and many of them would take their custom to the newly-established company.

So on 30 November 1964, two sewing machines were carried into an apartment at Via Tevere 6, which his friend Dino Zanardo had lent him, and this was the start of everything.

Tirelli Costumi's first "client" was Pier Luigi Pizzi who, fifty years later, is still a fundamental pillar of the Sartoria, where he has created the costumes for more than two hundred productions:

We can say that the Sartoria began precisely with *David Copperfield*, a huge project, eight episodes for television; then, immediately afterwards they started work on *Three Sisters* with the Compagnia dei Giovani, for which Umberto and I went to Paris to look for material at the Marché aux Puces.

For *Three Sisters* we made new costumes, which were combined with authentic clothes. Umberto and I had already tried out this method at Safas, but unbeknown to Signora Roux who was used to a different system: the costume designer would arrive with the sketches that were made up first by compiling fabric swatches and then having the seamstresses or tailors make the costume. But most of the time it was a question of basic styles that were not based on original models and did not differ from period to period. Safas was a great costumier, used by many artists from Visconti to Maria De Matteis; my experience there was fundamental to my formation as a costume designer, and it was a meeting place for young talents. That was where I met Piero Tosi, that was where my relationship with Umberto Tirelli began, which lasted until he died, and continued with the Sartoria. At Safas the work was always of the highest quality, but they lacked the interest in research and analysis that would characterize and qualify the new Sartoria Tirelli. I get emotional when I look back on those early days, adventurous days yet full of promise and fired by the energy we had then, our enthusiasm, trust, determination, optimism, recklessness. And high spirits! Because we worked like hell, but we also had a lot of fun.

I remember how our first production, *Three Sisters*, came into being. We were on our way back from Russia with Giorgio De Lullo and Romolo Valli. While travelling by boat along the Danube from Budapest to Vienna to continue the tour, we were still fascinated by the images of that country and were imagining and devising new projects. That's how we got the idea for *Three Sisters*. When the tour ended, we stopped in Venice for three days. In a second-hand shop I happened to see a nineteenth-century pram made of iron and wicker. "It's perfect for Bobik!" Naturally, we bought it. That was one of our favourite productions, and it came into being with Umberto and a new burst of euphoria. And the actors

Elena Cotta, Ferruccio De Ceresa, Romolo Valli, Elsa Albani, Piero Sammataro and Rossella Falk in the Sartoria's first play, *Three Sisters*, 1965, directed by Giorgio De Lullo with sets and costumes by Pier Luigi Pizzi
Photo by Alceo Trouché

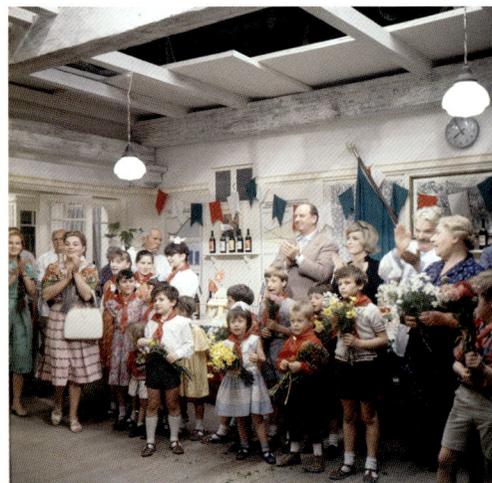

Gino Cervi and Fernandel in the Sartoria's first film, *Il compagno Don Camillo* (*Don Camillo in Moscow*), 1965, directed by Luigi Comencini with costumes by Danda Ortona
Reporters Associati & Archivi

wore authentic clothes, not costumes. Suddenly everything became more real, more poetic.

Our passion for the authentic was born in Paris. We followed the example of Lila de Nobili, who rummaged around at the Marché aux Puces, finding precisely in period clothing her inspiration as an artist and the ideal starting point for her extraordinary work. In his turn, Piero Tosi found fundamental answers to his many doubts, to his endless quest for perfection in the study of authentic pieces. I used this kind of material differently, with less rigour.

At the Marché aux Puces we discovered and learnt things that we didn't know or had underestimated. This enabled us to mature. Umberto got it immediately, with that remarkable insight of his, and he encouraged and guided us along this path. Lila was the first, after Bérard, who by going to the Marché aux Puces discovered that it yielded valuable sources and that you had to start from there.

I was less fond of detail than Piero and used what I found to create a feeling of lyrical realism. This is exactly what happened on that 1964 production of *Three Sisters*. Umberto gave his very best, with tremendous enthusiasm and generosity. Gianna Giachetti, who played Natasha, wore a dressing gown that I had had made which, based on an authentic cashmere Second Empire model, reflected the symmetry of the design. This dressing gown has remained in the collection; it still exists at Formello. A precious shawl was sacrificed, but the result was a masterpiece of tailoring. Umberto didn't hesitate…

Yes, Umberto "didn't hesitate". Unlike many of his tailor colleagues who remained within the four walls of their shop, Tirelli "went out": avidly curious, he was always involved in the creative processes of his costume designers, whom he would follow, support and even urge to be more daring. We can say, then, that the collection – the company's pride and joy – came into being with the business itself.

In those early years Piero Tosi – the other tutelary deity of the company – did not sign productions, and only began to do so in 1968, when he created the costumes for *The Damned* by Visconti and *Medea* by Pasolini. But even then he was a constant presence at the shop and the young trainees, seamstresses and cutters, spurred by his proverbial perfectionism, could always benefit from his example and his advice. But we'd like to reveal a secret: Piero Tosi has created many great masterpieces, but he has always been reserved and, above all, "lazy". He likens himself to a cat, and as a cat he is always ready to run away, terrified that he might be grabbed by the tail (his flights from Fellini or Zef-

Umberto Tirelli fits Omar Sharif with a costume designed by Giulio Coltellacci for *More than a Miracle*, 1966

firelli, with whom he has a fraternal relationship, are well known). He says of himself:

Professionally speaking, I've always been plagued by doubts, hesitation. I've always waited until the very last minute for something to happen. I've waited for a miracle. I've always been in the dark, a miner in a cave with a pickaxe who, because he keeps chipping away will finally find the nugget, the vein of ore. After doing a sketch, I've never been able to say: "This is great, we're there, it's perfect". No. I put it aside and start drawing again.

The constant presence of Tirelli, who had been by his side since way back in 1955, was vital, therefore, because he managed to grab those sketches from him:

Umberto has always injected vitality, enthusiasm, strength, optimism and get-up-and-go into my life and my work as a costume designer. Without him I often would have fled, thrown in the sponge, or given up. He began to be all-important to me when he was still at Safas, where he solved the problems concerning the difficult materials for the costumes of *Uncle Vanya* directed by Visconti, by personally going to buy up all the Rome shops where the ladies went to find the lightest wool cloths, the best fabrics, in order to copy French fashions.

If Tirelli, as head of a tailoring shop that was not his, scoured the Rome shops for fabrics that were "indispensable" for making the extremely well-documented costumes designed by his perfectionist friend, you can easily imagine what their collaboration was like when Tirelli finally set up on his own.

Sartoria Tirelli officially opened its doors in November 1964 and was soon working flat out. Costume designers and directors arrived en masse and the five seamstresses

Dolores del Rio and Omar Sharif in *More than a Miracle*, 1967, directed by Francesco Rosi with costumes by Giulio Coltellacci. Sartoria Tirelli did all the costumes for the film, except Sophia Loren's

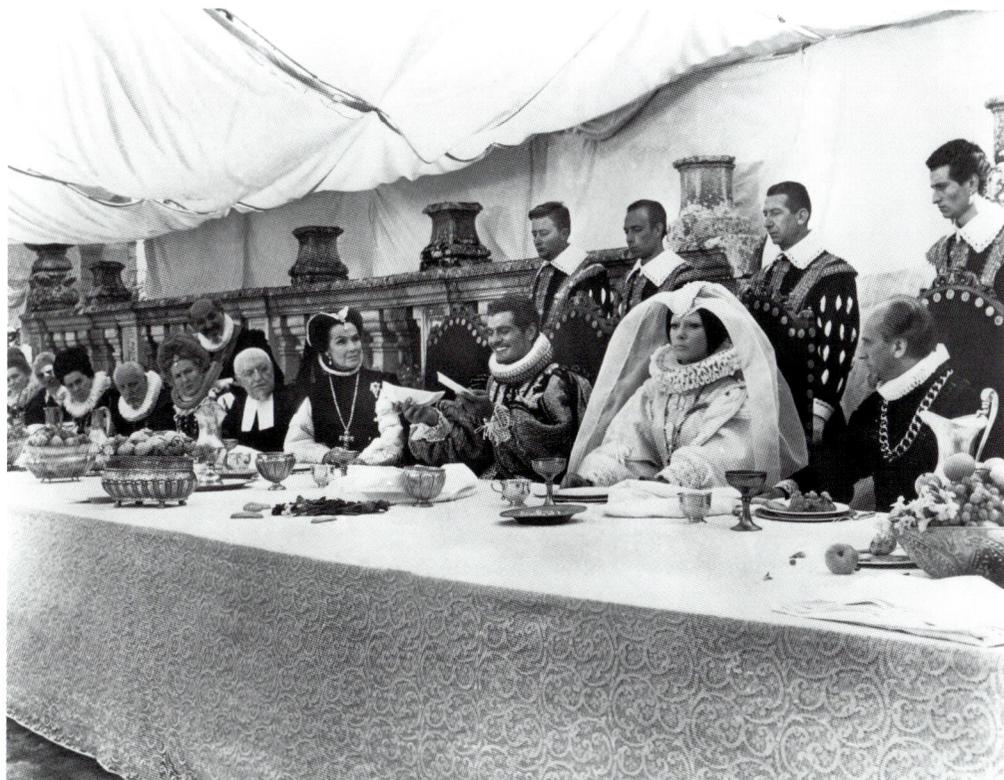

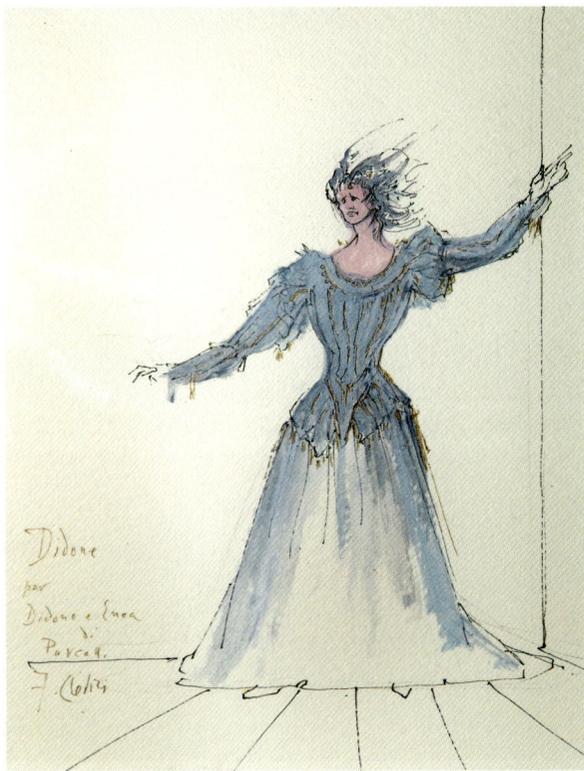

Sketch by Fabrizio Clerici
for *Dido and Aeneas*, 1965

who had followed Umberto in his new venture were already no longer enough. Tirelli "invented" the external seamstress.

After six months, the Sartoria had outgrown the Via Tevere premises. They moved to Via Settembrini, occupying several floors. The big names were soon part of the family and in 1965, after being in business for just a year, you would not only pass Pier Luigi Pizzi and Piero Tosi in the corridor, but also Anna Anni who was doing the costumes for *Tosca* directed by Mauro Bolognini (Tirelli's first opera), Danda Ortona preparing *Don Camillo in Moscow* directed by Luigi Comencini (Tirelli's first film), Maurizio Monteverde designing *Lucia di Lammermoor* for Sandro Bolchi, and Danilo Donati jumping from *Mademoiselle de Maupin* by Mauro Bolognini to *Scaramouche* for television and *El Greco* by Luciano Salce. Giulio Coltellacci was also there for *More than a Miracle* by Francesco Rosi, along with Filippo Sanjust, Fiorella Mariani, Fabrizio Clerici and even Giacomo Manzù. The Sartoria received two important commissions from the newly established Teatro Stabile di Roma: *The Cherry Orchard* directed by Visconti, who also designed the costumes together with a very young Ferdinando Scarfiotti, and *The Merchant of Venice* directed by Ettore Giannini, with costumes by Lila de Nobili.

These high-sounding names were accompanied by the still relatively unknown ones of their assistants, many of whom would receive tremendous input from their experience at that Sartoria where the door was always open, and they soon began to shine on their own account.

After Lila came Claudie Gastine:

I met Umberto not long after I had started working with Lila.
Fifty years have gone by since I first came to Rome for the first night of the ballet *Roi des gourmets*; Umberto had just left Safas and opened his Sartoria.
Immediately afterwards I found myself being welcomed by him as assistant to Lila, to Jean-Marie Simon, and Stiva Doboujinski (for Eugène Berman), and then as a costume designer in my own right.
One of my earliest memories dates back to when I did an *opéra de foire* at Baux de Provence for the Communauté Théâtrale founded by Raymond Rouleau (in other words, on a shoestring), and a few days before the opening Lila arrived from Rome with a wicker basket of costumes for the peasants, sent by Umberto. There weren't that many costumes, but it was a generous gesture on his part, also because he did not approve of our venture at all. In fact, once when Lila had dragged him to our premises in Rue Mouffetard, I had heard him say that we would all die of starvation! Umberto was so practical and conscious of his own worth that you would never have expected him to part with even a small portion of the collection he had just put together.
He often came to Paris and would actually ransack the flea market at Clignancourt where you could find some superb pieces. He had immediately got all the useful addresses and this enabled him to build up a nucleus of original costumes, not just elegant or custom-made outfits, but also clothes in poor condition: he used to say, quite rightly, that the more tattered and patched they were, the better.
He came to see Lila often, and would take away a bag of drawings and gouaches that she got rid of by the dozen. He literally couldn't get enough of her work. At

the beginning, when I didn't know Lila very well, I would be outraged because I thought he was stealing from her. But very soon I became an accomplice and go-between in these "thefts". Indeed, when I came to Rome to prepare with him the *Bohème* that Jean-Marie Simon was staging in Lucca, I brought him a drawing by Lila that depicted him as the Princess in *Histoire du soldat* (the first show directed by Jean-Marie). Later I realized that Lila gave him her drawings in exchange for favours for her protégés, and that she liked to see her portraits and drawings on the walls of friends' houses and in the places she loved. She once said to me: "I like Umberto so much: he loves painting like other people love chocolate".

I loved the atmosphere at the company from the very beginning, the orderliness and coordination that reigned supreme, even though I was scared by the sudden appearance of "Signor Tirelli", the undisputed king of the outfit, who upon seeing a request he found excessive shattered the calm of the workshops by shouting: "Enough, that's enough! I've already had de Nobili and Piero Tosi in my life!" You could hear his thunderous voice echoing, changing tone and switching from comedy to drama, asking questions and answering them, as he went from one room to another, climbed the stairs, descended to the dyeing room, climbed the stairs again, going from one workshop to another, and finally die out when he entered his office and shut the door to devote himself to serious things at last. I was fond of Anna, of her sweetness and great talent for cutting, and Enrica who came after her. I was fond of Luigi, the men's tailor, because he was so patient and despite his being averse to period styles. I was fond of Maria, who finished off the costumes, and Elsa, the first milliner, who work magic with her hands… Piero Tosi was the ultimate point of reference, whether he was at the Sartoria or on a film set. He has always given me his friendship and support.

Every so often I found myself in difficulties with Umberto, because he was a man who made snap decisions and couldn't stand my dithering: "You must say yes or no, you mustn't say hmmm!". But it was a real pleasure to go and buy materials with him: he was quick, determined and always chose the right fabric. Apart from

Ingrid Bergman, Romolo Valli, Fabrizio Clerici and Piero Tosi at Tirelli and Trappetti's home, 1979

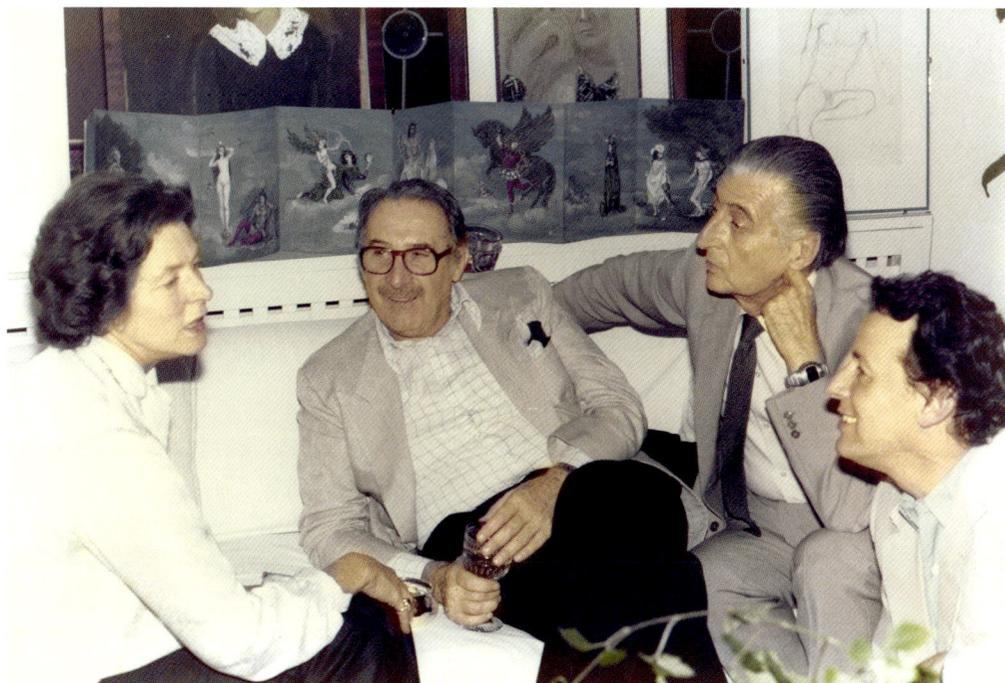

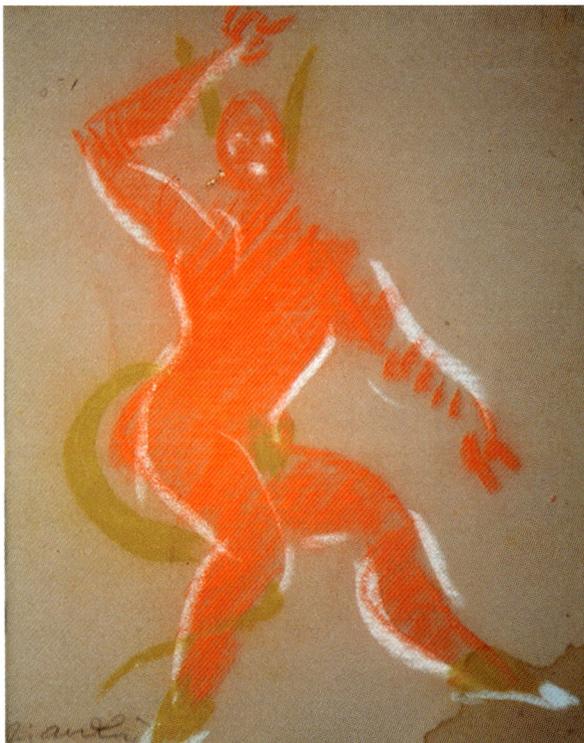

Sketch by Giacomo Manzù for the Devil,
Histoire du soldat, 1965

his love for and knowledge of costume, he was also capable of justifying a budget for the producer when necessary. This was a great comfort to us costume designers, and to me personally on several occasions. The most pleasant moments were in the early morning, when he would water the plants and see that everything was in order and how he wanted it throughout the Sartoria; or when he would invite me to eat lunch with him in the kitchen and ask me about our life in Paris.

There was also a young lad from Modena who learnt the ropes with Piero Tosi. His name was Franco Carretti.

I met Umberto at Safas when I was working as volunteer assistant to Piero Tosi on *The Lovemakers*. But I helped with the set dressing, not the costumes; I was a bit out of my depth, because I really didn't know much about cinema. The set dresser was the famous Brosio.
Later I worked on *Careless* with Piero, as his assistant. The only one, this time: I was *the* assistant. Only on the costumes though, because I had discovered that I preferred doing costumes rather than set dressing. Then we did Claudia Cardinale's tests for *The Leopard* at the De Paolis studios. I was really wound up, I was sure I was going to work on *The Leopard*, but Tirelli recommended Franco Folinea to Piero instead. I suffered like hell, and you can't imagine how much I hated him at that moment; but later I loved him like you wouldn't believe, because you couldn't but love Umberto. The first film I personally did as costume designer with Tirelli, at least in part, was *Investigation of a Citizen above Suspicion* by Petri, then *Mondo candido* by Jacopetti, for which we dressed thousands of cut-out figures.
There was no digital then and we had to have a lot of soldiers, whom I dressed in Tirelli's Carabiniere uniforms, complete with large hats with the Eye of Providence. But they still weren't enough and so I made a suggestion: "Let's photograph them, make cut-out figures in plywood and dress them at the Sartoria". They liked

Umberto Tirelli and Giacomo Manzù during
the preparation of *Tristan und Isolde*, 1971

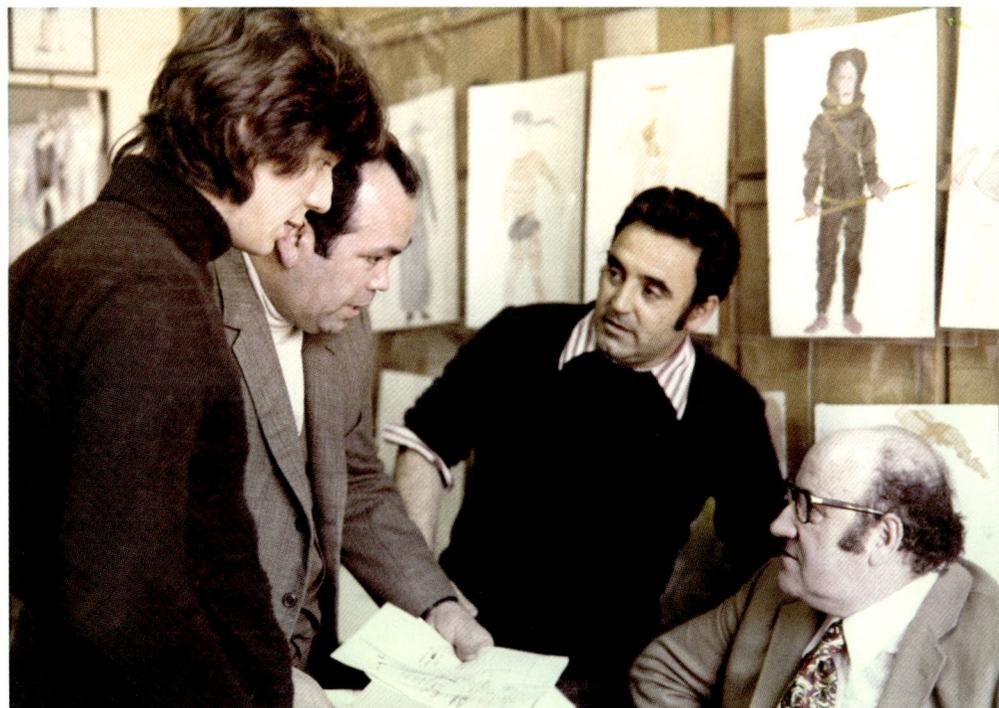

Sketch by Giacomo Manzù for the King, *Tristan und Isolde*, 1971

the idea and it worked a treat: in the battle scenes they went down like skittles, bang, bang, bang. It worked visually and cost a whole lot less: once the cut-out had been made, we just had to hire the costume. We covered an entire hill with them. Umberto was moody but extremely generous. For example, when I did *Ligabue* he went on his own initiative to the hospice where the painter had lived at Gualtieri, and succeeded in obtaining all Ligabue's things, which I copied. They are still at Formello. When you find really small shirts, they are those from the hospice. When you see a small, skimpy jacket, it's one from the hospice. Nowadays a boy of ten could just about get into it. Sizes have changed completely. The actor Flavio Bucci, who resembled Ligabue so closely, was as thin as a rake, but the clothes still didn't fit him.

I also did *Duck, You Sucker* by Sergio Leone with Tirelli. I had gone to Los Angeles to measure Rod Steiger and James Coburn for the costumes. James Coburn came in person, but Steiger sent a stand-in. I arrived in Almería with all the costumes ready, and finally Steiger deigned to put in an appearance. He tried some things on and said nothing fitted him. I called Tirelli, saying: "Umberto, I'm desperate". He understood and sent me two tailors, Luigi and Renzo. And I can assure you that people hardly ever sent two tailors. They were there the next day. Umberto had a perfect sense of what a tailor should be, and he felt wholly responsible. He was a giver and never let you down.

Later, as Steiger was short and James Coburn very tall, and they always appeared together, I made Steiger a pair of boots with raised soles and a very high heel. When he put them on he changed his attitude. Suddenly he adored me. He asked for twelve pairs and took them all with him.

A few years later, in 1979, I decided to move to America and open a theatrical costumier business, because it was the only thing I knew how to do. It goes without saying that this business owes much to both Tirelli's example and his teaching. Everyone said I was crazy at the time. Everyone, that is, except Umberto: "Go Franco, you're doing the right thing…" We always remained great friends – always – and he often came to visit me.

Romolo Valli, Rod Steiger and James Coburn in *Duck, You Sucker*, 1970, directed by Sergio Leone with costumes by Franco Carretti

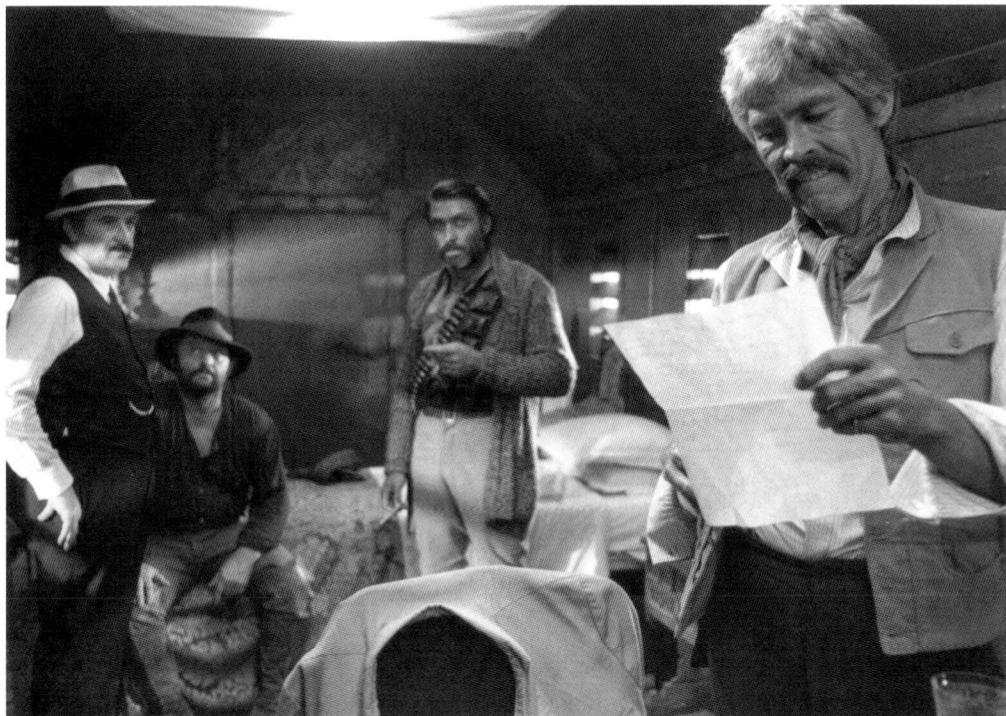

Among the young assistants who arrived at the newly-established Tirelli Costumi there was also an attractive tall, slim Tuscan girl, who first appeared at the Sartoria as Danilo Donati's shy but very determined assistant on the film *Mademoiselle de Maupin*. Her name was Gabriella Pescucci. Tirelli immediately sensed that she had the right stuff and took a liking to her: she would become like a "beloved daughter" to him. But at the time she was little more than twenty and had just left the Florence Academy of Fine Arts to try her luck in costume design in Rome. This is how she recounts her experience:

> I think I started as a volunteer, maybe second or third assistant, on a film directed by Bolognini, *Mademoiselle de Maupin*, which came out in 1966. I remember the Via Tevere premises perfectly, with those small brown capitonné leather armchairs; as soon as I walked in I heard a man shouting and said to myself: "Good Lord…" keeping as quiet as a mouse in a corner, terrified… How I happened to be there I honestly don't recall, because I had arrived in Rome and had a letter of introduction to Piero Tosi from my drawing teacher. But it seemed too daunting to start with him, because he was like a god to me; I was scared stiff, and I think I did the rounds with my folder under my arm, and maybe I also went to see Danilo Donati. And then the production called me and, as I said earlier, I was second or third assistant. I remember Umberto arriving one day with some packages, which he opened, triumphantly laying out the contents on the edge of the bathtub in the bathroom: they were authentic garments that he had bought from the famous Gazzoni sisters.

Yes, the famous Gazzoni sisters. This is how Pier Luigi Pizzi remembers them:

> The Gazzoni sisters had bought the Roman aristocracy's cast-offs to resell. They had an incredible number of clothes from various periods, from Queen Margherita to the 1930s, in an apartment on Via Merulana that smelt of mothballs and was full of wardrobes and cupboards. We were welcomed by Giovanna Gazzoni and her sister Concetta and husband, all wizened with age.
> The ritual was complicated: "We're looking for evening and day clothes from 1910". "We have none left." "Nothing at all?" "Perhaps if you could come back in a couple of days?" Two days later: "Would these do?" and then they showed us three or four stunning outfits, perfect in style and in excellent condition, which Umberto snapped up right away. "But don't you have anything else?" "We'll see. In a week's time." This time there were dozens of outfits, one better than the other, waiting for us on the counter. And the miracle was repeated every time, as if by magic.
> Umberto bought everything! And the best pieces formed the core of the Tirelli collection, part of which Umberto later donated to the Costume Gallery of Palazzo Pitti and to the Louvre.
> In addition to tracking down "sources", there is another important research carried out by Sartoria Tirelli: choosing fabrics, which always have to be of the very best quality. Umberto and I always went together to do the swatches. Nowadays, someone is often sent: "I need some heavy crêpe, in this colour range…" And they come back with samples of what they have found. Umberto and I had a different system: we would search and unearth fabrics that were used for specific purposes. For example, we would go to the suppliers of ecclesiastical garments, where we would find wonderful brown cloths for Franciscan friars, white wools for nuns'

habits or watered silks for cardinals. Then there were the large fabric stores like Bises and Maestosi, where you could find any kind of material. Umberto said that I had a particularly good "nose". Naturally I had the idea for the production in my head, I had the basic designs, very basic, because I have always considered the costume sketch as simply a working aid. Then I sought a way of making them up. So there we were looking around, at Bises as it happened, going through room after room, and suddenly I spotted on a counter different varieties of the same material, which lent themselves to creating a stylistically and chromatically consistent whole. Umberto said: "This is the production. We'll take it all". He emptied the counter and sent everything to the Sartoria. This happened so many times.

But let's go back to the young Gabriella, as she takes her first steps at Via Tevere and almost immediately moves on to Via Settembrini:

> We're talking about a tailoring shop, and a tailoring shop cannot exist without people who know how to cut and sew. Then there was Umberto's skill, he was fiendishly clever. He would buy books, he would buy clothes and deconstruct them to cut the model; and on top of that he had chosen from the very outset staff who were absolutely amazing.
> First of all there were Anna (women's tailoring) and Luigi (men's tailoring) and the elderly Maria who, like Anna, had come from Safas. After Anna there was Enrica, followed by Dina, Antonia, and young Mattia. The tailor Luigi worked for many years with Renzo, who was short and when he sized the clothes for the extras he used himself as a model; so he would write 54 on a costume that fitted him – but he was only one metre forty tall. We knew this and got a big laugh out of it. He had also come from Safas. Today, Roberto is at the cutter's table; he's very talented and collaborative, and is helped by Maria "the younger". Azucena was another important figure, we cannot but mention her. Azucena was an "outsider": she picked up the work and took it home. She did it at night – she had little kids – and was a woman with great vitality, tremendous physical strength. Years later the "Mafaldas" arrived – in actual fact one was called Mafalda and the other Fausta, but they were known as the Mafaldas because they were twins. They were also external seamstresses, both with a great feeling and passion for period clothes. Unfortunately, they recently decided to retire and I really miss them! For many years Giorgio D'Alberti was Umberto's loyal collaborator; now there is Laura Nobile, who is general coordinator, Flora who mainly follows the big productions, and Rosy who works closely with the costume designers. The first secretary was Dino Trappetti's sister Gianna; then she got married and left, replaced by Mario Ferrero's niece Nicoletta, a delightful woman. Then Nicoletta got married and Violetta arrived, who married an American and now lives in Los Angeles. Next came Simona. She was very good, unflappable, calm, always smiling; and never lost her head. Simona was the first to ask Umberto for a fax – and the fax for Sartoria Tirelli was one of the first to arrive in Rome – and later even a computer. Umberto said to me: "She wants it. What will it do?" Yet he bought it for her, because he trusted Simona, she was a real "techie". Now there's Daniela, patient and a friend to all. Last but not least, another legendary figure joined the list as "manager": Luigi Morena, a true pillar of the Sartoria, whom Umberto would often drive crazy, but who always succeeded, God knows how, in balancing the books.

Those were completely different times. People took pride, and I would say this lasted for twenty, or a good twenty-five years, in the reconstruction of Italy. I felt it very strongly. They took pride in saying: we made it. The greatest designers, the ready-to-wear houses, Armani etc. were just starting up in Milan. This pride in the rebirth of Italy existed among working people. I remember it very acutely. And because of this pride people were prepared to work until late to deliver a costume, without any problem. Umberto would buy pizza for everyone and we would eat there, and then he paid for the taxis home because there was no underground service. But we were proud to be part of the Sartoria, and Umberto's skill lay in creating this feeling of belonging and a sense of pride in an Italy that was getting back on its feet. I recall it so clearly. As I have often said, I dropped out of the Florence Academy of Fine Arts because I felt the world was waiting for me, that I had to go. These are the kind of strong feelings that console you when you grow old. I was happy to be Italian, to participate, to work for this costumier that produced such beautiful things. There was this pride, which I don't think exists anymore; there were the talents of Umberto, the "driving force"; there was his fantastic optimism that swept us along. He got himself heavily in debt, but he did it in that period; now it would be more difficult, even for him. He bought the apartment on Via Pompeo Magno, which became the Sartoria's new premises, with a small down payment and a bank loan. The banks supported small businesses then. It was a completely different climate. Just try now. Do you want to open a pizzeria? If your grandfather doesn't give you the money, you won't be able to.

Shortly after moving to Via Settembrini Umberto asked me: "Can you stay in the shop for a while and give me a hand?" Of course I said yes, and at the Sartoria I made a name for myself and worked as assistant to the "greats", Ezio Frigerio and Pier Luigi Pizzi, on two excellent TV productions directed by Antonello Falqui. At the Sartoria we organized "workshops". What exactly was a workshop in this sense? It was a way of devising methods for treating fabrics, stones and unusual materials to make them look like they belonged to another period. Workshops were usually set up to make early period costumes. They required skill and creativity: you could actually transform little plastic balls into stones! Tirelli workshops enabled you to construct something that did not exist, or no longer existed, and to do this you had to use what was available, so you had to take it, change it, split it, break it, dye it, weave it, glue it, layer it… You put three or four fabrics one on top of one anther, gather them, cut them… reinventing something that is no more, for which often you only have written and no pictorial documentation.
One of the first workshops Tirelli organized was for Pasolini's *Medea*. And it was there that – finally! – I had the chance to work for Piero Tosi. I remember Medea's elaborate "scapular". On the ground floor at Via Settembrini there was an enormous table occupied by the milliner Jose, a wonderful crazy woman whom we all admired and respected, and I had taken over a corner of the table, I had laid the cut-out "scapular" on it, and every so often I would add a small piece, whenever I had the time. Then Piero would come by and say: "No, let's move it". I had already spent about a month on it. "But let me just add these little bits." "Ah, yes, yes, nice…" And Umberto would say: "Well, this scapular has to be finished!". "No, let's leave it there!" I defended it with my life by making sure I didn't finish sewing it, because I stitched it by hand, and if it wasn't all stitched

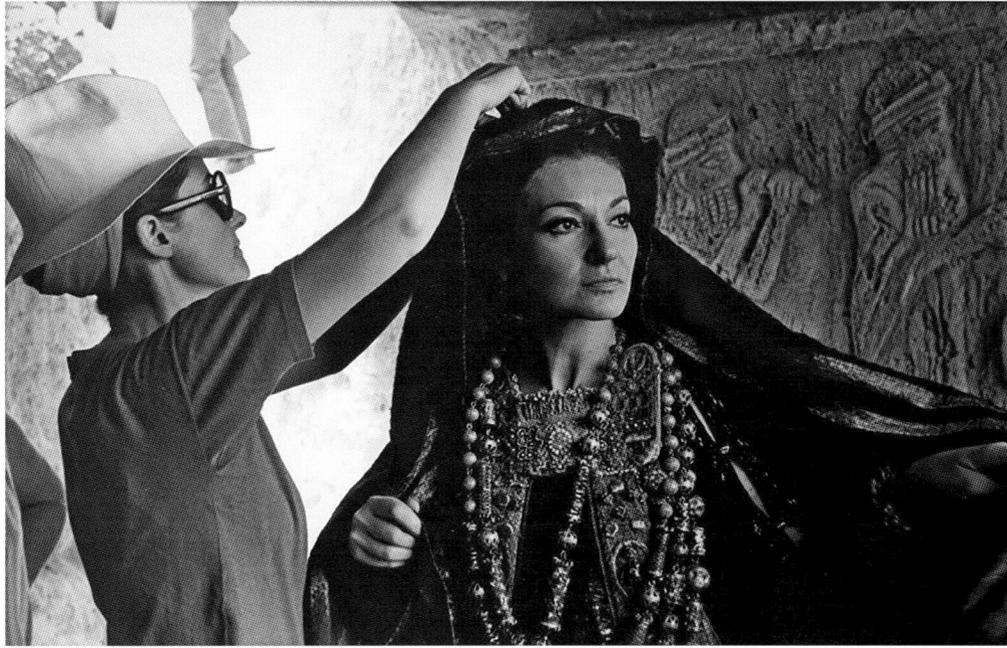

and you lifted it up, it would fall apart. And I wasn't sewing it. "Are you going to finish sewing this scapular!"

Emilia, the warehouse-keeper, was wonderful during that period: she was a good and generous woman and protected us young assistants. At Via Settembrini there was a stairwell and no lift, and one day Umberto was calling "Emiliaaa! Emiliaaa!" at the top of his voice from the second floor. Emilia arrived from the ground floor carrying a bowl, and shouted at him in Roman dialect: "*A sor Tirè! ci ho la Gallas nella bagnarola*!" In other words, she was dyeing fabric for one of Callas' costumes.

I was very fond of Emilia, and we all adored her. She also worked late at night, she would do anything. At 7 in the morning she arrived with the coffee, and began her day by serving it to Umberto. She was so naive that when they organized pranks on April Fools' Day, like they did every year, she would always be taken in, and Maurizio, who was her pet, would say to her: "Look, call in sick on 1 April, don't come to work". Nothing doing, she always fell for it. The next year they even kidnapped Dindo, Umberto and Dino's beloved Dalmatian, and she nearly had a heart attack. She was good, ingenuous, simple-hearted. She and Maurizio were so close…

The Maurizio in question was Maurizio Millenotti. This is his story:

I started at the Sartoria in 1968. At twenty I did my national service in Milan, then I went to Paris for six months, after which I returned to Milan where I worked for a small clothing manufacturer called Rosier. I'm from Reggiolo, a town near Gualtieri, Tirelli's hometown. I went to Rome because I had met Tirelli's brother, who was a winemaker and delivered wine to my mother and my aunt. I had seen a feature in *Uomo Vogue*, that famous one in which Tirelli dressed Visconti: it was entitled "Sei personaggi in cerca d'autore" [Six characters in search of an author] and the author was Tirelli, who had involved Luchino Visconti, Giorgio De Lullo and Romolo Valli and dressed them in clothes by Osvaldo Testa. I was really impressed and so I paid my compliments to his brother, who said: "Look, he's coming here next week, I'll introduce you to

Luchino Visconti, Umberto Tirelli, Romolo Valli, Osvaldo Testa and Giorgio De Lullo pose for a photo feature by Ugo Mulas for *Uomo Vogue*, 1968

him if you like". I went with my brother to meet him and he took a liking to me. He said: "If you want to come and work for me, you're welcome". "Yes, I'd really like that." "If you want to come, though, it'll have to be as a volunteer, because I can't pay you." The proposition interested me but I couldn't accept it because I had to earn my living. So it ended there. With a mutual liking, however. Then, after two months he called me and said: "Look, things have changed. One of the boys has left, so come if you want and see what the place is like". Of course I left Milan immediately. It was the weekend of the feast of St Peter and St Paul. I went to the tailoring shop, walked in, and the first person I met was Piero Tosi. I was very struck by the Sartoria, by its atmosphere, and above all by Piero who had come to have his trousers taken up, and took them off in front of everyone, remaining in his underpants. I was bowled over because I could identify with this nonconformist gesture, and I said: "I feel at home. This is the world I want to live in." Then I met Gabriella, who was Tosi's assistant then, and she was kind, warm… in short, I was really taken and fascinated by it all. I didn't think twice: I went back to Milan, gave in my notice and started as factotum at the company in September. The vats were downstairs, Vittoria Guaita used to do the dyeing, and I went down there with her and got started. Tirelli was the one who would teach me to do anything immediately, and I was interested in everything. But it was the warehouses that held me spellbound, there were things in there that I had seen in films, and I was dumbstruck to find what I had seen in a movie hanging up in front of me. I stopped constantly to look at, to study the colours, the various kinds of material. De Nobili's costumes, the ones for *The Merchant of Venice*, were a revelation. Those costumes really moved me deeply, I looked at them spellbound. Then there were Tosi's things, the costumes for *Arabella* of 1925 and those for *The Damned*, which had already been returned, Thulin's clothes…

I lived at Tirelli's; for six months I actually lived at the Sartoria. On Via Settembrini there was the apartment on the third floor, where the women's tailoring shop and the fitting rooms were located. On the second floor there was the men's tailoring shop. On the ground floor there was the apartment that had belonged to Princess

Lancellotti, where deliveries were made, and as well as my room there was the one occupied by the famous milliner, Elsa. She was wicked, mean, and really couldn't stand me. I was always going in there to watch, sometimes she would call me in to help her attach some feathers and keep telling me off because I didn't get them right. As I said, the deliveries were made here, and then there was a small room with a bathroom that overlooked the courtyard where there was a magnificent plane tree. I stayed there for six months, I lived at work.

Down below there were the storerooms with Giannini's costumes for all the various productions and television shows; and there were the small jackets for the boys in *The Damned*: in the evening I would go down there, dress up and go out. This was in 1968–69. There were also Carabinieri boots up to the knee, and I went around in long coats... I even went home to Reggiolo dressed like that, and my mother wanted me to change, saying: "Maurizio, don't do it for you, but for your brother because he has to live here". I would put on cloaks, Napoleonic greatcoats... Umberto suspected something, but let it go. I would wear 1930s jackets and off I went. It was the late 1960s when we began to let our hair down – in Rome we used to go to Piazza Navona. I also wore my outfits on the train... the trouble was that the Carabinieri boots were a size too small for me. My feet were killing me on the train, but the boots were cool, they looked so good on me. I didn't go to university, I went to technical college but had a natural talent. There's no doubt that everything I learnt, I learnt at Tirelli Costumi. I learnt by watching the tailors and seamstresses work, by studying the finished costumes, by being with the costume designers – and, it must also be said, through my determination and spirit of observation. Lucia Mirisola was the one who increased my standing with Tirelli, because she always asked for me at the Sartoria, and Tirelli let her do it. When we were doing *In the Year of Our Lord* in Rome, after I had finished at the Sartoria, I would go over to the Jewish ghetto and help her dress the actors...

As far as my training is concerned, the period working on *Medea* was fundamental. As well as looking after the warehouse I also assumed more responsibility for the aging and dyeing of materials; we no longer had Vittoria Guaita, who had done all the most important things until then, and external workers who had collaborated with Danilo Donati on *Satyricon* were involved. Even so, I still had my work cut out, indeed I had to dye Callas' famous costume, the purple one. I was terrified but I was the one who had to do it and, luckily, Piero was happy... I think *Medea* was one of the best things that Piero has ever done. He used materials never adopted before, gauzes and grandmothers' cast-offs, then there were the dyeing techniques, the methods used for gathering. Piero outdid himself, surpassed himself. In those costumes there is the whole world of Colchis, there is also painting, there is Braque. It was a complete mix of styles and knowledge... A miracle.

I stayed at Tirelli's as factotum for three and a half years – from September 1968 to spring 1972. Then I happened to meet Chiara Samugheo there. She was a photographer with whom we did photo shoots, which Tirelli let me do. She introduced me to a man from Carnaby Street, a fashion shop in Via Margutta, and they offered me what was an exorbitant sum at the time to go and work for them, and I went. Tirelli took it badly. He considered it a real betrayal. After going to Carnaby Street and staying there three months, I knew that I could never give a damn about fashion. Then Lucia Mirisola asked me to be her assistant, giving me the

chance to go back to Tirelli Costumi. She had to do a film that was subsequently shelved, but we began to prepare it. Meanwhile, I had moved into Gabriella Pescucci's place, and she was terrified for the Tirelli curse was still on me, because I had abandoned him. But it was a benevolent curse… You know, Umberto and I had the same roots, we came from the same place, we also used to speak to each other in dialect…

After Lucia, Elena Mannini called me, and we did *The Five Days of Milan*, and then Gabriella "dared" to ask me to do *Mahagonny.* In short, my career had taken off…

Fellini was responsible for the big step. It was 1981. I had done *The City of Women* with Fellini, as Gabriella's assistant. Since she was working on Leone's *Once Upon a Time in America*, Fellini started to call me for his new film *And the Ship Sails On.* I didn't want to do it because I didn't feel ready. I was terrified. I think he might have asked Piero Tosi about me, and then he insisted, I don't know why, maybe he had consulted a medium. I don't know how it happened. I didn't call him back when he left messages on my answering machine. I talked to his secretary Fiammetta, saying: "Please, tell him it isn't possible". She replied: "Look, he's determined." Then Fellini called me in person and left another message: "You absolutely must come tomorrow, out of respect for me", he said "so we can exchange ideas and talk about it". I remember I took a taxi, dressed in white, and after twenty minutes we had to turn around and go home, because I'd peed my pants".

Maurizio Millenotti and Federico Fellini
on the set of *And the Ship Sails On,* 1982
Reporters Associati & Archivi

In *And the Ship Sails On* there is the album with all the photos of the opera singer: we had to film and take loads of photos of the singer, who was brought from London. Her name was Barbara Jefford, the actress who had done *Nicholas and Alexandra*. I think Fellini used this as a pretext to see if I was up to it. It was a film within a film, because we had to do two operas, *La traviata* and another, with all the characters and the choir; then the singer with some friends in a boat on the lake in the Borghese Gardens in Rome; her leaving the station in Saint Petersburg; her photographed in Saint Petersburg, and her at home. As I said, a film within a film. It was a ten-day shoot. Fellini showed the photos to Piero, who said: "They're superb. Everything's perfect". After my career took off. The film was to have been in black & white, but then they decided on colour and I had to change quite a few things. There wasn't much money available. At a certain point Fellini asked me: "What if we call Piero to do the makeup?" "If only!" He said: "You ask him because if I ask him he won't come". So I asked Piero, as a favour. I said: "Federico doesn't dare ask you". I still used the polite form of address with Piero… I also used it with Tirelli, until the day he died.

Umberto Tirelli had seen that the young Millenotti had the makings of a tailor, and could perhaps become his successor at the helm of the Sartoria. But by co-opting him into becoming her assistant Lucia Mirisola opened up a career in costume design for him. When she first used the Sartoria, she was a young Venetian lady of thirty, she had already

studied at the Centro Sperimentale di Cinematografia and learnt the ropes elsewhere. She was married to an extremely talented young author who had just directed his first very modest film entitled *Faustina*: Gigi Magni.

This is how Lucia remembers those years:

I started out as a costume designer immediately after leaving the Centro Sperimentale, around 1956. I met Umberto Tirelli at Safas, which he was managing then. The first time I went there was for a film in modern dress, because then – the good old days! – the costumes for films in modern dress were done at the tailoring shop… it must have been a movie by Mattoli or Gallone, I don't remember… and Tirelli said no, it couldn't be done. That was when I met him: he was very nice and polite, even when sending me away. After that I went to see a lot of other Rome tailoring shops. But when I found myself having to do *In the Year of Our Lord*, which was my first costume film, and in colour to boot, it was the most daunting challenge. I didn't know what to do so I went to see Tirelli, who in the meantime had opened his tailoring shop.

In actual fact, the production company sent me to Tirelli to "back me up", perhaps because they felt they couldn't rely on me completely. And there I found a kingdom, yes, a kingdom. It was so organized, the collection was amazing, there were rooms equipped for painting and for aging costumes, it was an extraordinary set-up, absolutely great. Umberto always did things on a grand scale… the image of a Spanish grandee comes to mind… culture placed at the service of entertainment… it was magnificent. And there I met Maurizio Millenotti, that is I met a young lad with a head of curls who was wearing a black overall and doing the dyeing, whom Tirelli introduced to me while he was showing me around the Sartoria. Afterwards, when we were shooting the film, Maurizio very kindly came at night, after he had finished his work at the Sartoria, when we were filming on Piazza del Popolo or in the Jewish ghetto, and helped me to dress the cast – something I think Tirelli never forgave me for, because afterwards Maurizio left his job at the Sartoria, became my assistant, and then Maurizio Millenotti, one of today's most gifted costume designers.

Maurizio was always teaching me things, without knowing it. No, I tell a lie, he knew it and how, because I was always… well, I tended not to bother with the more "precise", the historically accurate aspects, and preferred to follow my imagination. One day he saw me folding the trousers worn by Manfredi, who was playing the priest, and I was folding them like they do today, which creates the centre crease: "Not with the crease, for God's sake!". I couldn't believe my ears: "We won't do it, we won't do it, OK?". And I'm sure that, had I asked him, he would have told me the exact date and the precise day on which the trouser crease was introduced.

Sartoria Tirelli was like a second school to me, precisely because of the way they worked. And then because of the vast range of materials they had… Umberto had bought up the shops selling furnishing fabrics, upholstery fabrics and silks all over Rome, Italy and Europe, and the choice was endless.

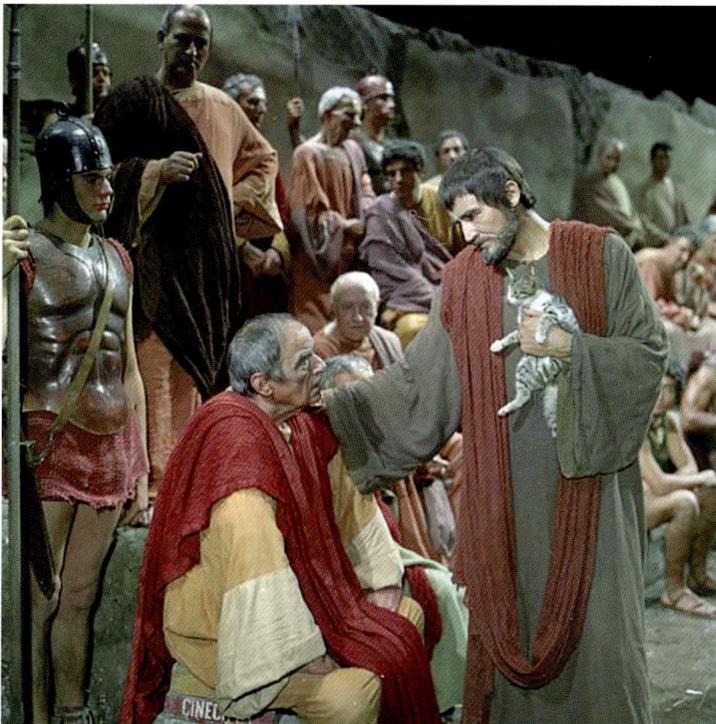

Vittorio Gassman in *Scipio the African*, 1970, directed by Luigi Magni with costumes by Lucia Mirisola
Reporters Associati & Archivi

Monica Vitti in a costume designed by Lucia Mirisola and made by the Sartoria for *Tosca*, 1972

I've always been very shy but, at the same time, very bold. I focused on colour rather than form. As in the costumes for *Scipio the African*, which Umberto created for me with stunning fabrics that had been skilfully aged. I was going to have to recreate Rome in the studio, at Cinecittà, then age it and reduce it to ruins, because the film was set in a Rome that was only 500 years old and internecine struggles were rife. But then Gigi and I said to ourselves: "There's Pompeii". So we created the costumes in relation to that idea for the set, inspired not only by the concept for the script but also by the visual. We didn't shoot everything at Pompeii, only the street scenes and some interiors, and the rest at Hadrian's Villa in Tivoli and Villa Ada off the Via Salaria in Rome. And a few other things at Cinecittà. The costumes were all by Tirelli. They were all "constructed". Instead of using white and red for the senators' costumes, like they did in the classic American movies, I adopted all the "Roman" colours, namely orange, with red and maroon togas. I was concerned with colour more than anything else. And in that respect Umberto supported me to the hilt… Later we did *Tosca*, set at the time of the Battle of Marengo, namely in 1800.

I did a lot of work on the nineteenth century at Umberto's. He had such remarkable stock. You know, Tosi had done films there with Visconti and stuff like that, so you can imagine all the stunning things you could find there, and, quite frankly, Umberto was happy if I could use them, even by altering them, especially for the extras. But I created new costumes for the leading actors, Gassman for example, also at Tirelli's, with those splendid fabrics he had… I also allowed myself a few "departures" from the periods in which films were set; for instance, I had found a gorgeous flowered shawl from the 1930s and it looked perfect when I put it on Tosca. I was scared that Umberto would shout: "No, you can't have her wearing that", but I did and he approved. Also because he respected imagination and creativity, even though, at heart, he was extremely rigorous and finicky. For example, the soldiers did not have uniforms but costumes that were put together somewhat "artistically", if you'll pardon the expression, using colour, hats and feathers… but of course I put them in uniforms for the Castel Sant'Angelo scene. Tosca had only two costumes, but one more stunning than the other. The first was in maroon velvet, to which I had added the shawl. The second, instead, was of "Tosian" inspiration, because I remembered *Death in Venice*, and… pity that dress was burned… Umberto had given it to Monica Vitti and it was destroyed in the fire at her house.

I learnt so much from Umberto. He had such a keen critical eye. He was very generous to the costume designers and the people who worked for him in general. He also had great relationships with the actors and directors: not just professional, but real, familiar friendships. I remember him saying to Vitti one day: "You're talented, adorable and divine dear, but please don't ever come to my Sartoria again because you reduce my first seamstress to tears". I remember exactly when he said it, because it was one of the times she came with her many fixations: "No, we'll take this in, we'll let it out…" The truth is that Monica, who was so beautiful, so remarkably talented, was always insecure and projected her insecurity onto the costumes.

Next I worked on *State buoni se potete*, another delightful movie. The costumes for this film were also done at Tirelli's… So I did a whole lot of different periods

with him, all with the same joy, the same exuberance, because it was great working with the Sartoria: you felt protected, safe. You could rely on them and, at the same time, use your own initiative, break the rules, be creative and feel understood.

This is another worthy characteristic of the Sartoria: the willingness to encourage the costume designer's creative flair. Now we'd like to sum up the eclectic makeup of Tirelli Costumi. We know that its owner was an enterprising young man – at this point in our story Umberto was just over 40 – backed by solid experience and with a wide-ranging culture. As well as being practised in his profession he had also completely assimilated the experiences of his predecessors, marrying Sensani's analytical rigour, in other words his love for historical detail and reconstruction, with the imaginative flair of Caramba, as Luigi Sapelli was known. I can still see Tirelli, with his half-serious, half-joking smile, and hear his voice and that unmistakable accent as he put "the question" to the director who had come to do a new project (the first person to whom it was addressed was Luca Ronconi, who often used the wildest combinations in his productions), which indicates the two main areas in which his company was forging ahead. The question was: "Period or madhouse?"

In both cases, the company was able to satisfy the client's needs by drawing on its "archaeological" skills, while always willing to invent and experiment.

Pizzi recounts:

A lot of new ideas were actually born from the discovery of new materials.

Plastic textiles, like vinyl, enabled me to obtain some extraordinary effects through the lighting. The costumes for the first *Tancredi* at the Rossini Opera Festival and those for *Ariodante* at La Scala were one of the strong points of these productions. At a certain point we discovered Alcantara, a kind of artificial suede: it wasn't fustian – it was even better. We made all the costumes for *I puritani* at the Petruzzelli with this material and the result was so good that we used them on various other occasions with great success.

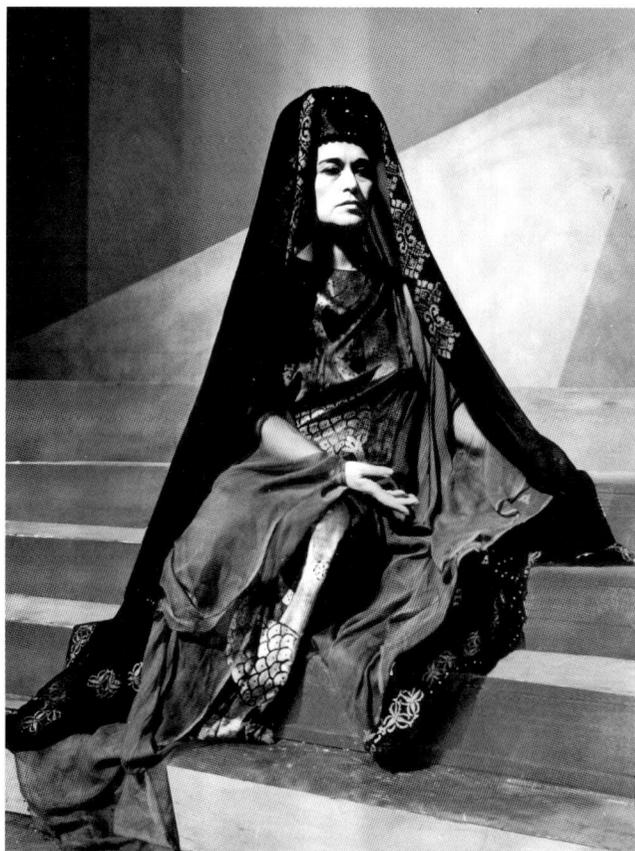

Leyla Gencer in *Belisario*, 1969.
The costume, created by Pier Luigi Pizzi, was made using Gallenga's printed fabrics
AFI

Then there was Gallenga. When Umberto bought the patent for Gallenga's block printing technique, which was very similar to the method used by Fortuny to print on fabrics, I think I was the first to apply it. At that time I was staging Donizetti's *Belisario* at La Fenice, and with Umberto's help I was able to dress Leyla Gencer using the masterpieces inherited from Gallenga. In fact, we were so enthusiastic about our new discovery that we got carried away and dressed the entire female choir in sublime tunics in voile printed with silver and gold. Having the blocks and having the glue – unfortunately nowhere to be found today – on which to fix the metal dust enabled me to use this process especially on the velvets I adopted for many productions, with amazing results: *Armide* by Gluck at La Scala, to mention just one.

It was a pleasure to experiment with Umberto, because he always made excellent suggestions for improvements. He rarely got discouraged, even when you asked him to make costumes that were out of the ordinary. As was the case with the costumes-cum-sculptures for *Semiramide*. For *Bianca e Falliero* at Pesaro I had in

mind costumes inspired by Veronese, but I didn't want to use damask furnishing fabrics. I suggested creating a damask effect with taffeta by cutting out the design and laying this on top of another taffeta in a contrasting colour, used as a ground. At first it seemed impossible to realize, but Umberto liked the idea and we found a way. The effect was astonishing. Nothing was impossible!

The decade between 1964 and 1974 was a very special one for Italian entertainment. In parallel to the cinema of Visconti and Fellini, which reaped international success, the theatres hosted plays directed by the great Strehler and the golden age of opera; the Festival of Two Worlds in Spoleto was an international attraction, and even television offered high-quality productions. The Sartoria worked on all fronts: its clients were Visconti and Strehler, Fellini and Pasolini, Eduardo and Scola, Monicelli and Petri, Bertolucci and Blasetti, Leone and Cavani, Patroni Griffi and Ronconi, De Lullo and Squarzina, Comencini and Rosi, Fassini and Sequi, Bolognini and Menotti; but also leading foreign directors like Roger Vadim, Tony Richardson, François Truffaut and Raymond Rouleau. Respect for the quality craftsmanship turned into friendship and familiarity. Alongside the directors there were the writers and intellectuals, painters and artists. Not to mention the actors and singers, from Gassman to Mastroianni, from Silvana Mangano to Lucia Bosè, from Mina to Maria Callas. Umberto Tirelli and Dino Trappetti's house became a meeting place, a catalyst for ideas and projects. Tirelli Costumi was the place to be.

This is how Carlo Diappi tells it:

When I arrived, the company was already a big name; in fact, I started with them late compared to the others. I would never call him Umberto, I called him Tirelli, I have always called him Tirelli. Tirelli comes naturally to me, not Umberto, and he used the polite form of address with me throughout his life. We always used the polite form of address with each other, never the familiar *tu*. Because he had decided that from a certain point on, he would use the polite form with everyone who came in.

The first time I went to the Sartoria was in 1977, but before working there as Pizzi's assistant I had gone because Pizzi had sent me from Florence, where we were doing *Nabucco* with Ronconi, to pick up something… a taled… a scarf… So

Umberto Tirelli with Luca Ronconi and Ezio Frigerio, 1982
Photo by Lelli and Masotti
© Teatro alla Scala

I came to Rome to go to the Great Sartoria, and the first thing I heard, of course, were the shouts. I was a bit disconcerted. But Tirelli was very kind and gave me the scarf: "Don't forget now, I'm only giving it to you because…" Then I went back again in November while we were doing *Il trovatore*, again with Ronconi, and subsequently for all the productions that Pizzi was doing around and about.

Then Pizzi started directing his productions – in 1977 I think. It was *Don Giovanni*, I believe, in Turin. And in 1979 I designed my first costumes.

My first production was *Don Pasquale* at Henze's Cantiere d'Arte in Montepulciano, on which Riccardo Chailly also made his debut as conductor. Then for a few years I continued as assistant to Pigi, as Pizzi was known affectionately, and to do a few of my own projects until, at a certain point, when I was receiving so many offers that I was no longer able to do both, I gave up working as assistant, but this was really where I got my training. Since I had not embarked on specific studies, for reasons I won't go into here, everything I knew I learnt from Pizzi and subsequently from Tirelli himself, at the Sartoria. And then Tosi would come to the Sartoria, for example, Frigerio would come, all the big names would come, so you could learn a lot by always keeping your eyes open and shamelessly watching everything they did.

Sartoria Tirelli… well, every costumier has its own special character. Costumiers are a world apart, special, because they have nothing to do with the usual work environment. I had worked in business, interpreting in French, and a bit of English and German, for my father whose work was as dull as ditchwater. So I had experienced work environments that were completely different from the alluring and imaginative one of a theatrical costumier. The atmosphere at Tirelli was jolly and very, very pleasant; but I have to tell you that most of the time I felt quite inadequate due to my lack of experience: I was always on the alert, always terrified of making a mistake, of people realizing that I didn't know certain things, that I had gaps – so I was always tense. It's not that there was any great rivalry with the other costume designers: we were all on the best of terms. For example, I connected with Vera Marzot and Gabriella Pescucci right away. Wonderful friendships.

Tirelli was really unpredictable. He would suddenly fly into a rage, and was notorious for his shouting. He went to work early, at eight, eight thirty, and if you could hear his yelling when you were in the street, your blood ran cold: "Oh God, this morning I'll never be able to ask him if he'll do this for me or he'll let me do that, how will I be able to get him to accept the fact that we need ten more costumes…". However, these outbursts were like summer storms; they were soon over, and everything was forgotten. Then he had his serious, positive side, because although he let us do things our way, he always kept everything under control. If you did something stupid he would intervene without so much as a by-your-leave, but if he saw that you were not really a shirker, on the contrary, that you were serious, committed to your work, he supported you, gave you tips, maybe saying en passant: "You're doing a pretty good job there. But maybe I would do it like this… ". And he would give you a hint, a suggestion, but make nothing of it. A great help.

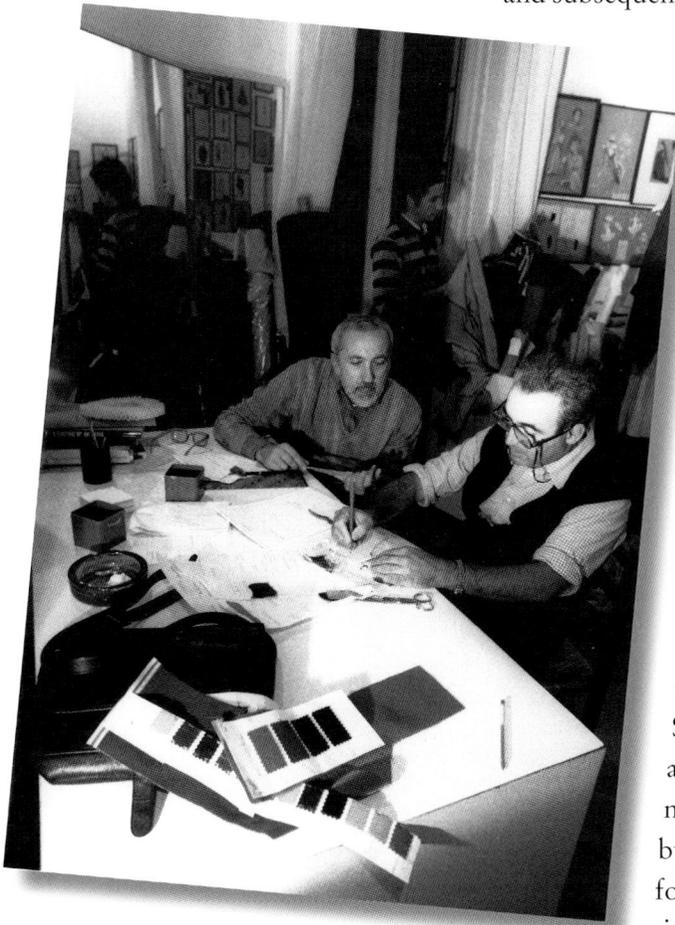

Pier Luigi Pizzi and Umberto Tirelli at the Sartoria, 1980

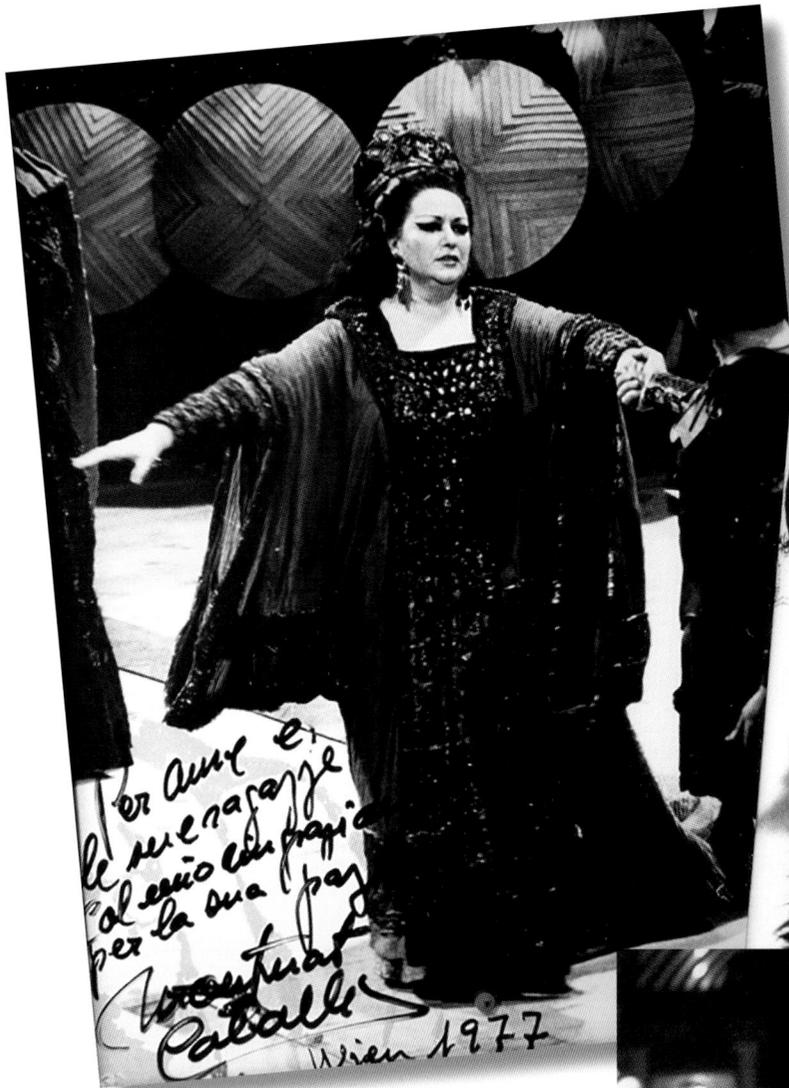

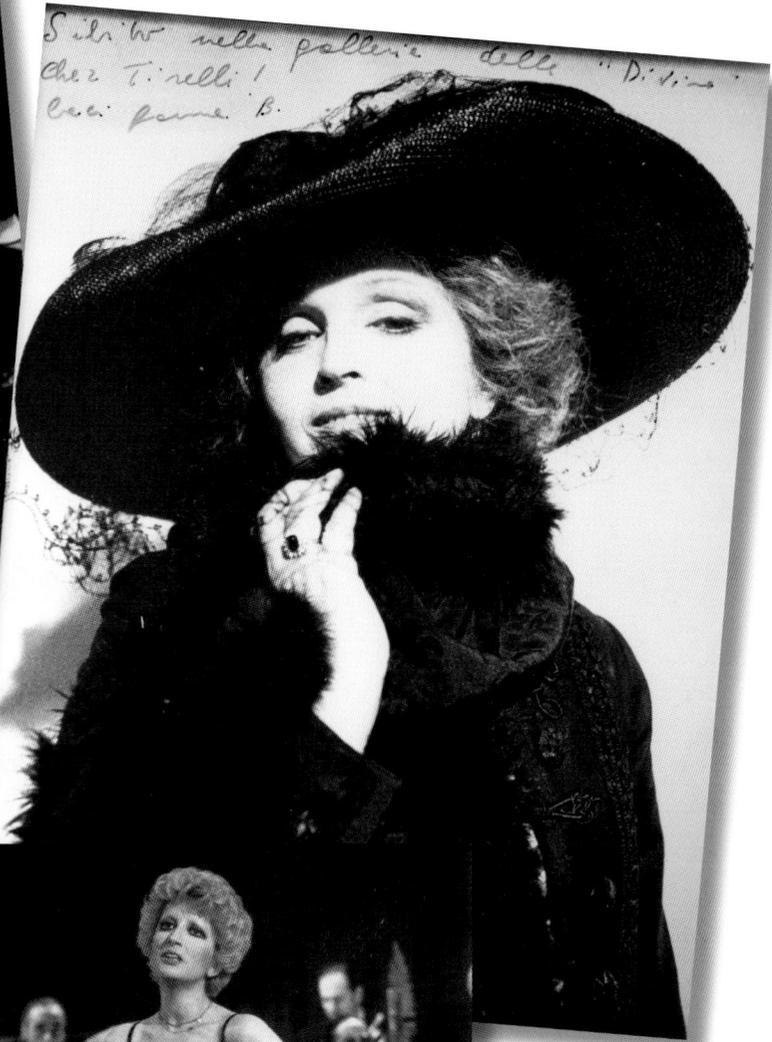

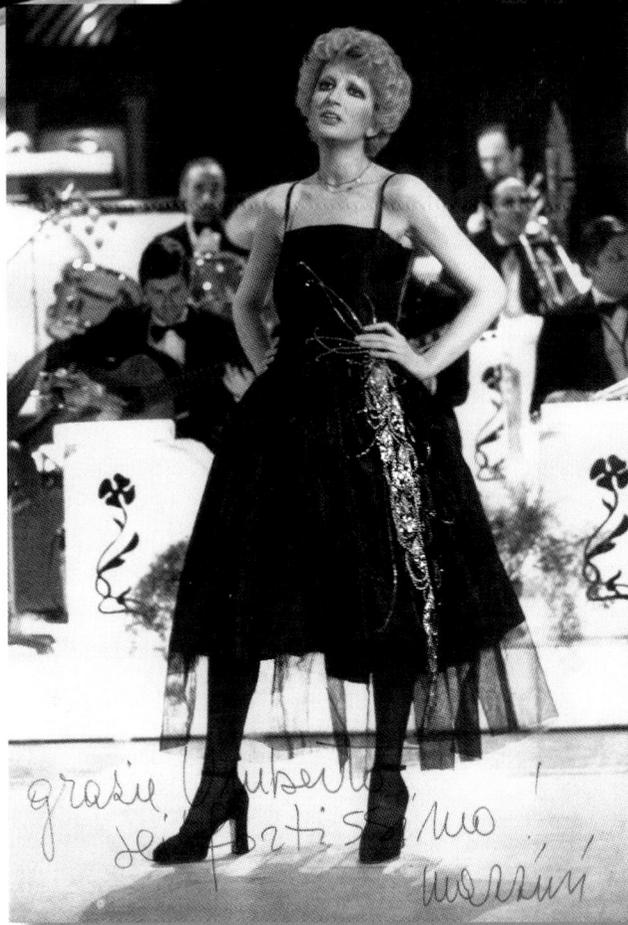

Montserrat Caballé wearing a costume
designed by Gabriella Pescucci and made
by the Sartoria for *Norma*, 1972

Laura Betti in a costume designed by
Gabriella Pescucci and made by the Sartoria
for *The Seagull*, 1977

Mina wearing a dress by Jeanne Lanvin
(1925) from the Tirelli collection, which was
made available for the television variety
show *Milleluci*, 1974

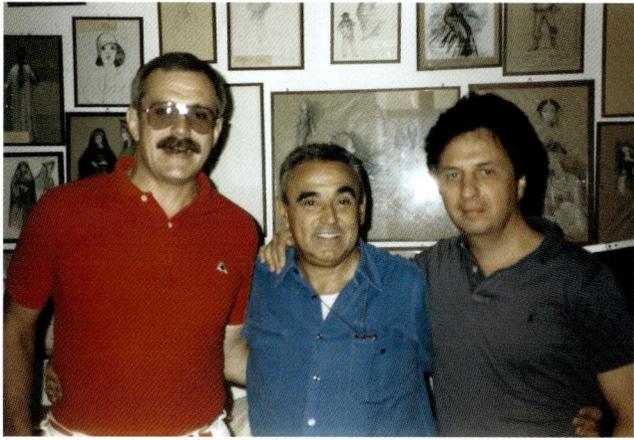

Nikita Mikhalkov, Umberto Tirelli
and Michael Cimino at the Sartoria, 1986

Then there was the training: if you weren't an idiot you put your back into it, made the most of your volunteer period. We've all done it, every single one of us. I started by dyeing tons of stuff, aging material, also working on Saturday and Sunday: it's part of the apprenticeship. An invaluable apprenticeship, for which there is no substitute. The same goes for the relationship with the workers. I was from Milan. Well, the Rome tailors are a world unto themselves. There was Signor Luigi, a tiny little man. I remember when Marcello Mastroianni came to try on the costumes for *Dark Eyes* at my house. He didn't want to go to the Sartoria for a fitting because he was pretending he wasn't in Rome and the Sartoria was right next to his house. We had to fit the costumes at my house and Tirelli sent Signor Luigi over… *Dark Eyes* was quite an adventure. Tirelli had liked the project, he had even gone to Moscow to visit the Mosfilm tailoring shop and was delighted with it…

At the same time, Gabriella was preparing *The Family* directed by Scola, and Michael Cimino had also arrived with his film *The Sicilian*. We, the friends, felt a bit left out. Tirelli sensed this, and when shooting was wrapped on Scola's film I received a Bulgari watch and so did Gabriella. This was so like him. He knew how to apologize, he felt guilty, and he would always make it up to you somehow… It's really difficult to acknowledge your own mistakes, but it's a form of greatness.

Pasquale Grossi also used the polite form of address with Tirelli:

Sartoria Tirelli was already famous. I was preparing *Il trovatore* for the Teatro La Fenice and, on Alberto Fassini's insistence, I dared to cross the threshold. Tirelli said: "If you give me a hand, we can do it…". And he said some very sound things: "Excuse me, but the soldiers' costumes are all black and you've got metal breast plates, helmets and collars that virtually hide them. If you don't need new ones and I can give you these – which were perfect, they were in black cloth with black

Christopher Lambert in a costume designed
by Wayne Finkelman and made by the
Sartoria for *The Sicilian*, 1987

Mikhail Baryshnikov. The Sartoria made some of his costumes for the film *Dancers* (*Giselle*)

cloaks – I can make new costumes for the more important characters. That way you'll stay within your budget".

To tell the truth, the first time he agreed with me I was only a little over thirty and I felt thrilled, but also "accepted", like someone who has finally entered the world of the VIPs, in the sense of quality, of course. I never visited Tirelli when I was an assistant, because I had started out with Pierluigi Samaritani and they did not get on very well; in fact, Samaritani continued to go to Safas. Then I became part of the Bolognini, Fassini and Menotti circle and then Tirelli took a liking to me, either because I was serious, or, by contrast, because when he said something to me I would answer back and make him laugh. Once he said: "What do you want me to do, throw myself out of the window?" And I replied, "Good Lord no, we're on the first floor and you might be crippled for life!" or something silly like that, and he had a good laugh. I always liked him because he was always frank and straightforward. Once I chose a certain velvet for a project and he said: "Look, I'd rather not give it to you for five choristers who are on the right in the background. Gabriella Pescucci is very keen on this velvet and she'd like it for something else". Another time I had chosen some inferior fabrics that seemed OK to me, once again for costumes for members of a choir. "Do you mind making them with this better quality material, you can't see it from the stalls, but it lasts longer, and so they may come in useful later". And another time I was working on *Bianca e Fernando* with Sandro Sequi, set in 1825, and therefore with Empire line dresses. He said to me: "Listen, I'll make the bodice with a point, which if it's placed under the skirt is well hidden. I'll make a separate pair of puff-sleeves, that way if I have to do *La traviata* I'll add a crinoline and I can use them again".

He gave me a load of practical tips. I was always for copying the historical model, taken from this or that "sacred" text, but Tirelli would say things like: "Look, if you add a cut here, they can let out the jacket in five minutes, if necessary. If you make it in one piece like the model they have to take it all apart, which would take three hours and in the end either it turns out badly or they can't widen it at all". A cut there or a cut behind where no one can see it. When you get fifty chorister jackets and you have half a day to make them fit, and thirty-five have to be let out (because even choristers lie about their measurements!), well… In other words, there was always this practical experience. Obviously Tirelli was not born with this knowledge but had acquired it, absorbed it from expert tailors he had known and made it his own by studying and working. He put it to good use and generously passed it on to others.

He was a giver. He made his books available to everyone and would say: "This is for those who can't draw! Make copies!" He had an enormous library.

Once he treated me very badly because of a *Eugene Onegin* – but it wasn't my fault… The Paris Opéra had three co-producers for that production, but in the end two pulled out and only one was left, so the budget had been considerably reduced. I went to Tirelli and found him in a furious mood. "Oh, that's that, it's out of the question! Don't count on me." And I left with my folder of drawings under my arm and my tail between my legs. But at 7 o'clock the following morning the phone rang: "Pasquale, sorry. Alright, come over and we'll find a solution". His name was, and still is, extremely prestigious. Other costumiers would say:

Carlo Poggioli also remembers the "shouts":

I arrived at Sartoria Tirelli after attending at the Academy of Fine Arts in Naples. I was with a friend from the Academy, Sasà, and we didn't even know how we were going to pay the rent, so we started looking for something at once. It wasn't an easy time, 1983–84, and there wasn't much work around. We arrived with our folders under our arms and did the rounds of all the tailoring shops. We went to Farani, and Farani told us there wasn't much work; we went to GP11, Peruzzi, all the big names, and then finally to Sartoria Tirelli, though we didn't have any hope, since everyone had told us that there was nothing doing. Instead, a fortnight later I got a call from Tirelli who offered me a job with Carlo Diappi, dyeing fabrics. I'd never dyed fabrics in my life and didn't know where to begin, but because I'd done a few things in Naples and I liked sneaking into a theatre when I got the chance, I boldly turned up at Sartoria Tirelli and threw myself into the job. My first impression of Umberto Tirelli was terrible, because he came downstairs and said: "You'll never manage to do this dyeing. It's impossible". But I'm a stubborn Capricorn and anyway I knew about colour from painting and managed to do what Diappi asked me to. And Tirelli began to believe in what I could do. The costumes were for *Countess Mizzie*, a film with Umberto Orsini and Anna Maria Guarnieri.

Gérard Depardieu wearing an authentic eighteenth-century outfit in the film *Danton*, 1983, directed by Andrzej Wajda with costumes by Yvonne Sassinot de Nesle

While I was there doing the dyeing, I also got to know Gabriella Pescucci, who was preparing *The Name of the Rose* directed by Jean-Jacques Annaud, and one day she asked: "What are you doing this summer?". "Nothing, why?" Then she said: "Well, as we're closed for the month of August, but I have to come in all the same because I've got to prepare this big project, if you like you can come and give me a hand".

And that's how I began working with Gabriella, which lasted virtually twenty years, and even now when we get the chance to do a job together we accept. While working on *The Name of the Rose* I was lucky enough to meet Piero Tosi, and to collaborate on Zeffirelli's *Sparrow*; and then I met Maurizio Millenotti, who called me to do *The Voice of the Moon* directed by Fellini. This was later obviously; it was at the beginning of the 1990s. Well, that's where I started.

I owe my whole career to Tirelli, let's face it, because by learning the ropes in the Sartoria, apart from Gabriella, Piero and Maurizio, it was Tirelli himself who gave me a good training, training not only technically regarding how to make a costume, but also training for life, because his vitality is something that has remained with me… in other words, he was a great example in every sense of the word. Certainly, however, when he lost his temper he could be terrifying.

I will never forget the terrible scene he made about *The Name of the Rose*. There was no one in the tailoring shop in August, but we had an account at our ironmonger's so Gabriella and I went there to get dyes. Well, he came back and found a bill of four million lire for colours, because we went there and bought up tubes of Superiride, without even asking how much they cost. I'll never forget how he

Piero Tosi and Milena Canonero in the tailoring shop during the preparation of *Wolfman*, 2010

and workmanship with a view to creating new ones. In England costumiers had always done this, also because there was an enormous quantity of material available. But Tirelli's selection was far richer, varied and original. And looking for costumes there was fascinating. Umberto's horizon was wide and he didn't only buy in Italy, but also in Paris and from private collectors. On various occasions, knowing how much I enjoyed this, he asked me as a favour to buy beautiful clothes at auctions in England. It was interesting how Umberto was a very good businessman and had a great vision of the Sartoria and its role. Naturally his vision went beyond the tailoring shop itself, he often told me how he wanted Sartoria Tirelli to go down in theatre and cinema history.

The first film I hired costumes from Tirelli for was *Chariots of Fire*, followed by *The Cotton Club*, *Out of Africa* and subsequently, of course, all the period films I did. Either by hiring out or making new costumes, Sartoria Tirelli has always been part of my artistic contribution to those films.

The first time I worked with Umberto on new costumes was for the opera *Andrea Chénier* at the Staatsoper in Vienna, directed by Otto Schenk, with Placido Domingo and a magnificent cast of singers. It was a resounding success. Placido Domingo, who was used to wearing costumes that were as heavy as a diver's suit, hesitated when he saw how light his costumes were. He put on the first one and said it was like a second skin. It was Andrea Chénier's skin!

Working with Umberto personally was a wonderful experience. There were not many other occasions for making new costumes, because unfortunately the fact that my projects were abroad made it impossible, at least until *Marie Antoinette* and then *Wolfman* and various others, but unfortunately that was after Umberto's untimely death.

His voice and manner live on in my memory. He was quite something. Umberto was "over the top".

The young assistants at Sartoria Tirelli in the 1980s included Flora Brancatella and Carlo Poggioli, who still often work with the company. Like many others, they also designed costumes. Flora Brancatella, in particular, has made available her excellent knowledge of tailoring shops by acting as a go-between for new costume designers and Sartoria Tirelli, and helping them considerably with their projects:

To me, crossing the threshold of Sartoria Tirelli for the first time was like the sound of a ship's siren for a sailor. I shall never forget it. It was 24 April 1984 and I was immediately captivated by the warm embrace in which those rooms enfolded me. I fell in love with the place at once and thought – with the courage and ambition that you have at 25 – I wanted to work there, in that beautiful setting, at all costs. My journey began there. The chance to meet Umberto Tirelli and work at the Sartoria came soon afterwards, with my first really important job: *The Betrothed*. At the time I was an assistant of Maurizio Monteverde, my first teacher. I too, like many others, learnt many things from Umberto Tirelli: first and foremost I've understood the significance of and need for absolute professionalism. I've learned the work ethic. His attitude to life, full of passion, courage and determination was another great example to follow. These things remain with me and always remind me of him, his "shouts" and his "kind words" and those wonderful, unforgettable years spent together.

do this in a few places in the world. Perhaps Tirelli alone has such a wide range, and such high quality costumes. Have you any idea how many costumes there are at Formello? There are tens of thousands. And there is absolutely everything. The warehouses are extraordinary. There is also a large room with a lot of things that are not hired out but are kept for study purposes, arranged according to costume designer or famous films. For example, there is the suit worn by Silvana Mangano in *Death in Venice*, which is entirely authentic: "Look but don't touch!"

This is also why Sartoria Tirelli is known and esteemed the world over. And the greatest costume designers run there as fast as they can. So many Academy Awards for Best Costume Design are indebted to Tirelli.

The first Academy Award for Best Costume Design won by a movie made with the assistance of the Sartoria was awarded to *The Great Gatsby* in 1975, for which Theoni V. Aldredge had hired many costumes; the second came two years later with Federico Fellini's *Casanova*; in this particular case Danilo Donati had shared out the work between various costumiers and Tirelli had made, among other things, the costumes for the leading actor, Donald Sutherland.

Soon afterwards, in 1982, Milena Canonero was awarded her second Academy Award for Best Costume Design for *Chariots of Fire*, for brilliantly using many costumes from the Tirelli collection:

I met Umberto through Piero Tosi. I don't remember exactly when or how. I liked him very much and the feeling was mutual. I was greatly amused by his very particular way of speaking and his laugh. He was intelligent, clever and very entertaining, extremely hospitable and loved good food. Something I've always much appreciated. When I came to Rome he would invite me to his home above the Sartoria, where I met a lot of my colleagues and so many other interesting people from the world of show business. He, Dino and Dindo, the beautiful Dalmatian who lay on the white sofas in princely fashion, as though he were the owner. We became good friends before working together. Nearly all my work was in London and it was more practical for me to make costumes in England. But this wasn't important to Umberto, what counted more was our friendship. Every time I came, Umberto would very proudly take me on a tour of the Sartoria and with his irresistible enthusiasm he would show me the wonderful things he was preparing for the theatre and movies. The place was an exciting hive of activity with Umberto directing all the many seamstresses, milliners and assistants. He had understood that by offering not only top-quality work, for which his Sartoria had become famous, but also a refined and elegant ambience to costume designers, actors and directors, he combined professionalism and hospitality with a personal touch, in a smart and original way. Whatever the project, large or small, he would make you feel part of one big family.

Until the early 1990s it was rare to go from one country to another for costumes. But even though the film was being shot in London or the US, I would insist on going to Tirelli's in Italy because he had a collection of incredibly beautiful pieces. Umberto's stock not only included costumes made by his tailoring shop for so many amazing shows, but spurred on by Piero Tosi, he continued to collect authentic clothes from all periods, to hire them out and to study the cut

Martin Scorsese and Umberto Tirelli on the set of *The Last Temptation of Christ,* 1987

"I've worked with Tirelli" and maybe they only once supplied him with stockings for a group of peasant women; the name very soon became – and has still remained – a point of reference, a synonym of quality and this is where those ridiculous statements came from, such as "I was Tirelli's assistant", when in actual fact all the person did was take drawings from the station to the theatre.

When he passed away his death deeply affected me, because it was something that was almost against nature. He was so full of vitality, so interested in others, in the outside world, in life, for better and for worse. In fact, it was the only non-family funeral I have been to.

Following Pasquale Grossi, in 1981, another young man from Verona named Alberto Spiazzi, with some experience at the Arena, joined the Sartoria in Rome:

Pasquale Grossi, with whom I did a *Salome* for the Teatro Verdi in Trieste, introduced me to Tirelli. But my stroke of luck was the result of a *Samson and Delilah* for which we only made one new costume and all the others came from stock. By going from warehouse to warehouse, I put together a piece by Pizzi, a piece by Tosi, a piece here and a piece there. And the show won the Abbiati Prize, which much impressed Tirelli, who paid me many compliments and asked me if I wanted to work with Tosi. Can you imagine? With Tosi! I remember it as though it were yesterday, I was so excited and thrilled I went out into the street and jumped wildly into the air, clicking my heels like Charlie Chaplin. So I was taken on as first assistant for Zeffirelli's *La traviata*. We began work in 1981, but we did most of it in 1982. An immense task: chests of costumes from a *Traviata* that Zeffirelli had done with Donati in Brazil were added to the many new items. But all those costumes were also redesigned, reworked, re-elaborated and reconstructed by Tosi. Those were different times. Different budgets. Soon afterwards came the period of exhibitions: *Visconti e il suo lavoro* at Palazzo delle Esposizioni, which was great and subsequently travelled to other venues; then there was Tirelli's donation to Palazzo Pitti. In the meantime, I continued to work partly with Tosi and partly with Gabriella Pescucci. During the first months of 1990 Umberto became ill. I remember his pale face when he came downstairs to say hello at the Sartoria party in November. He spoke in a low voice. As though he'd given up. He died on 26 December. But the company had inherited his vital force. I can't remember a year when there was so much work. In 1991, I did a film with Bolognini, a production with Giancarlo Cobelli, I went to Vietnam to work on *Indochine* with Gabriella, and on my return I did a *Don Carlo* with Tosi and Bolognini for La Fenice... Indeed Sartoria Tirelli was snowed under. And new recruits continued to arrive: Carlo Poggioli in 1987, Flora Brancatella immediately afterwards. We made up a threesome Flora, Carlo and I, and we shared the work with Gabriella: *The Age of Innocence, The Scarlet Letter, Mistress of her Fate...*
The first film I did alone was with Pupi Avati in 1984. Today I work mostly abroad and travel a great deal. With the director Paolo Micciché I've done shows in Washington, Baltimore and we are now going to China, Germany and Canada. And of course there is work here. A film that gave me great satisfaction was *Tea with Mussolini*, a good example of a fusion of old and new, which is always a challenge. It's not easy to use stock costumes and succeed in creating a show that has your signature. Recently I did *Un ballo in maschera* in Catania on a very low budget, where I only used stock costumes, also pieces by Tosi and Pescucci; the only new item was a shawl. It turned out to be a great production. However, you can only

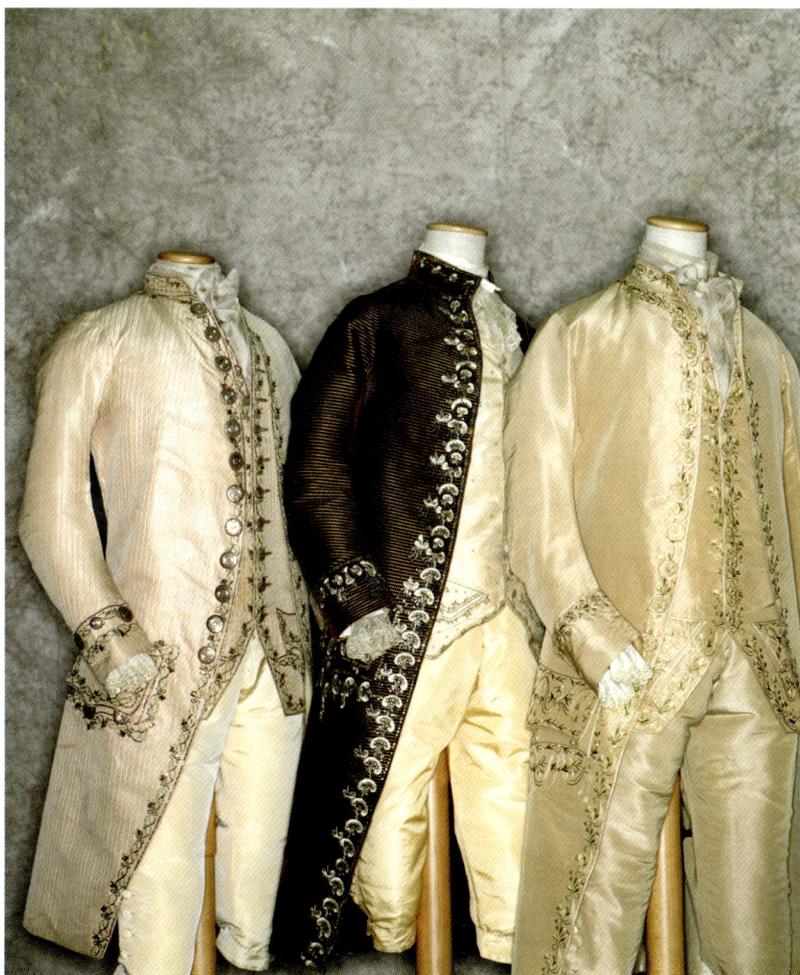

Eighteenth-century outfits from the Tirelli collection lent to the costume designer Yvonne Sassinot de Nesle for *Danton*
Photo by Fiorenzo Niccoli

yelled at us, especially at Gabriella obviously, but also at me for being her accomplice on that crazy spending spree.

Finally, it was Tirelli himself who backed me when Ronconi was looking for a new recruit to work on *Strange Interlude.* It was Umberto who gave him my name and I did the costumes with Gabriella. This is another thing he should be credited with, helping young people, supporting them and pushing them.

Tirelli has been very important in my life. I still remember how devastated I was when he passed away. I was supposed to work on something with Ronconi and he died just before I started the job. It was a great loss because when he was around it gave you confidence, both about facing any problems that might crop up and about technical difficulties regarding actual costume making. Suddenly we found ourselves alone, that person was no longer there to guide, help us and support us.

His death was a trauma for all of us and going into the Sartoria and not hearing his laughter and shouting is not the same… we all miss him so much.

That's for sure; he had such a strong personality! But I say that Tirelli is still with us. All you have to do is take a look at the masterpiece that is his legacy, all you have to do is enter Via Pompeo Magno 11b. His personality was such that even if you no longer hear his shouts he has certainly left his mark. Dino Trappetti resolutely took the helm of the Sartoria and everyone has remained in their place. Just like after the weekend that we moved from Via Settembrini to Via Pompeo Magno: the following Monday the seamstresses were at their tables and the Sartoria never stopped working.

Since it first opened its doors many things have changed. The whole world has changed. And also the way of conceiving a theatre or film production. It goes without saying that the Sartoria has moved with the times and adapted. In addition to the main building on Via Pompeo Magno 11b warehouses have gradually sprung up to hold the increasingly vast collection of costumes made by the company and authentic clothes, which has been added to over the years by valuable donations. Together with numerous international acknowledgements, many commissions arrived from abroad, first from France: these began already at the time of de Nobili, who lived in France and was more than well known both in France and England, where people sang her praises. Then commissions came from England, Austria, Switzerland and Germany, where they were mostly for opera, and finally from America, where the directors of the younger generation know and love the films by the great Italian masters of cinema. The fame of Tirelli Costumi has definitely crossed all borders.

Theodor Pištěk had most of the costumes for the multi-prize winning *Amadeus*, which was epoch making, made in the Sartoria, and also those for *Valmont*, both directed by Miloš Forman. Yvonne Sassinot – a very talented woman, generous, elegant and unaffected – began working with the Sartoria on *Danton*, and Umberto Tirelli made

Yvonne Sassinot de Nesle, Umberto Tirelli, Jeremy Irons and Volker Schlöndorff at a costume fitting for *Swann in Love*, 1983

available authentic eighteenth-century pieces. She came back several times over the years for shows she did with various directors.

Ann Roth, who had great experience and a prestigious career, came to Tirelli in 1995 for the costumes of *The English Patient* directed by Anthony Minghella, for which she won her first well-deserved Academy Award for Best Costume Design. That was the beginning of a long-lasting friendship and working relationship. More recent but already well-established are the relationships with Sandy Powell, Penny Rose, Colleen Atwood and many others.

The way of staging a show has changed, no longer are all the costumes made from scratch but existing stock is drawn on more and more frequently and costumes are changed, altered, reworked. So in order to obtain a quality product it is vital to be able to count on a top-level collection and on the previous work of the Sartoria, which is more than well qualified to meet these requirements. Tirelli's far-sightedness has born fruit and Dino Trappetti – who comes from quite a different background – finds himself at the helm of this company that has a friendly, even familial atmosphere, though it has become established on a vast, truly international scale. Dino overcame his initial bewilderment and took over authoritatively and intelligently. He set up the Fondazione Tirelli Trappetti and realized Tirelli's dream of bringing together the warehouses scattered throughout the city in the single wonderful complex at Formello, which Ann Roth has described on several occasions as "The finest costumier in the world".

The great thing is that everything in the Sartoria is continuing as it was. And young would-be costume designers keep knocking on the door.

For example, a youngster called Alessandro Lai from Cagliari:

I arrived at Sartoria Tirelli ten years after Carlo Poggioli, in 1994. Eleven to be precise, and when I arrived Tirelli was no longer there. The first people I got to know were Carlo Poggioli and Alberto Spiazzi, Dino Trappetti was at the helm and it is thanks to him that I got into the Sartoria. I had been studying Film History and Contemporary Art History in Paris and Cagliari for years and had met Piero Tosi because I was passionate, obsessed with Tosi and Visconti, on whom I had written my thesis.

I had managed to meet Piero Tosi once, by insistently calling the Sartoria and asking to speak to him, because I'd written him letters to which he never replied. This was before 1994, in 1992, and I was 22. In the end he gave me a very hasty appointment. However, after that we remained in touch until I graduated, because at the time he was impressed by the way I had filed all his and Visconti's work. After I got my degree he introduced me to Dino Trappetti, and Dino, since he trusted Piero, asked me if I wanted to work at the Sartoria. And to think that at the time I'd never set foot in a tailoring shop. I'd studied a great deal, it's true, so let's say I was quite ready, but only in theory. In fact I knew so much about it that the older guys (Carlo Poggioli, Alberto Spiazzi and company) ironically called me "Zanichelli" after the Italian encyclopaedia. However, joking apart, it was Dino who had the insight – or rather the daring – to offer me a job at the Sartoria. I didn't hesitate for a moment and after a week I was already there. I spent three years at the Sartoria, working alongside Carlo, Alberto, Gabriella, Maurizio, and of course especially Tosi – alas without Tirelli, as I have already said, he was no more. And I must say they were the best years of my life.

I too, like Carlo, can say and I say it again and again: I owe everything to Tirelli Costumi. I say it with joy, because it changed my life, there I learnt a wonderful profession and I got to know them all. We became a real family. I started at the Sartoria with Massimo Cantini Parrini, and we were "guided" into the profession not by the "elders", but by those of the "in-between generation", namely Carlo Poggioli, Alfonsina Lettieri, Alberto Spiazzi and Flora Brancatella.

Now, in a way, we are carrying on and going ahead. For me the Sartoria has been more than a family, it has been a workshop. There was Tirelli's wonderful will that made Dino head of the company but left shares to his staff. We have also in some way benefitted from this testament. I, for example, together with Massimo and other young people have found masters like Gabriella Pescucci and Piero Tosi who are always in the Sartoria and ready to guide us in our work: they are part of this moral legacy. I learnt at the side of Gabriella and Piero, who are still there explaining how to construct clothes, how to make swatches, how to cut, dye and age clothes. In other words, passing on the craft.

That's wonderful and I think that in a time of crisis such as now, it is one of the strong points of a company that is determined to continue, that wants to carry on courageously and overcome this difficult phase. Because we are talking about a profession, a craft that is unique and extraordinary… An asset that must not be lost.

Massimo Cantini Parrini arrived hot on the heels of Alessandro Lai:

I tried to set foot in the Sartoria many years before I finally ended up there, because I've always been crazy about costumes and all my studies have revolved around this. I did Fashion and Costume at the Istituto d'Arte, then at the Polimoda, which was at that time affiliated to the Fashion Institute of Technology in New York. I also studied for a Philosophy and Letters degree with a specialization in Costume. Then I did the entrance exam for the Centro Sperimentale and they accepted me, and during my two-year course (1994–96) at the Centro I graduated. Earlier, when I was 17, my mother was stressed out because I had this fixation about costume, but didn't know where to turn. Until one day my mother said: "Get the Yellow Pages, look in the Yellow Pages". I found Sartoria Tirelli and

called them; Simona answered: "We take on people, but at the moment there's no opening – we're full, full up, really full. Try later". I tried thousands of times, but nothing doing. Afterwards I tried Annamode. For two years I did my first training in costume there, but only in the summer, because I was still studying. Then I went to the Centro Sperimentale, and when I finished the Centro, Piero Tosi, who was teaching there, introduced me to Gabriella Pescucci and I began to work at Sartoria Tirelli.

Dino Trappetti offered me the job of assistant, but almost at the same time I began to work with Gabriella; when she did a film I stopped work at the Sartoria and went with her, and afterwards returned to Sartoria Tirelli. That went on for a few years.

My "big break" came in 2007–08 with *Carnera*, which I did at Sartoria Tirelli. Silvia Nebiolo called me because she was pregnant and very generously said: "Massimo, I can't do it alone, if you feel like giving me a hand, we'll take the credit together". I said: "Of course! Absolutely". For the first time I thought I'd also be able to handle a project on my own.

There is a difference between working at Sartoria Tirelli and another costumier. And I feel… I can't say "at home" because that's another thing – however, it's a place I'm extremely indebted to. In addition to the theory I was able to learn the practice there, by going to the warehouses and working for the others I can say I know everything about the Formello complex.

As well as being Gabriella Pescucci's assistant, I have also worked with Francesca Sartori and Maurizio Millenotti. Then Martinelli called me again. I had already done *Carnera* for him, and subsequently I also did *Barbarossa* and *September Eleven 1683*. For me these were important experiences, though not big box-office successes; they were commercial films that put me to the test professionally and financially, since film budgets were drastically reduced and movies in period costume were rare.

I adore Formello! Professionally it has changed the life of so many of us costume designers, because you can wander around in one place and find everything, not

only clothes, but actual ideas, inspiration, if I may say so. If I could I would do everything there, workshops, everything! I would spend all my time at Formello. I would live there. What Dino Trappetti has done is great, I think it's really wonderful! It's so vast and yet there is already virtually not enough room. It's full up… There's a vital energy concentrated there, it's like entering the Cheops pyramid. There are authentic things, things set aside because of their historic value, from film masterpieces of many years ago… it's just fantastic… And the warehouse men, Valentino, Antonio and Fausto are angels and great to work with.

The wonderful thing about our profession is the studying, reconstructing, re-working… it gives you great satisfaction and at Tirelli Costumi you can do this. Of course you have to always be practical about the costume, you have to take the body into consideration, the female figure is not what it was, so you can't turn a normal sized woman of today into an anorexic of 1800; however, a solution can always be found. This is the hallmark of a brilliant tailor. Even now as I'm finishing Garrone's film, set in 1600, it's been tough, because fitting the actors with such tight clothes has not been easy. I tend not to use mirrors at the beginning of costume fittings. I only bring the mirror in once I've finished the costume, if they see they look good, they forget their weight, the whalebones, nothing else matters. They're pleased with themselves, it's done!

I was 17 when I decided to become a costume designer and met Silvia Nebiolo who said: "But you know about the Centro Sperimentale? That's where Tosi teaches…". And that's where it all started… So I owe her so much and also Cristina Giorgetti, who is an important Italian historian and was my costume teacher at the Polimoda. But above all I am most indebted to the Formello complex, to Gabriella, Tosi, Trappetti, and the Tirelli "house" and all those who live there. A debt that must somehow be repaid.

The young Ursula Patzak (who is not Italian, even though she lives in Bologna and works in Italy, mostly with Mario Martone), in her almost perfect Italian, also speaks of a debt to be repaid and an exceptional craft to be protected:

I began by working in the theatre; I didn't enter the film world until very late – and in fact I've done really little. My training was in the theatre, especially opera, so the first time I went to Sartoria Tirelli it was for an opera and I was amazed at the quantity and quality of the stock that was available. It is a truly extraordinary collection, because the biggest names have worked there. The problem today is that we seem to be going through a permanent economic crisis. Our budgets are becoming more and more limited and we can rarely afford to make new costumes. There's never enough time and there's not much money for productions. When I work on operas, I can only do the main costumes, because I haven't got the time or the money to do the choir or extras. Unfortunately for us of the younger generation it's always like that now, so we have to hire costumes and this is a shame, because the great thing about this profession is actually making the costumes and giving them your own personal touch; but actually we have very few possibilities of doing so. Obviously the same thing applies to movies. I don't do much cinema, I've worked on some films with Mario Martone and only a few other small movies, I feel opera is more my thing. You know, I've never been lucky enough to work on a film where you have a year to prepare it and you can think about the character, discuss it and build it up. Today unfortunately films are made without

much time for preparation and you have to use what there is to hand. It's great that Tirelli Costumi has so many beautiful things so you always manage to re-invent something good.

Indeed, Tirelli is one of the few costumiers to have such a vast collection of theatre and opera costumes, because as well as Pizzi, who used them for a lot of operas, many other famous costume designers have used the Sartoria, so you always find something that is wonderfully theatrical, because theatre costumes are very different from those of a film, there are other requirements, other priorities and Tirelli Costumi, I must say, has everything. The Formello complex is beautiful and extremely well organized, and the staff are very knowledgeable about the costumes and what there is to offer. They are real professionals. Even someone who is not a costume designer could go there and say: "I'm putting on an opera set in 1910" and they would suggest the right things. Often you find items that you had never thought of and that's great. In that enormous space you wander around saying: "Oh, look at that… isn't this lovely".

The Formello complex also contains a lot of "invented" costumes. Millenotti's, for example, are extraordinary; he is a truly great artist, and there you can find many of his creations. And then of course Piero Tosi's costumes are amazing, that goes without saying. They are really and truly great artists, great costume designers who enriched the Sartoria because they made new costumes that were then added to the collection. That's fantastic because you are helped, you say: right, I can do it, because if I make a new piece the way I want it, and they like it and buy it, and then hire it out, I can manage to stay within my low budget.

Now I'm working on *Aureliano in Palmira*, a little-known opera by Rossini in Pesaro (and I must say it's quite an undertaking…), directed by Mario Martone with whom I've been working for fifteen years. He was the one who asked me to do my first film, an important movie, with a large cast of characters, set in different periods. He had more courage than me, since it's a bit reckless to entrust a beginner in the cinema with a big film like *We Believed.* A big risk for him and a big debut for me. However, I must say that the Sartoria helped me a lot, because Dino Trappetti greatly admires Martone and so he was very interested in the film. It is essential that such an important costumier like the project, because if this is the case, when there are any difficulties, in the end they'll give you a hand. And with *We Believed*, and now with *Leopardi*, Trappetti has always been very willing to meet us halfway. We've worked together for so many years that we've become a kind of… I don't want to say family… though in the end it is a bit like a family. I can say quite frankly: "I've only got this… what can I do?" When you make a film, especially a movie in period costume, it is the costume designer above all who creates the film's image. Often, unfortunately, production companies don't give this enough importance. You always have to do battle with as little as possible, and they even think that is too much. And so it's always a struggle, you're always hard pressed, with not enough staff and not enough costumes… What a mistake! Because this is what Italy is famous for worldwide. Beauty, aesthetics, and costumes, because the greatest costume designers are all Italian, so this is a great pity. Just as it's a pity to risk losing that great asset known as Italian craftsmanship.

If you want to make something beautiful, such as leather cuirasses, you have to know how, and it's expensive because they are made by hand. Of course, you can always get plastic ones from the Chinese, or whoever, and they'll cost much less, but they'll never be as beautiful, nor will they have the quality that comes with

craftsmanship. Because it's a question of craftsmanship, right? All the crafts are disappearing. There are fewer and fewer cutters, fewer and fewer seamstresses. And this used to be a quality, a source of pride, an excellence that was typically Italian, in my opinion, and it's a real pity that increasingly less importance is being attached to what is one of the great resources of an extraordinary country.

Mariano Tufano also started in opera and moved on to cinema:

The first time I went to Tirelli Costumi I was as assistant to Maurizio Millenotti, who was preparing a film in nineteenth-century costume, *Piccolo mondo antico*, for television.
But let's start from the beginning. I had been working at the Teatro San Carlo in Naples for six years, when along came Millenotti who was doing the Neapolitan shooting of *La Bohème*, directed by Zeffirelli, with costumes designed by Piero Tosi and made by Tirelli. When I saw those costumes close up and realized that the workmanship was underpinned by remarkable technique, I was convinced that this was the ultimate school. I have tailoring experience, I started out as a tailor, I know how to ply a needle, so I can recognize quality when I see it. I also understood that I wanted to specialize in that kind of costume: the faithful period reconstruction. That was what I wanted to learn, and Tirelli was the right place. So a month later I came to Rome and introduced myself to Maurizio Millenotti, asking him to take me on as an assistant. I had a real nerve, because he already had a lot of assistants. In fact, he told me he had too many. But then one of them – Gianni Casalnuovo – had an accident on his motor scooter… just like in the movies! So Maurizio took me on for a film in modern dress. And he must have been happy with my work, because after a while he called me again, this time for a film in costume – finally! This was when I went to Tirelli Costumi for the first time, when they were at Via Pompeo Magno, it must have been 1999–2000. I was excited, because it was an achievement. I thought they were one of the finest costumiers in the world, and I still think so. There are few others like them anywhere, maybe one in London…

Tirelli has a vast amount of authentic pieces, which you can look at, touch and study. You can measure yourself against an approach to making costumes of the highest standard; you can learn a working method based on pinpoint precision. Then there's another thing: it wasn't so easy to work there back then. Because the costume designers were in some respects chosen by the Sartoria, rather than the market. So not everyone was automatically accepted. But my experience as an assistant stood me in good stead, as did the other films I had done, also as an assistant, with Maurizio. When Emanuele Crialese offered me the chance of debuting as costume designer on *Golden Door* in 2009, I tentatively offered it to Tirelli Costumi. Dino Trappetti very kindly believed in me and accepted, but since they were very busy they couldn't take on the entire film and we had to divide the work between four costumiers. There were loads of costumes: nineteenth- and twentieth-century stock pieces and about two hundred new ones to be made; but there wasn't loads of money, because I was making my debut and they gave me a lower budget than an established costume designer would have obtained. Notwithstanding this, the Sartoria was very generous, helping me in all kinds of ways. For example: I had chosen regional costumes for the emigrants that are

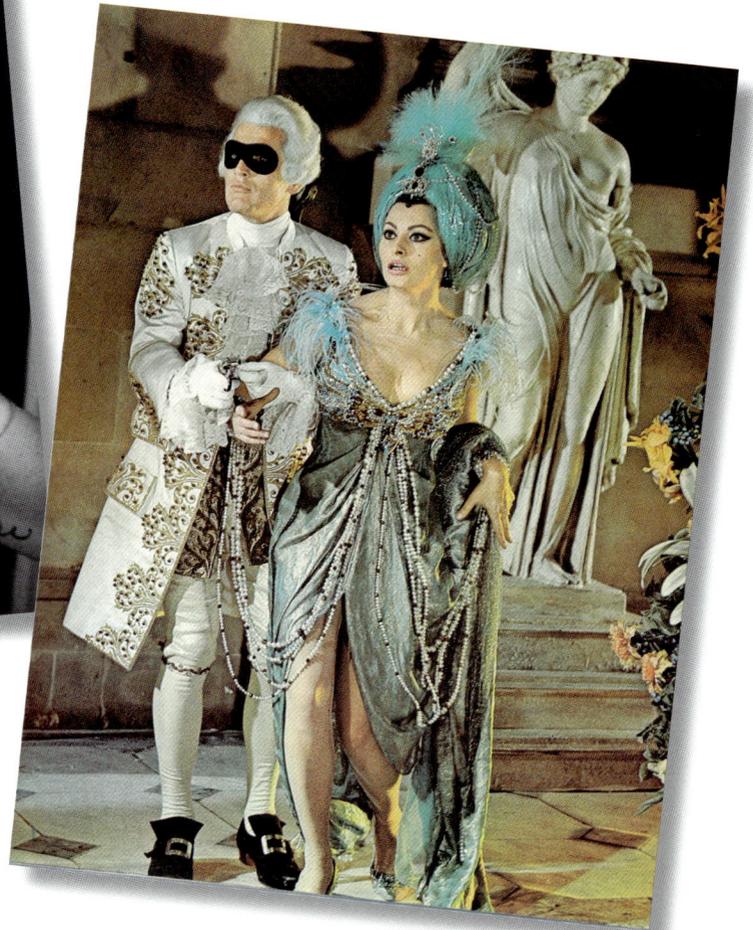

Paul Newman and Sophia Loren in *Lady L*, 1965, directed by Peter Ustinov with costumes by Marcel Escoffier. Piero Tosi recounts that just after Sartoria Tirelli had opened, Sophia Loren, in agreement with Marcel Escoffier, the costume designer of *Lady L* that she was shooting at the time, asked Umberto Tirelli to create her costume for the masked ball sequence. Tirelli accepted enthusiastically, but when they asked him to bring the costume to Scotland ahead of time, he had nothing ready. Without losing his nerve, he arrived at the fitting with a selection of fabrics and "improvised". The result – as can be seen in the photo – was more than satisfactory. Recently, Sophia Loren came to the Sartoria Tirelli for *The Human Voice*. The dedication to the Sartoria shows how pleased she was

held on Ellis Island. It turned out that these could not be hired, and I was very disappointed. Dino said to me: "Do you feel like doing them from scratch?", and they did just that, without charging me anything. I'll never forget that.

They don't make many period films nowadays, so I don't often have the chance to work with the Sartoria. But I returned recently with a film, *The Human Voice*, which had a very small budget but a truly great actress: Sophia Loren. And it was fantastic, a real satisfaction, to see her try on a suit cut by Roberto and tailor-made for her: she looked at herself in the mirror, stroked the jacket and said: "Now, this is what I call a suit: Schuberth."

Sergio Ballo expresses himself in the same vein:

I first set foot in the Sartoria when I was doing a small job with Gabriella Pescucci, which was followed by another with Maurizio Millenotti: so I had a very good introduction. Signor Tirelli was no longer there, but Dino Trappetti gave me a very warm and friendly welcome, as he always has done, not because I could have become somebody, but simply because we instinctively took a liking to each other. Personally, if I had had the chance to work even for nothing in that Sartoria for a few months, I would have gone like a shot. Nowadays it wouldn't be possible

to do what they did then, because as soon as the doorbell rang you'd have to hide in the nearest dyeing vat… Unfortunately, it's also become difficult for them to manage this kind of apprenticeship also from a bureaucratic and fiscal standpoint. Nevertheless, like others, I live on the Sartoria's legacy to some degree. *The Nanny* was my first film in costume. I didn't know Bellocchio then like I do now, but I did know that he was very wary of period dress. It was also the first time I had tackled this kind of film and I certainly didn't want to run any risks, and by choosing to rely on Tirelli Costumi (even though I couldn't do all the costumes there) I knew I could count on the work done previously by people whom I considered in a class of their own. I'm talking about Piero Tosi, people like that. Let's say that, as far as my work was concerned, the costumes for that film were rather academic. This doesn't mean that Tirelli's costumes were academic, rather the use I made of them. I felt less free then, but at the same time I needed to "cover myself", to defend myself by relying on a certain kind of cut, a certain kind of quality, the kind that Tirelli costumes offer. When I returned to do *Win*, I had already acquired more freedom and knew that I could take a few risks, I no longer felt intimidated. Everyone knows how much the preparation time for a project has been reduced, and so the best thing to do is to rely on the stock of a leading costumier. Of course, you have to be very familiar with it, know it like the back of your hand, and seek, perhaps by altering and reinterpreting the pieces, to develop what will become your own style, by mixing that amazing legacy with what our predecessors have passed on to us; in other words, to survive precisely with what we've inherited from them… Sartoria Tirelli has always made a point of working with first-rate costume designers, and as Piero Tosi's approach is quite unlike that of Pier Luigi Pizzi, though they are equally great, the Sartoria can offer you their different styles and "works". There are costumes that are faithfully reproduced, and more abstract ones. Everything you could possibly want.

For the last project I worked on, *Borgia: Faith and Fear*, I wasn't able to go to Tirelli because they were already doing *The Borgias* with Gabriella Pescucci: this made it impossible. But a few months before starting my Borgias, let's put it like that, I did a *Rigoletto* for television directed by Bellocchio for the producer Andrea Andermann. Bellocchio and I had drawn our inspiration from El Greco, I liked the idea of the choir dressed in black. Andermann had the horrors about it because, he said, a choir in black on television would be like a hole in the screen; whereas I knew that Bellocchio really liked to use a solid block like this. For the opening scene I took the costumes Pizzi had designed, I think, for a production of *Orfeo ed Euridice*. These would be the costumes for the dancers, because they were in coloured shantung silk: oranges, yellows, pinks, reds, which worked beautifully with the black of the choir. I had neither the time nor a budget that permitted me to do the costumes from scratch, but at the Sartoria you know you're sure to find a good percent of what you're looking for. If I hadn't been so familiar with the warehouses (and at Formello they also have some excellent warehouse keepers, Antonio and Valentino, to whom you can say: "Can't you think of anything?" and they immediately respond: "Yes, maybe, you could do…"), and with the budget I had, I would not have been able to do new costumes for the women. In other words, the budget for the opera was very, very low. It was much the same thing with *Win*, and also for the small film I did for German television, which we finished three or four weeks ago. Tirelli had the knack of putting together a collection of the highest quality. Without making comparisons, he was a born

craftsman, and it shows. Unfortunately, I never met him, but there is no doubt that someone who created such a vast operation relying on his own strength must have had an extraordinary personality. It's true that he had friends like Zeffirelli, Tosi, Pizzi and other leading costume designers, who certainly helped the Sartoria to grow, but he himself must evidently have done more than his share. The new management – the one that I'm familiar with – works in the same way. When there's a big cake everyone has a slice, but when there's a small cake, you don't just go there to say hello and have a coffee, you go there, you talk things through, and try to give everyone a slice of the small cake. I'll say it again, I was really sorry I couldn't do my *Borgia* with them, also because I was desperate since nowhere else can you find such a fine selection of 1490s costumes – apart from the fact that I was obliged to make a stylistic choice completely different from Gabriella Pescucci's, for obvious reasons. But now I have been able to return, and hope to have enough work in the future to give everyone a slice of the small and the big cakes. I also think that costume designers have the great responsibility of saving the costumiers. It must be done, there's no question about it, because our professional standing is one of the few things that Italy still has to sell to the world; however, our reputation will exist only as long as we have these costumiers. If they disappear, we'll be like all the rest.

About the small project I did a few weeks ago: it wasn't easy to persuade the German production company to get the costumes in Italy, because you can't have the effrontery to say: "Where have you sent me? They're awful". You can't do that. But you have to find a way. And in this regard a costumier like Tirelli's was capable of realizing that a small step had to be taken and a concession made, in order to demonstrate the quality, which was recognized as the work proceeded. It was recognized by the director, it was recognized by the actors, and, above all, it was recognized by the production company, because they didn't spend a penny more than they would have if I had gone to get the costumes from one of their warehouses. I don't want to speak badly of other places in the world, but it's true that Italy has a tradition of style that virtually does not exist anywhere else. The English have it, due to their particular school, but it ends there. It really does end there. So you have to insist, you have to bring the work here: in fact, this depends on the costume designers, but I hope that more and more costumiers will understand that they need to be competitive financially as well as regarding the quality of the service they offer. Tirelli Costumi seems to be moving in this direction. It's a fact that they have these remarkable warehouses at Formello – we call them the "supermarket", in the sense that you say "What have you got for us today?" – where you know, at a glance, if you can go in one direction or another. And there really is the possibility of doing it, because there's so much stuff, all you need is a little humility and hard work…

Just think, even the actors, the stars… what I mean is if I put a Tirelli costume on an actor, he feels gratified, even if it is from the stock, because the tailoring shop has a great reputation anyway, and so you're dressing him in a superb piece: only the best craftsmen have ever worked at the Sartoria.

It's true. As Piero Tosi also acknowledges, with his typical modest charm and reserve:

I also send my students at the Centro Sperimentale to the Sartoria. I think it's important for them to get the feel of the "craft". And I'm not just talking about

the variety of the vast stock in the warehouses at Formello. You also find so much craftsmanship, so much tradition in the extraordinary collection of sketches on the walls of the Sartoria that the idea of working there becomes irresistible: it stimulates the imagination and, I hope, also the desire to go beyond the past.

Now a different voice overlaps Piero's. It is the unmistakable, and slightly emotional, voice of Claudia Cardinale. It is 16 November 2013, we're in Los Angeles, where in the evening Piero will be presented with the Honorary Oscar that will crown his prestigious career.

> Piero Tosi was deeply moved when he heard that he had unexpectedly been awarded the life achievement Oscar. An award for which he thanks all the members of the Academy, and accepts gladly because he believes that in recognizing him the Academy is also recognizing the work of all costume designers.
> Although Piero Tosi is not here tonight, there are many of his colleagues and travelling companions sitting at his table – I see Ann Roth, Milena Canonero, Gabriella Pescucci, Dino Trappetti, the managing director of Tirelli Costumi, and Carlo Poggioli – with whom he wishes to share this award.
> But he wanted me, an actress, to collect his Oscar, because he has always said that the costume designer's work primarily concerns us, the actors. I suspect that he chose me because he thinks he made me suffer so much during the eight films we did together. Even though he told me something different: "My dear Claudia, you go and receive my award. With you there will be Angelica and Bianca (*The Leopard* and *The Lovemakers* – Visconti and Bolognini), and all the Italian cinema to which I have devoted my career".

After so many voices, I'd like to go back to the first that came to my assistance, that of Pier Luigi Pizzi. "What about today?" I ask him.

> Everything's changed. We meet at Via Pompeo Magno every so often, to discuss with Dino, Luigi Morena, Piero, Gabriella and Pietro Elia whether we should move in new directions, while guaranteeing the continuity of Tirelli for the new generations.
> We meet with Dino and Morena for every new project, to evaluate the possibilities of realizing it when faced with increasingly low budgets.
> But luckily there is Formello, where Dino has created a vast complex that houses the whole collection. New costumes are made increasingly less, and so existing ones are adapted. Every time I walk along the endless warehouse corridors, accompanied by Luca, Antonio, Valentino and Alessandro, I'm amazed that I've done so much work. I discover forgotten productions. Through the years styles have become passé, but not the materials, because quality was everything to Tirelli. You can't wait to get your hands on them again.
> I know that young costume designers draw on my work and that of others. That's fine by me. Also because the same costume in a different context takes on a completely different look, assumes a new identity. And here, I believe, lies the significance of that continuity to which our friend Umberto Tirelli aspired.

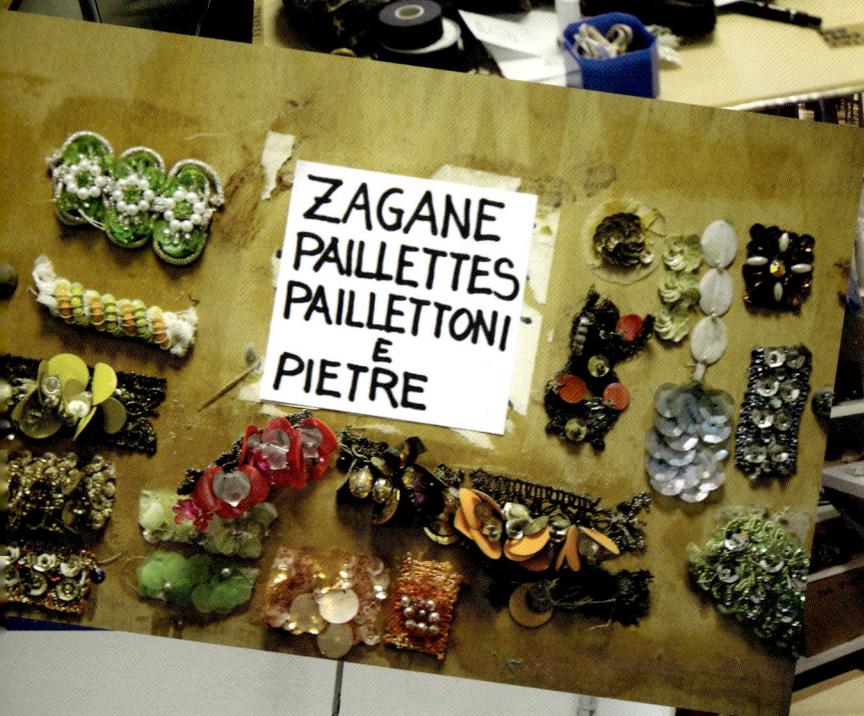

ZAGANE
PAILLETTES
PAILLETTONI
E
PIETRE

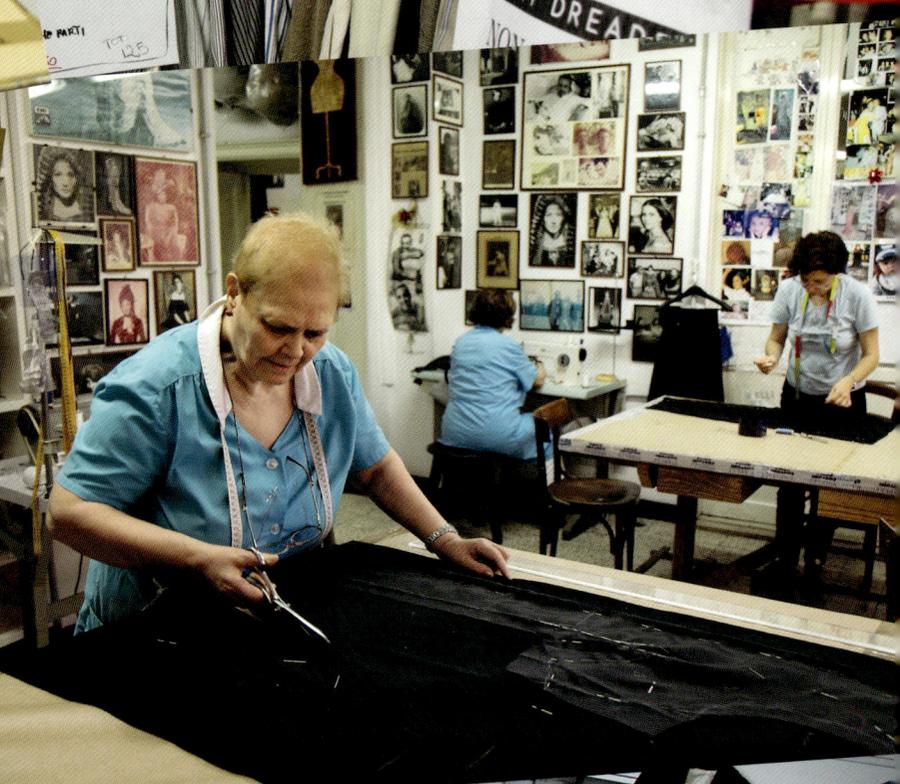

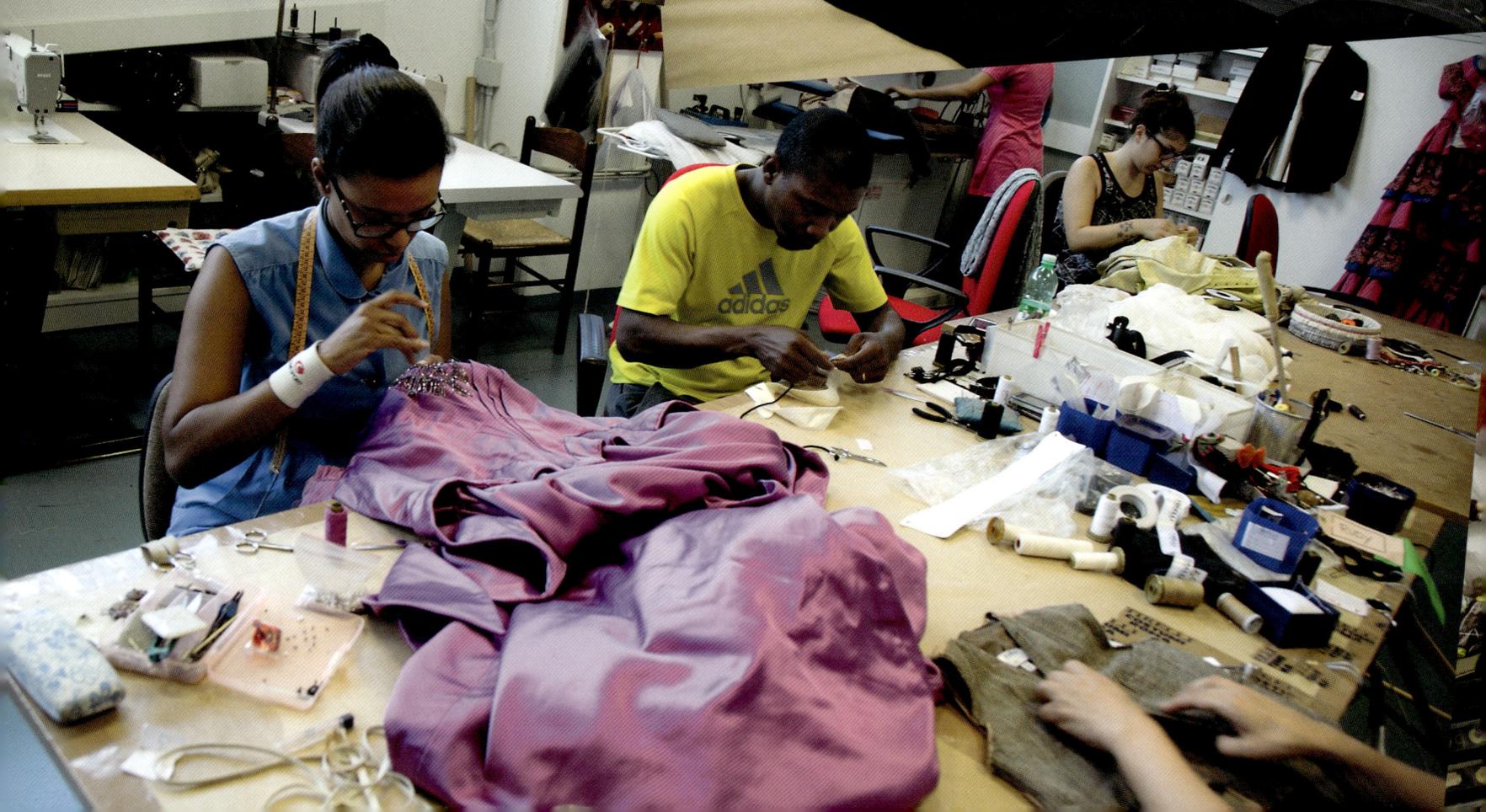

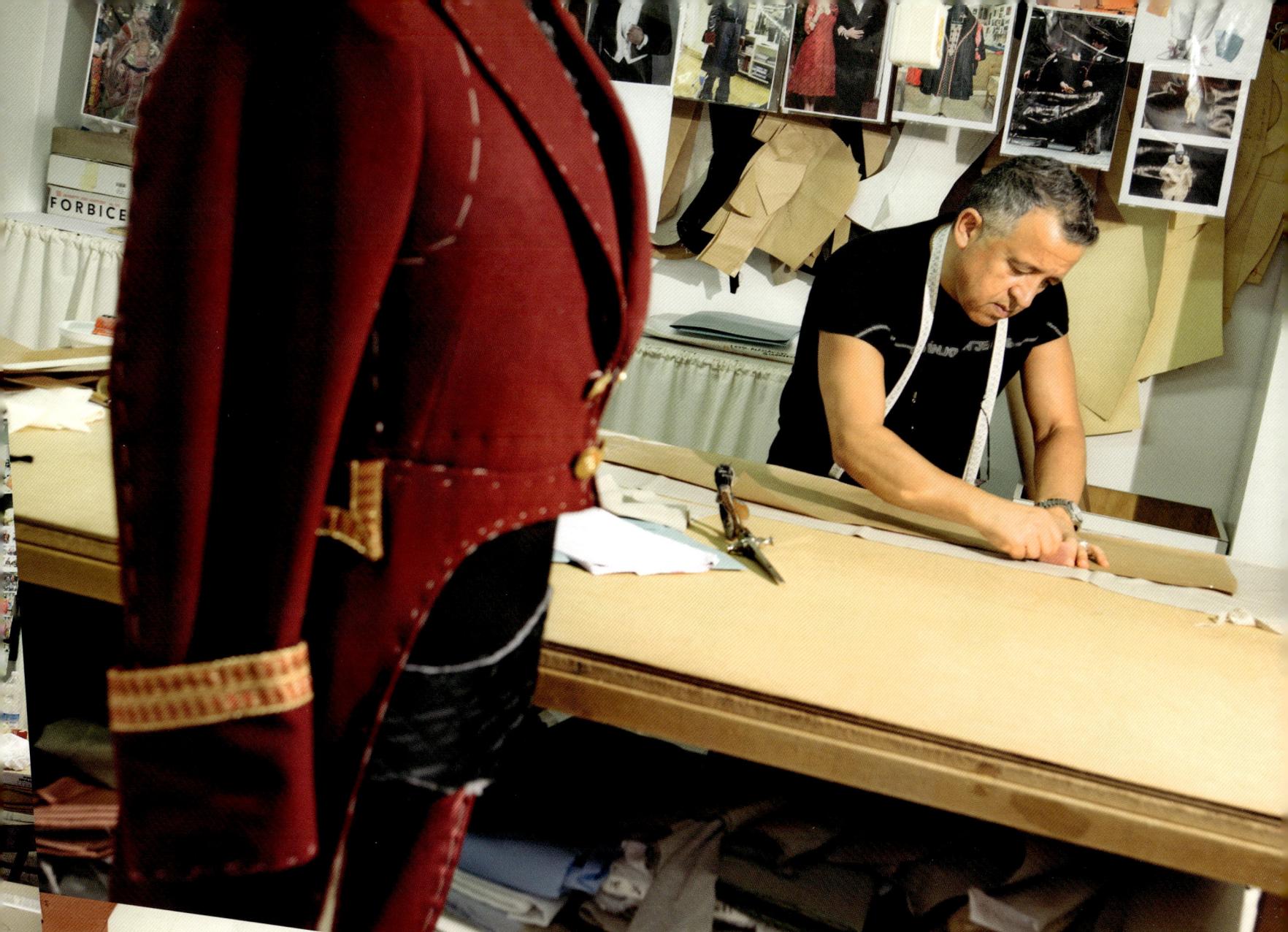

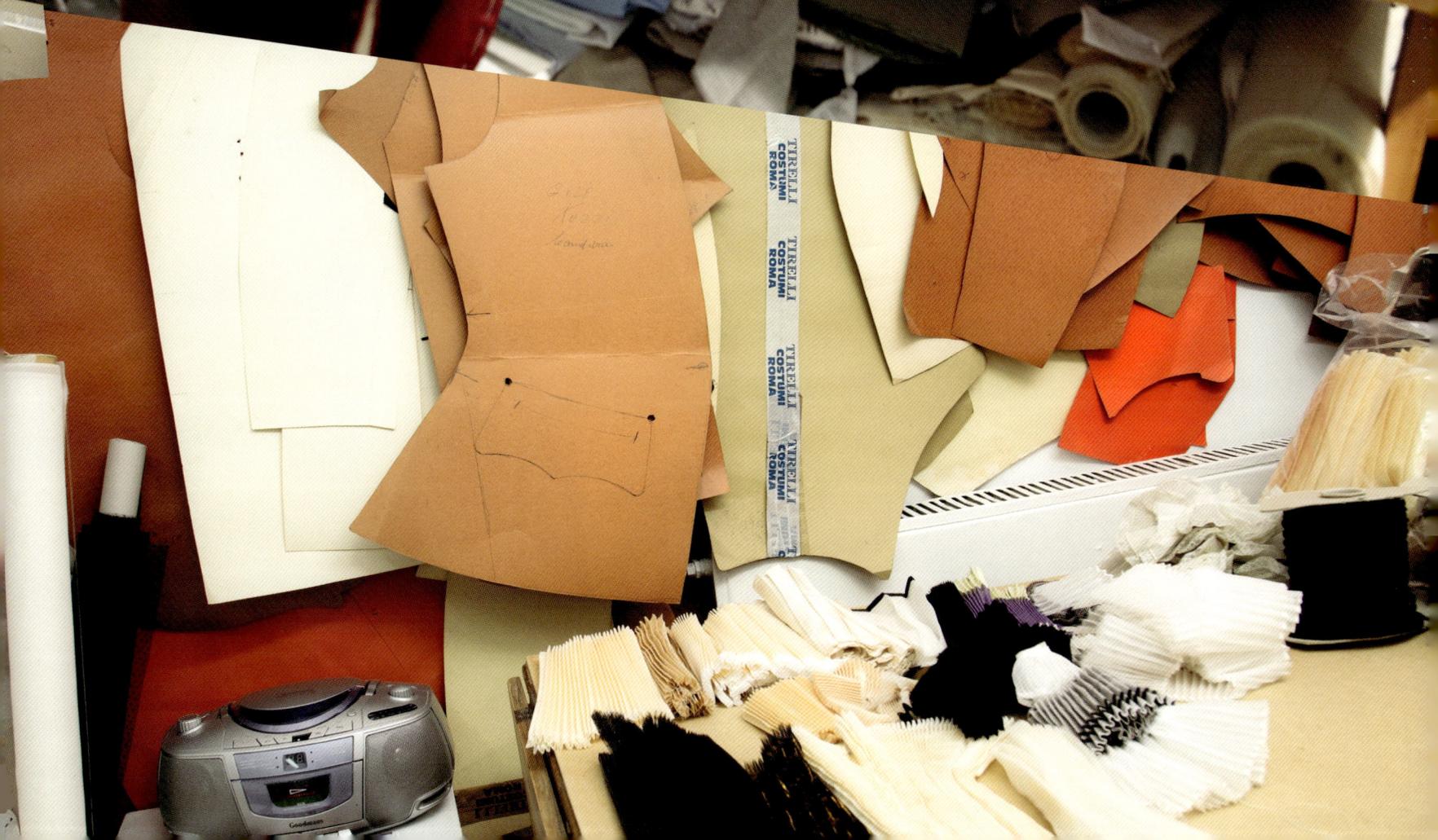

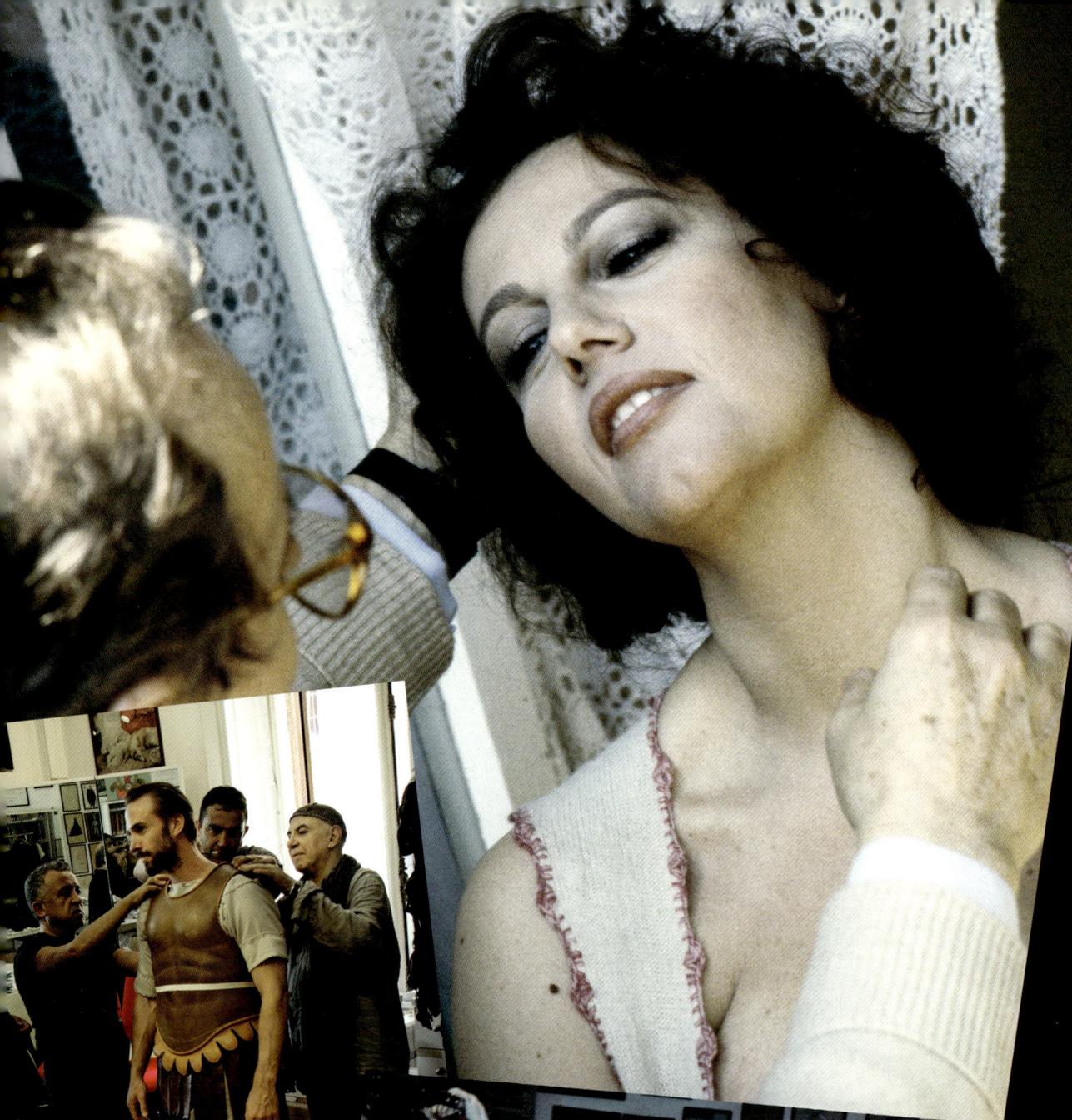

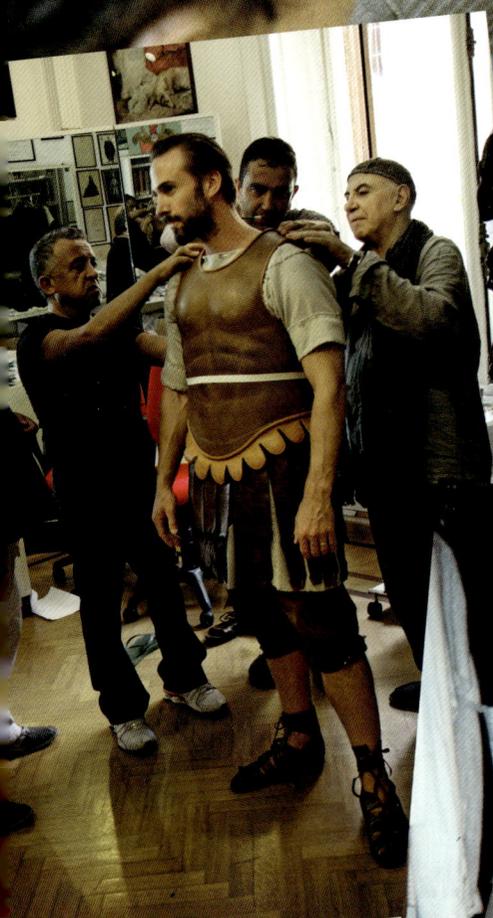

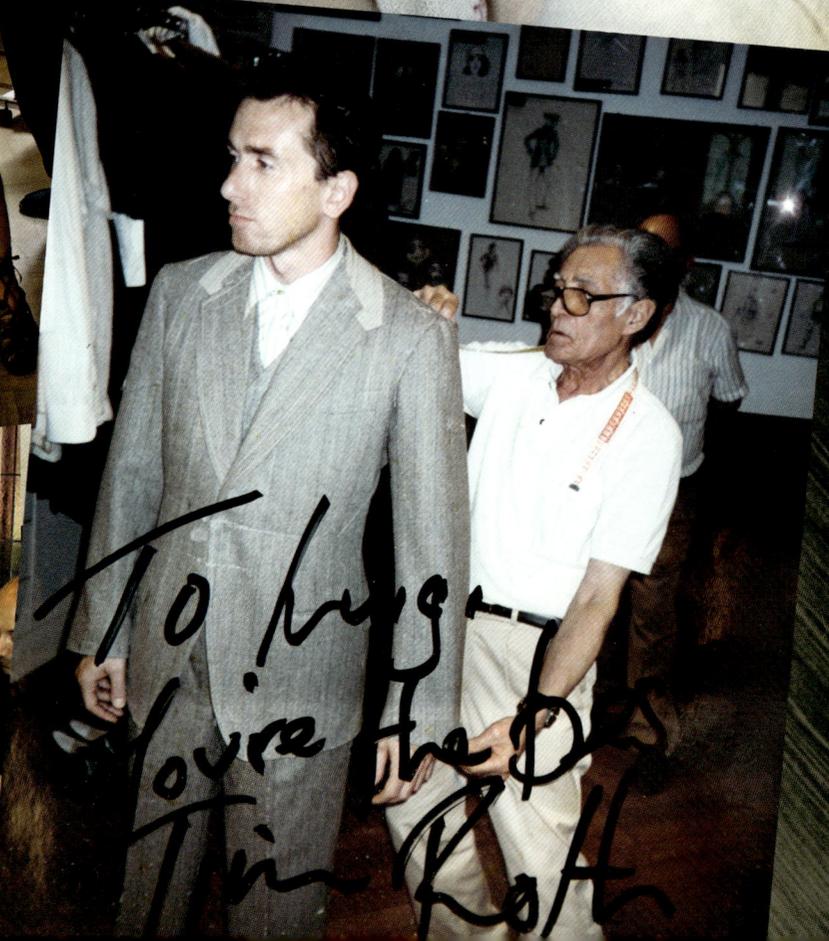

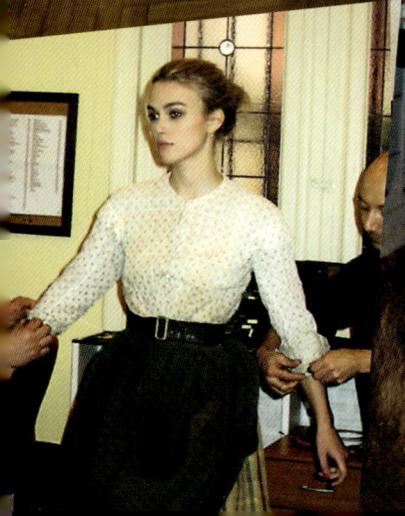

To Luga
You're the Best
Tim Roth

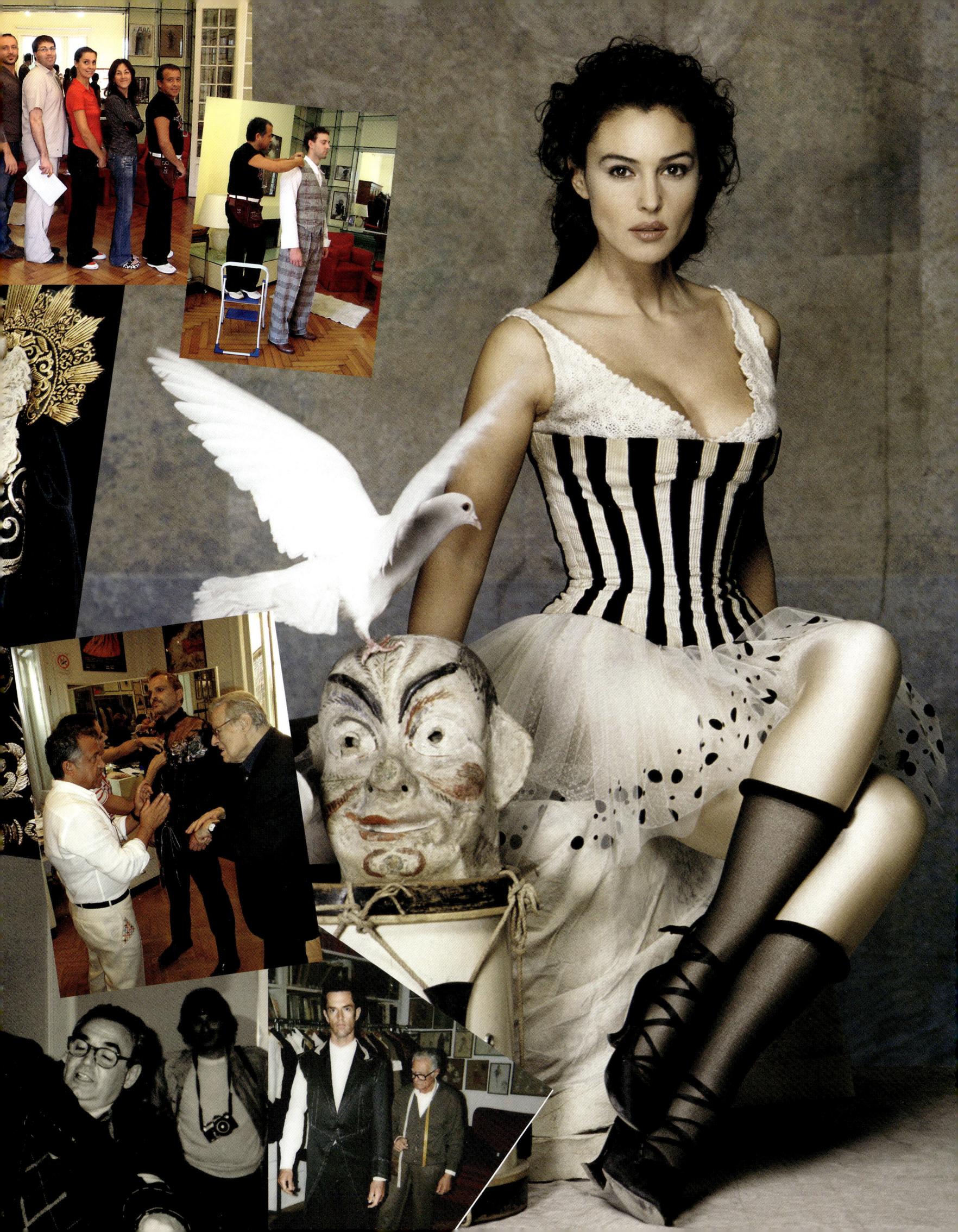

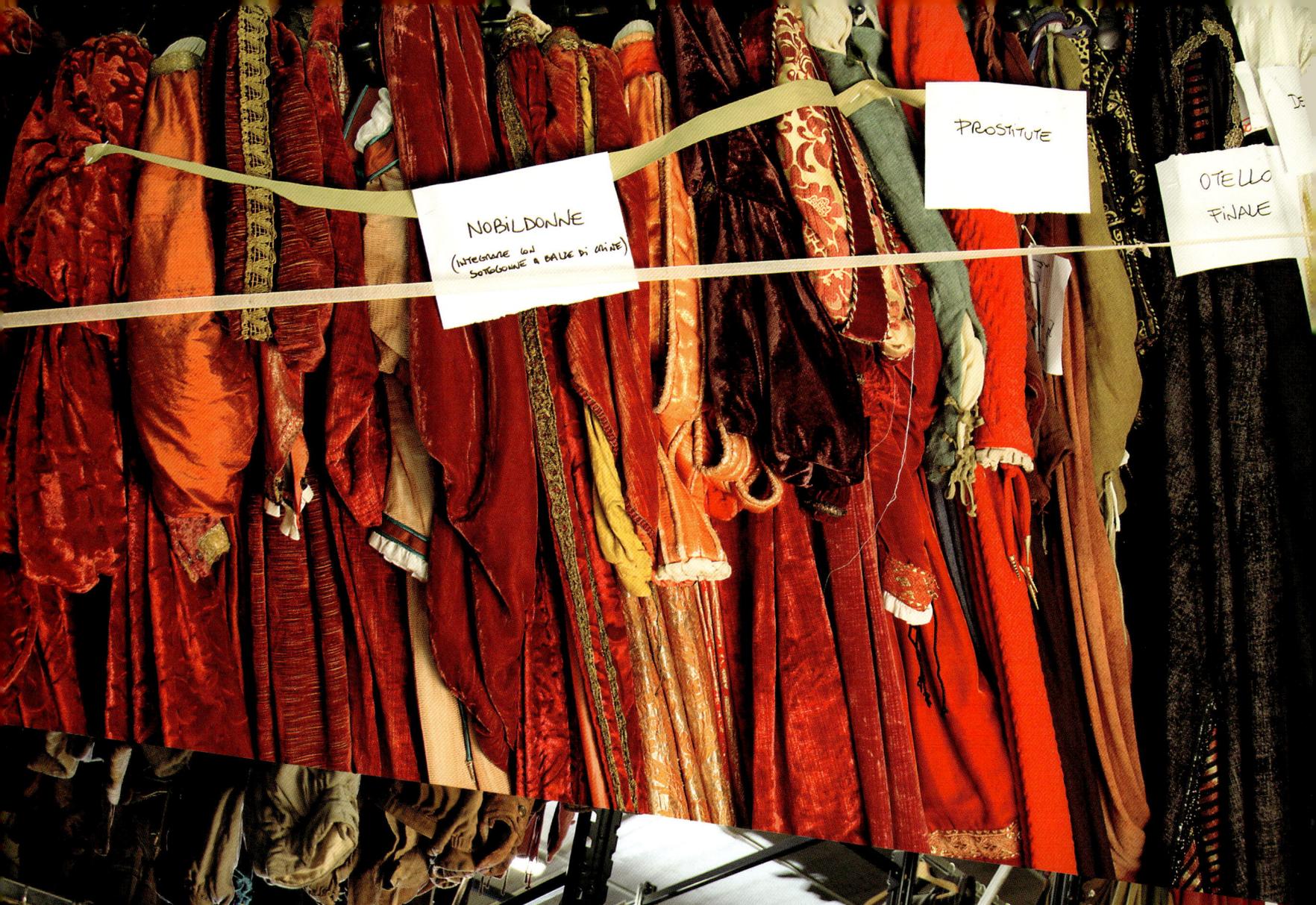

PROSTITUTE

NOBILDONNE
(INTEGRARE CON
SOTTOGONNE A BALLE DI CRINE)

OTELLO
FINALE

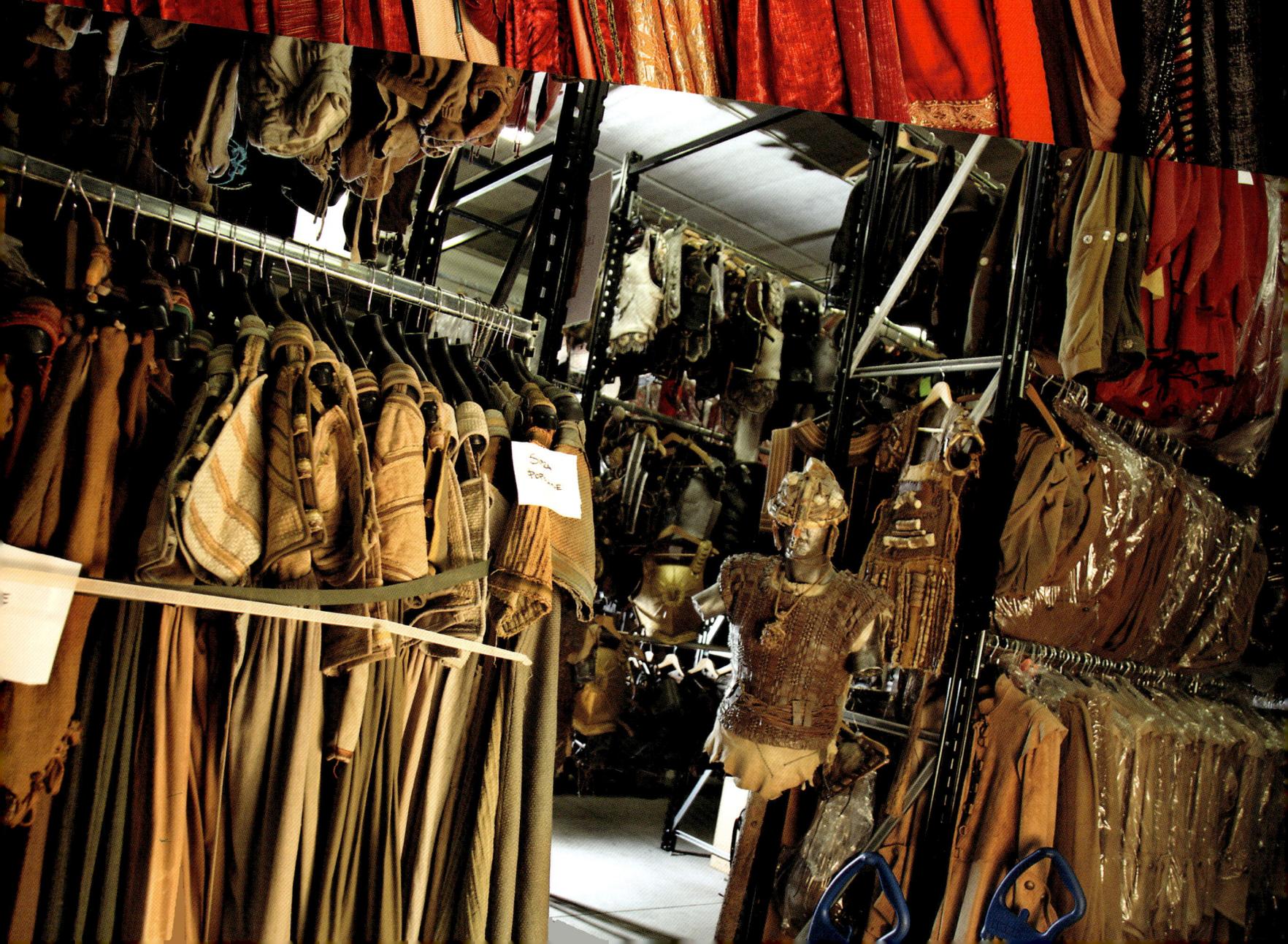
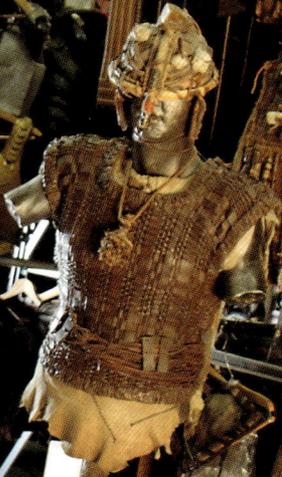

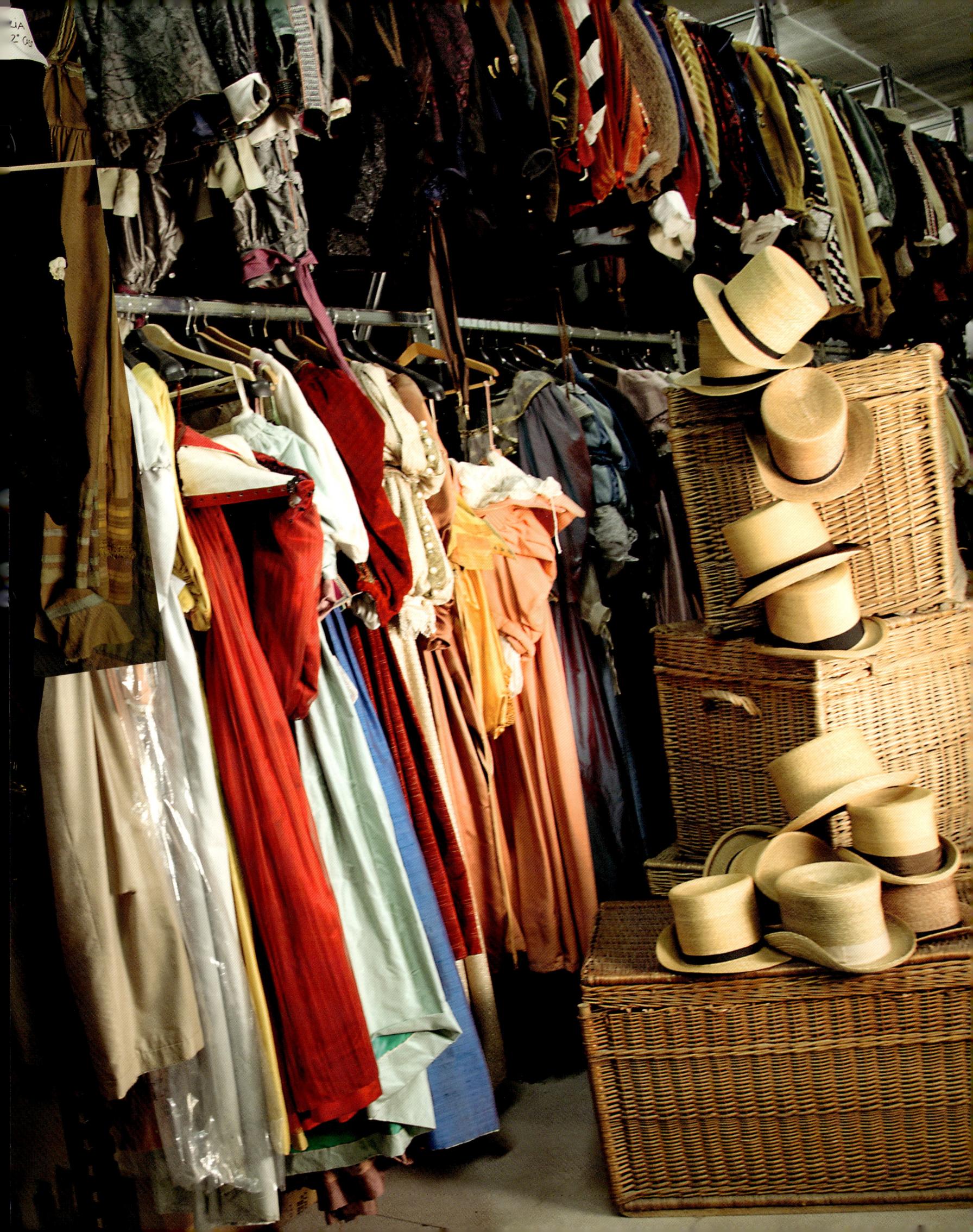

THEA

ATRE

PROSE

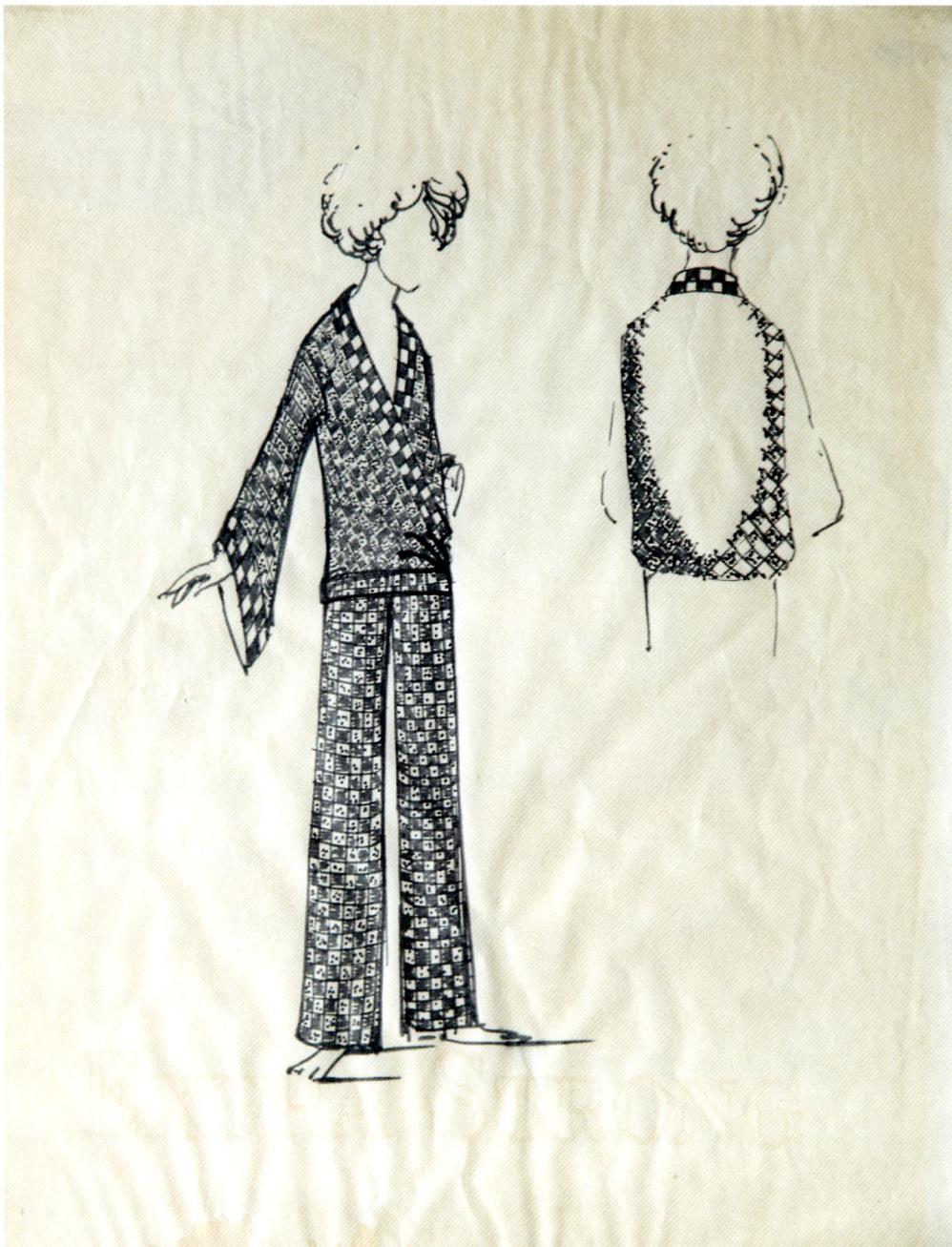

PIER LUIGI PIZZI

Il giuoco delle parti
[*The Rules of the Game*]
by Luigi Pirandello, 1965
Directed by Giorgio De Lullo

Study for Silia (Rossella Falk)

Below, Daniele Formica, Romolo
Valli and Gabriele Tozzi in the revival
of the production at the Teatro Eliseo,
Rome, 1976
Photo by Tommaso Le Pera

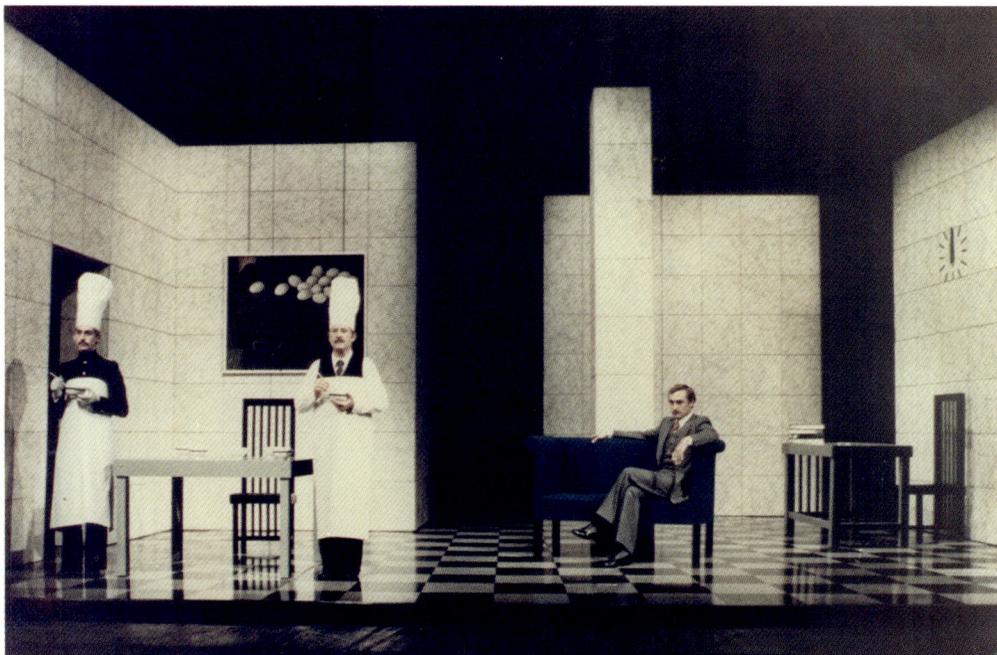

PIER LUIGI PIZZI

Così è (se vi pare)
[*Right You Are (if you think so)*]
by Luigi Pirandello, 1972
Directed by Giorgio De Lullo

Study for Lady Sirelli
(Anita Bartolucci)

Below, Romolo Valli, Nietta Zocchi,
Isabella Guidotti, Elsa Albani,
Ferruccio De Ceresa, Angela Lavagna,
Anita Bartolucci, Paolo Stoppa,
Rossella Falk, Rina Morelli,
Gabriele Tozzi, Antonio Colonnello
and Alessandro Iovino
Photo by Tommaso Le Pera

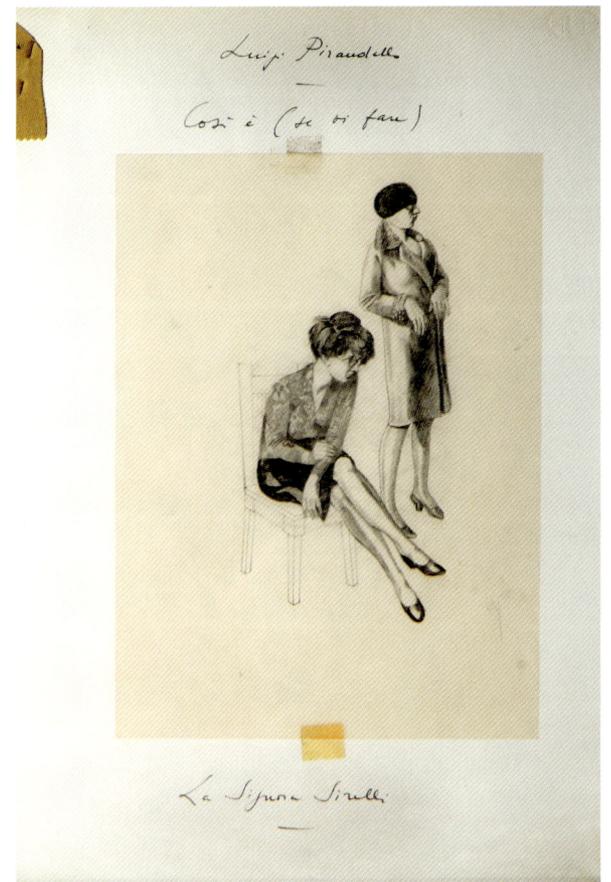

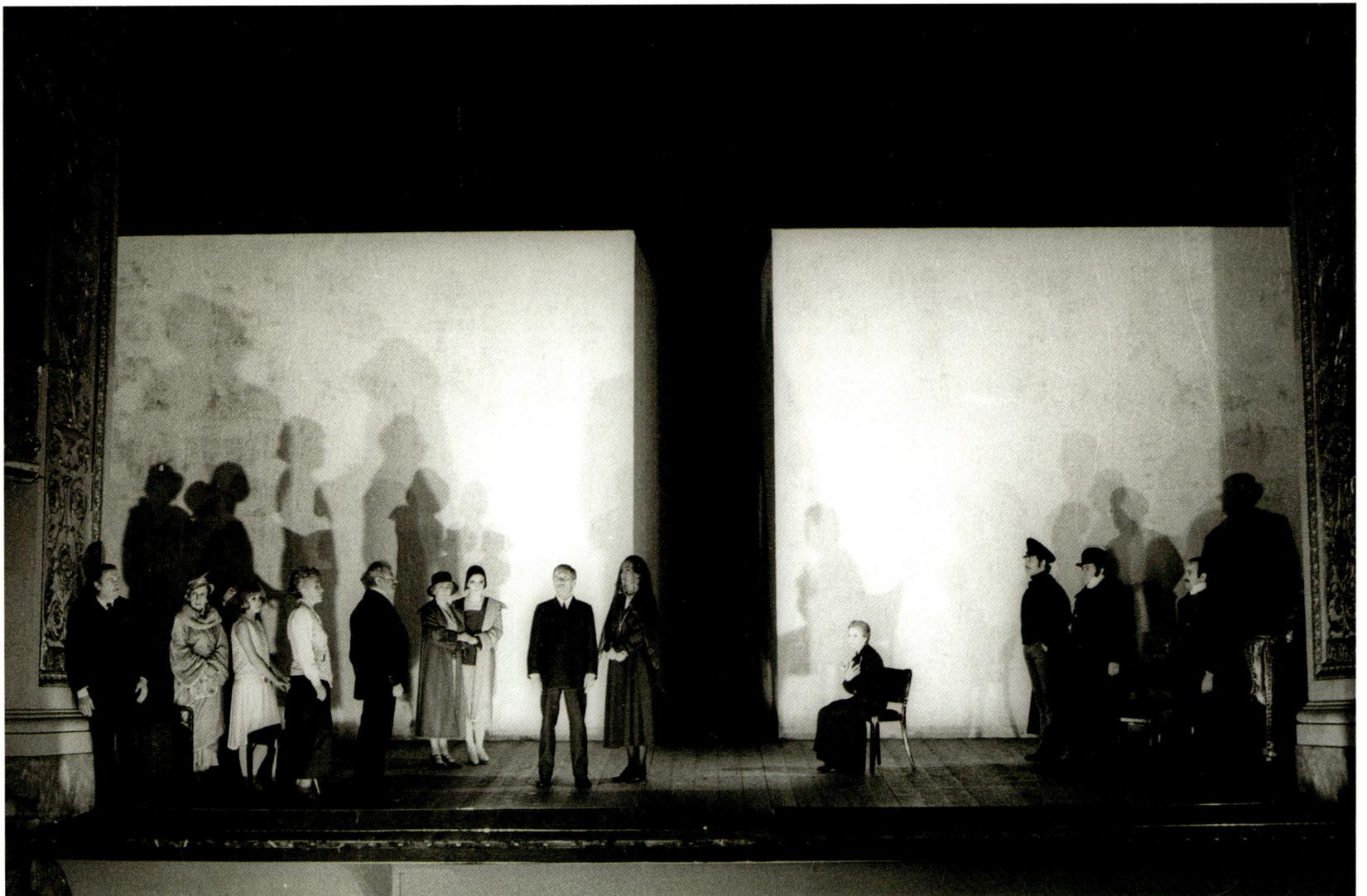

Così è (se vi pare)
[*Right You Are (if you think so)*]
Below, Romolo Valli, Nietta Zocchi,
Isabella Guidotti, Elsa Albani,
Ferruccio De Ceresa, Angela Lavagna,
Anita Bartolucci, Paolo Stoppa,
Rossella Falk, Rina Morelli,
Gabriele Tozzi, Antonio Colonnello
and Alessandro Iovino

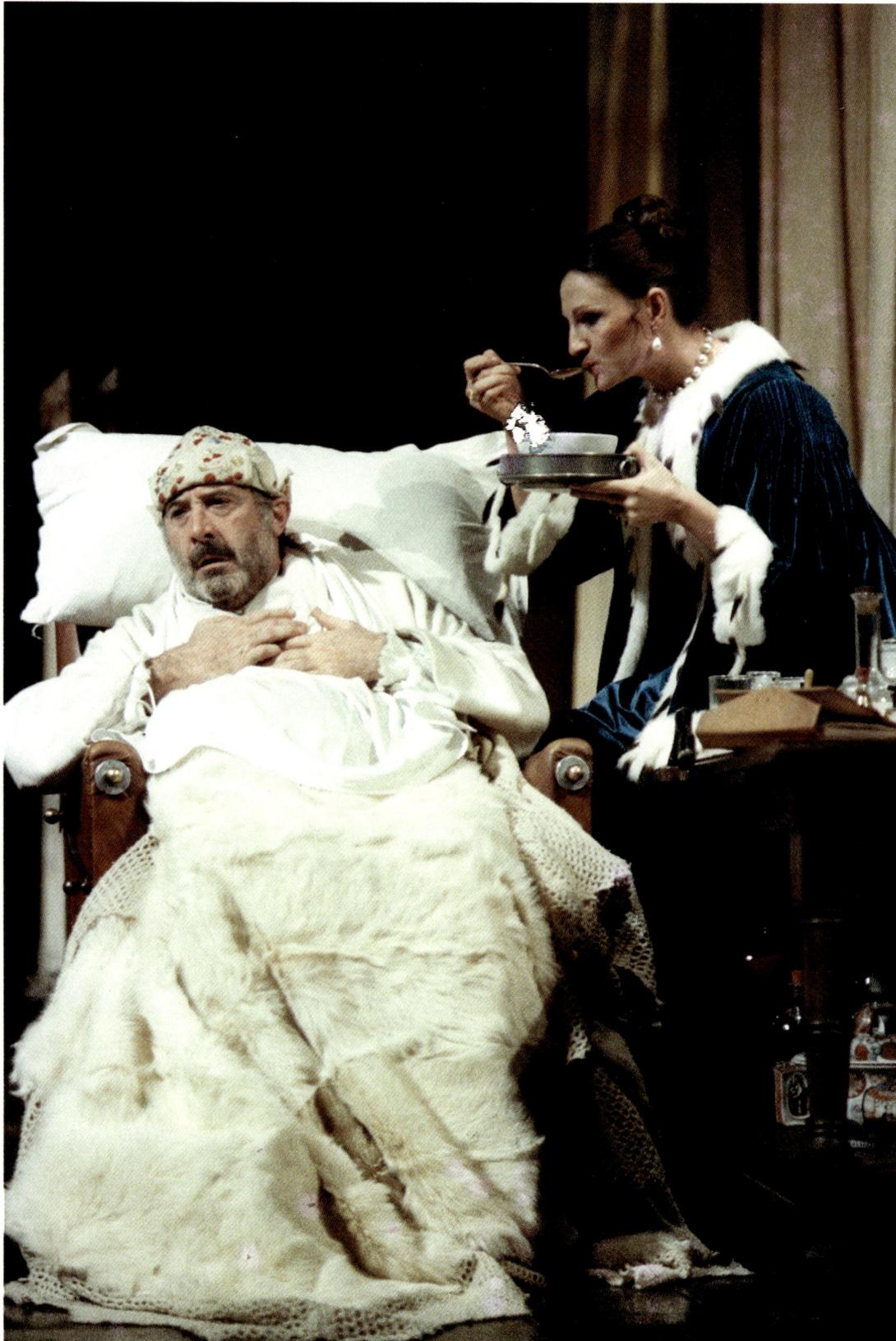

PIER LUIGI PIZZI

*Il malato immaginario
[The Imaginary Invalid]*
by Molière, 1974
Directed by Giorgio De Lullo

Romolo Valli, Anita Bartolucci
Photo by Tommaso Le Pera

Right, study for Belina
(Anita Bartolucci)

Opposite, Romolo Valli
Photo by Tommaso Le Pera

Following pages

PIER LUIGI PIZZI

Enrico IV [Henry IV]
by Luigi Pirandello, 1977
Directed by Giorgio De Lullo

Romolo Valli

Gianna Giachetti and Romolo Valli
Photos by Tommaso Le Pera

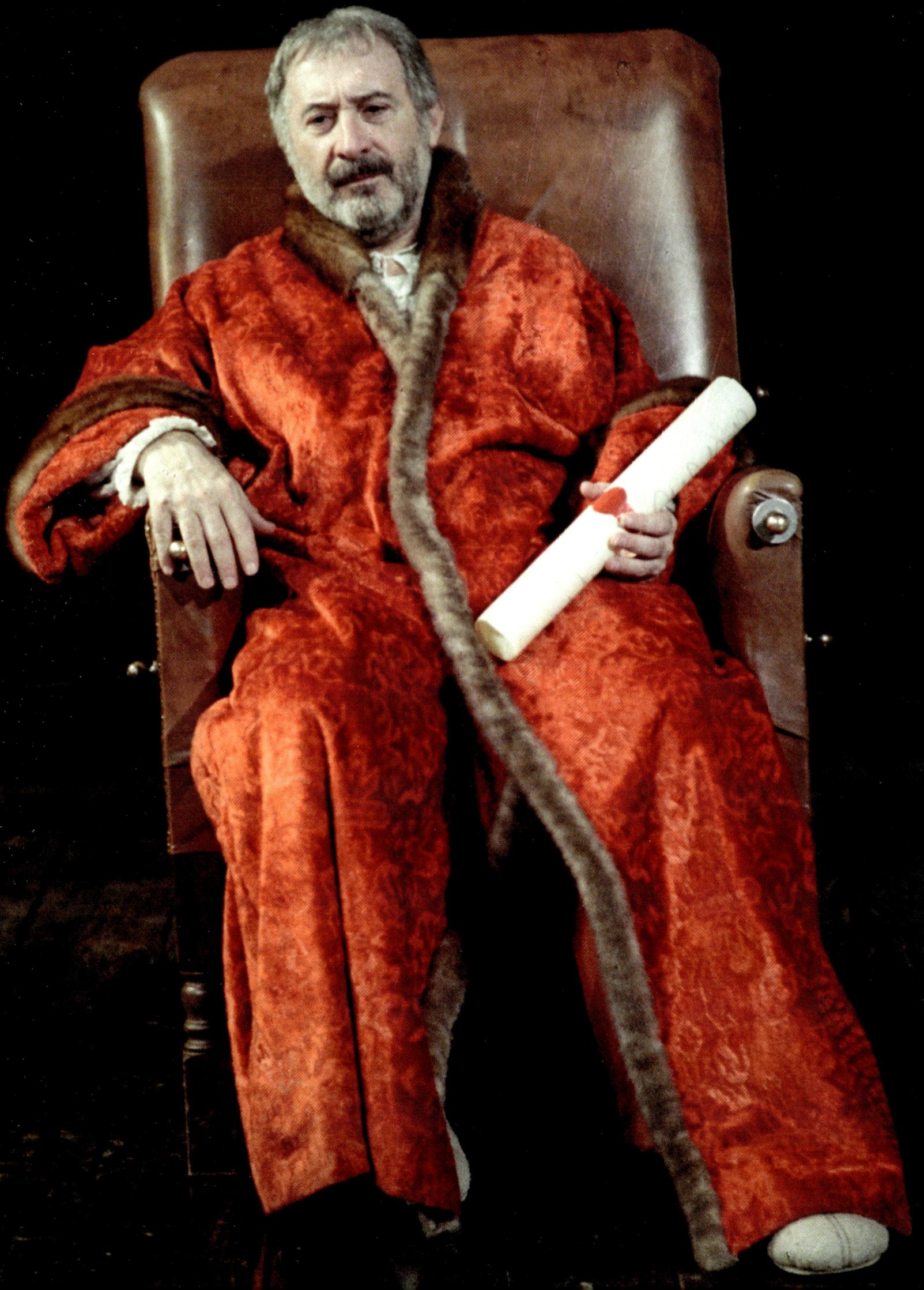

Feste, buffone

PIER LUIGI PIZZI

La dodicesima notte [Twelfth Night]
by William Shakespeare, 1979
Directed by Giorgio De Lullo

Monica Guerritore
and Massimo Ranieri
Photo by Tommaso Le Pera

Left, study for Feste
(Massimo Ranieri)

Opposite, Giovanni Crippa
and Anita Bartolucci
Photo by Tommaso Le Pera

Right, Dino Trappetti and Pier Luigi
Pizzi on Capri in the summer prior
to the staging of *Twelfth Night*;
Dino Trappetti is showing Pier Luigi
Pizzi's first study for the single set
of the play

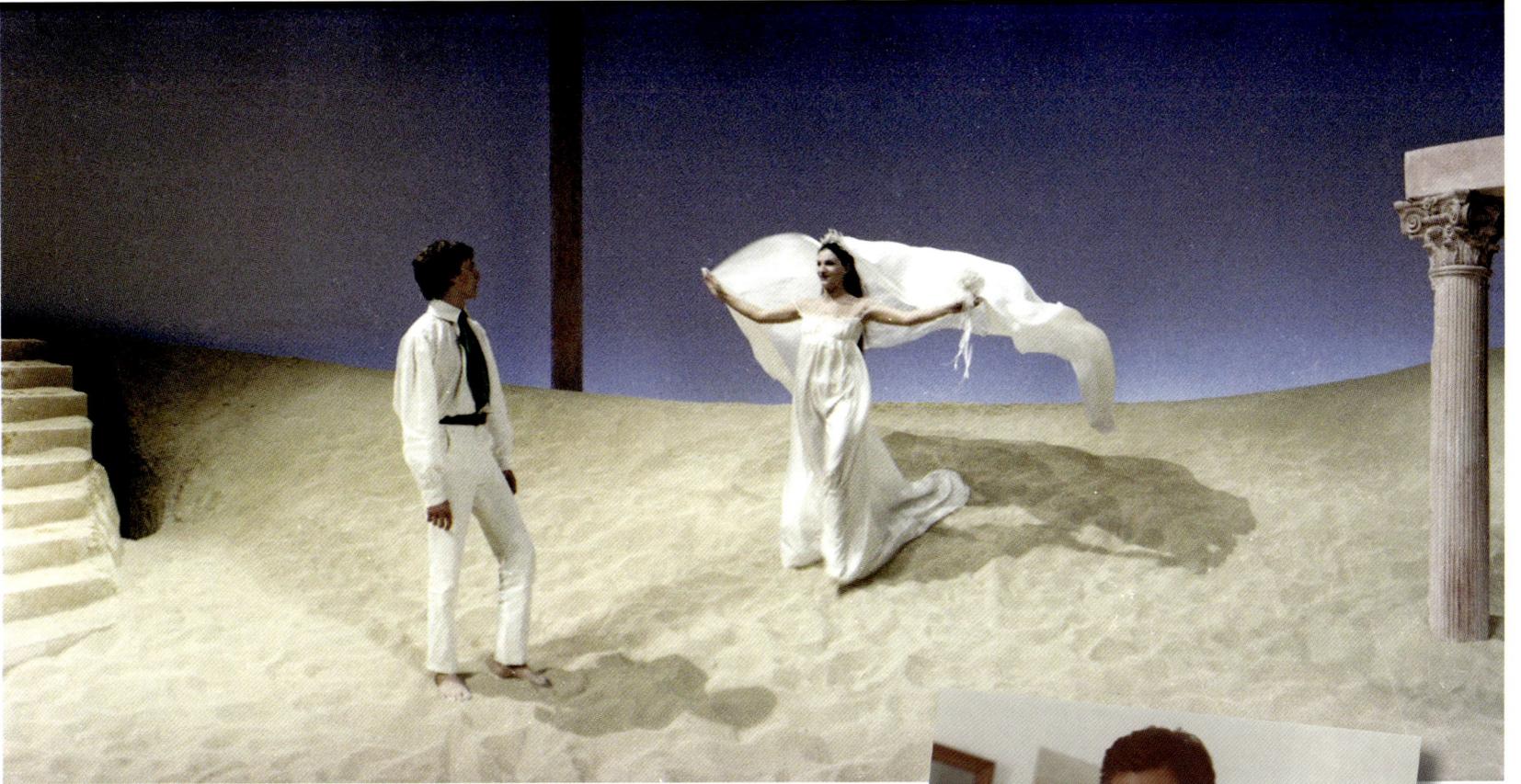

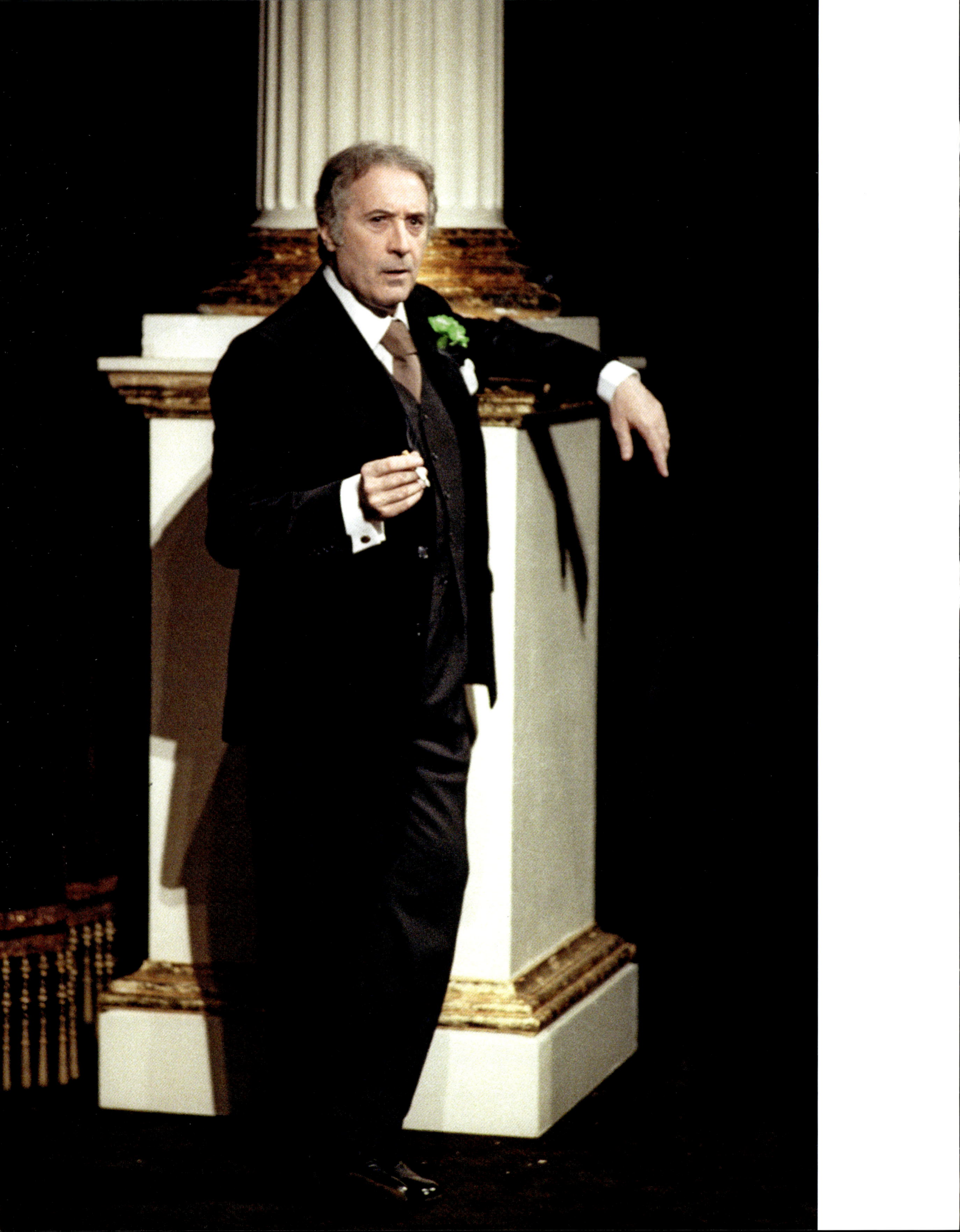

Opposite

PIER LUIGI PIZZI

*Divagazioni e Delizie
[Diversions and Delights]*
by John Gay, 1979
Directed by Giorgio De Lullo

Romolo Valli
Photo by Tommaso Le Pera

PIER LUIGI PIZZI

Prima del silenzio [Before the Silence]
by Giuseppe Patroni Griffi, 1979
Directed by Giorgio De Lullo

Romolo Valli

Right, Fabrizio Bentivoglio
and Romolo Valli
Photos by Tommaso Le Pera

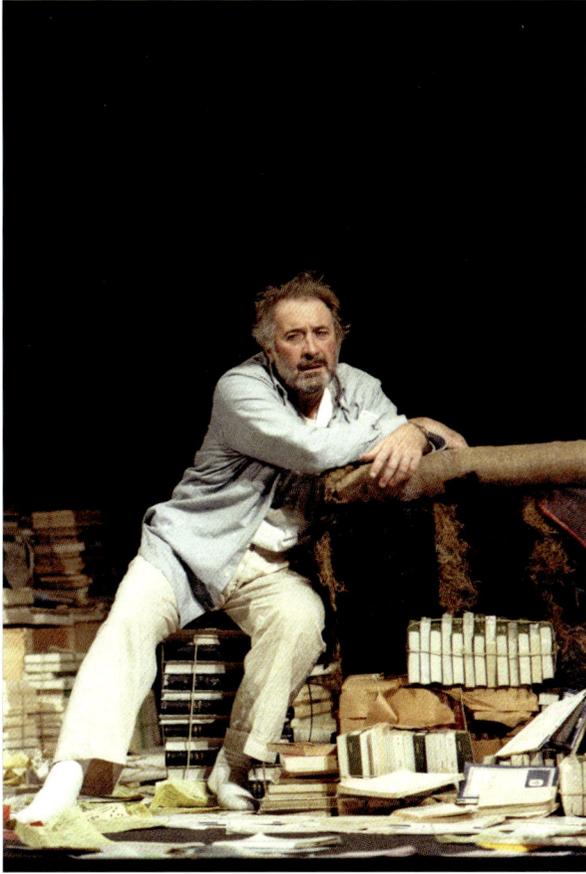

PIER LUIGI PIZZI

Tre sorelle [Three Sisters]
by Anton Chekhov, 1980
Directed by Giorgio De Lullo

Gianna Giachetti, Sergio Fantoni,
Gabriele Tozzi, Caterina Sylos Labini
and Anita Bartolucci
Photo by Tommaso Le Pera

PIER LUIGI PIZZI

Una delle ultime sere di Carnovale
[One of the Last Nights of Carnival]
by Carlo Goldoni, 2007
Directed by Pier Luigi Pizzi

The play was performed at the Scuola
Grande di San Giovanni Evangelista
in Venice

Anita Bartolucci
and Stefano Scandaletti

Below, the dinner
Photos by Emanuele Cattozzo
(Teatro Stabile del Veneto)

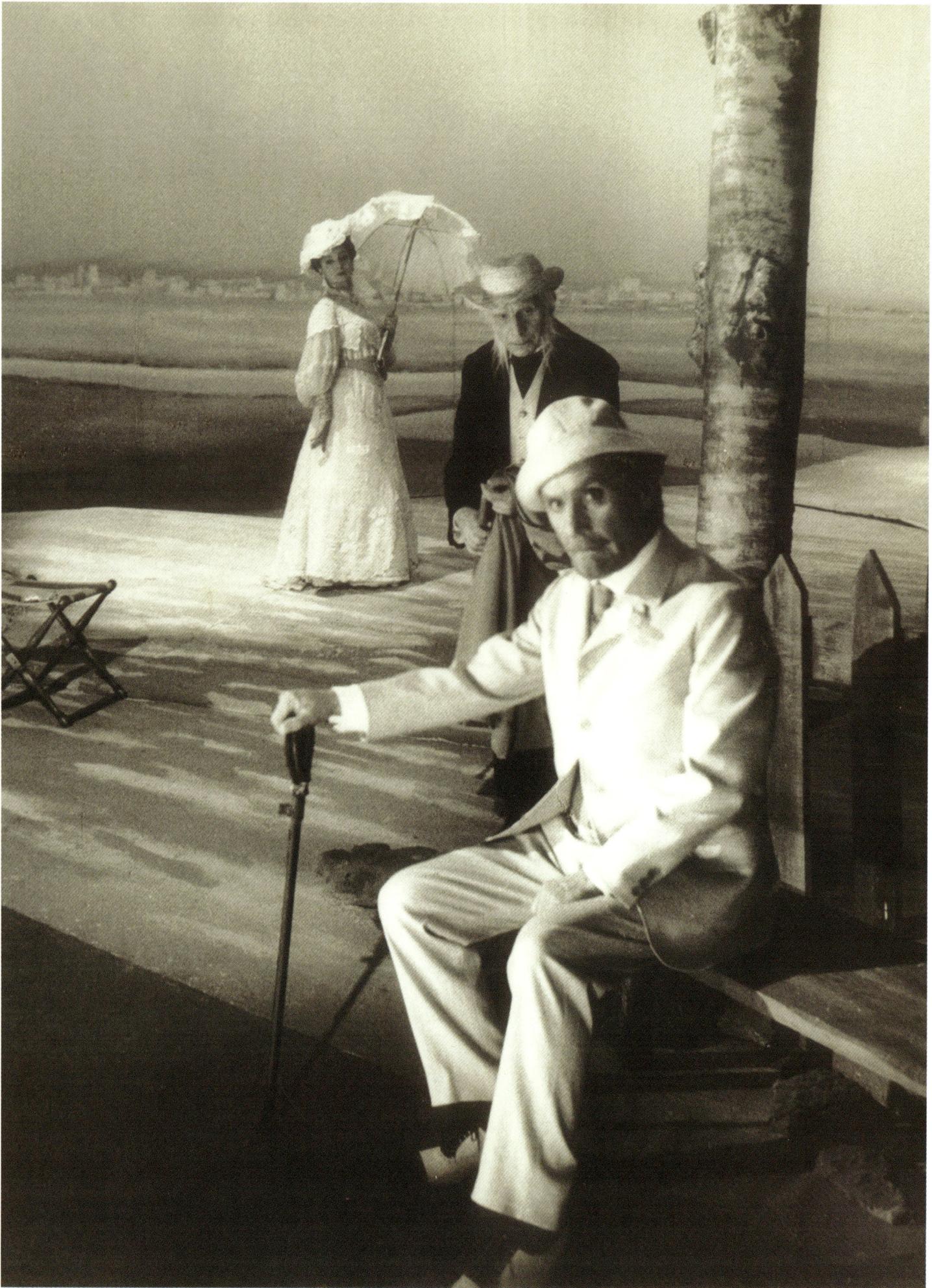

Opposite

**FERDINANDO SCARFIOTTI,
LUCHINO VISCONTI**

*Il giardino dei ciliegi
[The Cherry Orchard]*
by Anton Chekhov, 1965
Directed by Luchino Visconti

Rina Morelli, Sergio Tofano
and Paolo Stoppa
Photo by Gastone Bosio

LUCIANO DAMIANI

*Il giardino dei ciliegi
[The Cherry Orchard]*
by Anton Chekhov, 1974
Directed by Giorgio Strehler

Valentina Cortese, Cip Barcellini
and Gianni Santuccio
Photo by Luigi Ciminaghi / Piccolo
Teatro di Milano

MAURIZIO MILLENOTTI

*Il giardino dei ciliegi
[The Cherry Orchard]*
by Anton Chekhov, 2014
Directed by Luca De Fusco

Gaia Aprea and Enzo Turrin
Photo by Tommaso Le Pera

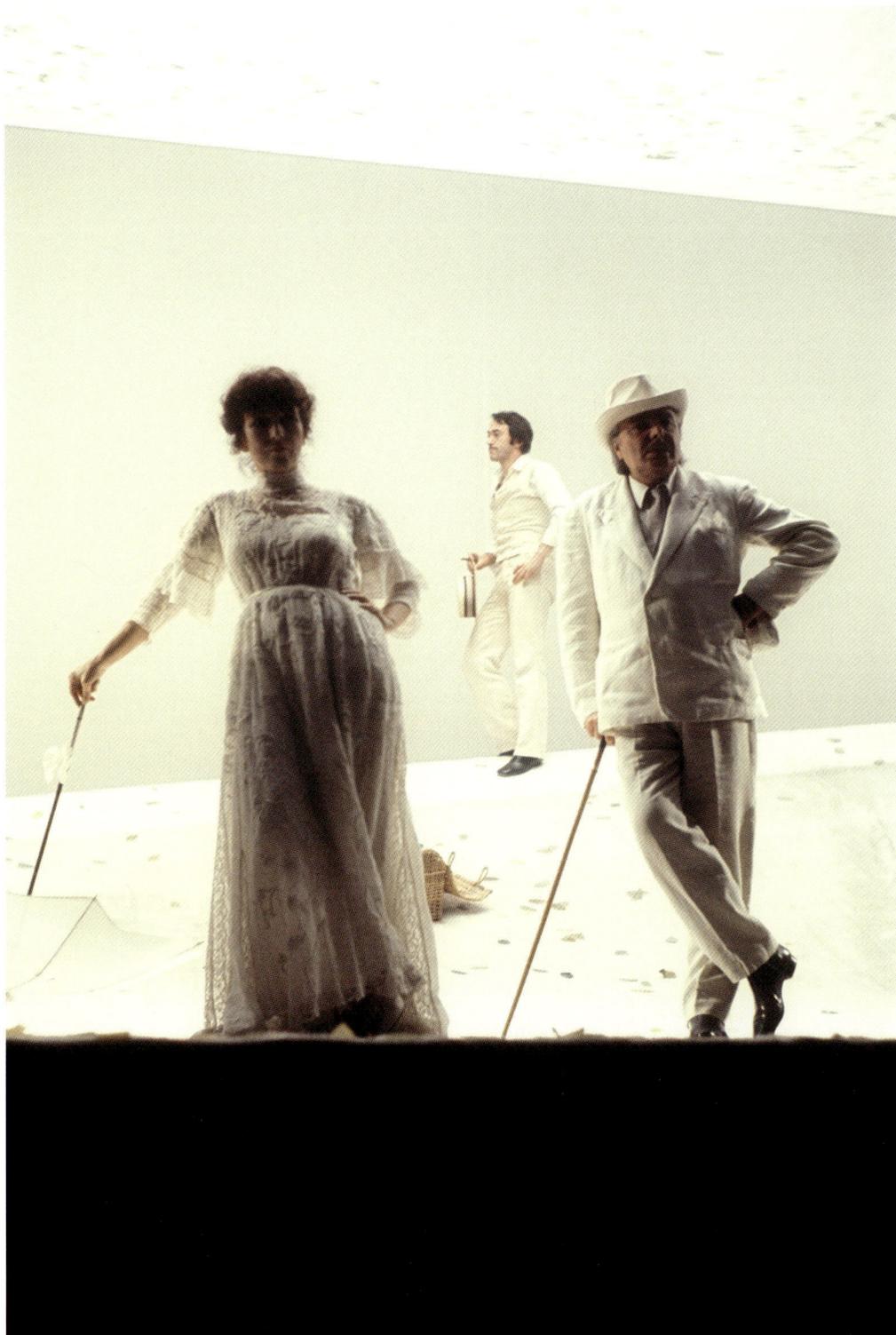

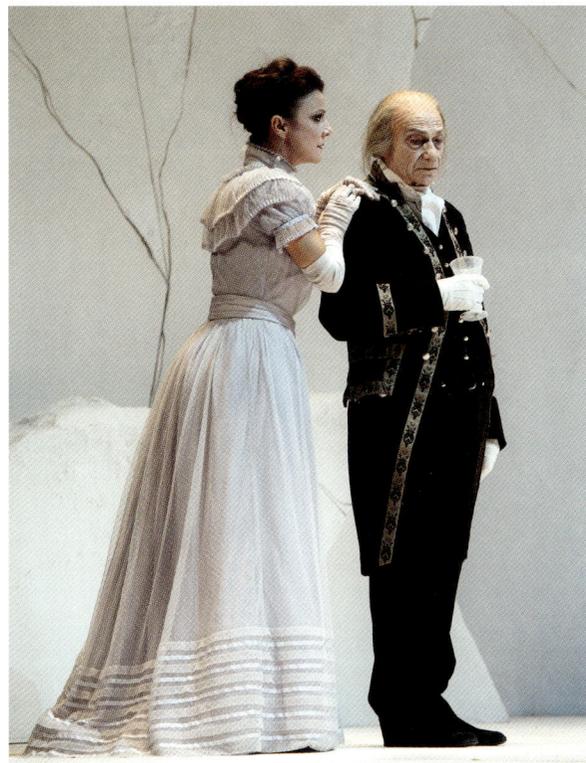

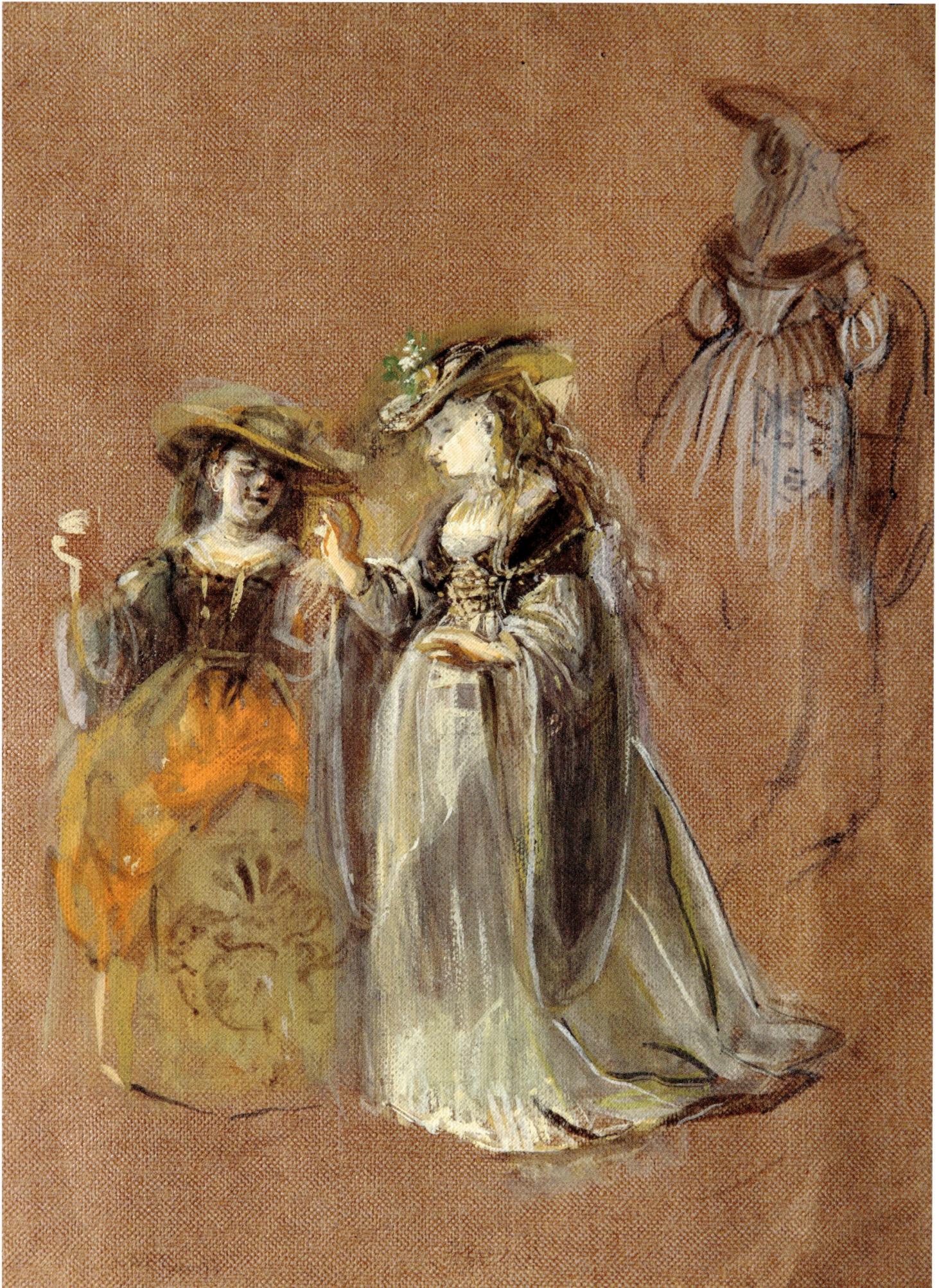

LILA DE NOBILI

*Il mercante di Venezia
[The Merchant of Venice]*
by William Shakespeare, 1966
Directed by Ettore Giannini

Opposite, study for the female
characters

Study for the set

Below, study for the male characters

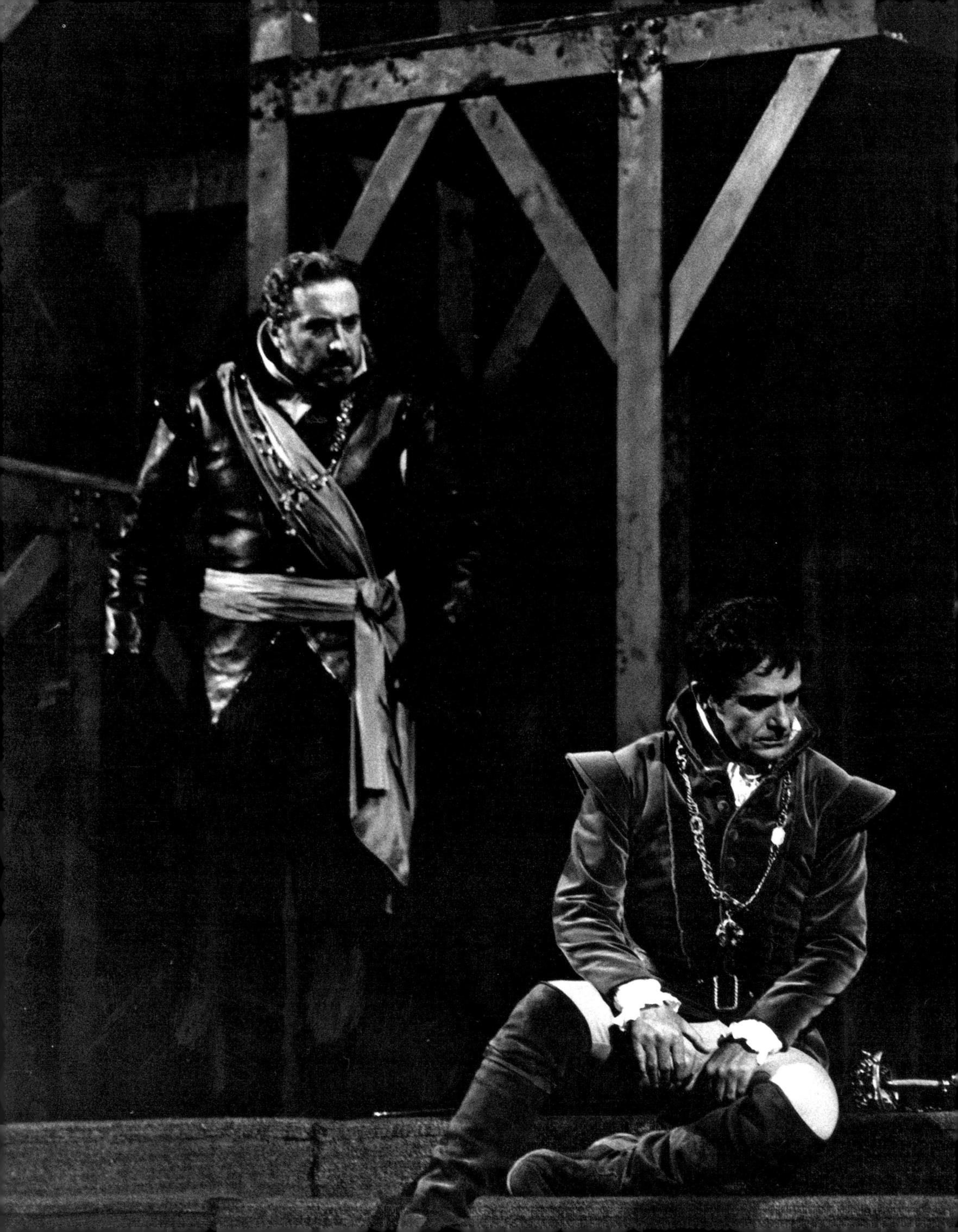

FERDINANDO SCARFIOTTI

Egmont
by Johann Wolfgang von Goethe, 1967
Directed by Luchino Visconti

Romolo Valli and Giorgio De Lullo
Photo by Marchiori, Florence –
Florence, Teatro del Maggio Musicale
Fiorentino – Fondazione, Archivio
Fotografico Allestimento Scenico

FERDINANDO SCARFIOTTI

Victor o i bambini al potere
[Victor, or Power to the Children]
by Roger Vitrac, 1969
Directed by Giuseppe Patroni Griffi

Elsa Albani, Romolo Valli,
Giorgio De Lullo and Nora Ricci
Photo by Tommaso Le Pera

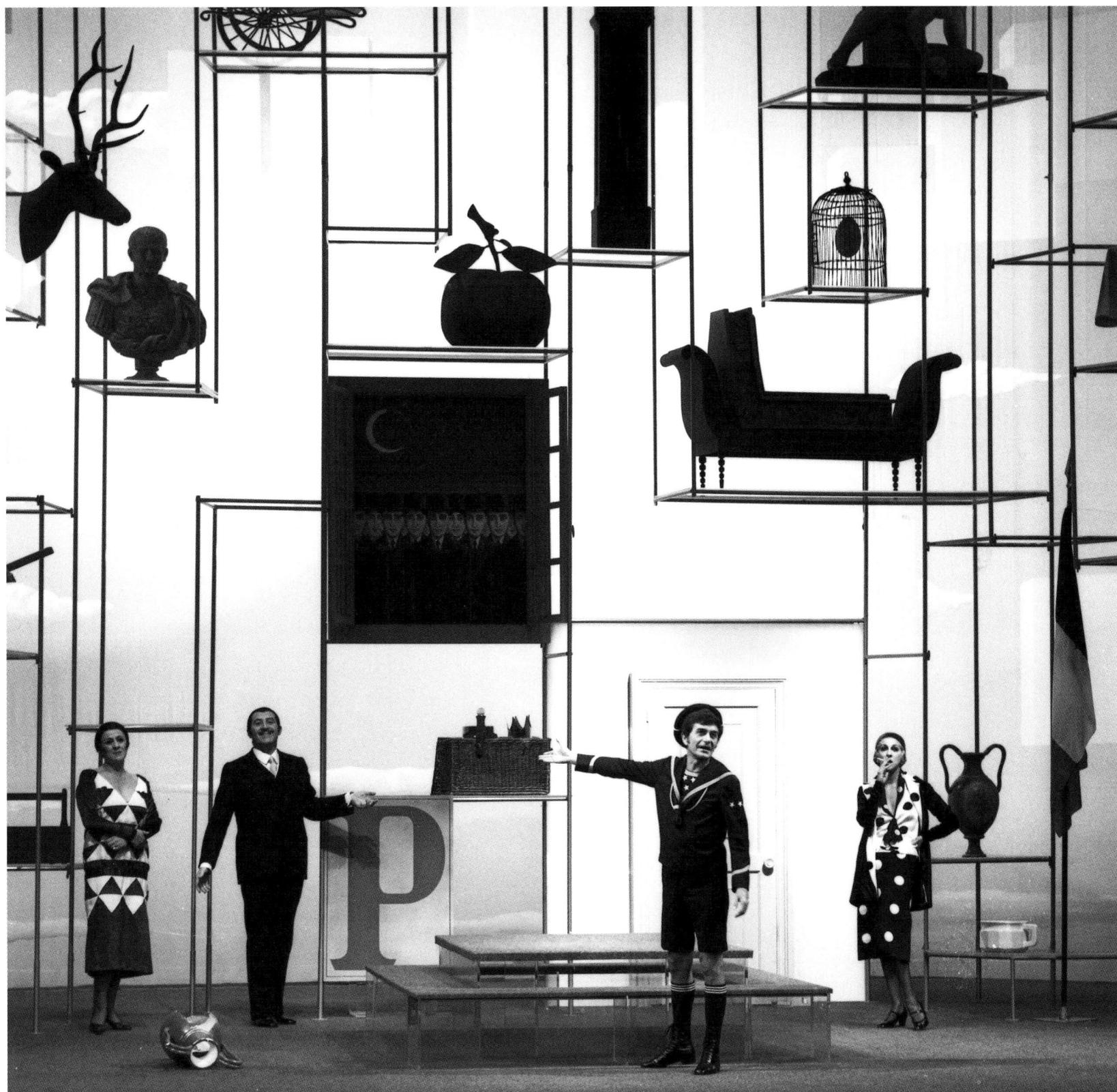

EZIO FRIGERIO

Re Lear [King Lear]
by William Shakespeare, 1972
Directed by Giorgio Strehler

Left, study for the Fool
(Ottavia Piccolo)

Right, study for King Lear
(Tino Carraro)

Opposite, Tino Carraro
and Ottavia Piccolo
Photo by Luigi Ciminaghi / Piccolo
Teatro di Milano

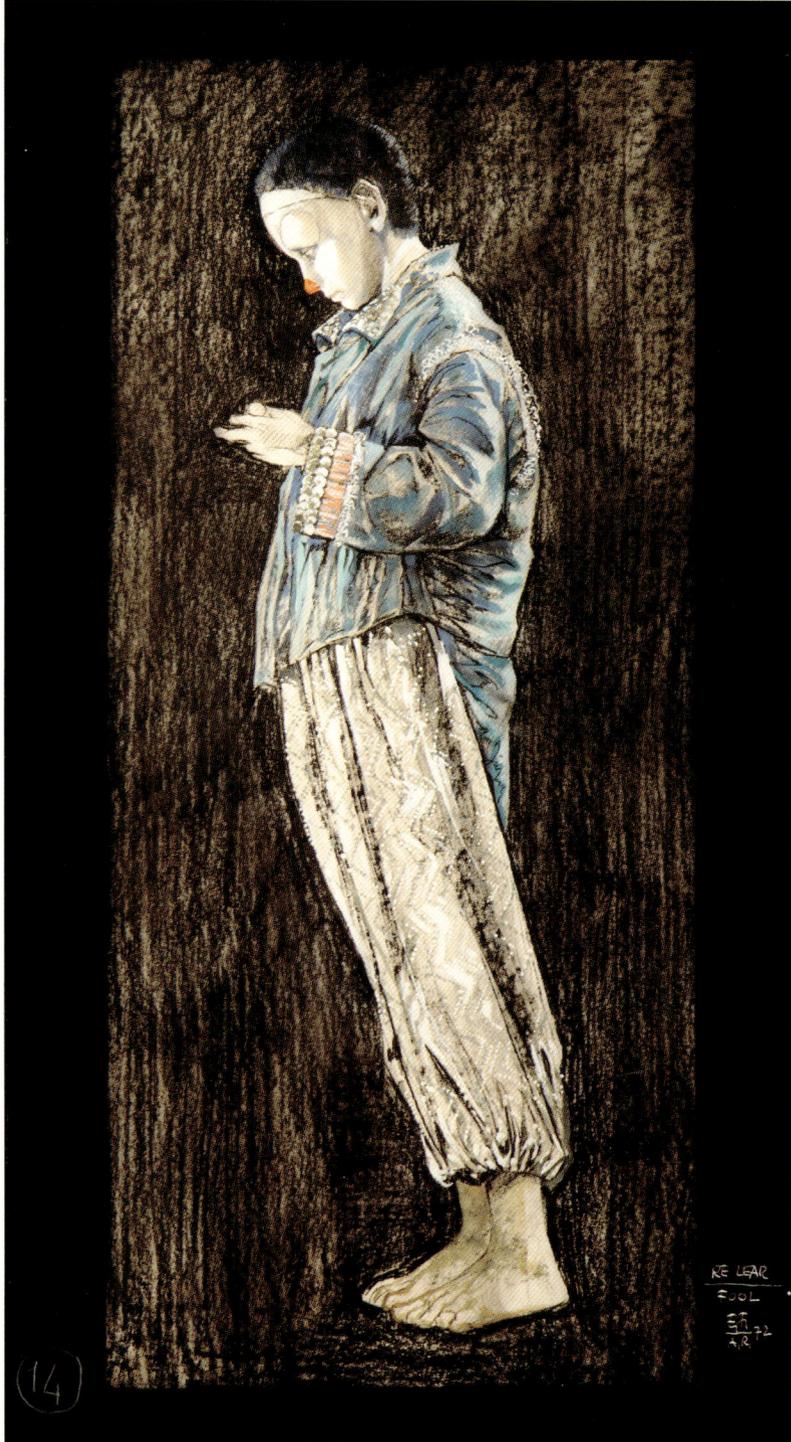

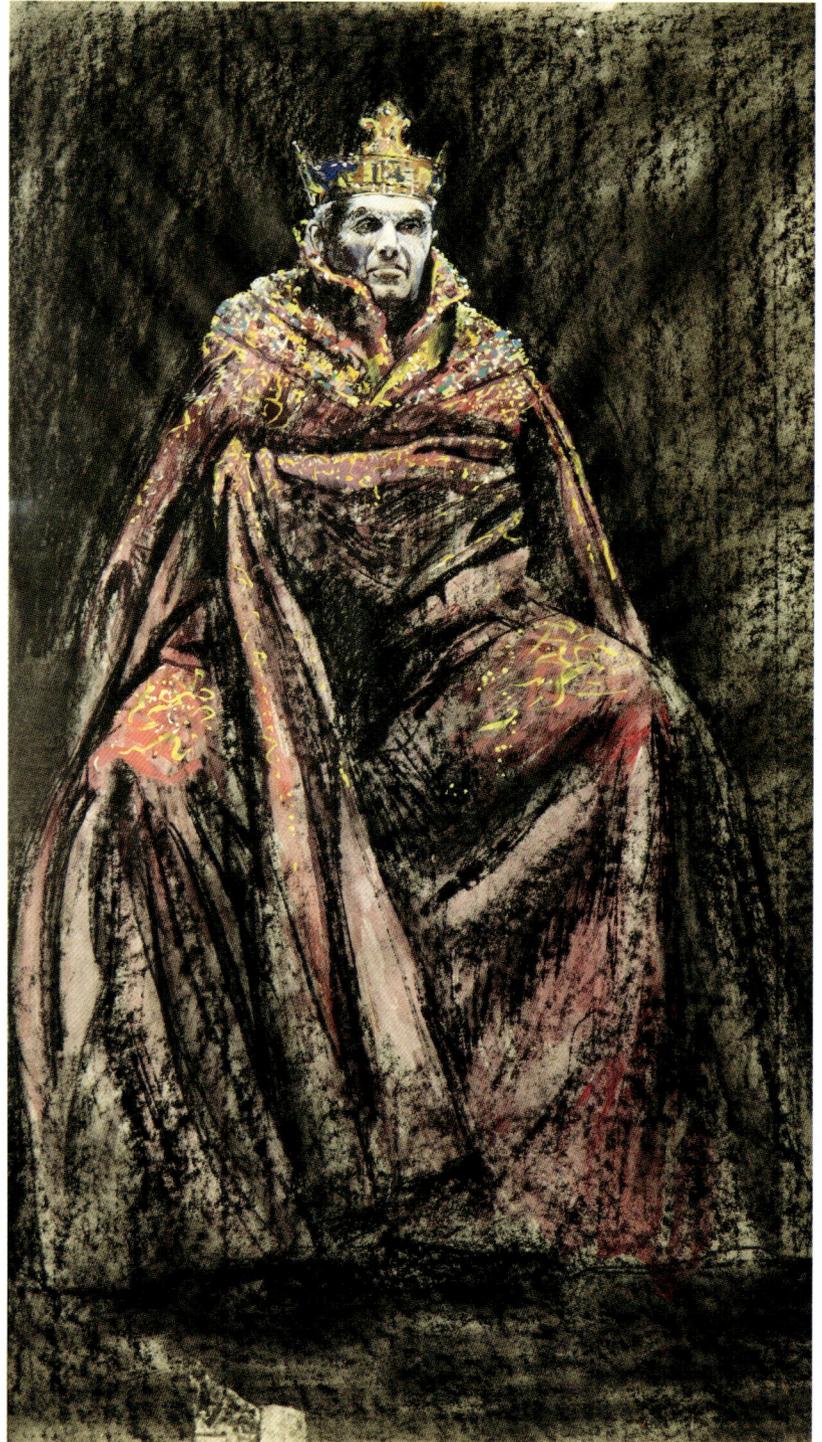

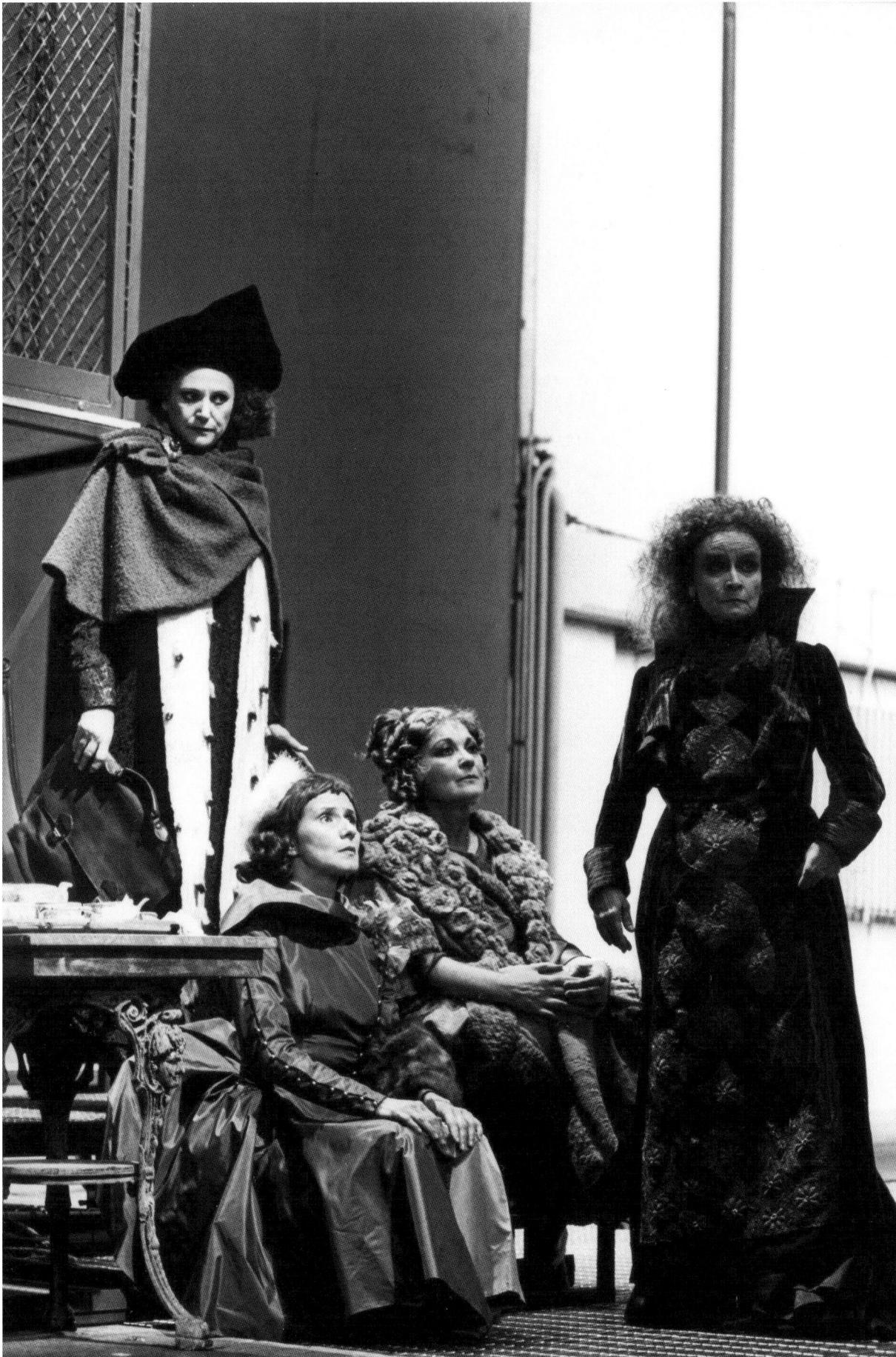

La pazza di Chaillot
[The Madwoman of Chaillot]
by Jean Giraudoux, 1991
Directed by Luca Ronconi

Anna Maria Guarnieri
Photo by Tommaso Le Pera

**PIERO TOSI,
MAURIZIO MONTEVERDE**

La locandiera [The Mistress of the Inn]
by Carlo Goldoni, 1981
Directed by Giorgio De Lullo

The theatre programme announced:
"*La locandiera* – the mise-en-scène
devised by Luchino Visconti in 1952,
revived by Giorgio De Lullo, Piero
Tosi, Umberto Tirelli and Maurizio
Monteverde"

Gianna Giachetti and Roberto Alpi
Photo by Tommaso Le Pera

Below, costume study by Piero Tosi
for Mirandolina, played by Rina
Morelli in the 1952 edition of the
production, directed by Luchino
Visconti

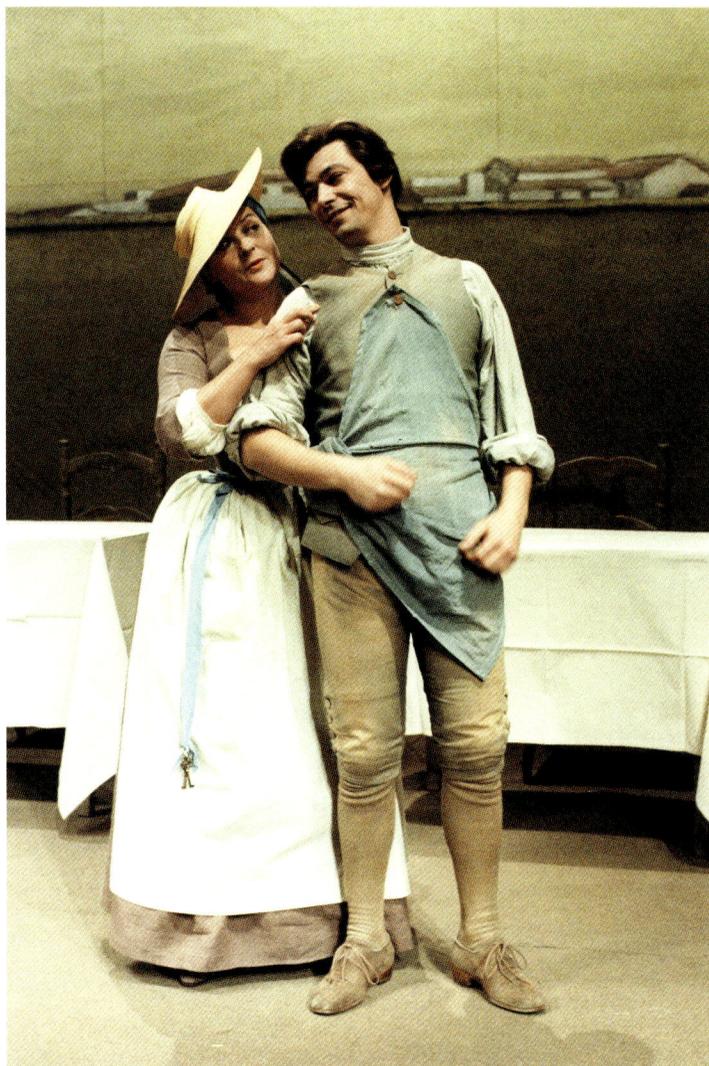

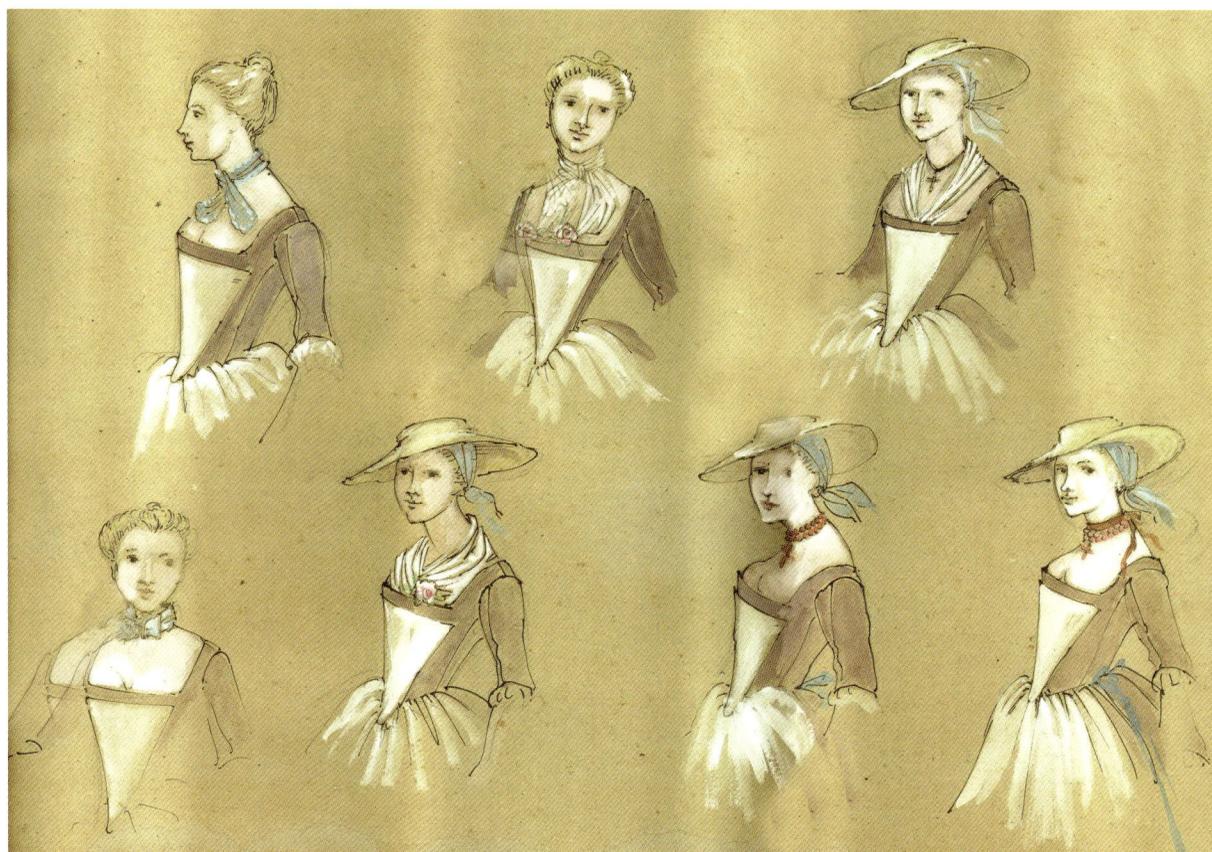

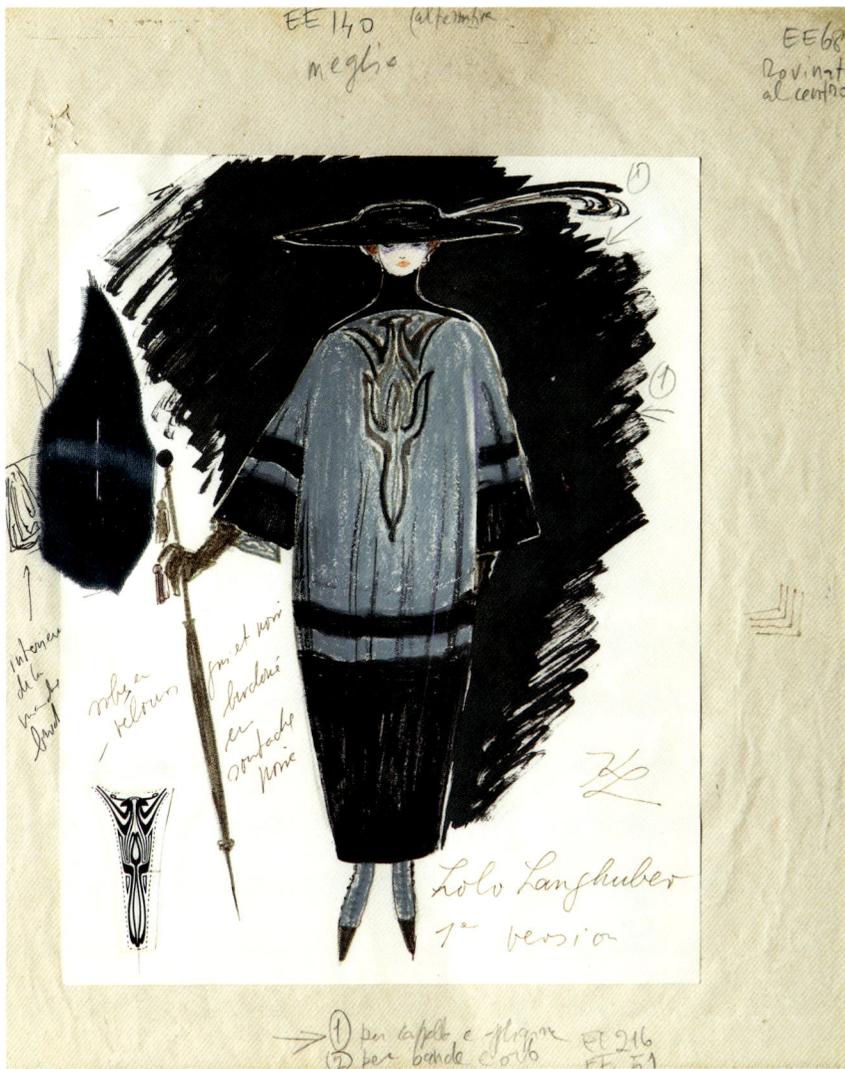

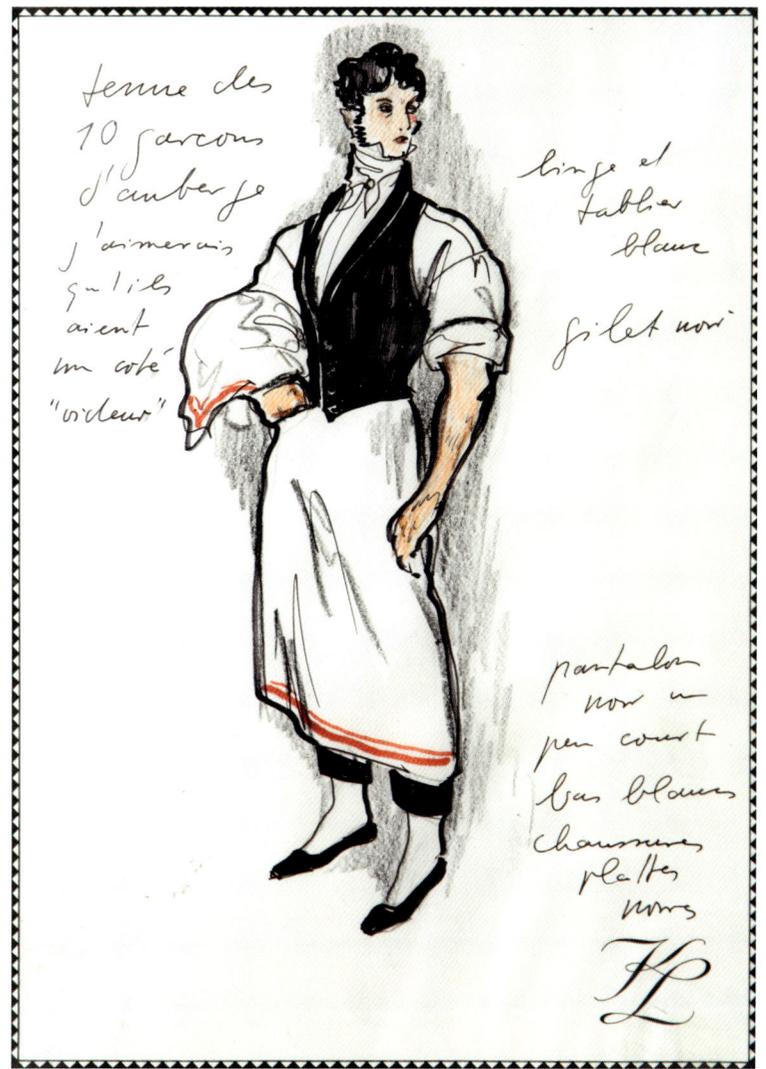

KARL LAGERFELD

La contessa Mizzi [Countess Mizzie]
by Arthur Schnitzler, 1978
Directed by Luca Ronconi

Above left, study for Lolo
(Giuliana Calandra)

Above right, study for the valets'
costumes

Right, note from Karl Lagerfeld
to Tirelli with some thoughts about
the realization of the costumes

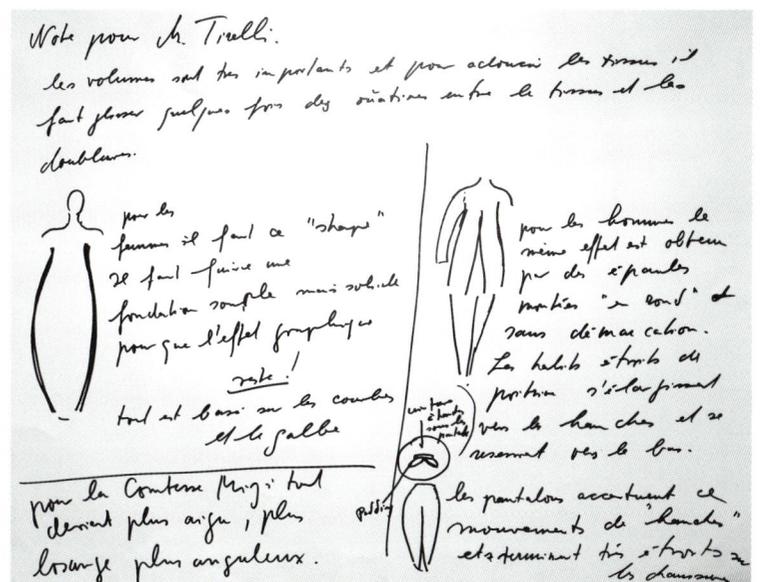

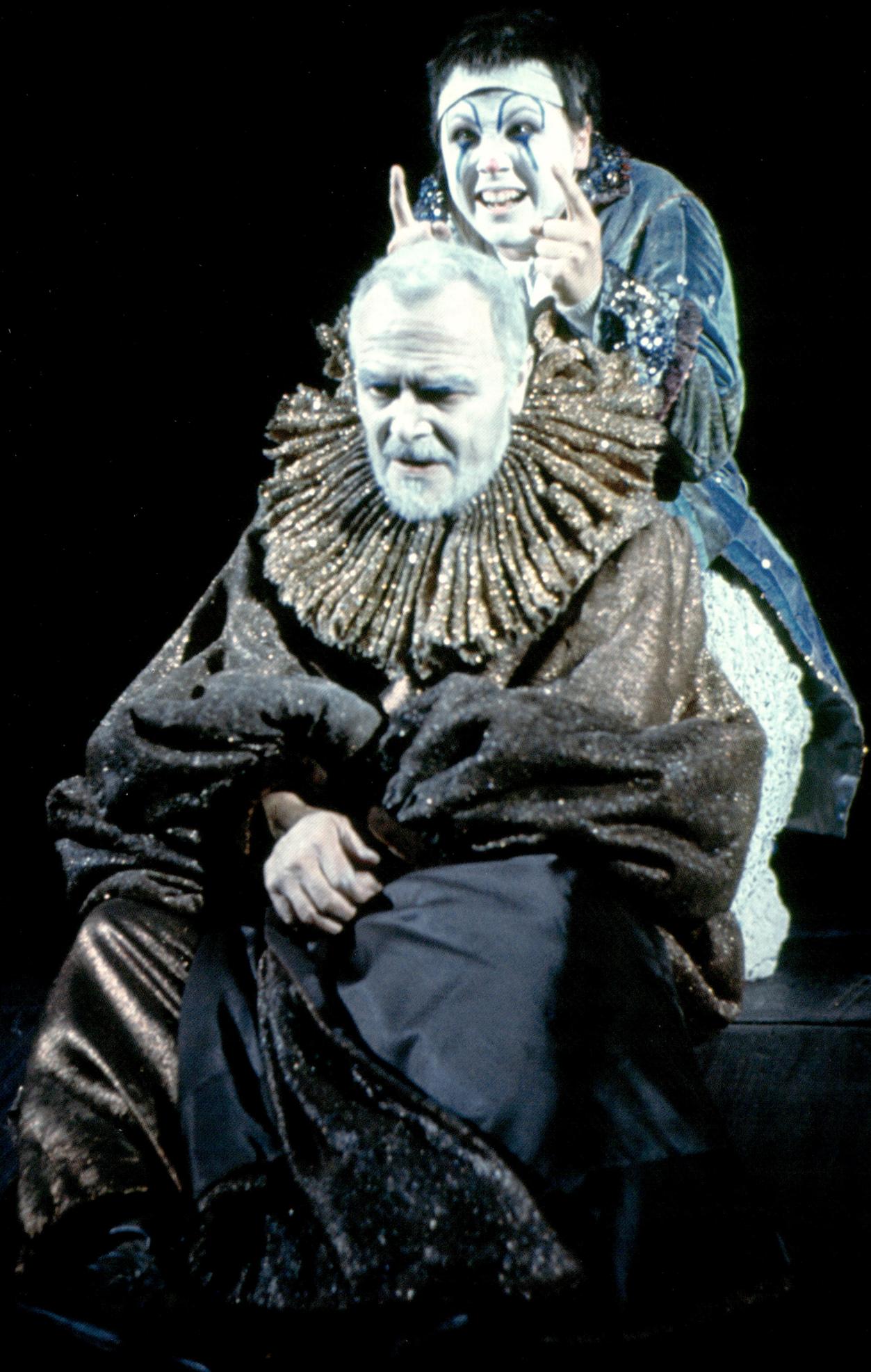

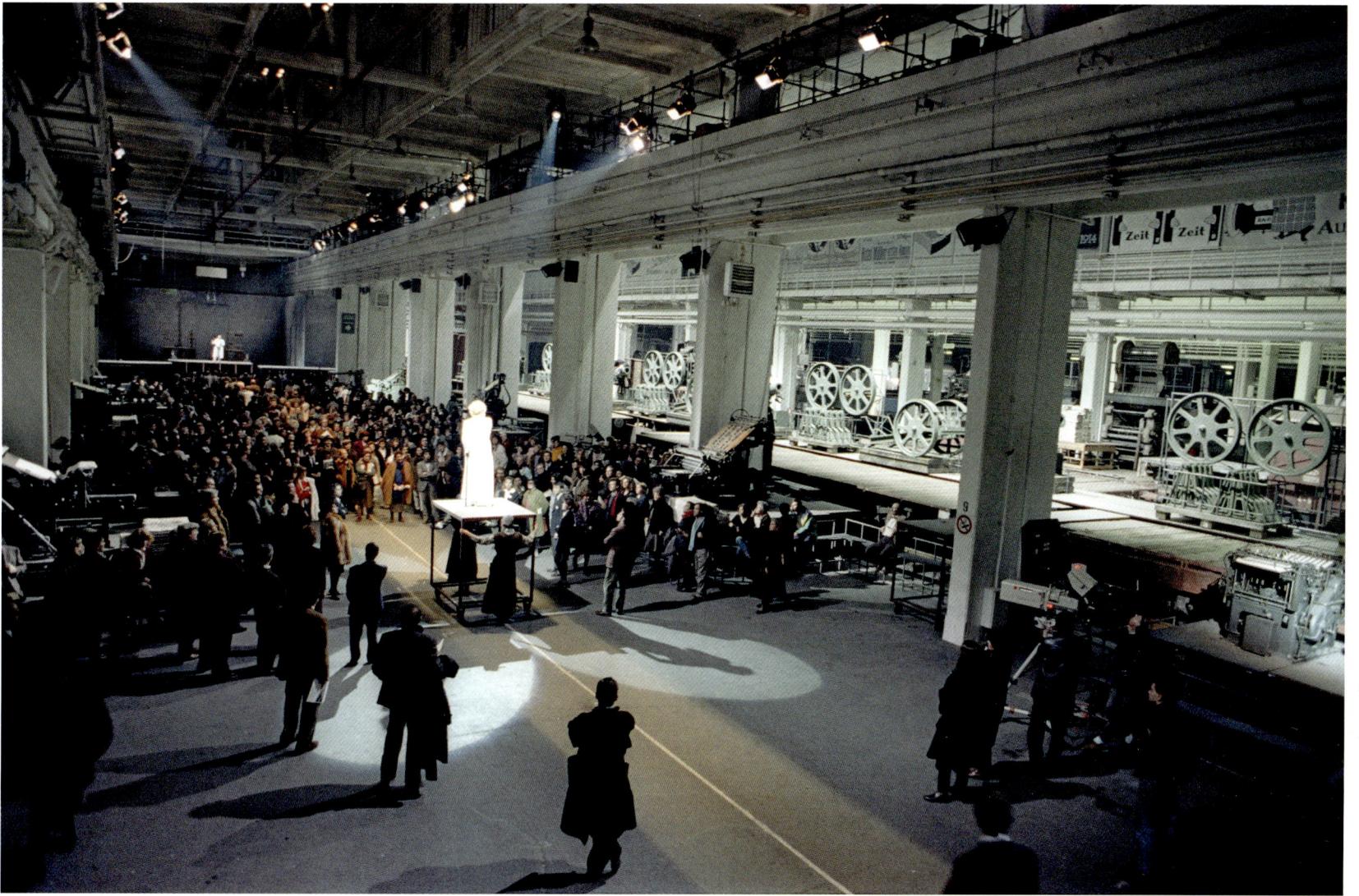

GABRIELLA PESCUCCI

*Gli ultimi giorni dell'umanità
[The Last Days of Mankind]*
by Karl Kraus, 1990
Directed by Luca Ronconi

Overall view of the production
staged in the Sala Presse at the
Lingotto, Turin

Right, Anna Maria Guarnieri
Photos by Tommaso Le Pera

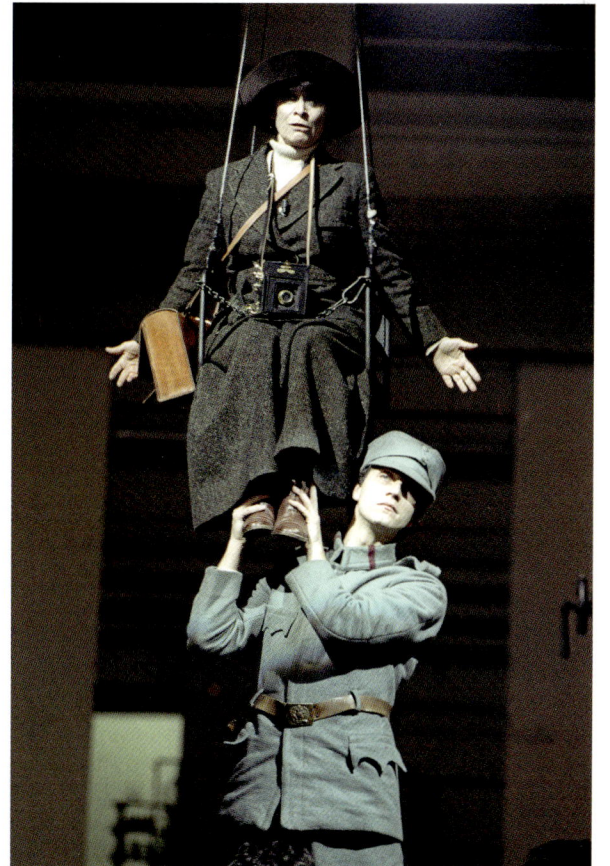

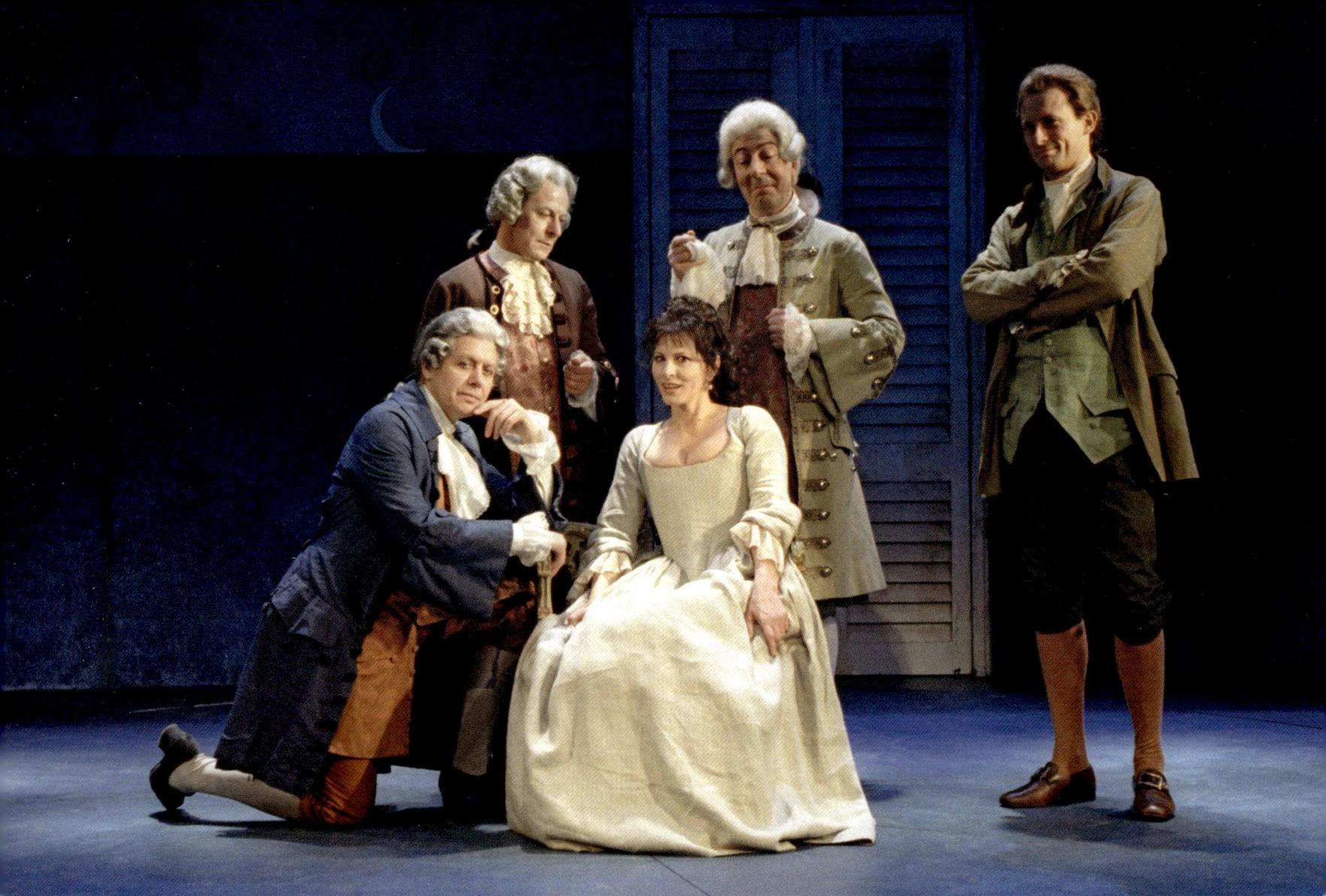

ROBERTO BANCI

La locandiera [The Mistress of the Inn]
by Carlo Goldoni, 1993
Directed by Marco Bernardi

Carlo Simoni, Alvise Battain, Patrizia
Milani, Mario Pachi and Andrea Emeri
Photo by Tommaso Le Pera

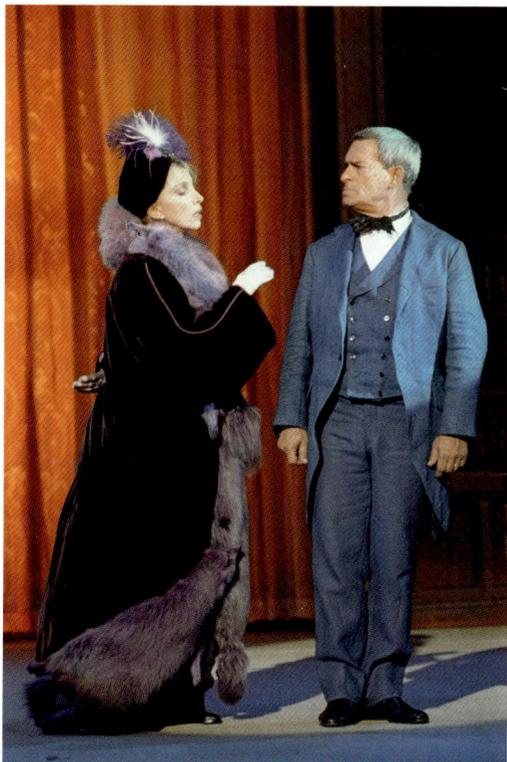

FRANÇOISE TOURNAFOND

La dame de chez Maxim
[The Lady from Maxim's]
by Georges Feydeau, 1998
Directed by Alfredo Arias

Mariangela Melato and Eros Pagni

Right, Mariangela Melato
Photos by Tommaso Le Pera

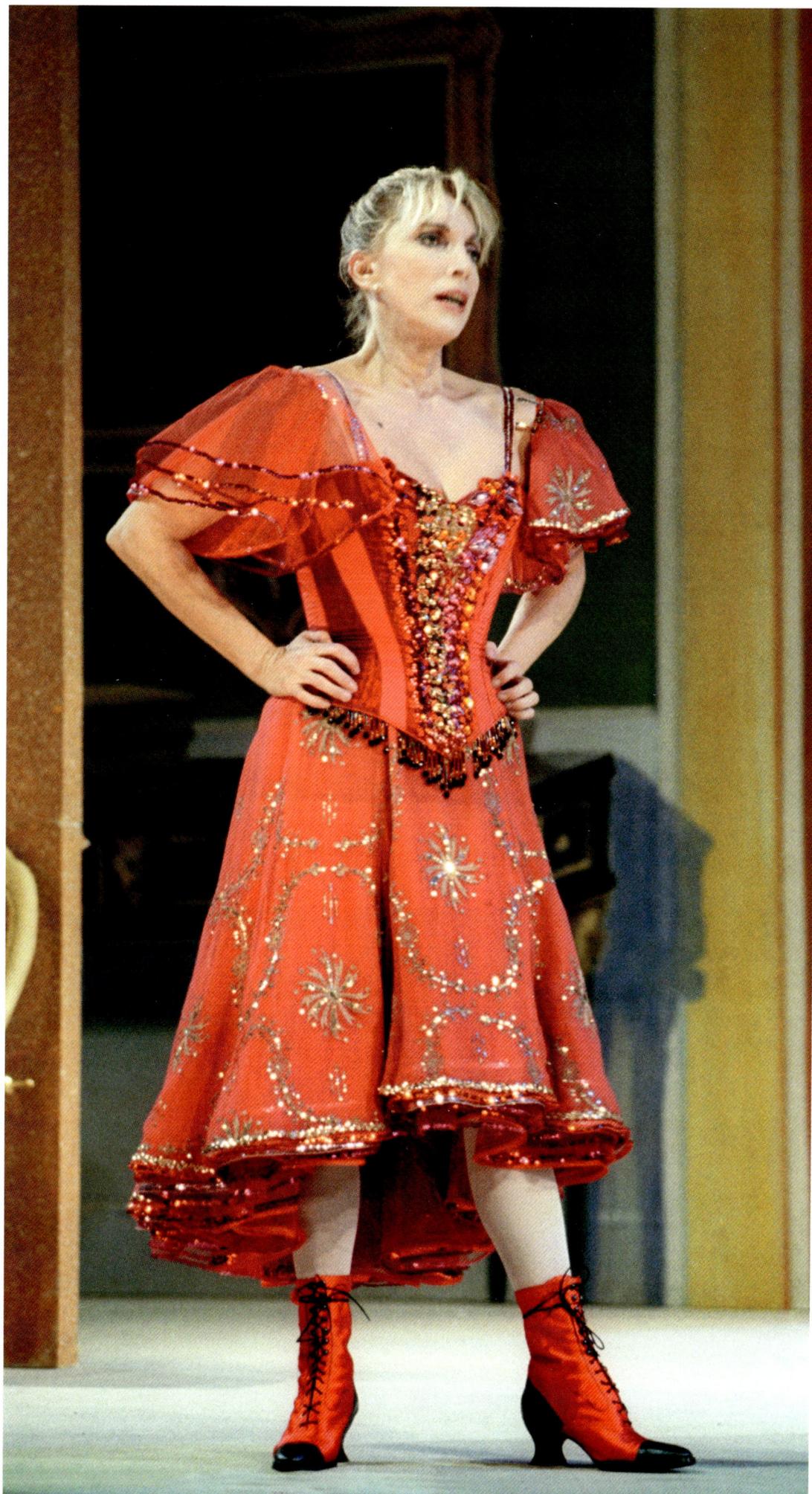

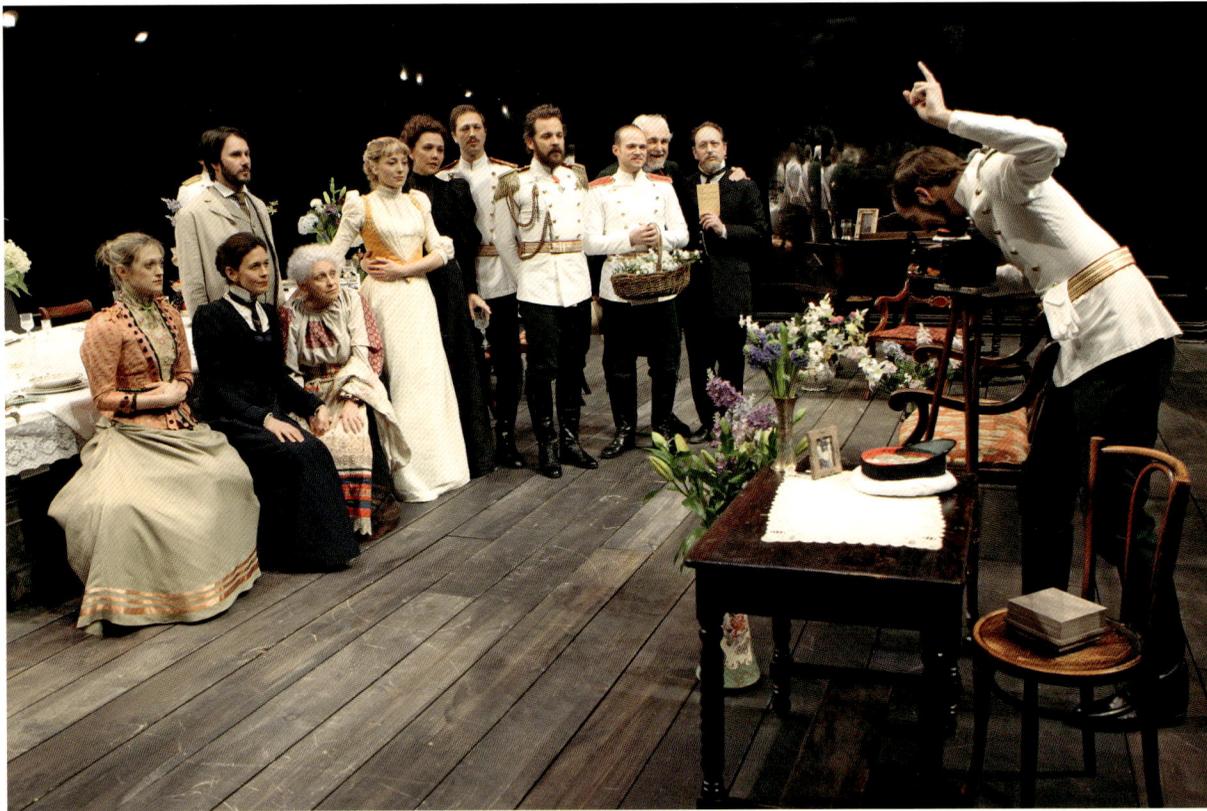

MARCO PIEMONTESE

Three Sisters
by Anton Chekhov, 2010
Directed by Austin Pendleton

Marin Ireland, Jessica Hecht, Josh
Hamilton, Roberta Maxwell, Juliet
Rylance, Maggie Gyllenhaal, Ebon
Moss-Bachrach, Peter Sarsgaard,
Gabriel Bettio, Louis Zorich, Paul
Lazar and – behind the camera – James
Patrick Nelson
Photo by Joan Marcus

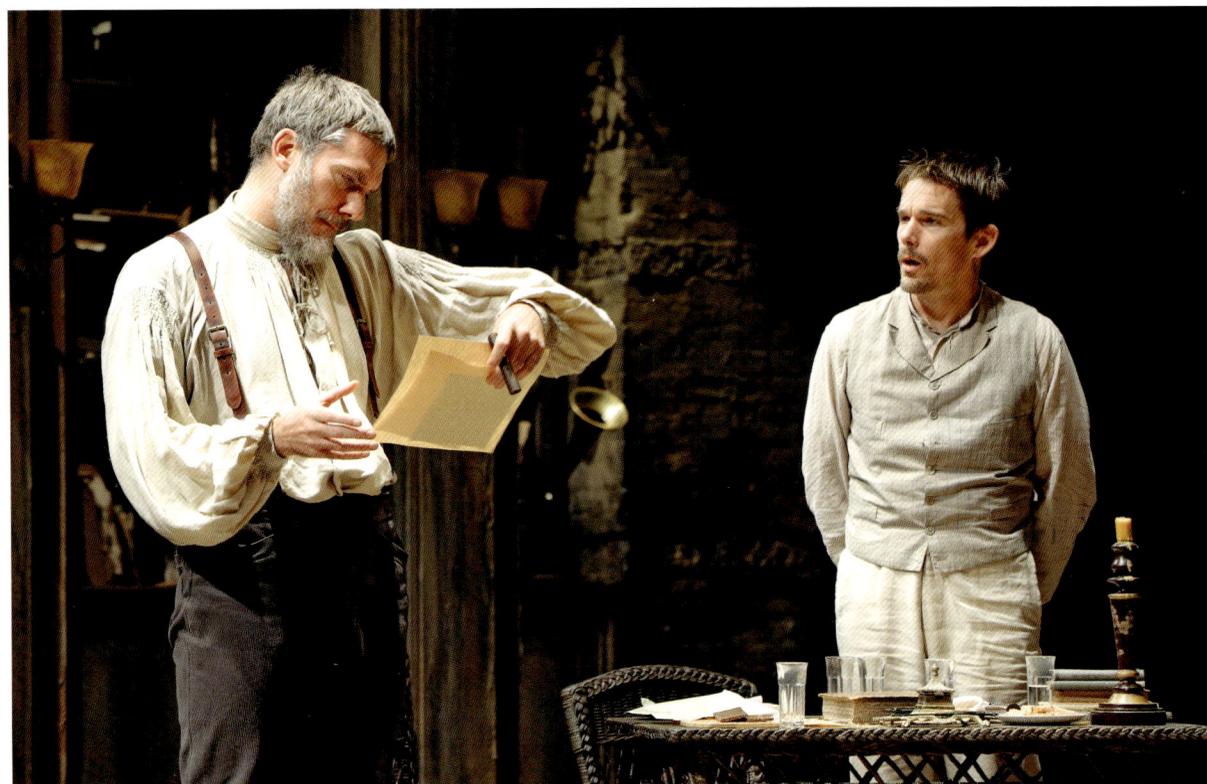

MARCO PIEMONTESE

Ivanov
by Anton Chekhov, 2012
Directed by Austin Pendleton

Glenn Fitzgerald and Ethan Hawke
Photo by Joan Marcus

ALESSANDRO LAI

Furioso Orlando. Ballata in ariostesche
rime per un cavalier narrante
based on Ludovico Ariosto, 2012
Directed by Marco Baliani

Stefano Accorsi and Nina Savary
Photo by Pino Le Pera / Nuovo Teatro

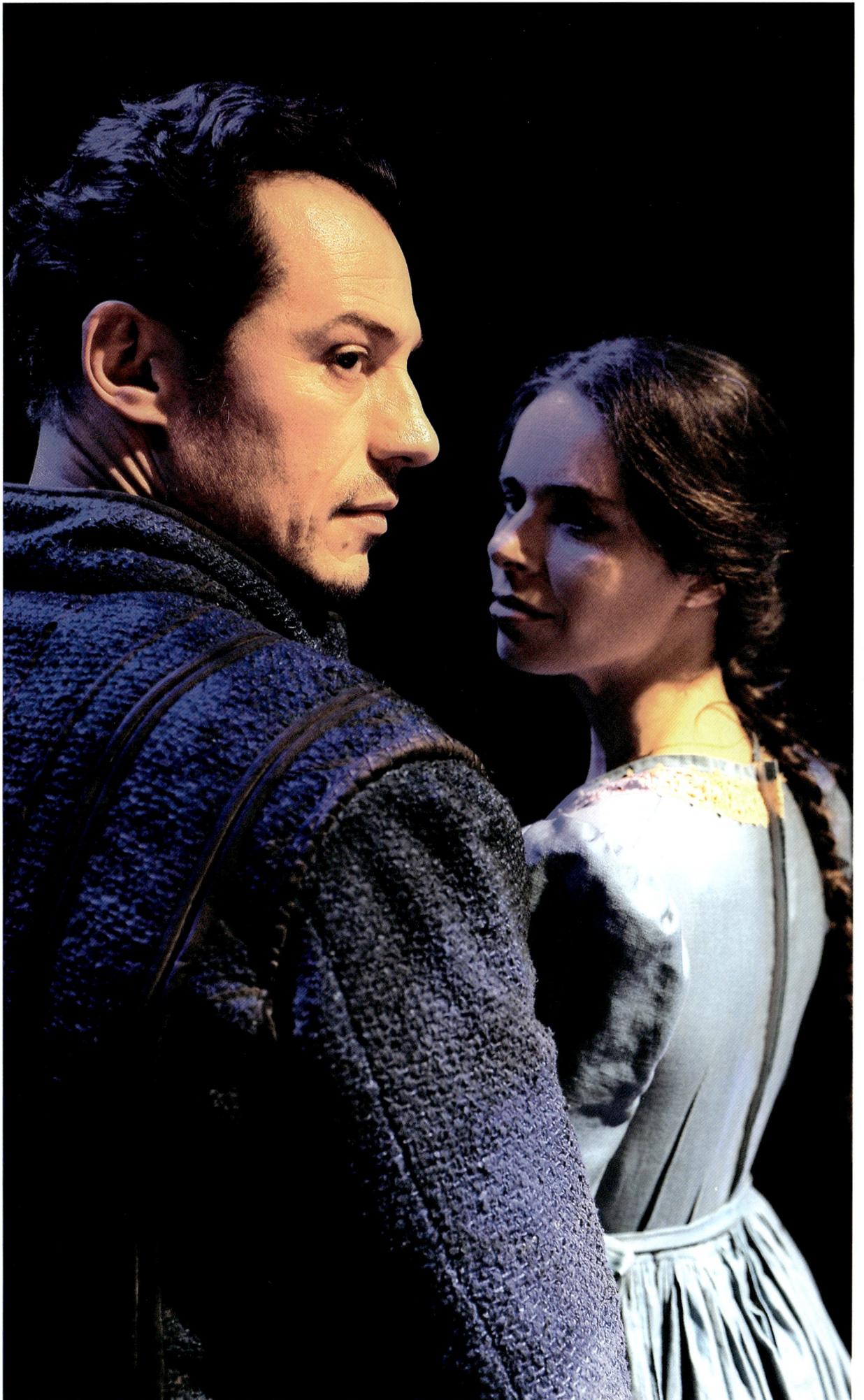

MAURIZIO MILLENOTTI

Circo Equestre Sgueglia
[Sgueglia Equestrian Circus]
by Raffaele Viviani, 2013
Directed by Alfredo Arias

Group scene on stage

Opposite, "the pasta procession"
Photos by Fiorenzo Niccoli

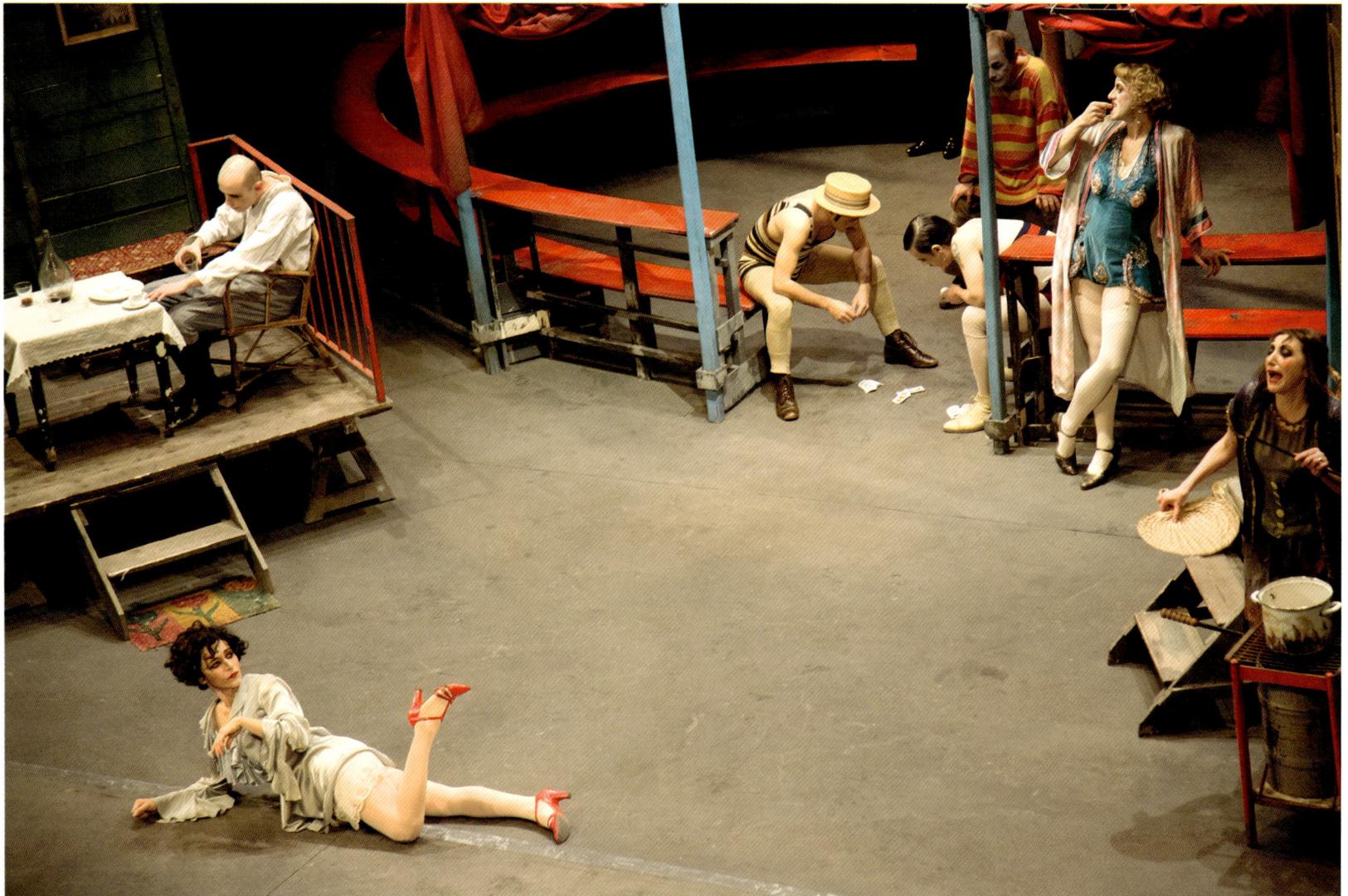

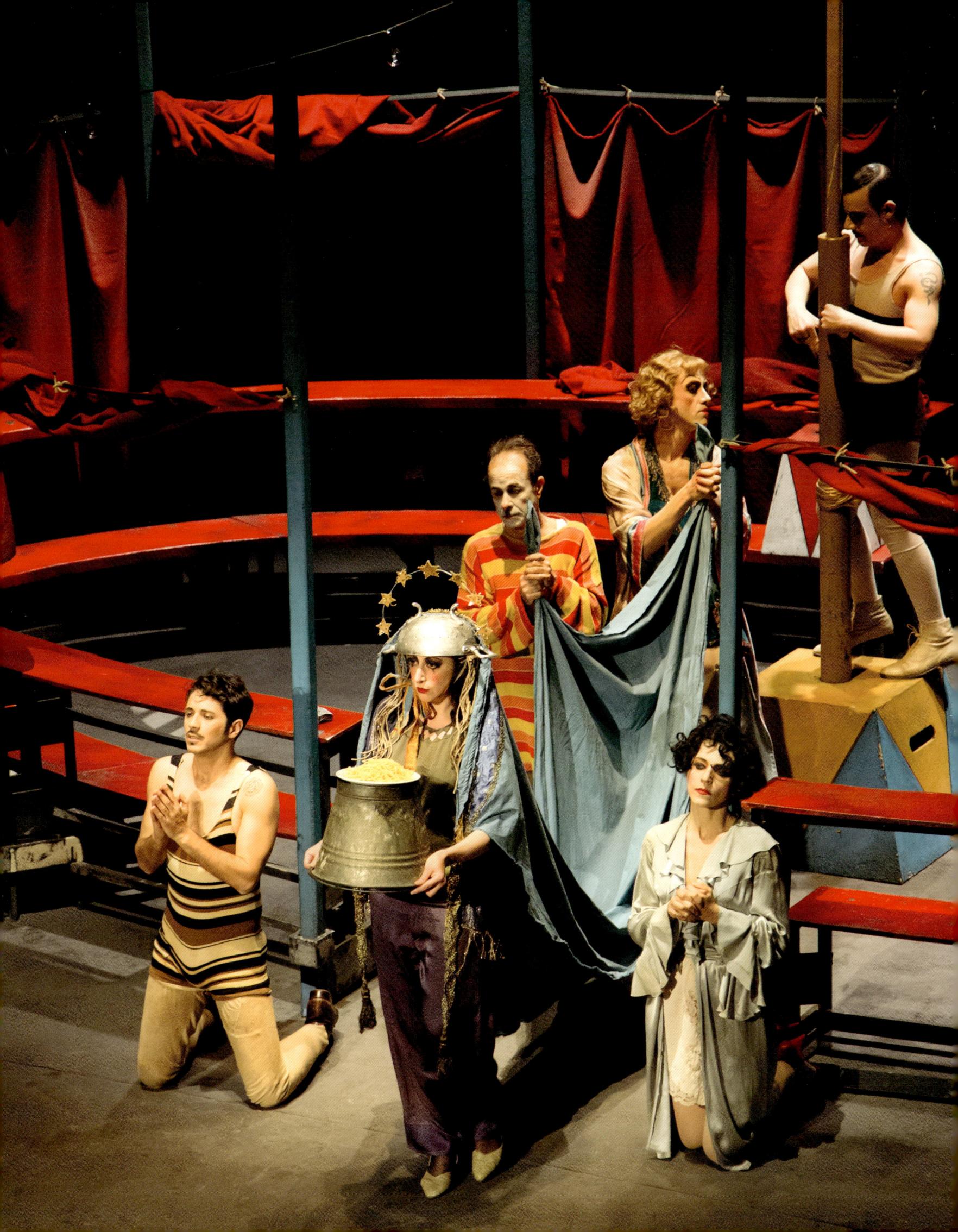

THEA

ATRE
MUSIC

ANNA ANNI

Tosca
by Giacomo Puccini, 1964
Directed by Mauro Bolognini

Studies for Tosca (Régine Crespin)

This was the first production for
which Sartoria Tirelli did the costumes

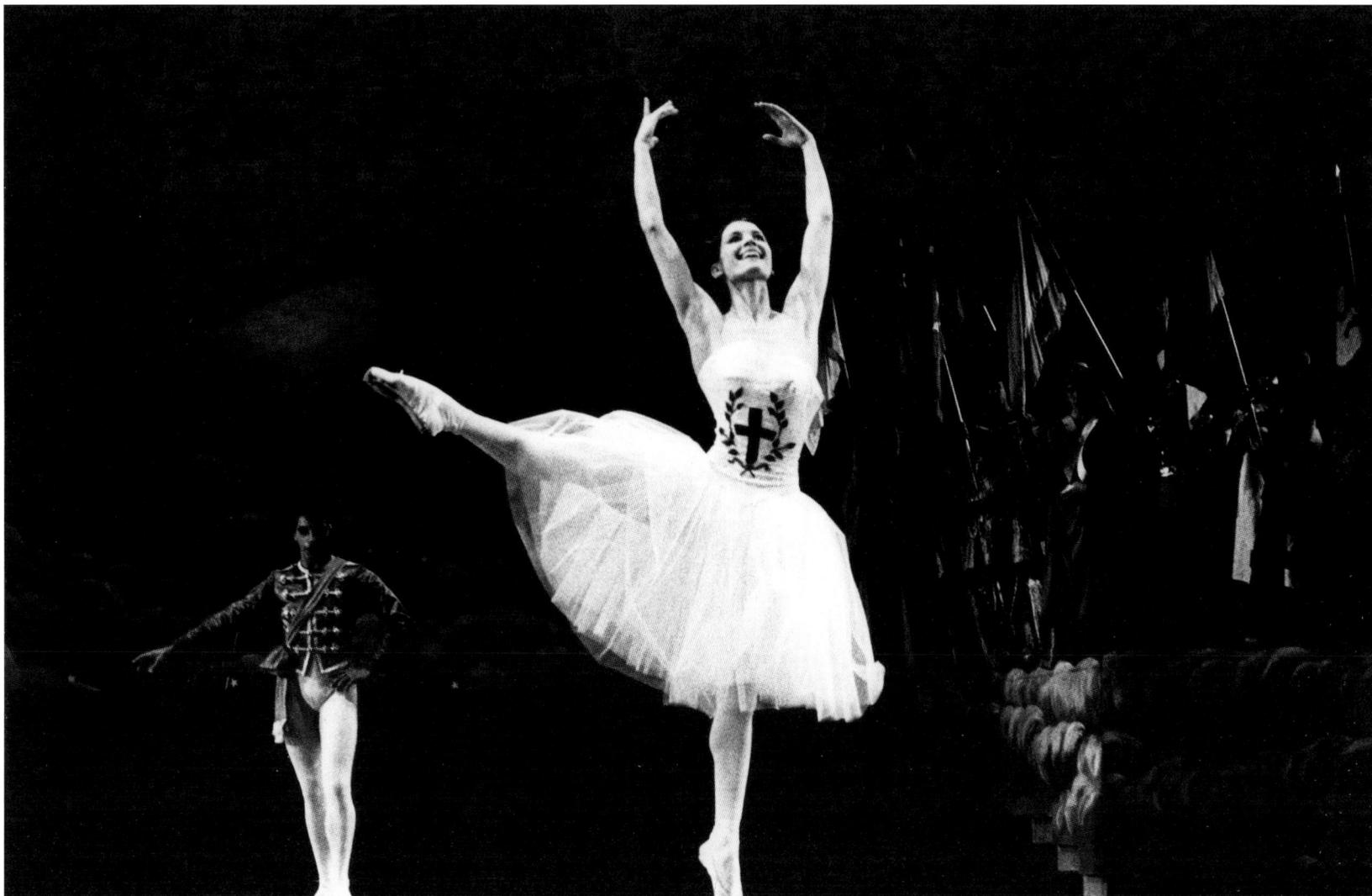

GIULIO COLTELLACCI

Excelsior
ballet mime by Luigi Manzotti with
score by Romualdo Marenco, 1968
Directed by Filippo Crivelli,
choreography by Ugo Dell'Ara

Carla Fracci

Right, Ludmilla Tchérina
Photo by Marchiori, Florence –
Florence, Teatro del Maggio Musicale
Fiorentino – Fondazione, Archivio
Fotografico Allestimento Scenico

**PIERO TOSI,
GABRIELLA PESCUCCI**

Manon Lescaut
by Giacomo Puccini, 1973
Directed by Luchino Visconti

Study by Piero Tosi for Des Grieux
(Harry Theyard)

Below, Nancy Shade
Photo by Lionello Fabbri

PIERO FAGGIONI

Don Quichotte
by Jules Massenet, 1982
Directed by Piero Faggioni

The production was staged in fifteen opera houses throughout the world. These images refer to the version performed at the Teatro di San Carlo in Naples in 1986

Ruggero Raimondi as Don Quixote, a role sung exclusively by him in the many productions of the opera from 1982 to 2003

Below, Pegasus carries Don Quixote through the sky to the realm of glory
Photos by Luciano Romano
Courtesy Teatro di San Carlo –
Archivio Storico del Teatro
di San Carlo, Naples

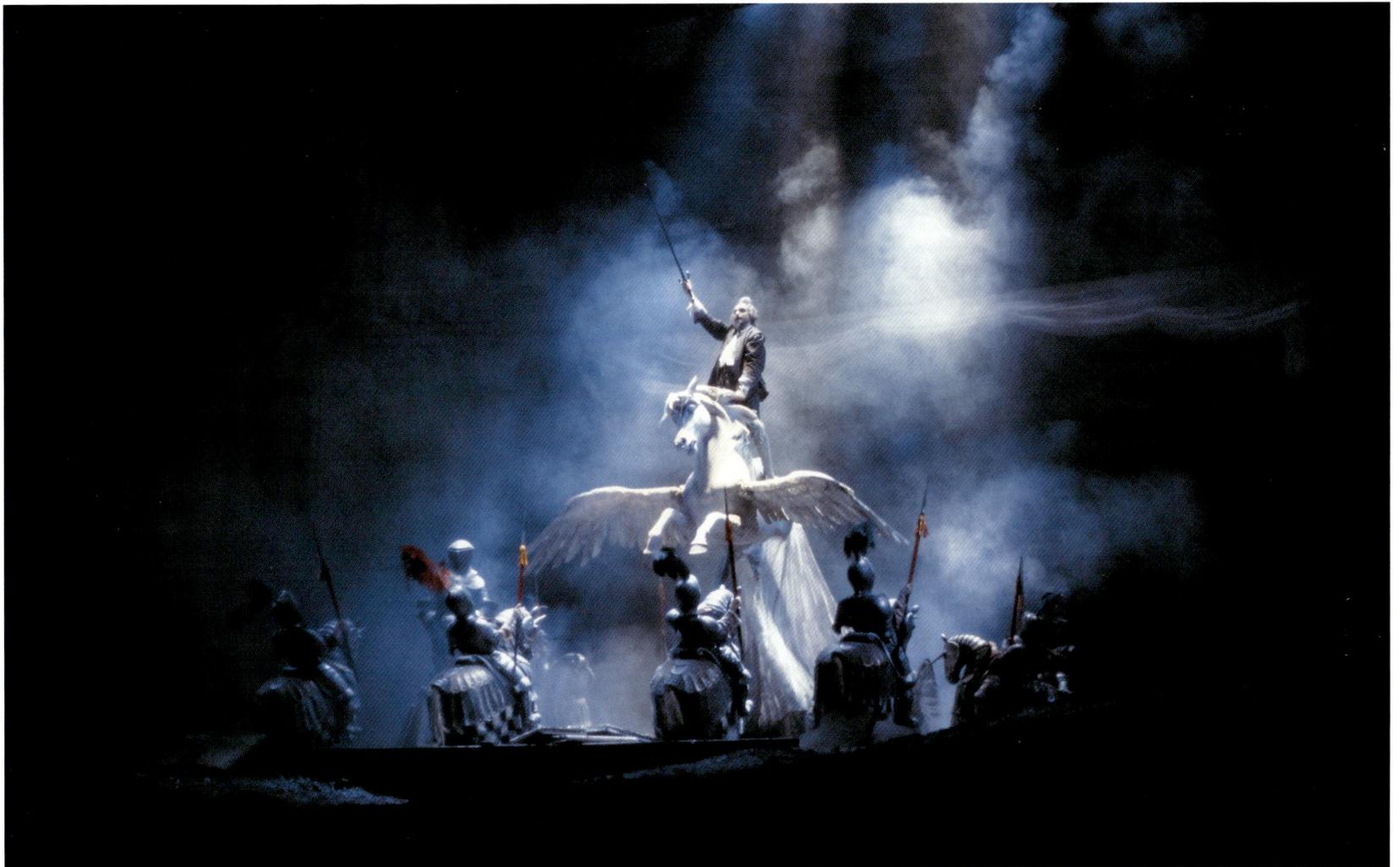

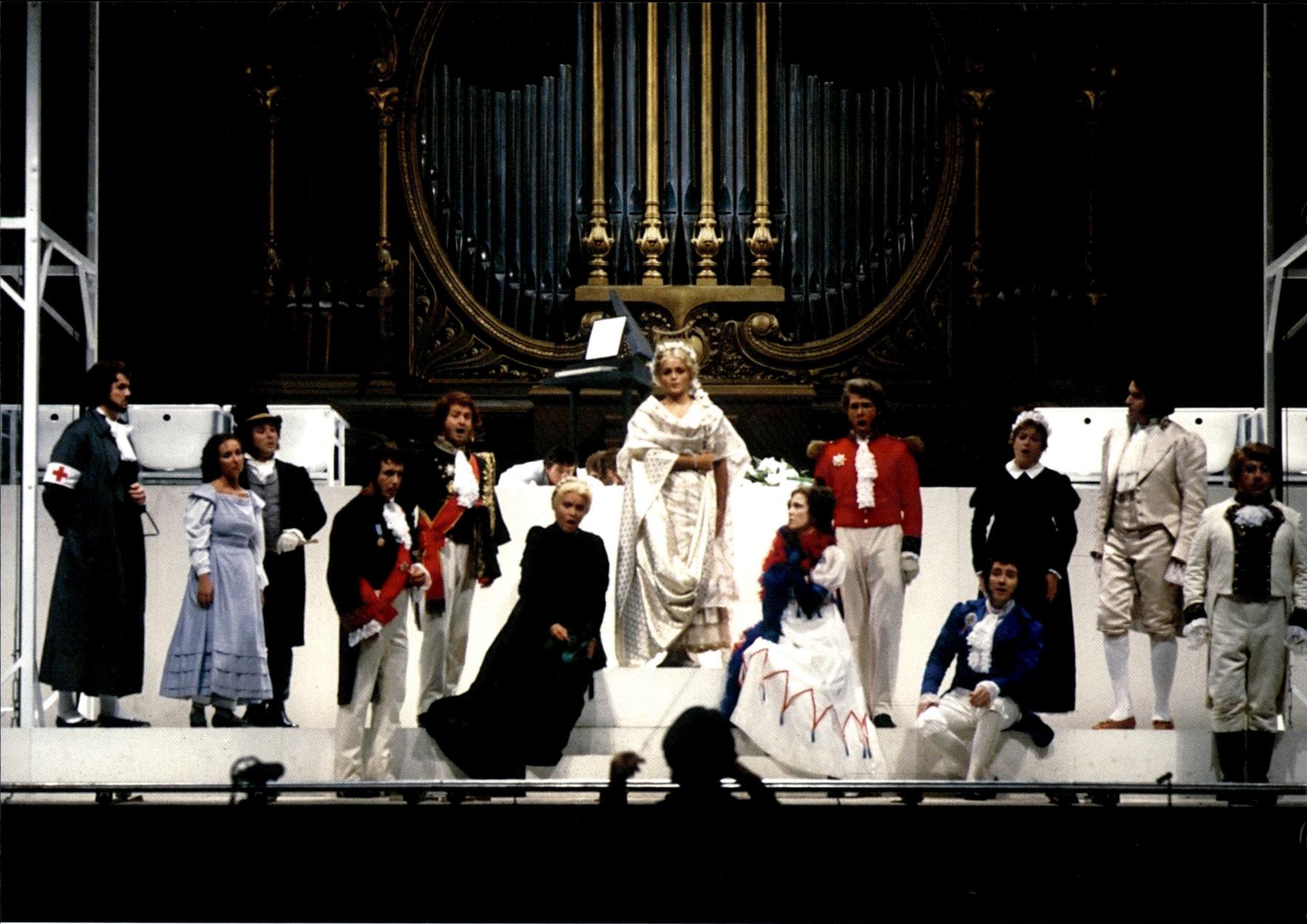

GAE AULENTI

Il viaggio a Reims
[The Journey to Reims]
by Gioachino Rossini, 1984
Directed by Luca Ronconi

We recognize: Antonella Bandelli,
Lucia Valentini Terrani, Cecilia
Gasdia, Lella Cuberli, Samuel Ramey,
Edoardo Gimenez, Bernadette Manca
di Nissa, Ruggero Raimondi
and Enzo Dara
Photo by Studio Ambrosini
di Roberto Angelotti

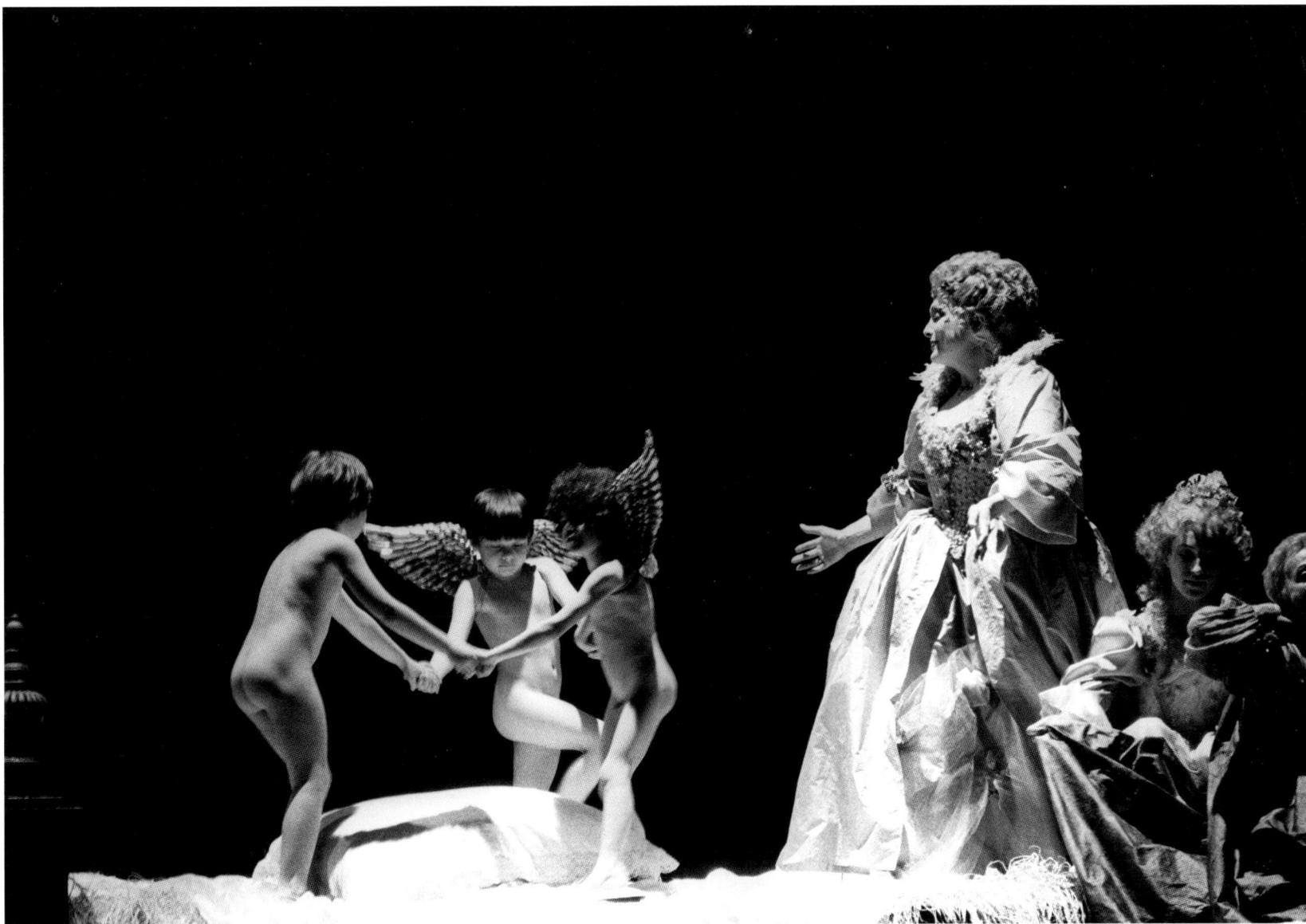

CARLO DIAPPI

Orfeo
by Luigi Rossi, 1985
Directed by Luca Ronconi

Gina Longobardo

Right, Rita Talarico
Photos by Lelli and Masotti
© Teatro alla Scala

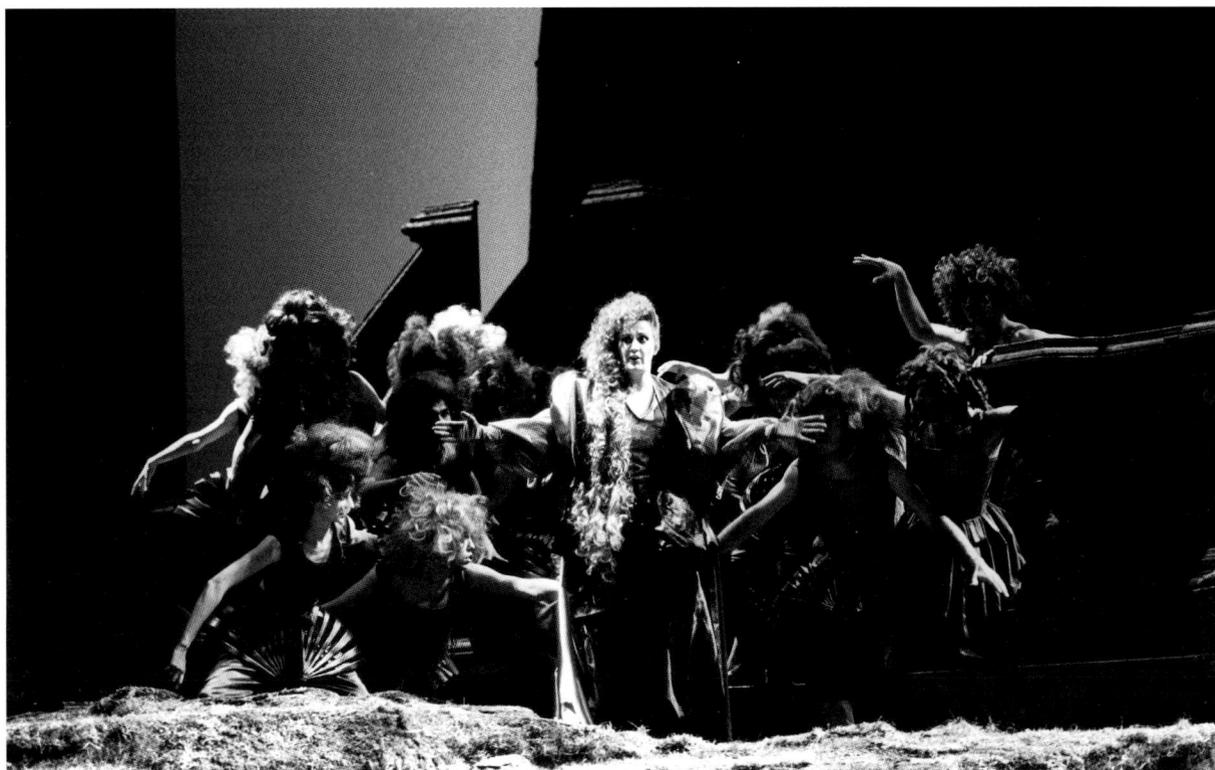

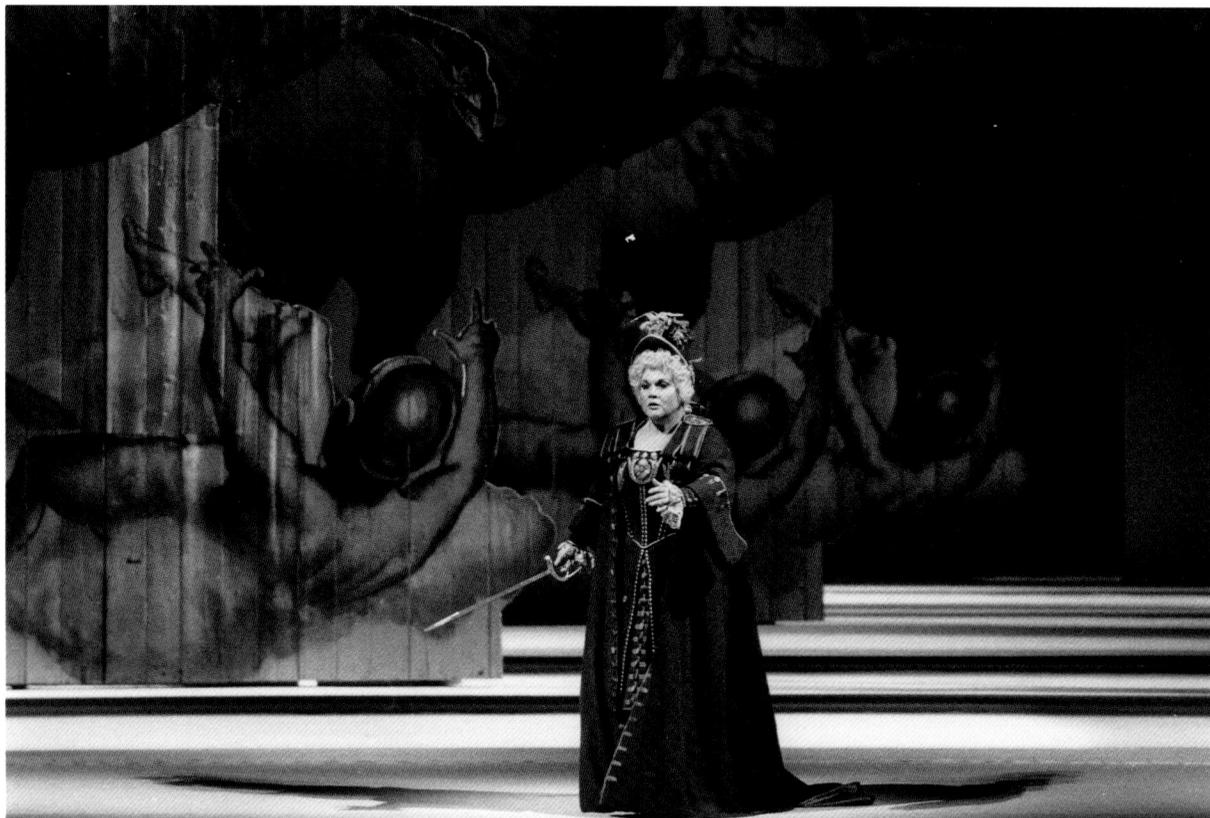

PASQUALE GROSSI

Orlando
by George Frideric Handel, 1985
Directed by Virginio Puecher

Marilyn Horne

Below, Lella Cuberli
Photos by G. Arici and M. Smith –
Archivio Storico del Teatro La Fenice

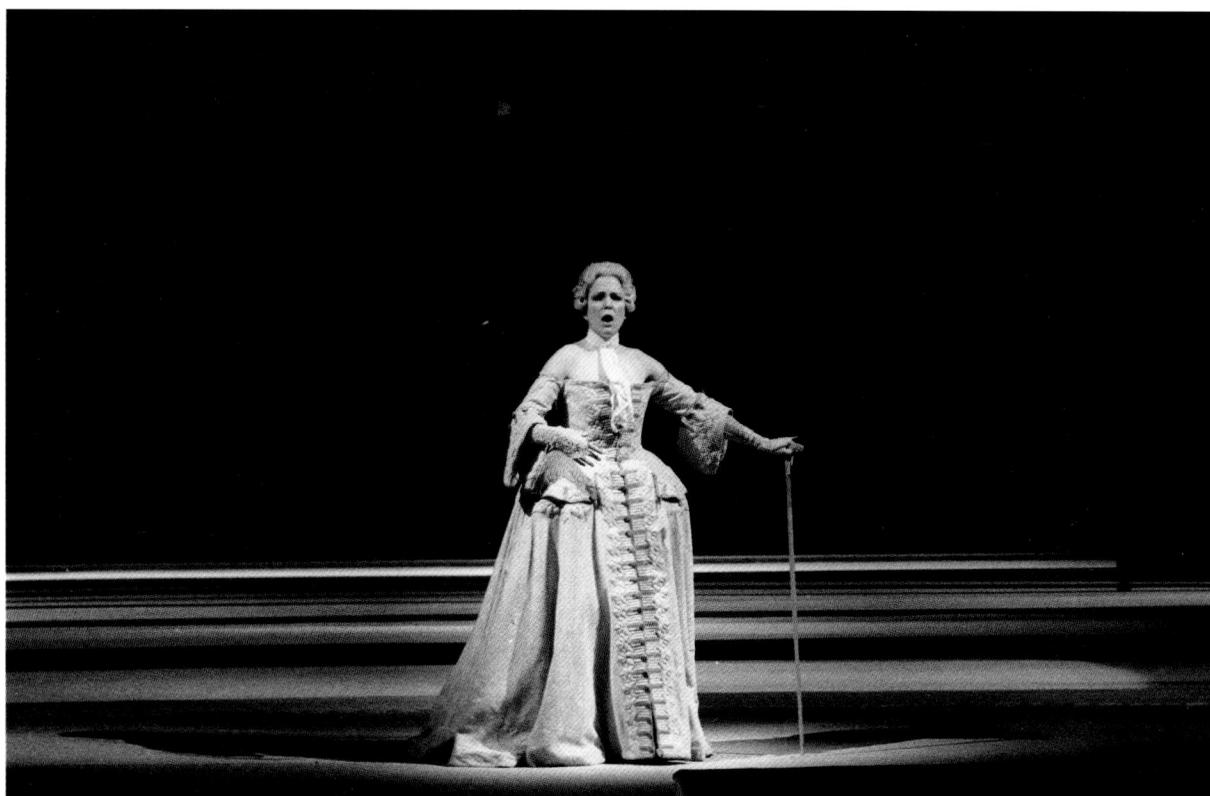

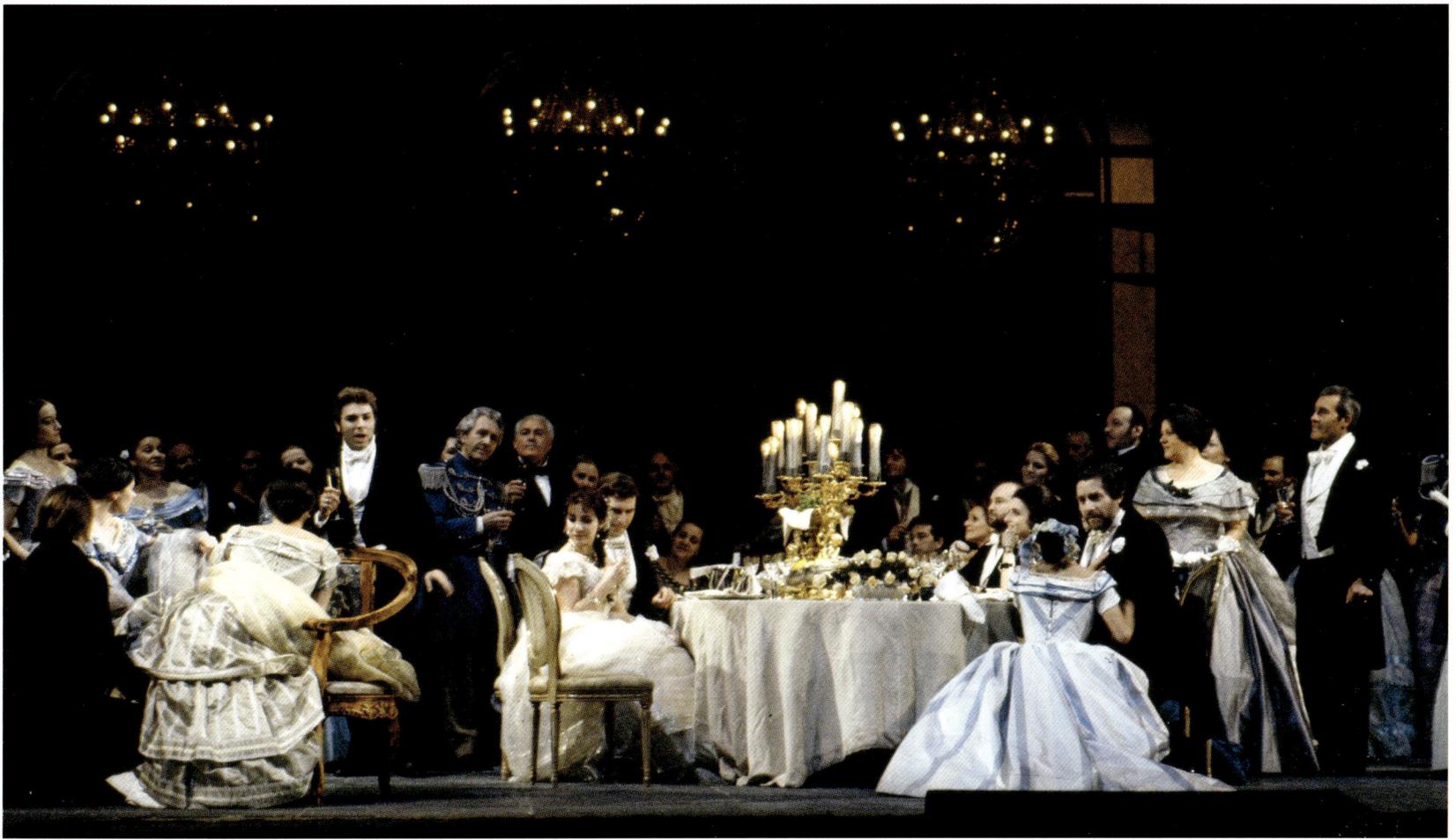

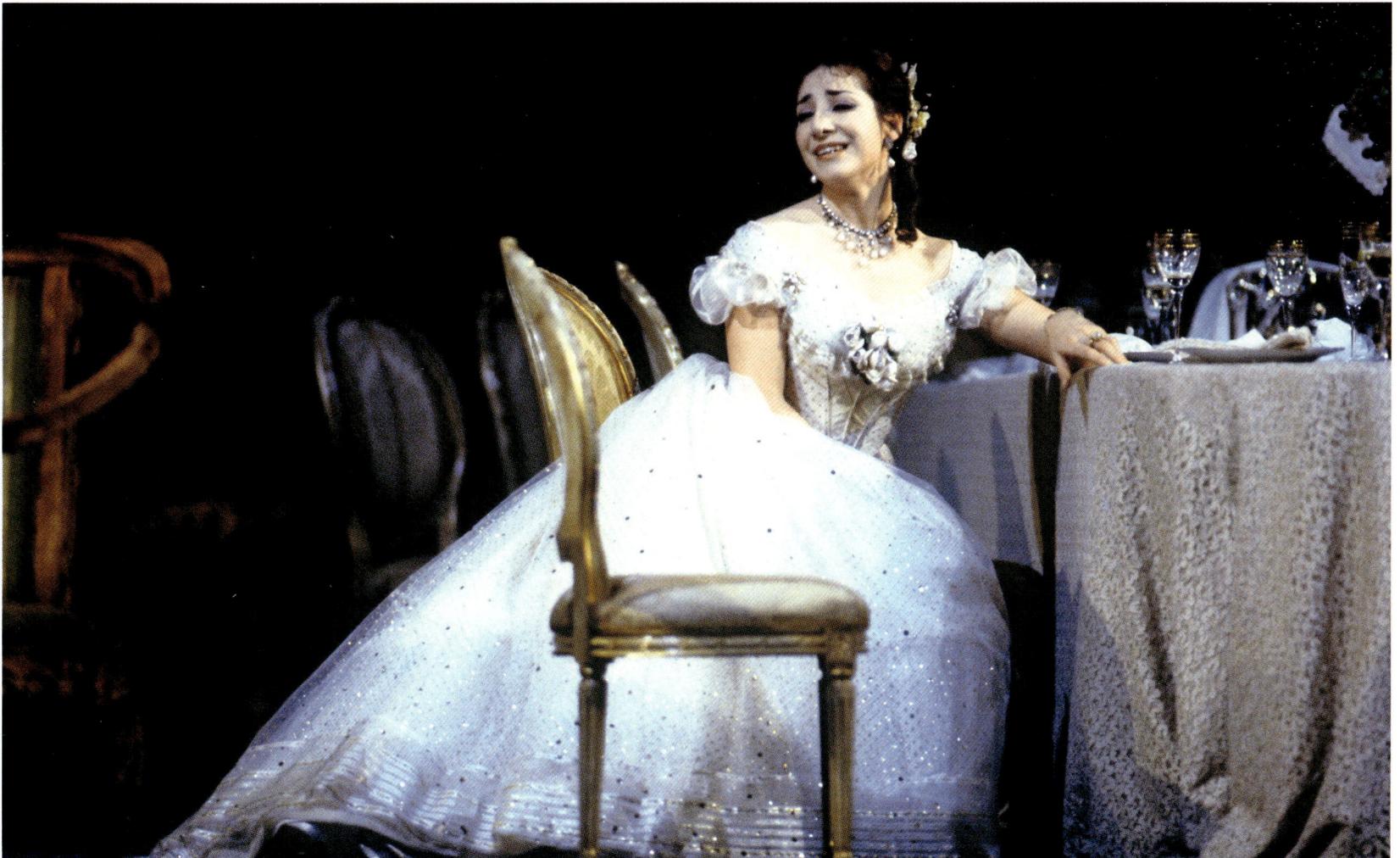

YVONNE SASSINOT DE NESLE

Carmen
by Georges Bizet, 1988
Directed by Claude d'Anna

Study for Carmen
(Lucia Valentini Terrani)

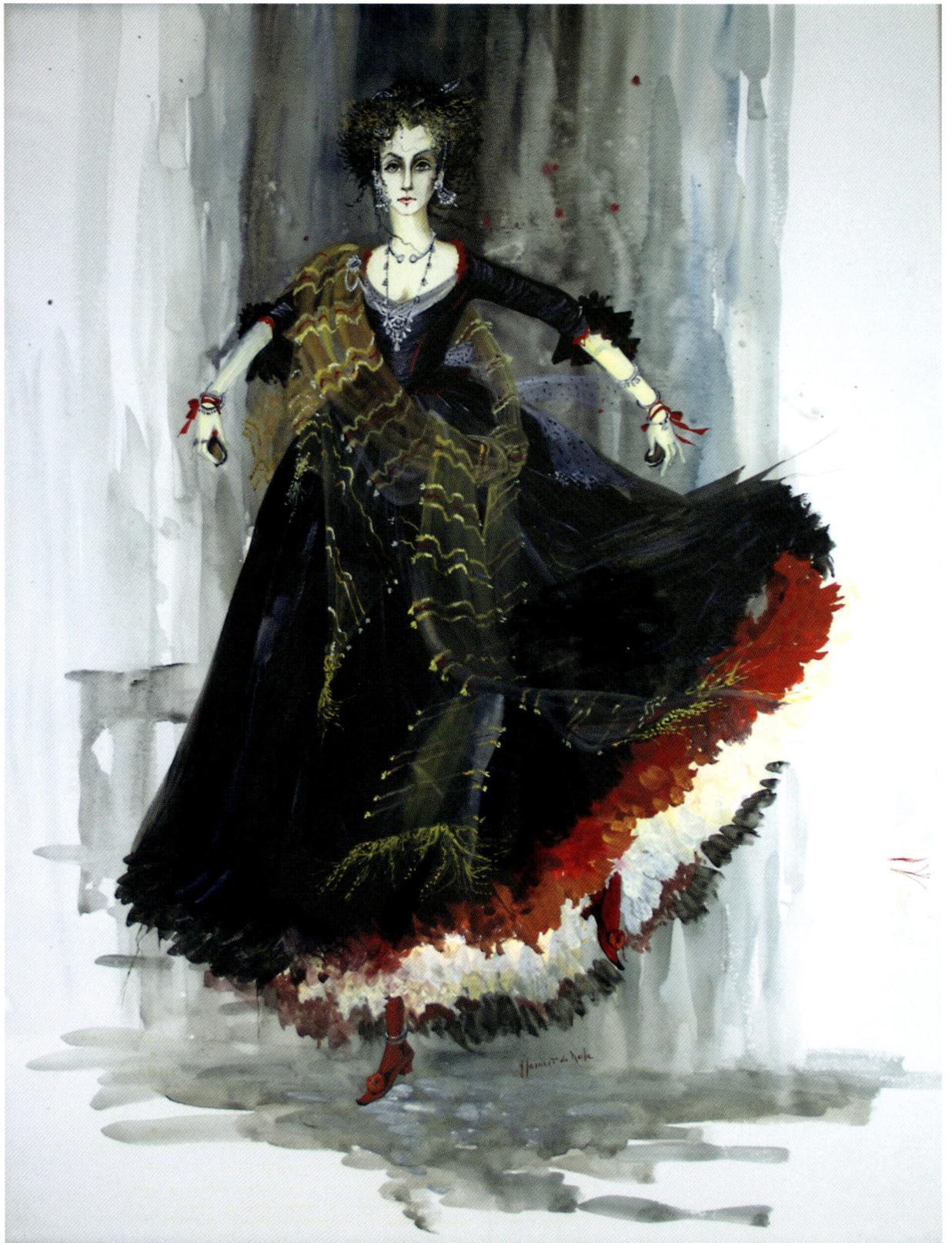

Souvenir de Léningrad
ballet by François Weyergans
Music by Pyotr Ilyich Tchaikovsky
and The Residents, 1987
Choreography by Maurice Béjart

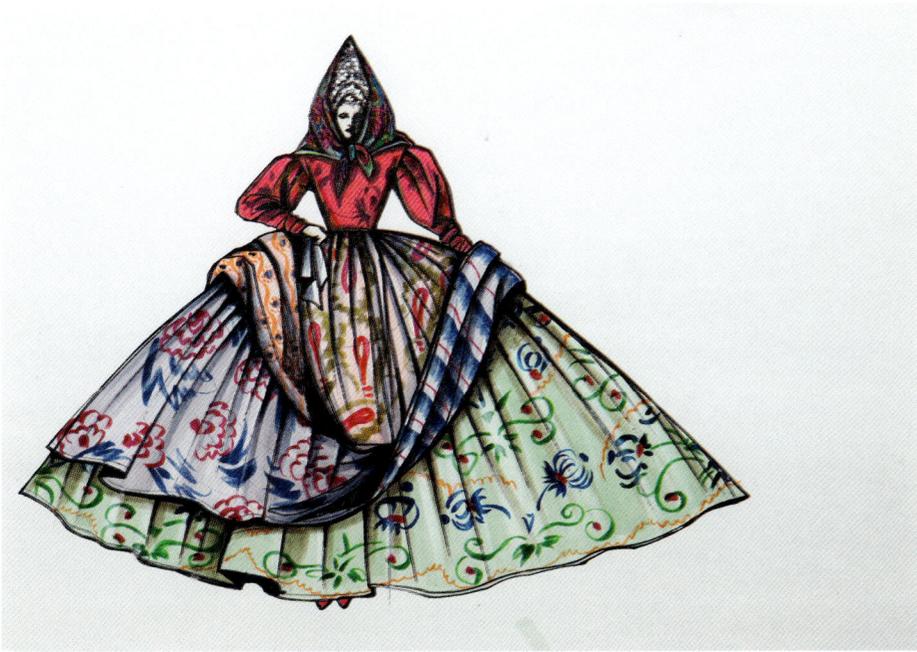

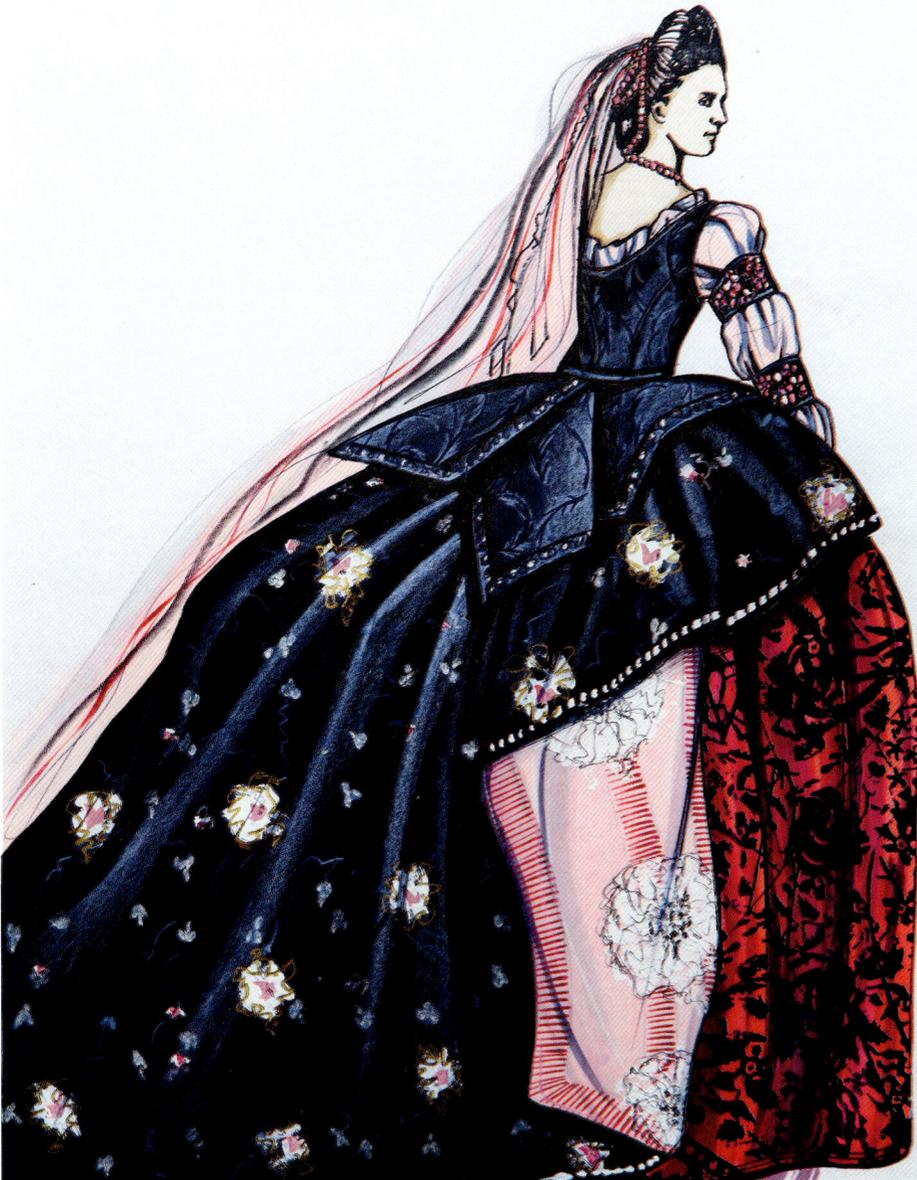

Costume sketches

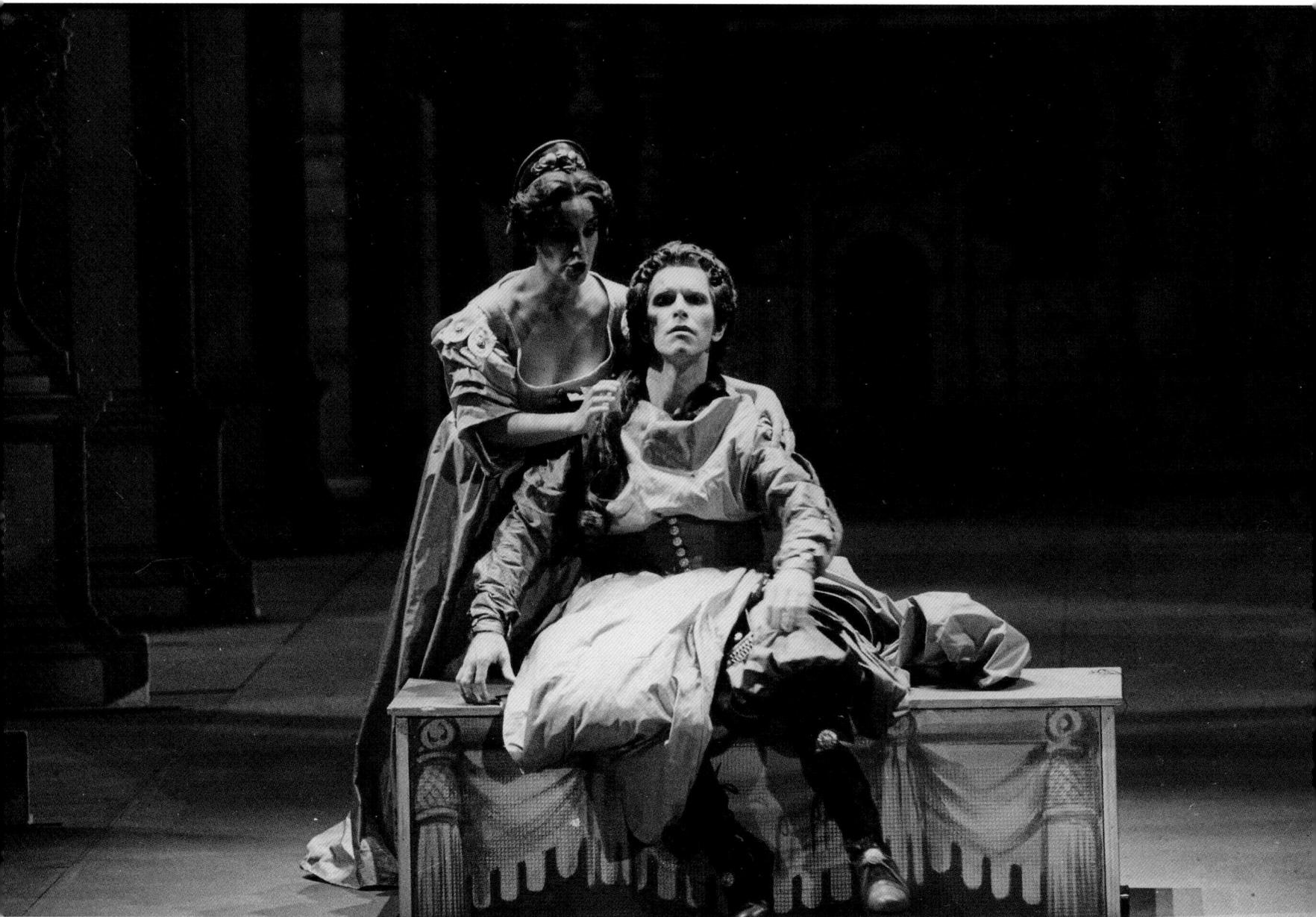

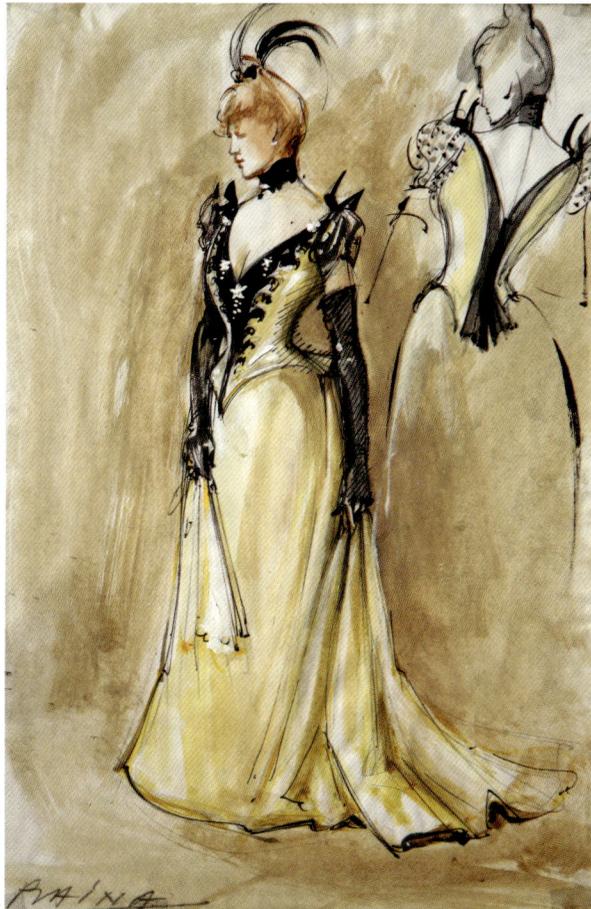

Opposite

GABRIELLA PESCUCCI

La traviata
by Giuseppe Verdi, 1990
Directed by Liliana Cavani

Roberto Alagna
and Tiziana Fabbricini

Below, Tiziana Fabbricini
Photos by Lelli and Masotti
© Teatro alla Scala

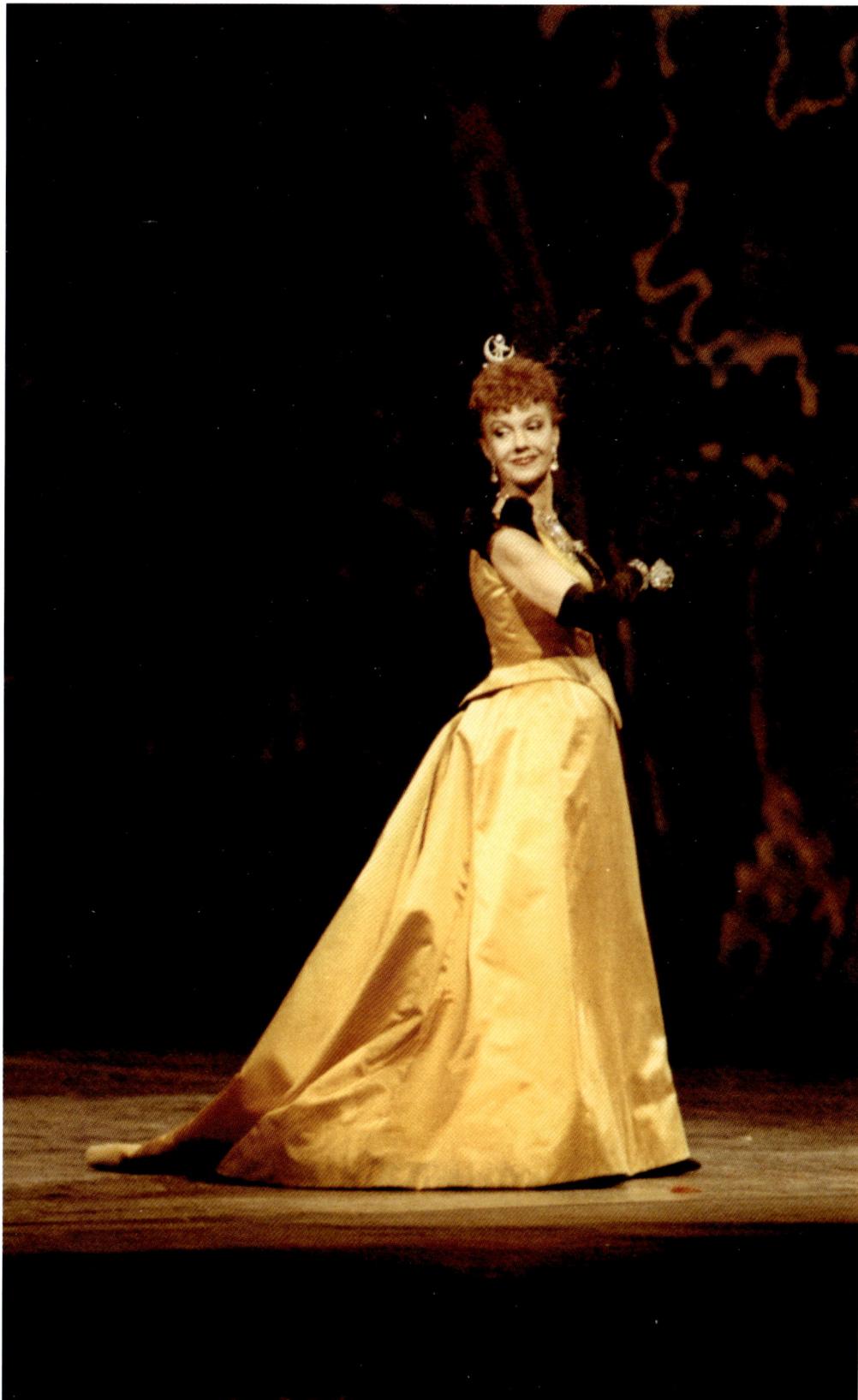

PIERO TOSI

La vedova allegra [The Merry Widow]
by Franz Lehár, 1985
Directed by Mauro Bolognini

Study for Hanna (Raina Kabaivanska)

Right, Raina Kabaivanska
Photo by Luciano Romano
Courtesy Teatro di San Carlo –
Archivio Storico del Teatro
di San Carlo, Naples

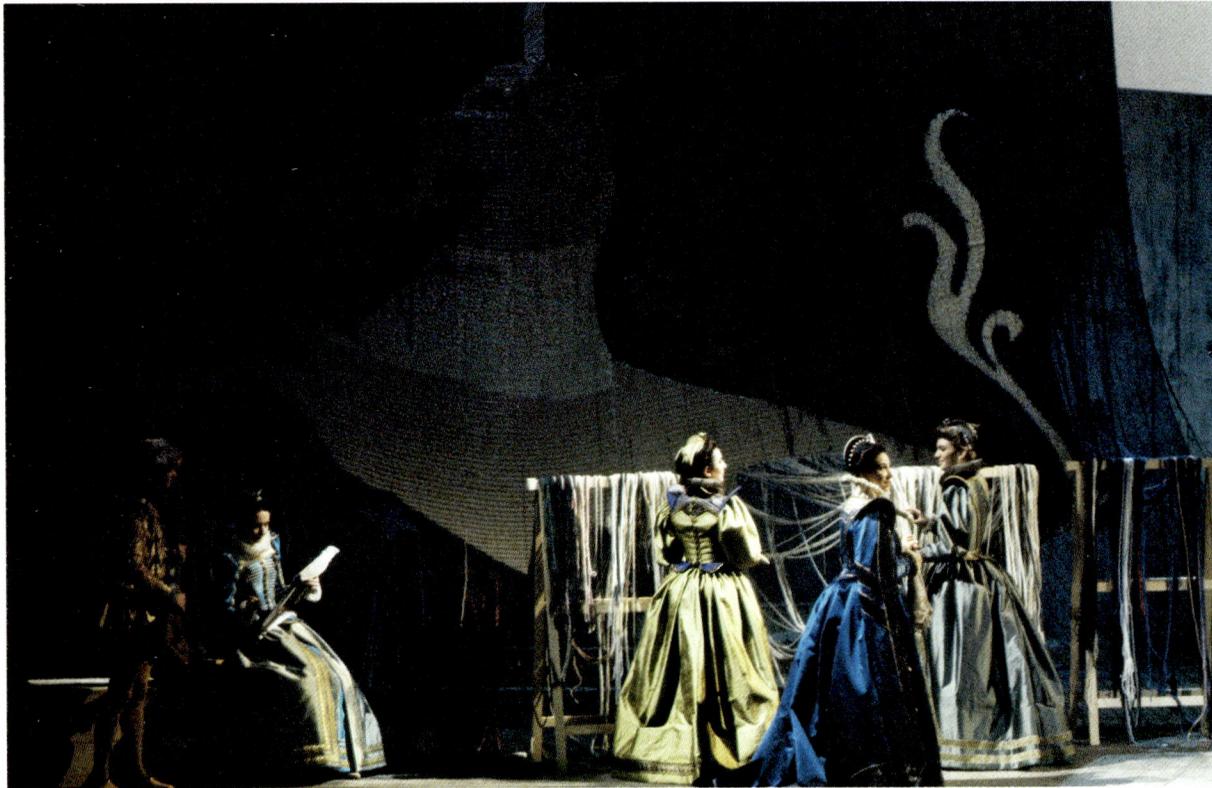

PIERO TOSI

Don Carlo
by Giuseppe Verdi, 1991
Directed by Mauro Bolognini

Giovanna Casolla

Below, Michael Sylvester,
Samuel Ramey and Daniela Dessì

Opposite, Raina Kabaivanska, photo
with dedication to the Sartoria
Photos by Fiorenzo Niccoli

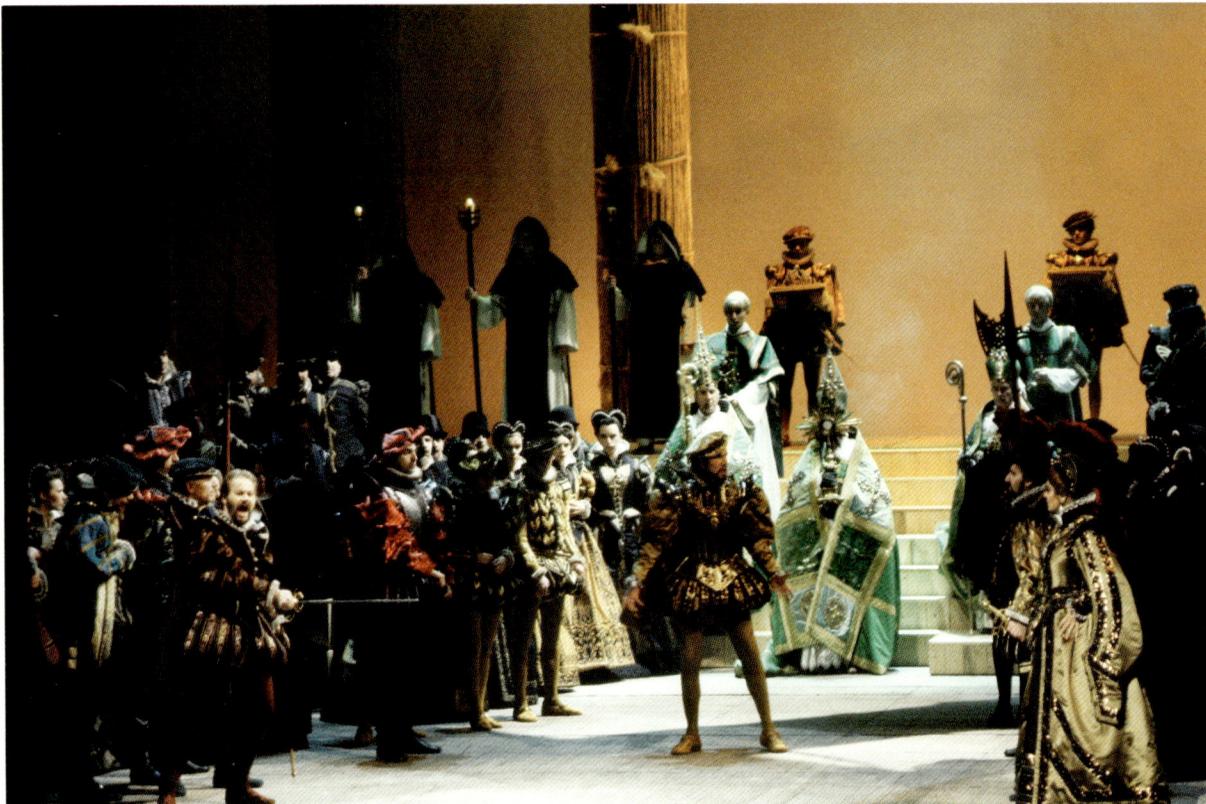

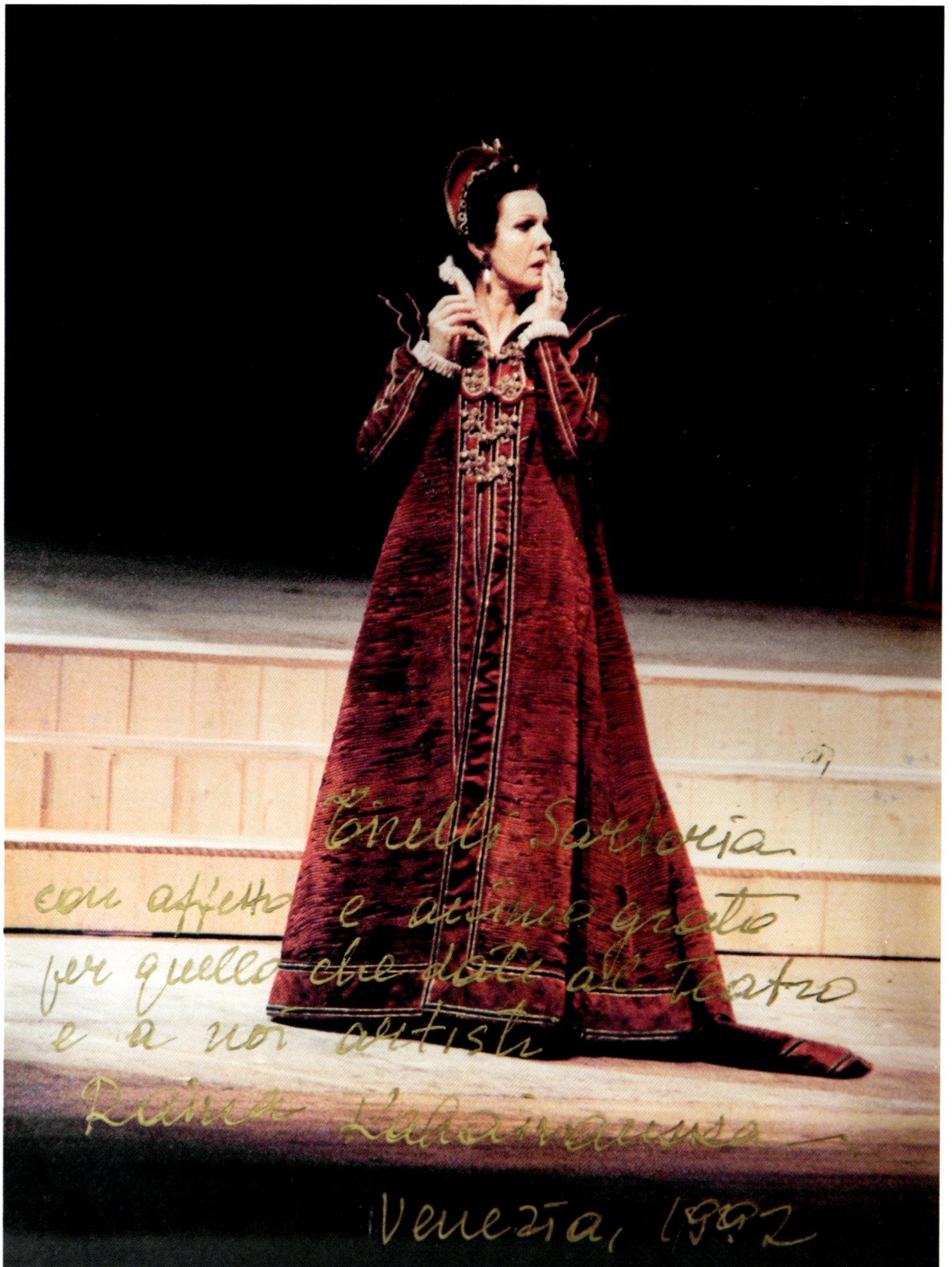

Tirelli Sartoria
con affetto e animo grato
per quello che date al teatro
e a noi artisti
Raina Kabaiwanska

Venezia, 1992

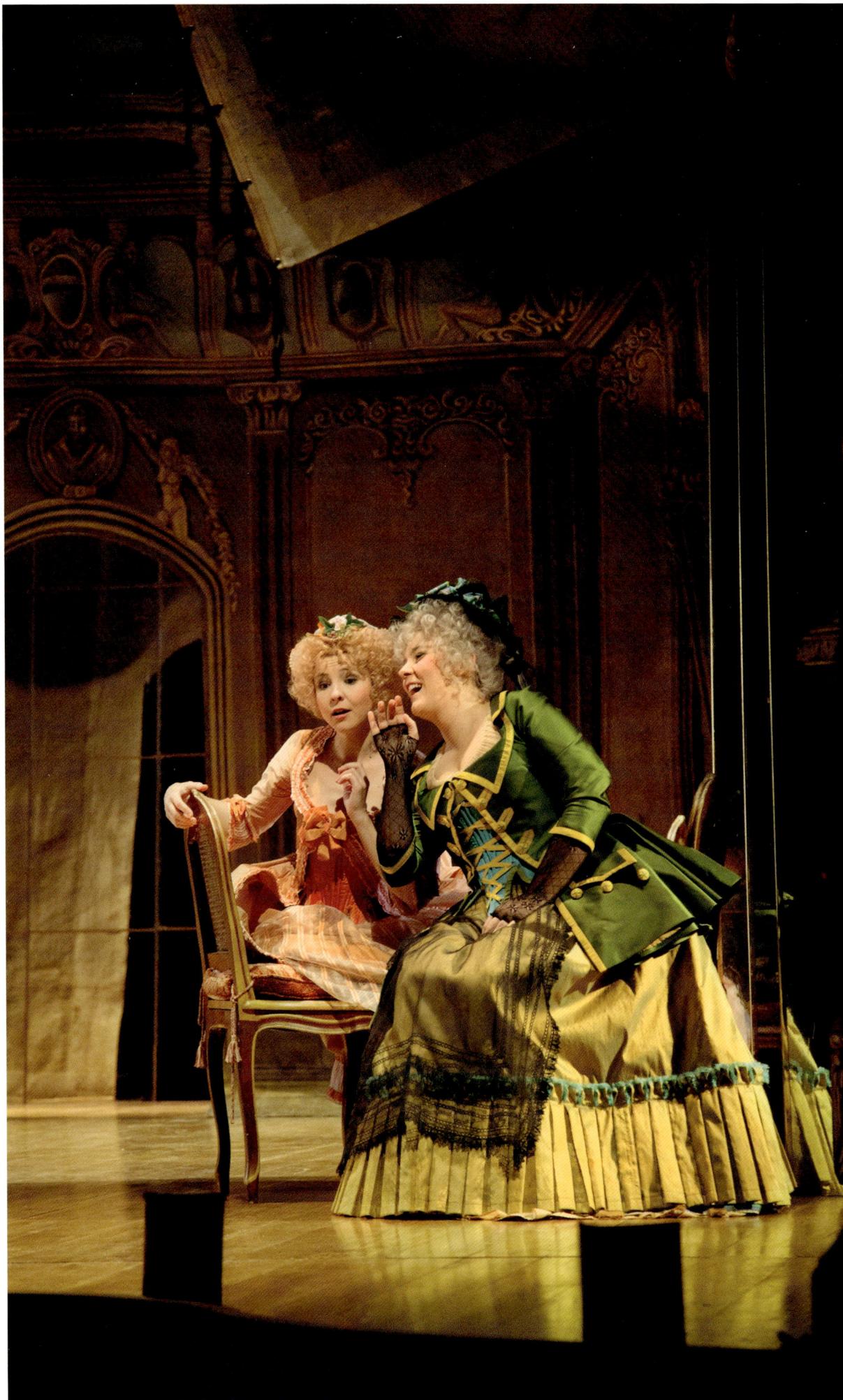

PIERO TOSI

Il matrimonio segreto
[The Secret Marriage]
by Domenico Cimarosa, 2013
Directed by Quirino Conti

Valentina Farcas and Teresa Iervolino
Photo by Fiorenzo Niccoli

ALESSANDRO LAI

La traviata
by Giuseppe Verdi, 2012
Directed by Ferzan Ozpetek

Carmen Giannattasio
Photo by Luciano Romano
Courtesy Teatro di San Carlo –
Archivio Storico del Teatro
di San Carlo, Naples

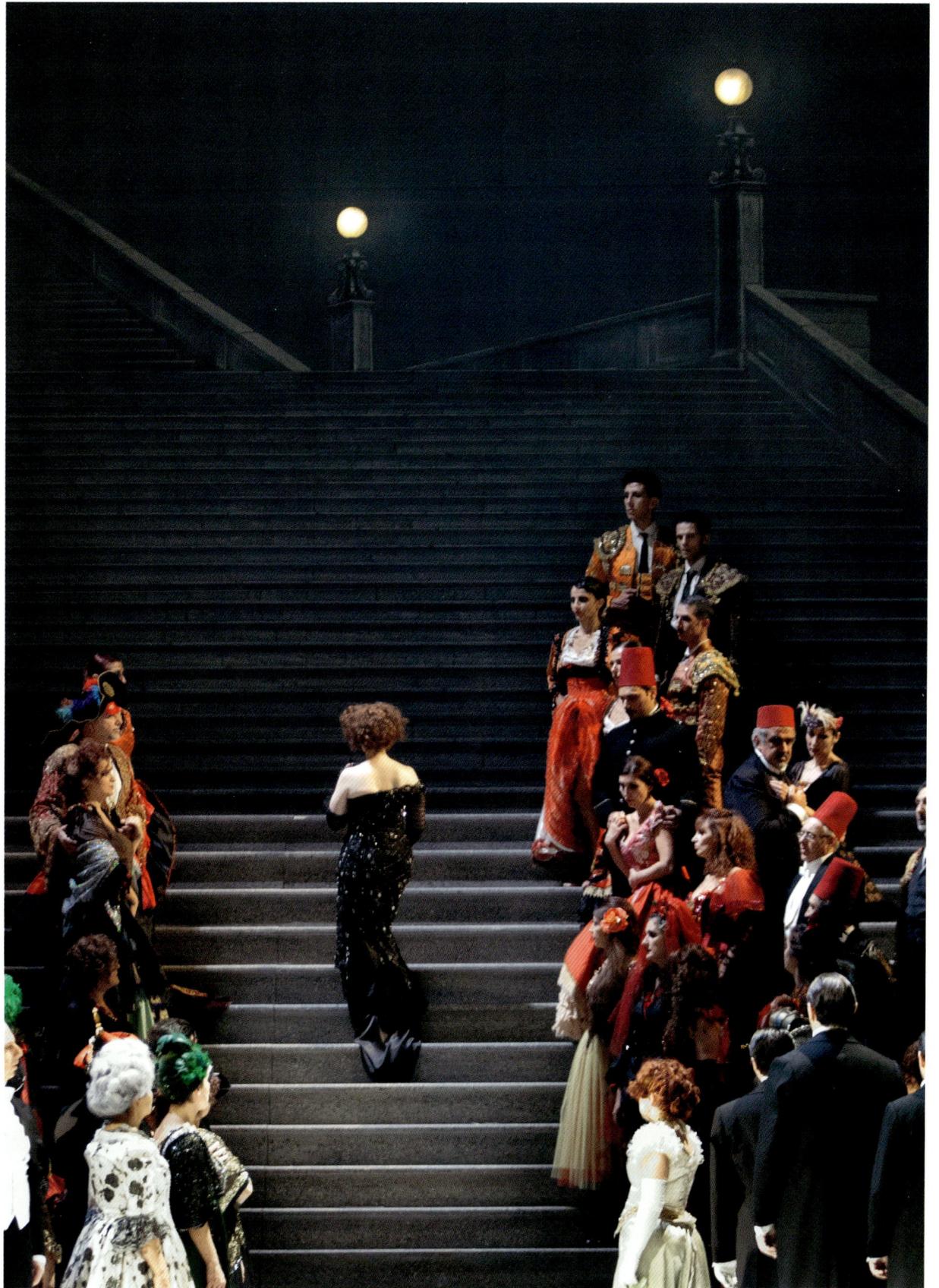

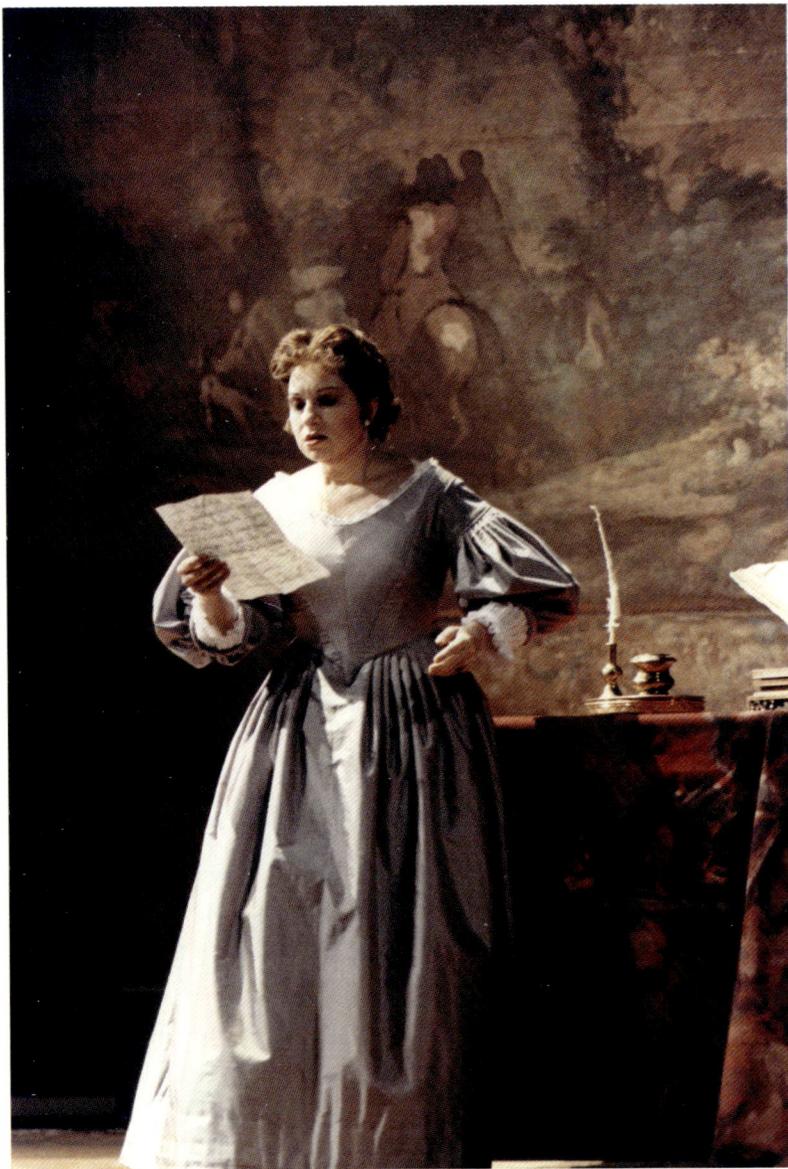

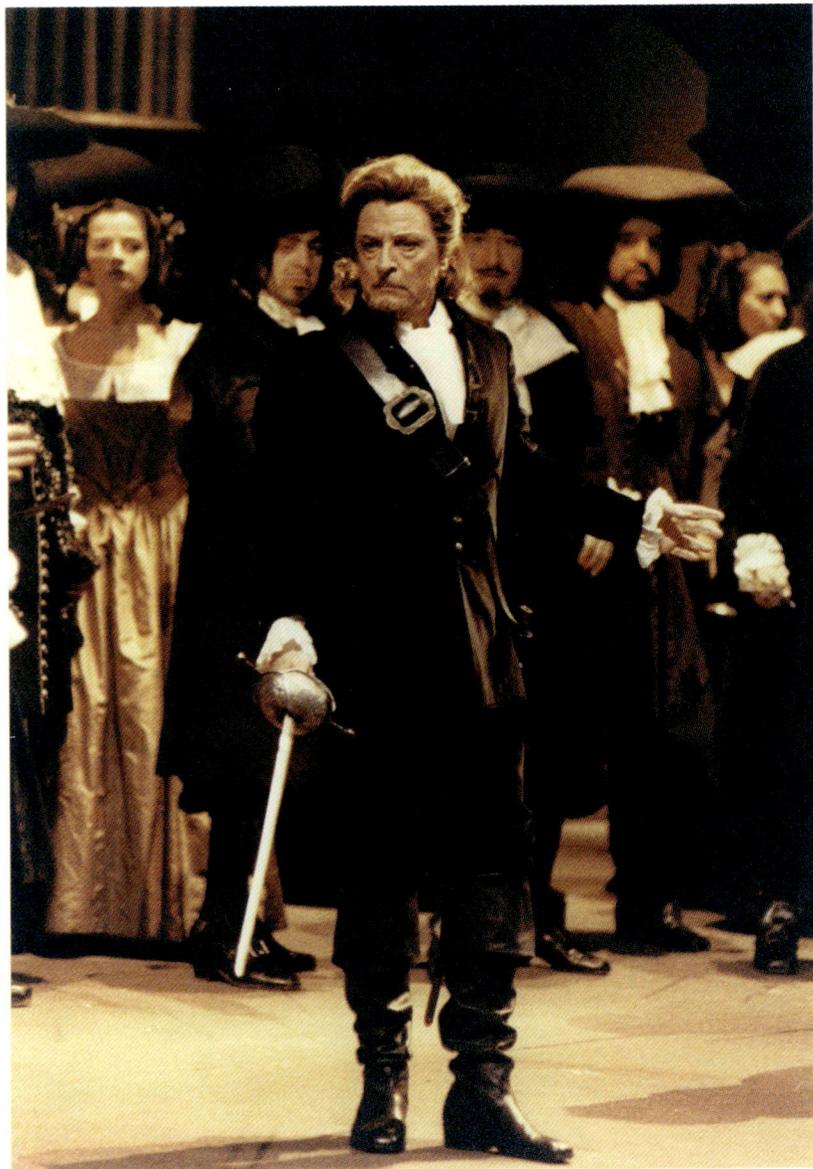

CLAUDIE GASTINE

Lucia di Lammermoor
by Gaetano Donizetti, 1992
Directed by Gian Carlo Menotti

Mariella Devia

Right, Alfredo Kraus
Photos by Corrado Falsini
Courtesy Fondazione Teatro
dell'Opera di Roma – Archivio Storico

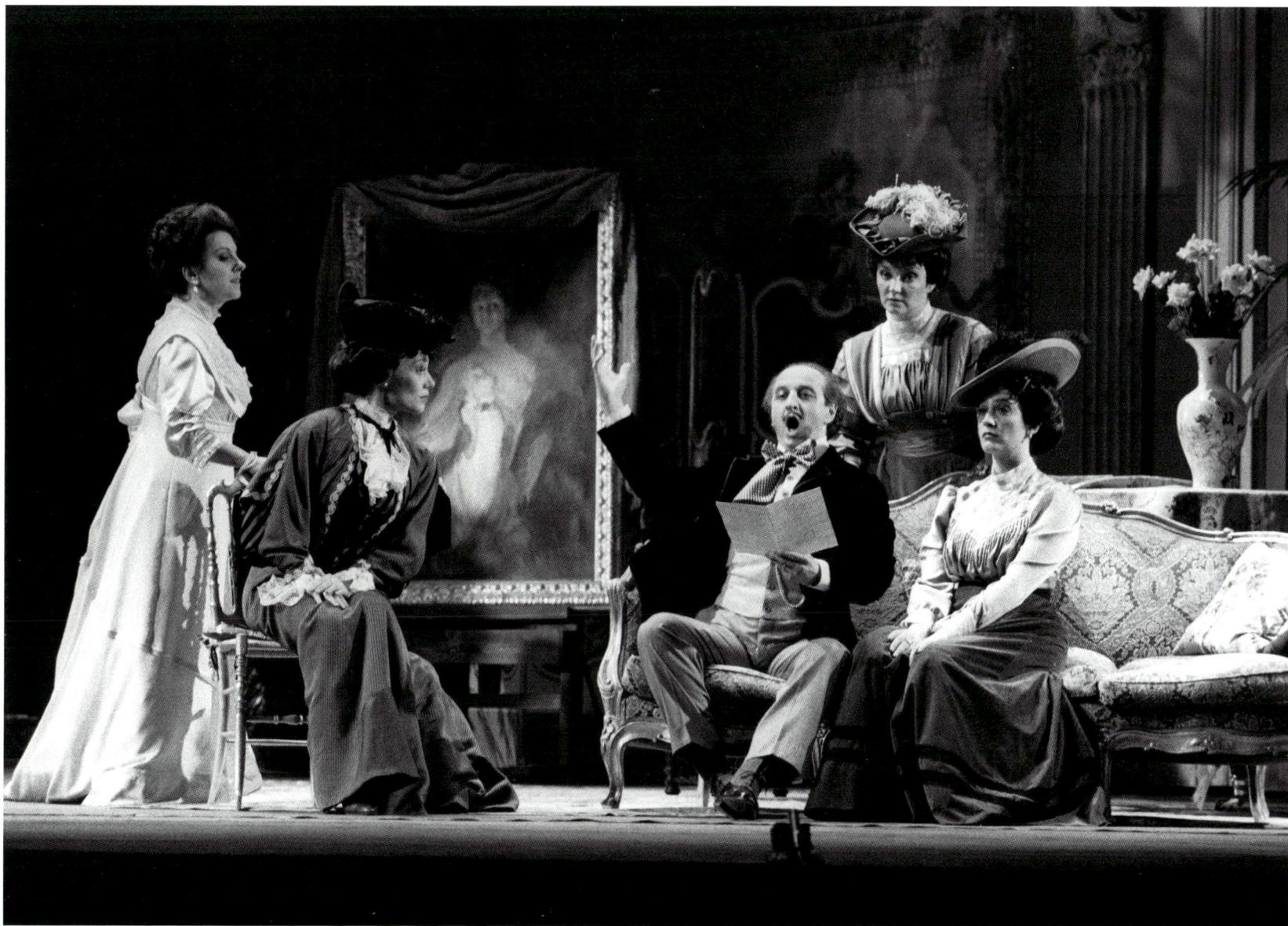

CLAUDIE GASTINE

La rondine [The Swallow]
by Giacomo Puccini, 1994
Directed by Nicolas Joel

Denia Mazzola Gavazzeni, Claudia
Nicole Bandera, Paolo Barbacini,
Elisabetta Battaglia and Anna Catarci
Photo by Lelli and Masotti
© Teatro alla Scala

Right, study for the characters'
costumes

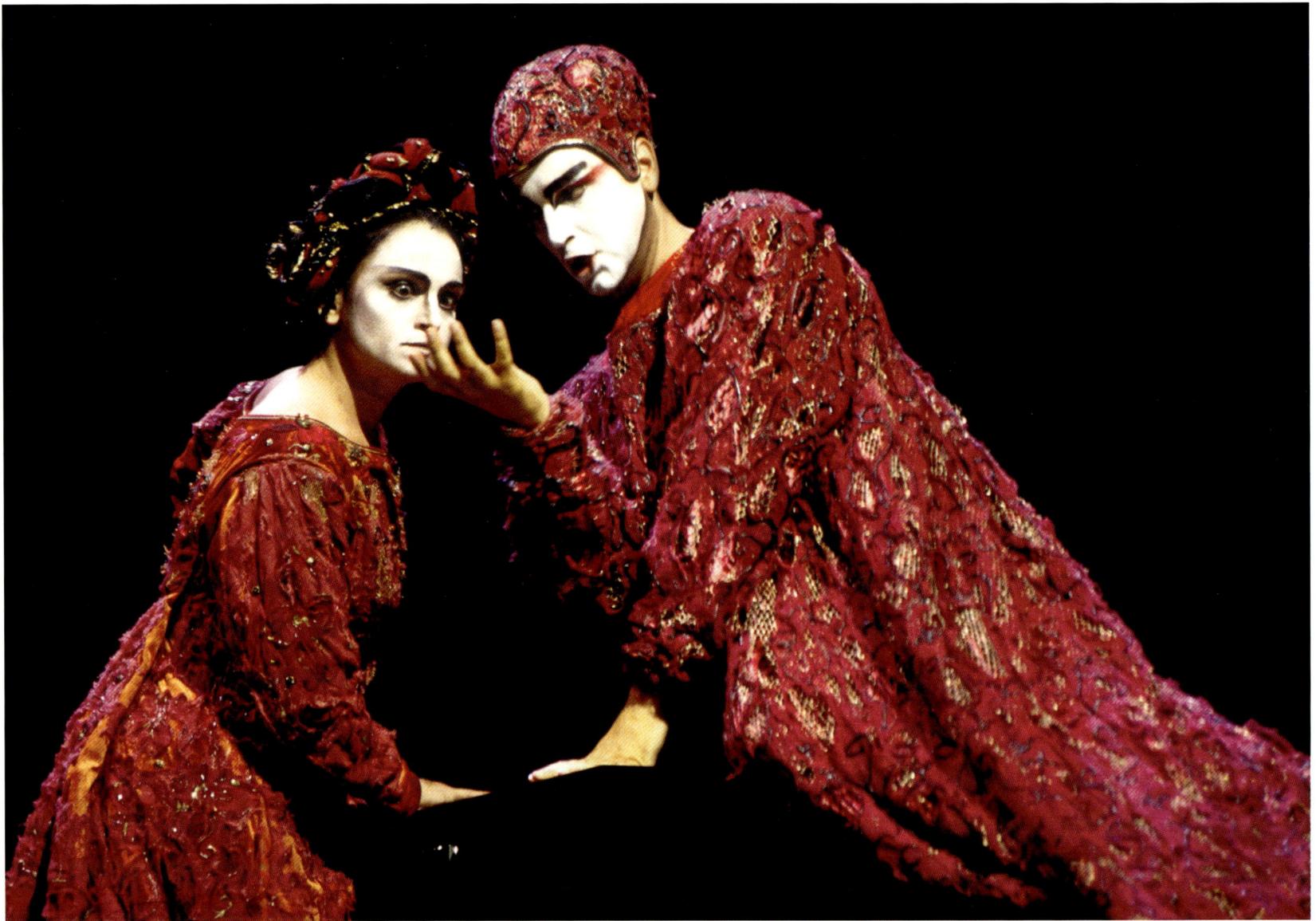

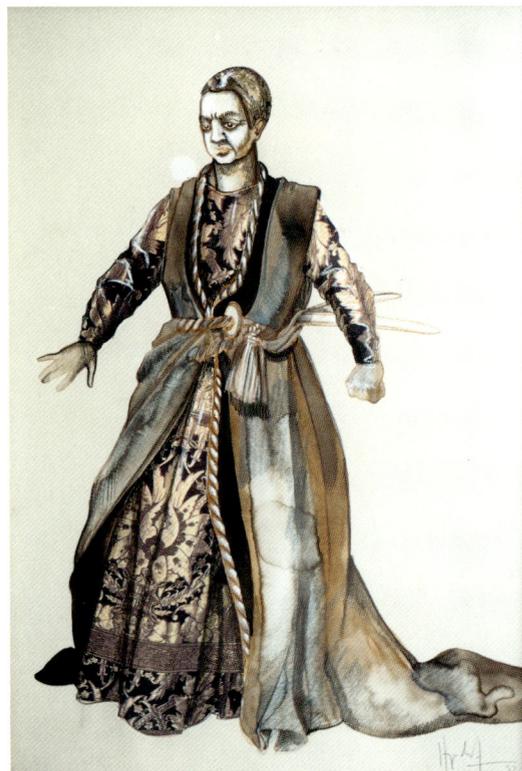

HUGO DE ANA

Semiramide
by Gioachino Rossini, 1992
Directed by Hugo de Ana

Gloria Scalchi and Michele Pertusi
Photo by Studio Amati Bacciardi

Left, study for Assur (Michele Pertusi)

"Whenever I hear the name Sartoria Tirelli I sail off on a sea of memories. When I used to watch the great Italian films at the cinema in Buenos Aires, I was struck and dazzled by the costumes, true works of art designed by masters like Danilo Donati, Piero Tosi and Franco Zeffirelli, to name just three. Then, as I followed the closing credits, I noticed that their 'genius' was always accompanied by the signature of Sartoria Tirelli. So, I dreamed of one day having the honour of being able to work with the Sartoria. In all humility I felt that their concept of authenticity in costume was very similar to the one I favoured. When I began to work in Italy years later, the theatres offered me major productions that permitted me to collaborate with Sartoria Tirelli, and that youthful dream of mine came true."

Hugo de Ana

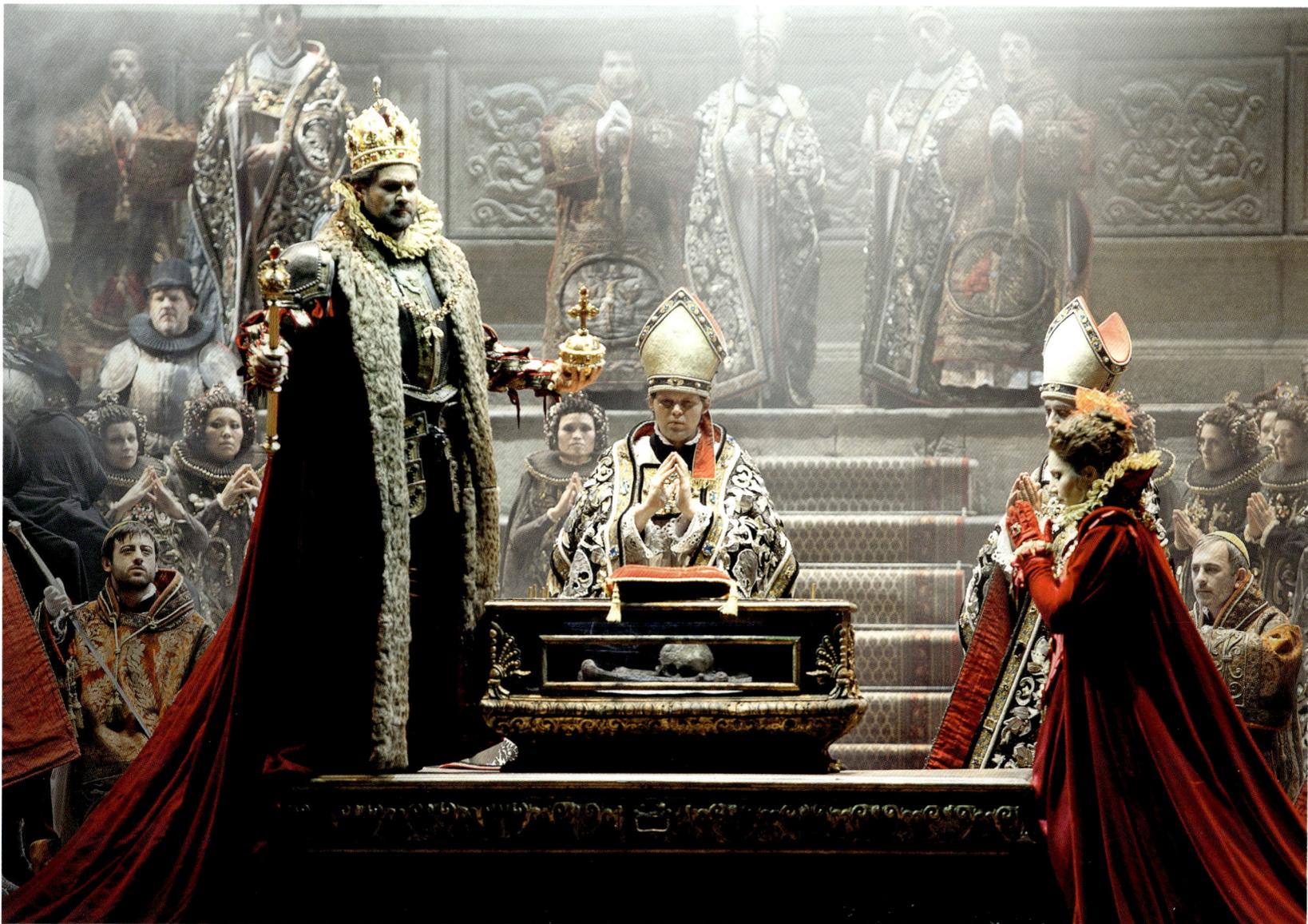

HUGO DE ANA

Don Carlo
by Giuseppe Verdi, 2013
Directed by Hugo de Ana

Ildar Abdrazakov and Barbara Frittoli

Right, Sonia Ciani and Daniela
Barcellona
Photos by Ramella&Giannese
© Teatro Regio Torino

The first edition of the production
was staged in Madrid in 2001

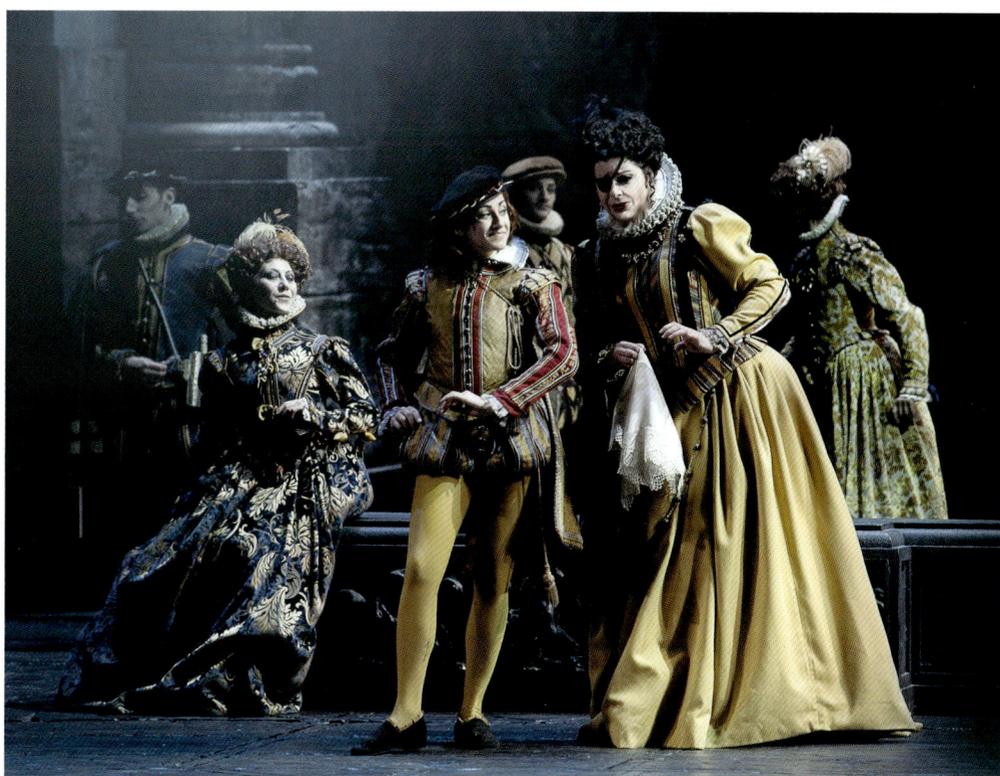

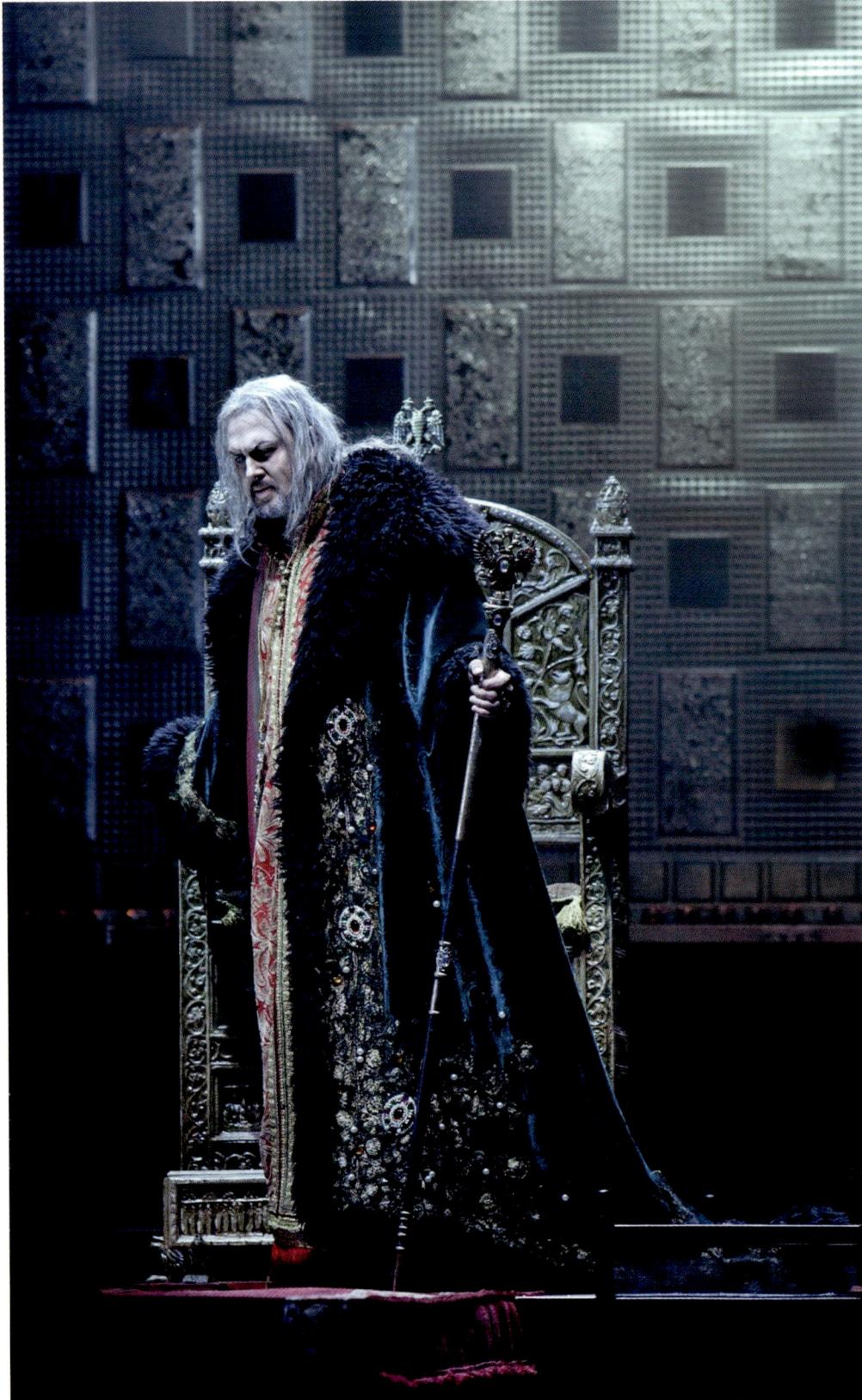

HUGO DE ANA

Boris Godunov
by Modest Mussorgsky, 2011
Directed by Hugo de Ana

Roberto Scandiuzzi

CARLO POGGIOLI

Gustavo III
by Giuseppe Verdi, 2001
Directed by Ruggero Cappuccio

The closing scene of the masked ball
Photo by Luciano Romano
Courtesy Teatro di San Carlo –
Archivio Storico del Teatro
di San Carlo, Naples

CARLO POGGIOLI

Il ritorno di Don Calandrino
[The Return of Don Calandrino]
by Domenico Cimarosa, 2006
Directed by Ruggero Cappuccio

Group scene on stage
Photo by Silvia Lelli

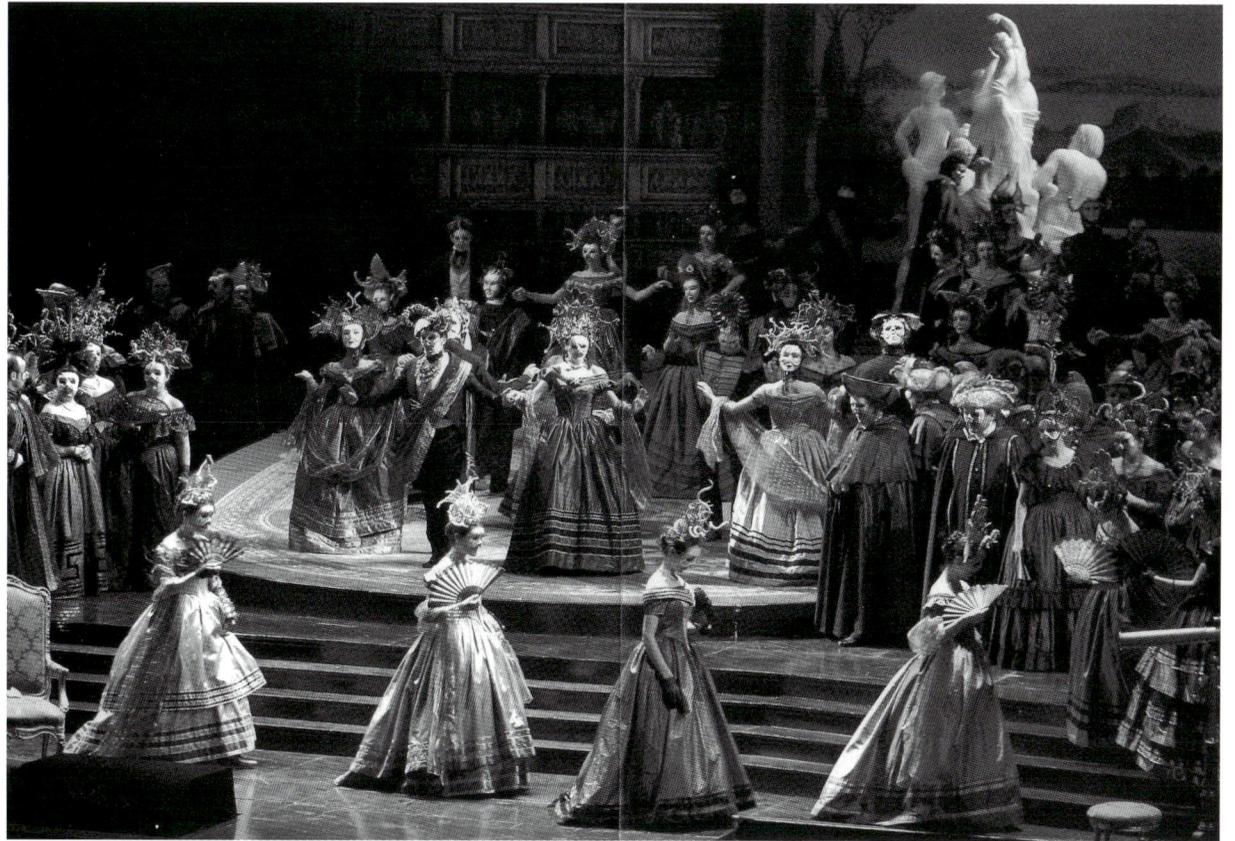

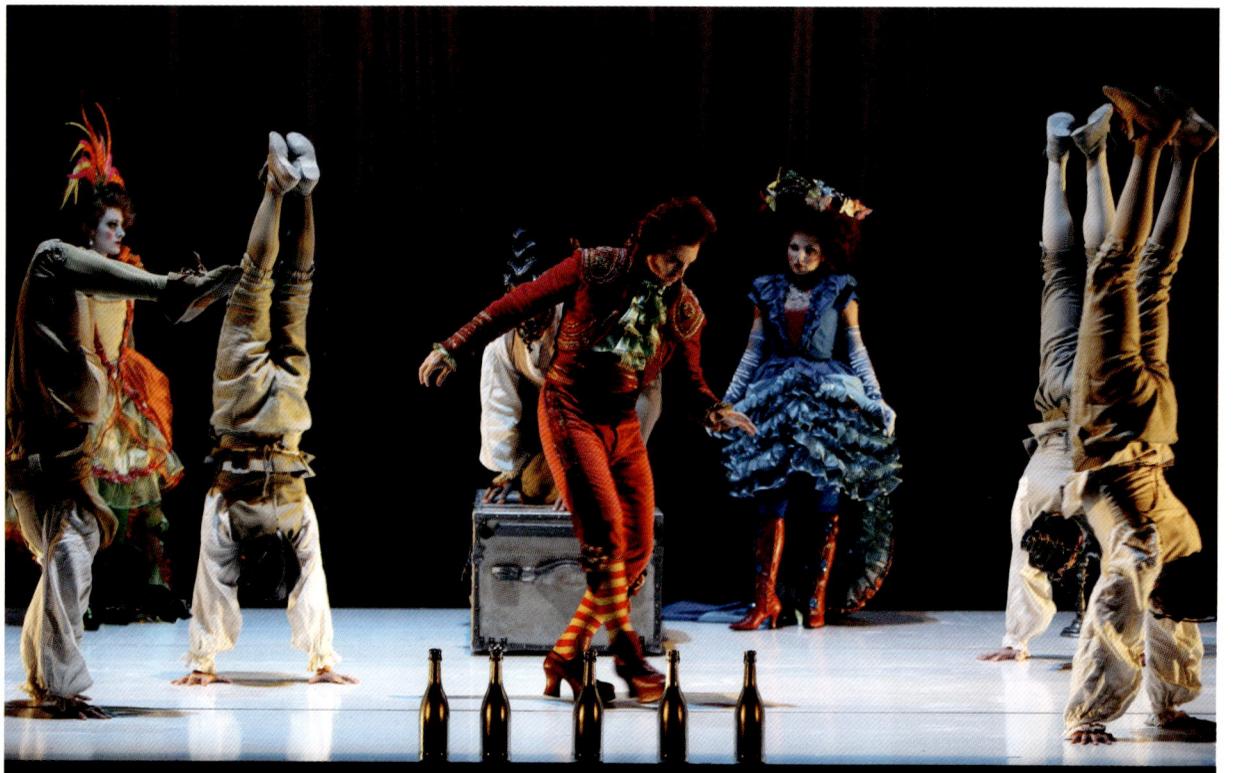

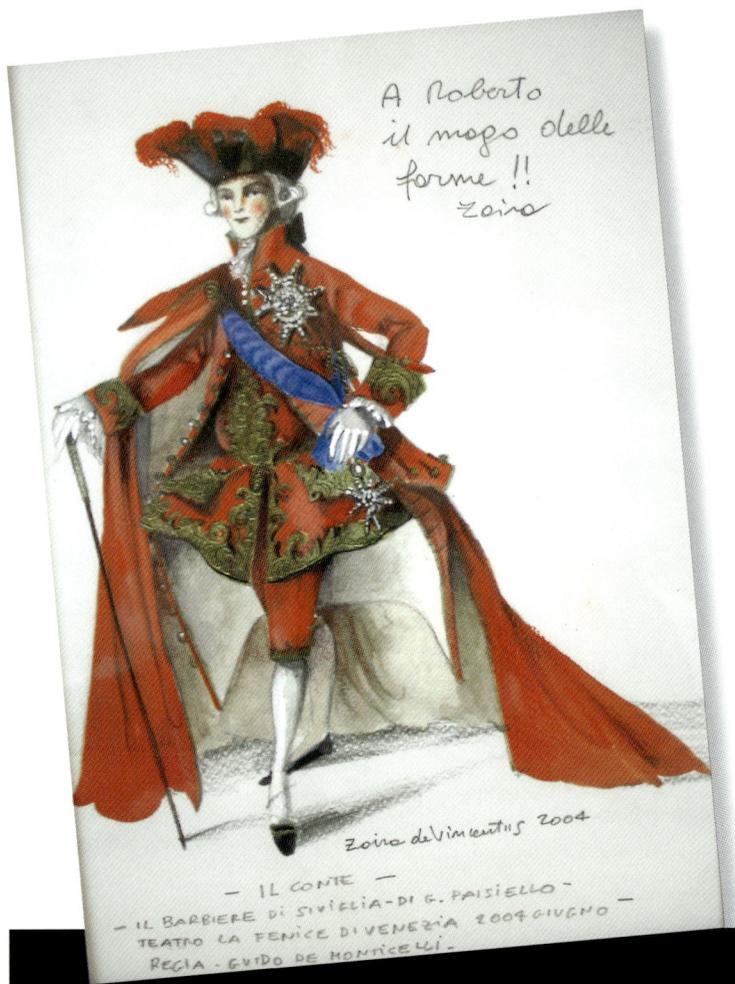

A Roberto
il mago delle
forme !!
Zaira

Zaira deVincentiis 2004

— IL CONTE —
— IL BARBIERE DI SIVIGLIA - DI G. PAISIELLO -
TEATRO LA FENICE DI VENEZIA 2004 GIUGNO -
REGIA - GUIDO DE MONTICELLI -

ZAIRA DE VINCENTIIS

Il barbiere di Siviglia
[The Barber of Seville]
by Gioachino Rossini, 2004
Directed by Guido Monticelli

Costume sketch for the Count of
Almaviva (Mirko Guadagnini), with
dedication to Roberto the cutter

Below, Stefania Donzelli
and Mirko Guadagnini
Photo by Michele Crosera – Archivio
Storico del Teatro La Fenice

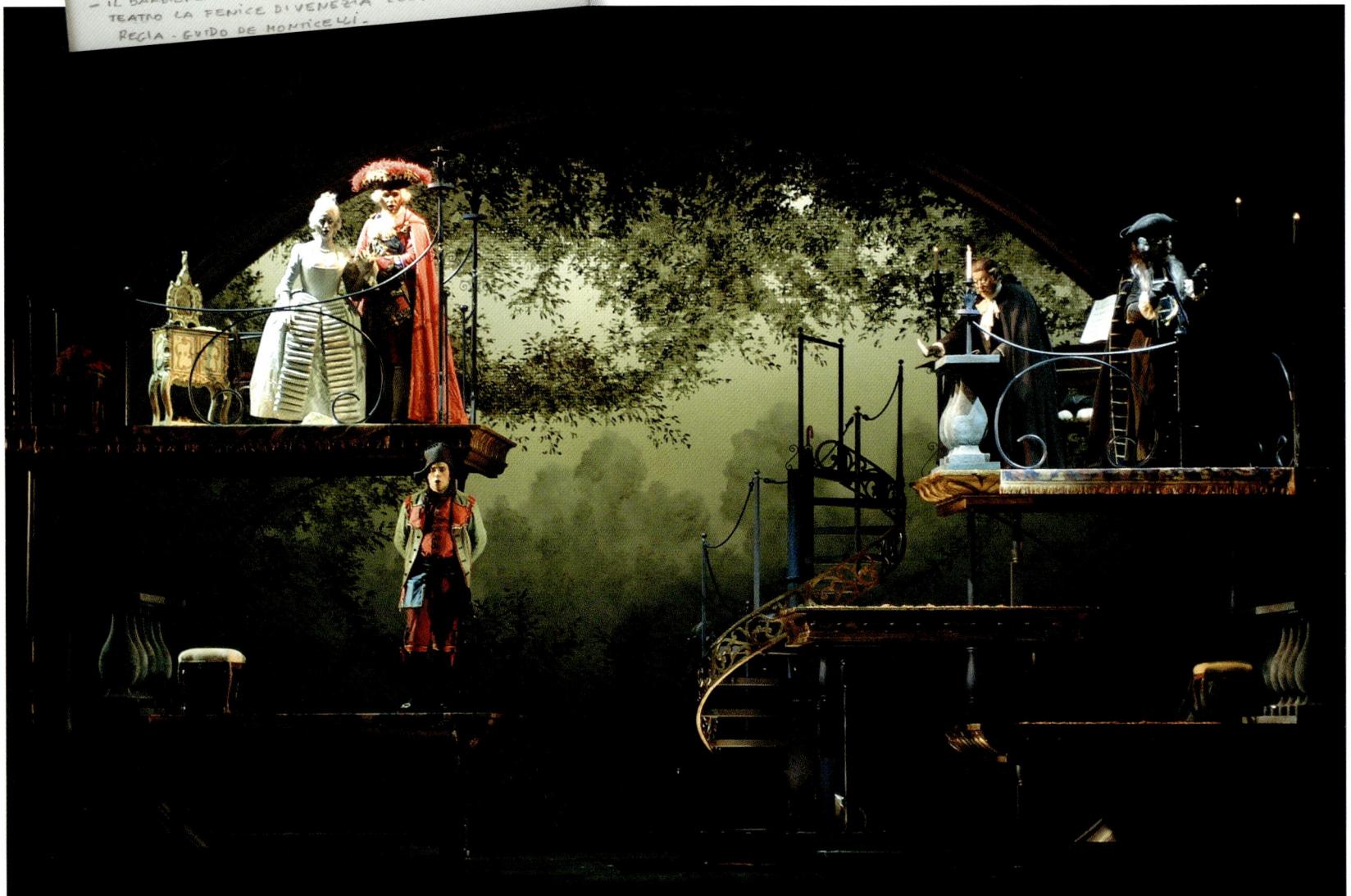

MASSIMO GASPARON

Tosca
by Giacomo Puccini, 2008
Directed by Massimo Gasparon

The *Te Deum* scene
Photo by Alfredo Tabocchini

"I'm probably what you might call a new arrival at the Tirelli 'stable', even though my career already spans over twenty years.

I started out as a costume designer with Sartoria Brancato in Milan, without actually having had the chance to do the usual apprenticeship as an assistant. When my teacher Pier Luigi Pizzi accompanied me to Via Pompeo Magno for the first time, I regretted not having had the chance to meet the great Umberto Tirelli, but Dino Trappetti gave me such a warm and friendly welcome and immediately made me feel at ease.

Despite the extraordinary atmosphere you breathe in every room, surrounded by hundreds of mannequins wearing models that have made the history of costume and by posters of memorable evenings – which practically cover the walls of the Sartoria and evoke moments of great theatre – the mood is always stimulating and creative. Later, when I went to their warehouse in Formello, I literally gasped when I saw they had everything you could possibly imagine or want for any show.

So, a lot of productions soon came into being and Tirelli's historical collection, made outstanding by its authenticity and craftsmanship, always inspired and completed my personal and artistic work as a costume designer."

Massimo Gasparon

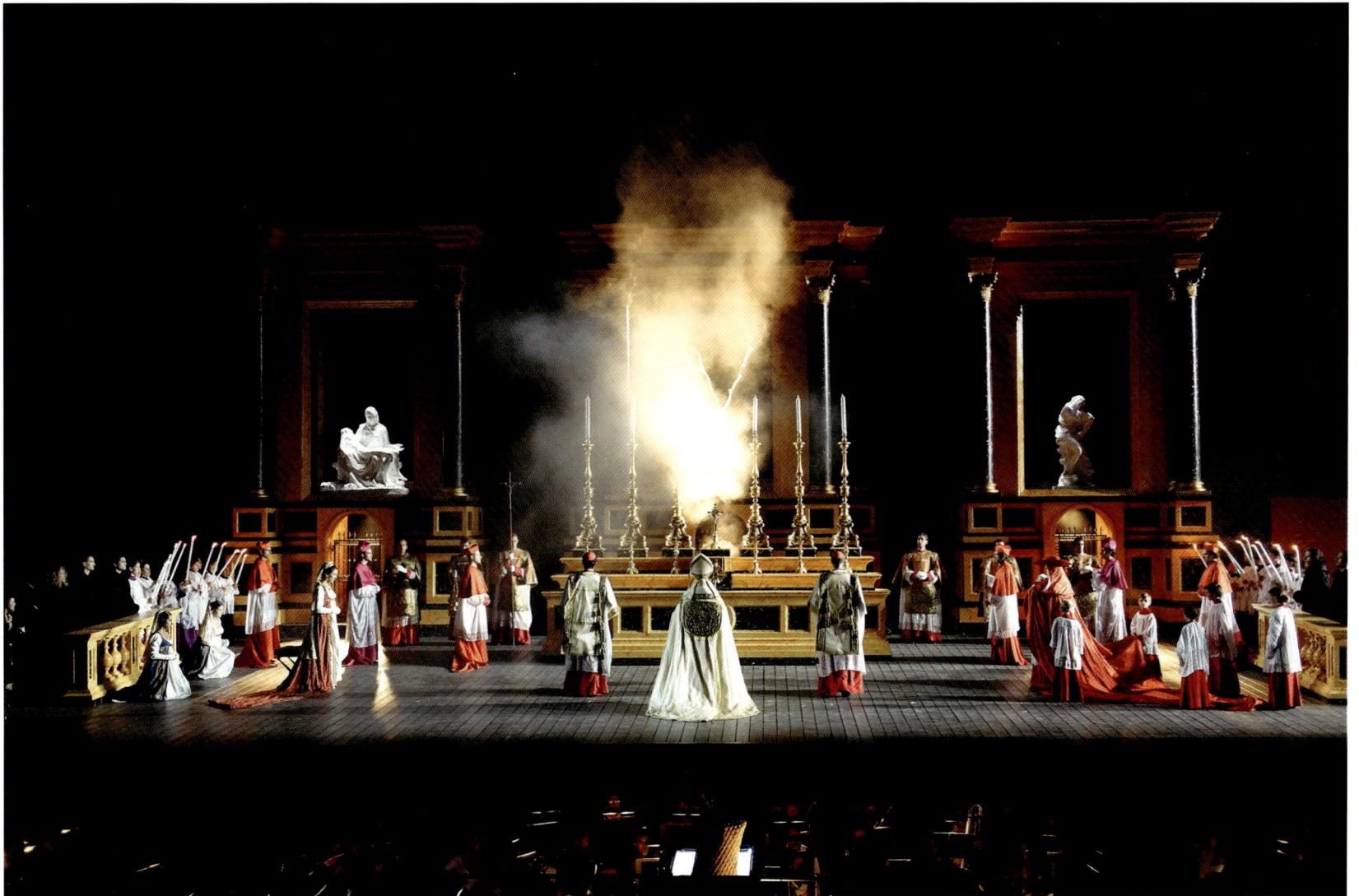

STEFANO PODA

Thaïs,
by Jules Massenet, 2008
Directed by Stefano Poda

Barbara Frittoli

Opposite, group scene on stage
© Stefano Poda

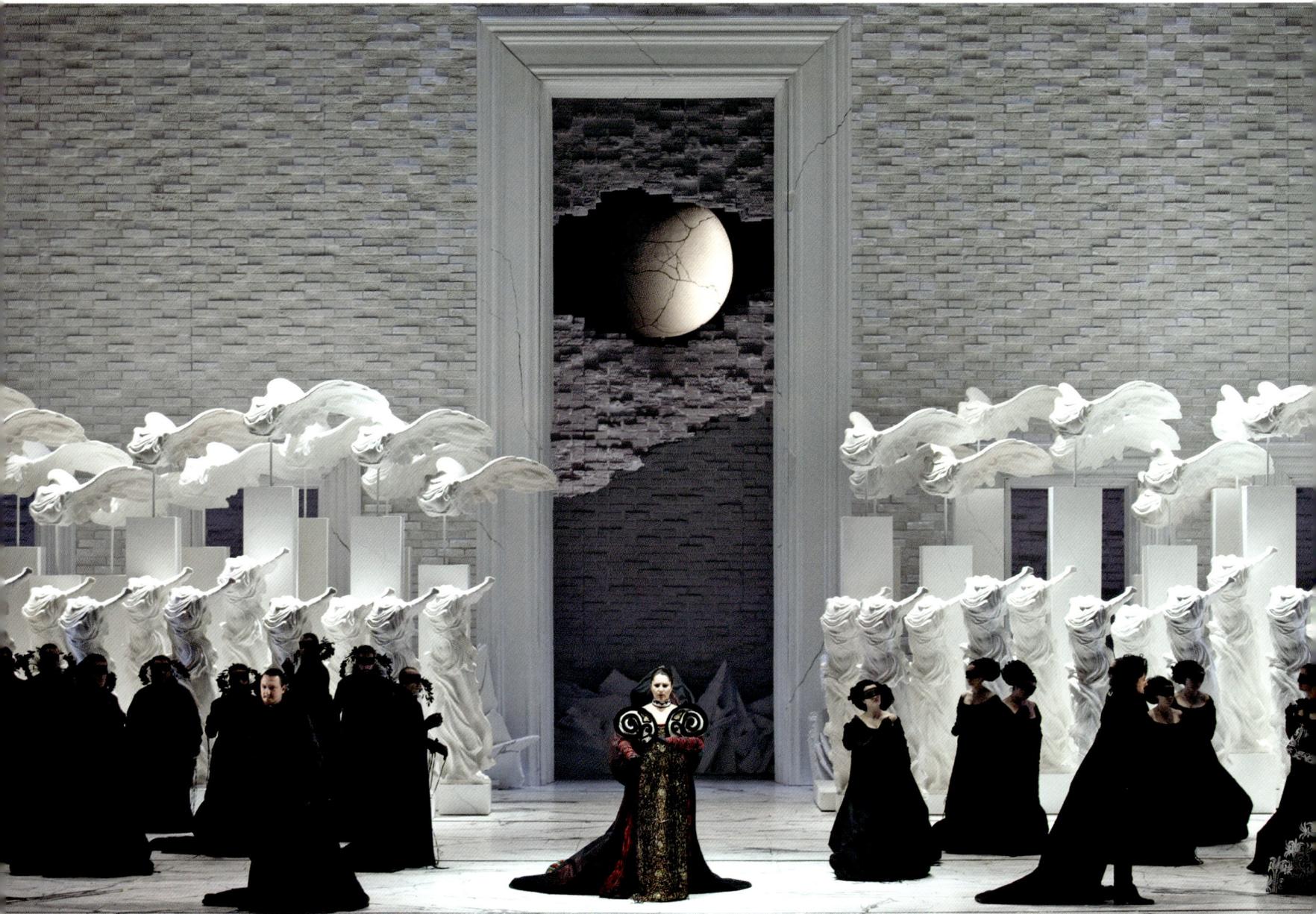

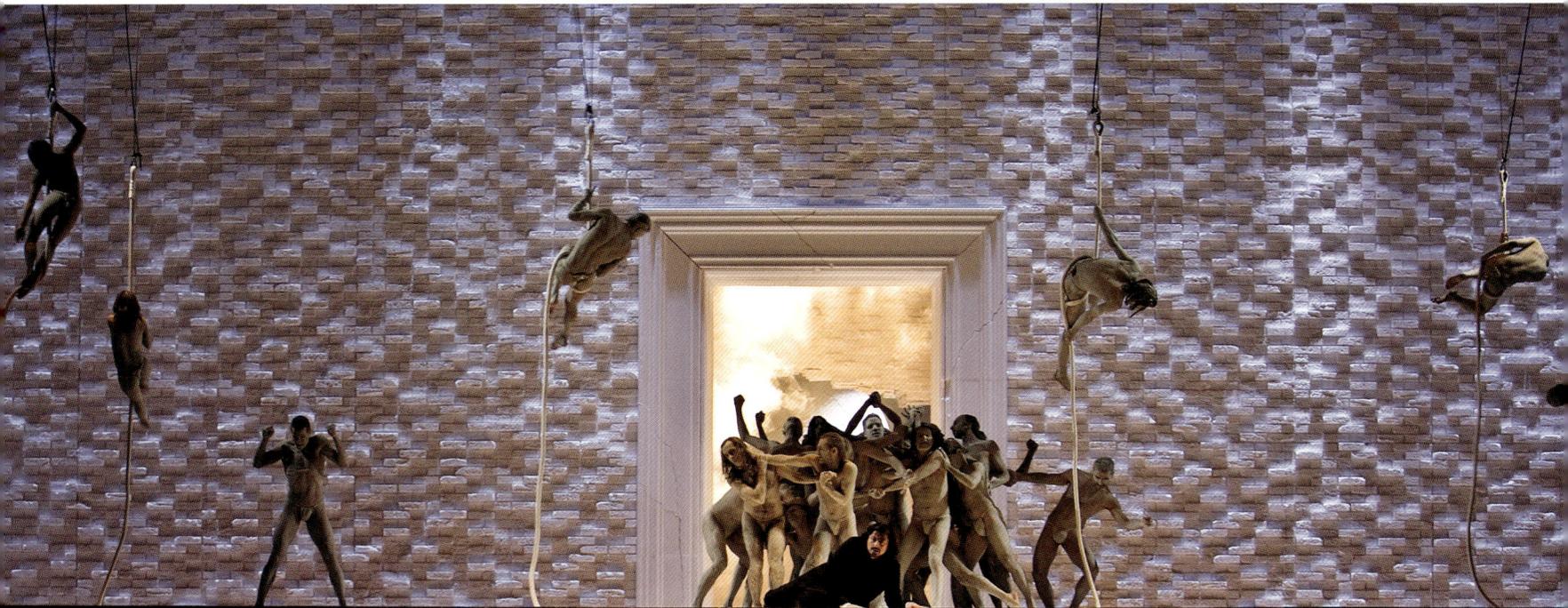

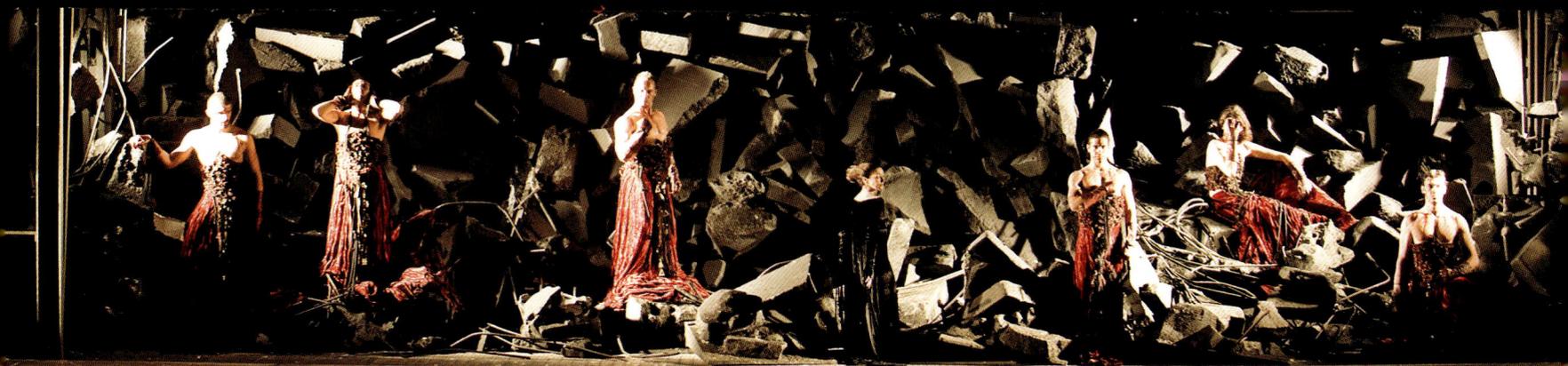

"On stage I am not driven by a rational analysis of the direction or set design, but by an instinct for dreams of a lost homeland. Similarly, the characters who live on stage do not wear 'costumes', but are enveloped by emanations of their inner life and their human complexity. Not clothing, but the beautiful remnants of lost and noble yearnings.
How do you obtain costumes that are containers of souls, if not through the history and profundity of the place in which they are created? In this respect, Tirelli is like an alchemist's workshop that has allowed me the privilege of conducting research and experimenting through the generosity of the artisans who inhabit it, who have supported me with their know-how: a journey from form to non-form and back again.
A synthesis I have developed as the layering and testimony of centuries: the eighteenth-century corset, the styles of the sixteenth century and the discoveries of twentieth-century art, through a new approach to working fabrics and reinterpreting techniques. Giuseppe Verdi wrote: 'Let us turn to the past: that will be progress'. This is the kind of serene wisdom to be found daily in the Tirelli atelier."

Stefano Poda

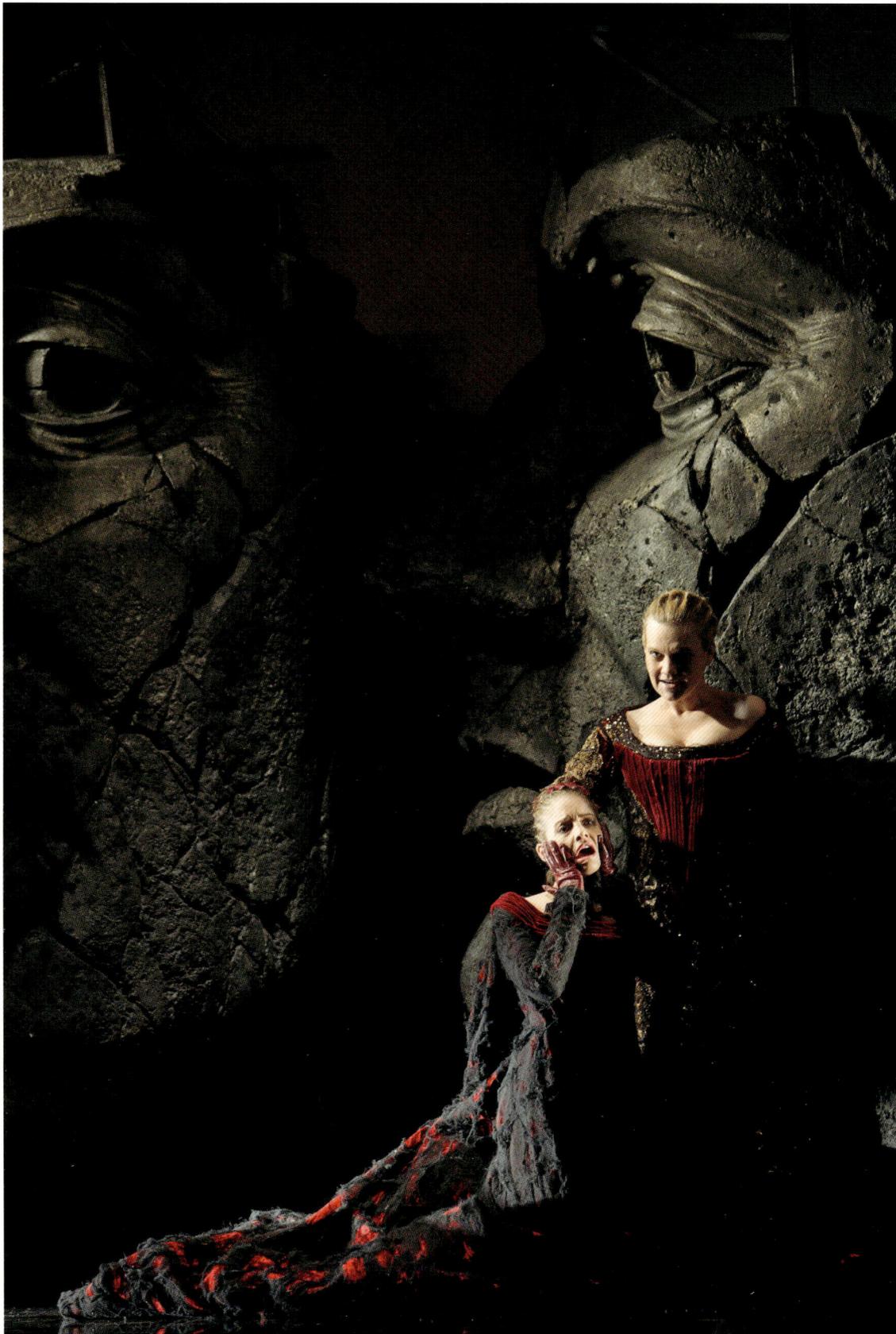

STEFANO PODA

Maria Stuarda
by Gaetano Donizetti, 2012
Directed by Stefano Poda

Margareta Klobučar
and Dshamilja Kaiser
© Stefano Poda

STEFANO PODA

Tristan und Isolde
by Richard Wagner, 2014
Directed by Stefano Poda

Photo by Simone Donati /
TerraProject
© Maggio Musicale Fiorentino

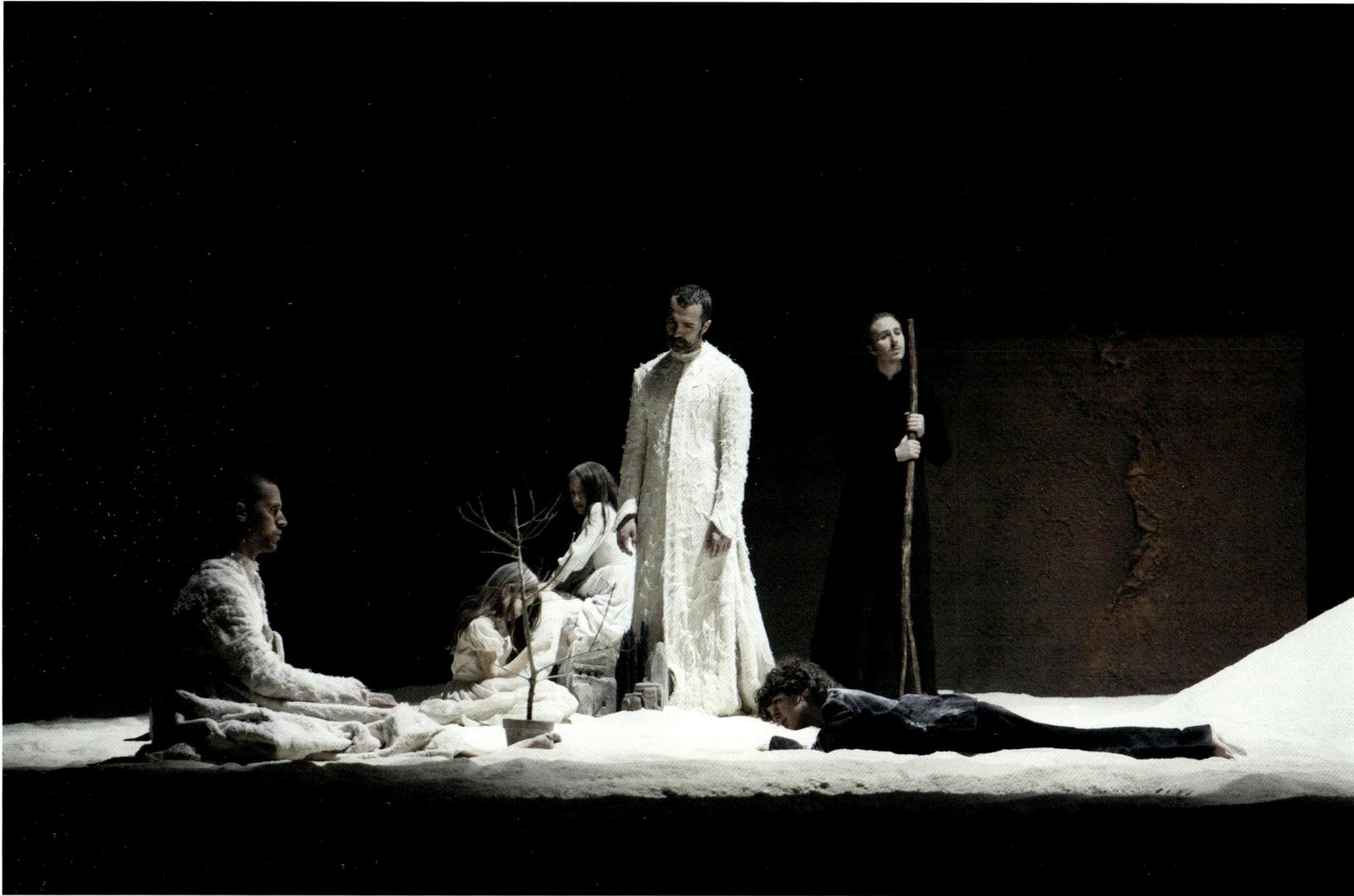

MAURIZIO MILLENOTTI

Turandot
by Giacomo Puccini, 2011
Directed by Franco Zeffirelli

Martina Serafin
Photo by Corrado Falsini

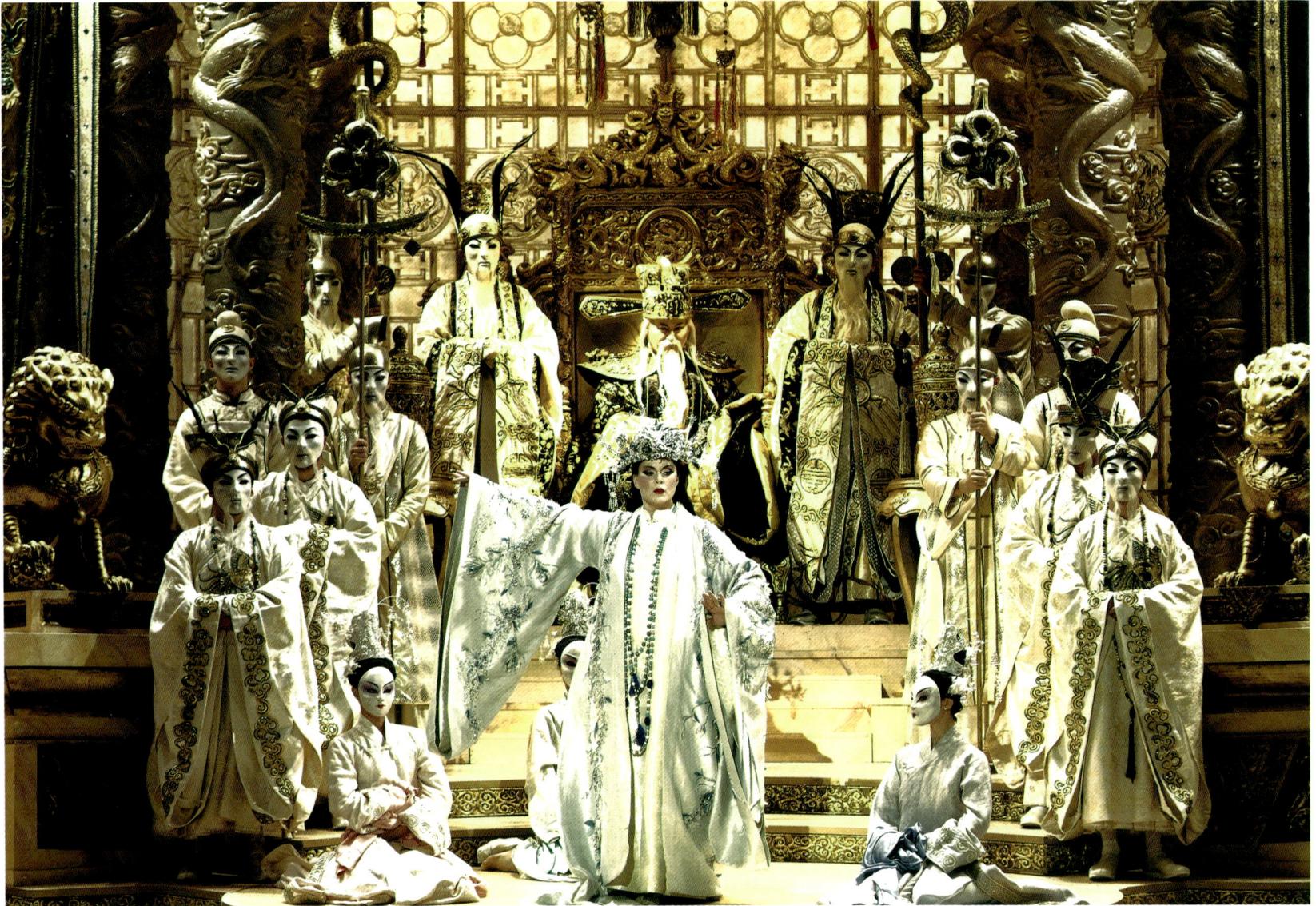

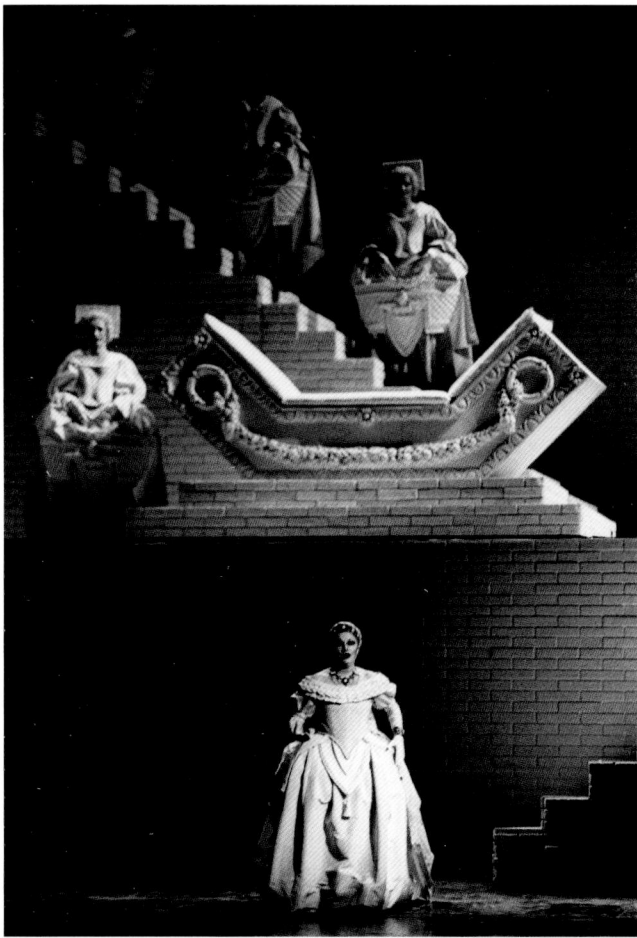

PIER LUIGI PIZZI

Semiramide
by Gioachino Rossini, 1992
Directed by Pier Luigi Pizzi

Mariella Devia

Ewa Podles
Photos by G. Arici and M. Smith –
Archivio Storico del Teatro La Fenice

The first edition of the production was
staged in Aix-en-Provence in 1980

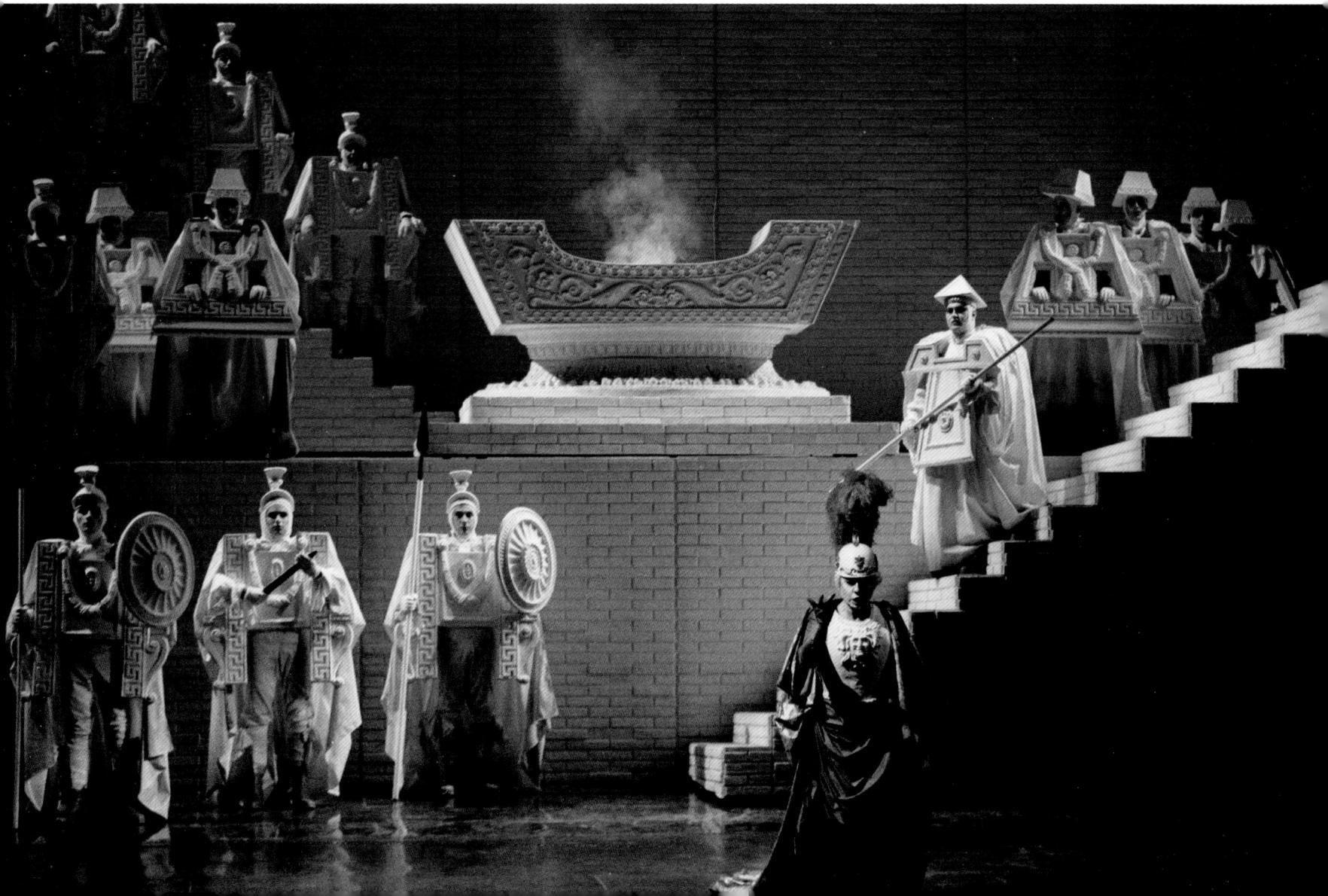

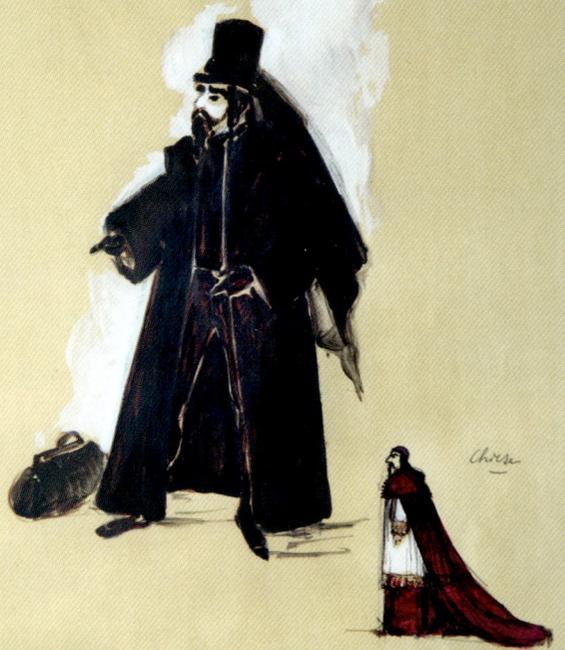

PIER LUIGI PIZZI

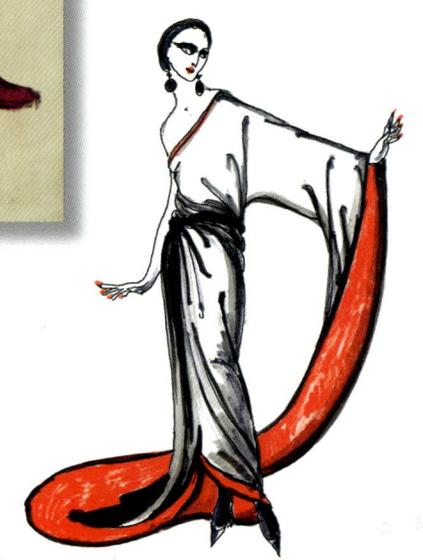

Studies for the following productions (clockwise from top left): *Orlando Furioso* by Antonio Vivaldi, 1978; *Orlando Furioso*, TV film, 1975; *Hippolyte et Aricie* by Jean-Philippe Rameau, 1983; *Faust* by Charles Gounod, 1975; *Le domino noir* by Daniel Auber, 2003; *Armide* by Christoph Willibald Gluck, 1992; *Attila* by Giuseppe Verdi, 2012; *Salome* by Richard Strauss, 1984

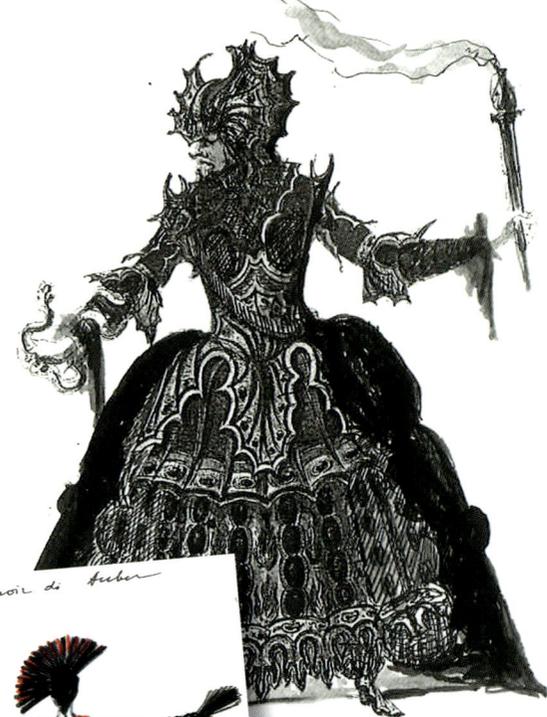

Orlando

alla follia fuggir : elmo, sudo, corazza, mantello.

Orlando
Paladino

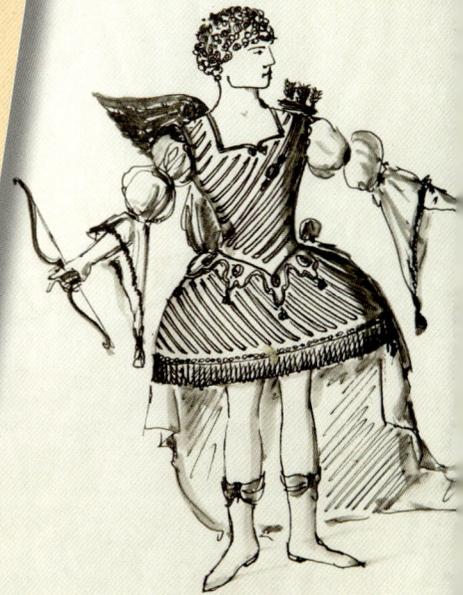

Prologue

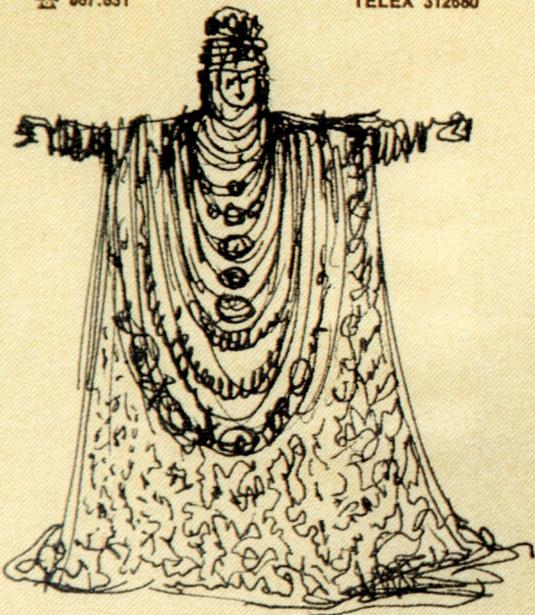

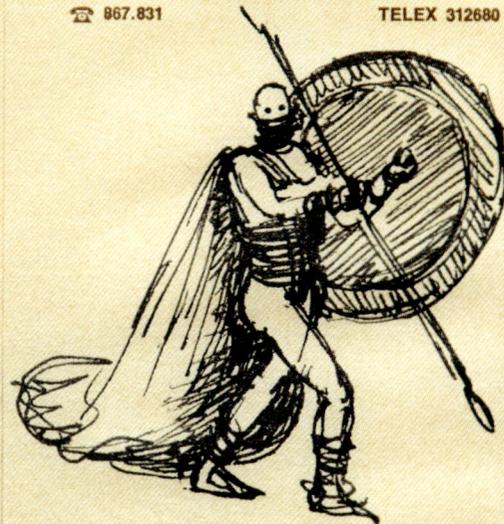

MAURIZIO MILLENOTTI

Falstaff
by Giuseppe Verdi, 2012
Directed by Luca Ronconi

Roberto De Candia
Photo by Carlo Cofano

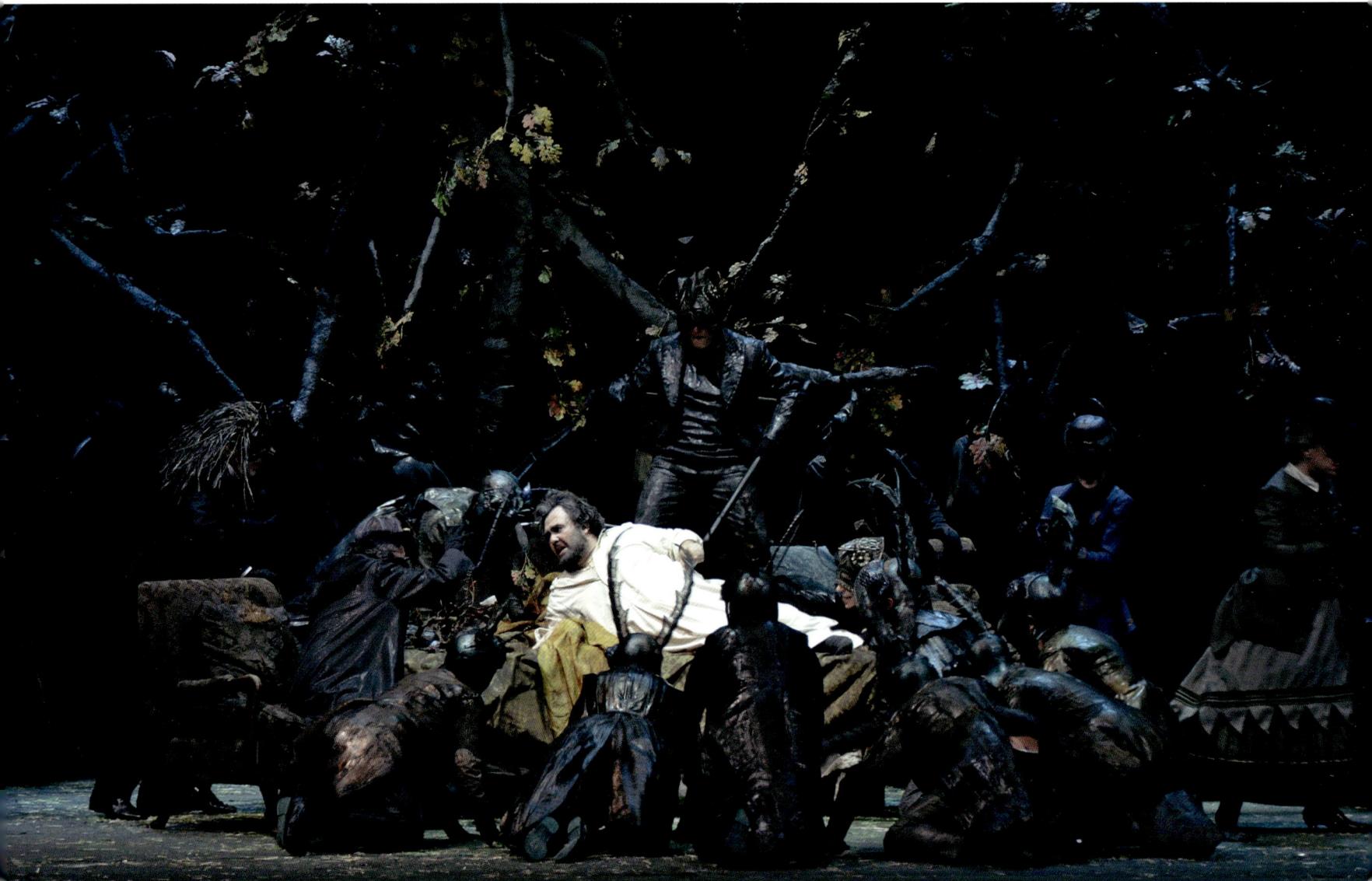

PIER LUIGI PIZZI

Tancredi
by Gioachino Rossini, 1982
Directed by Pier Luigi Pizzi

Katia Ricciarelli and Lucia Valentini
Terrani
Photo by Studio 33 di Roberto
Angelotti

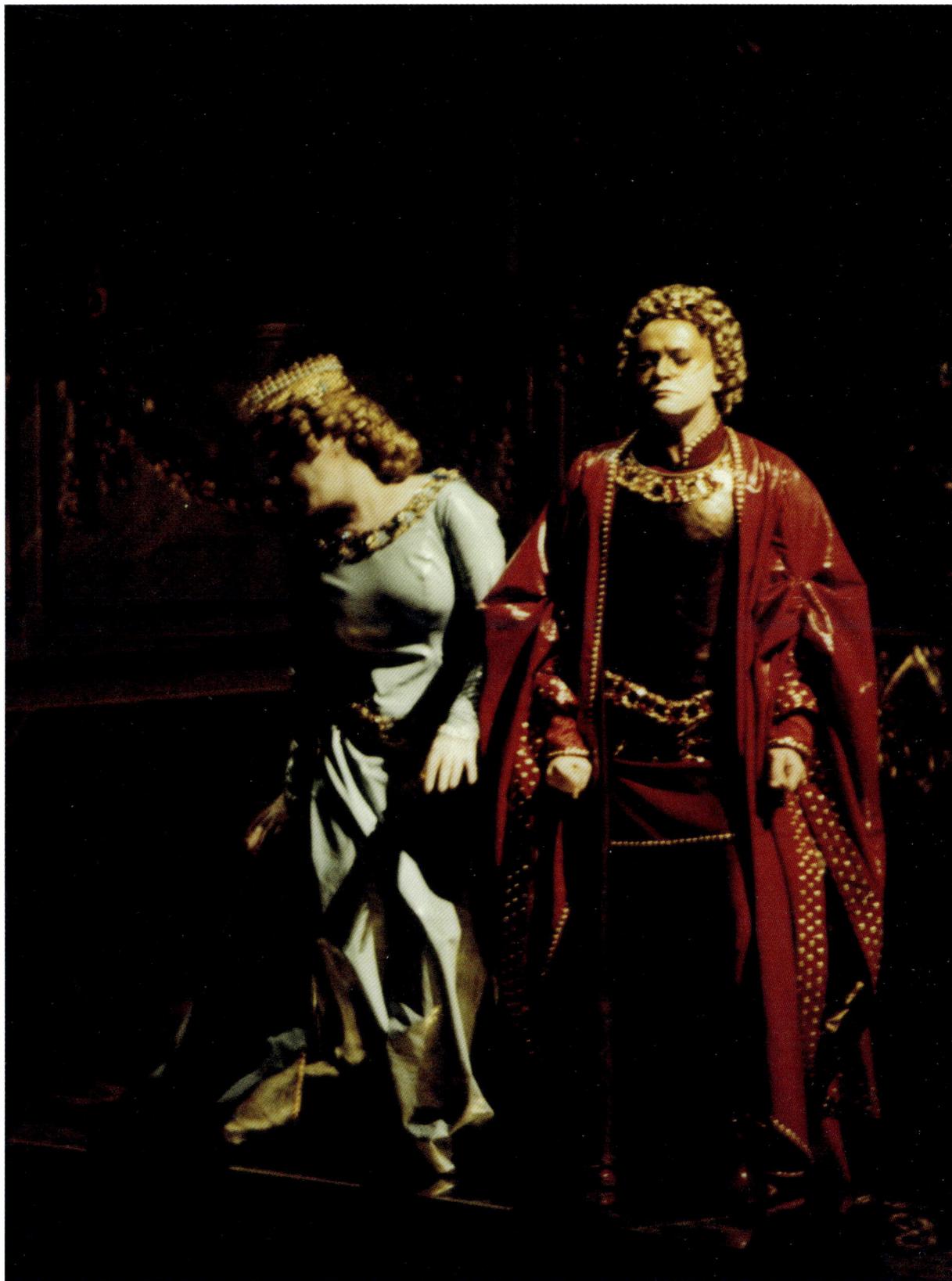

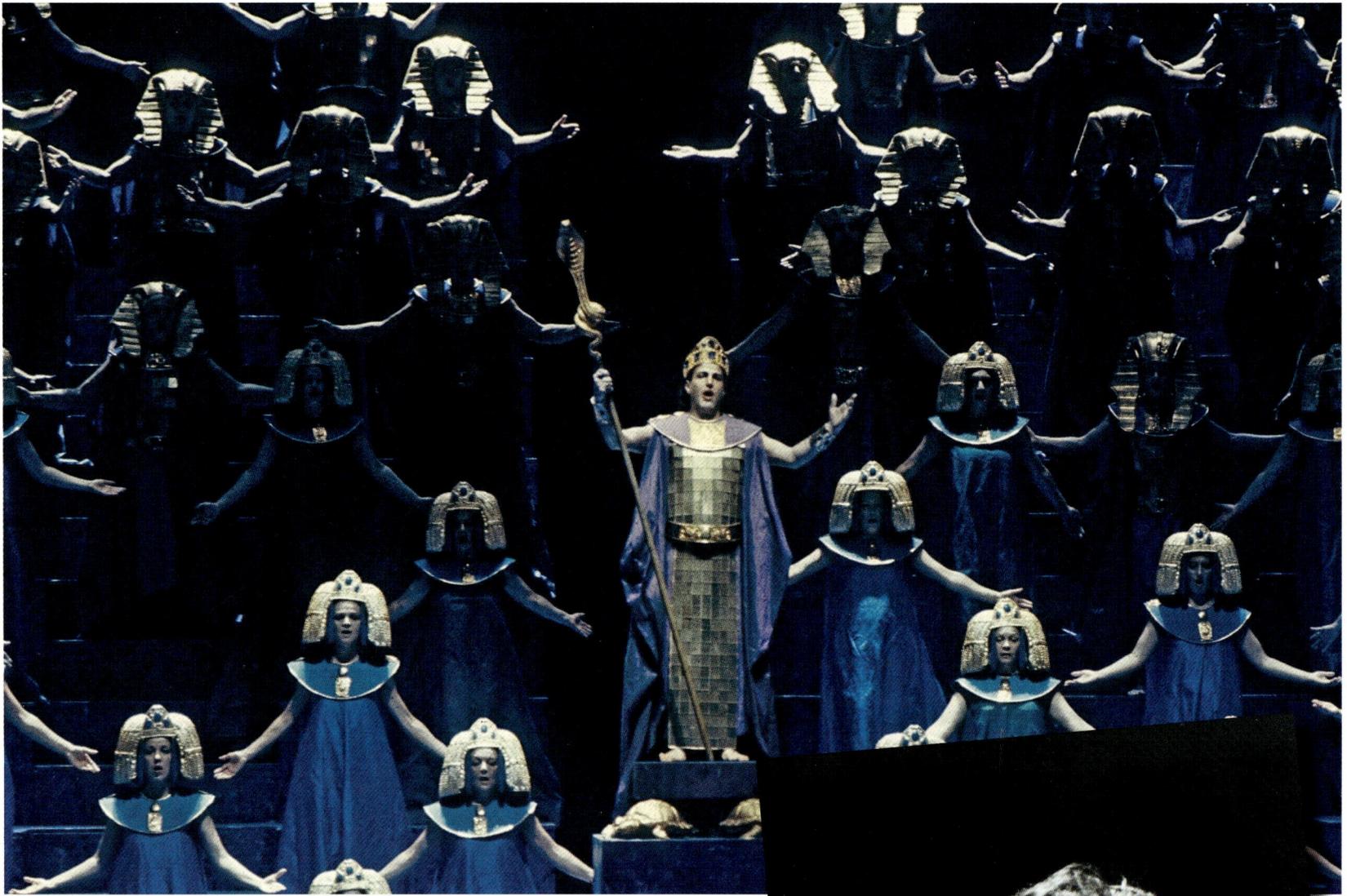

PIER LUIGI PIZZI

Mosè in Egitto [Moses in Egypt]
by Gioachino Rossini, 1983
Directed by Pier Luigi Pizzi

Simone Alaimo as the Pharaoh
Photo by Studio Tornasole

Right, photo of Boris Martinović,
who played Moses, with dedication
to Dino Trappetti

PIER LUIGI PIZZI

Les Indes galantes
[The Amorous Indies]
by Jean-Philippe Rameau, 1983
Directed by Pier Luigi Pizzi

Photos by Roberto Masotti

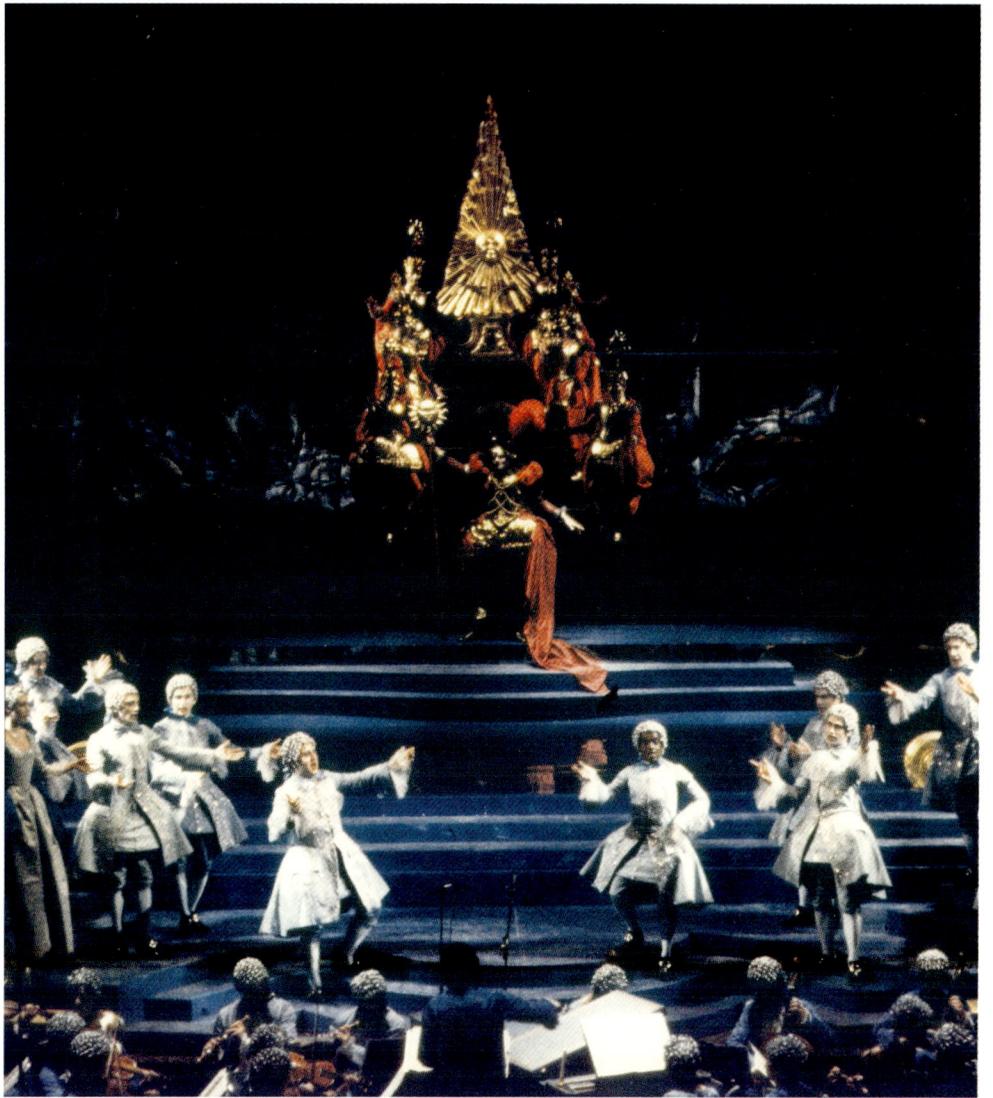

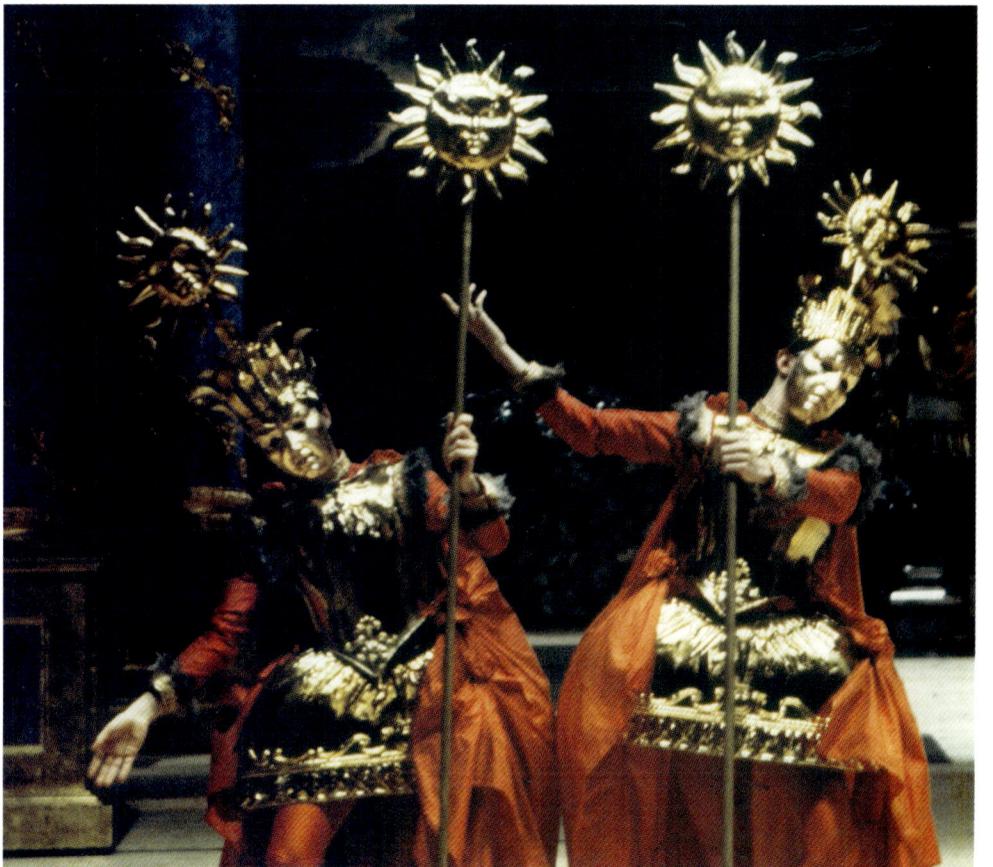

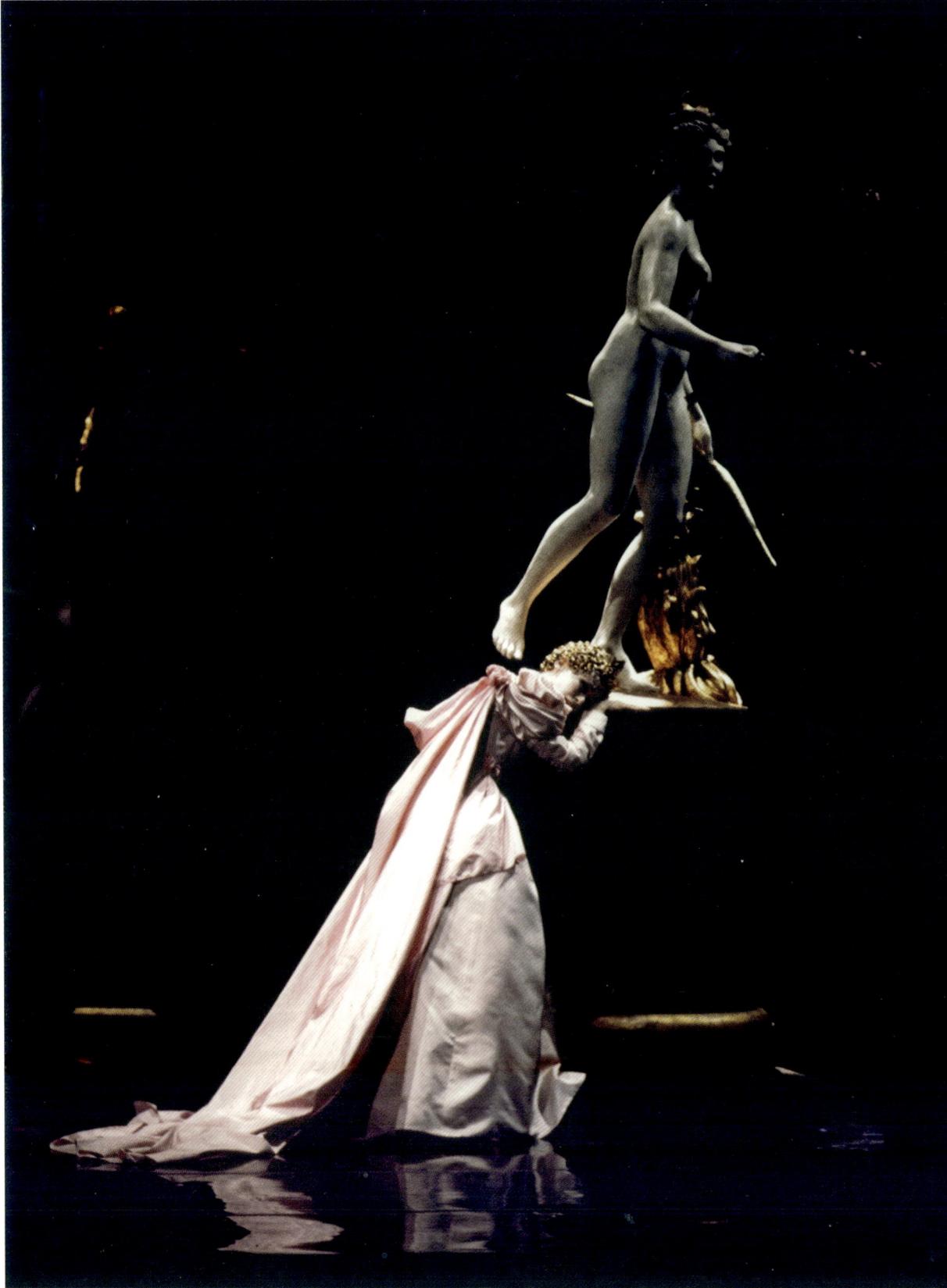

PIER LUIGI PIZZI

Hippolyte et Aricie
by Jean-Philippe Rameau, 1983
Directed by Pier Luigi Pizzi

Rachel Yakar
Photo by Lelli and Masotti
© Teatro alla Scala

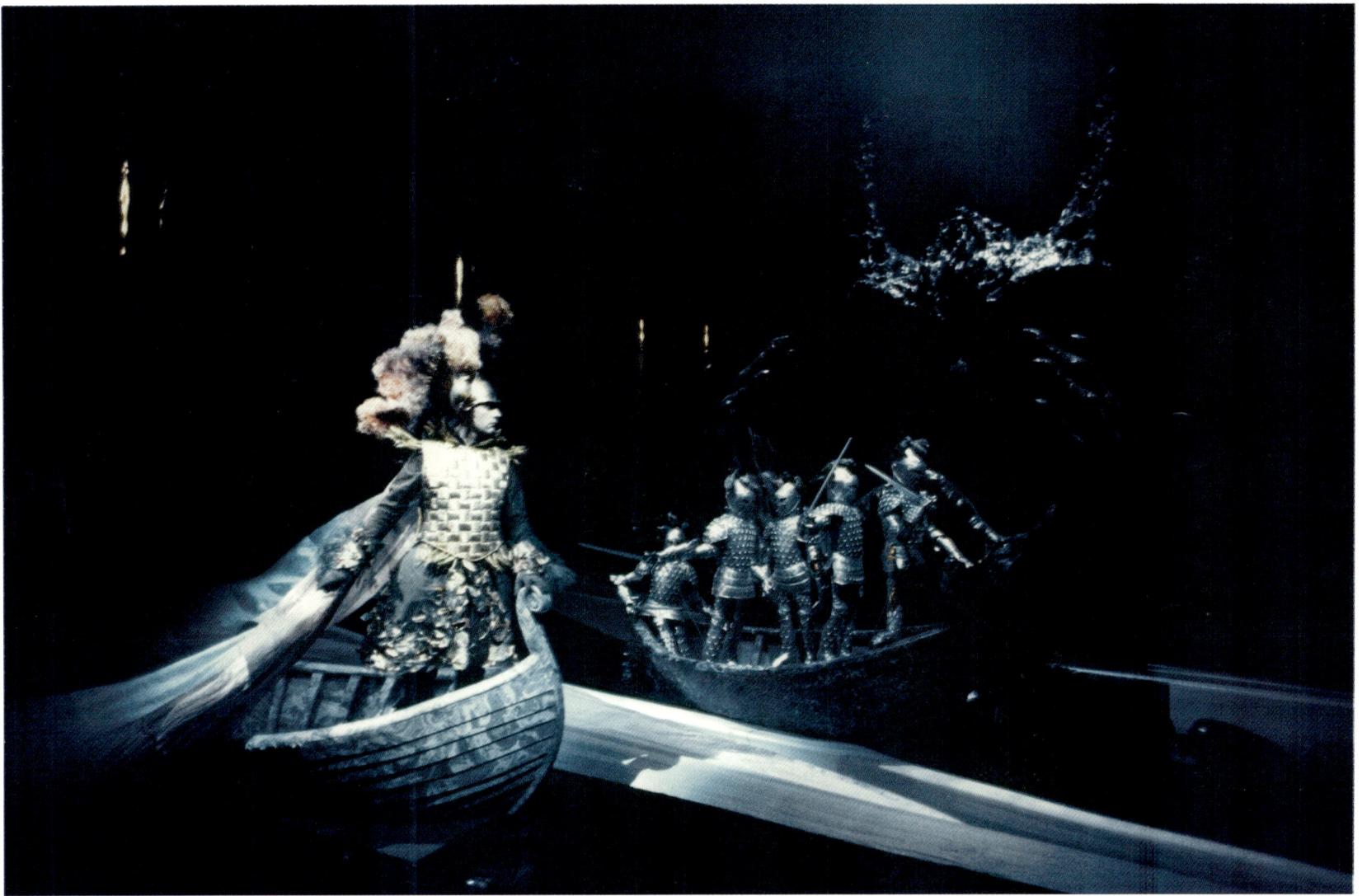

PIER LUIGI PIZZI

Rinaldo
by George Frideric Handel, 1985
Directed by Pier Luigi Pizzi

James Bowman

Right, Simone Alaimo
and Elizabeth Pruett
Photos by Roberto Masotti

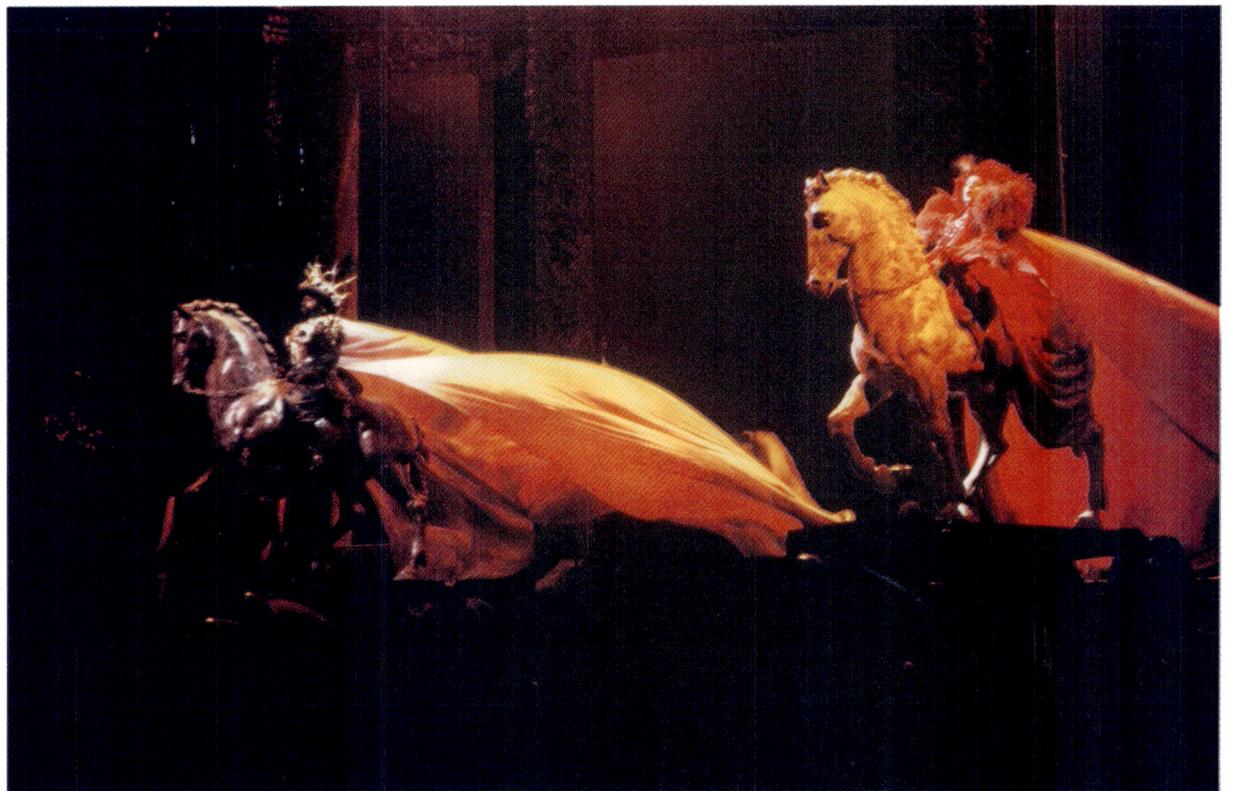

PIER LUIGI PIZZI

Maometto II
by Gioachino Rossini, 1993
Directed by Pier Luigi Pizzi

Michele Pertusi and Cecilia Gasdia
Photo by Studio Amati Bacciardi

Right, photo of Samuel Ramey,
who sang the lead in the first edition
of the production in 1985, with
dedication to Dino Trappetti

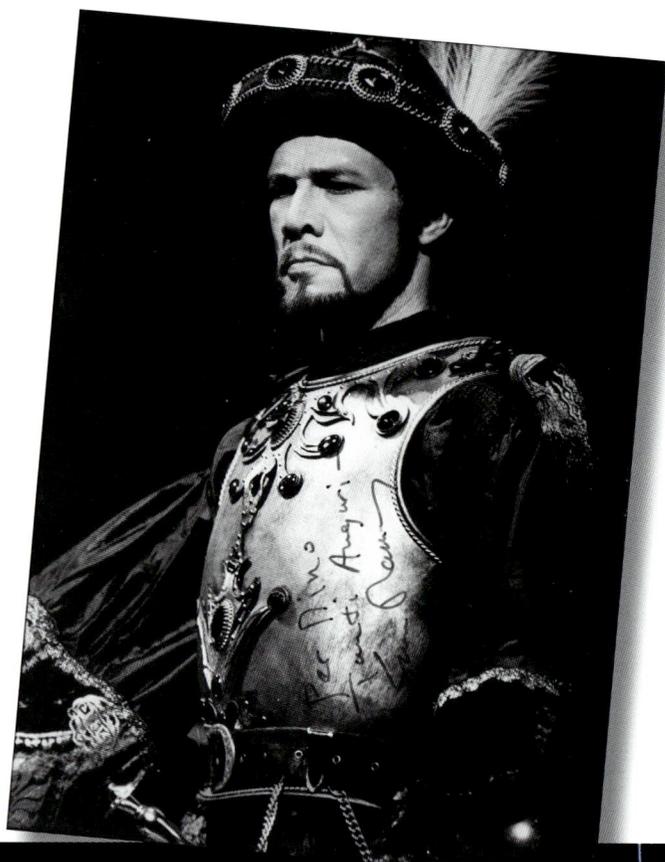

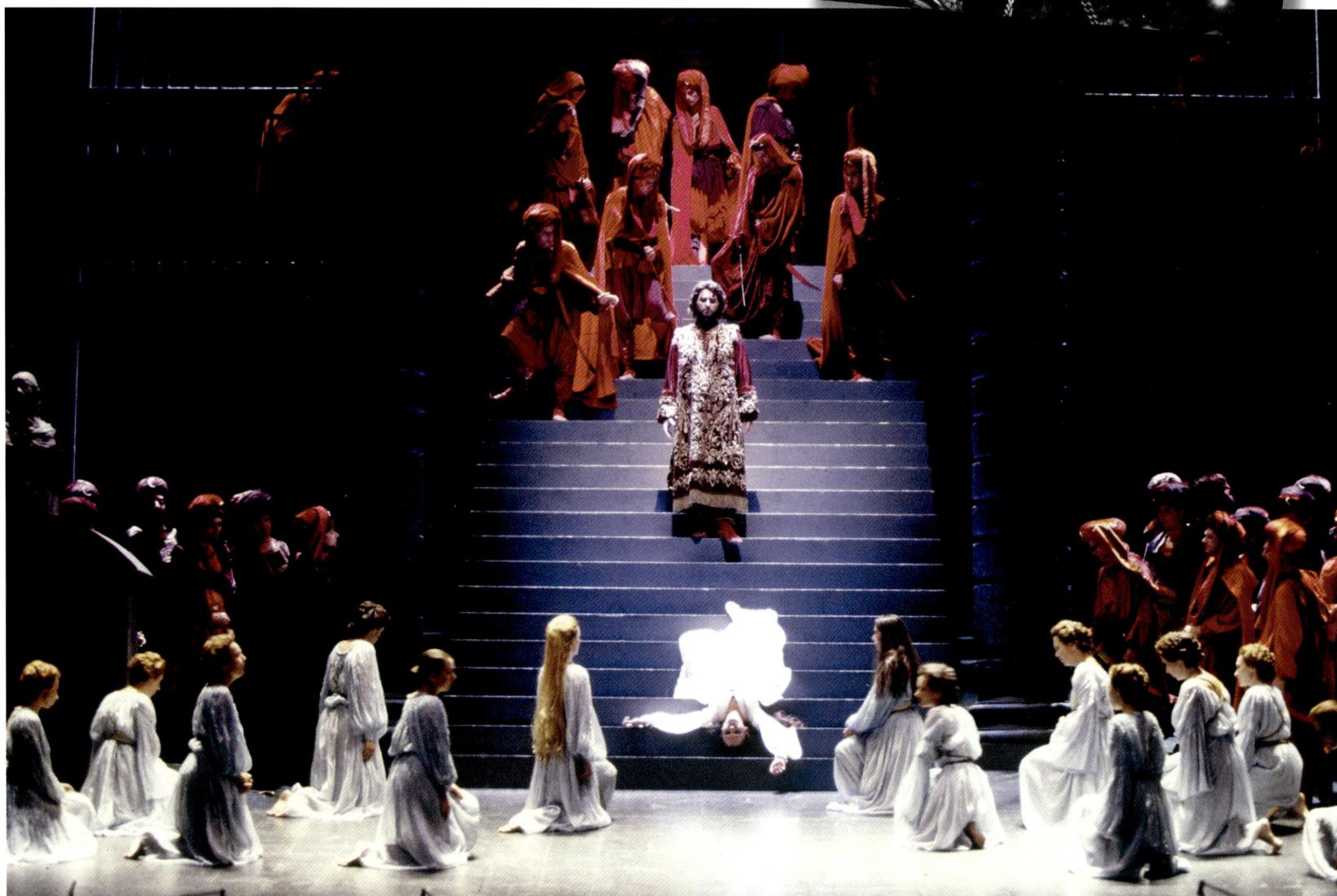

PIER LUIGI PIZZI

Bianca e Falliero
by Gioachino Rossini, 1986
Directed by Pier Luigi Pizzi

Marilyn Horne and Katia Ricciarelli
Photo by Studio Tornasole

Below, Lella Cuberli, Chris Merritt
and Martine Dupuy in the revival
of the production in 1989
Photo by Studio Amati Bacciardi

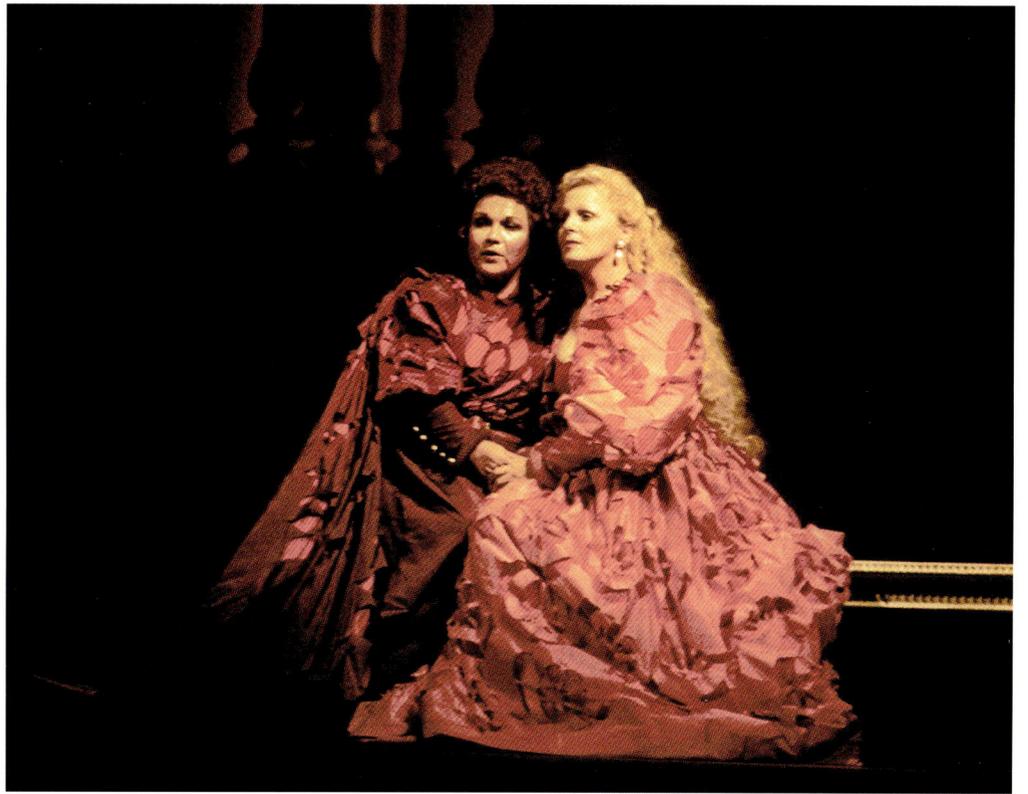

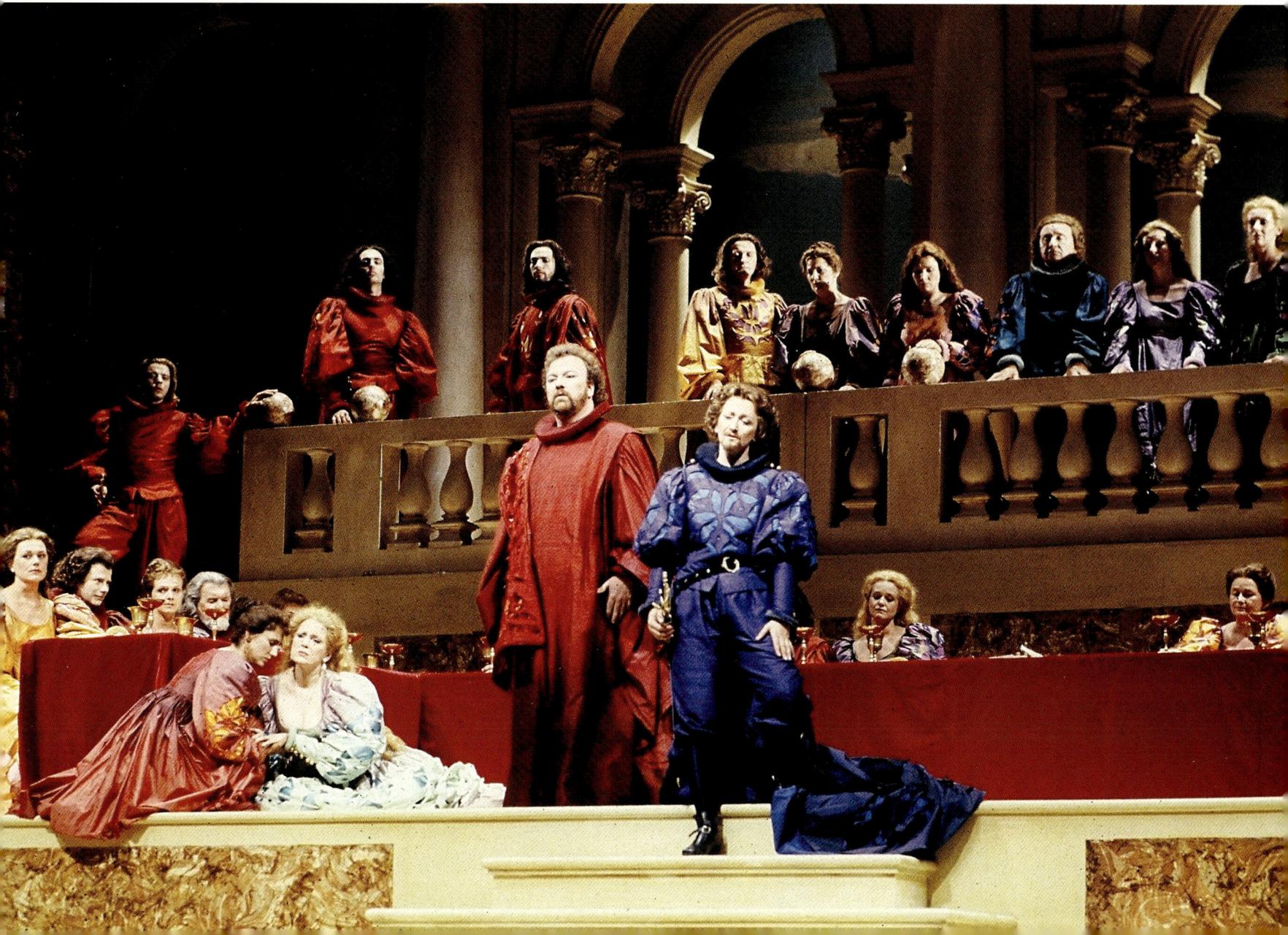

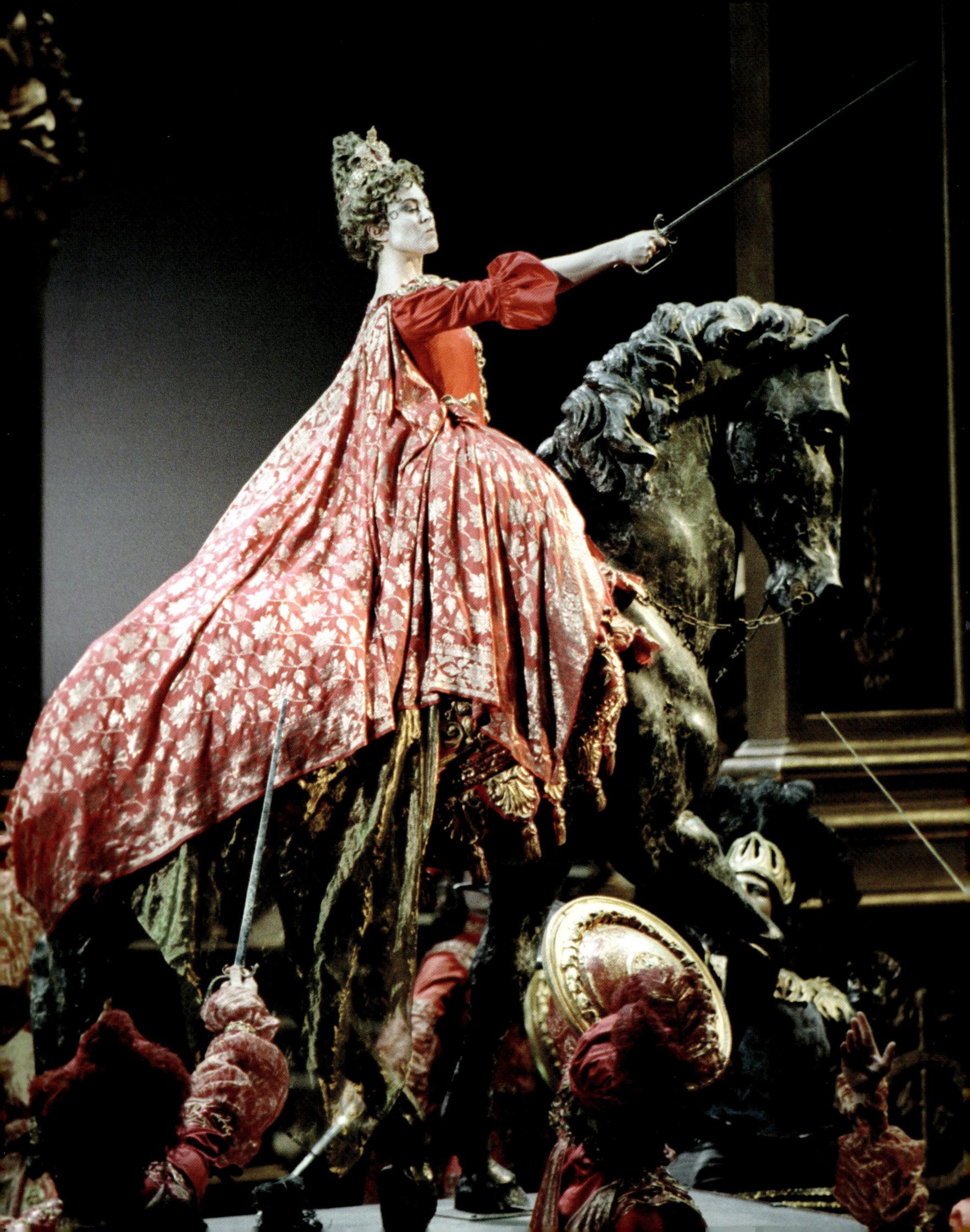

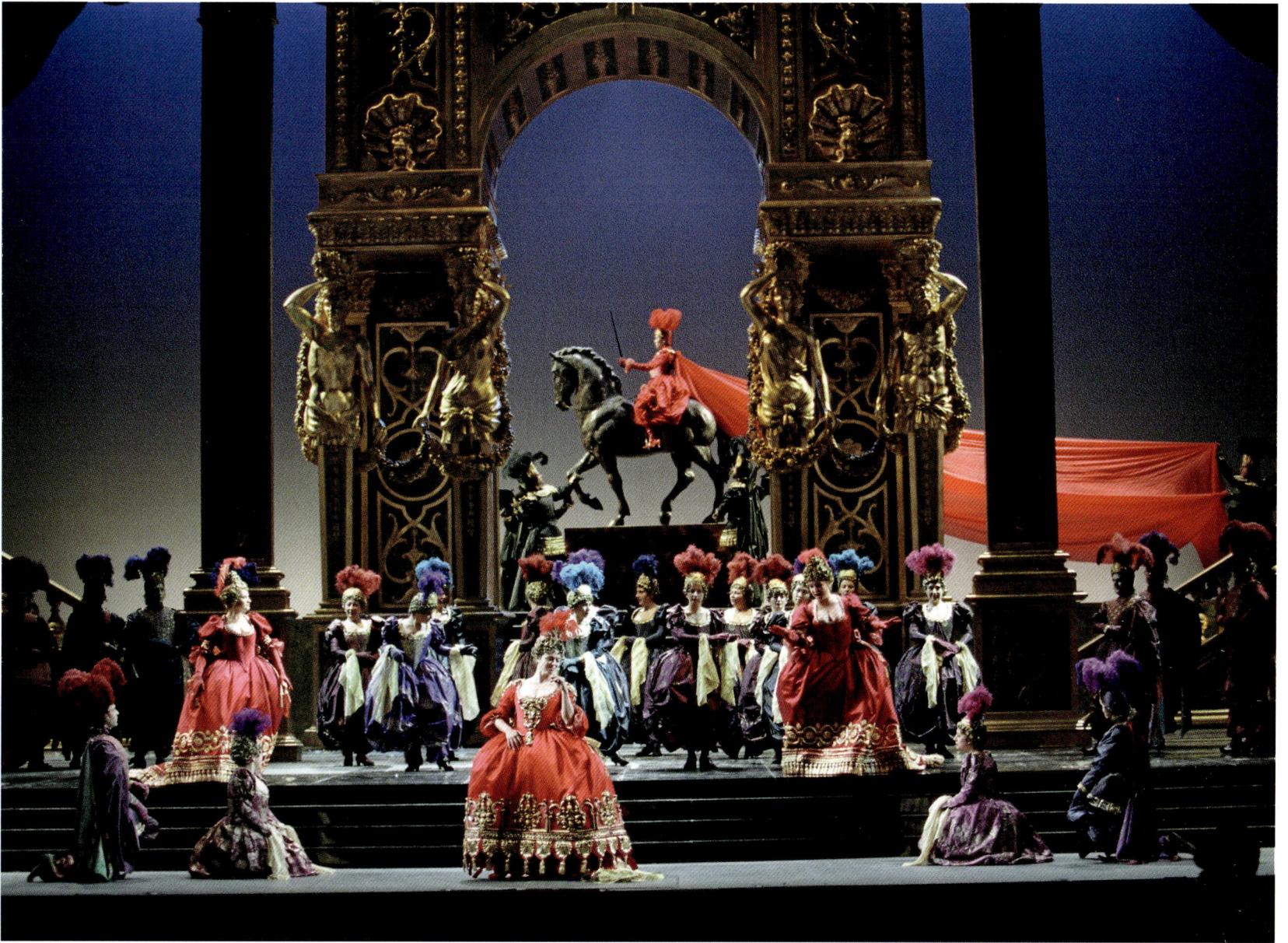

PIER LUIGI PIZZI

Armide
by Christoph Willibald Gluck, 1996
Directed by Pier Luigi Pizzi

Anna Caterina Antonacci
Photos by Lelli and Masotti
© Teatro alla Scala

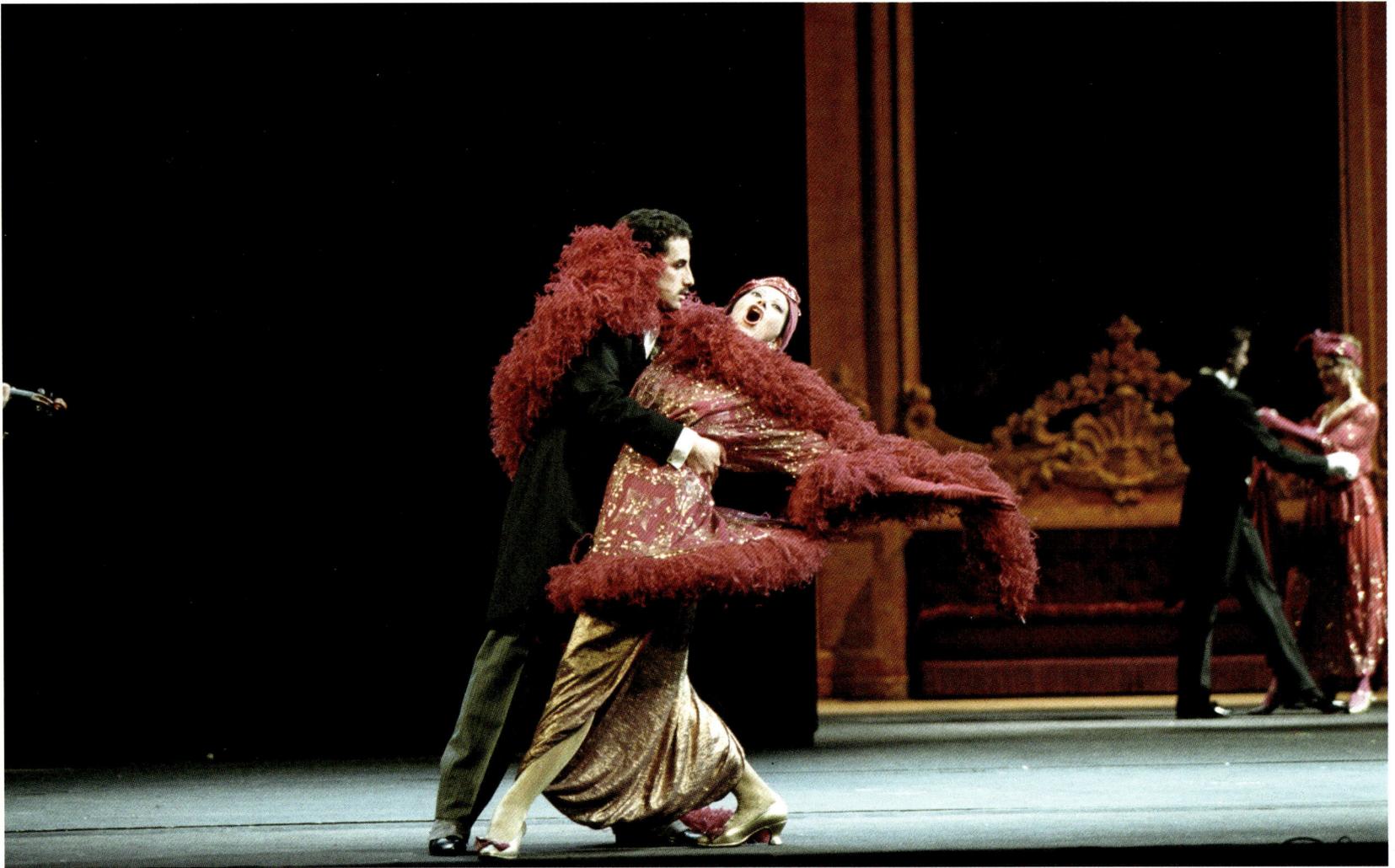

PIER LUIGI PIZZI

Il cappello di paglia di Firenze
[The Italian Straw Hat]
by Nino Rota, 1998
Directed by Pier Luigi Pizzi

Juan Diego Flórez
and Francesca Franci
Photo by Andrea Tamoni
© Teatro alla Scala

The first edition of the production
was staged at the Teatro Romolo Valli
in Reggio Emilia in 1987

Il turco in Italia [The Turk in Italy]
by Gioachino Rossini, 1998
Directed by Pier Luigi Pizzi

Ángeles Blanca Gulín
and Michele Pertusi
Photo by Claude MacBurnie

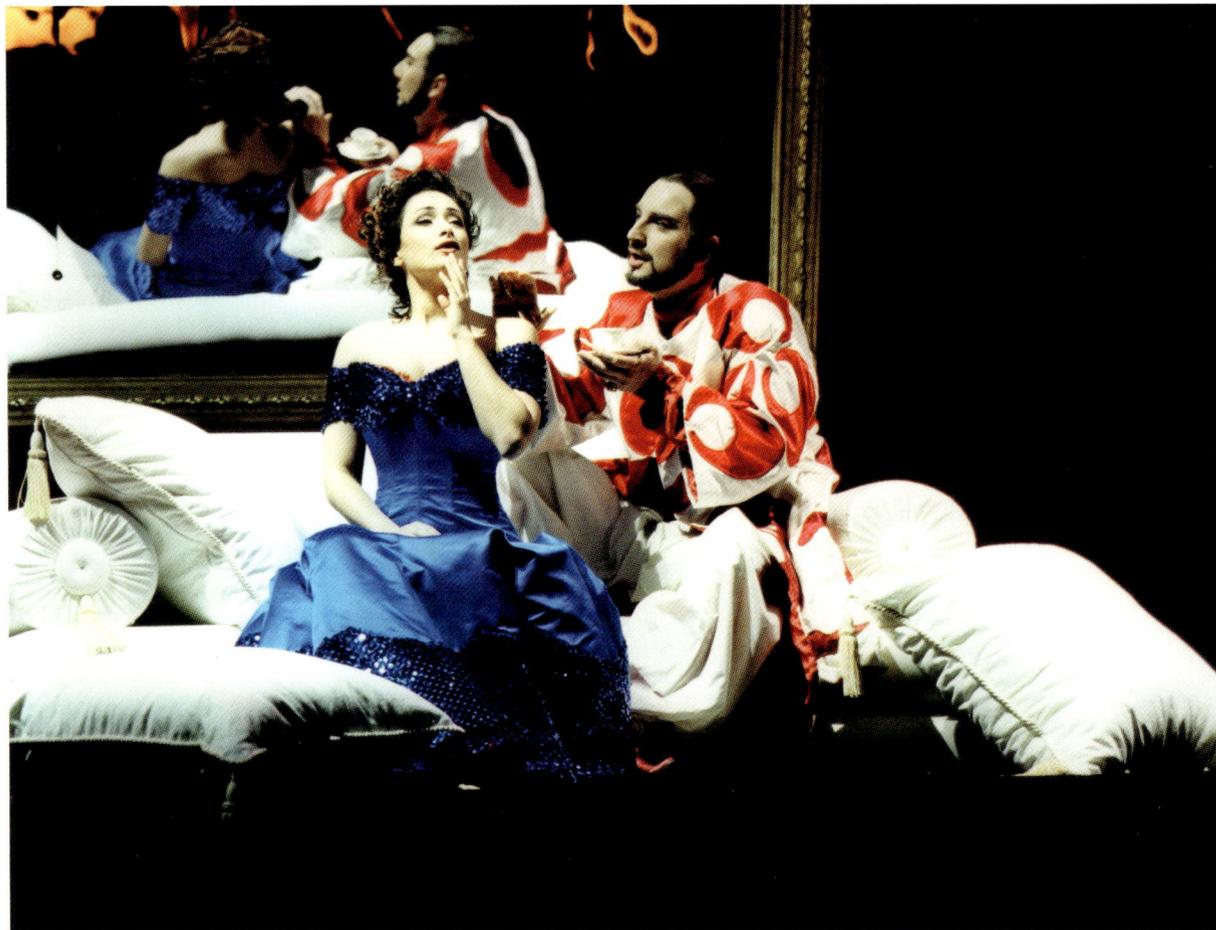

PIER LUIGI PIZZI

Orfeo
by Antonio Sartorio, 2005
Directed by Pier Luigi Pizzi

José Ferrero

Below, Corinna Mologni

The first edition of the production
was staged at the Teatro della Fortuna
in Fano in 1999

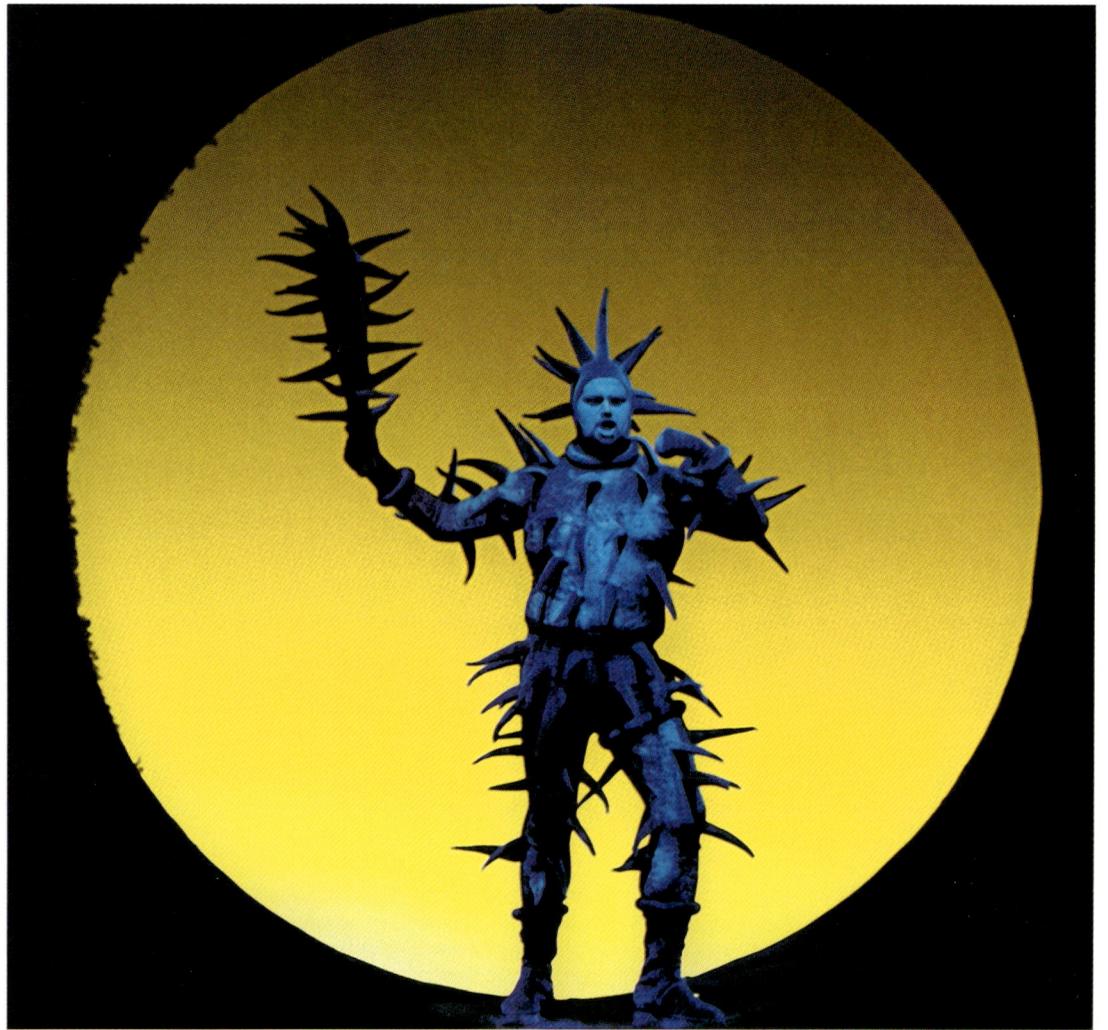

Following pages

PIER LUIGI PIZZI

Die Zauberflöte [The Magic Flute]
by Wolfgang Amadeus Mozart, 2006
Directed by Pier Luigi Pizzi

Victoria Joyce
and Angeles Blancas Gulin
Photo by Alfredo Tabocchini

Le domino noir [The Black Domino]
by Daniel Auber, 2003
Directed by Pier Luigi Pizzi

Photo by Michele Crosera – Archivio
Storico del Teatro La Fenice

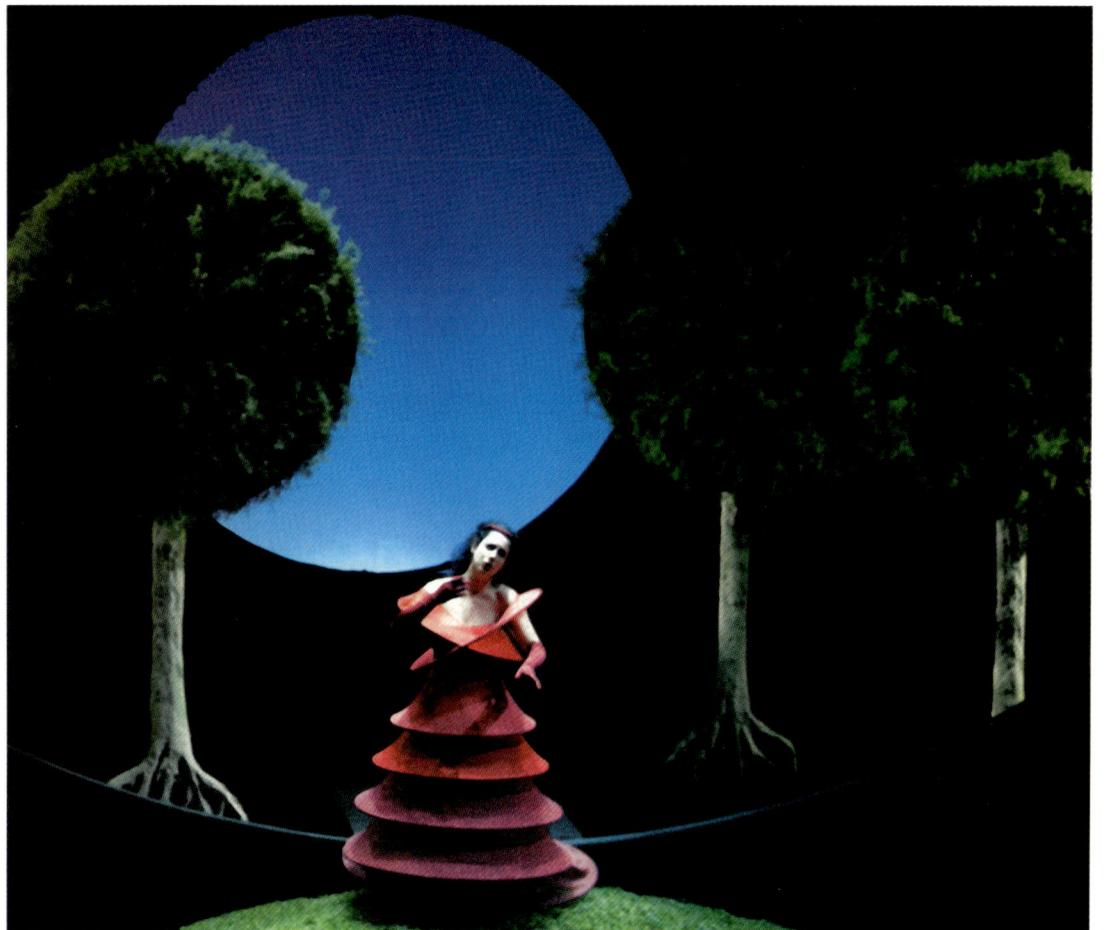

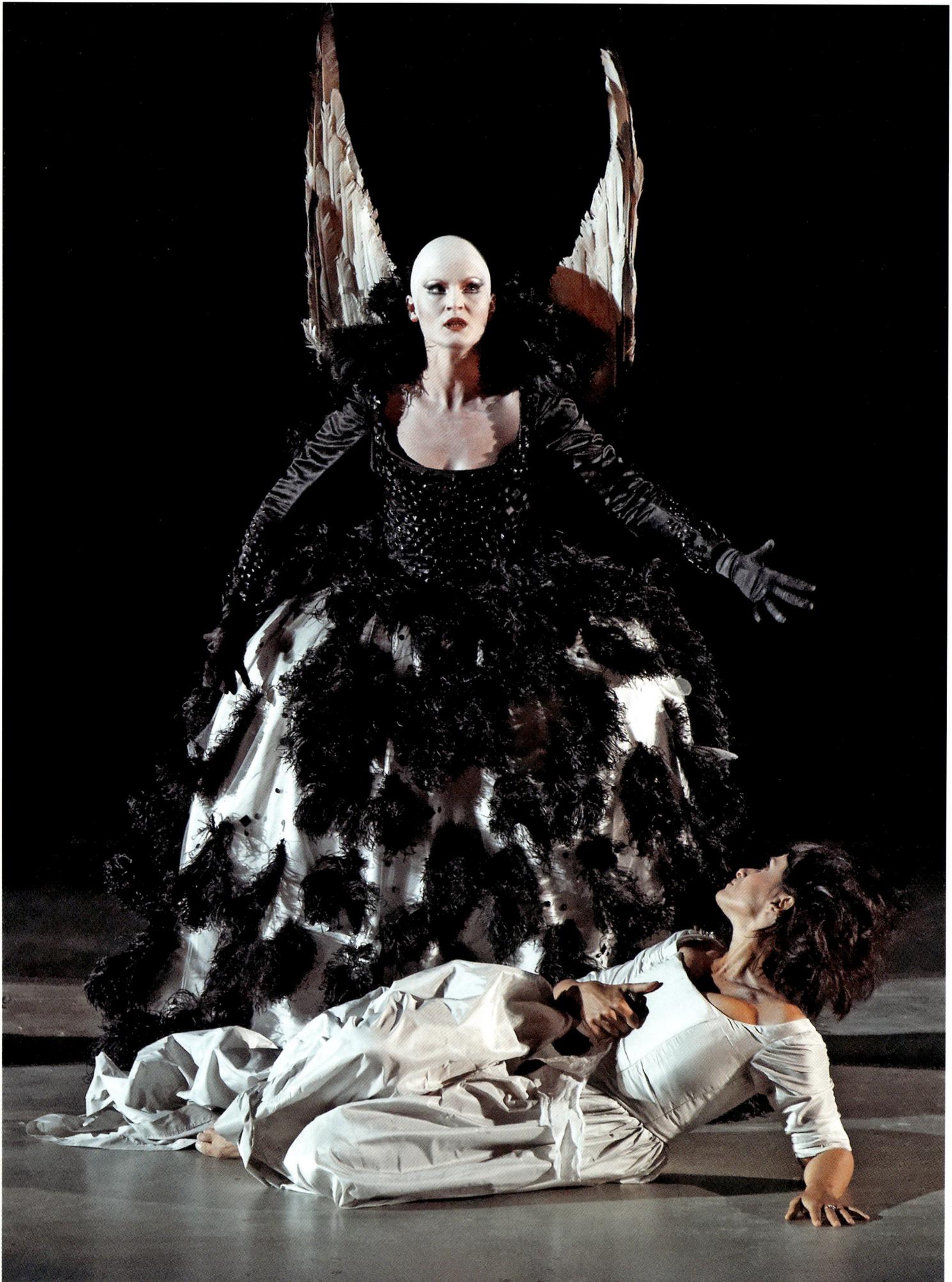

CIN

EMA

LILA DE NOBILI

The Charge of the Light Brigade, 1968
Directed by Tony Richardson

Study for the set. As a costume
designer, Lila de Nobili was mostly
active in the theatre. This was
one of her rare – and uncredited –
collaborations in cinema

Che cosa sono le nuvole?
[What Are Clouds?], episode from
*Capriccio all'italiana [Caprice
Italian Style]*, 1968
Directed by Pier Paolo Pasolini

Study for the characters

Below left,
Totò and Ninetto Davoli

Below right, Totò and Ciccio Ingrassia
Reporters Associati & Archivi

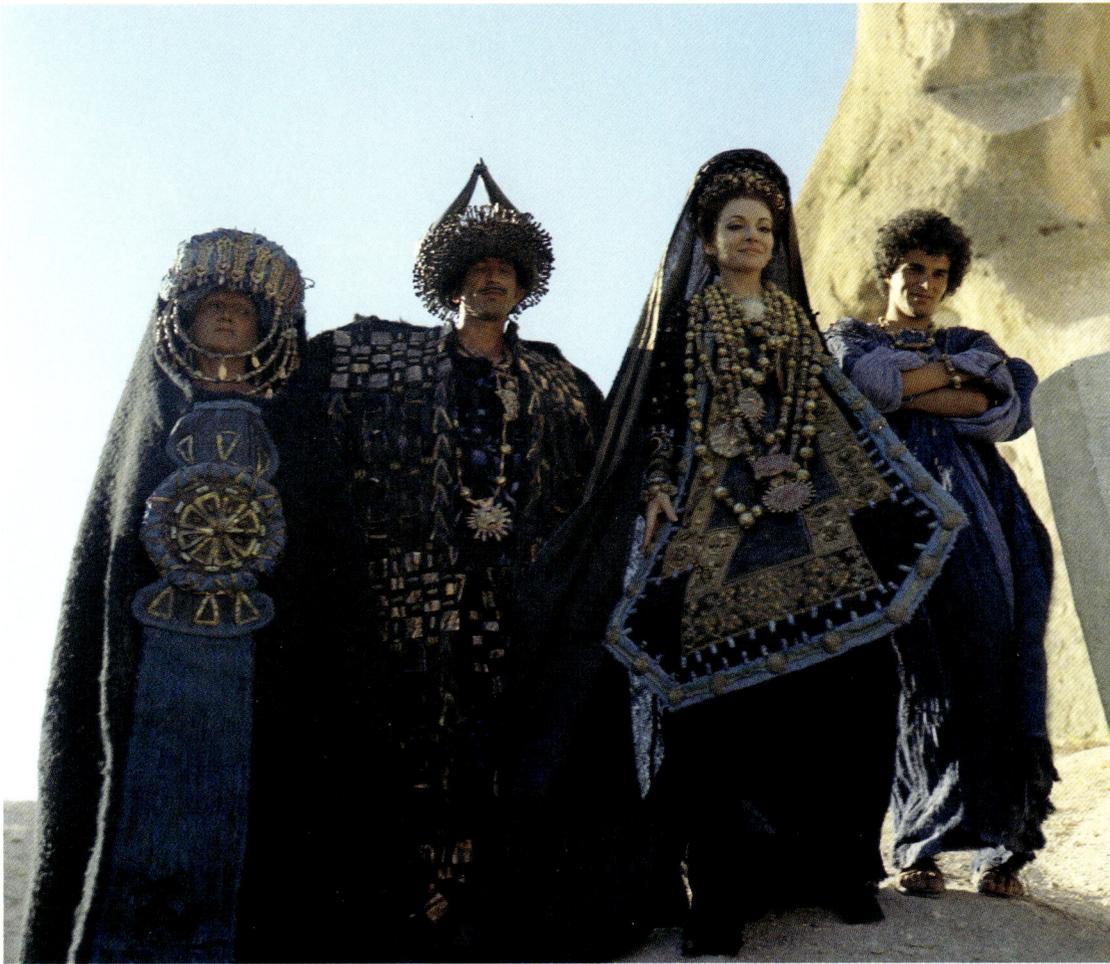

PIERO TOSI

Medea, 1969
Directed by Pier Paolo Pasolini

Maria Callas
Photos by Mario Tursi – Archivio
Storico del Cinema – AFE

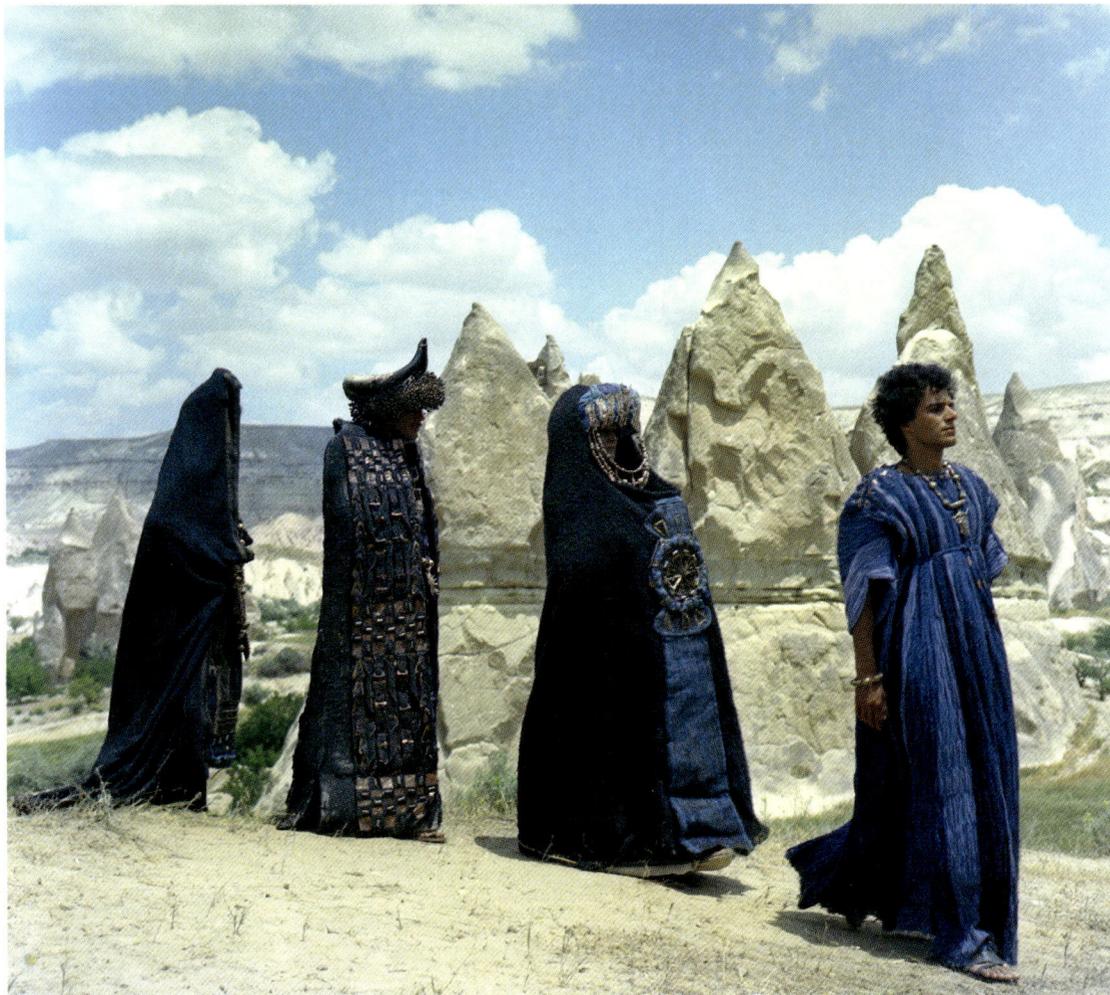

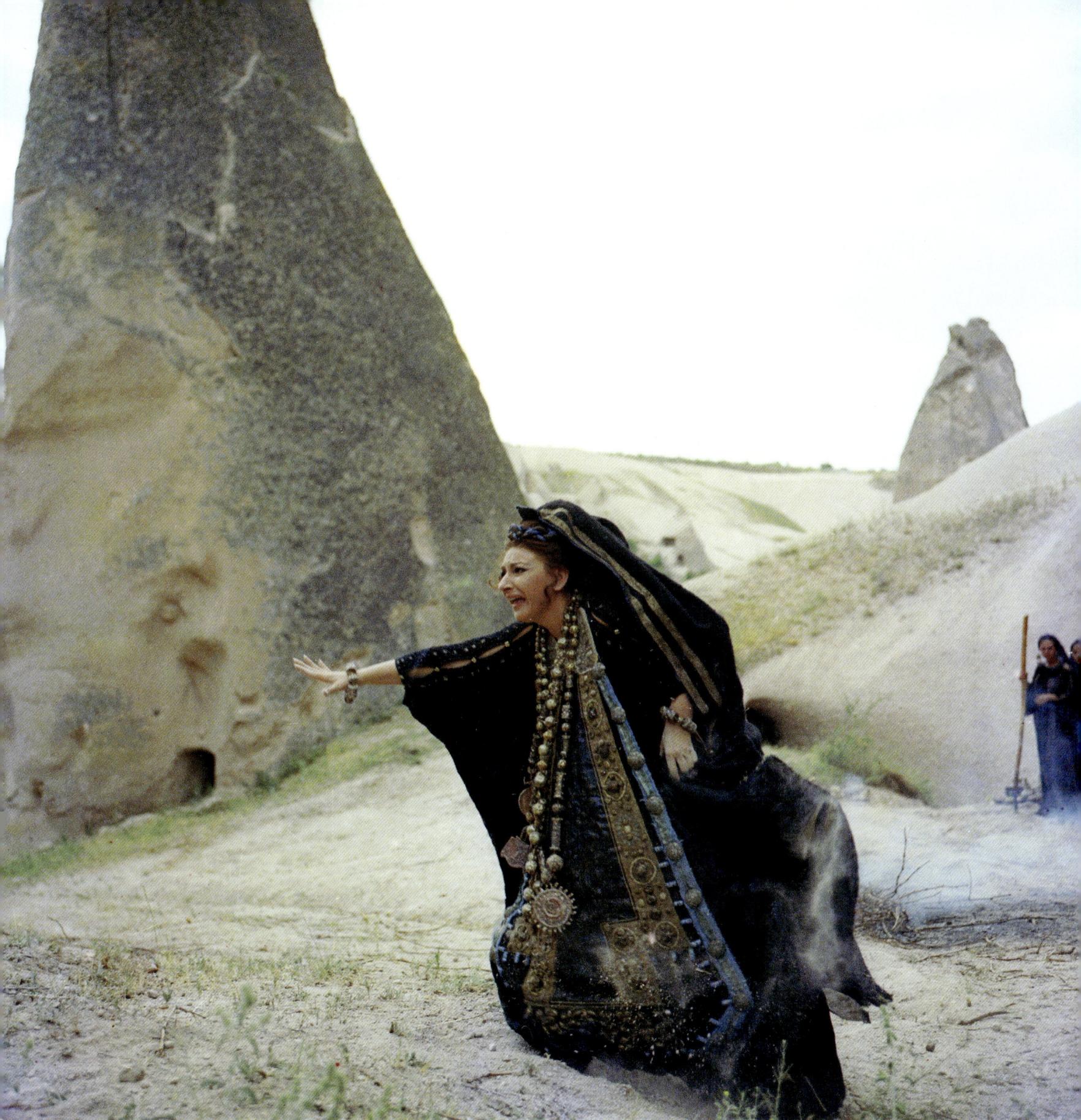

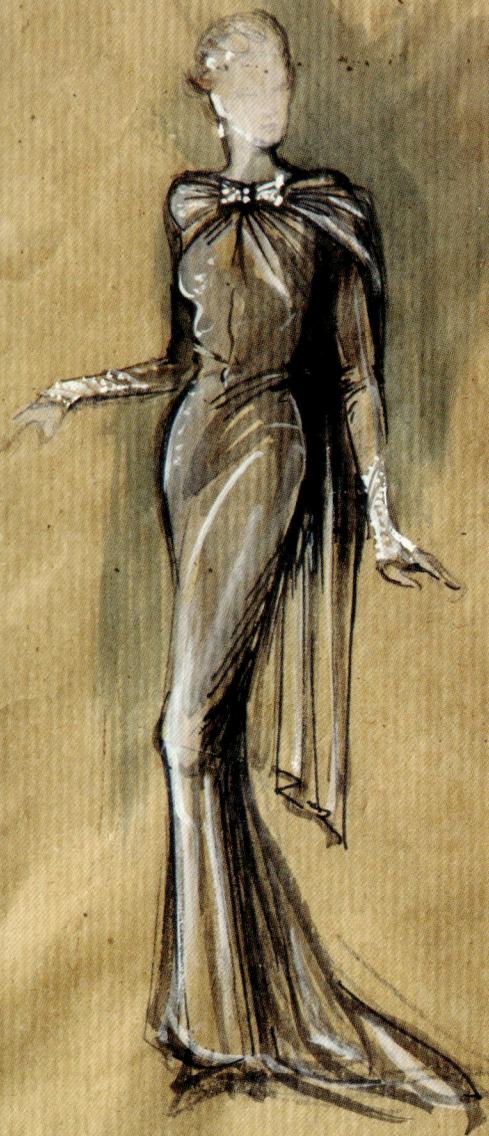

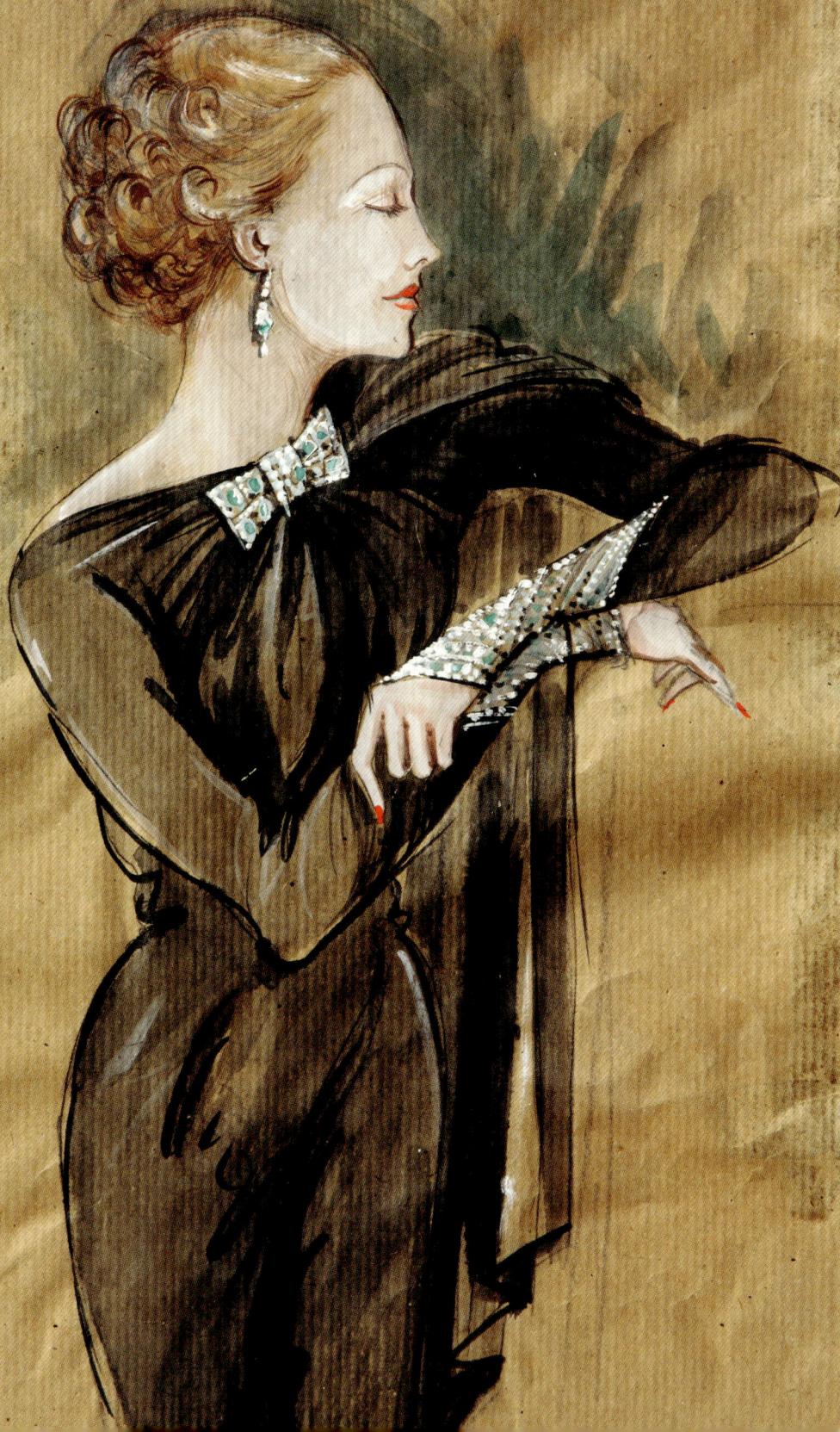

2ª PRANZO

PIERO TOSI

La caduta degli dei
[The Damned], 1969
Directed by Luchino Visconti

Opposite, study for Sophie
(Ingrid Thulin)

Ingrid Thulin

Below, the dinner that brings the
opening sequence to a close, in which
all the characters are introduced:
around the table, Albrecht Schoenhals,
Helmut Griem, Renaud Verley,
Nora Ricci, Reinhard Kolldehoff,
Ingrid Thulin, Umberto Orsini,
Dirk Bogarde, Helmut Berger
and Charlotte Rampling
Photos by Mario Tursi – Archivio
Storico del Cinema – AFE

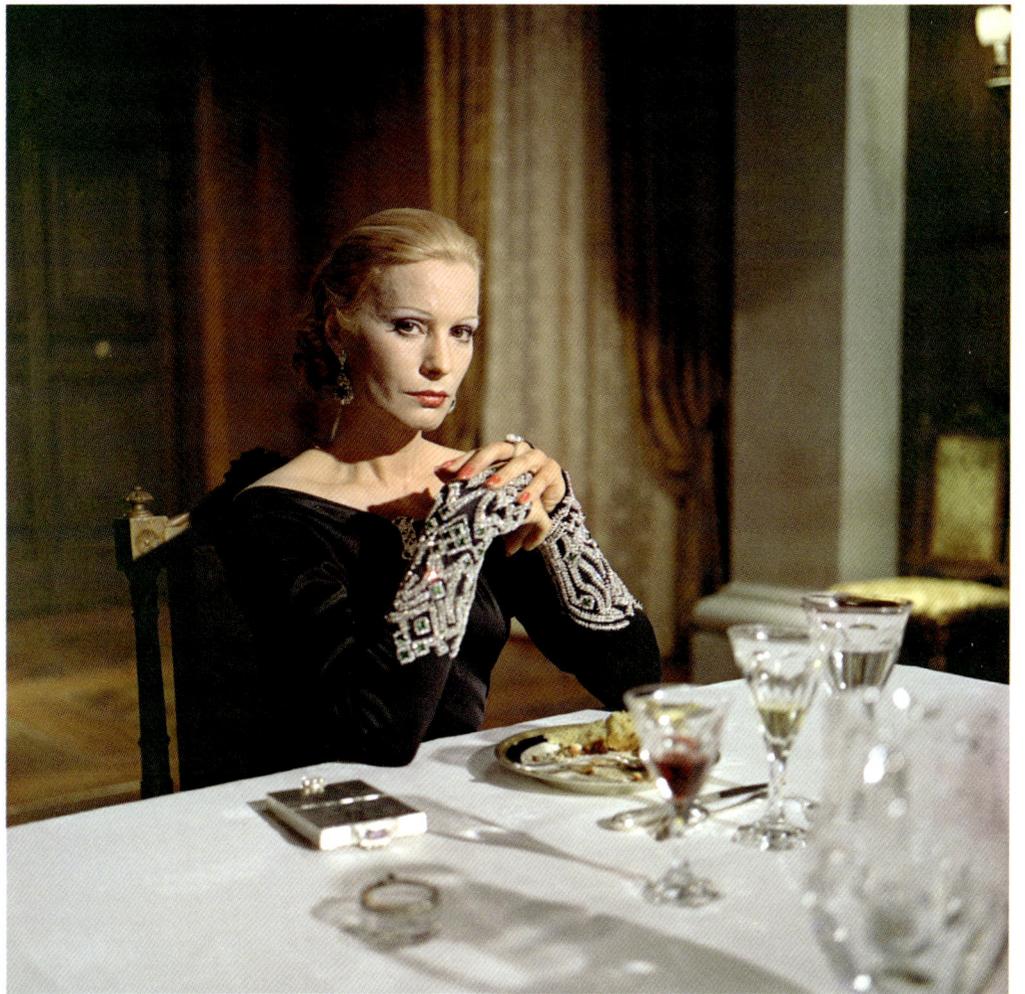

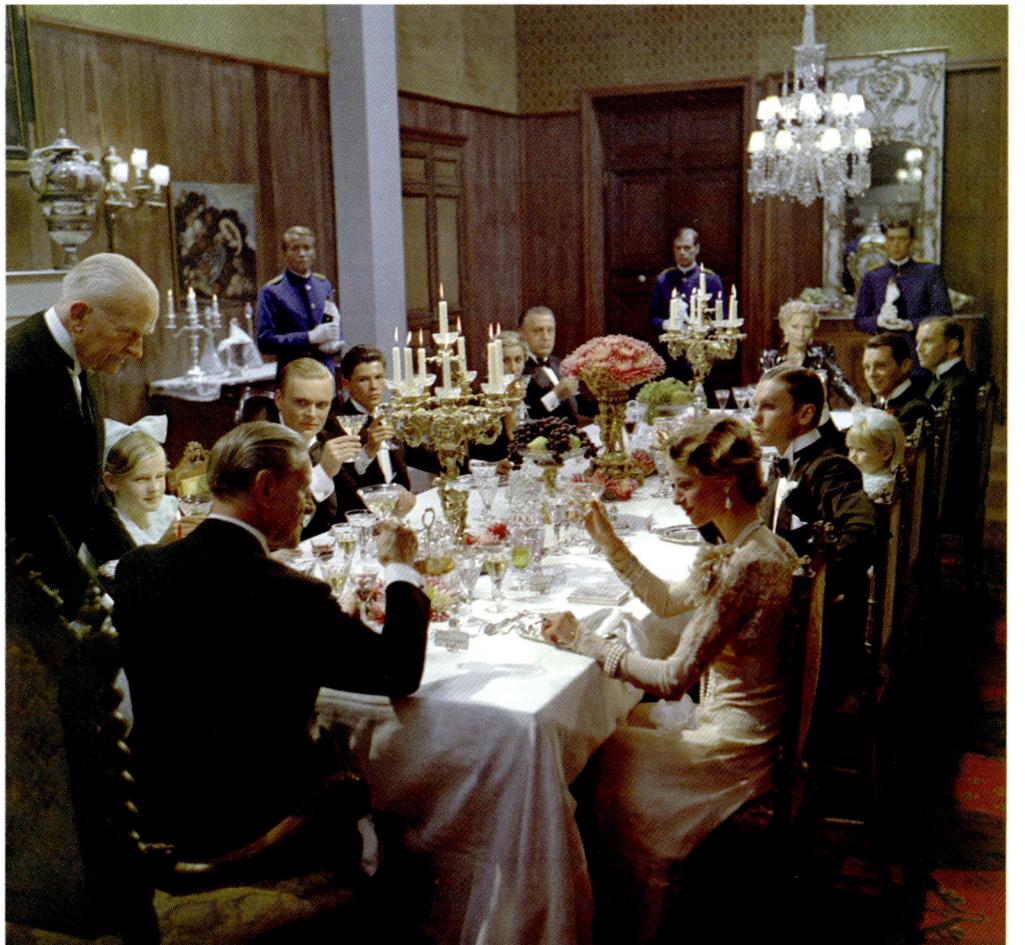

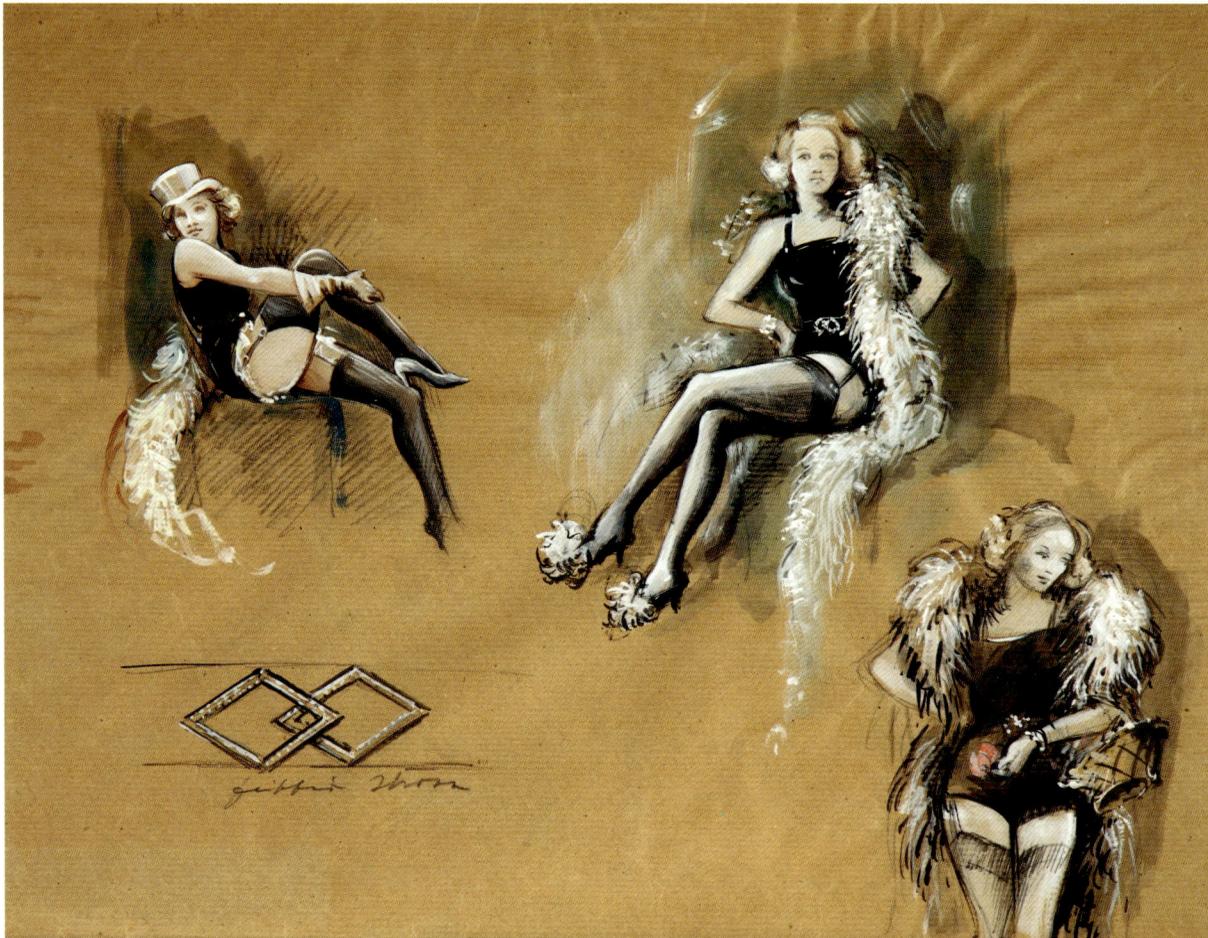

Study for the drag costume worn by Martin (Helmut Berger)

Below, Helmut Berger performing at the baron's birthday celebration

Opposite, Ingrid Thulin and Dirk Bogarde in the finale
Photos by Mario Tursi – Archivio Storico del Cinema – AFE

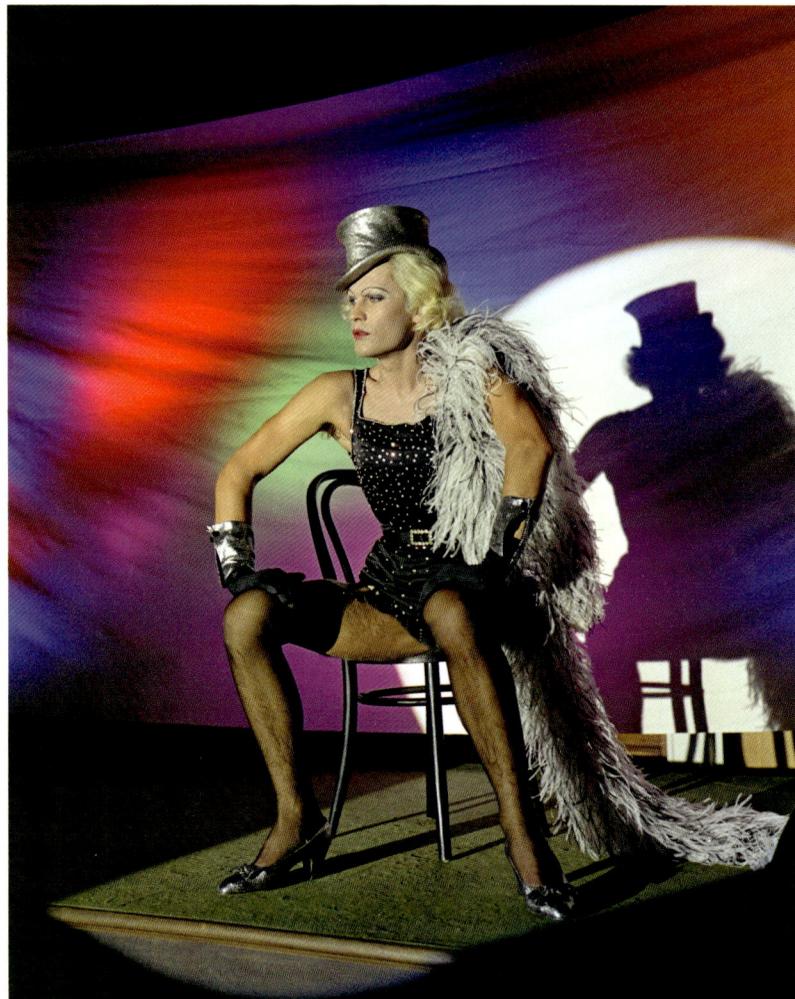

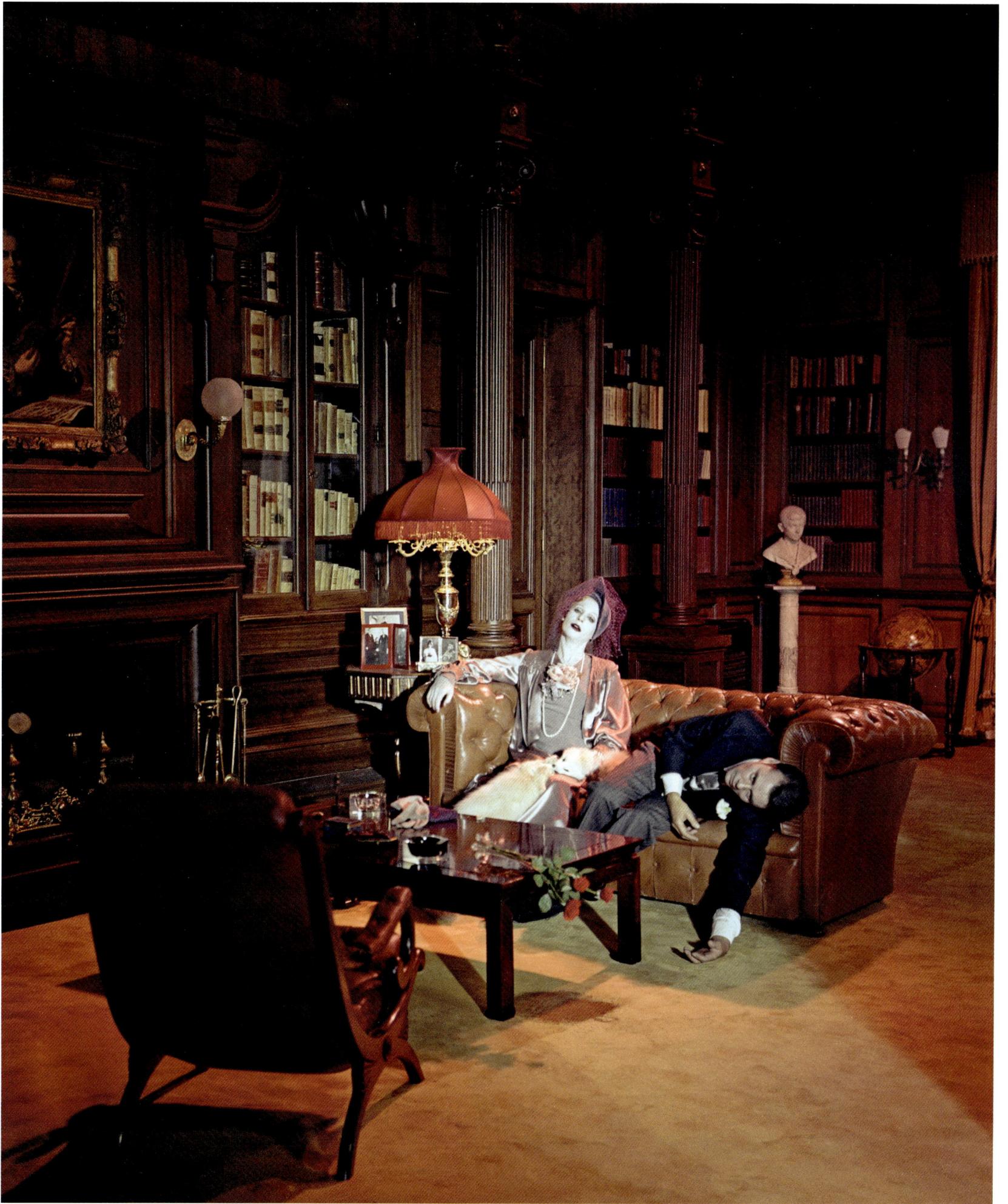

PIERO TOSI

Morte a Venezia [Death in Venice],
1971
Directed by Luchino Visconti

The beach

Below left, Dirk Bogarde
and Björn Andrésen

Below right, Silvana Mangano and
Björn Andrésen

Opposite, Silvana Mangano
Photos by Mario Tursi – Archivio
Storico del Cinema – AFE

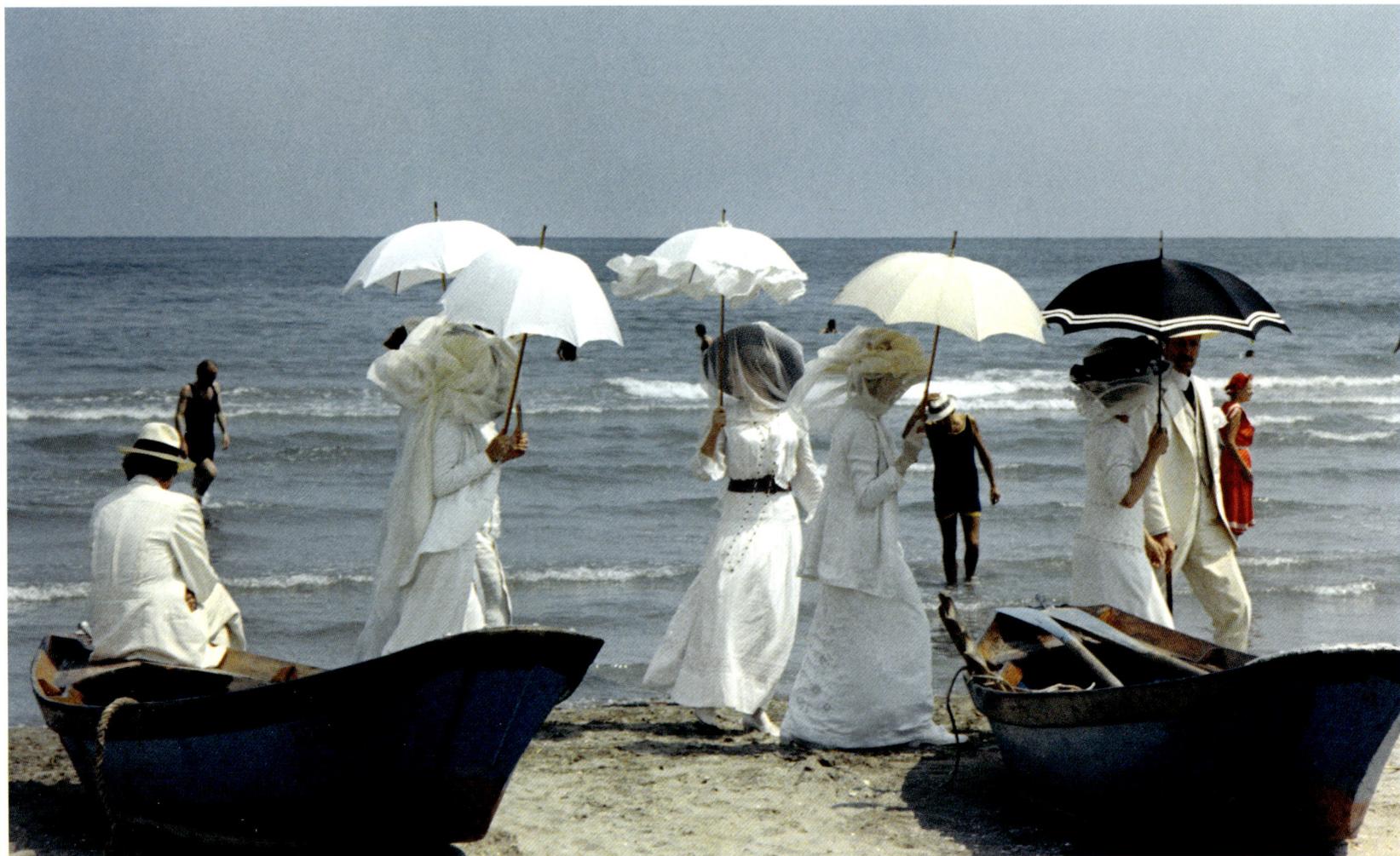

PIERO TOSI

Ludwig, 1973
Directed by Luchino Visconti

The coronation: Helmut Berger,
Umberto Orsini and Izabella
Telezynska

Opposite, the engagement: on the
sofa, Sonia Petrova and Anne-Marie
Hanschke
Photos by Mario Tursi – Archivio
Storico del Cinema – AFE

Following pages

Romy Schneider and Luchino Visconti
during filming

Romy Schneider and Nora Ricci
Photos by Mario Tursi – Archivio
Fotografico della Cineteca
Nazionale – Centro Sperimentale
di Cinematografia

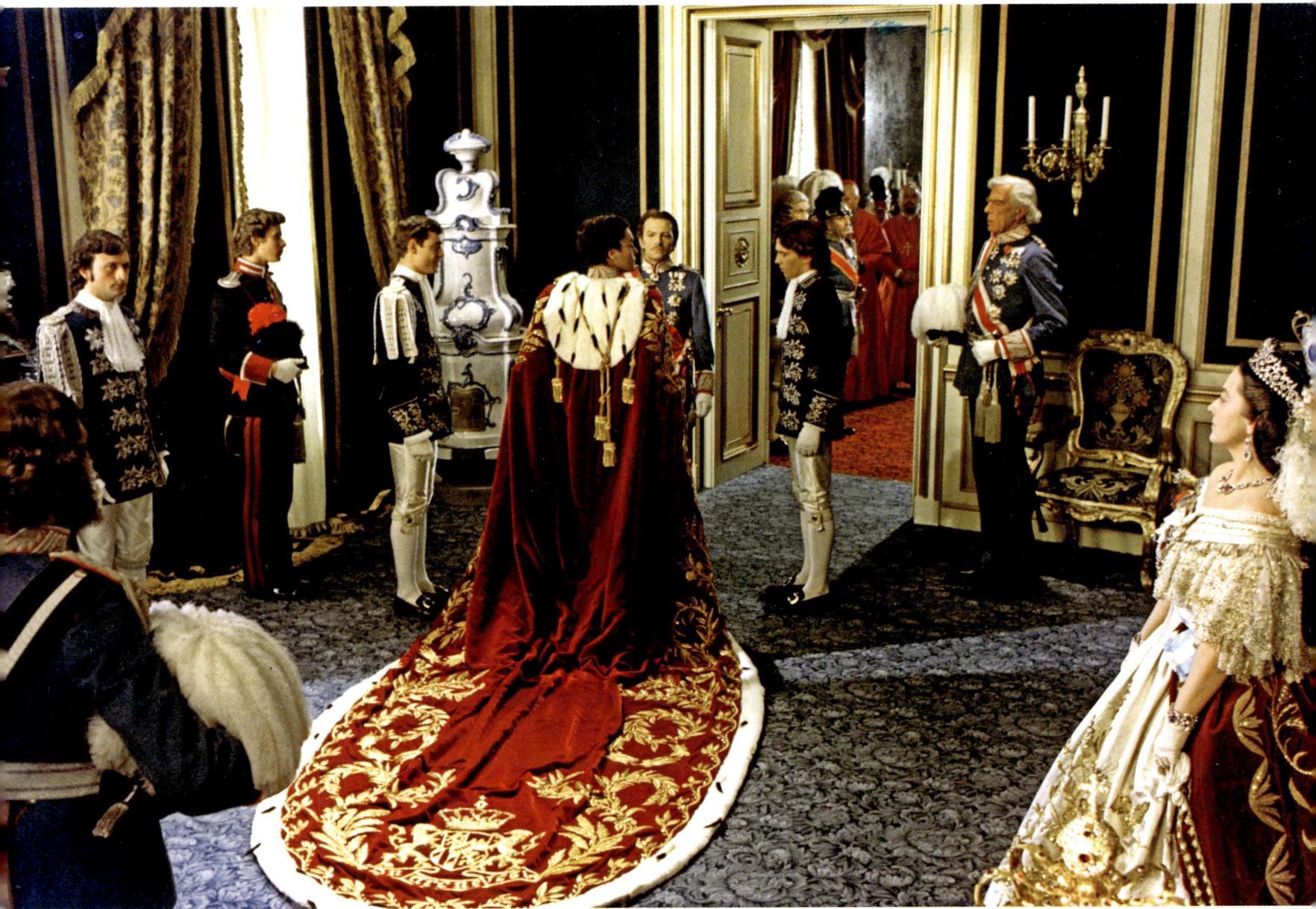

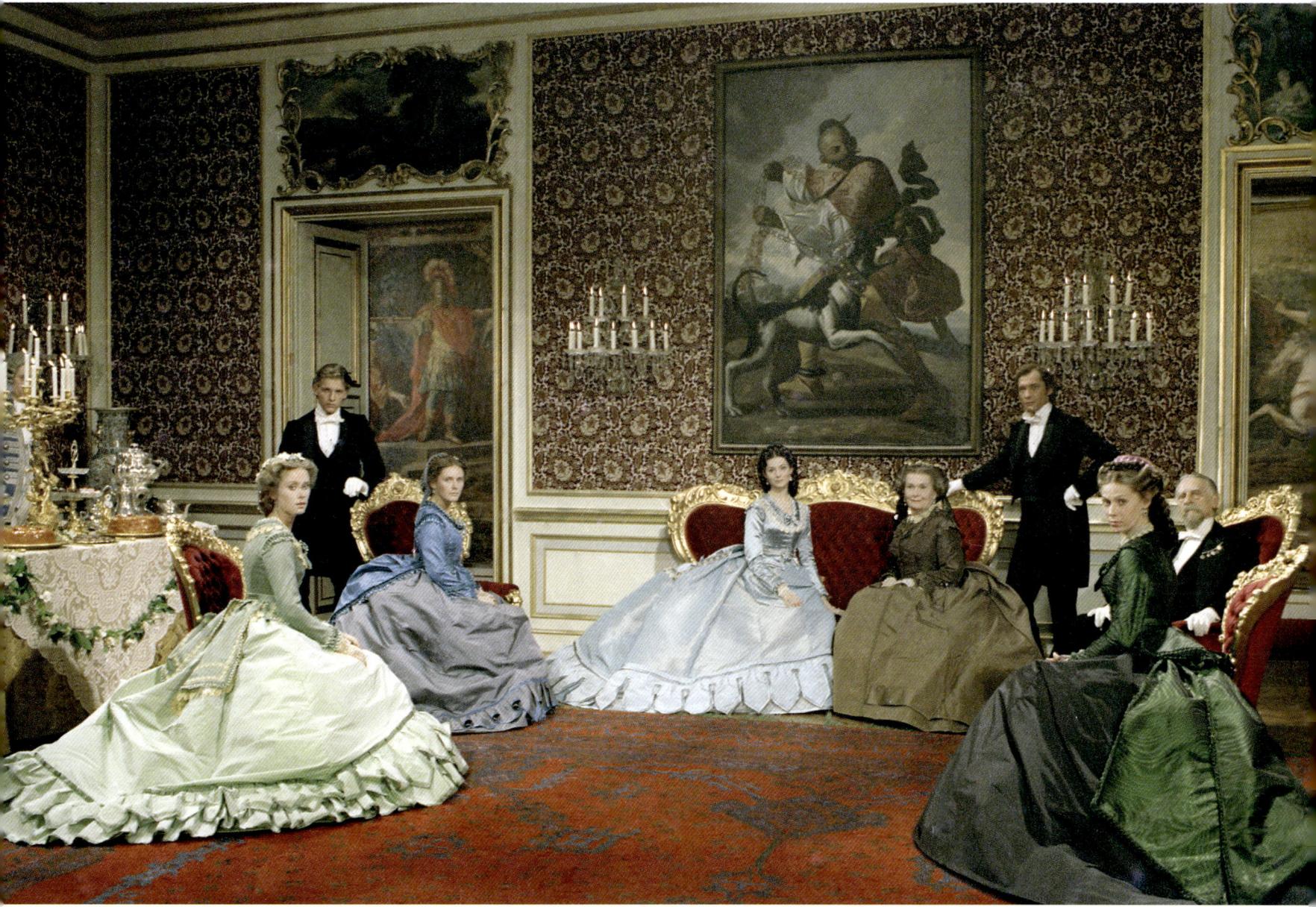

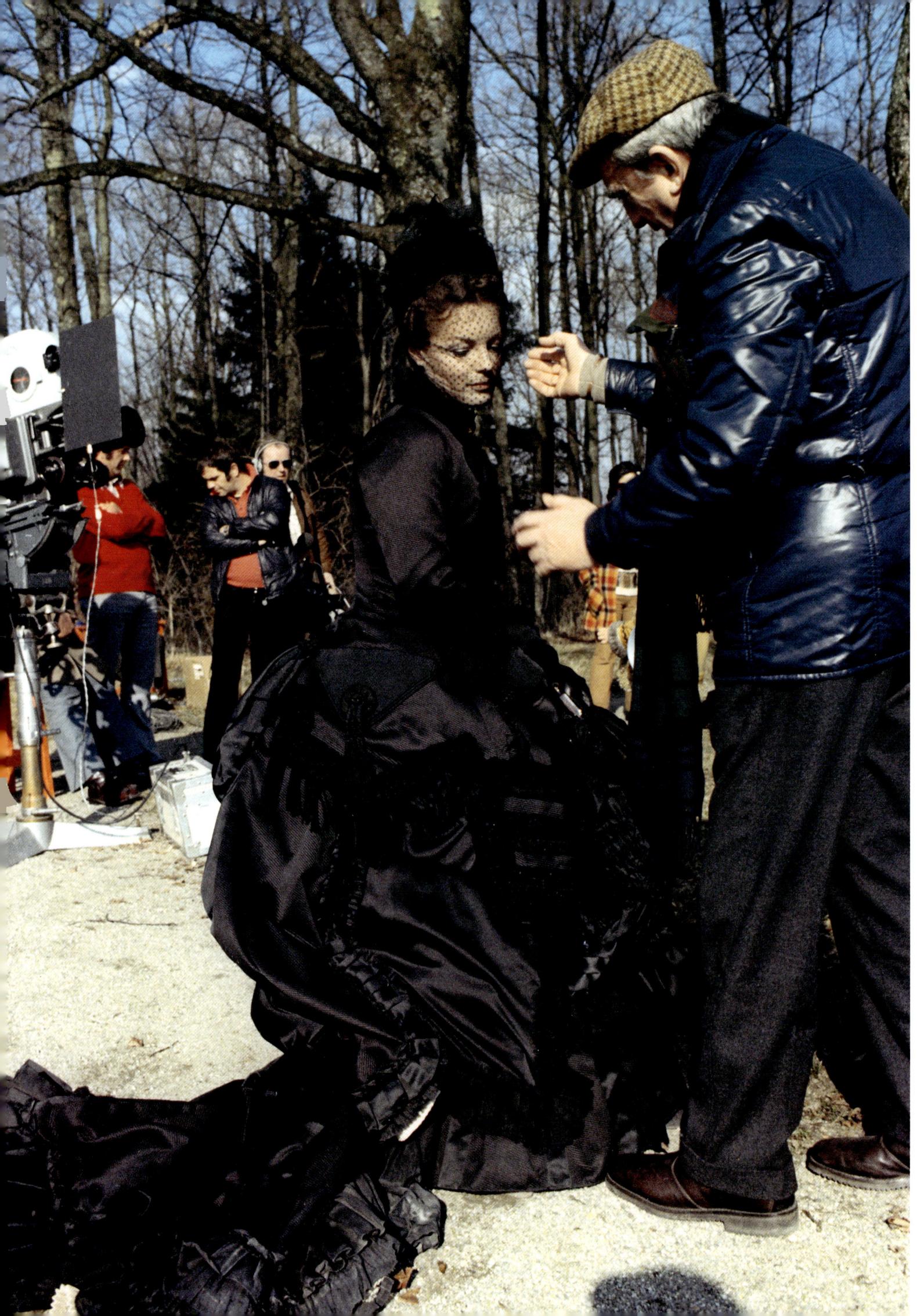

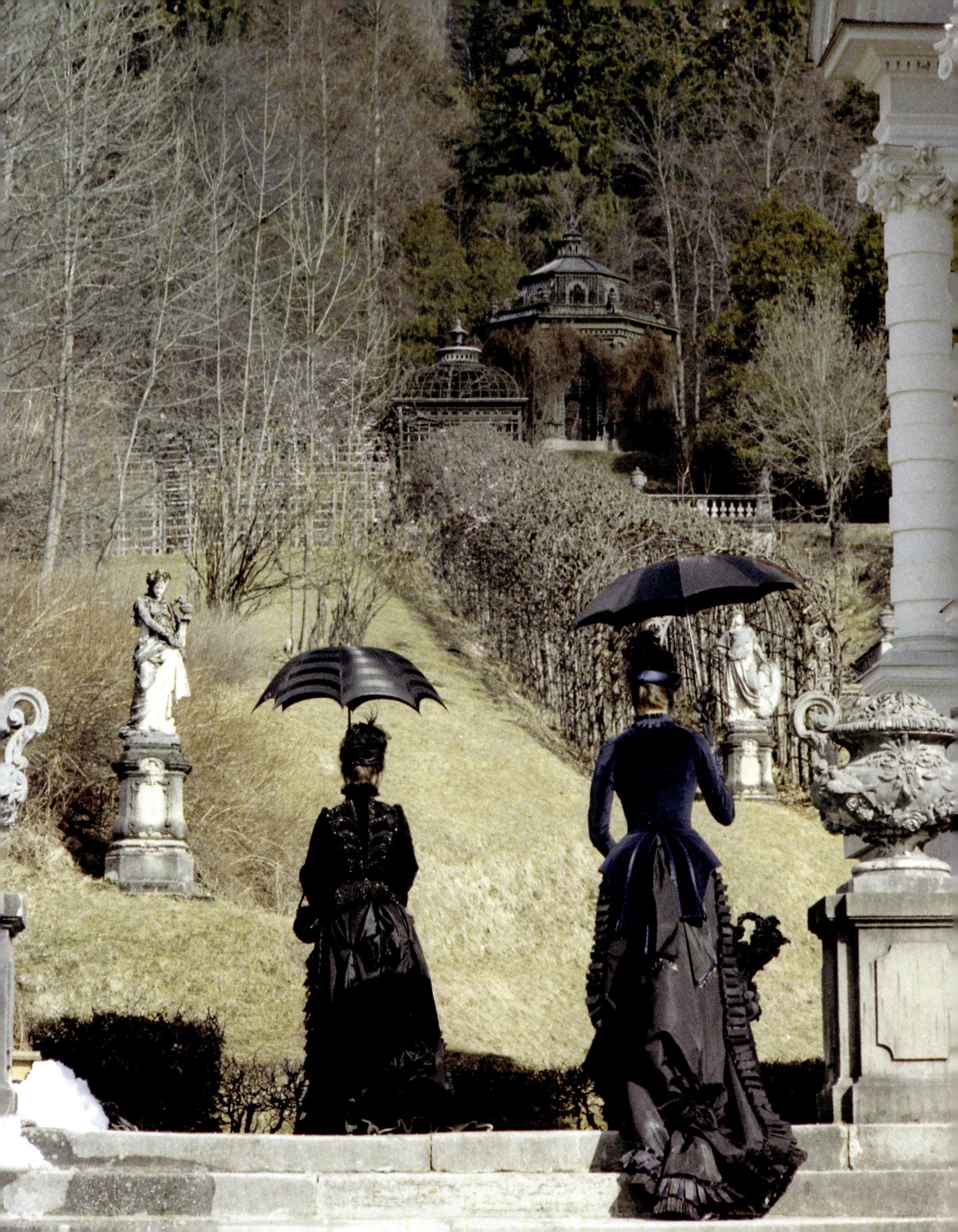

PIERO TOSI

Gruppo di famiglia in un interno
[Conversation Piece], 1974
Directed by Luchino Visconti

Claudia Cardinale
Photos by Mario Tursi

Following pages

PIERO TOSI

L'innocente [The Innocent], 1976
Directed by Luchino Visconti

Giancarlo Giannini
and Laura Antonelli
Photo by Mario Tursi – Archivio
Storico del Cinema – AFE

The concert: on the sofa, Marie Dubois
and Laura Antonelli

Below, Jennifer O'Neill
Photos by Mario Tursi – Archivio
Fotografico della Cineteca Nazionale –
Centro Sperimentale di Cinematografia

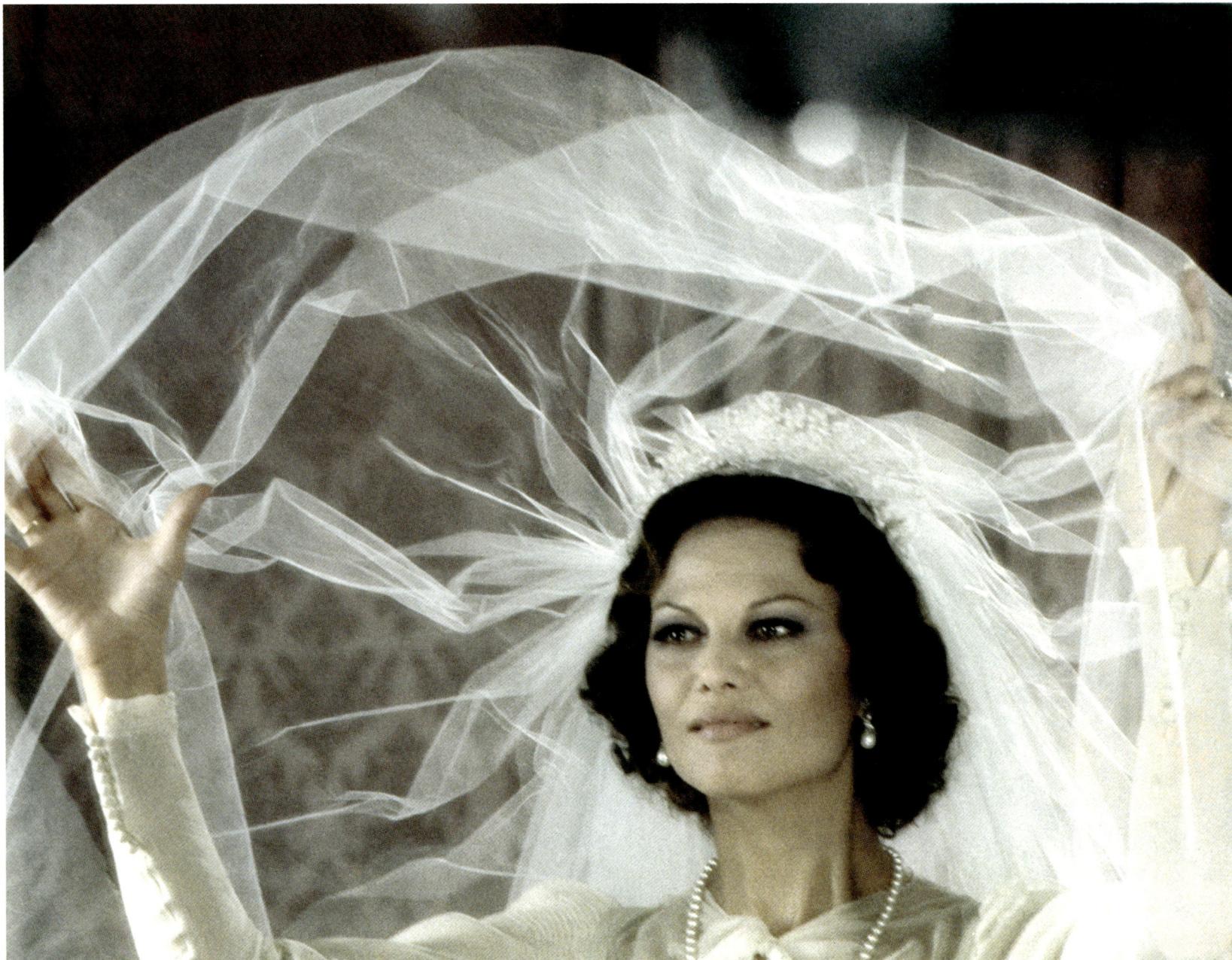

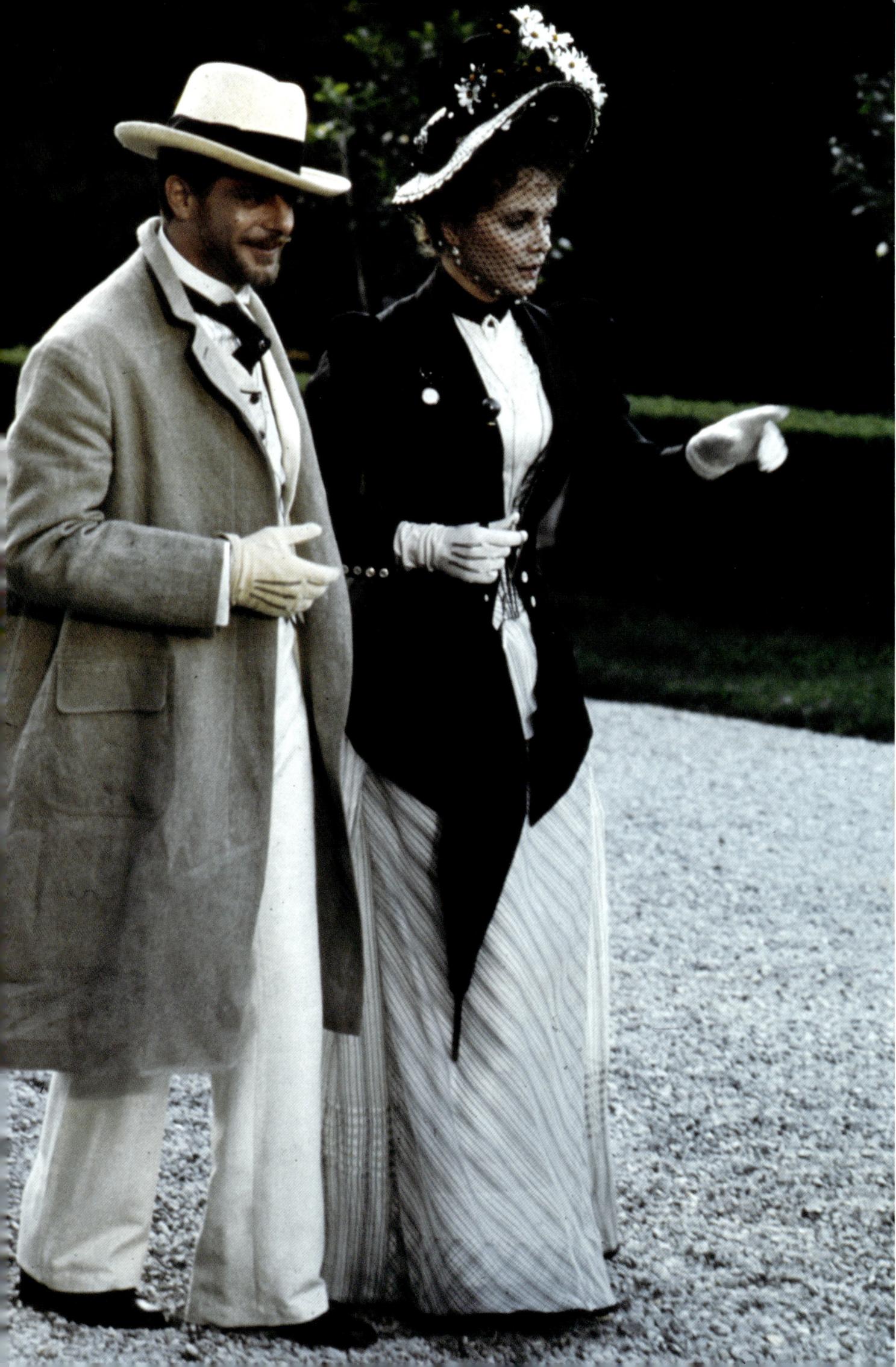

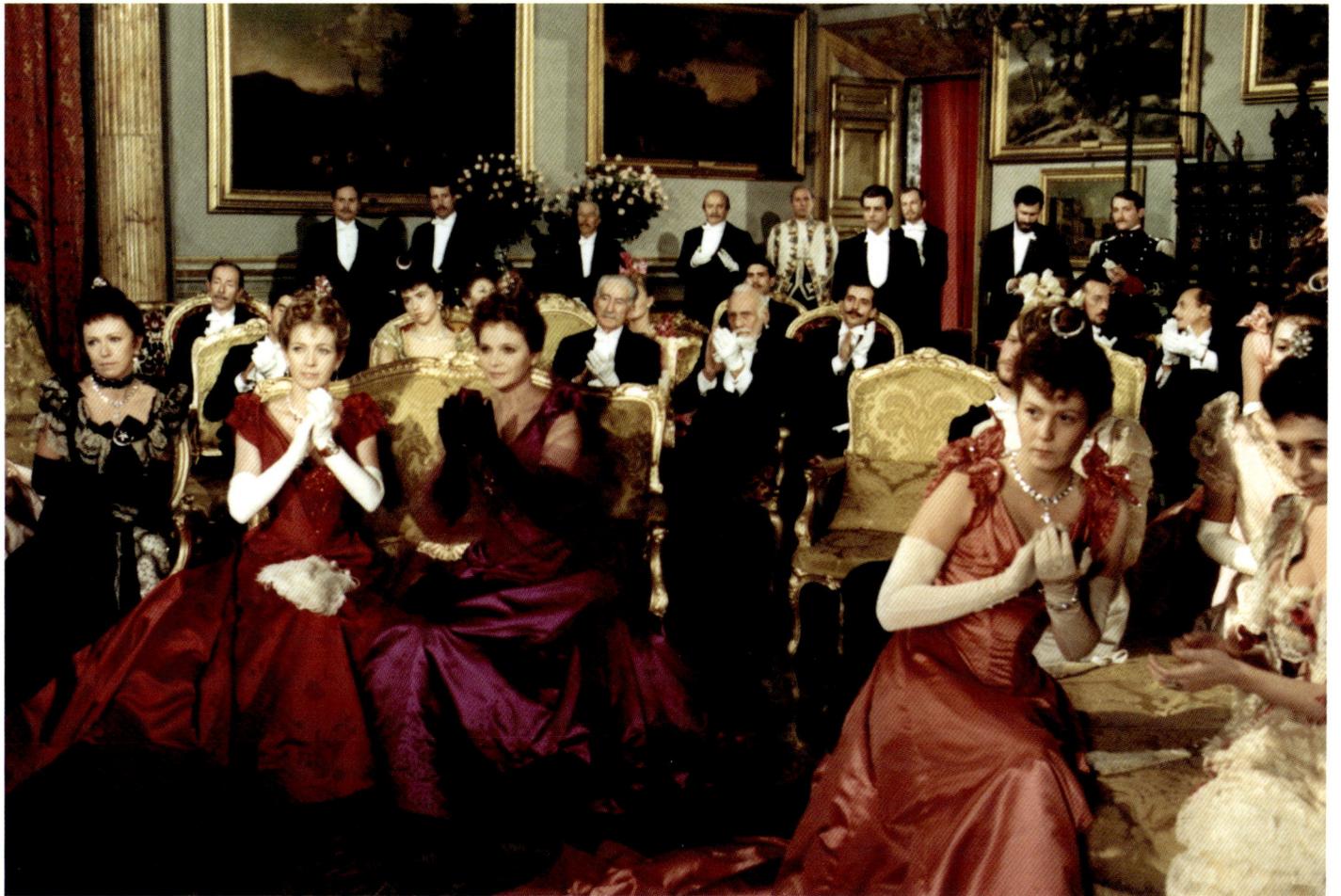

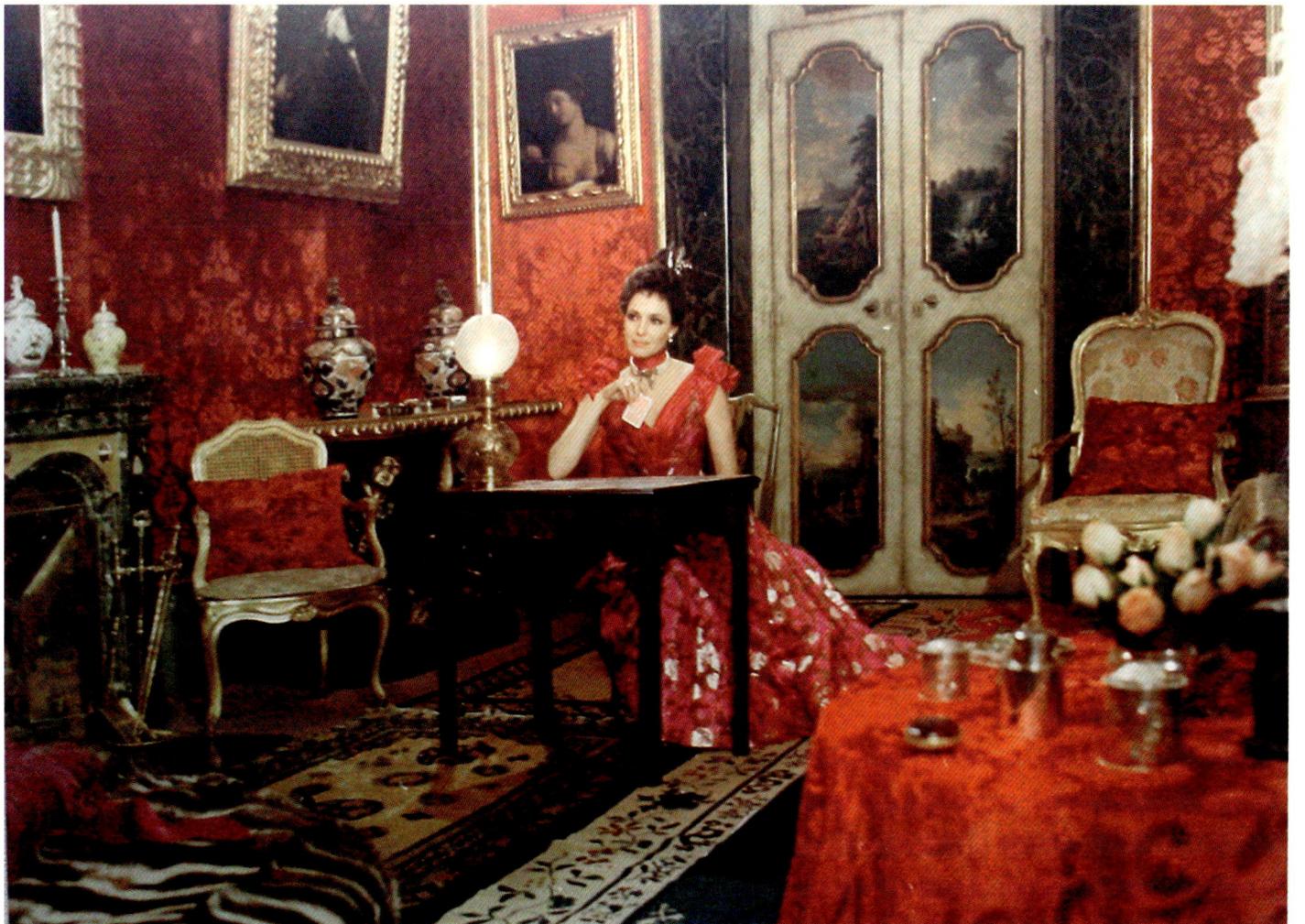

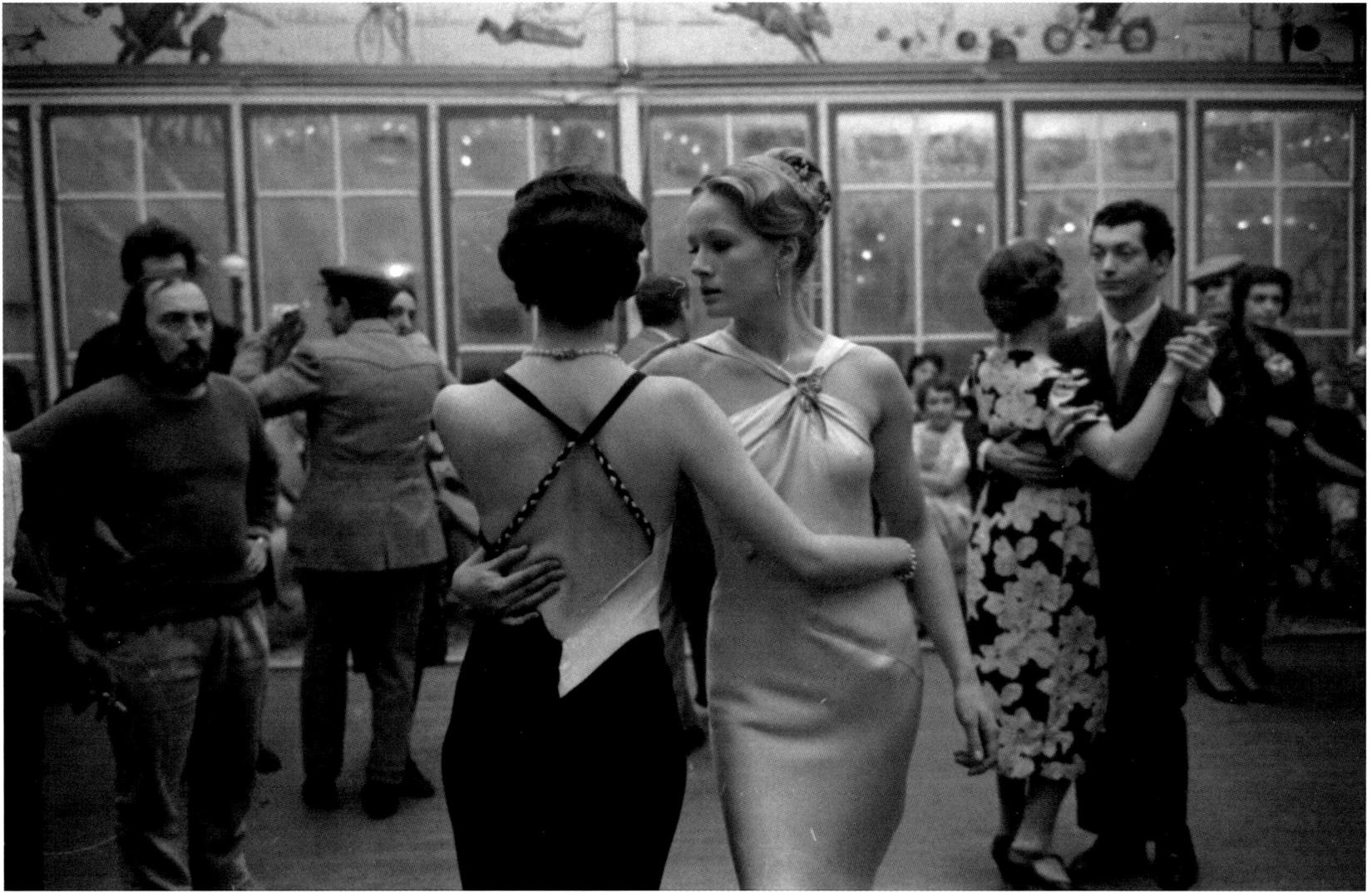

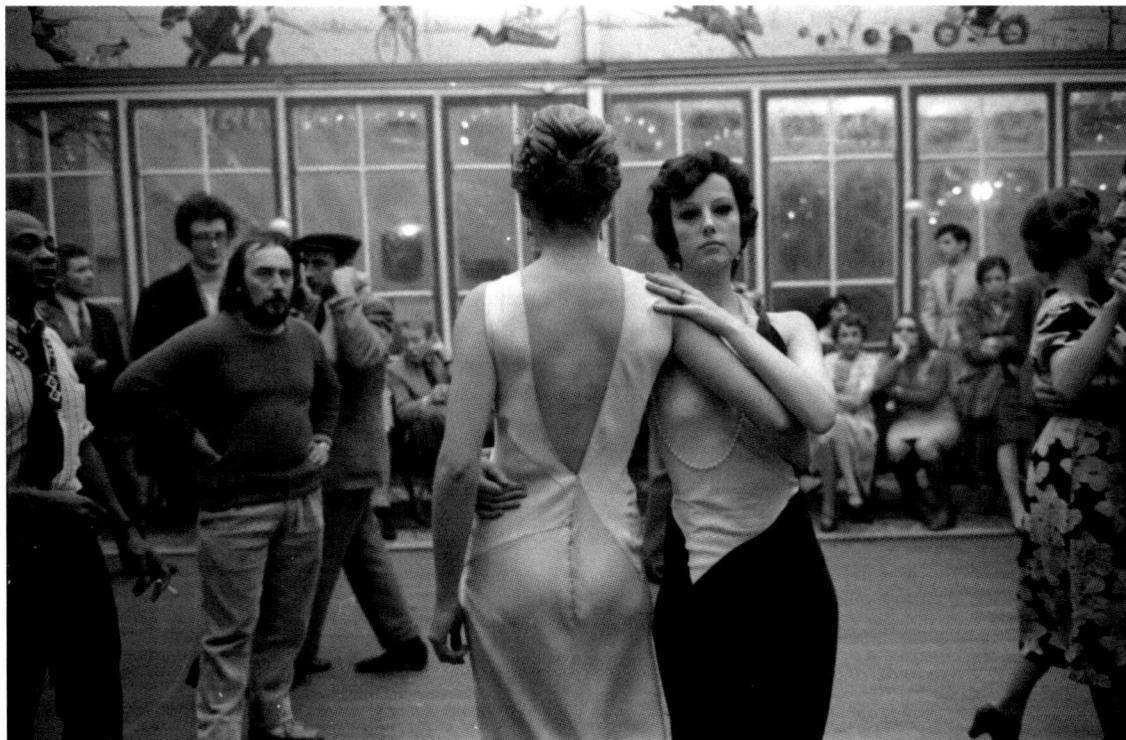

GITT MAGRINI

Il conformista [The Conformist], 1970
Directed by Bernardo Bertolucci

Two shots of Stefania Sandrelli and
Dominique Sanda during filming

Opposite, Stefania Sandrelli
and Dominique Sanda; on the right,
Bernardo Bertolucci
Photos by Angelo Novi – Cineteca
di Bologna

Novecento [1900], 1976
Directed by Bernardo Bertolucci

Dominique Sanda, photo with
dedication to Umberto Tirelli
Photo by Angelo Novi

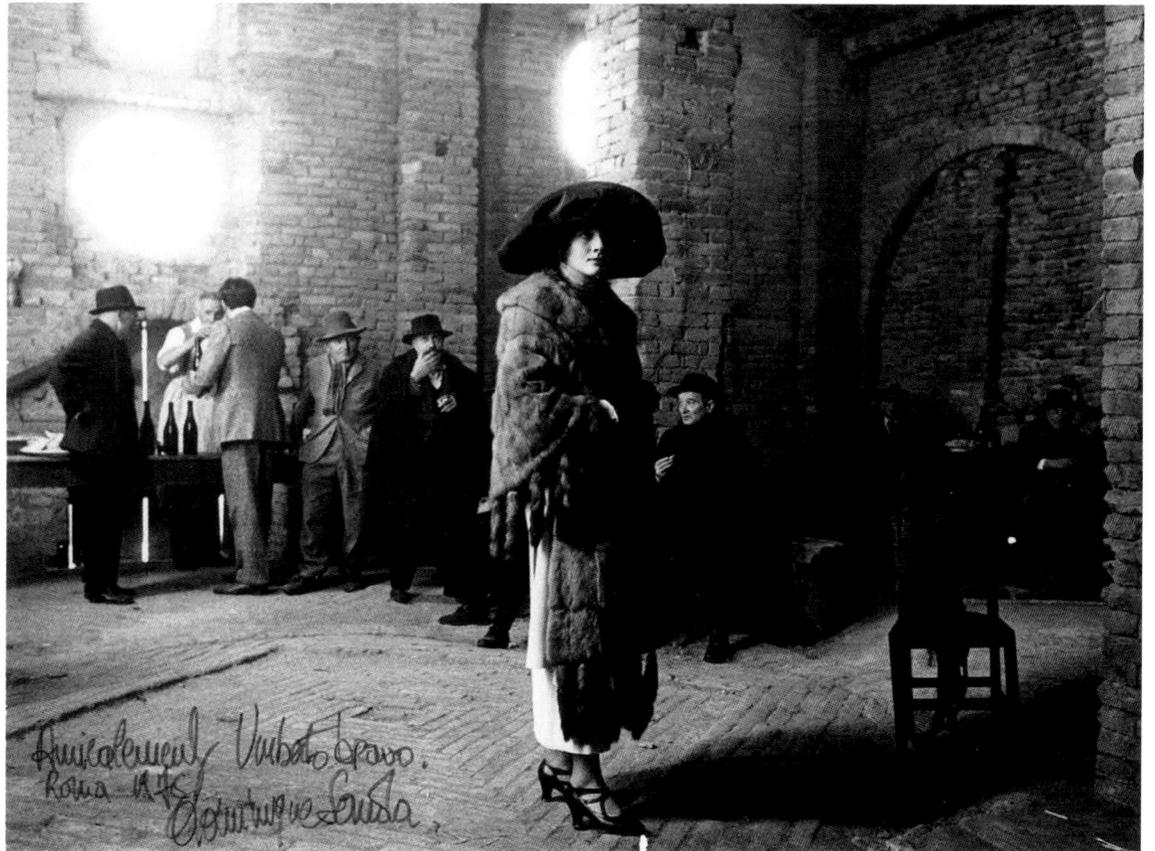

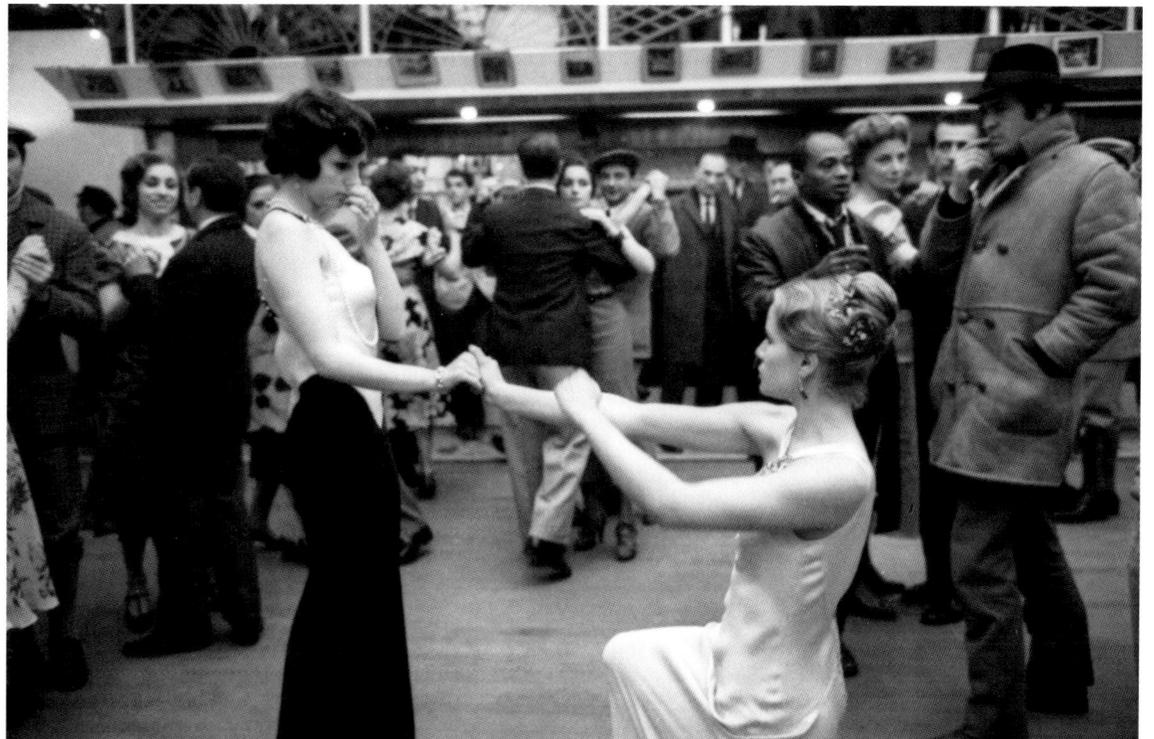

LUCIA MIRISOLA

Nell'anno del Signore
[In the Year of Our Lord], 1969
Directed by Luigi Magni

Claudia Cardinale and Nino Manfredi
Reporters Associati & Archivi

Opposite

LUCIA MIRISOLA

Scipione detto anche l'Africano
[Scipio the African], 1971
Directed by Luigi Magni

Vittorio Gassman and Marcello
Mastroianni
Reporters Associati & Archivi

LUCIA MIRISOLA

La Tosca [Tosca], 1973
Directed by Luigi Magni

Vittorio Gassman and Monica Vitti
Courtesy of Fabrizio and Sandro Borni

FRANCO CARRETTI

Indagine su un cittadino al di sopra di ogni sospetto [Investigation of a Citizen above Suspicion], 1970
Directed by Elio Petri

Florinda Bolkan and Gian Maria Volonté
Photo by Mario Tursi – Archivio Fotografico della Cineteca Nazionale – Centro Sperimentale di Cinematografia

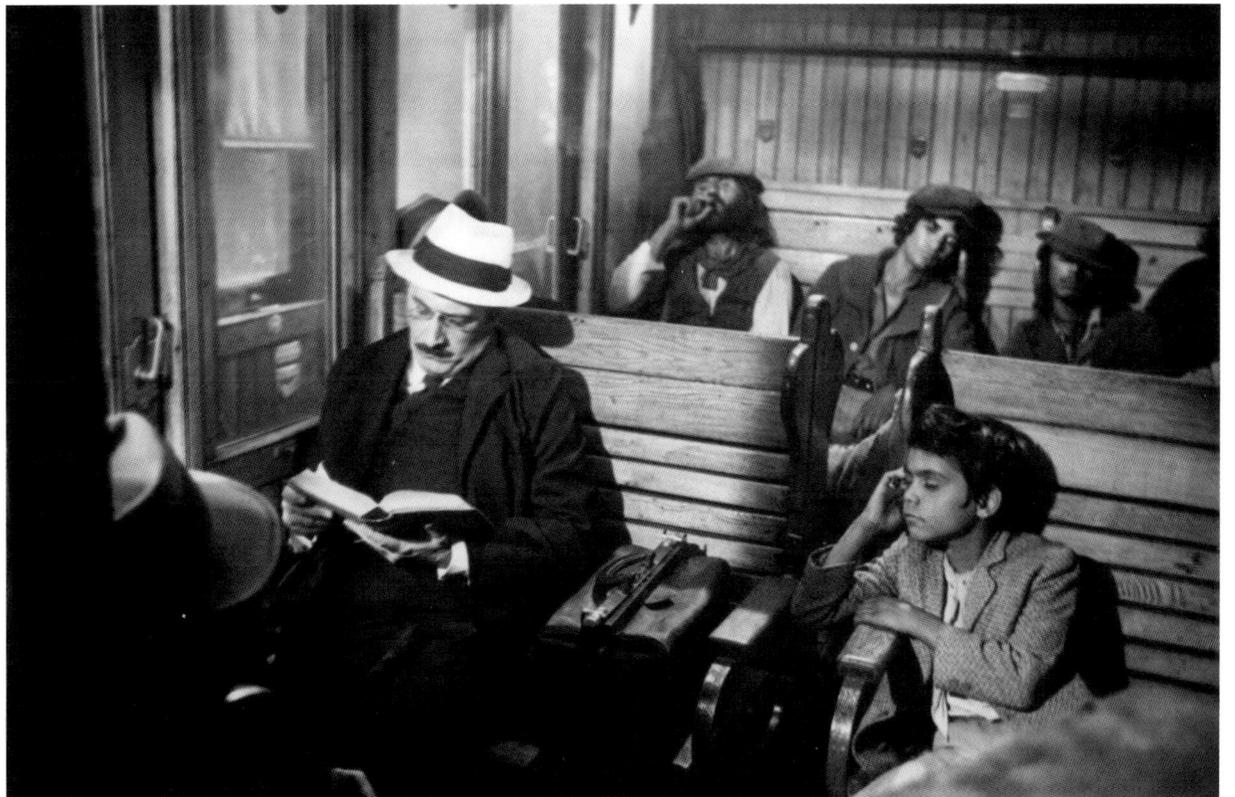

FRANCO CARRETTI

Giù la testa [Duck, You Sucker], 1971
Directed by Sergio Leone

Romolo Valli
Photo by Angelo Novi – Archivio Fotografico della Cineteca Nazionale – Centro Sperimentale di Cinematografia

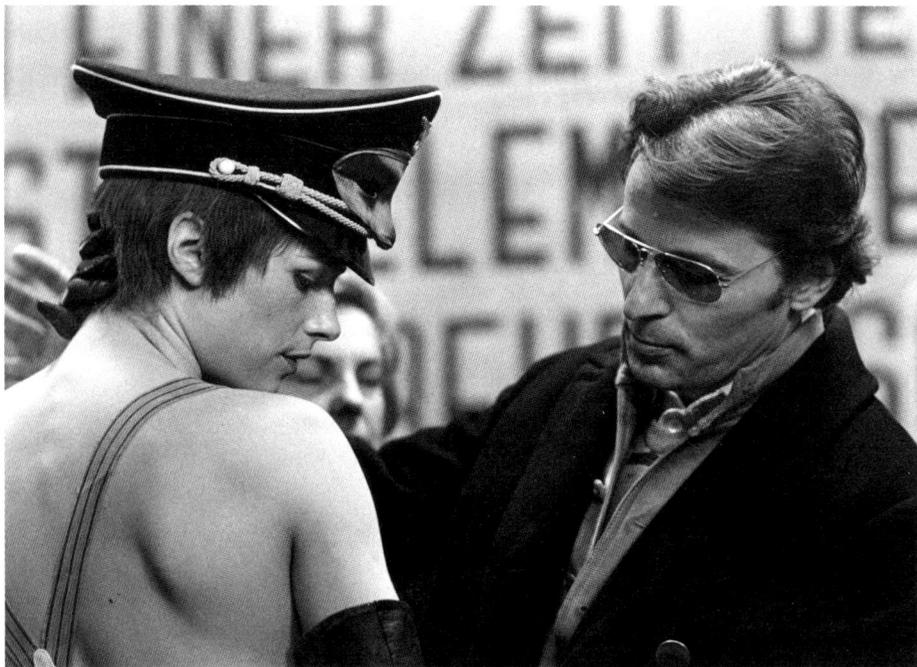

PIERO TOSI

Il portiere di notte [The Night Porter],
1974
Directed by Liliana Cavani

Charlotte Rampling and Piero Tosi
during shooting

Below, Philippe Leroy and Charlotte
Rampling
Photos by Mario Tursi – Archivio
Fotografico della Cineteca Nazionale –
Centro Sperimentale di Cinematografia

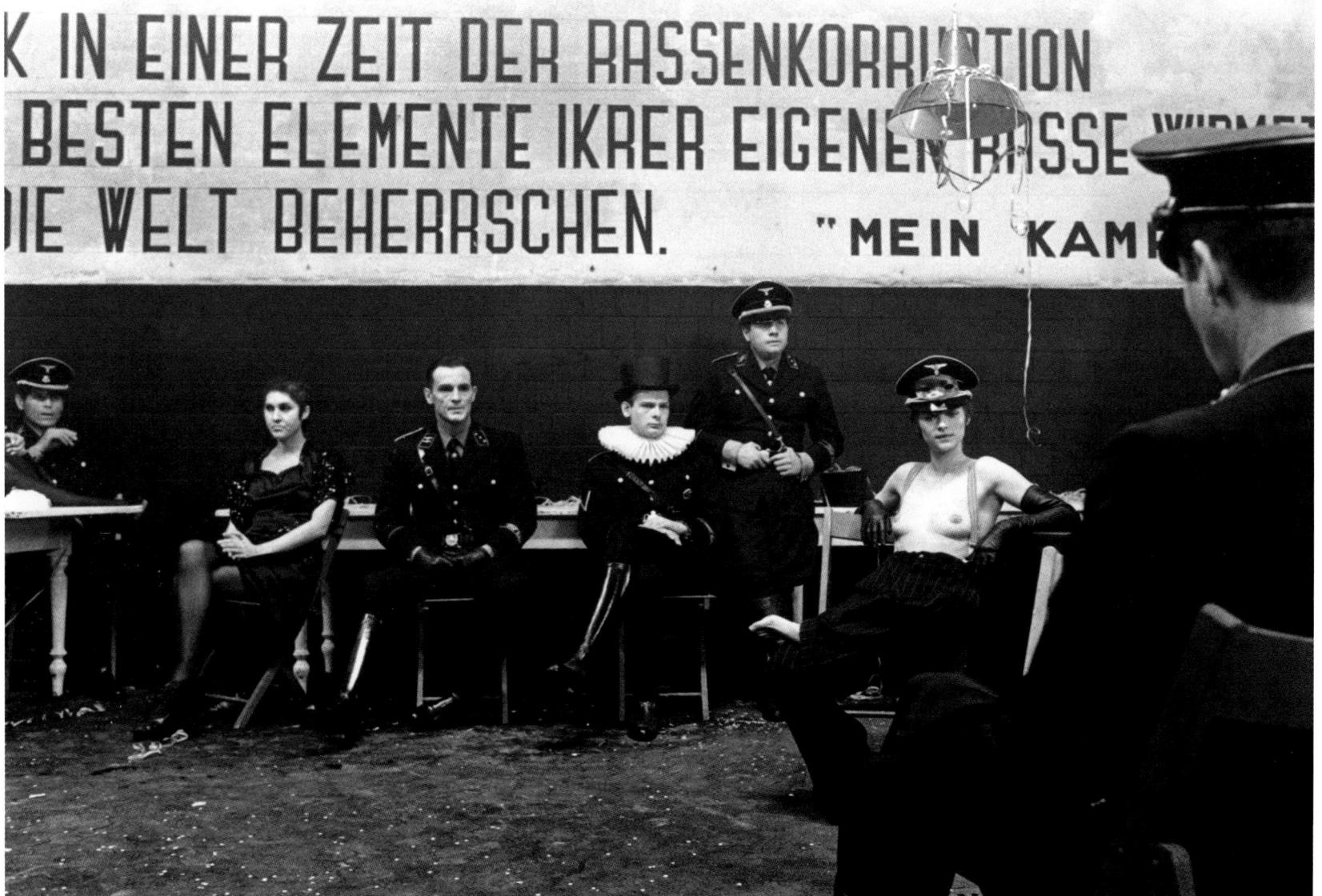

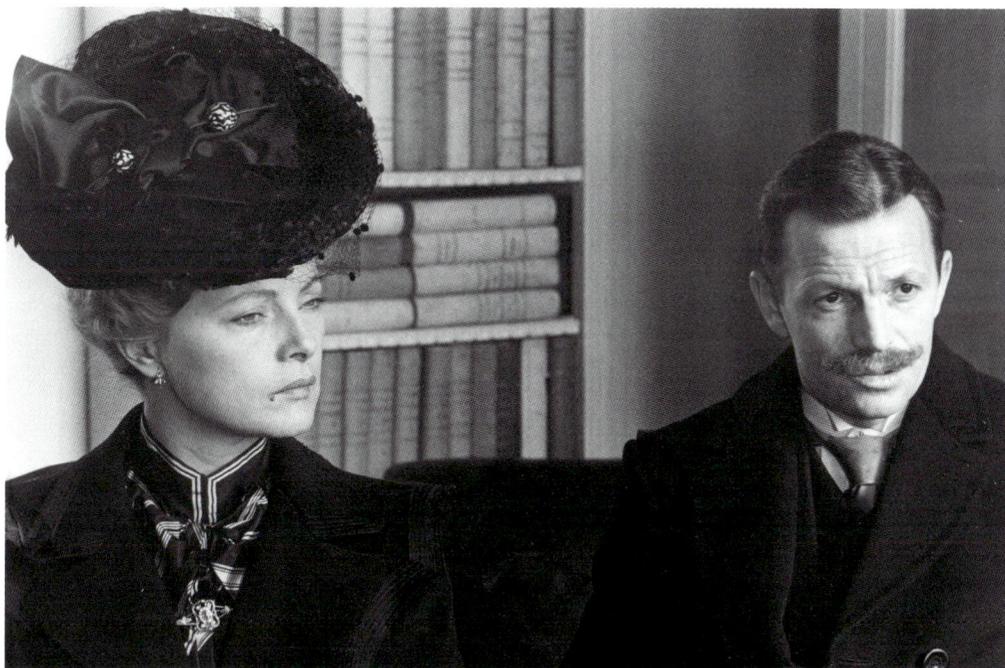

PIERO TOSI

Al di là del bene e del male
[Beyond Good and Evil], 1977
Directed by Liliana Cavani

Virna Lisi and Umberto Orsini
Photo by Mario Tursi – Archivio
Liliana Cavani

Below, the beer house
Photo by Mario Tursi – Archivio
Fotografico della Cineteca Nazionale –
Centro Sperimentale di Cinematografia

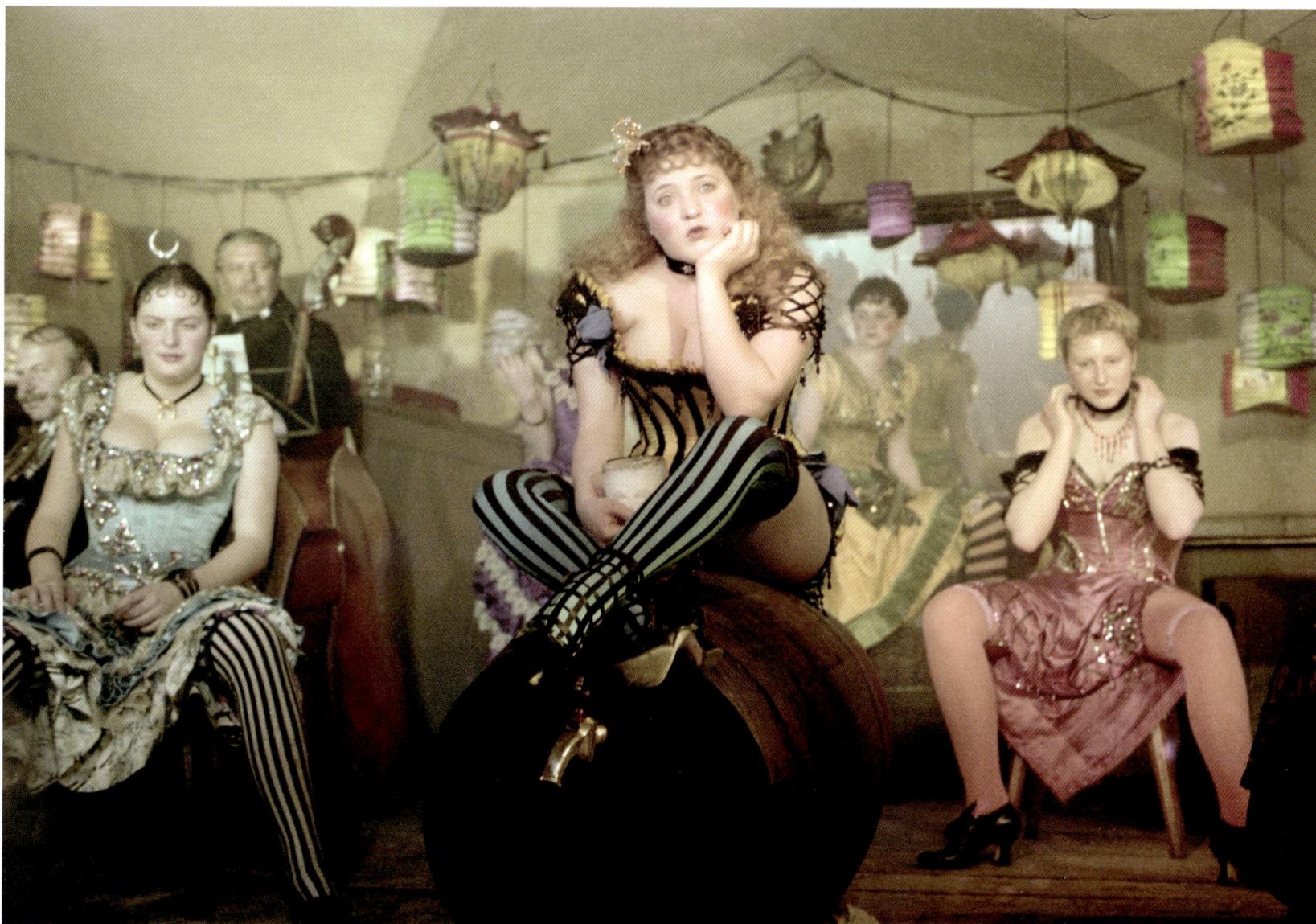

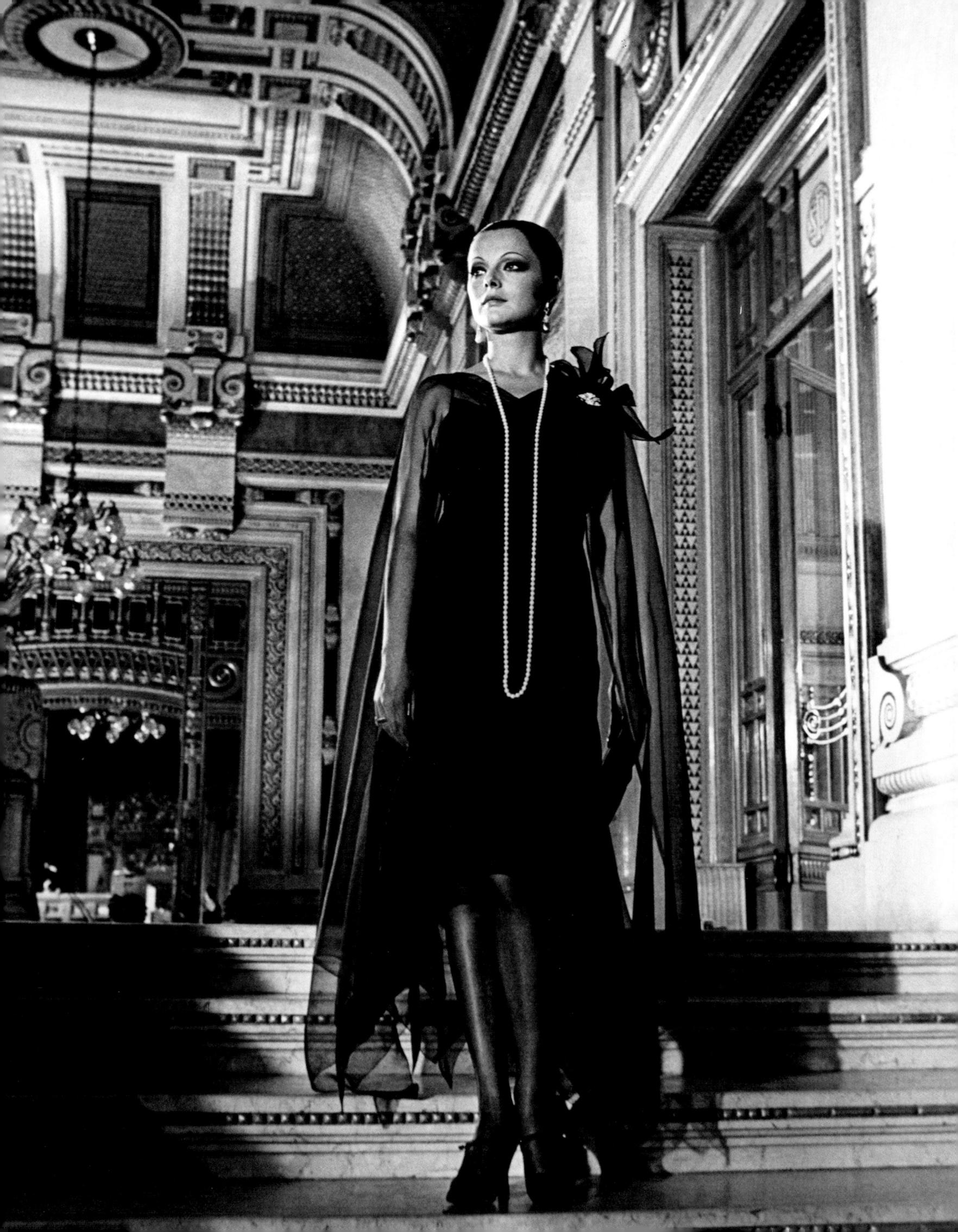

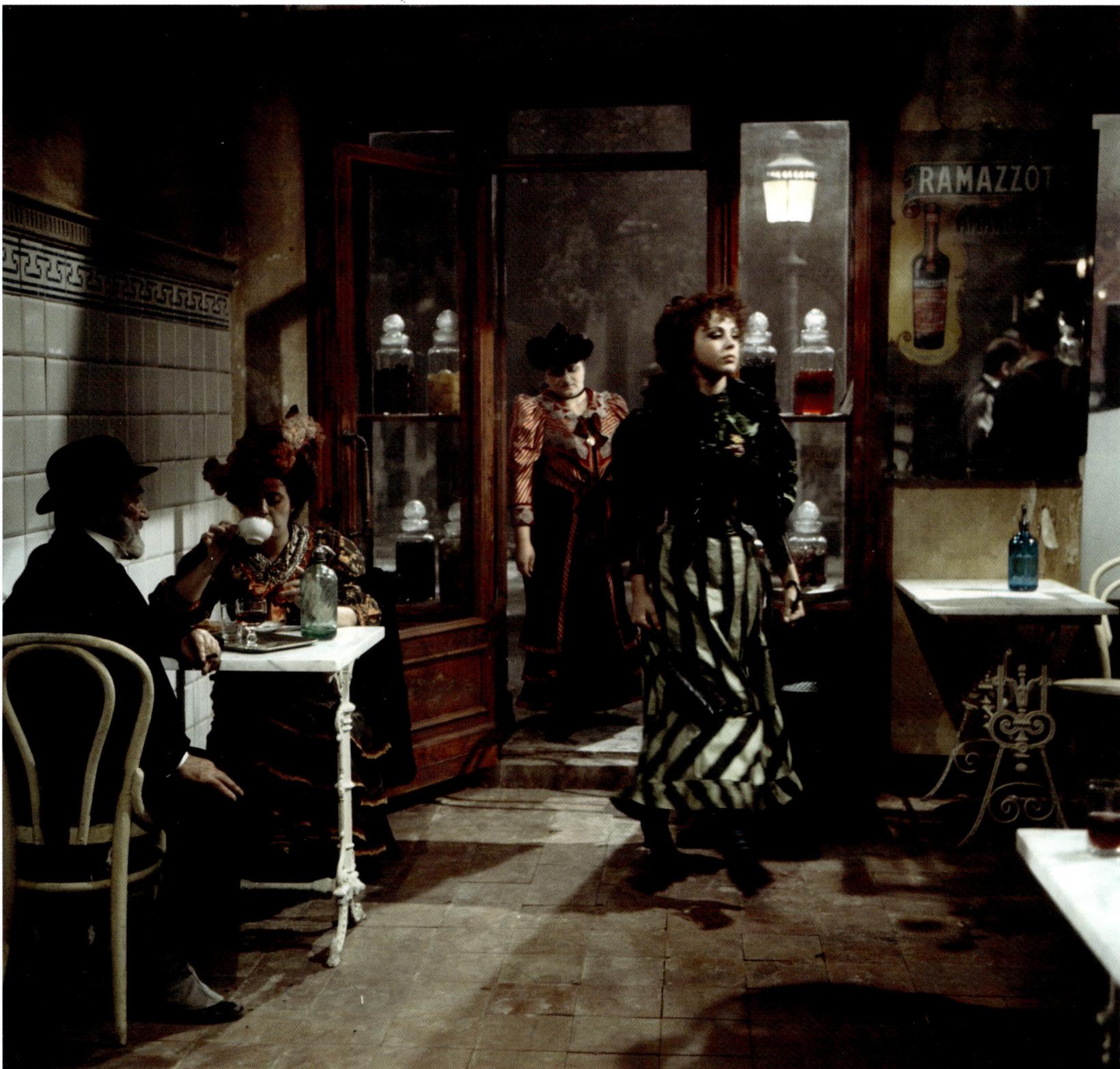

Opposite

PIERO TOSI

Arabella, 1967
Directed by Mauro Bolognini

Virna Lisi

PIERO TOSI

Bubù, 1971
Directed by Mauro Bolognini

Ottavia Piccolo
Photo by Gianni Tatti

PIERO TOSI

La storia vera della signora delle camelie [The Lady of the Camellias], 1981
Directed by Mauro Bolognini

Isabelle Huppert

Opposite, Carla Fracci
Reporters Associati & Archivi

Below, Mauro Bolognini, Piero Tosi and Alberto Verso during filming
Photo by Mario Tursi – Archivio Fotografico della Cineteca Nazionale – Centro Sperimentale di Cinematografia

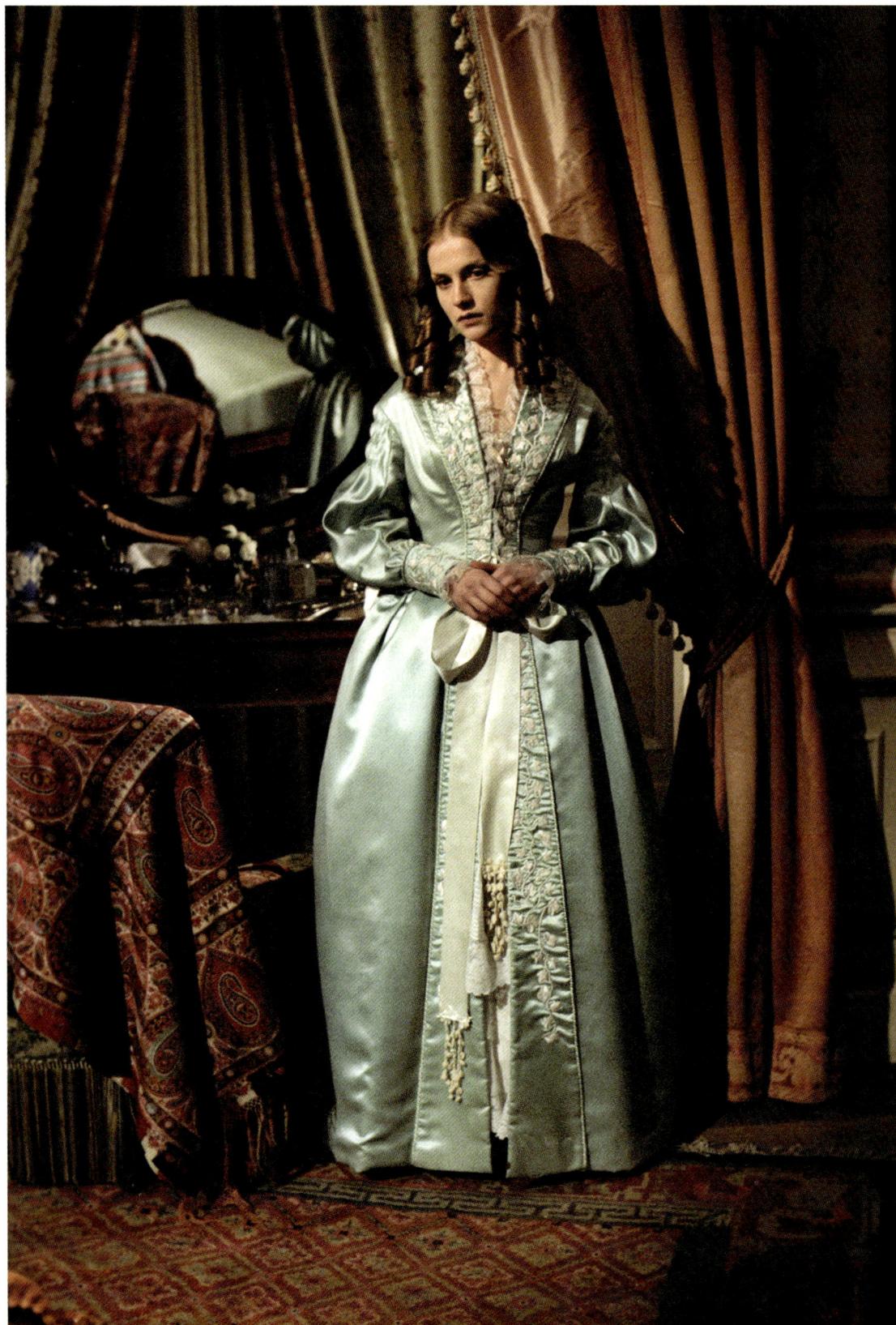

PIERO TOSI

La traviata, 1983
Directed by Franco Zeffirelli

Above and below left, Placido
Domingo and Teresa Stratas

Opposite, gypsies and matadors at
Flora's party: in the centre, Ekaterina
Maksimova and Vladimir Vasiliev
Photos by Paul Ronald – Archivio
Storico del Cinema – AFE

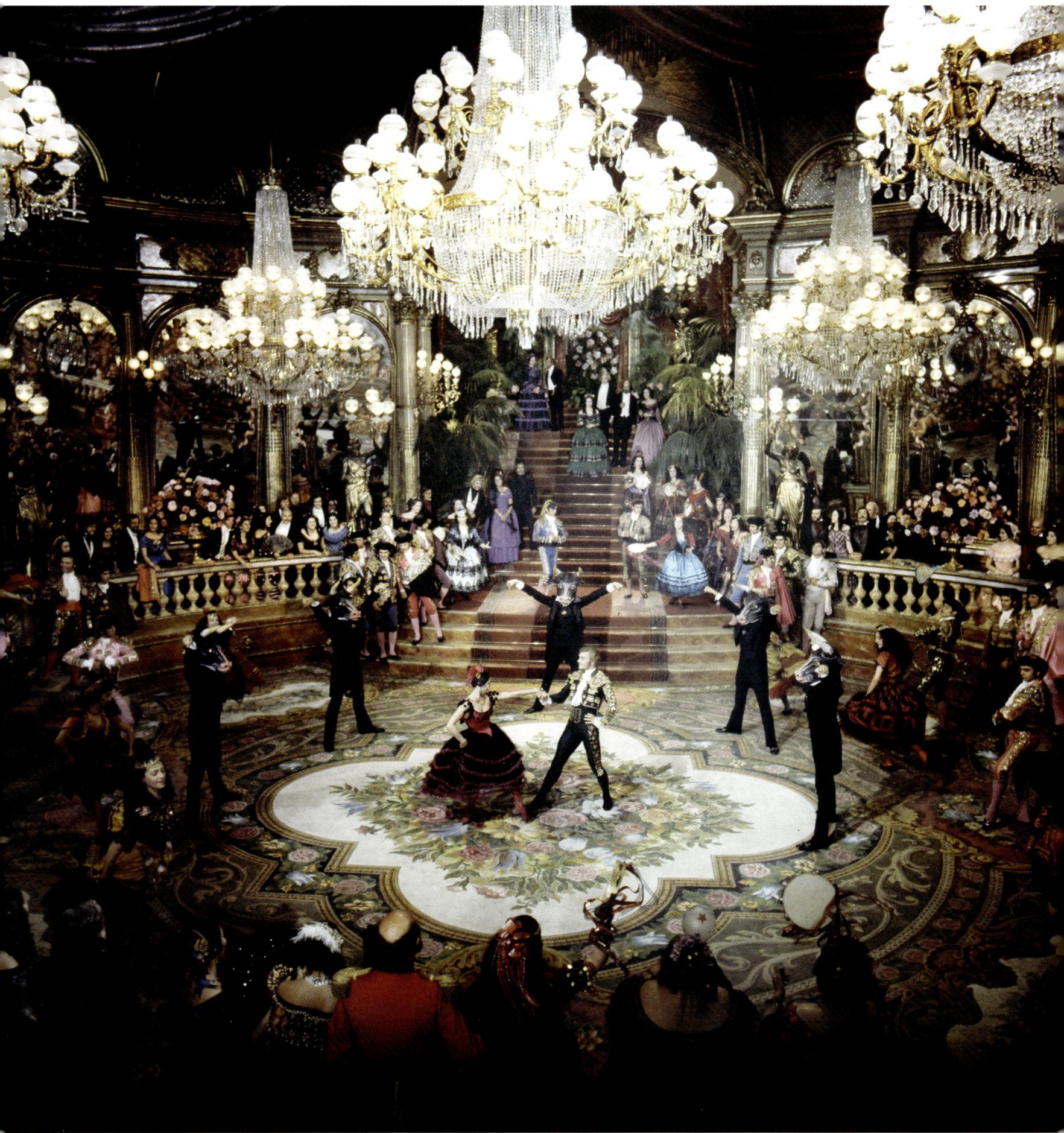

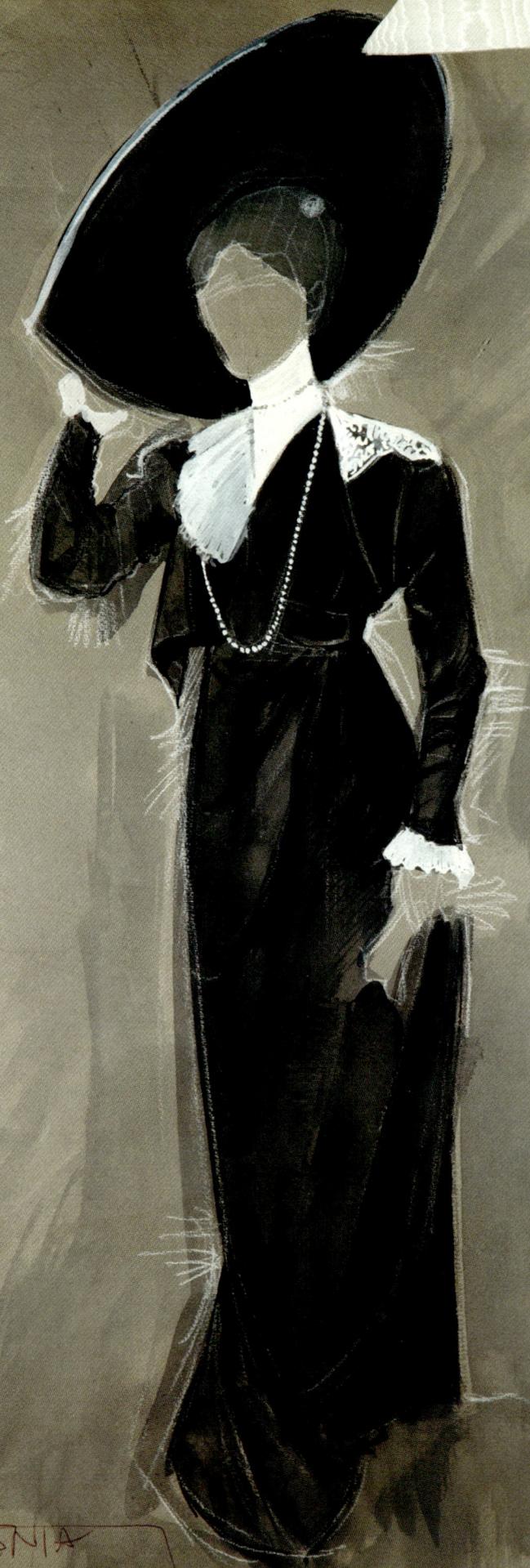

EUGENIA
ARCACHON
PASTICCERIA

PARIGI

DANTE FERRETTI

Mio Dio, come sono caduta in basso!
[Till Marriage Do Us Part], 1974
Directed by Luigi Comencini

Study for Eugenia (Laura Antonelli)

Opposite, Laura Antonelli
Photo by Paul Ronald – Archivio
Antonio Maraldi

GABRIELLA PESCUCCI

Fatti di gente per bene
[The Murri Affair], 1974
Directed by Mauro Bolognini

Tina Aumont
Archivio Fotografico della Cineteca
Nazionale – Centro Sperimentale
di Cinematografia

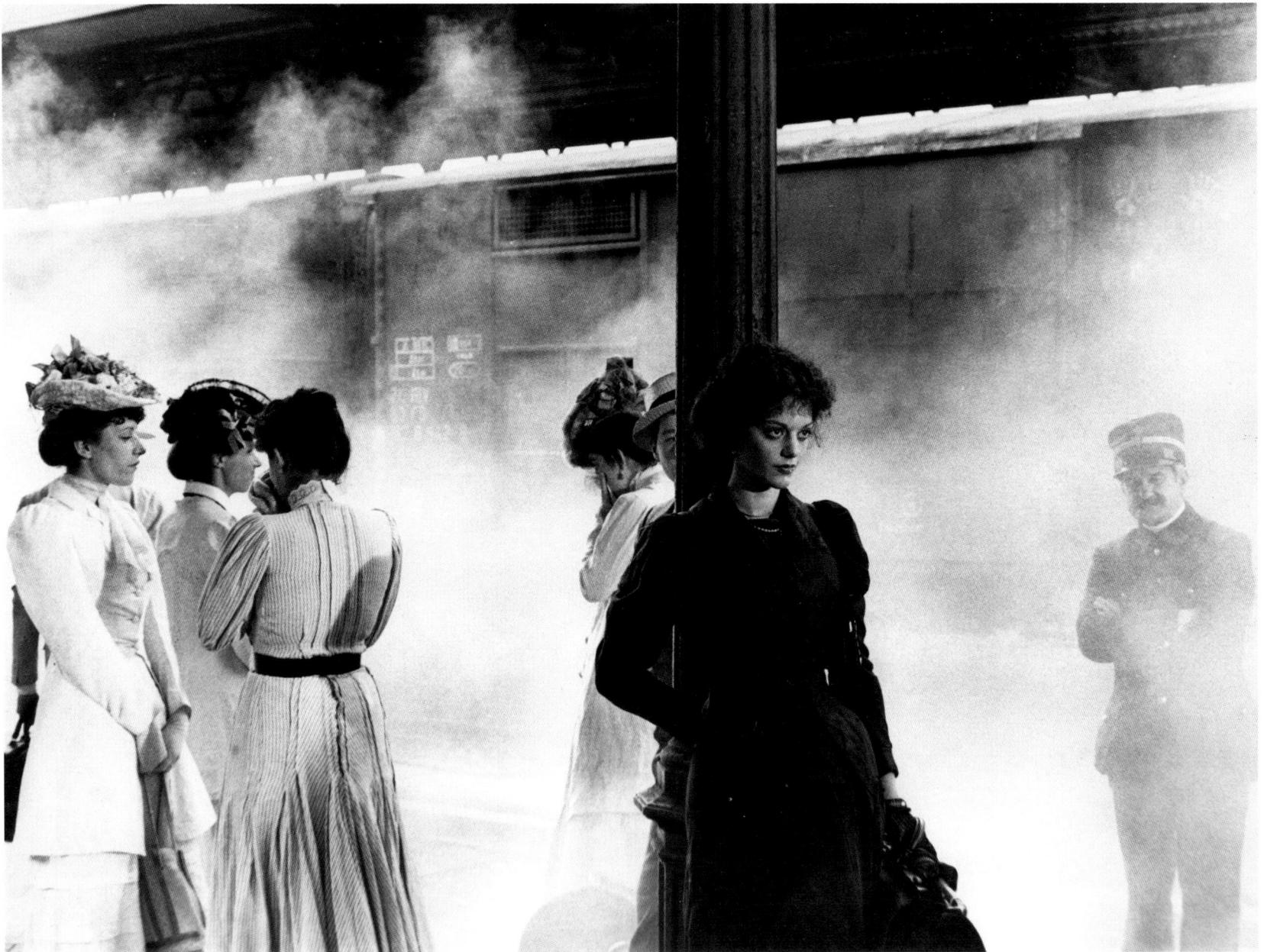

GABRIELLA PESCUCCI

Il mondo nuovo
[That Night in Varennes], 1982
Directed by Ettore Scola

Study for Madame Gagnon
(Andréa Ferréol)

Right, Marcello Mastroianni
and Andréa Ferréol

Below, Marcello Mastroianni
and Hanna Schygulla
Reporters Associati & Archivi

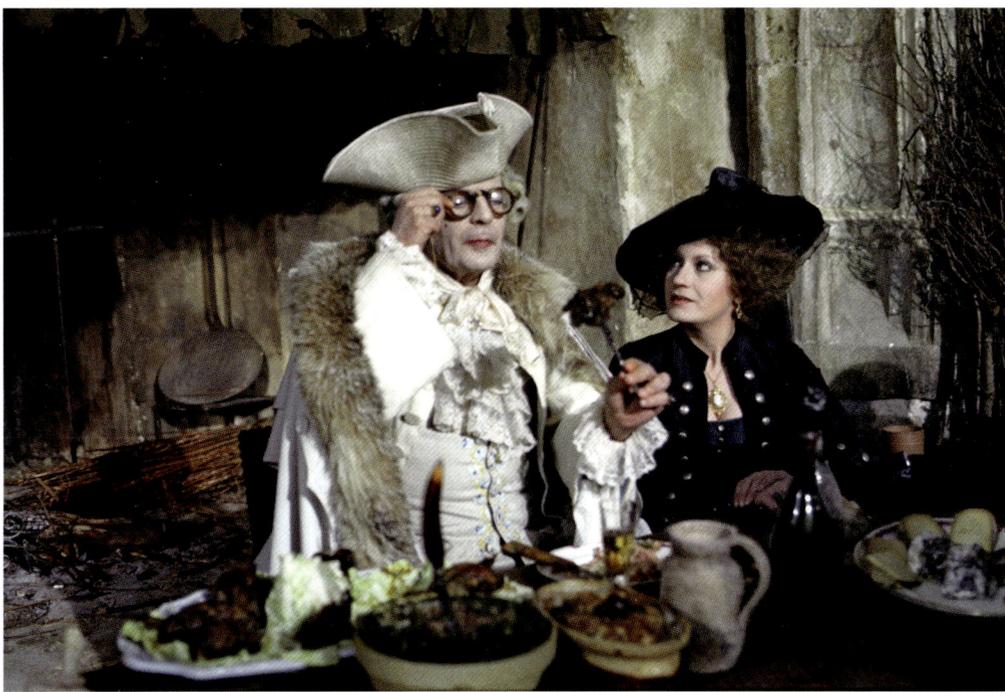

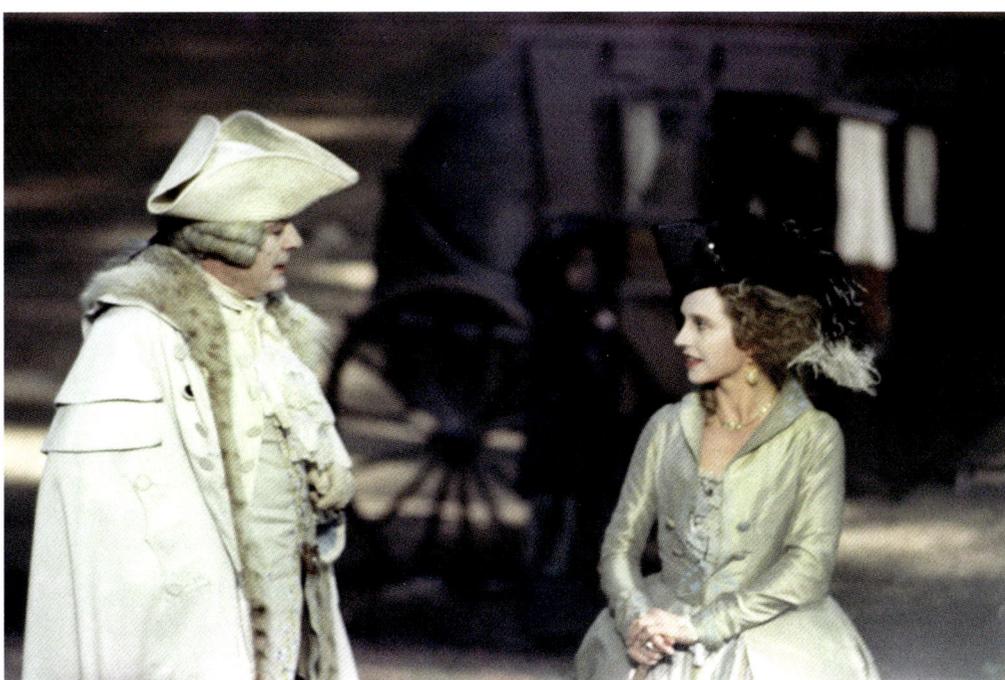

GABRIELLA PESCUCCI

*C'era una volta in America
[Once Upon a Time in America]*, 1984
Directed by Sergio Leone

Study for Deborah
(Elizabeth McGovern)

Below, Elizabeth McGovern
and Robert De Niro
Photo by Angelo Novi – Archivio
Fotografico della Cineteca
Nazionale – Centro Sperimentale
di Cinematografia

Opposite, Elizabeth McGovern
and Robert De Niro

Below, night at the speakeasy
Reporters Associati & Archivi

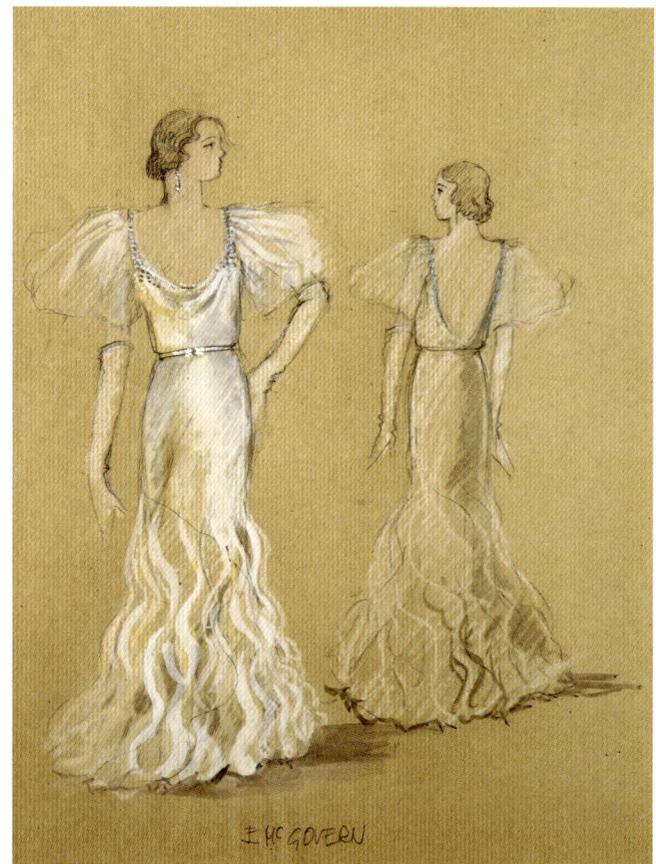

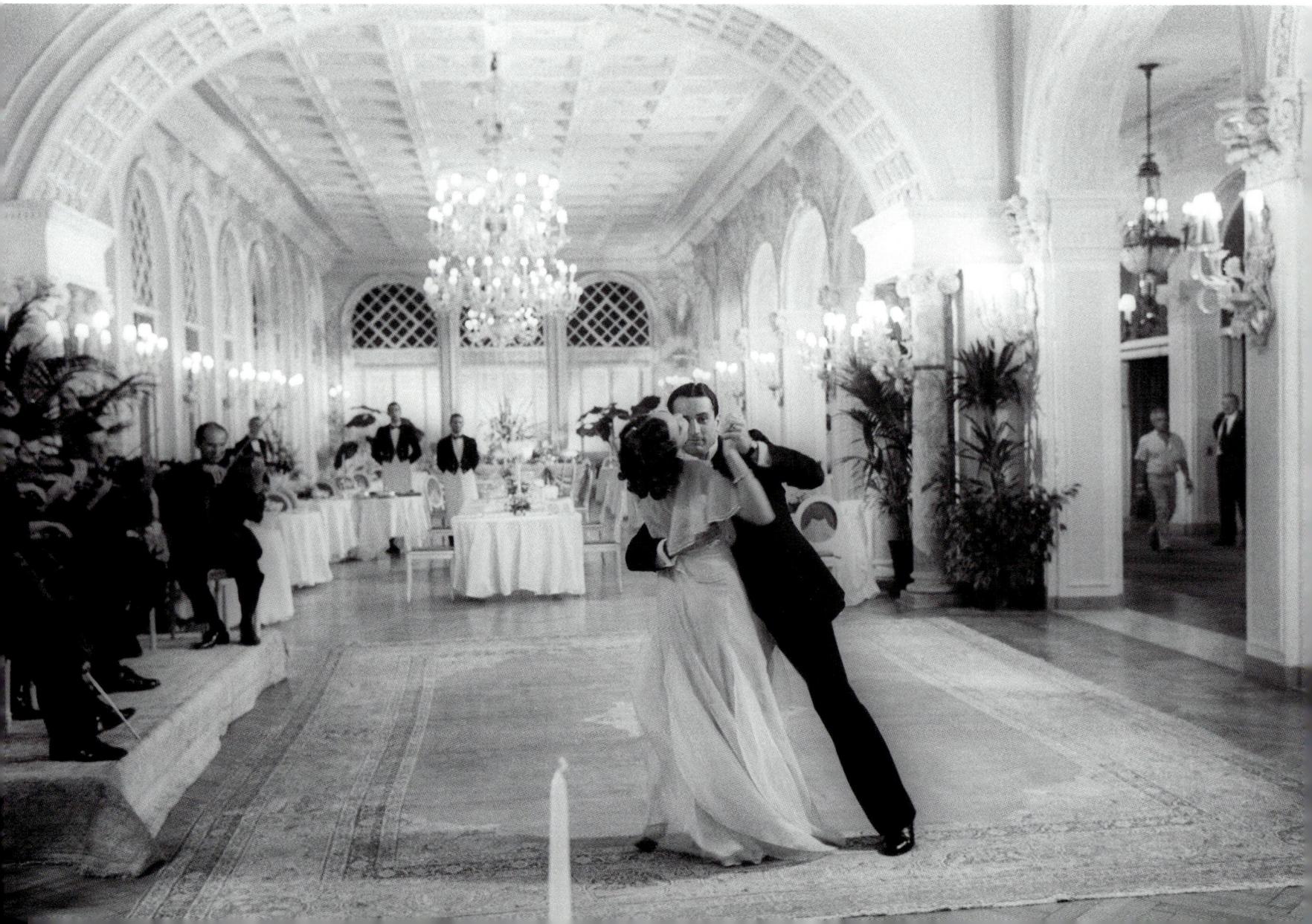

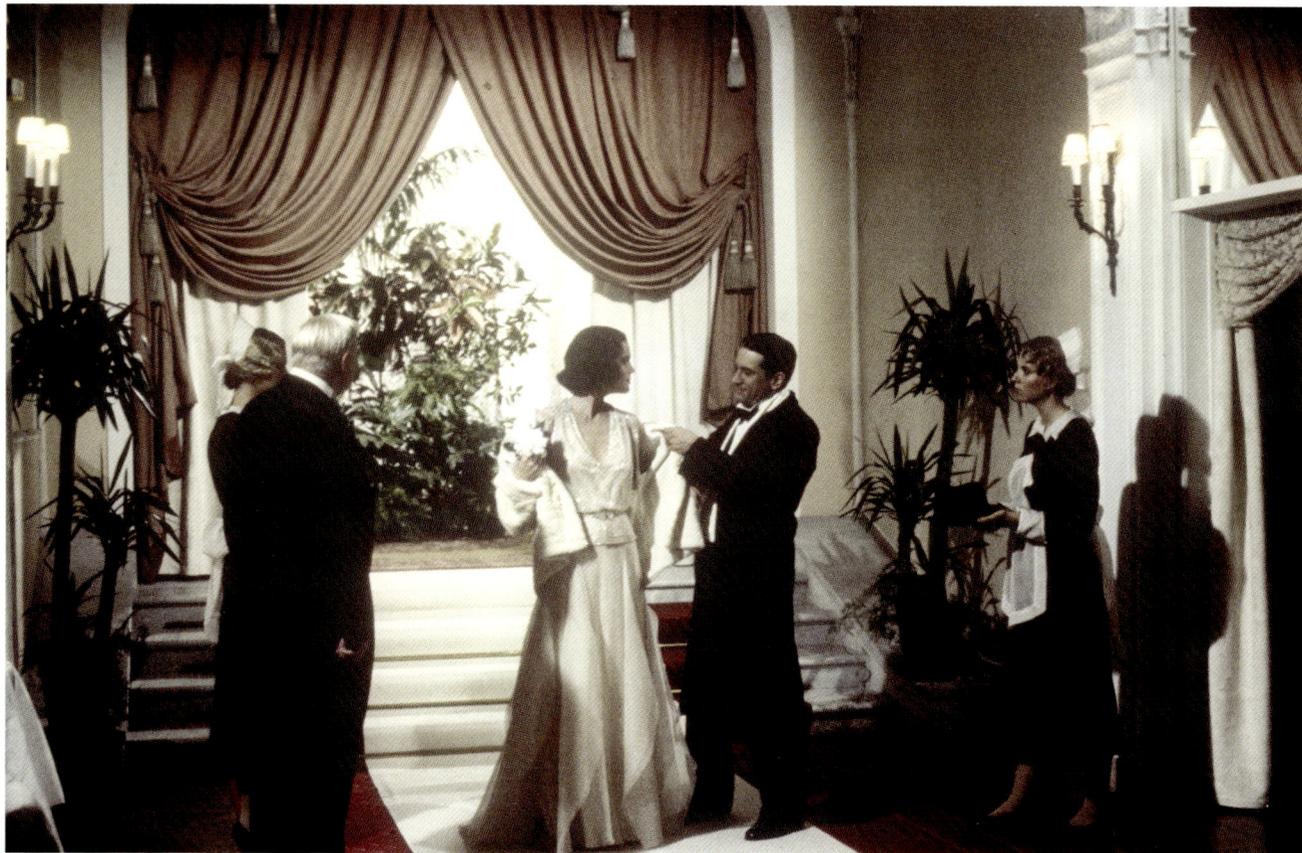

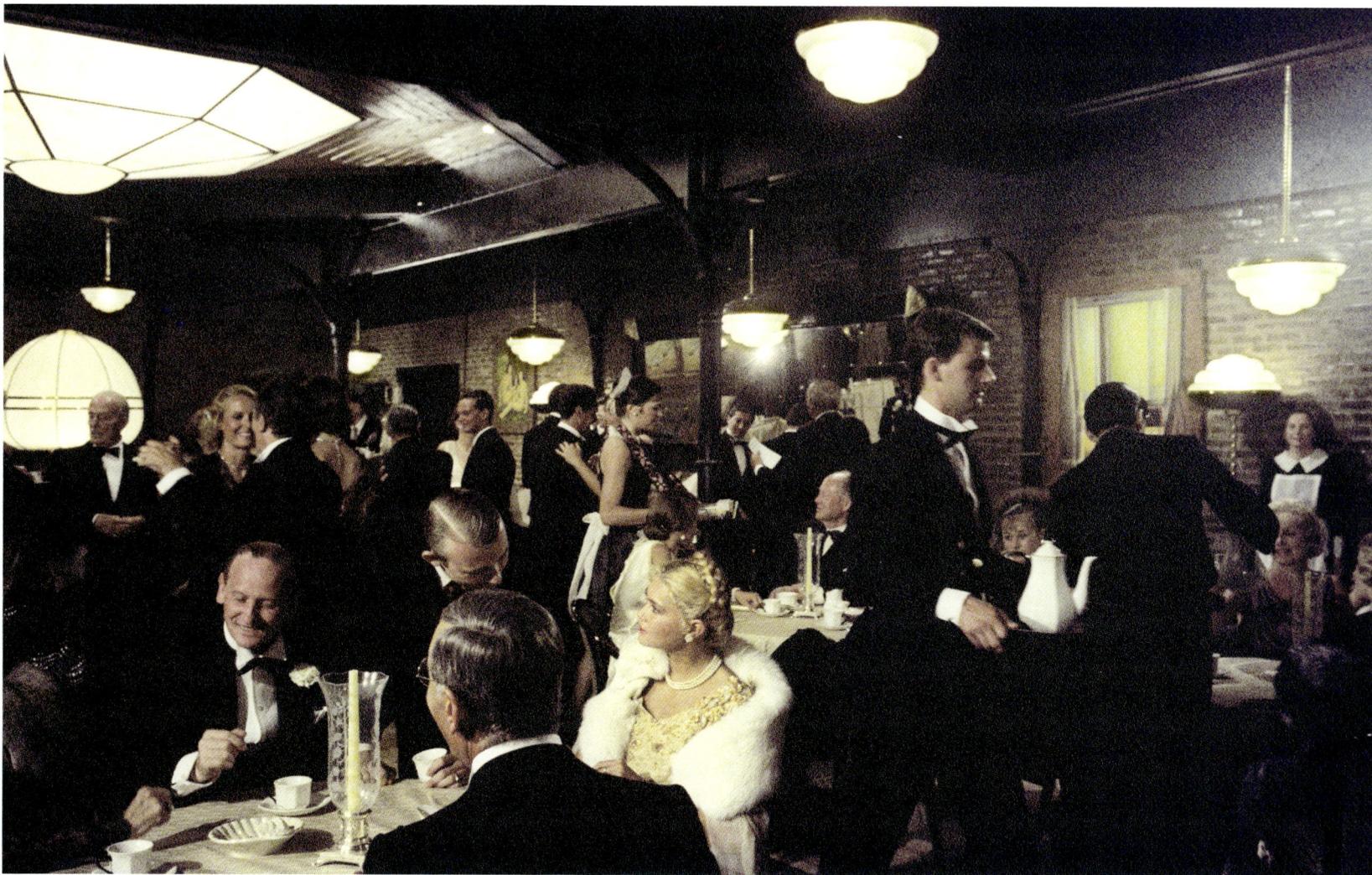

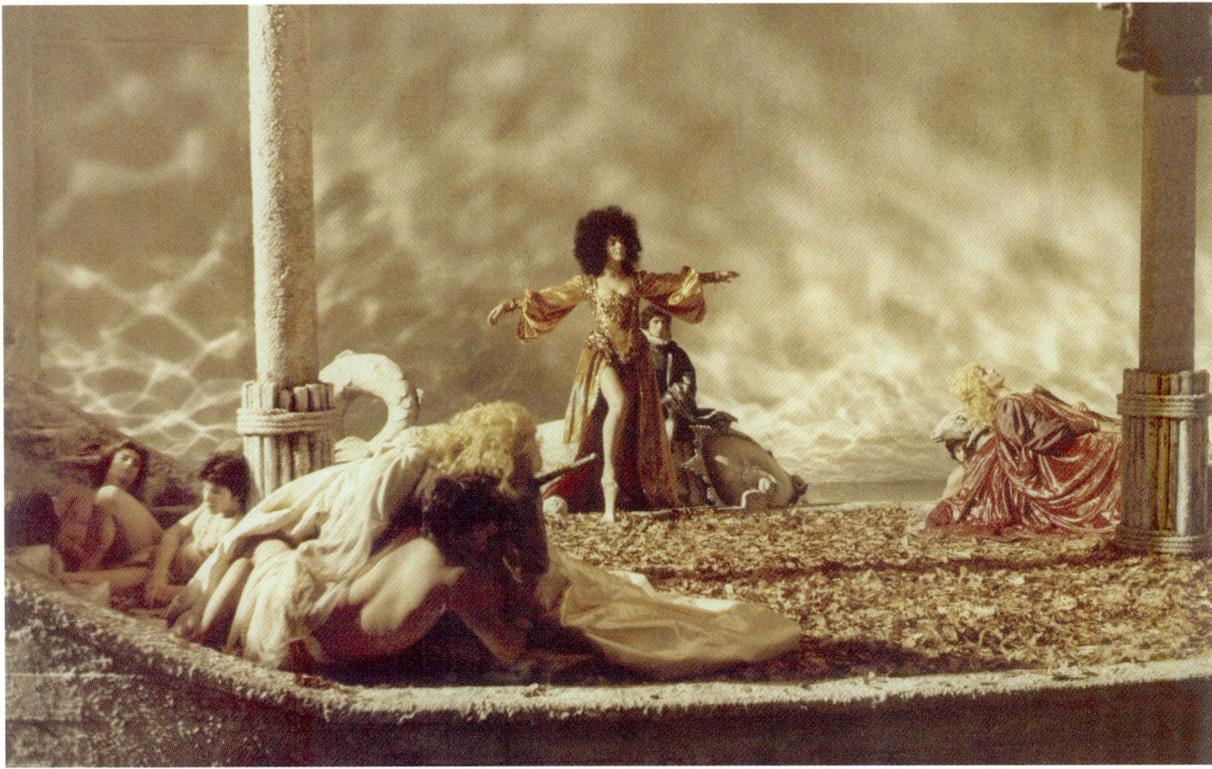

PIER LUIGI PIZZI

Orlando Furioso, 1975
Directed by Luca Ronconi

Marilù Tolo

Below, Massimo Foschi
Photos by Giovanni Battista Poletto

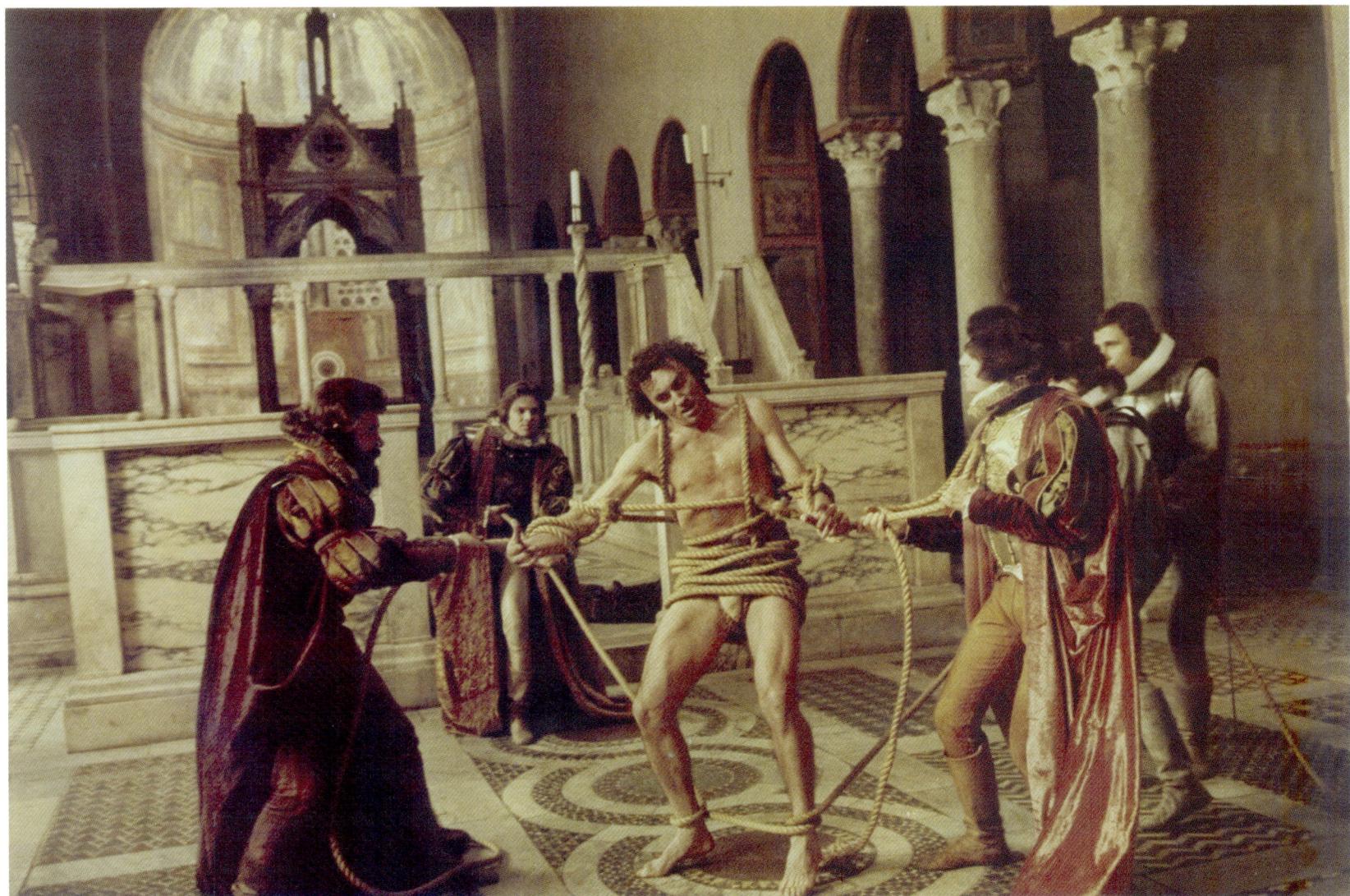

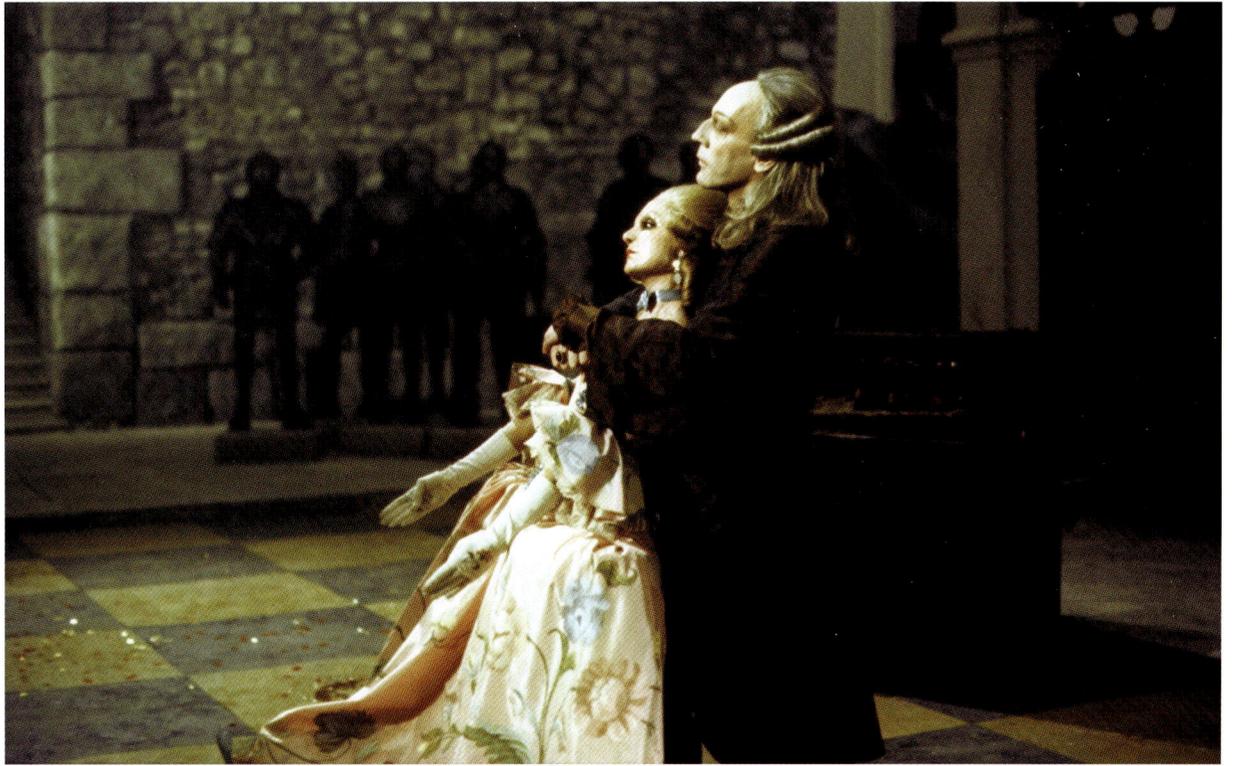

DANILO DONATI

*Il Casanova di Federico Fellini
[Fellini's Casanova]*, 1976
Directed by Federico Fellini

Leda Lojodice and Donald Sutherland

Below, Cicely Browne
and Donald Sutherland
Reporters Associati & Archivi

Danilo Donati won his second
Academy Award for Best Costume
Design with this film

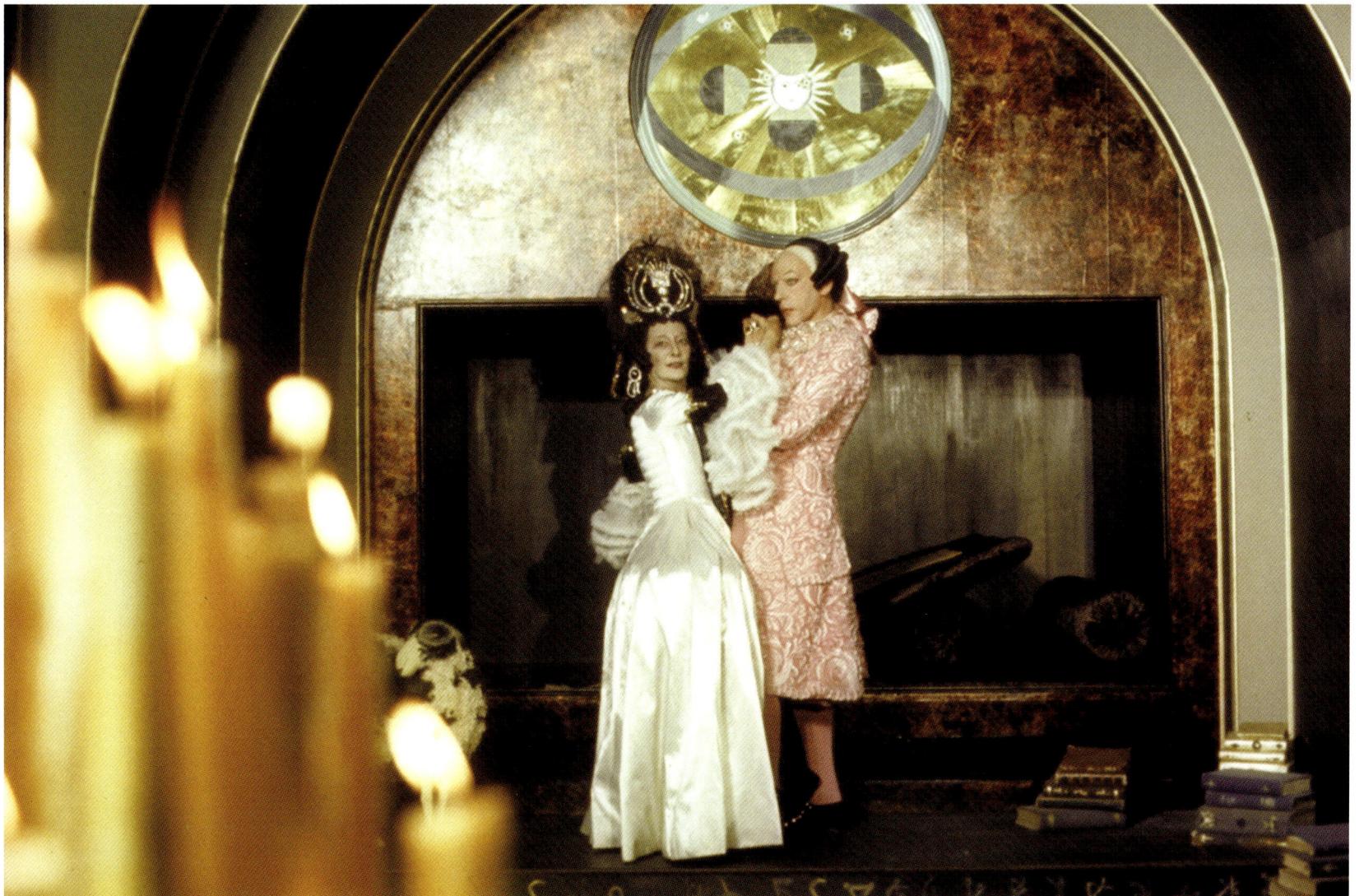

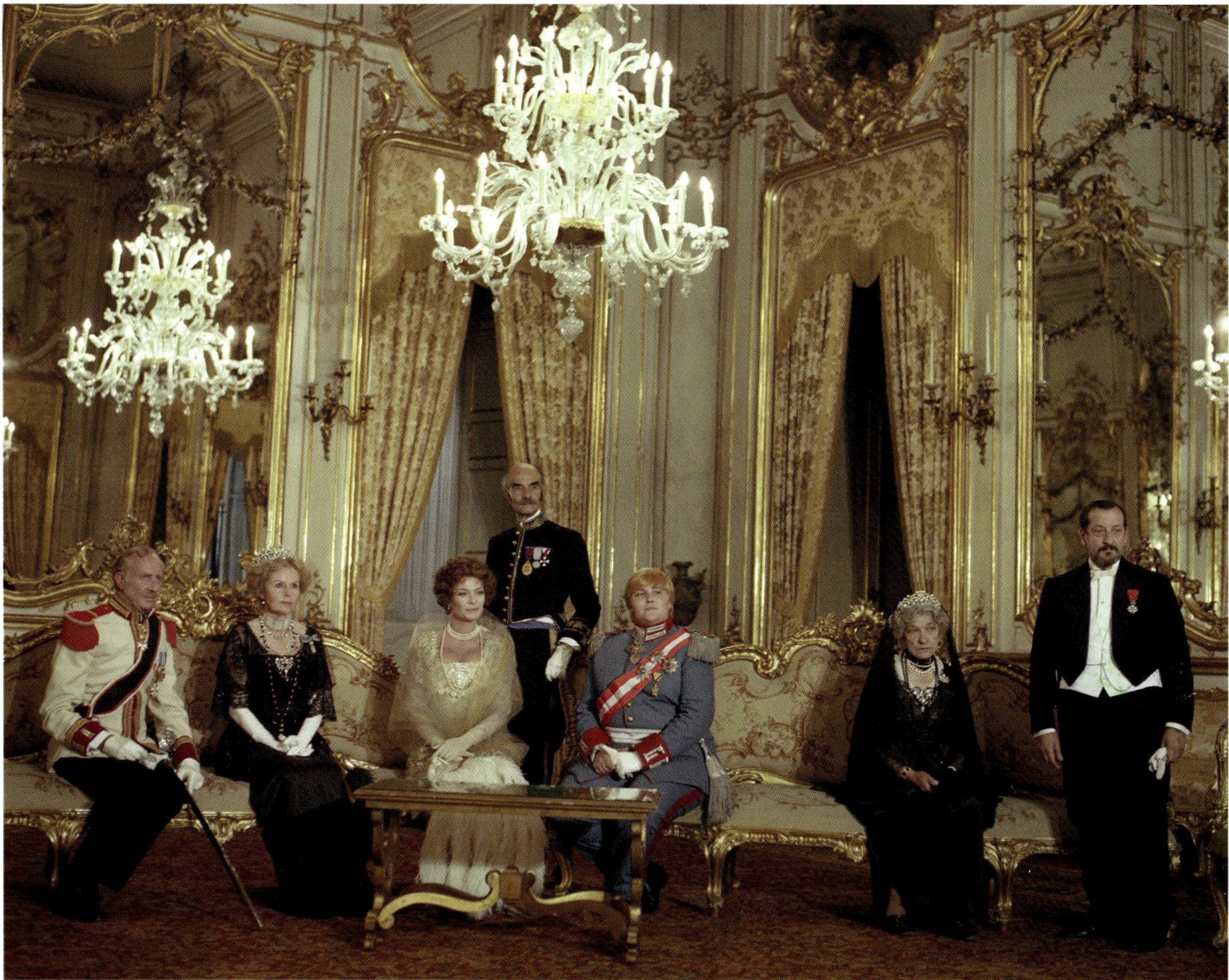

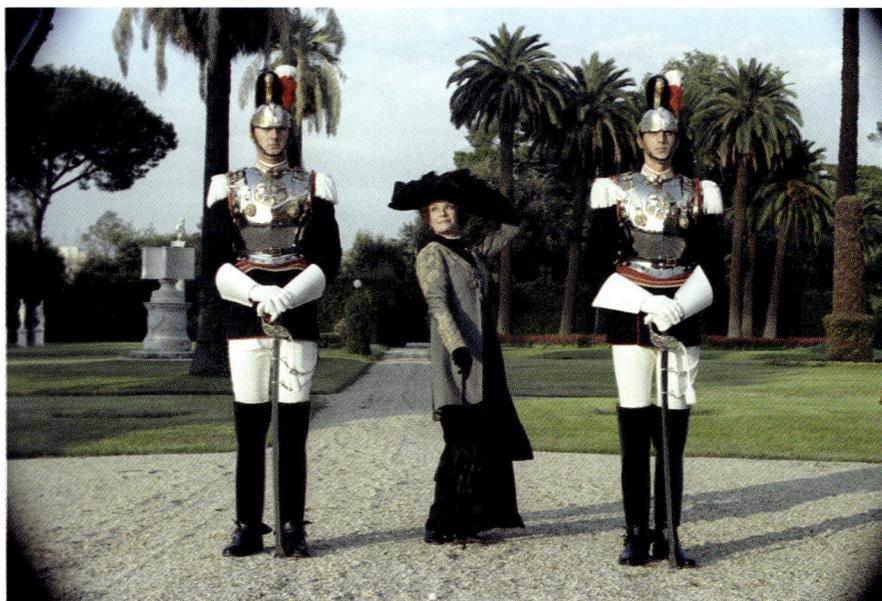

MAURIZIO MILLENOTTI

E la nave va [And the Ship Sails On], 1983
Directed by Federico Fellini

From the singer Ildebranda Cuffari's souvenir album: the concert at court

Left, Barbara Jefford (the singer) between two cuirassiers
Reporters Associati & Archivi

MILENA CANONERO

Chariots of Fire, 1981
Directed by Hugh Hudson

Cheryl Campbell

Below left, Ben Cross
and Ian Charleson

Below right, Ian Charleson
Archivio Fotografico della Cineteca
Nazionale – Centro Sperimentale
di Cinematografia

Milena Canonero netted her second
Academy Award for Best Costume
Design with this film

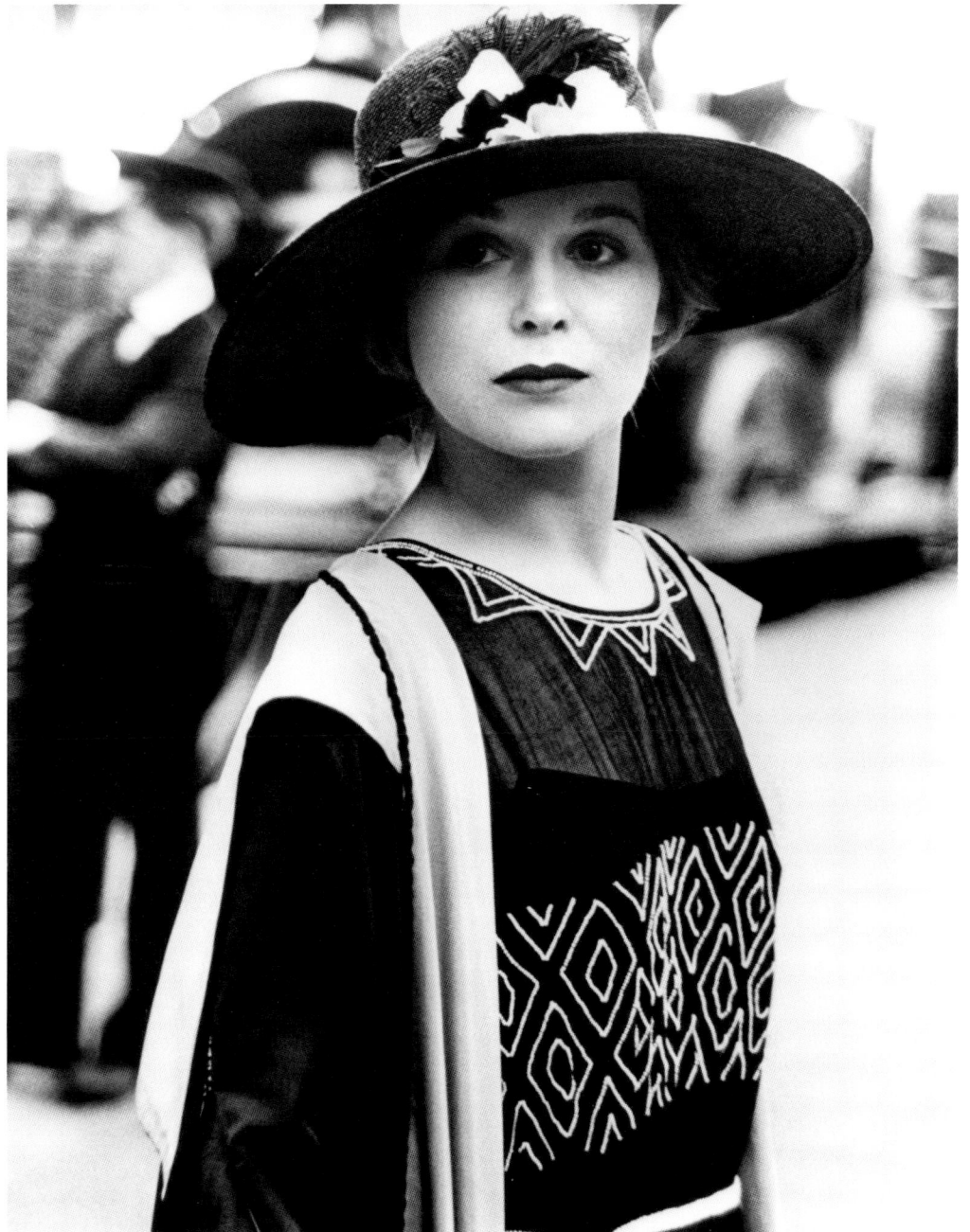

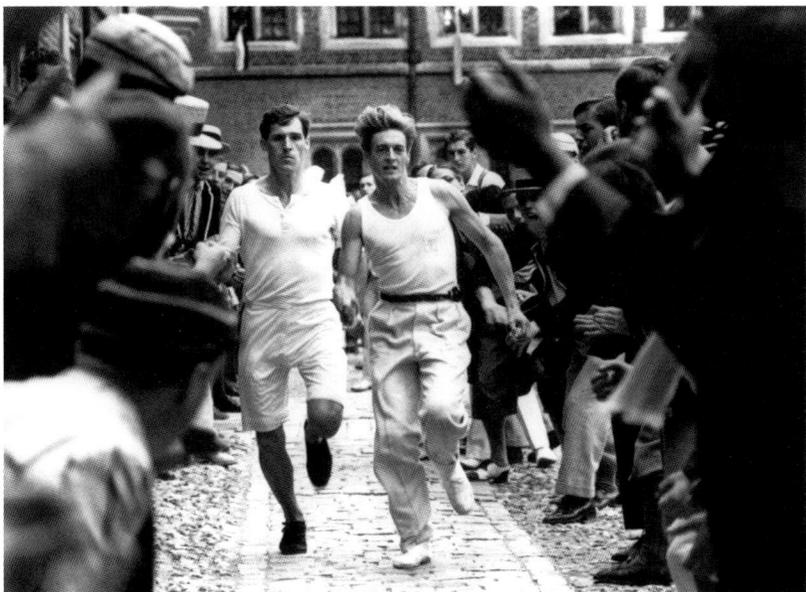

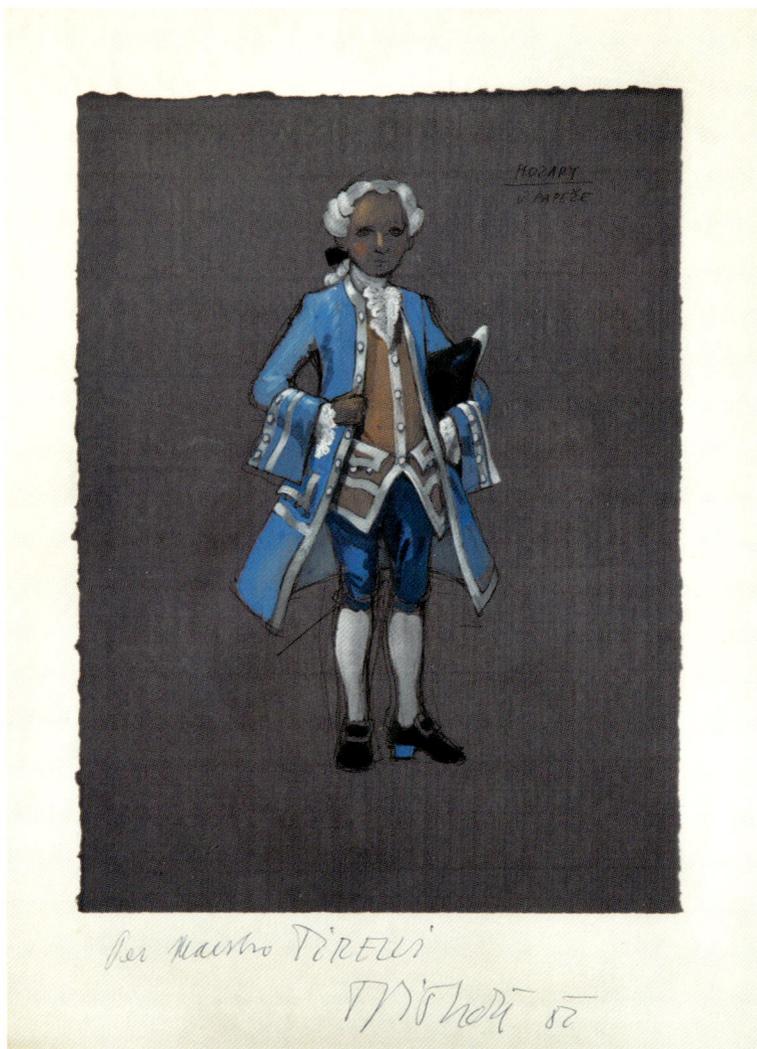

THEODOR PIŠTĚK

Amadeus, 1984
Directed by Miloš Forman

Costume sketch with dedication
to Umberto Tirelli

Right, Tom Hulce and Elizabeth
Berridge

Left, Tom Hulce
Archivio Storico del Cinema – AFE

Theodor Pištěk won an Academy
Award for Best Costume Design
with this film

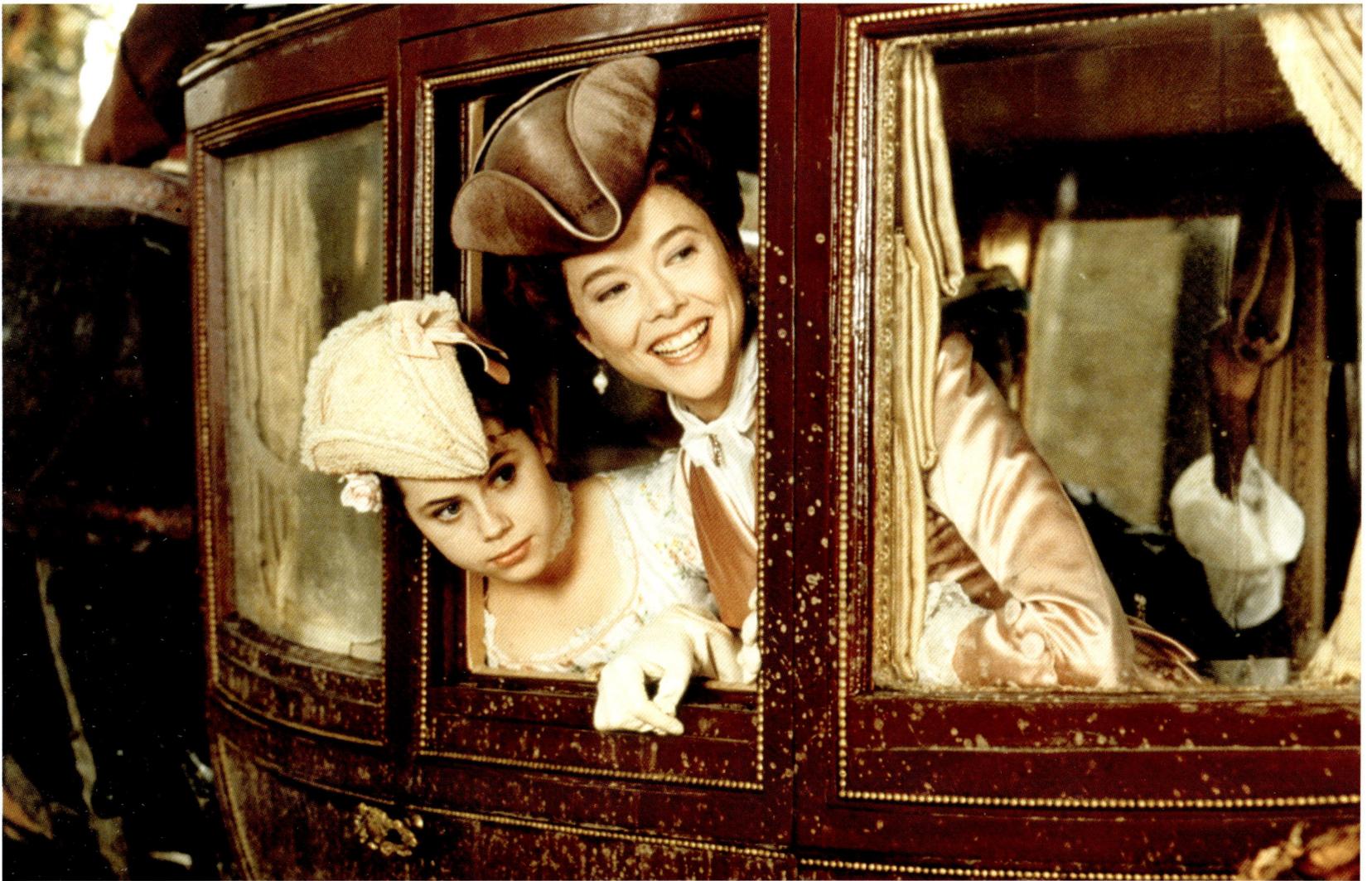

THEODOR PIŠTĚK

Valmont, 1989
Directed by Miloš Forman

Fairuza Balk and Annette Bening

Right, Annette Bening and Colin Firth
Courtesy BiM Distribuzione

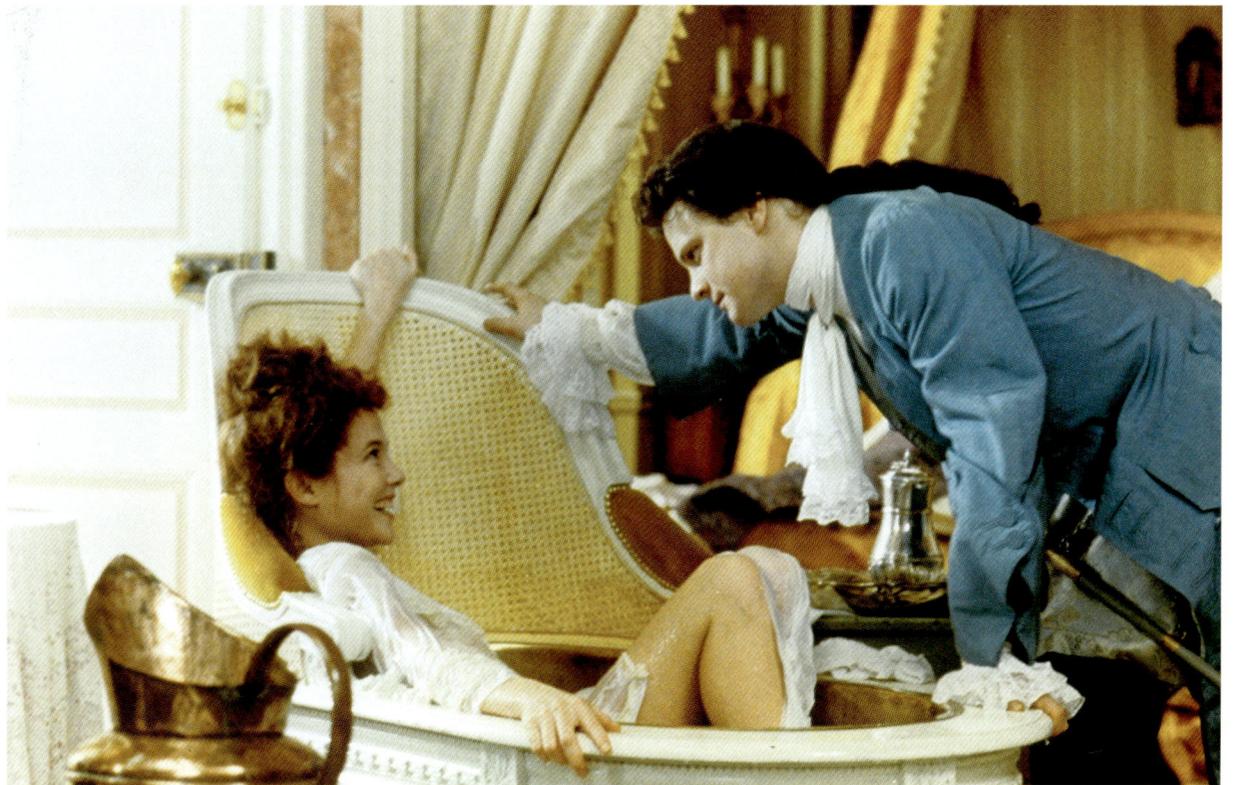

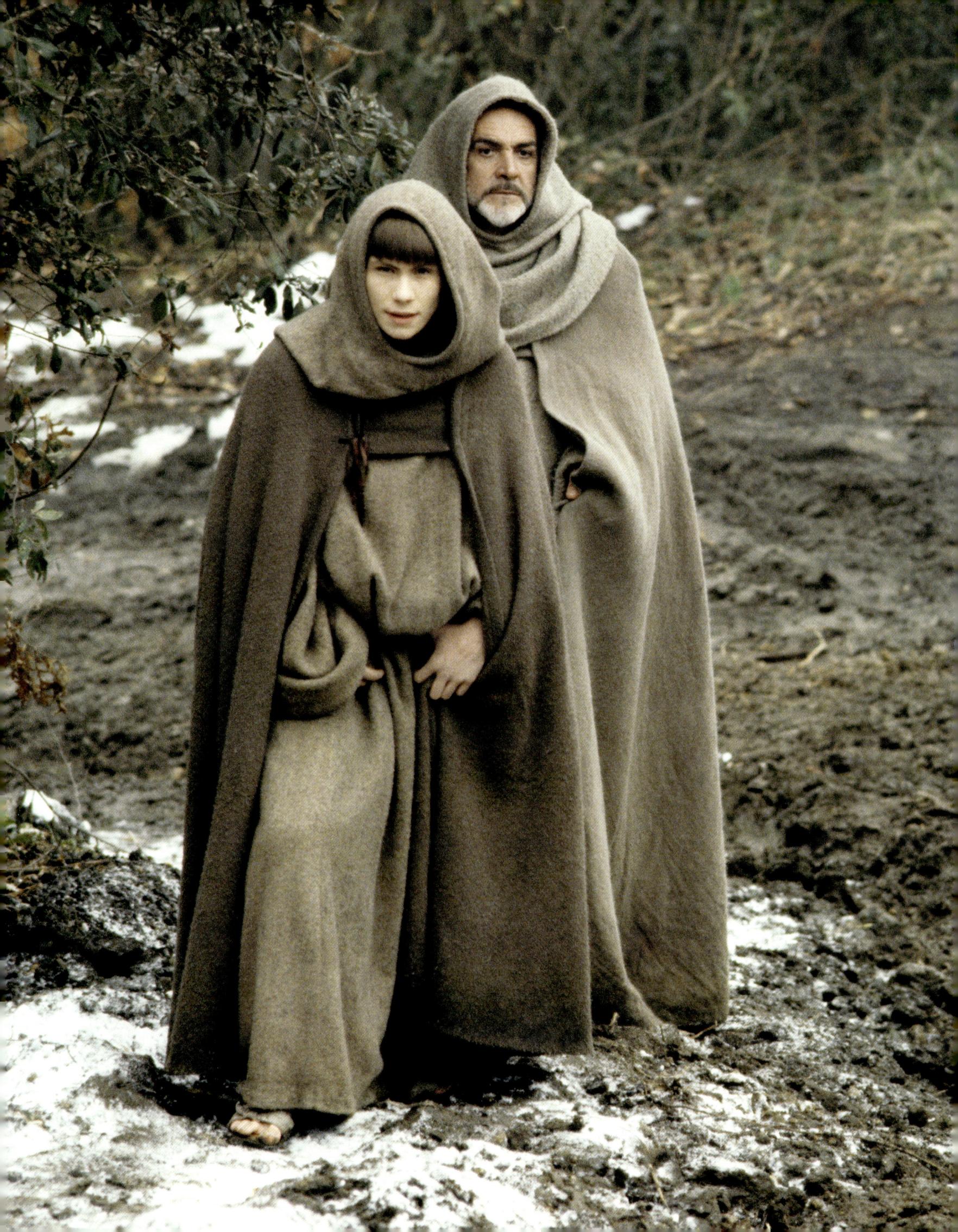

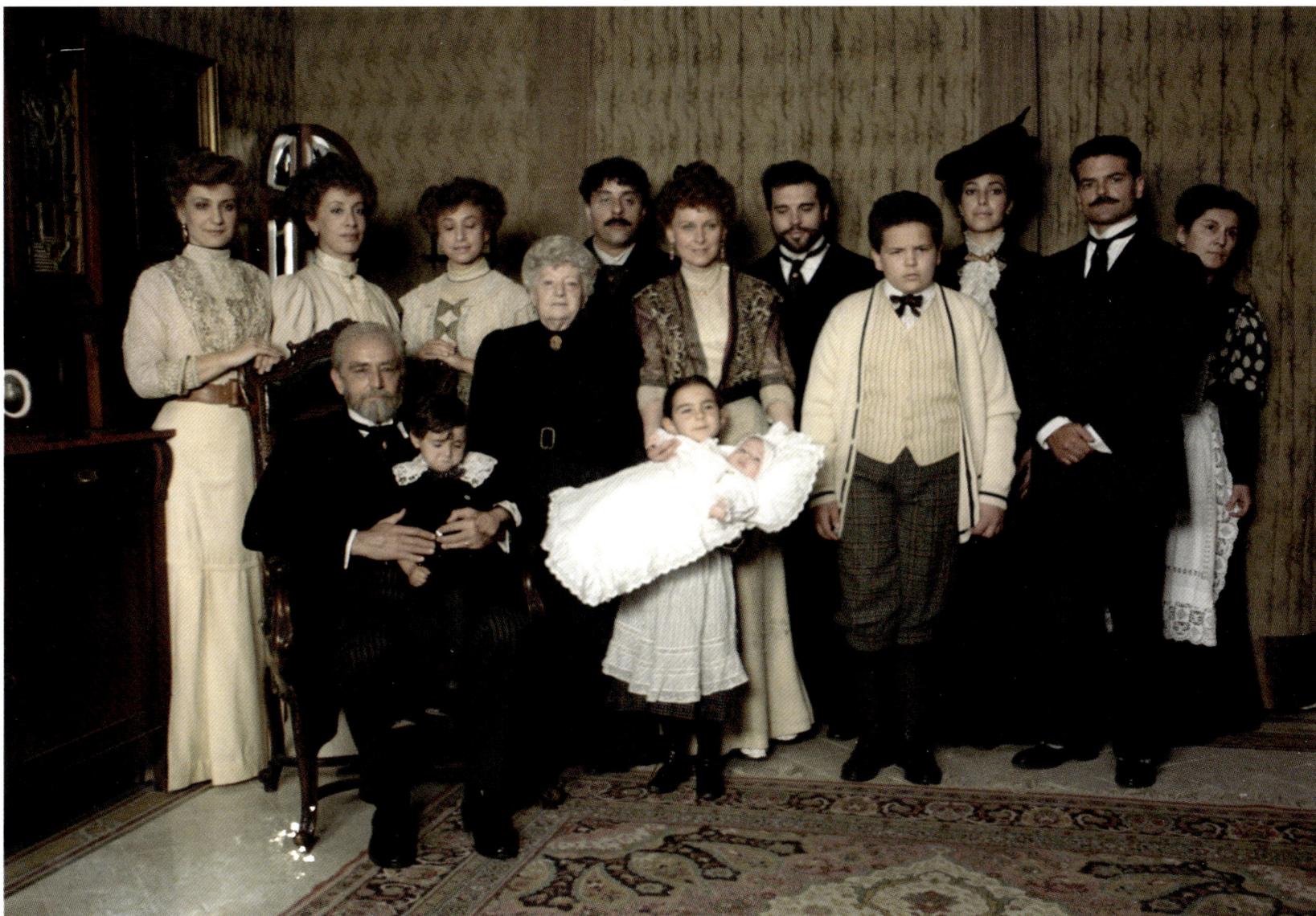

Opposite

GABRIELLA PESCUCCI

Il nome della rosa
[The Name of the Rose], 1986
Directed by Jean-Jacques Annaud

Christian Slater and Sean Connery
Photo by Mario Tursi – Archivio
Storico del Cinema – AFE

GABRIELLA PESCUCCI

La Famiglia [The Family], 1987
Directed by Ettore Scola

Photo of the family in 1906: seated,
Vittorio Gassman; standing behind
him, Monica Scattini, Athina Cenci
and Alessandra Panelli

Below, photo of the family in 1986:
in the centre, Vittorio Gassman;
seated beside him, Ottavia Piccolo,
Massimo Dapporto and Fanny Ardant
Reporters Associati & Archivi

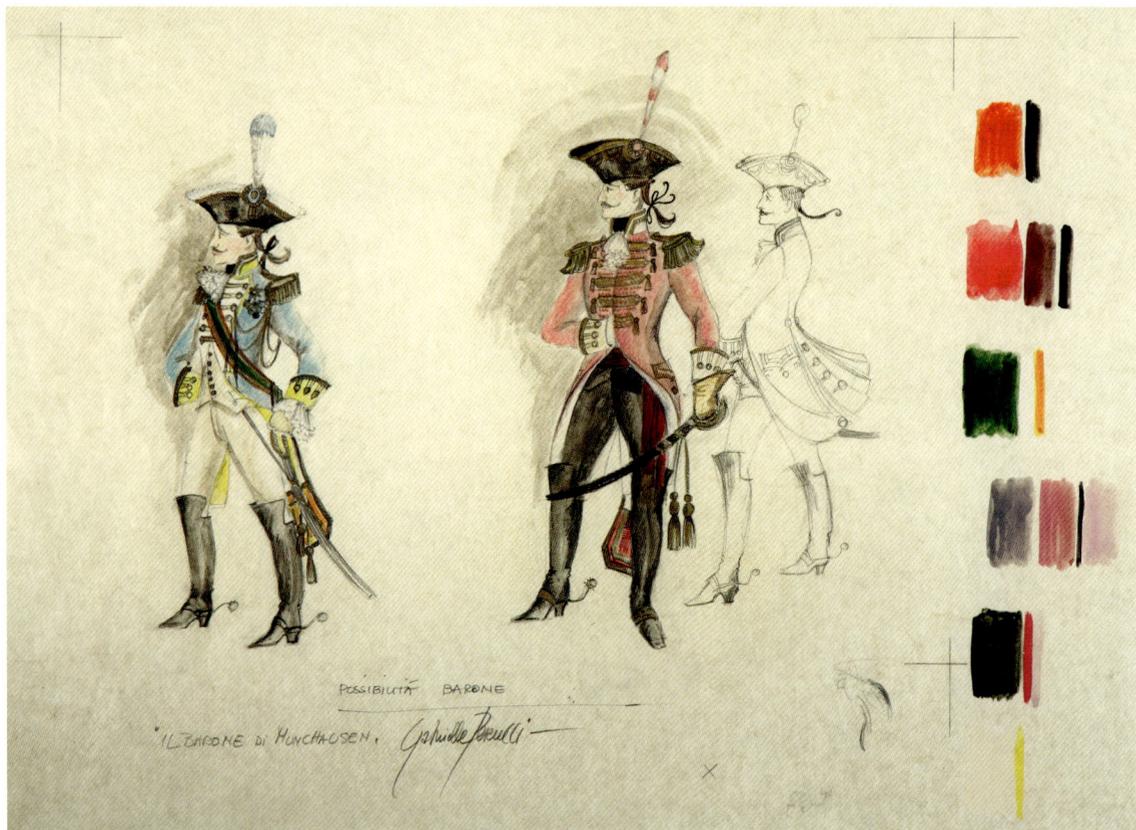

GABRIELLA PESCUCCI

The Adventures of Baron Münchausen,
1988
Directed by Terry Gilliam

Study for the Baron (John Neville)

Below, John Neville

Opposite, study for the harem scene

Below, the harem
Courtesy Penta Distribuzione

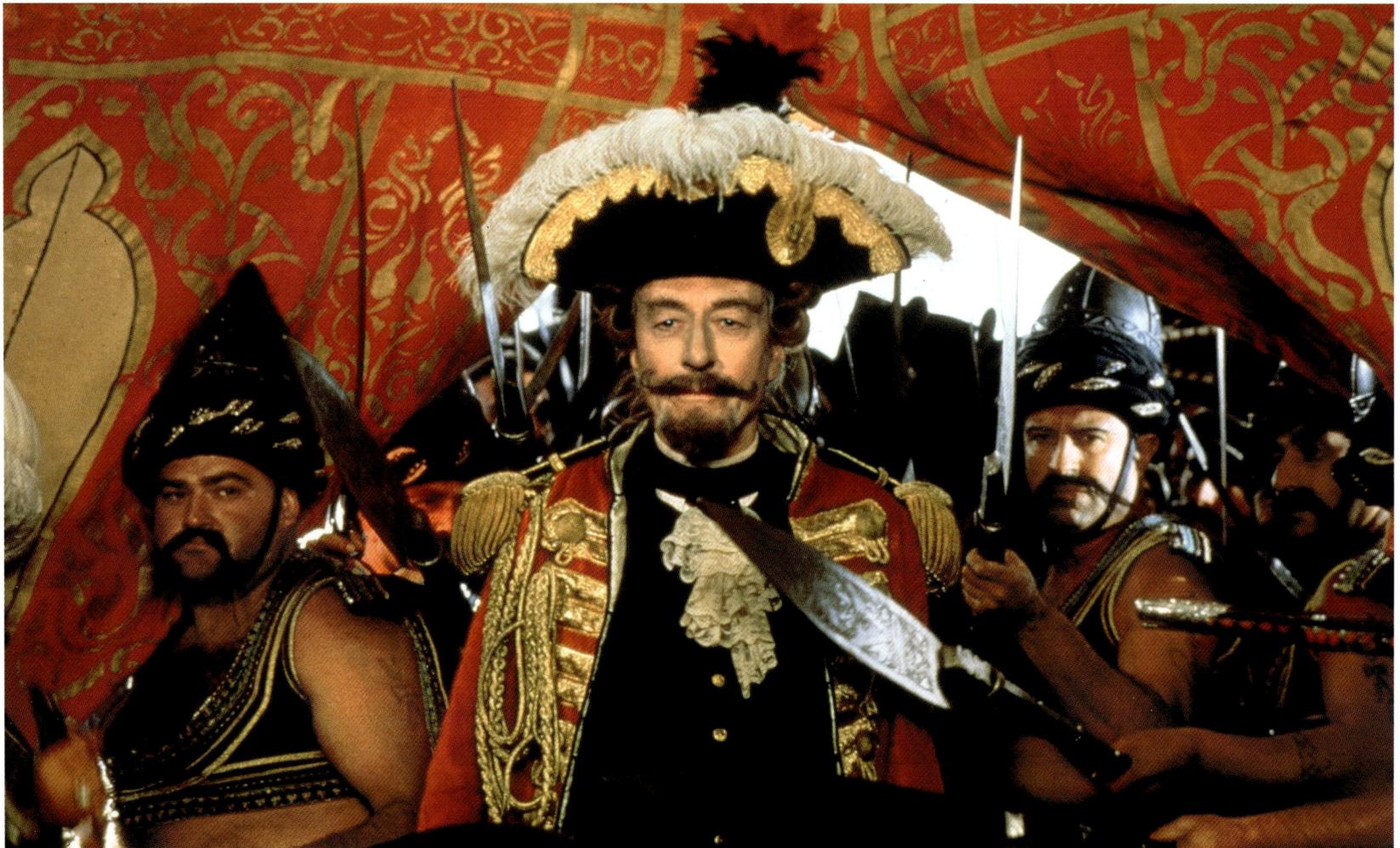

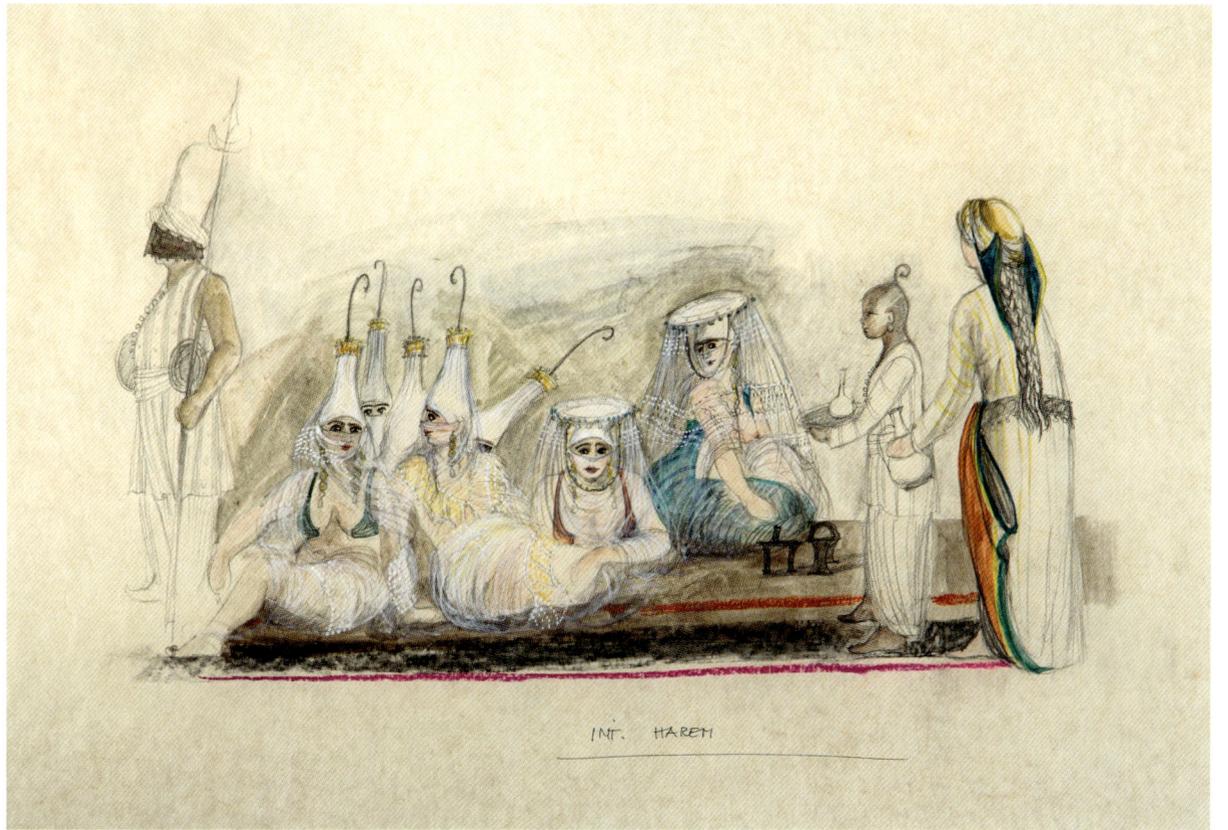

INT. HAREM

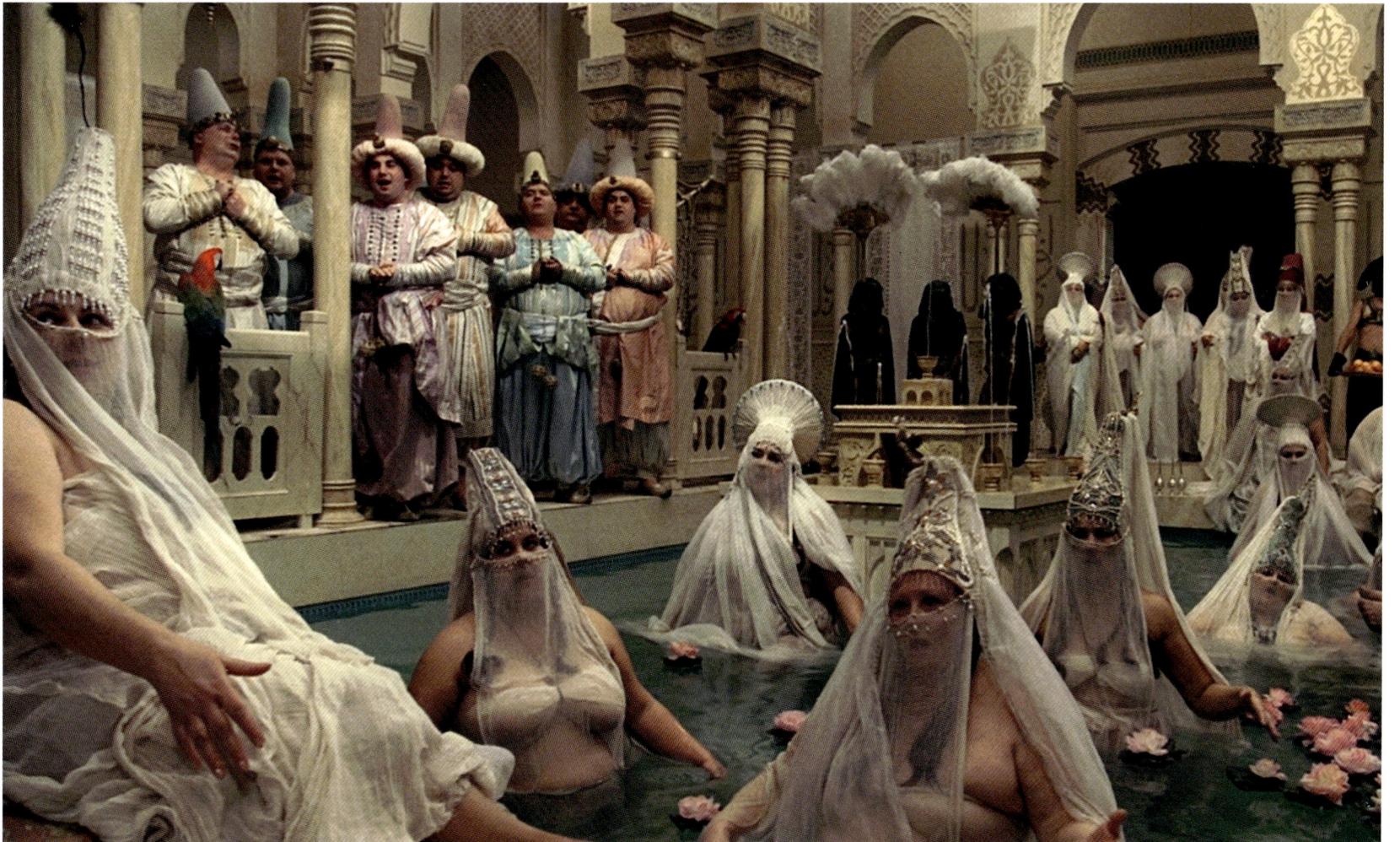

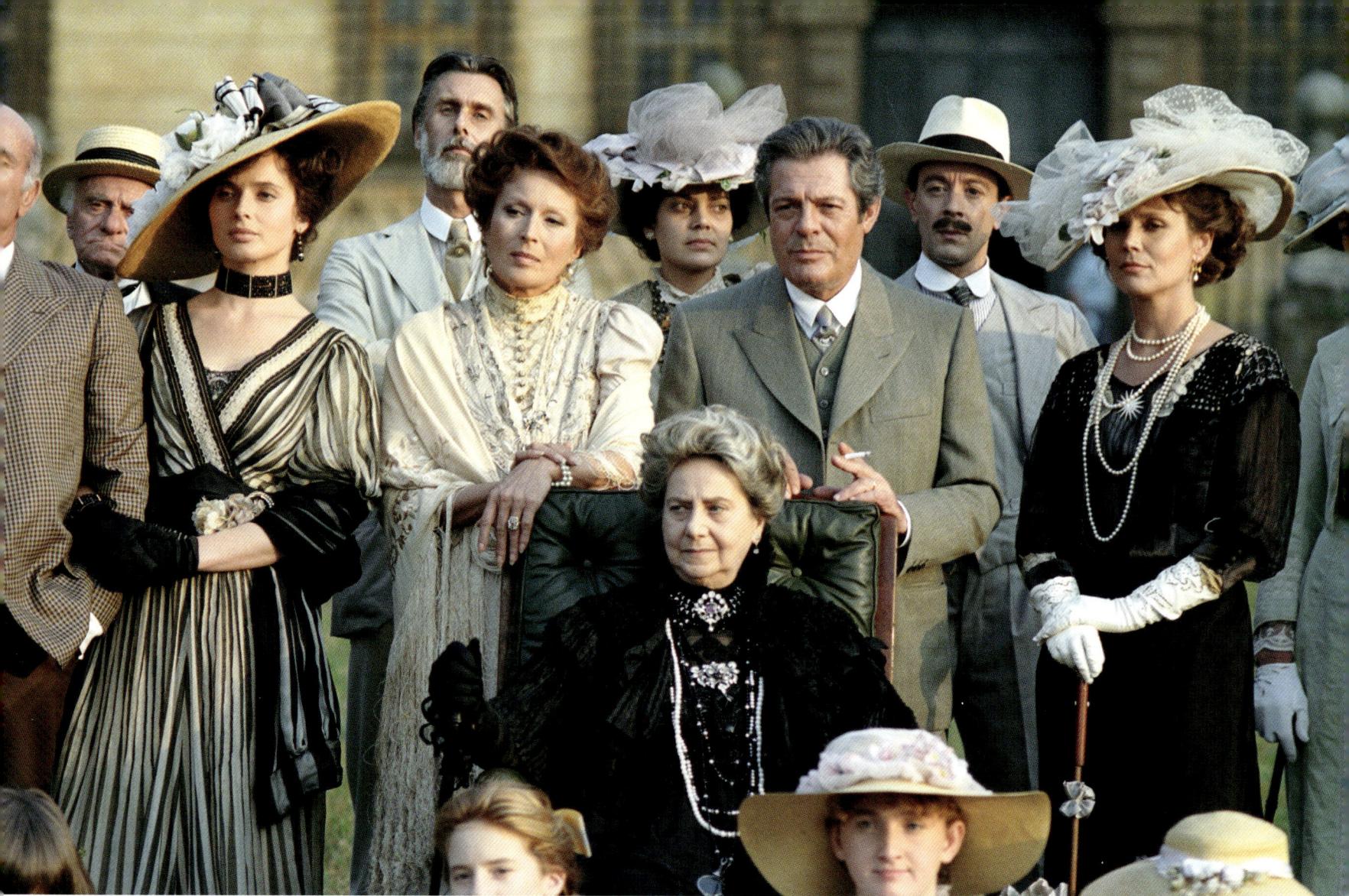

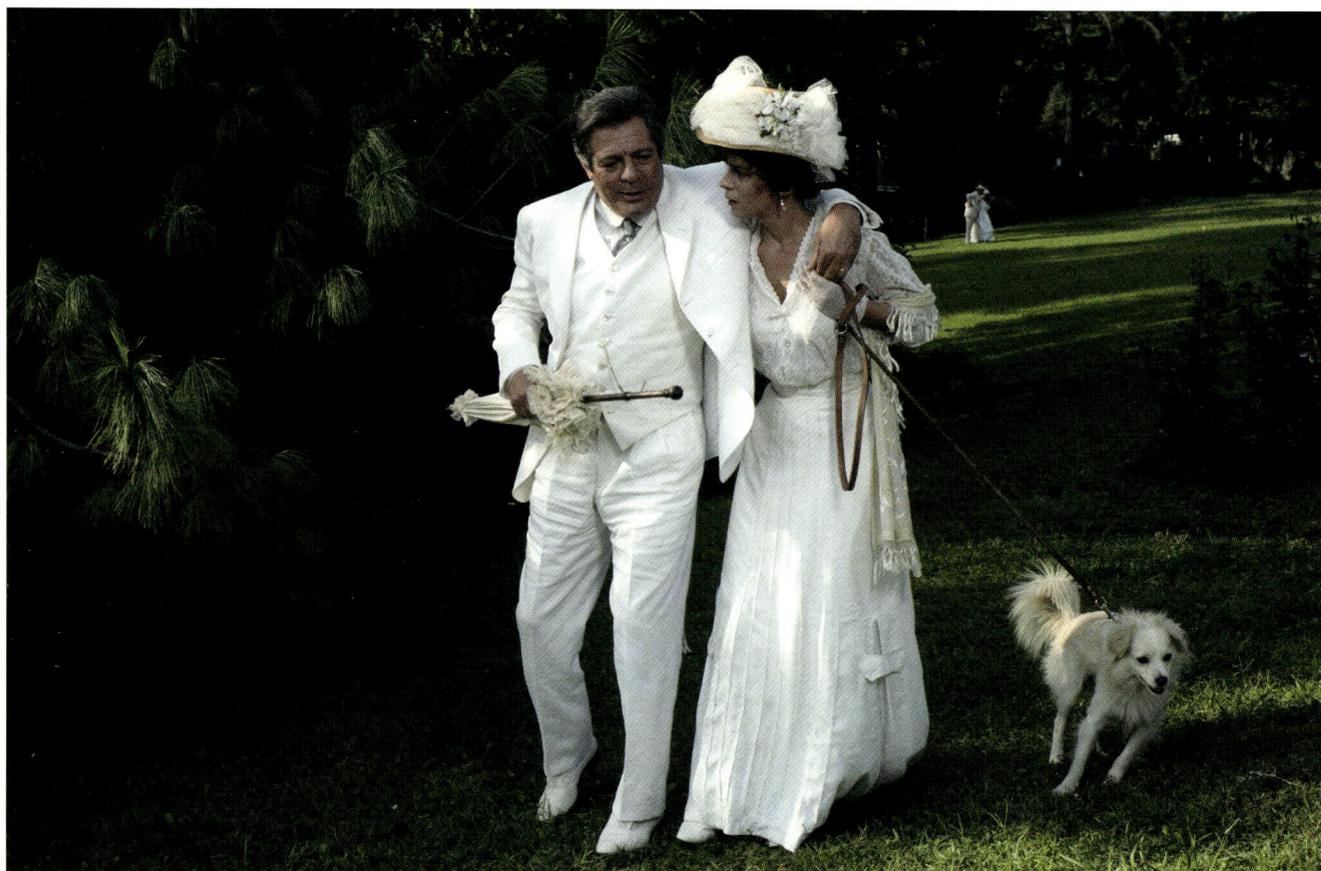

Opposite

CARLO DIAPPI

Oci Ciornie [Dark Eyes], 1987
Directed by Nikita Mikhalkov

Family photo: seated, Pina Cei;
standing behind her, Isabella
Rossellini, Silvana Mangano, Marcello
Mastroianni and Marthe Keller

Below, Marcello Mastroianni,
Elena Safonova and pet dog Yasha
Photos by Valerio Giannetti –
Reporters Associati & Archivi

CARLO DIAPPI

La puttana del re [The King's Whore],
1990
Directed by Axel Corti

Valeria Golino
Photo by Paul Ronald – Archivio
Storico del Cinema – AFE

ALBERTO VERSO

L'Avaro [The Miser], 1990
Directed by Tonino Cervi

Alberto Sordi
Photos by Enrico Appetito – Archivio
Storico del Cinema – AFE

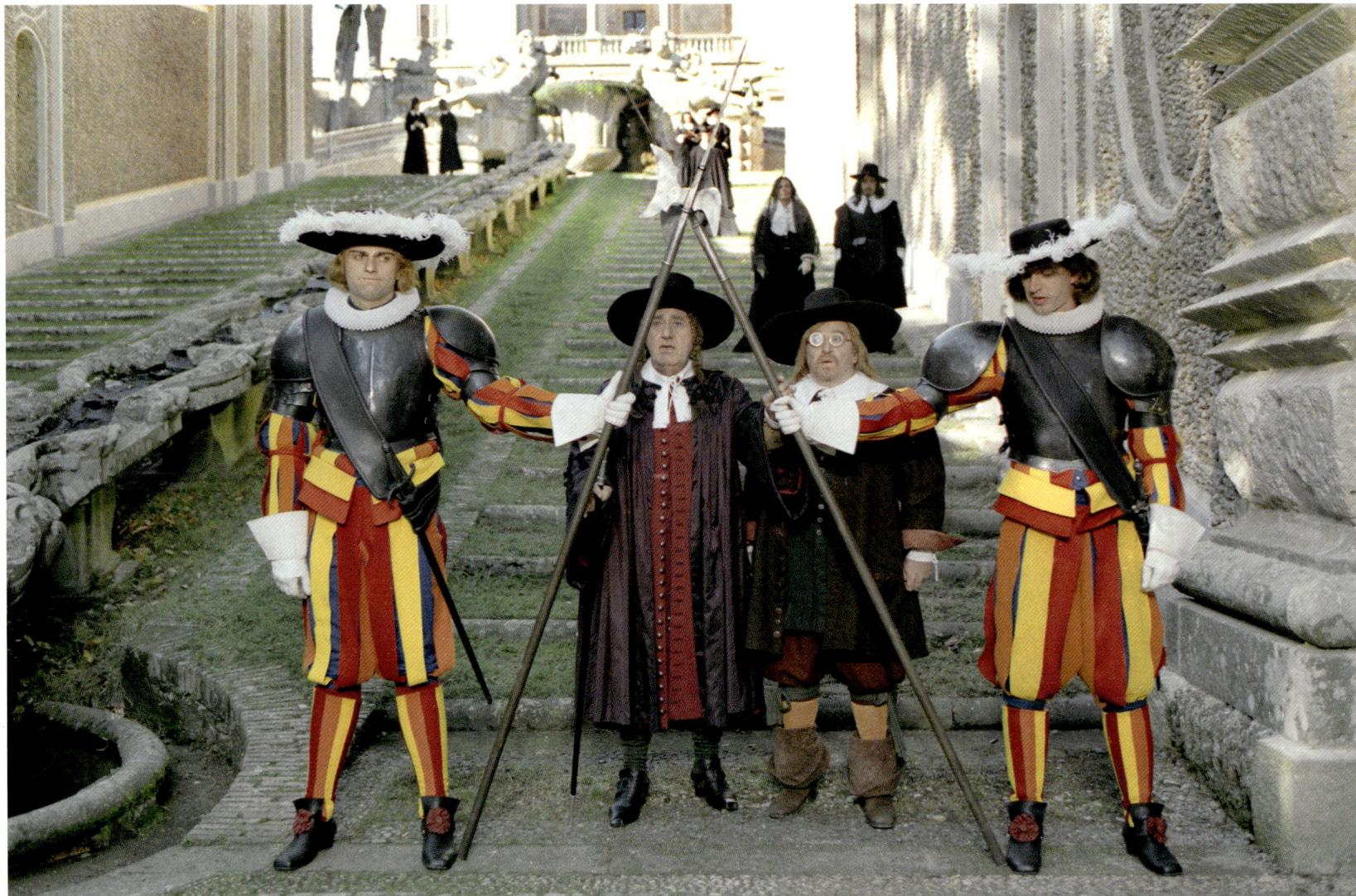

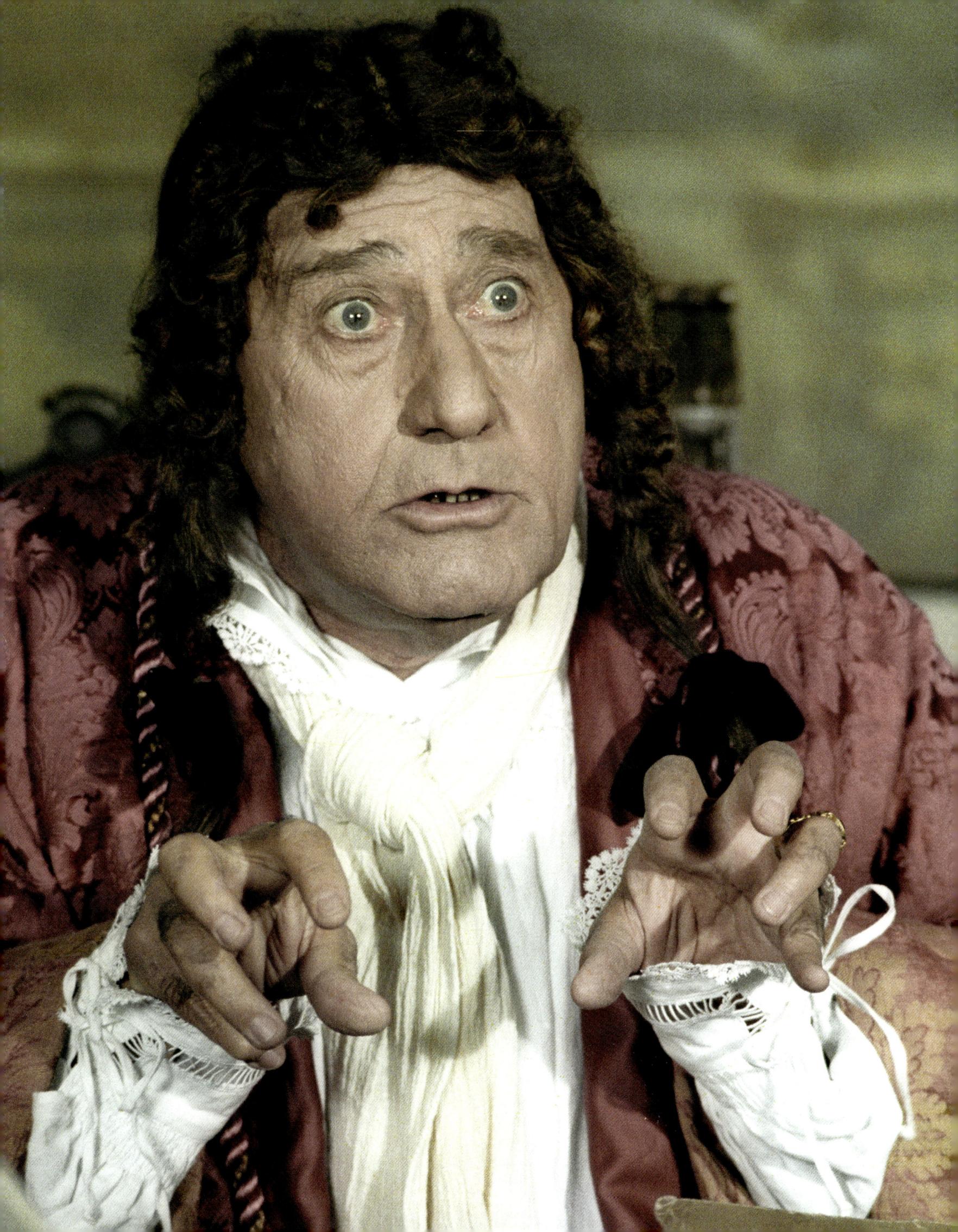

PIERO TOSI

Storia di una capinera [Sparrow], 1993
Directed by Franco Zeffirelli

Angela Bettis

Below, Franco Zeffirelli during filming

Opposite, left, Valentina Cortese

Right, Mia Fothergill
Photos by Paul Ronald – Archivio
Zeffirelli

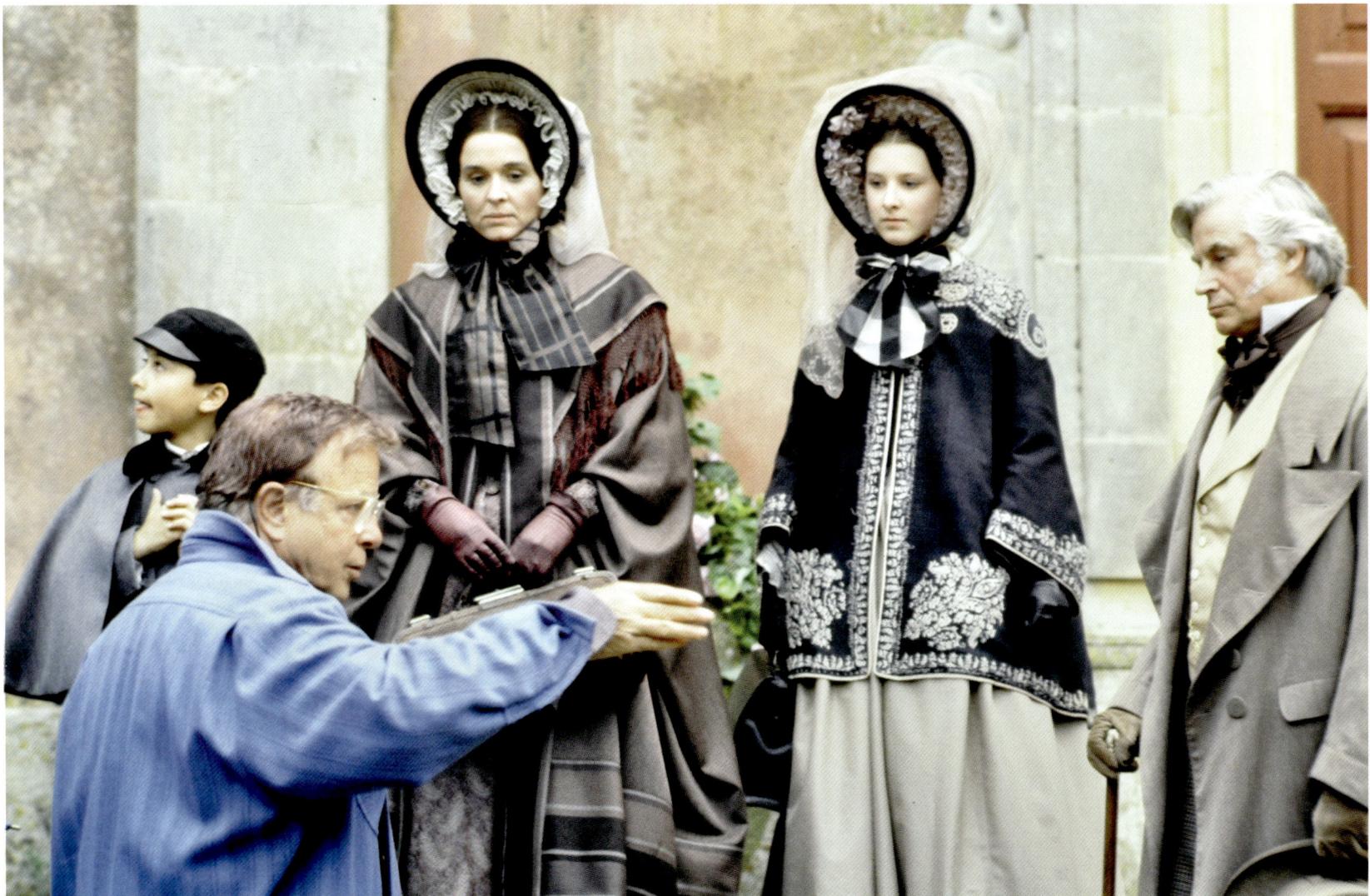

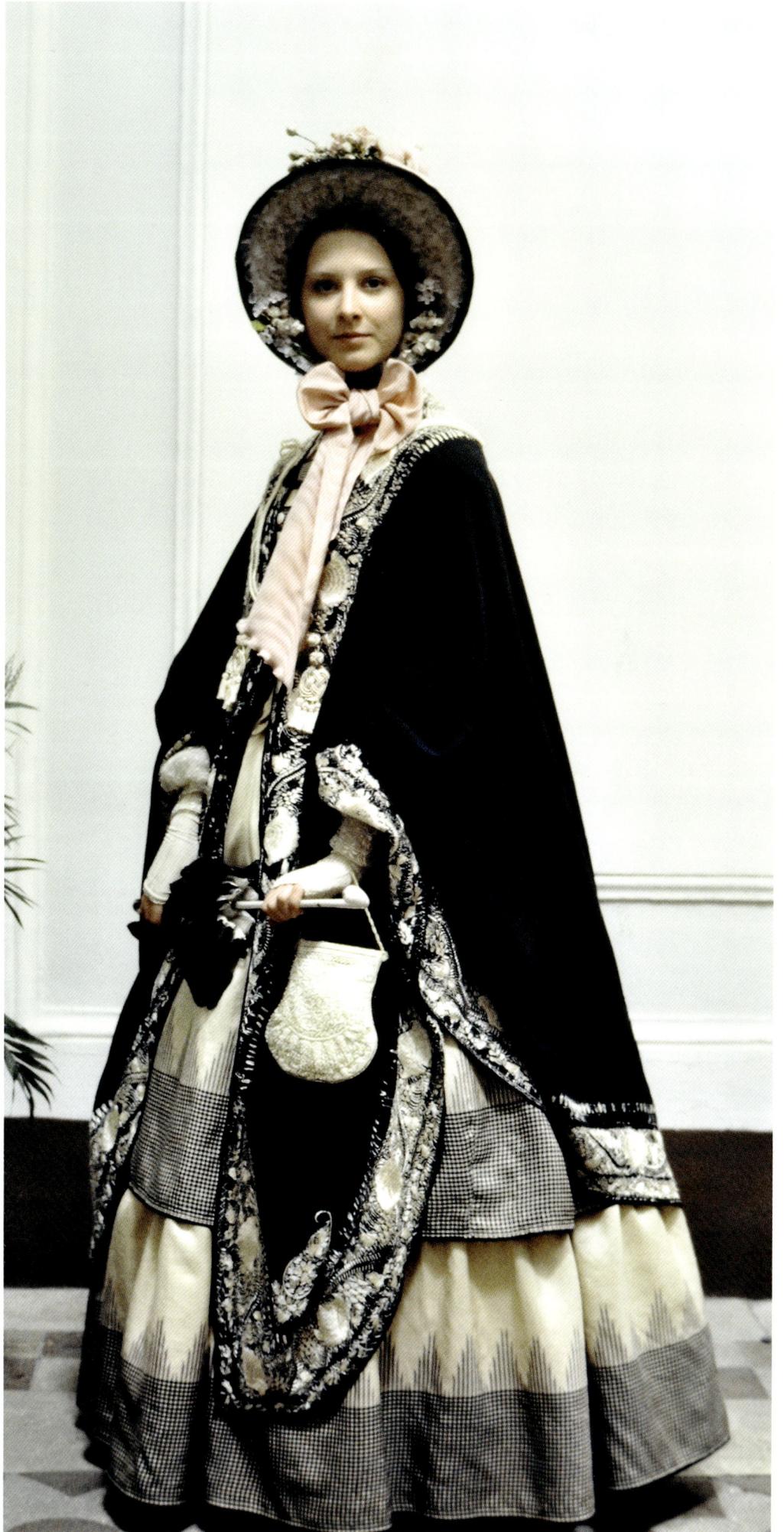

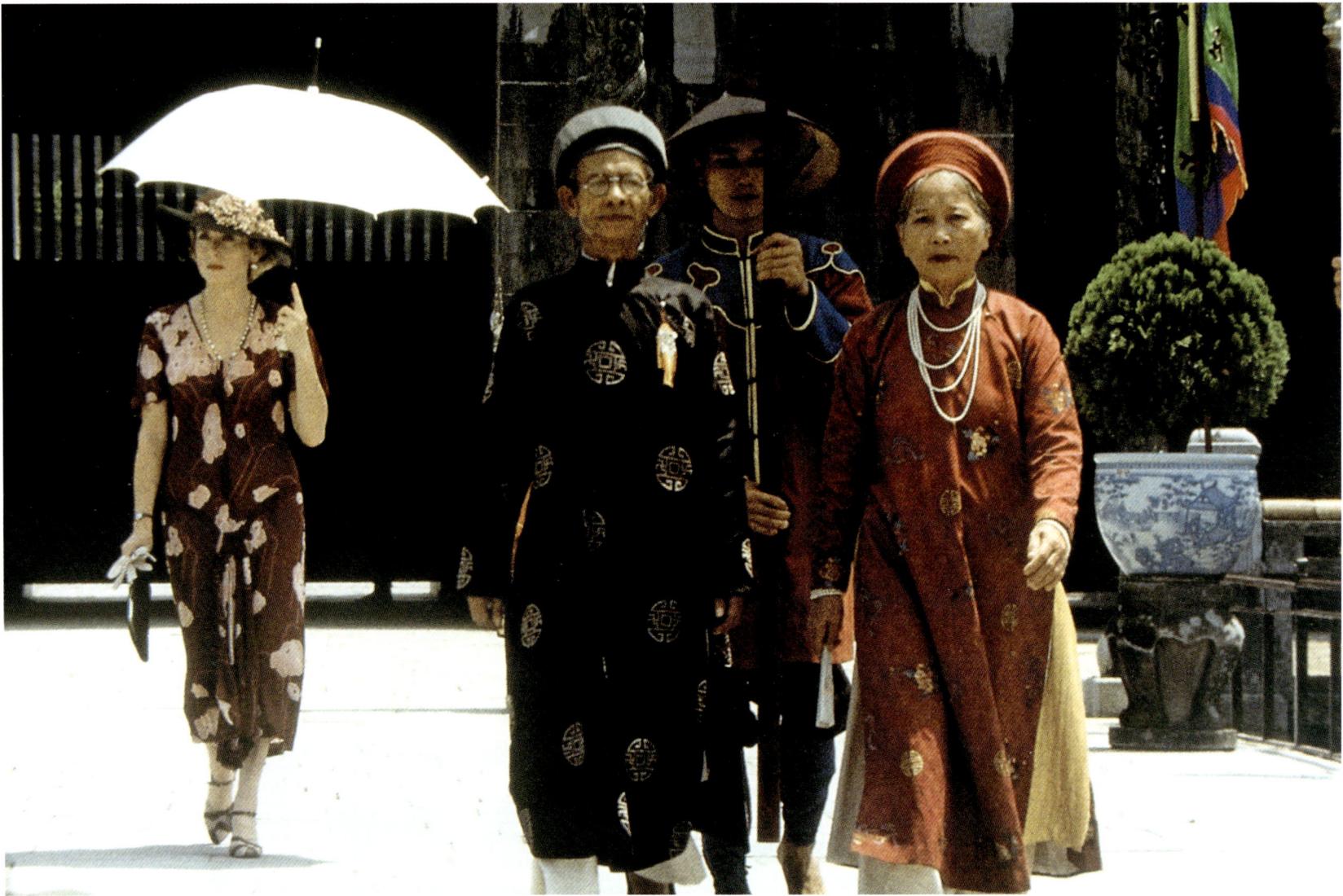

GABRIELLA PESCUCCI

Indochine, 1992
Directed by Régis Wargnier

Catherine Deneuve
Courtesy Skorpion Entertainment

Opposite

GABRIELLA PESCUCCI

The Age of Innocence, 1993
Directed by Martin Scorsese

Winona Ryder

Below, Daniel Day-Lewis,
Geraldine Chaplin and Winona Ryder
Courtesy Columbia Tristar

Following pages

Daniel Day-Lewis and Michelle
Pfeiffer

Winona Ryder
Courtesy Columbia Tristar – Archivio
Storico del Cinema – AFE

Gabriella Pescucci netted an Academy
Award for Best Costume Design
with this film

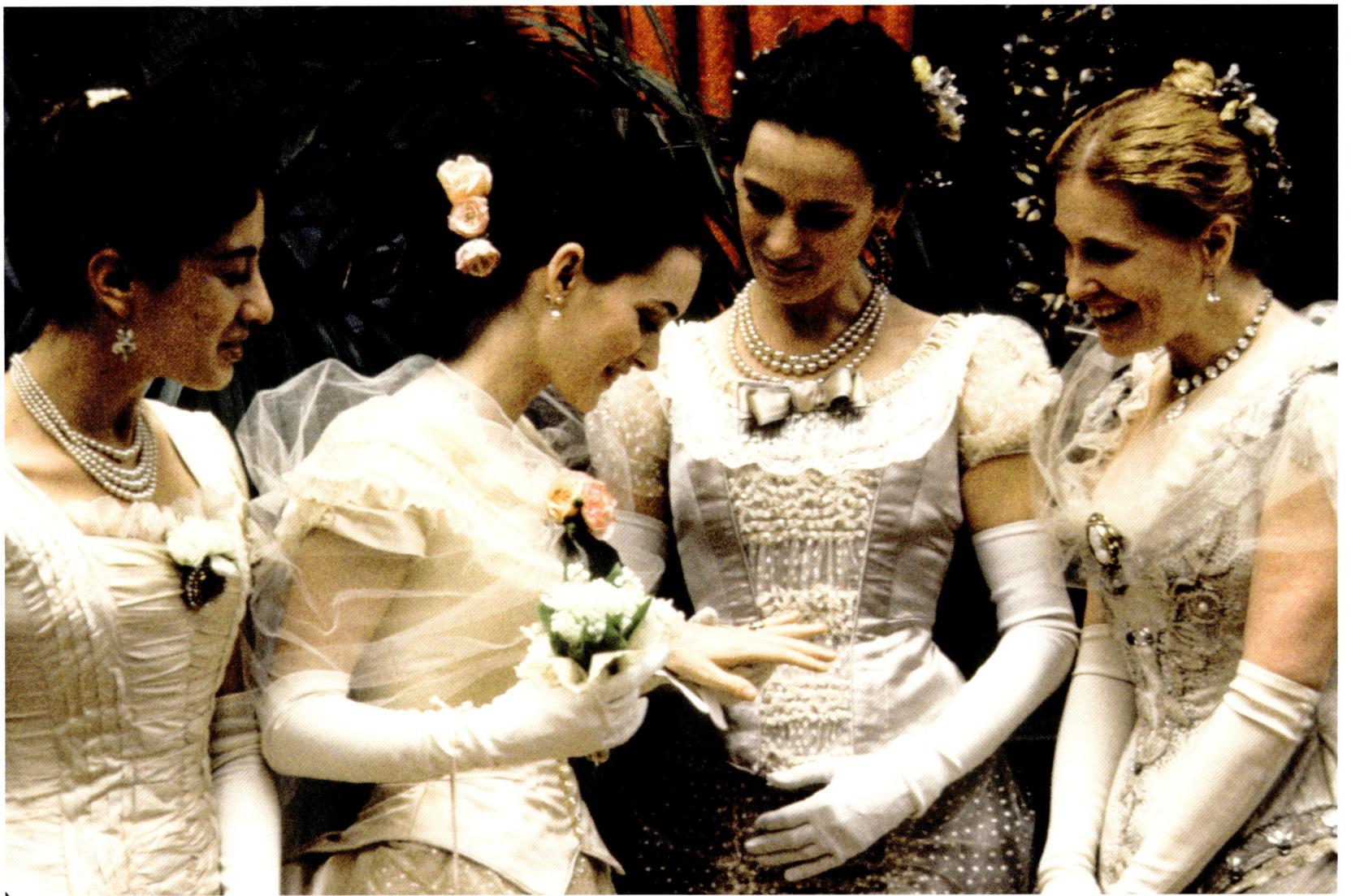

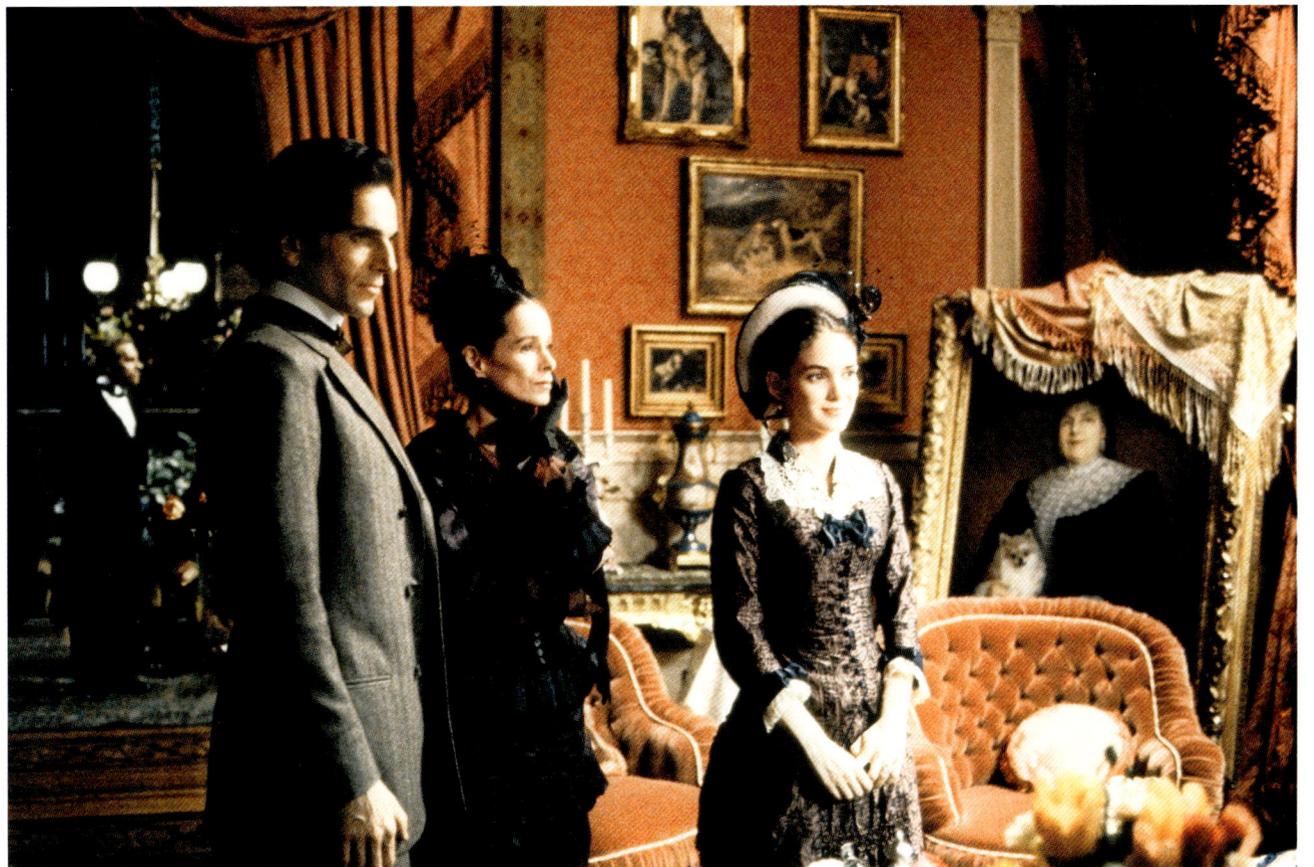

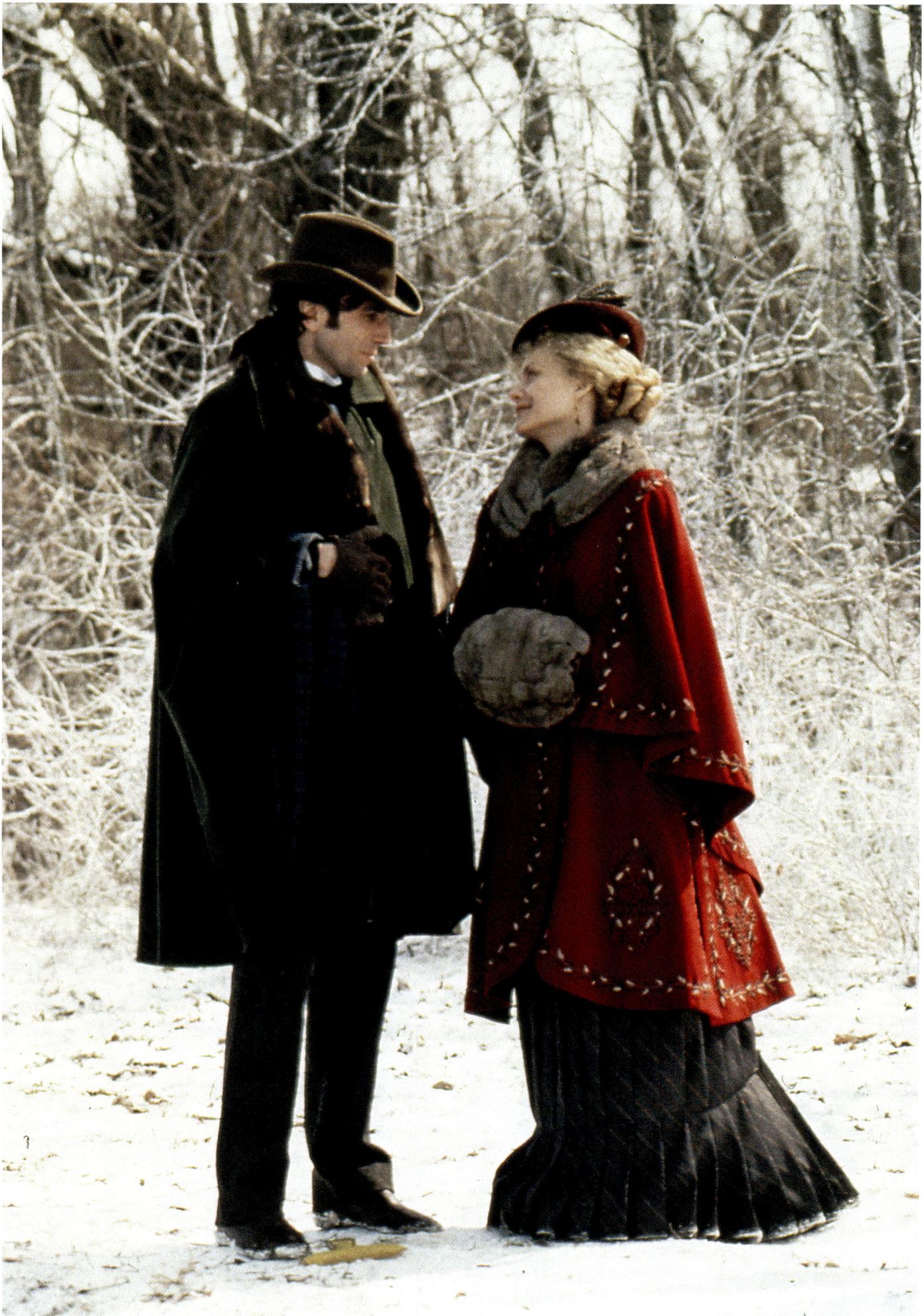

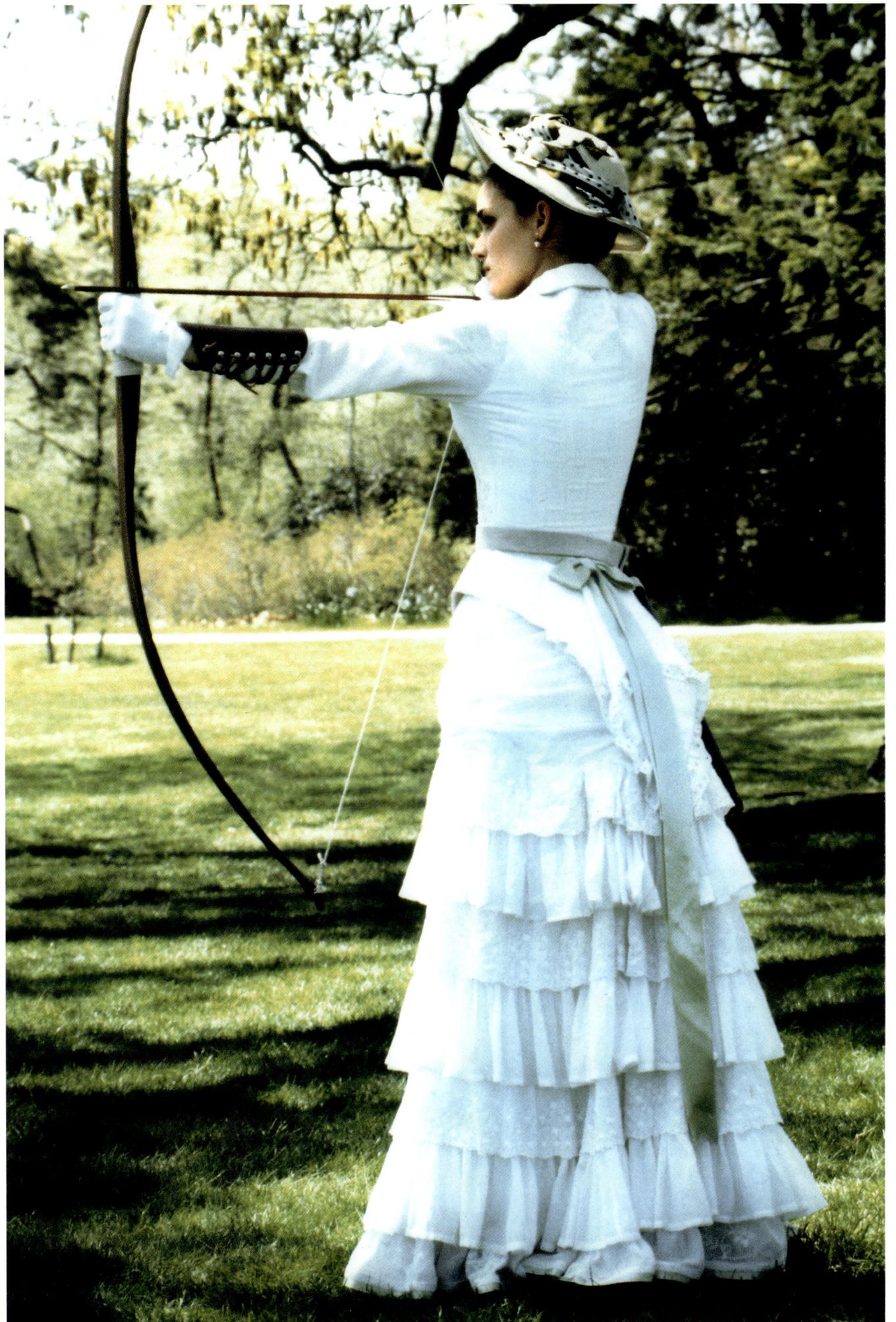

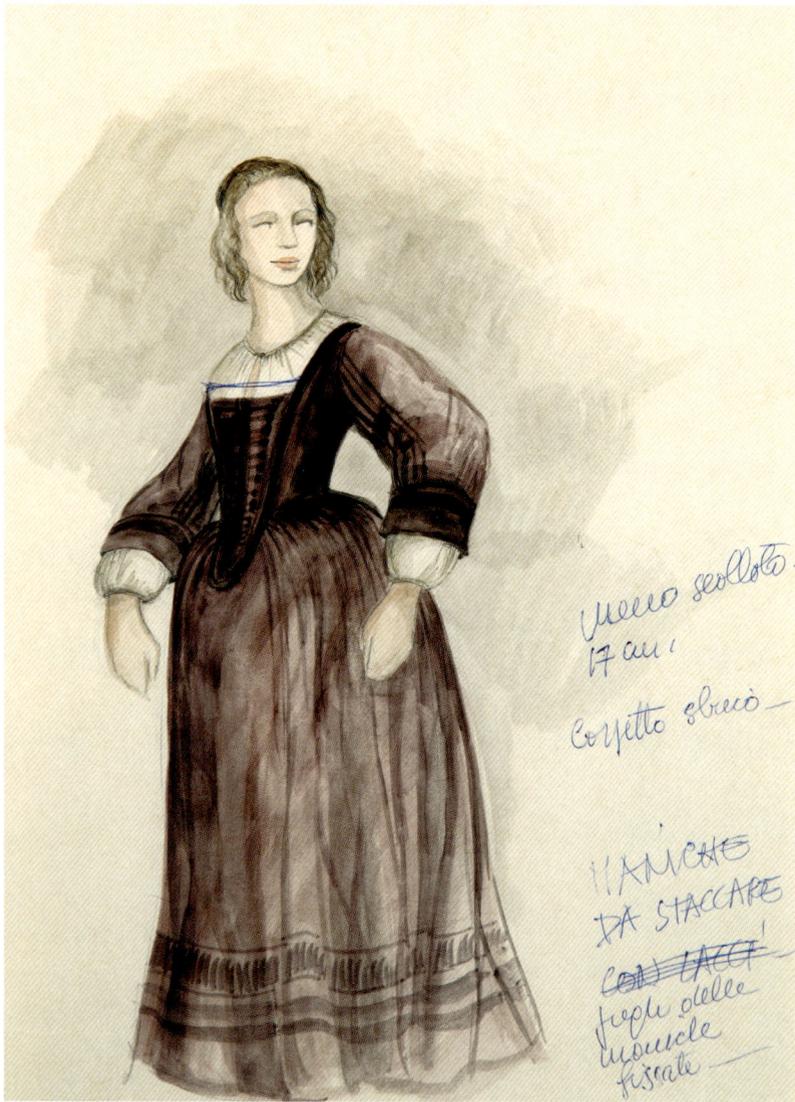

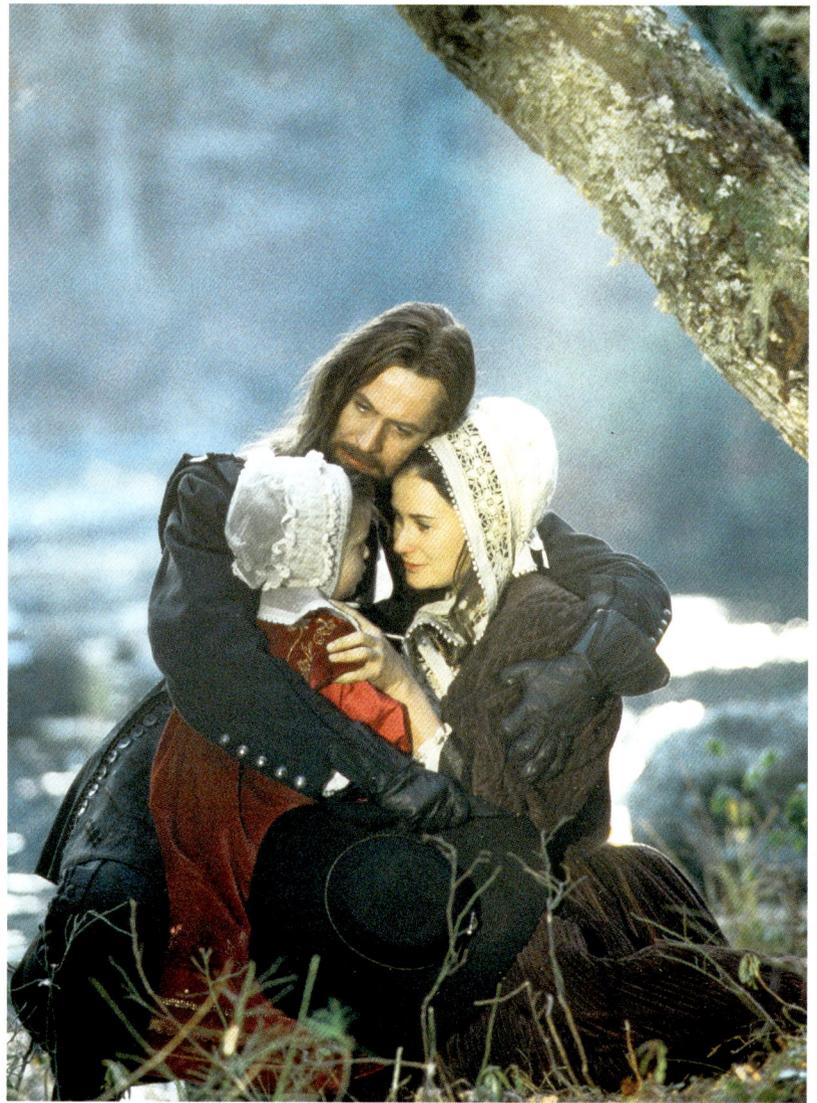

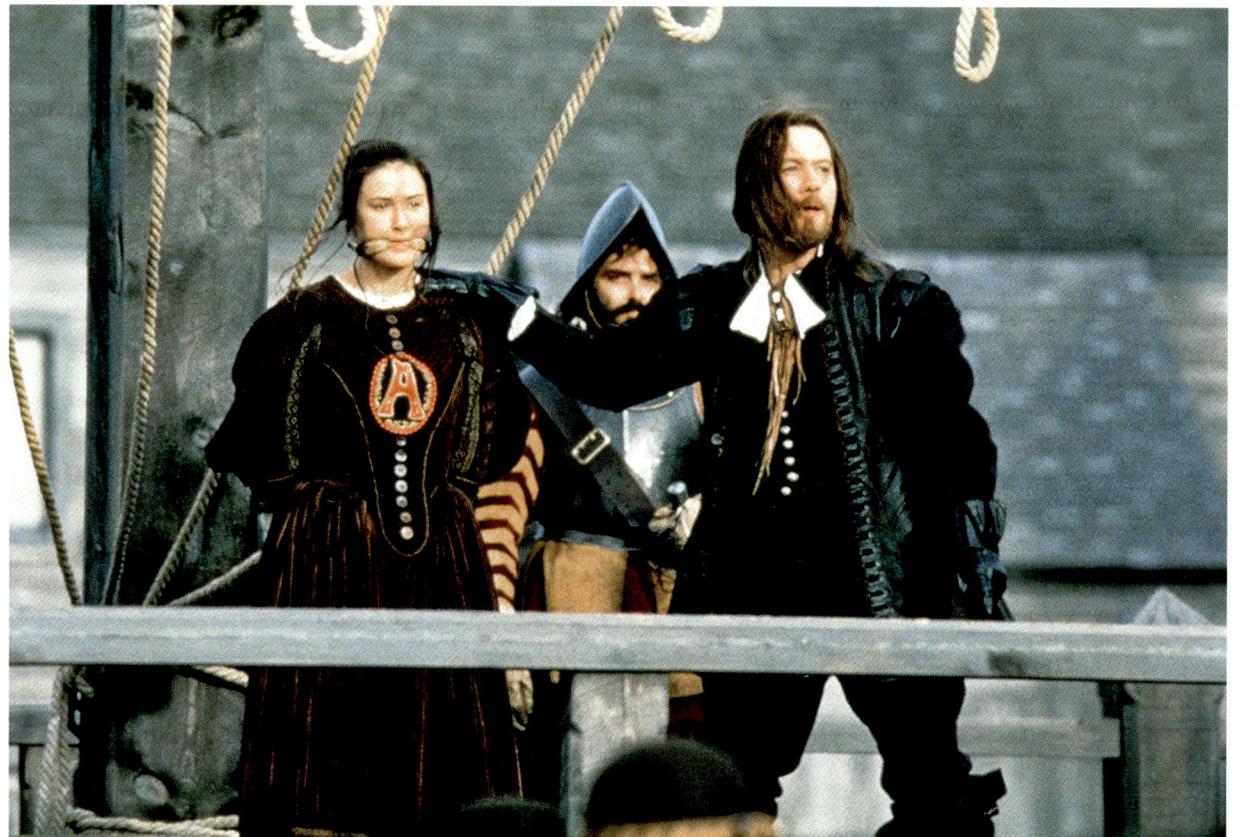

GABRIELLA PESCUCCI

The Scarlet Letter, 1995
Directed by Roland Joffé

Study for Hester (Demi Moore)

Above right, Gary Oldman
and Demi Moore

Right, Demi Moore and Gary Oldman
Courtesy Warner Bros Italia

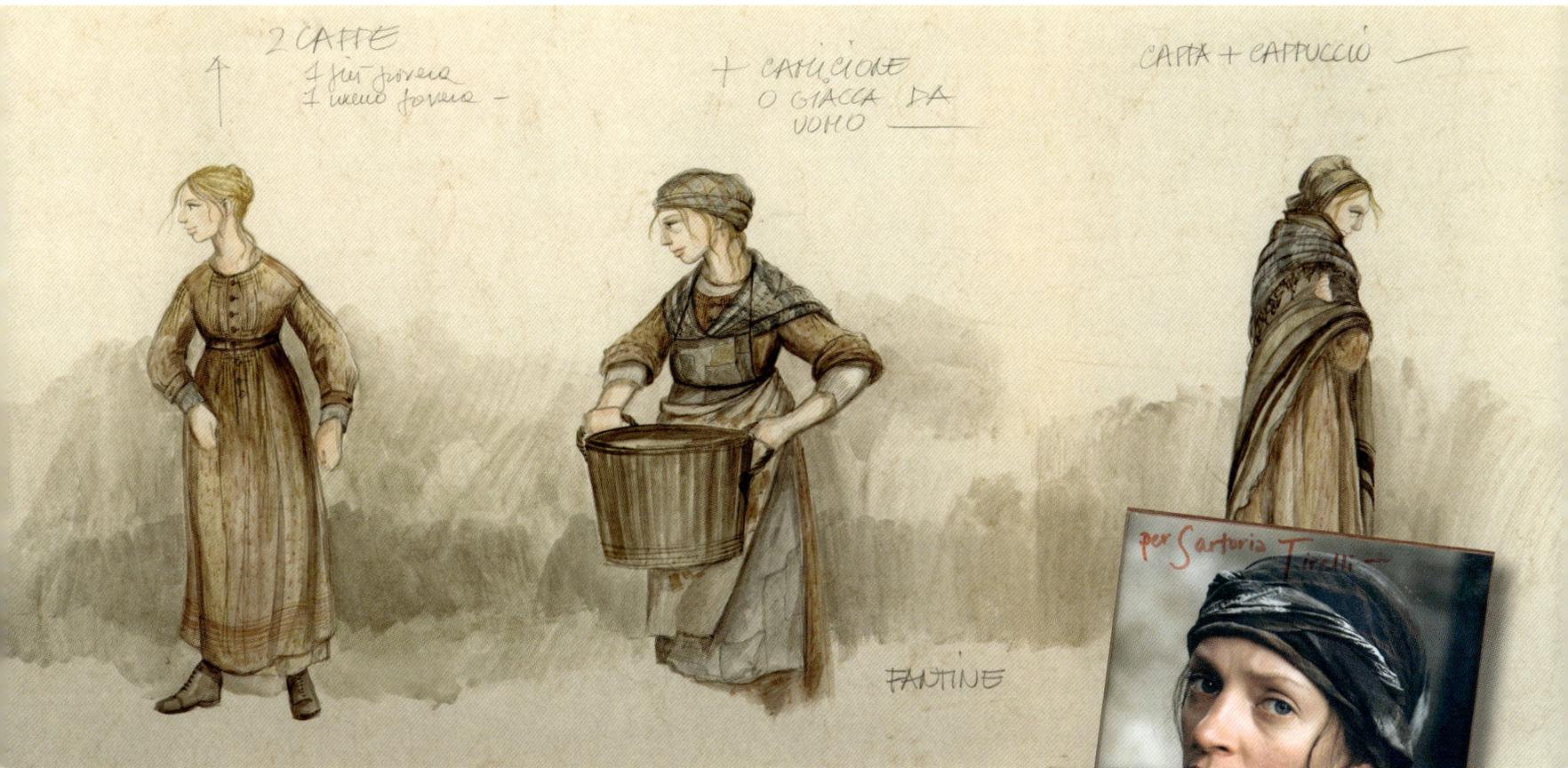

2 CAFFE
1 più forens
1 meno forens —

+ CAMICIONE
O GIACCA DA
UOMO —

CAPPA + CAPPUCCIO —

per Sartoria Tirelli —

FANTINE

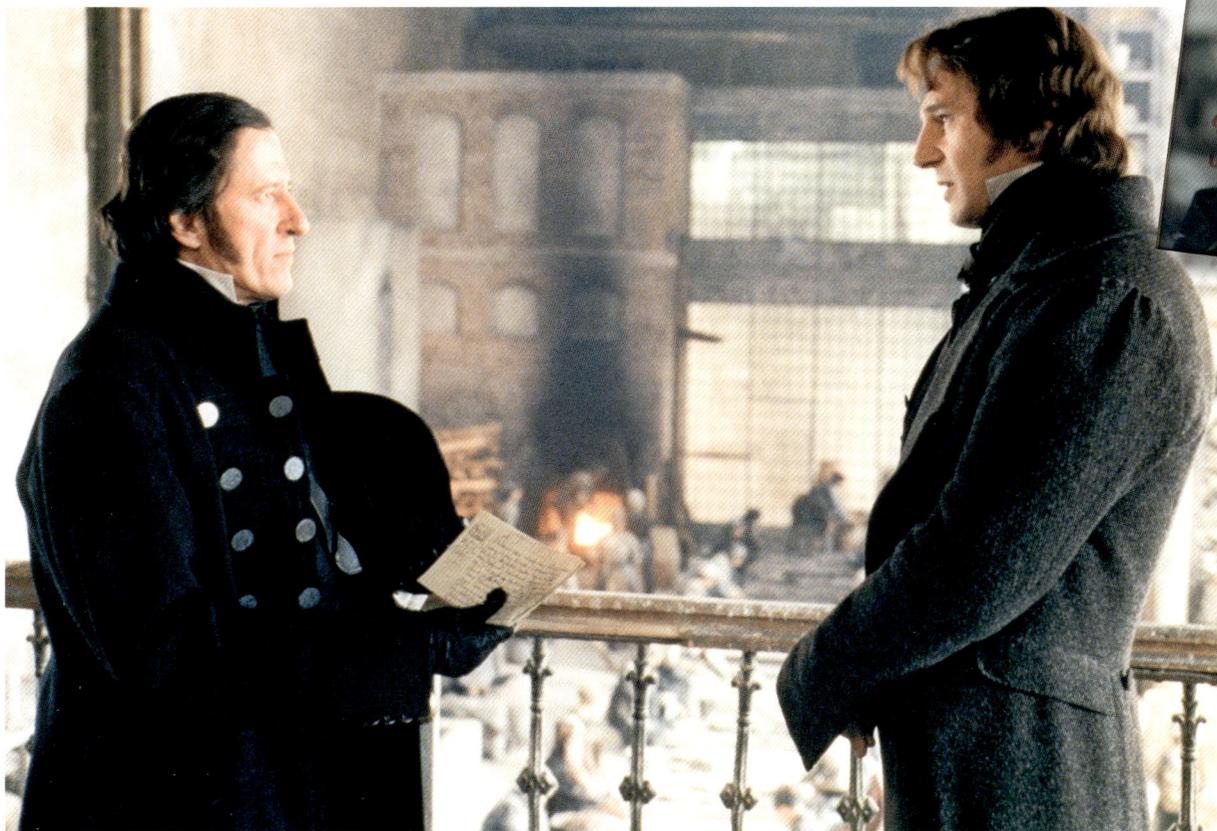

GABRIELLA PESCUCCI

Les Misérables, 1998
Directed by Bille August

Study for Fantine (Uma Thurman)

Photo of Uma Thurman with
dedication to the Sartoria Tirelli

Left, Geoffrey Rush and Liam Neeson
Courtesy Cecchi Gori Distribuzione

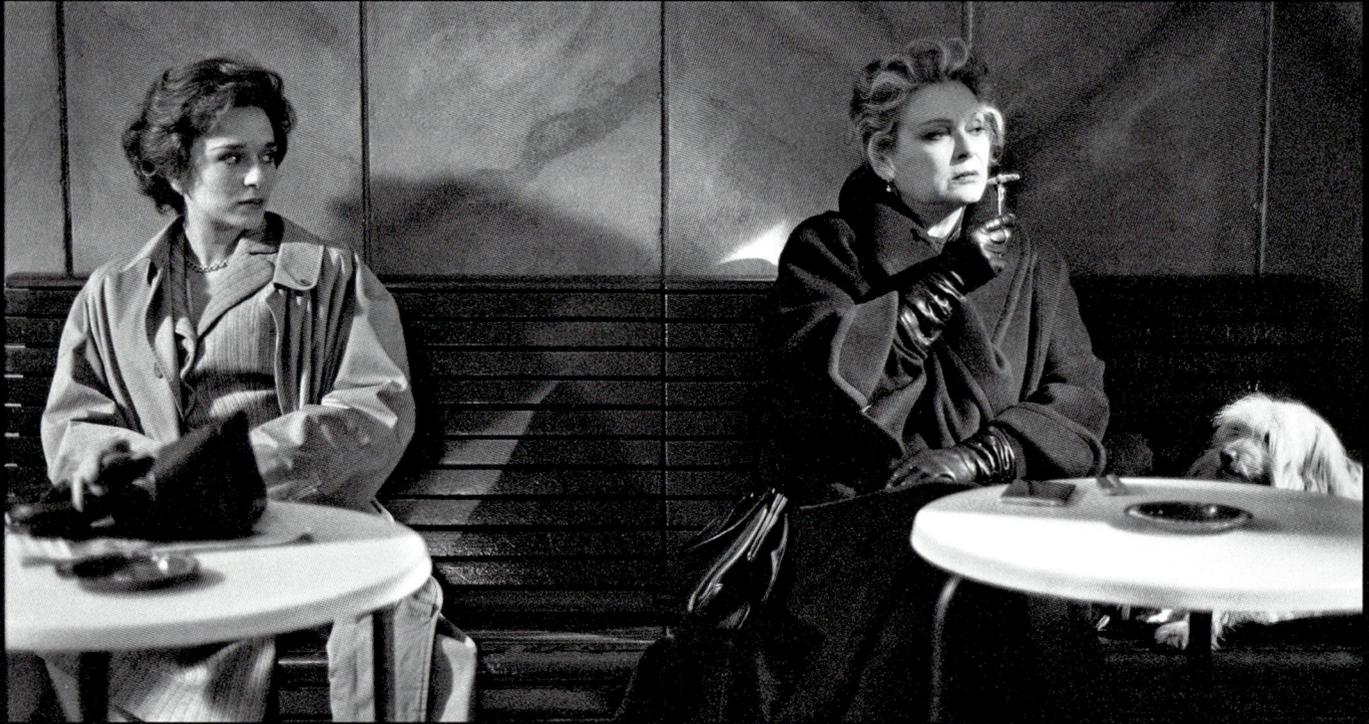

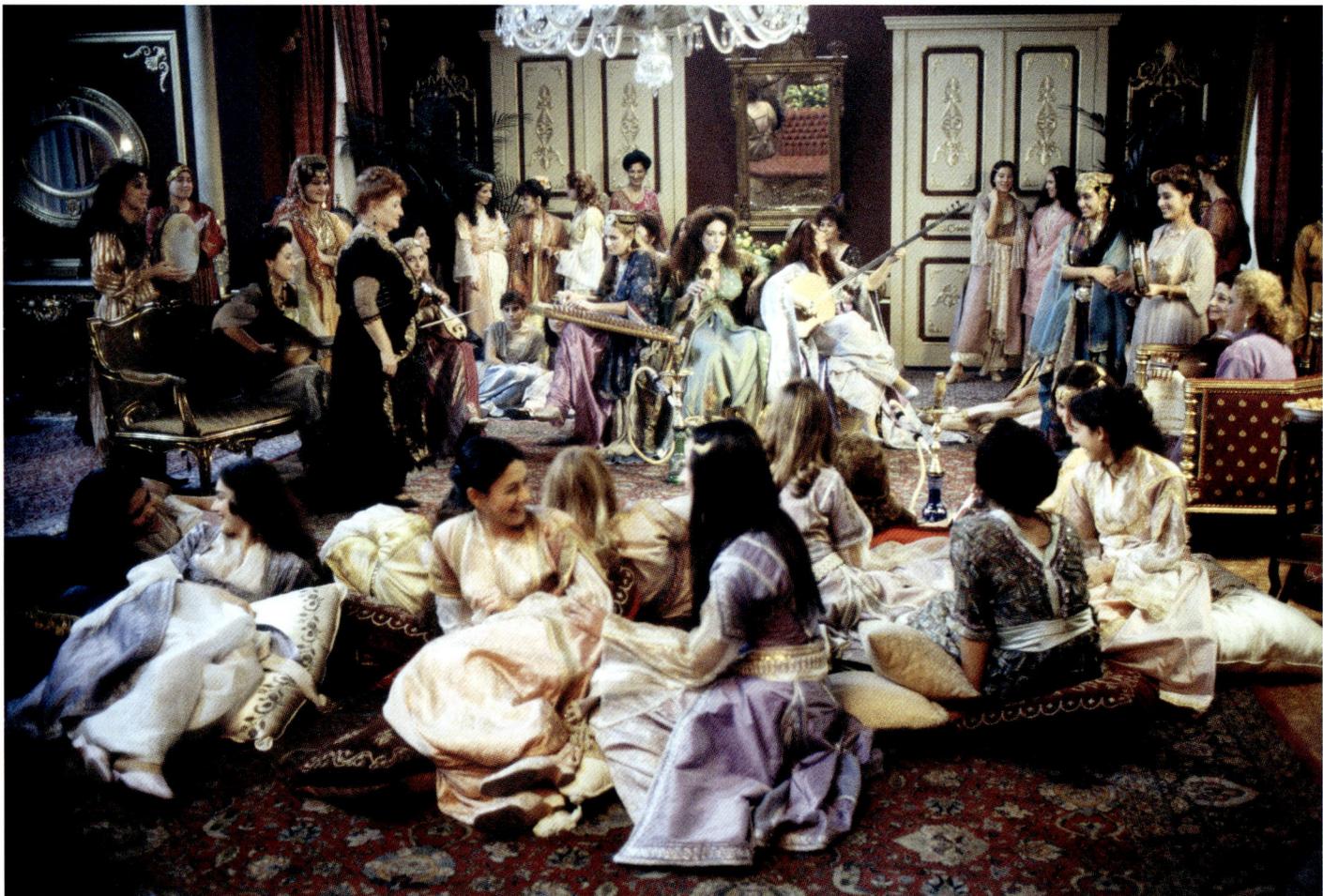

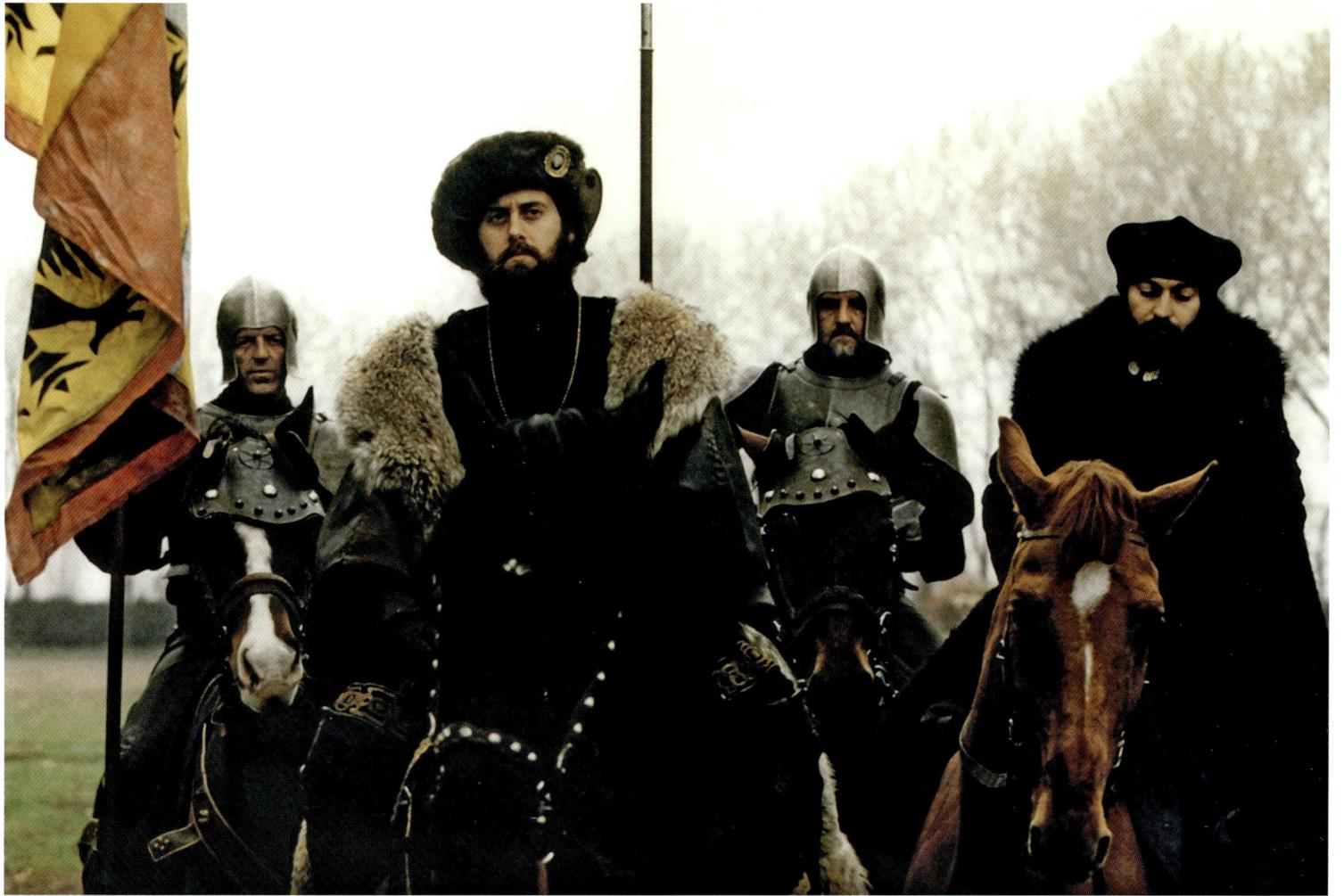

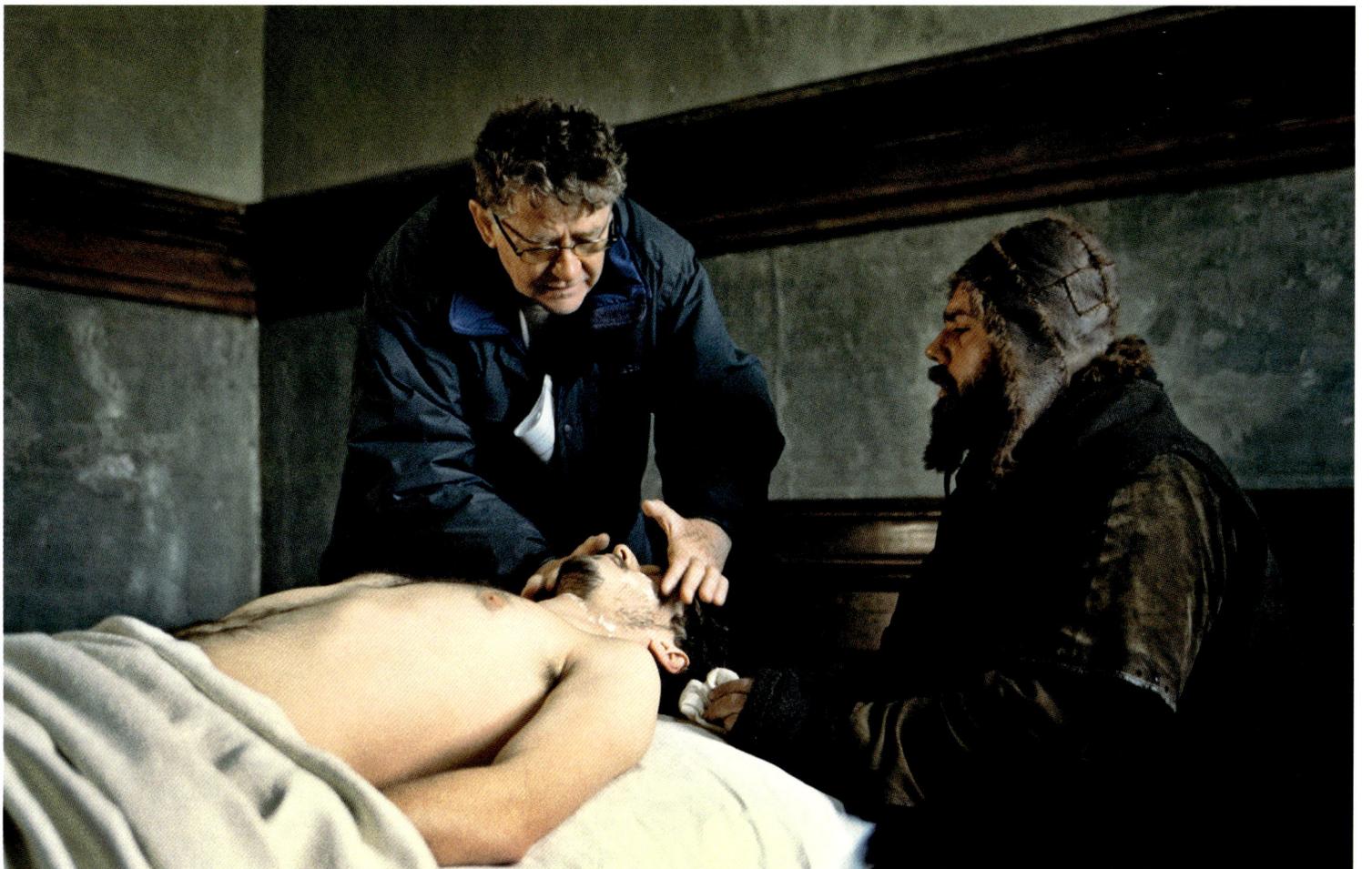

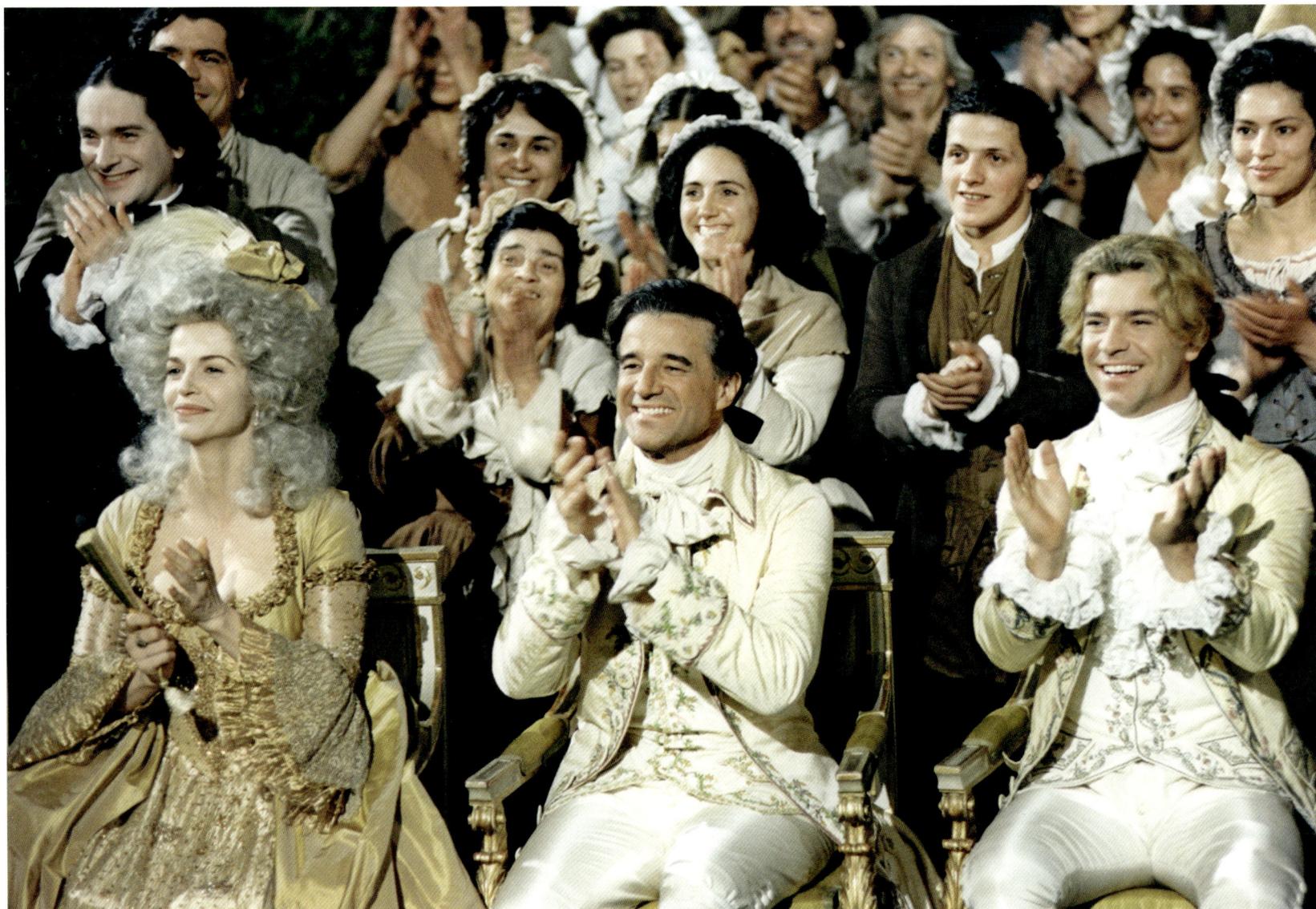

NICOLETTA ERCOLE

3, 1996
Directed by Christian De Sica

Anna Galiena, Christian De Sica
and Paolo Conticini
Courtesy Cecchi Gori Distribution

"In 1995 I had the opportunity of doing the costumes for 3, a film by Christian De Sica set in 1789, and I decided to use Sartoria Tirelli. Dino Trappetti said yes, and I finally realized just how inspiring the atmosphere at the Sartoria was. I found exactly what I had envisaged in their collection; everyone – assistants, cutters, tailors, the guys in the dyeing department, the administration – collaborated to the full. Working at Tirelli is like being part of one big family, where colleagues – who maybe are just passing through and are curious to see what the Sartoria is producing from the costume designer's labours – give valuable hints, first and foremost the great master Piero Tosi, who follows the new generations with care and discretion. I think that a lot of us costume designers would never have made the big time if our creative path had not crossed that of Umberto Tirelli and the extraordinary world he created fifty years ago, which Dino has successfully preserved with the help of his long-time collaborators. I have just one more thing to say: thank you."

Nicoletta Ercole

NICOLETTA ERCOLE

Letters to Juliet, 2010
Directed by Gary Winick

Franco Nero and Vanessa Redgrave
Study for Claire (Vanessa Redgrave)

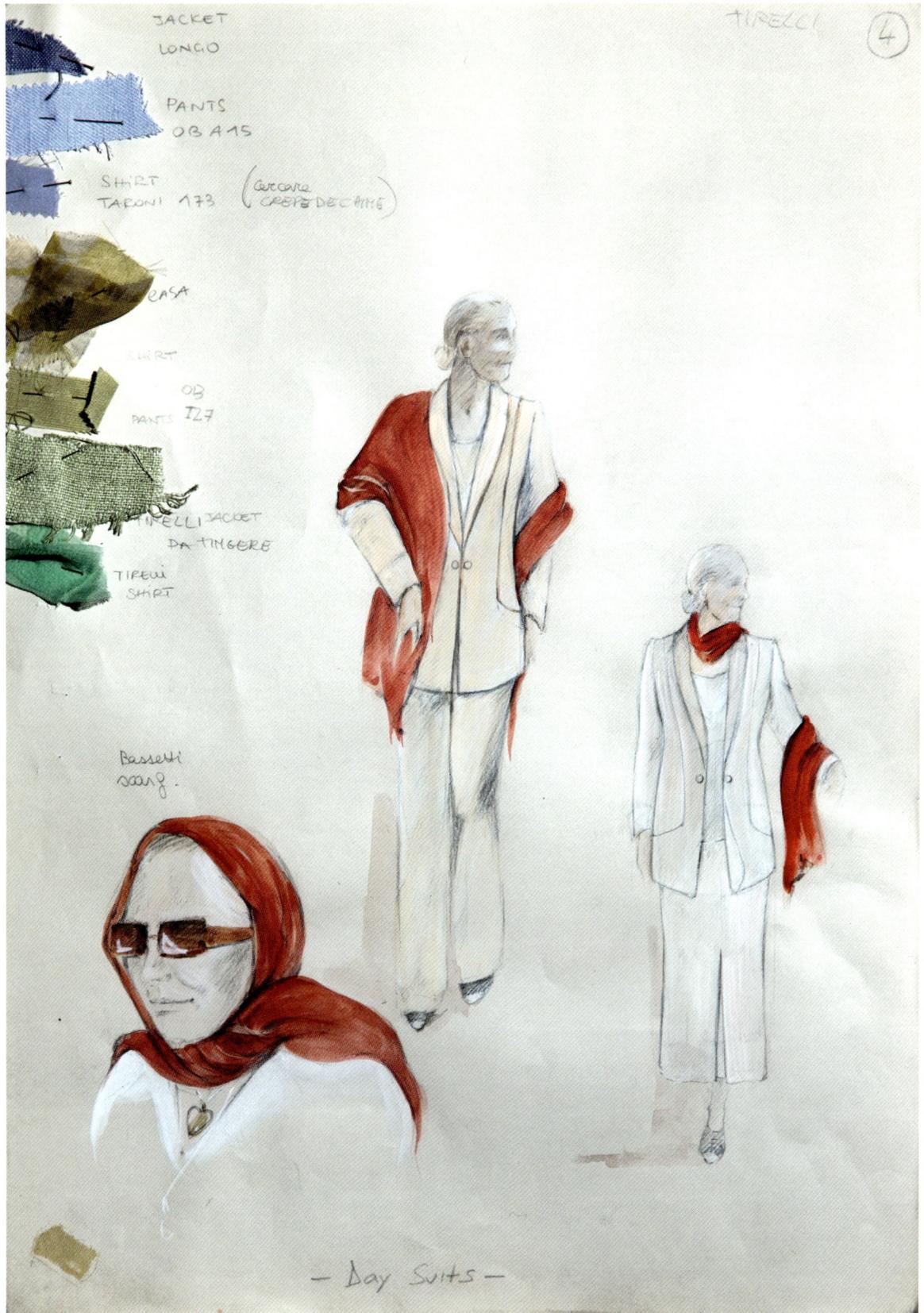

JACKET
LONGO

PANTS
OB A 15

SHIRT
TARONI 173 (ancone
CREPE DE CHINE)

casa

shirt
OB
PANTS 127

TIRELLI JACKET
DA TINGERE

TIRELLI
SHIRT

Bassetti
scarf.

— Day Suits —

MILENA CANONERO

Titus, 1999
Directed by Julie Taymor

Anthony Hopkins
Photo by Mario Tursi – Archivio
Storico del Cinema – AFE

Below, photo of Anthony Hopkins
with dedication to Sartoria Tirelli

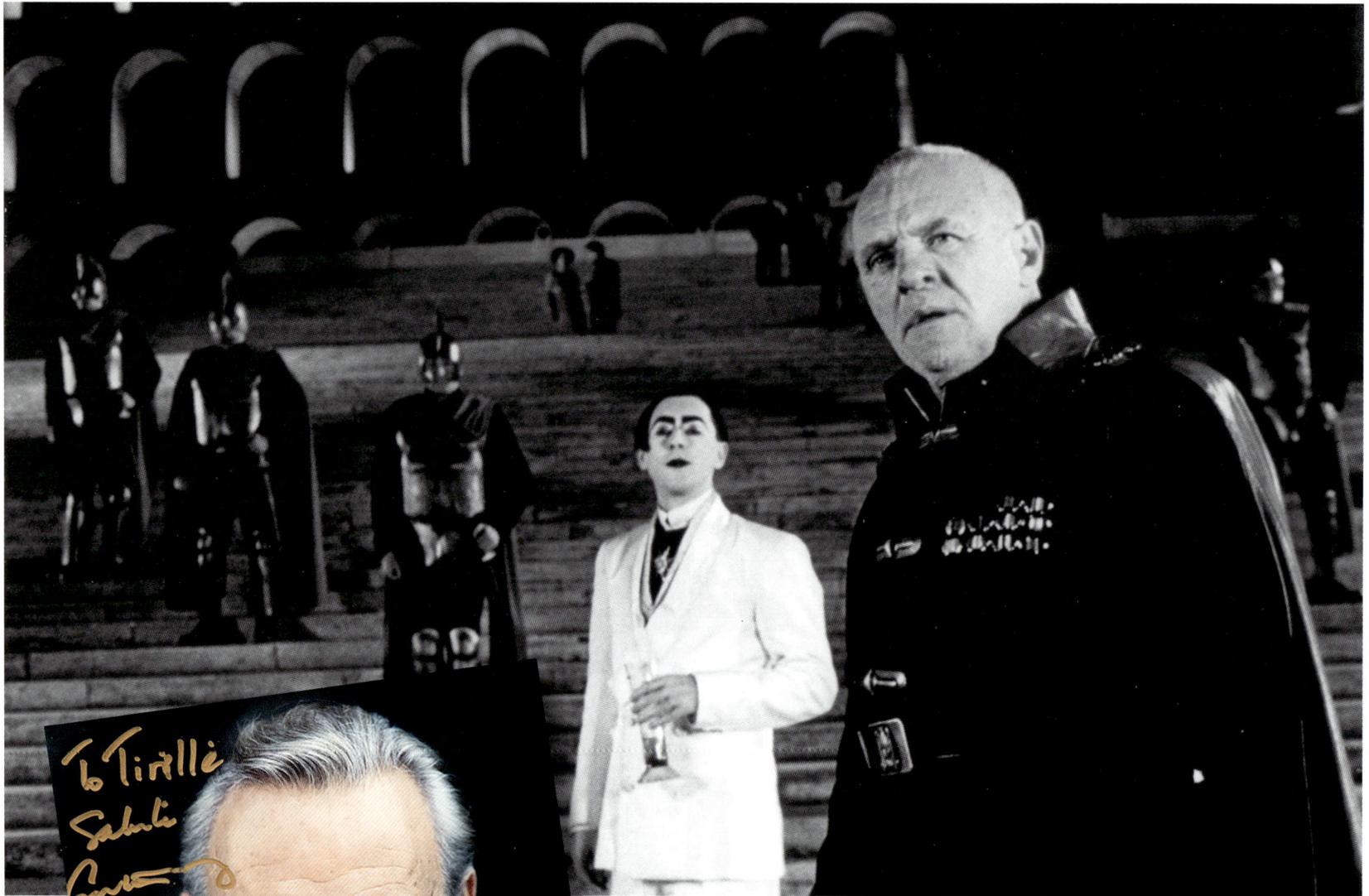

Opposite, Anthony Hopkins
Photo by Mario Tursi – Archivio
Storico del Cinema – AFE

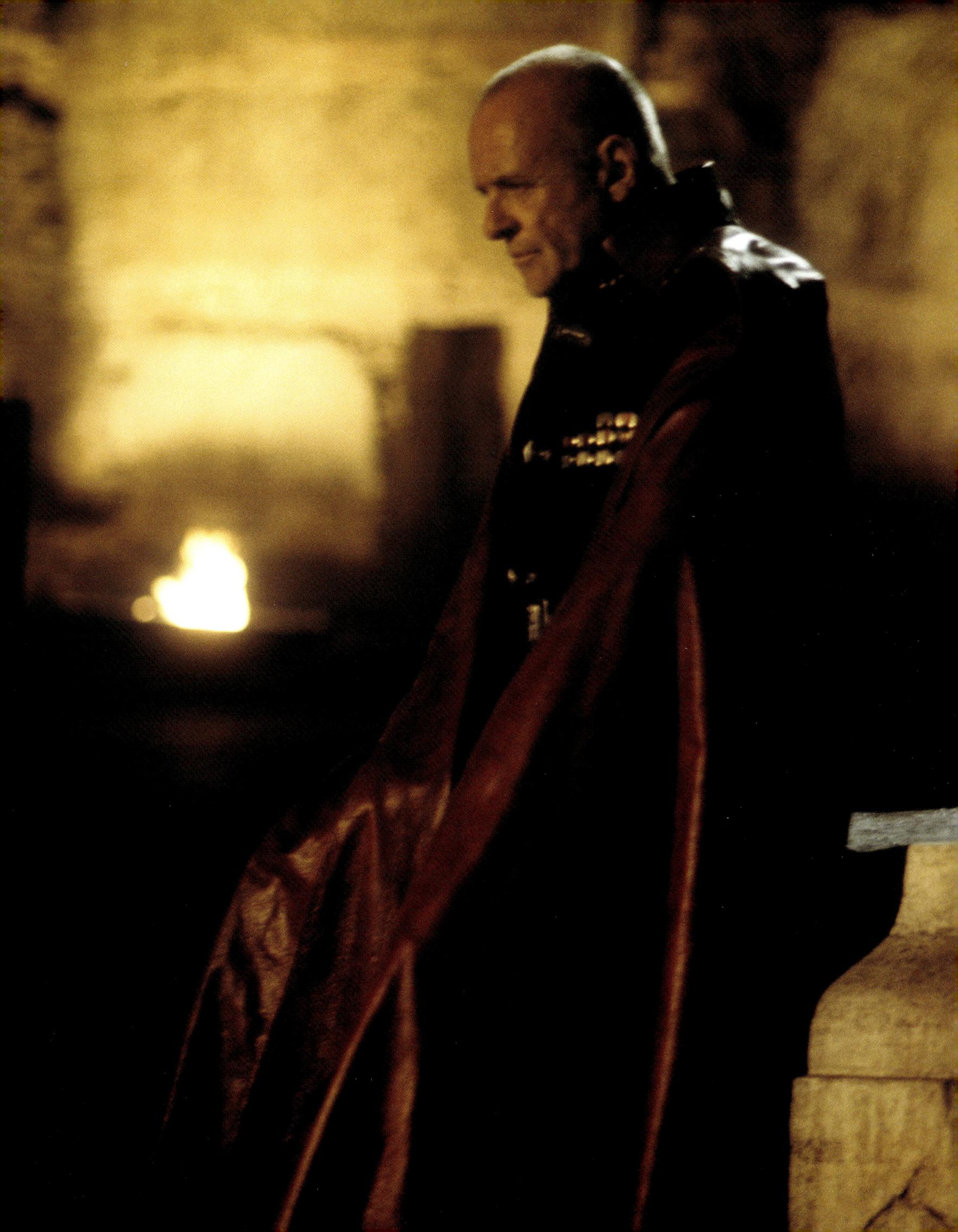

Opposite

PENNY ROSE

Evita, 1996
Directed by Alan Parker

Above, Madonna
Photos by David Appleby

PENNY ROSE

*Pirates of the Caribbean:
Dead Man's Chest*, 2006
Directed by Gore Verbinski

Geoffrey Rush
Courtesy Walt Disney Pictures

"My love affair with Tirelli began many years ago when I called to ask if I could visit to rent costumes for a TV commercial: Umberto said 'absolutely NO!' and I was broken-hearted. Several years later I was designing an Alan Parker film about Mr Kellogg set in 1900, The Road to Wellville. *I went to Rome and this time Dino encouraged me to come to the Sartoria, but sadly the Great Man had passed away. Luckily I speak Italian and the experience was every bit as wonderful as I anticipated. Tirelli made me some delightful period swimming clothes and cycling outfits and I rented a huge amount of lovely costumes from their stock aided by Valentino with all his charm. I vowed never to do another movie without first going to Tirelli. Then along came* Evita *starring Madonna, again directed by Alan Parker. We found terrific stock from 1930 through 1950 for the film. All these years later, we have collaborated on some wonderful jobs including* In Love and War *by Lord Richard Attenborough, all the* Pirates of the Caribbean *series and many others.*
Creating costumes at Tirelli is a unique experience. Luigi is so enthusiastic when you make the appointment, and now there is Laura! The sensation is similar to having a guided tour through some special private art collection. Each time you find something new, original and exciting. I look forward to working together the next 50 years."

Penny Rose

ANN ROTH

The English Patient, 1996
Directed by Anthony Minghella

Ralph Fiennes and Kristin Scott
Thomas

Below, Kristin Scott Thomas

Opposite, Kristin Scott Thomas
Courtesy Miramax Films

Ann Roth netted an Academy
Award for Best Costume Design
with this film

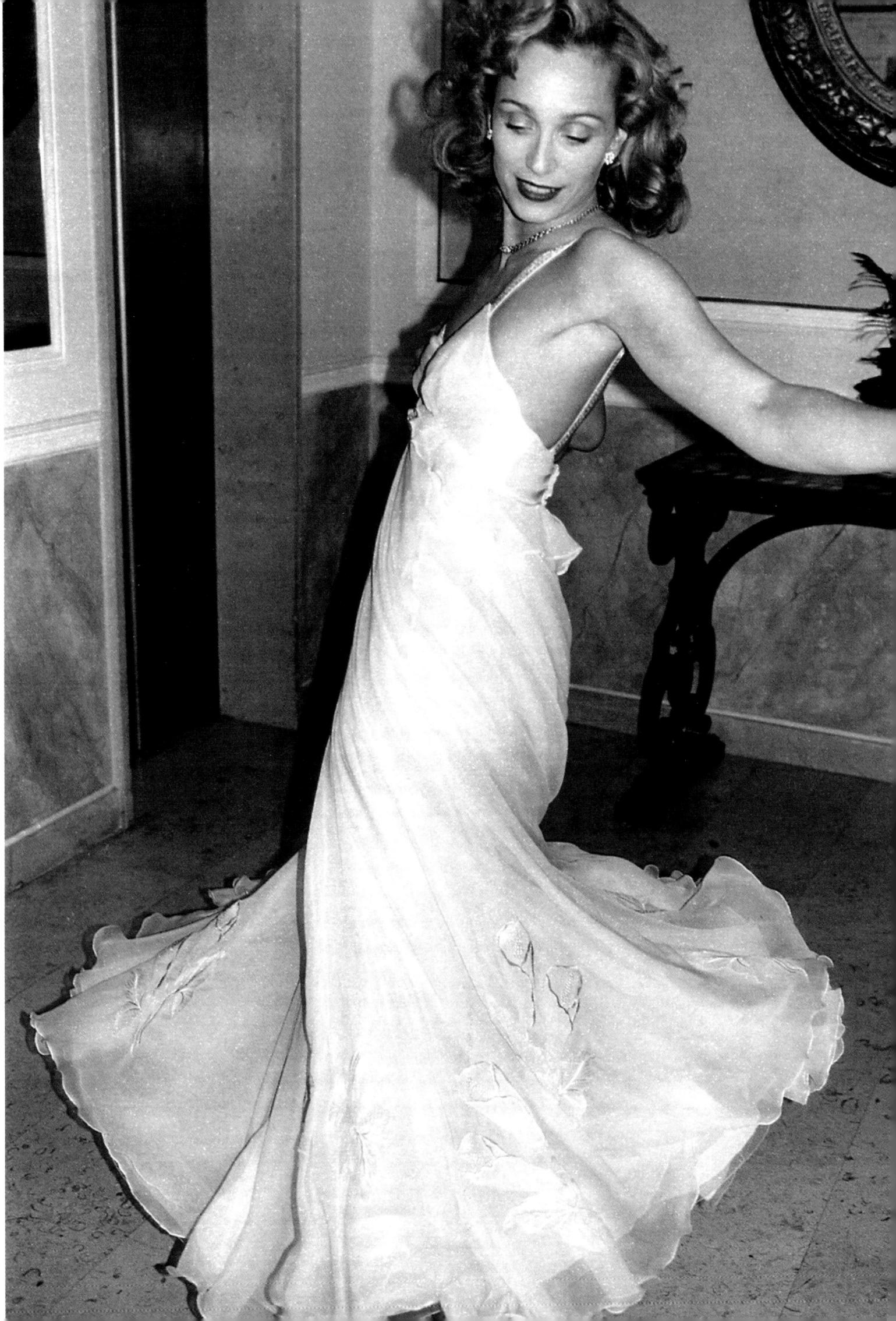

ANN ROTH

The Talented Mr. Ripley, 1999
Directed by Anthony Minghella

Matt Damon and Cate Blanchett

Below, Fiorello, Matt Damon
and Jude Law

Right, Gwyneth Paltrow
Courtesy Buena Vista

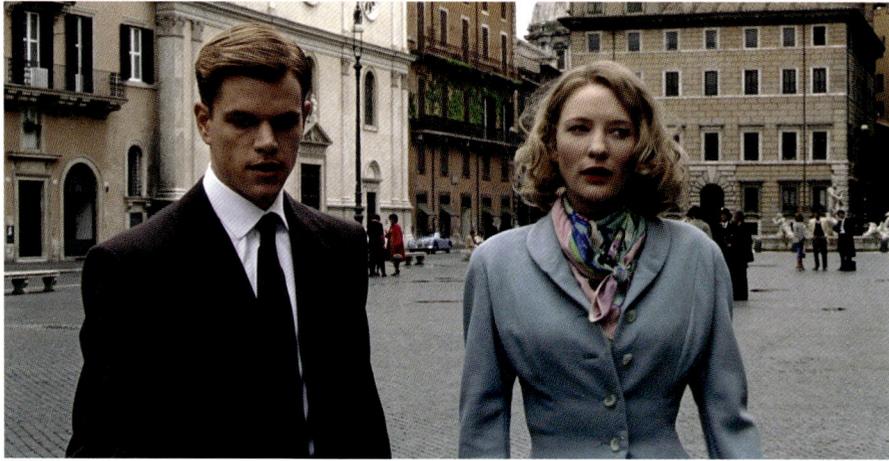

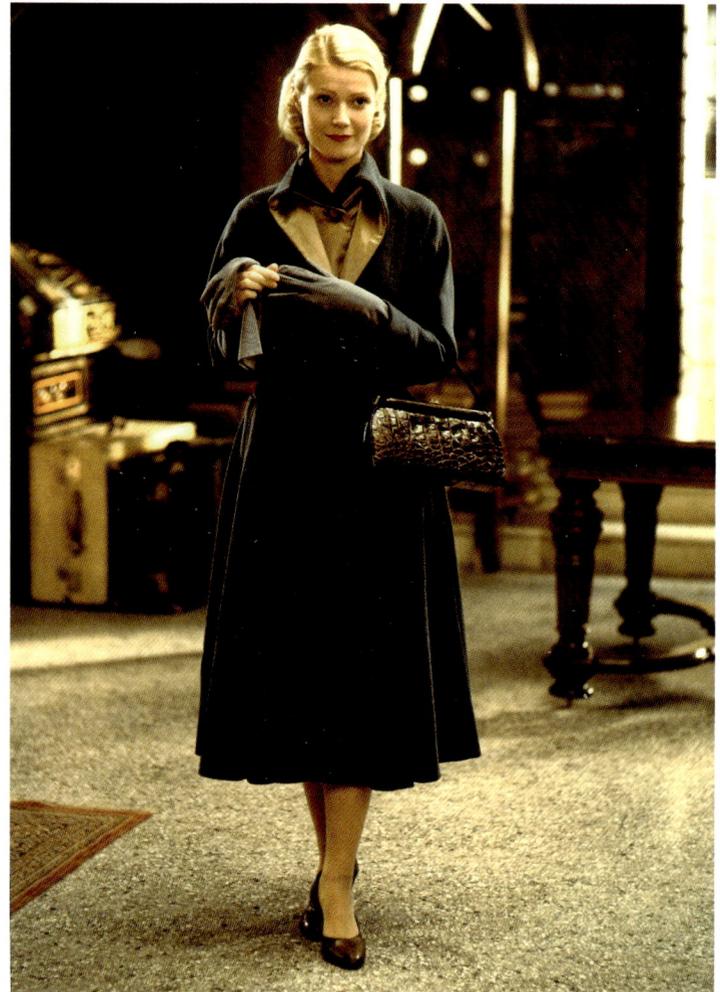

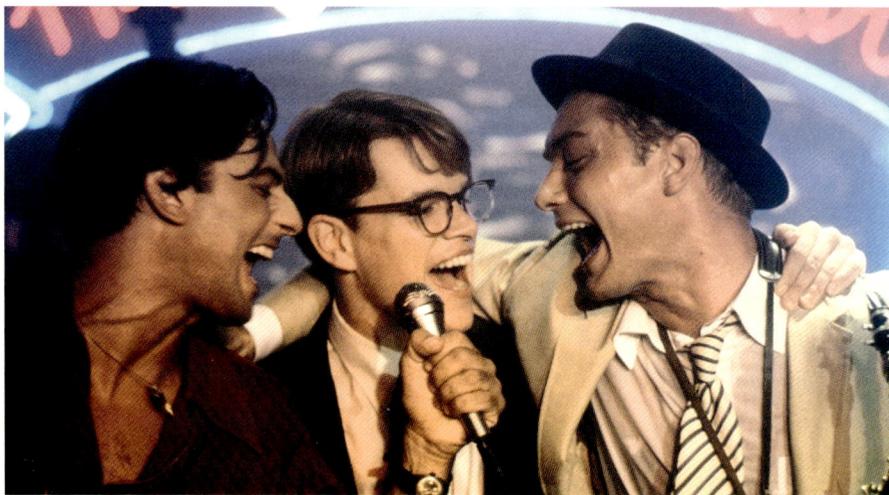

"As a young girl growing up in a small town in Pennsylvania, I dreamed of finding a community of artists and craftspeople from whom I could learn and with whom I would collaborate. When I was young, I was fortunate enough to have magnificent experiences in Hollywood and New York, learning from and working with great tailors, drapers, seamstresses, milliners, embroiderers, shoemakers, and all the rest that make up a complete costume shop. I assisted and designed for film and theatre, opera and ballet and had a phenomenal training.

How could I have known, then, that well into my career, I would find new teachers, new inspiration, and a new home?

When I came to Rome to prepare The English Patient, *my colleague Carlo Poggioli brought me to the inner sanctum of the Sartoria Tirelli Costumi. The tailors and seamstresses shared with me their craft and their warmth and the whole place was infused with the love of art. It is such a rare pleasure to work among such dedicated professionals. To work at Sartoria Tirelli means to be free to do your best work, never being overwhelmed by the "business" but always totally plunged into history, tradition and love of costumes. Of course, the great house that Umberto Tirelli built is a tremendous inspiration. The great Dino Trapetti has developed an atelier that fosters the work of the finest designers: Piero Tosi,*

Lila de Nobili, Gabriella Pescucci, Maurizio Millenotti, Danilo Donati, Milena Canonero. This legacy demands that you do your best work every day. The warmth and the camaraderie of these great artists lift you up so that you can do your best work. Some of my very greatest memories are of working on The English Patient, The Talented Mr. Ripley, The Hours *and* Cold Mountain. *Creating the costumes as a team, excited to work together. Some of my other best memories are of meals, coffees and glasses of wine with Dino and the new family he has given me. Mille grazie!"*

Ann Roth

ANN ROTH, CARLO POGGIOLI

Cold Mountain, 2003
Directed by Anthony Minghella

Nicole Kidman

Right, Jude Law and Nicole Kidman
Courtesy Buena Vista

Below, study by Ann Roth for Ada
(Nicole Kidman)

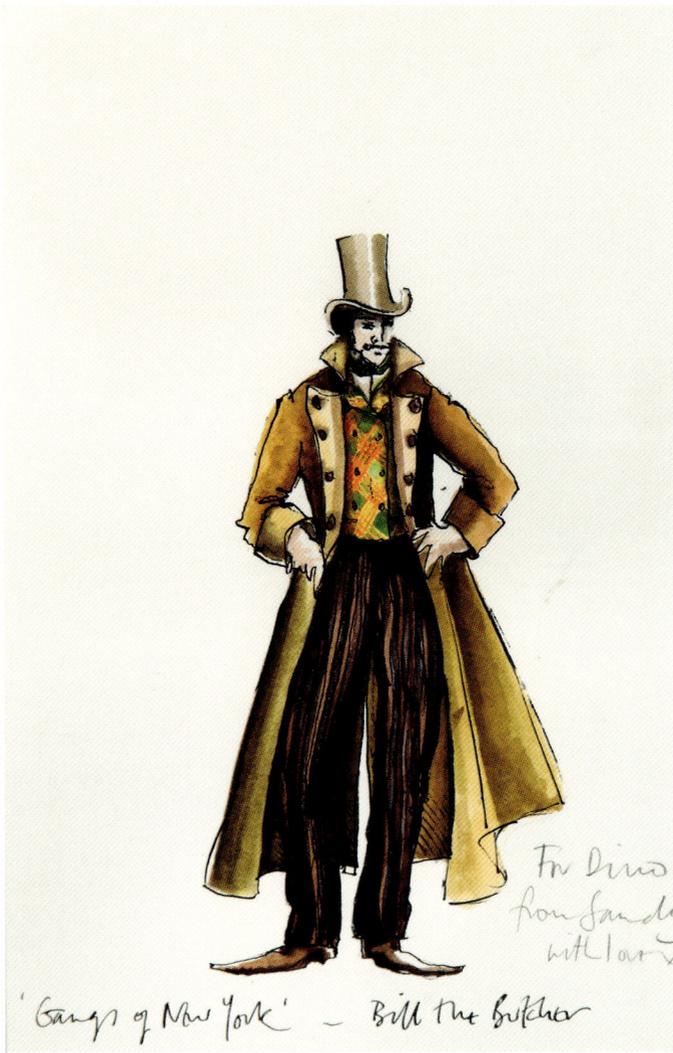

'Gangs of New York' — Bill the Butcher

SANDY POWELL

Gangs of New York, 2002
Directed by Martin Scorsese

Study for Bill the Butcher
(Daniel Day-Lewis)

Below, the Five Points district
in New York, reconstructed
at Cinecittà in Rome
Photo by Mario Tursi – Archivio
Storico del Cinema – AFE

"I have worked with the wonderful people at Tirelli for over twenty years on some of the most important films of my career, including Shakespeare in Love, The Wings of the Dove, Gangs of New York, Hugo, and most recently Cinderella.
It never ceases to be a joy to come to Rome and search through the thousands of beautifully crafted costumes to find the perfect looks to accompany my designs, safe in the knowledge that each and every one of the items found will be of the highest quality.
It was particularly useful to have access to the prolific stock during my year in Rome whilst working on Gangs of New York. As we were shooting, the scenes became bigger and bigger so I had to rely on costume houses such as Tirelli to keep up with the demand for more and more costumes.
I have always been treated with the utmost courtesy and I know that everyone from Dino and Laura down to the incredibly skilled technicians do their utmost to provide such an incredible service. It is a privilege to collaborate with a company so dedicated to its craft.
I can't wait for my next job to go back! Happy Birthday Tirelli."

Sandy Powell

SANDY POWELL

Hugo Cabret, 2011
Directed by Martin Scorsese

The railway station in Paris
Courtesy 01 Distribution

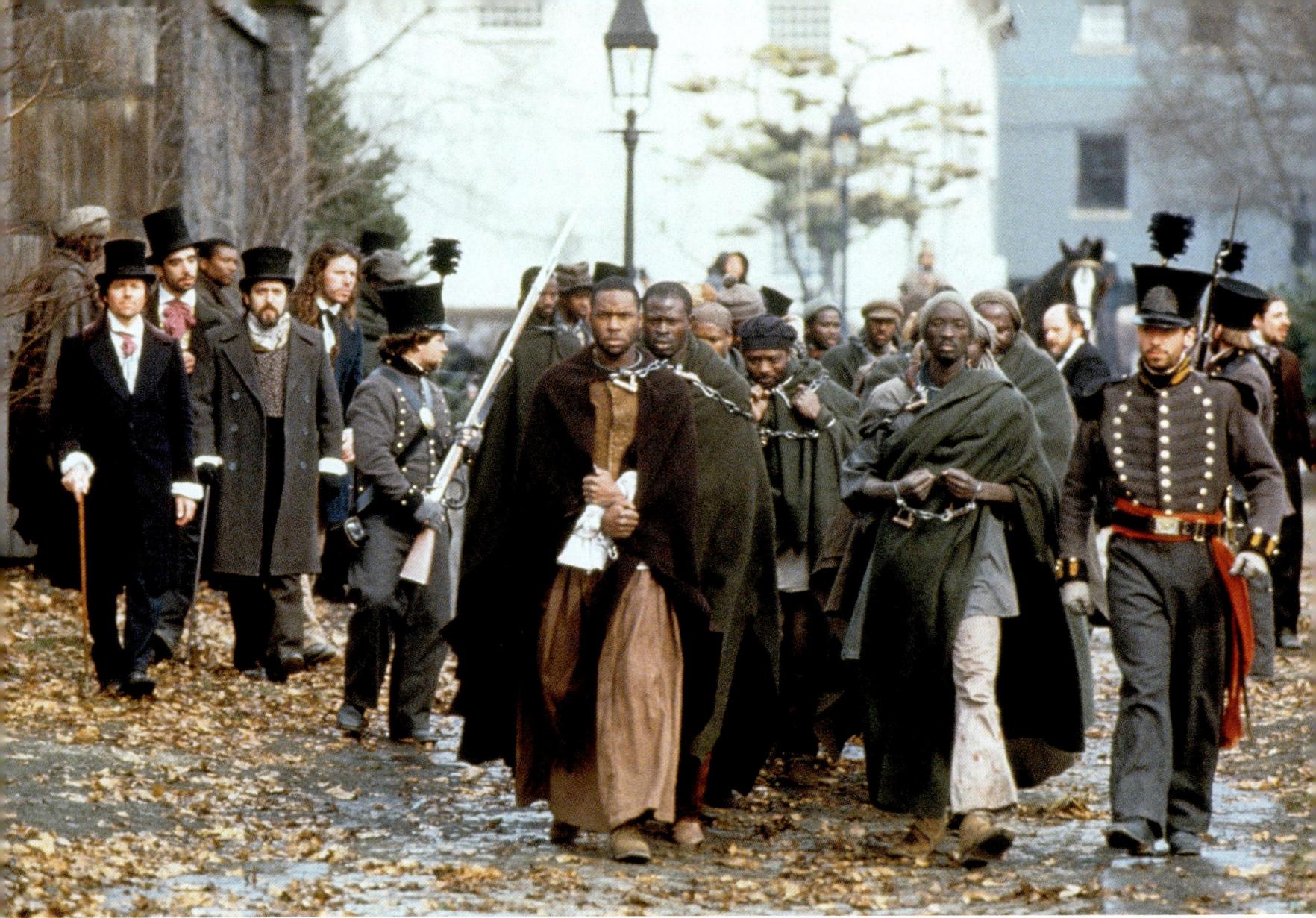

RUTH E. CARTER

Amistad, 1997
Directed by Steven Spielberg

Djimon Hounsou
Courtesy UIP

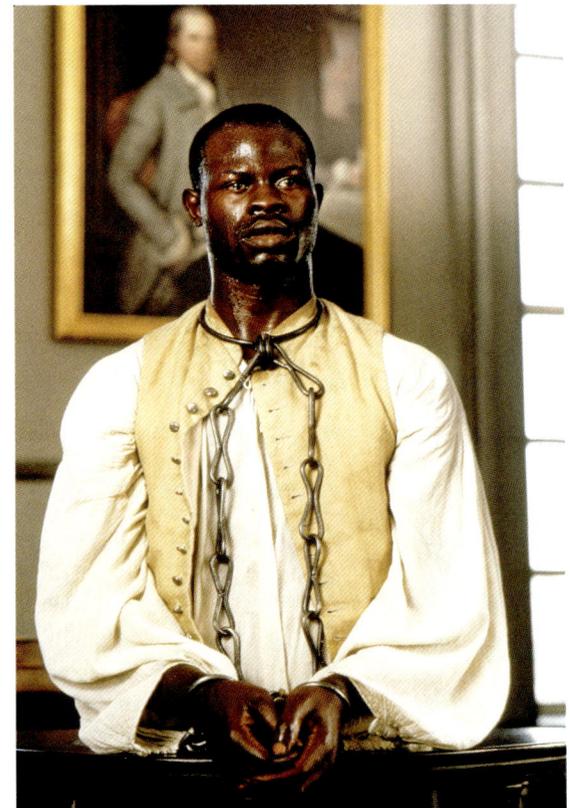

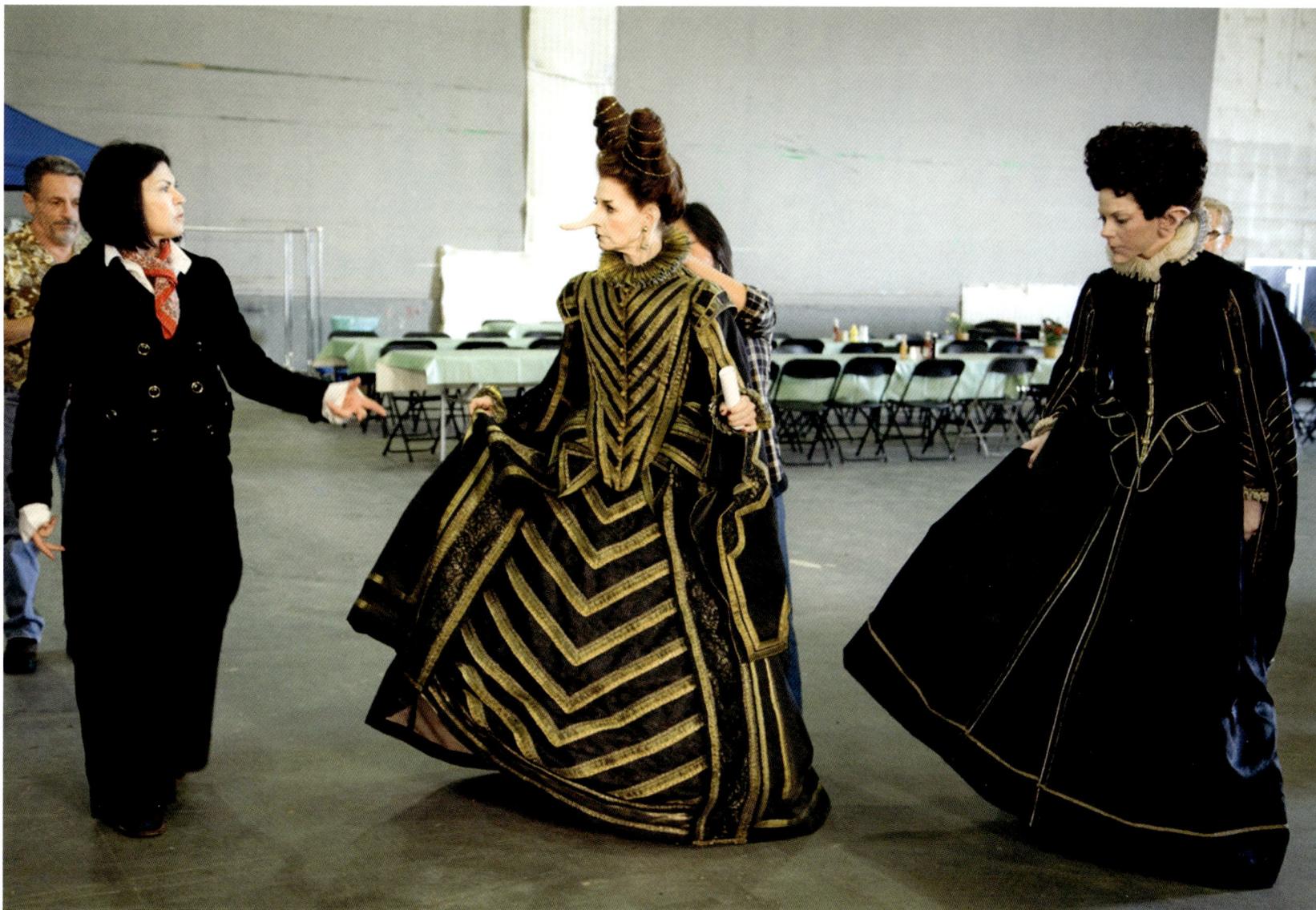

COLLEEN ATWOOD

Alice in Wonderland, 2010
Directed by Tim Burton

Colleen Atwood during filming
Courtesy Walt Disney Pictures

Colleen Atwood won her third
Academy Award for Best Costume
Design with this film

*"The costumes I used from the Tirelli
collection gave my opening sequence of
Alice in Wonderland a magical quality
I would not have been able to achieve
without their fantastic gentlemen's
linen suits and the lovely light and airy
ladies' gowns. It was inspirational for
me to be able to use these costumes
designed by some of my real heroes in
costume from the Italian cinema."*

Colleen Atwood

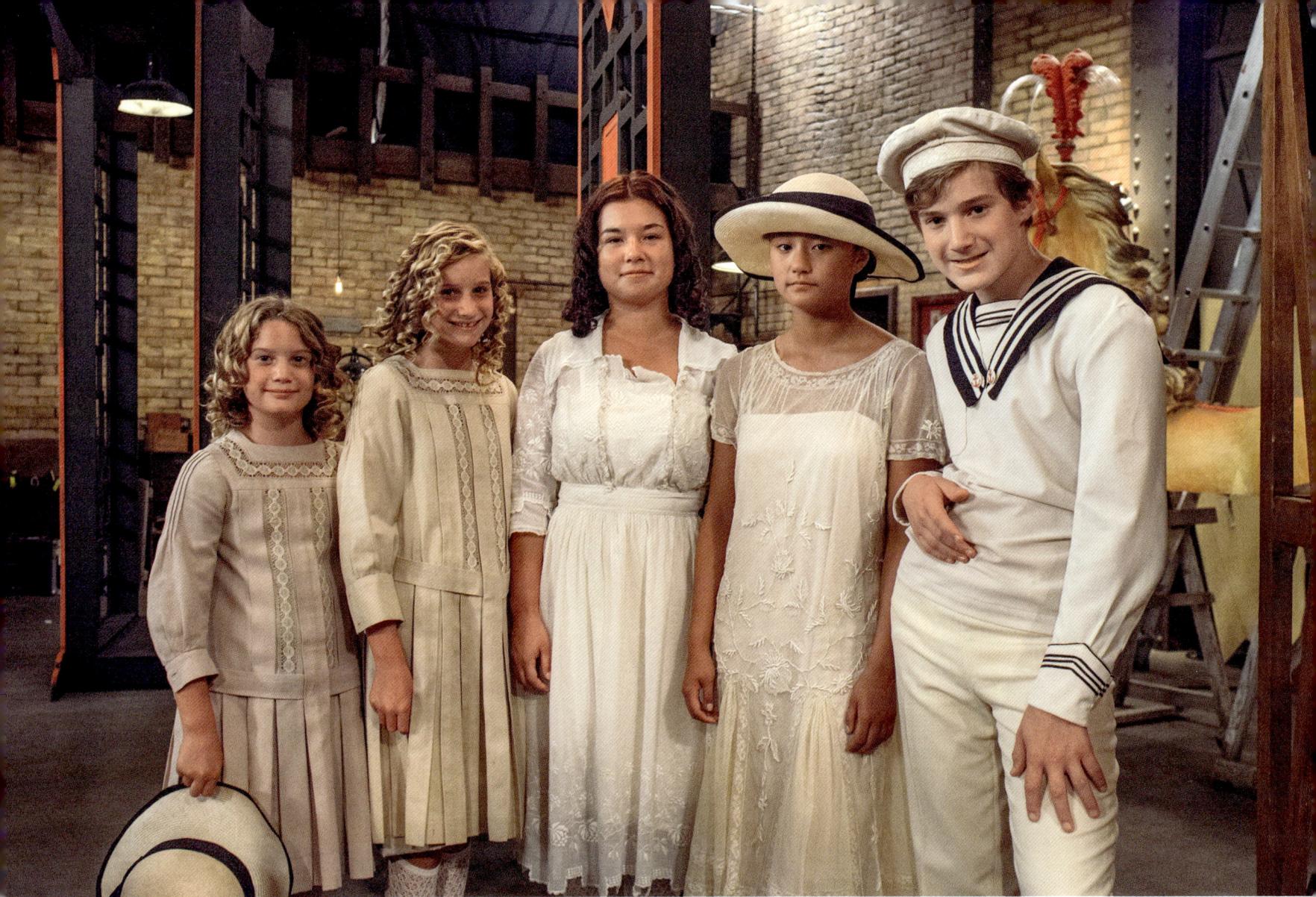

SONIA GRANDE

Magic in the Moonlight, 2014
Directed by Woody Allen

Authentic clothes worn by Lola Stern,
Ella Stern, Katherine Aronson,
Bechet Allen and Ethan Stern
Photo by Jack English
Copyright Gravier Productions, Inc.
2014

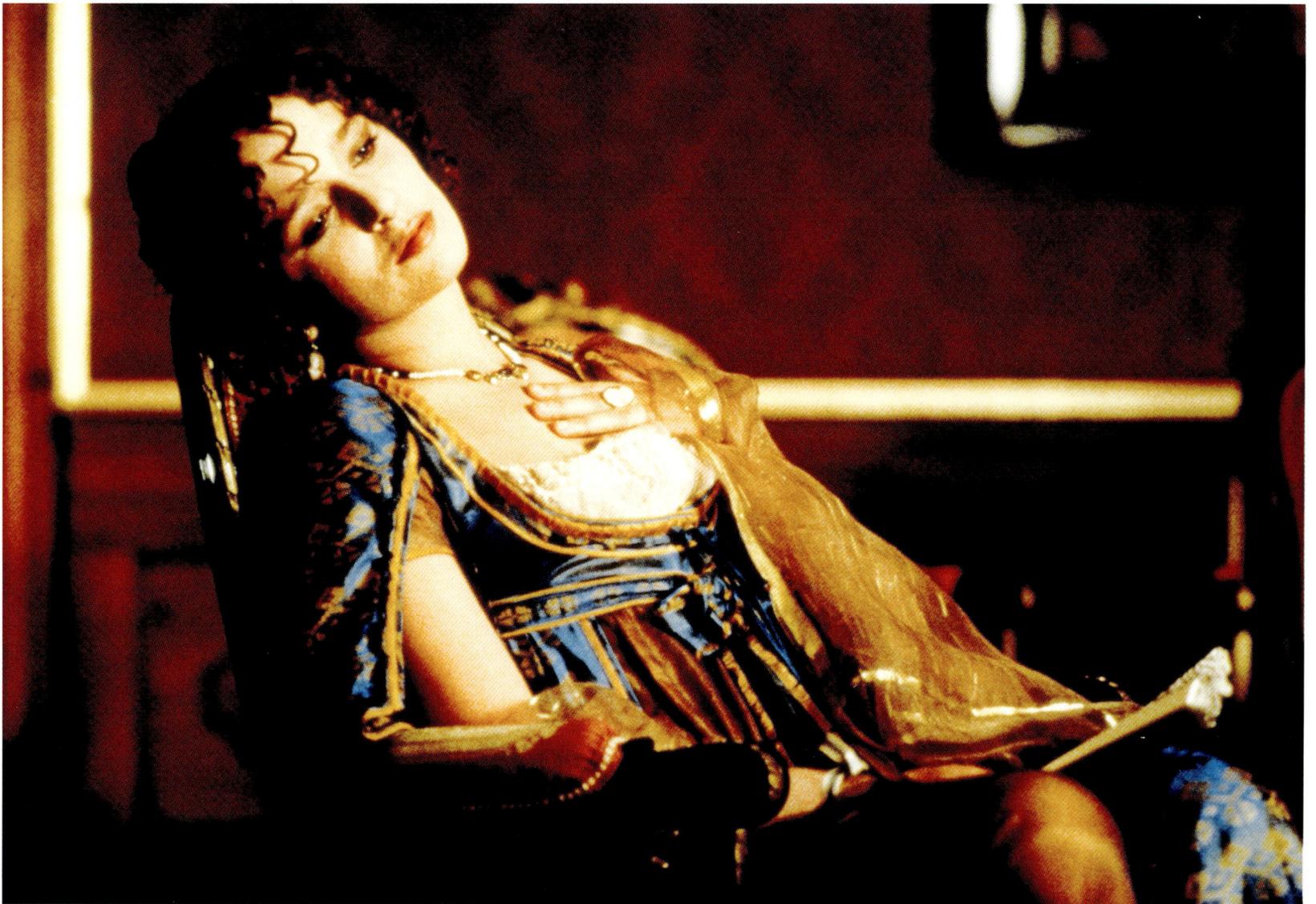

MAURIZIO MILLENOTTI

Immortal Beloved, 1994
Directed by Bernard Rose

Valeria Golino

Right, Isabella Rossellini
Courtesy Warner Bros Italia

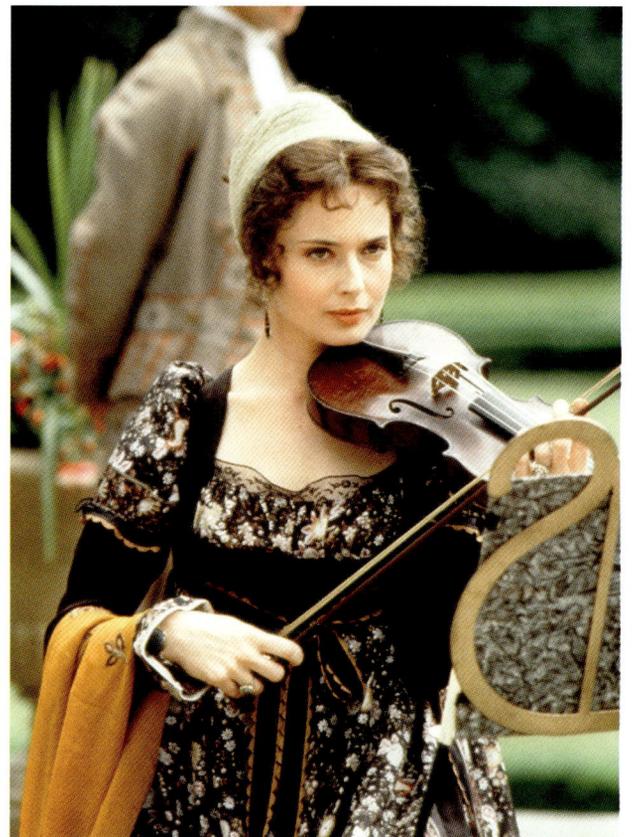

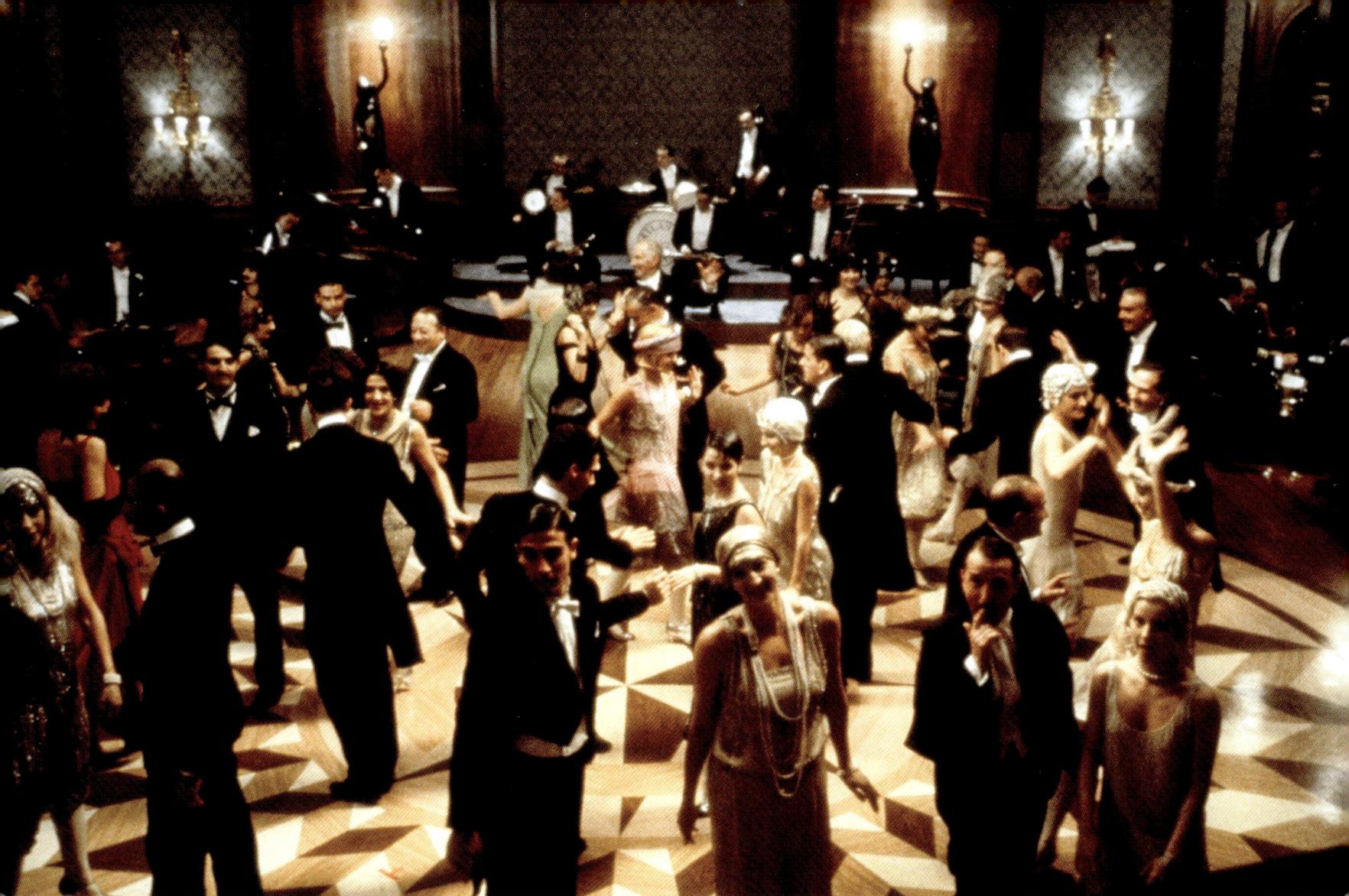

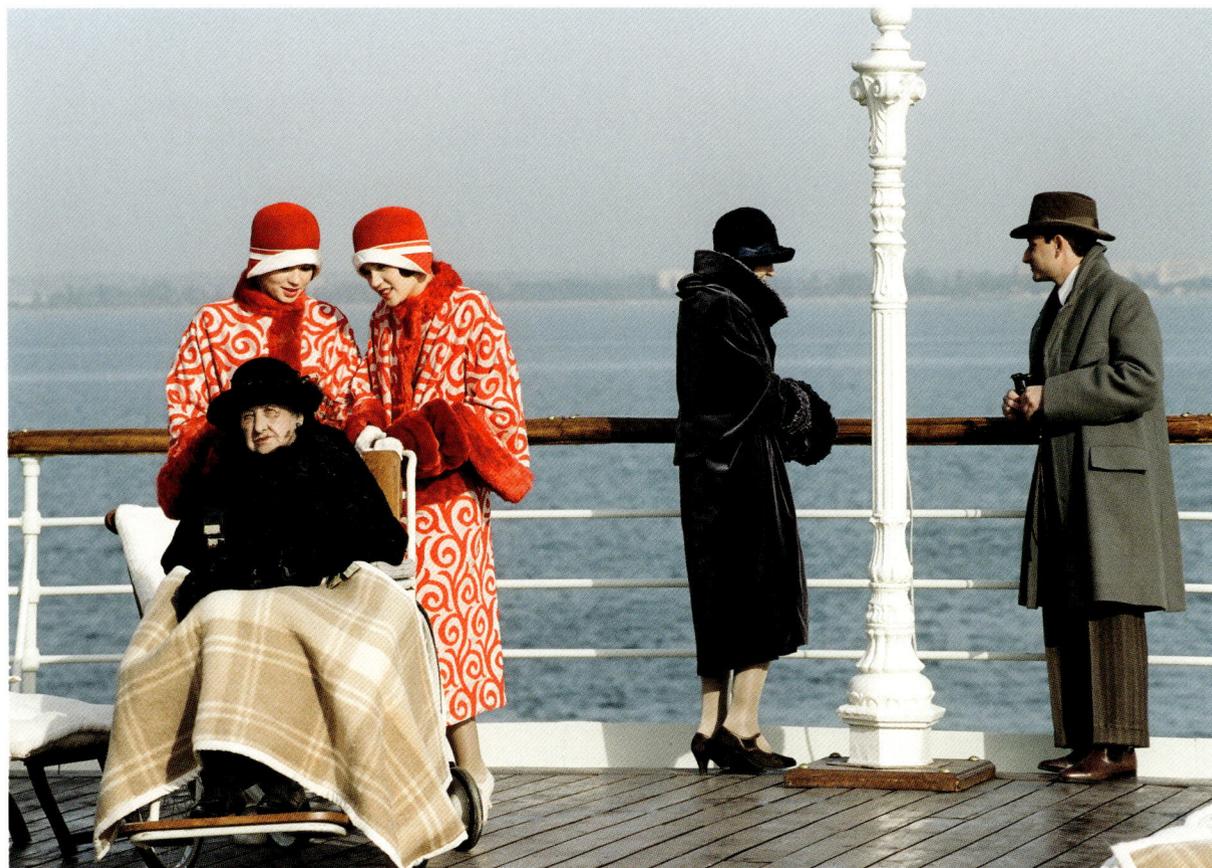

MAURIZIO MILLENOTTI

*La leggenda del pianista sull'oceano
[The Legend of 1900]*, 1998
Directed by Giuseppe Tornatore

A party on board ship

Below, on deck
Photos by Sergio Strizzi –
Courtesy MEDUSA FILM S.p.A.

Opposite

MAURIZIO MILLENOTTI

Malèna, 2000
Directed by Giuseppe Tornatore

Monica Bellucci
Photos by Sergio Strizzi
and Marta Spedaletti –
Courtesy MEDUSA FILM S.p.A.

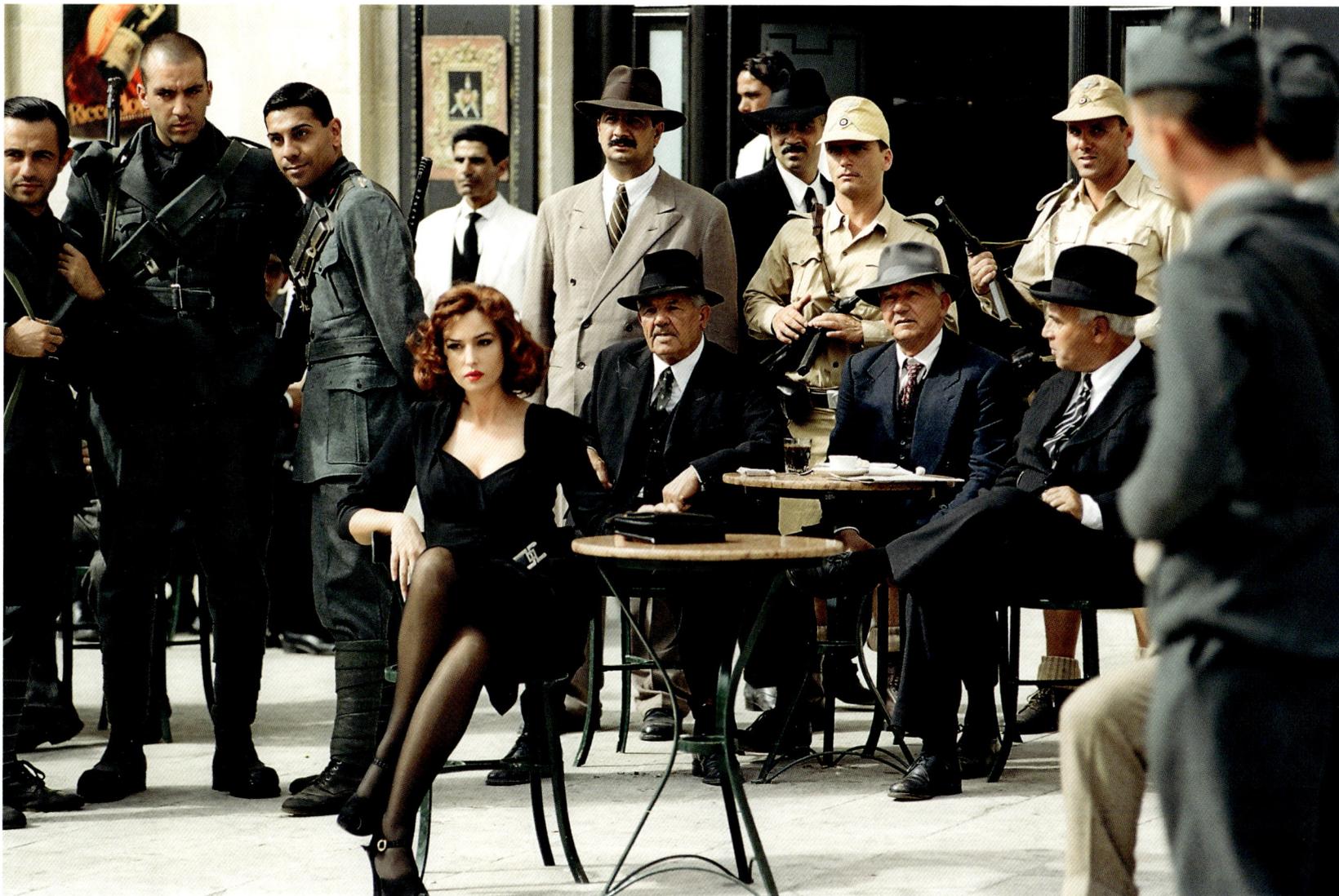

The Importance of Being Earnest, 2002
Directed by Oliver Parker

Rupert Everett and Judi Dench
Courtesy Miramax

MAURIZIO MILLENOTTI

The Passion of the Christ, 2004
Directed by Mel Gibson

Jim Caviezel, Hristo Shopov,
Pietro Sarubbi
Photo by Philippe Antonello

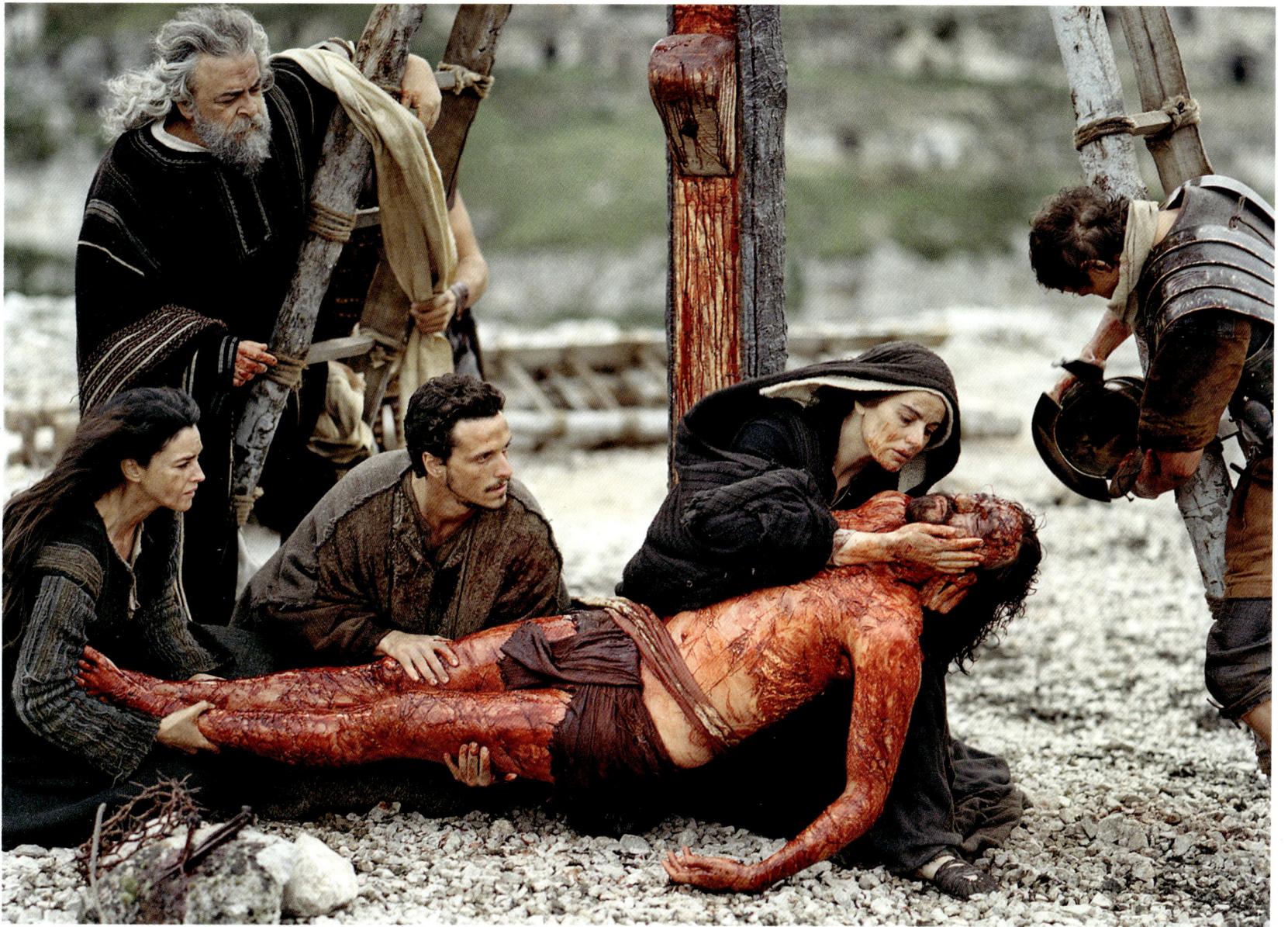

Opposite, Monica Bellucci

Monica Bellucci, Hristo Jivkov,
Maia Morgenstern and Jim Caviezel
Photos by Philippe Antonello

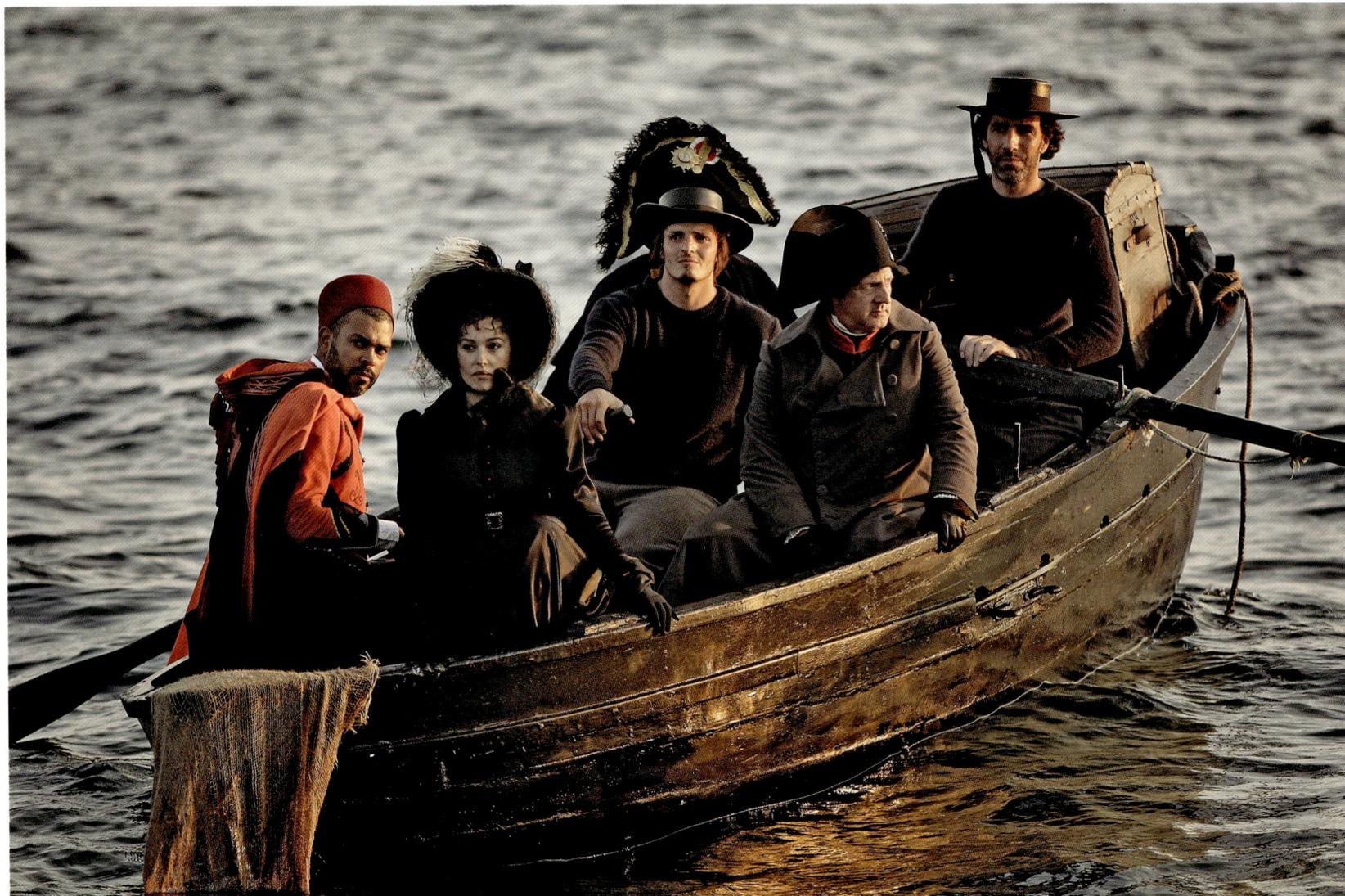

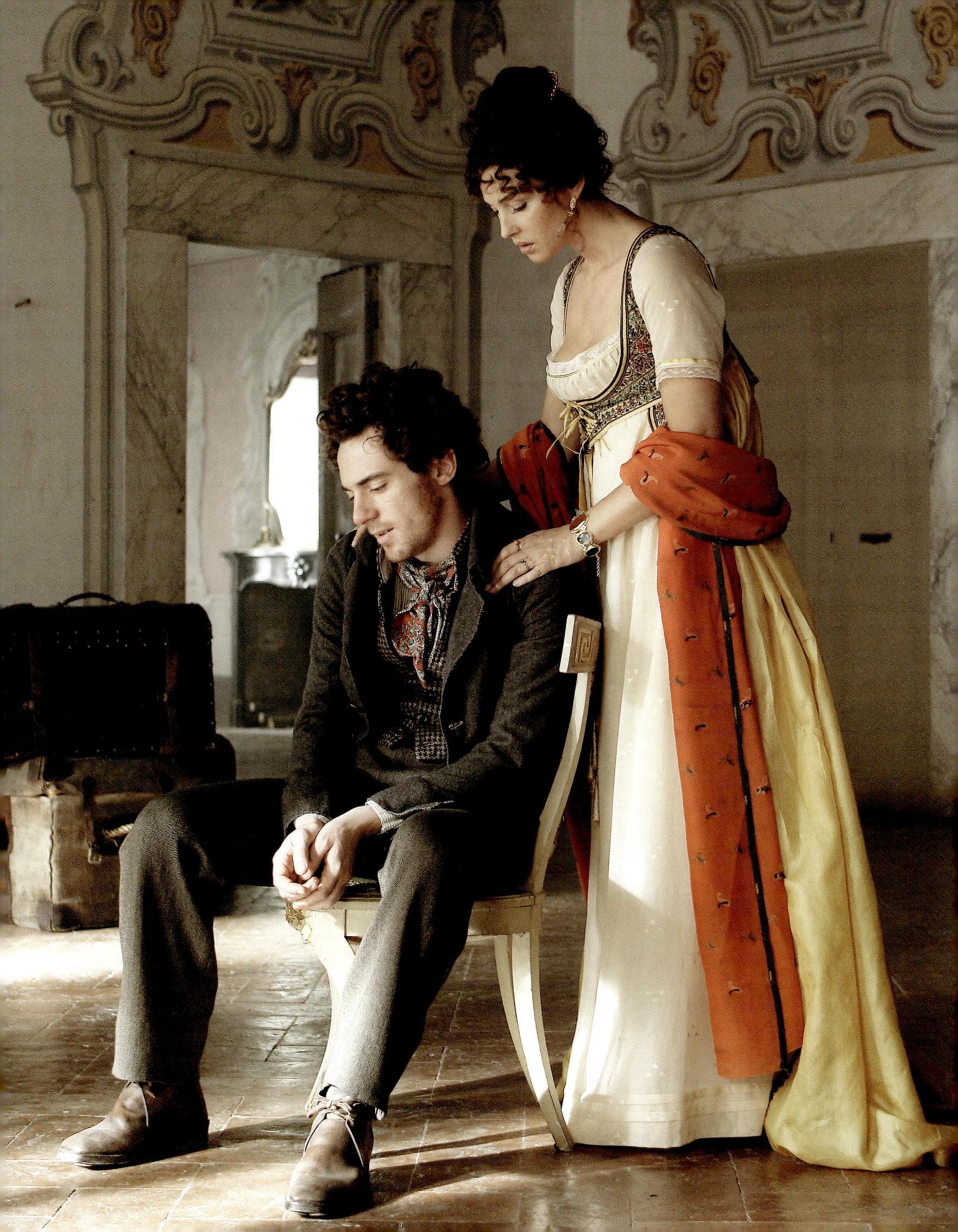

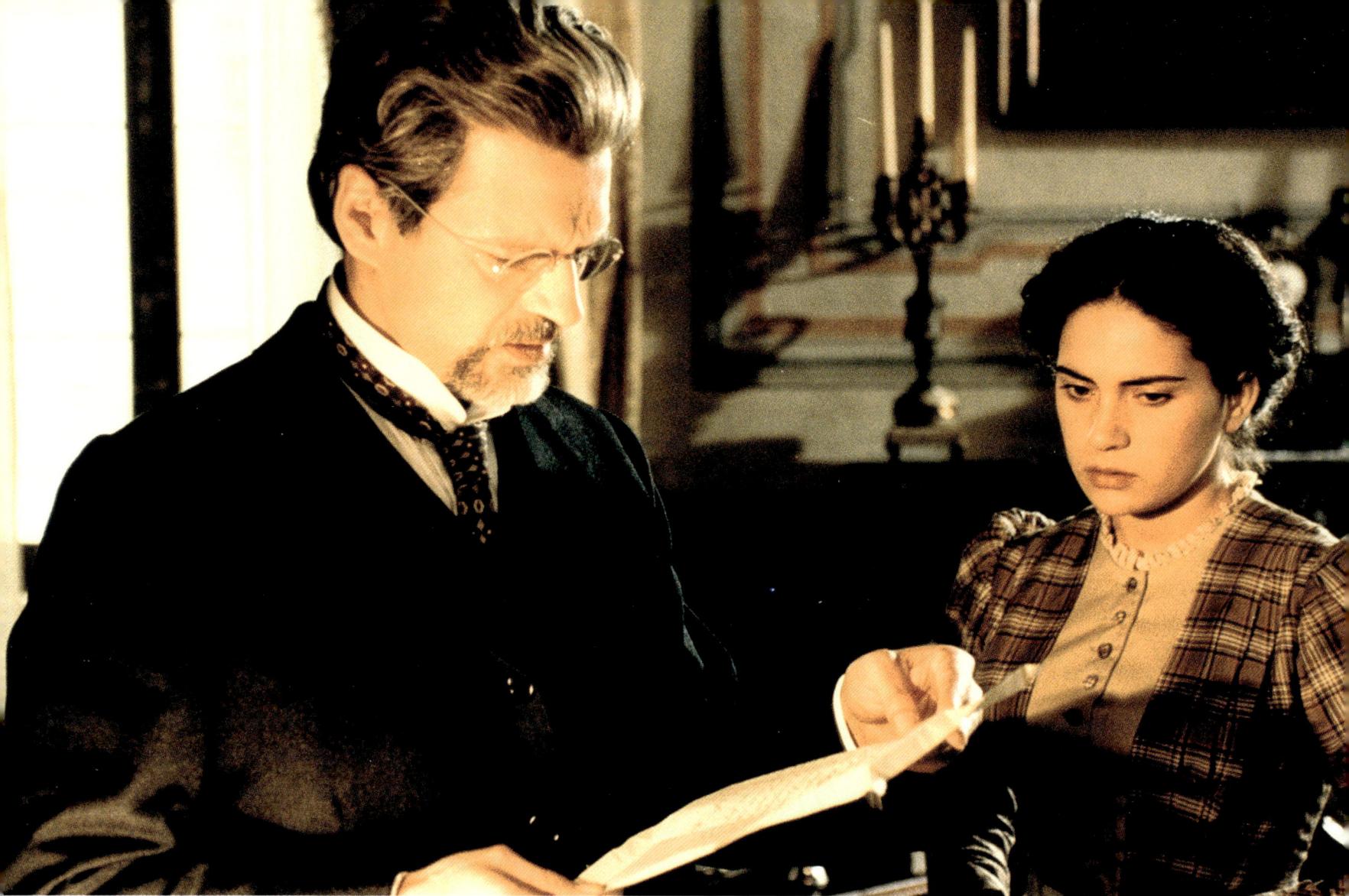

SERGIO BALLO

La Balia [The Nanny], 1999
Directed by Marco Bellocchio

Fabrizio Bentivoglio and Maya Sansa
Courtesy Istituto Luce

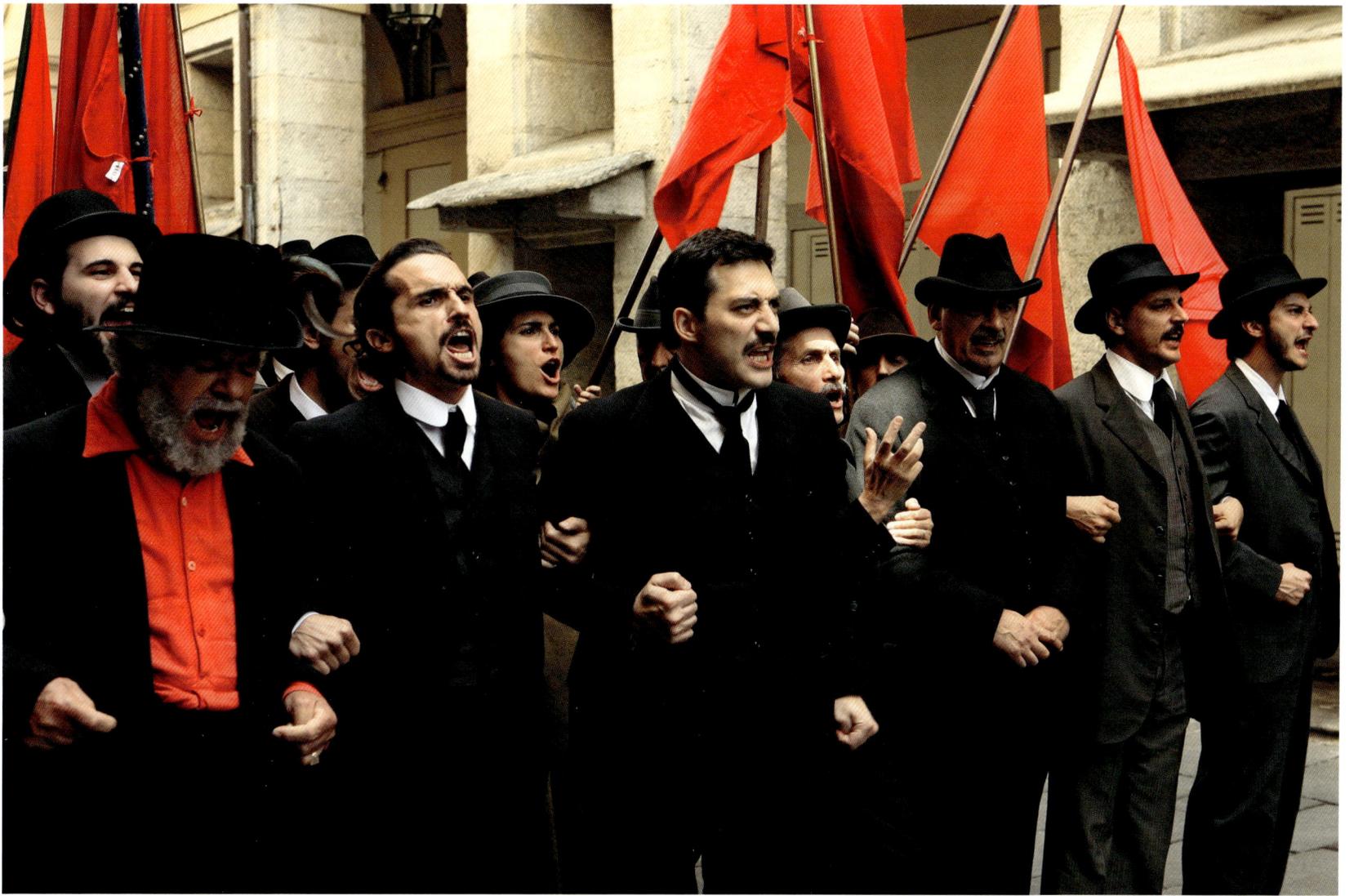

SERGIO BALLO

Vincere [Win], 2009
Directed by Marco Bellocchio

Piergiorgio Bellocchio
and Filippo Timi

Right, Giovanna Mezzogiorno
Courtesy 01 Distribution

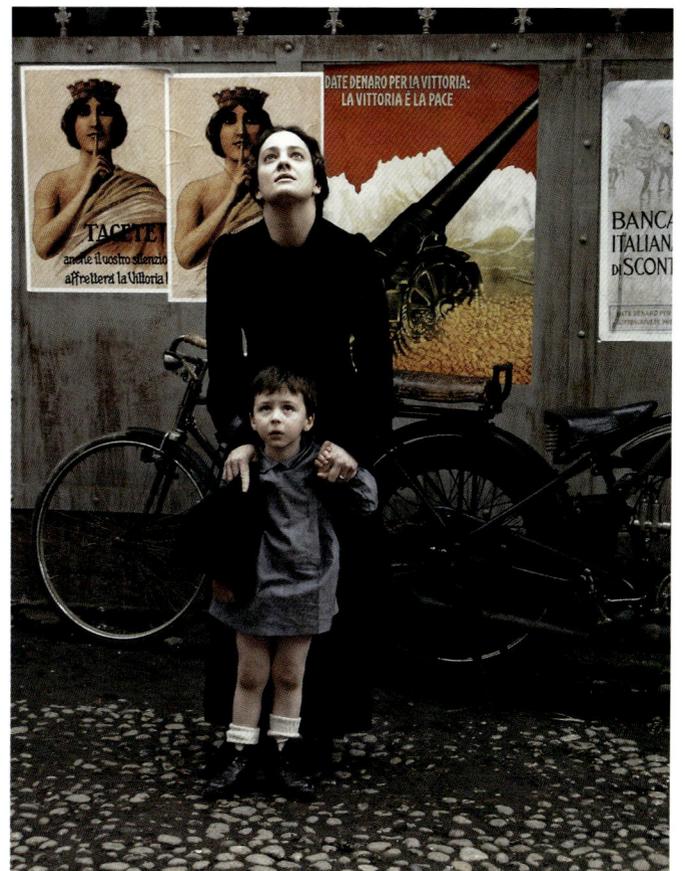

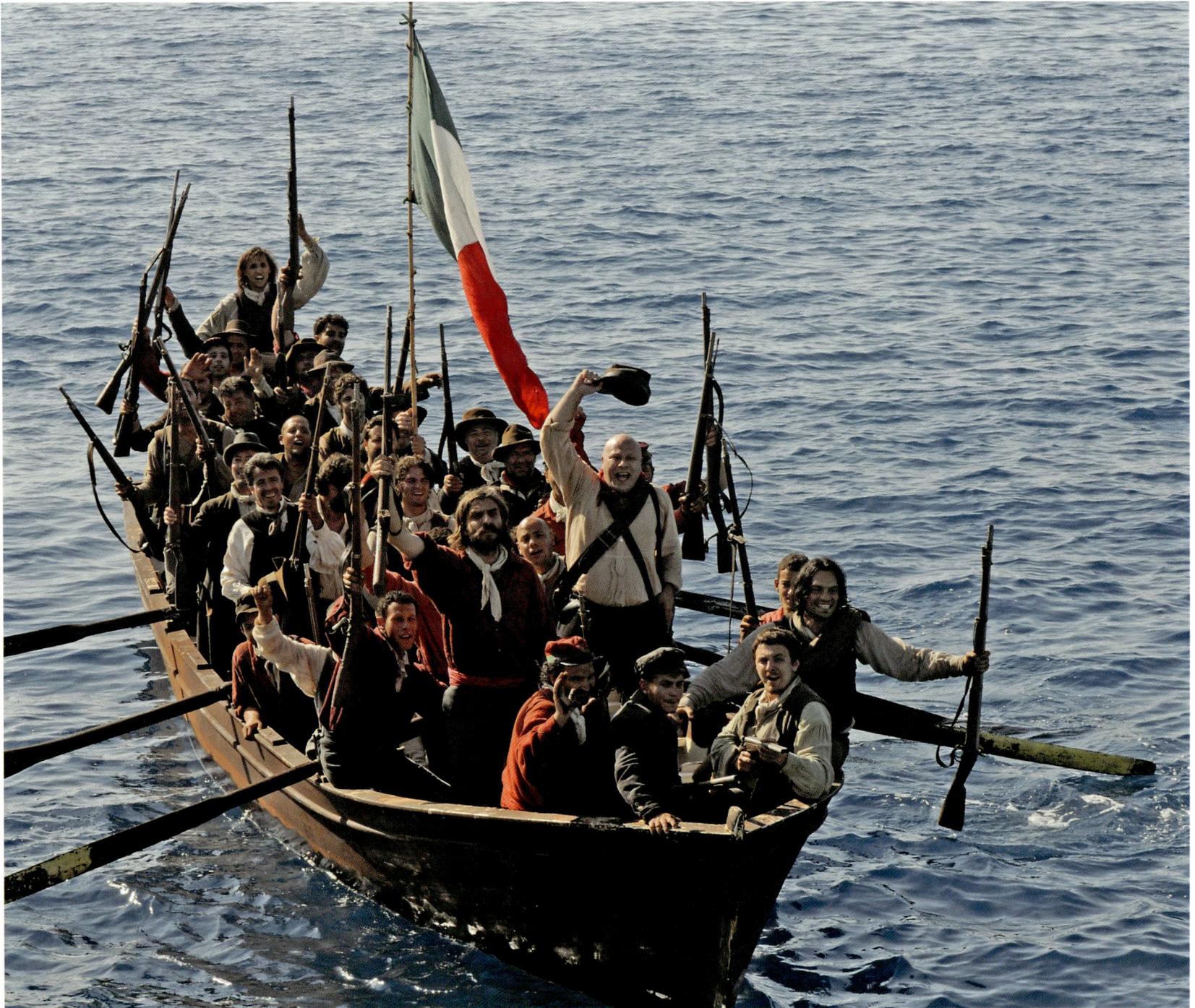

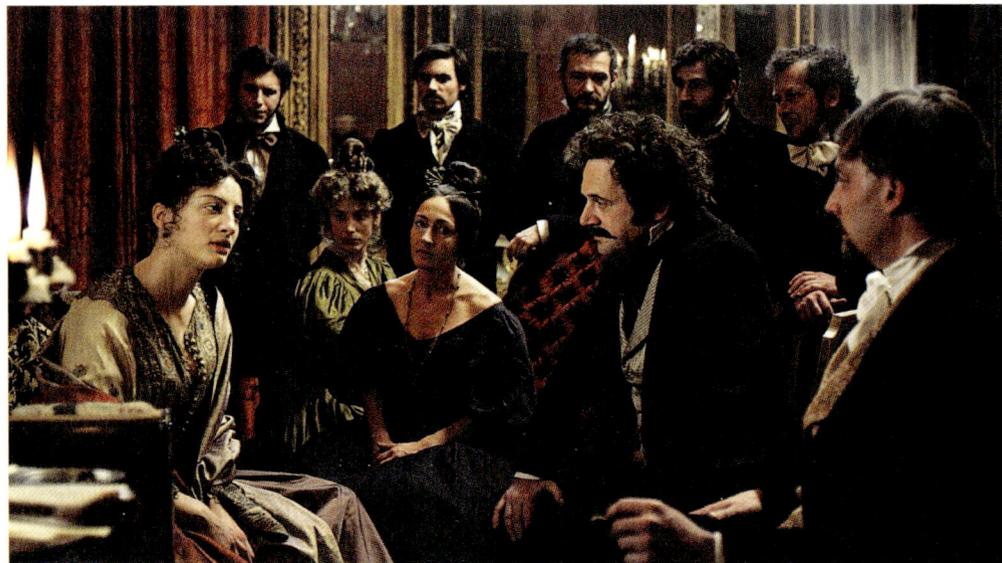

URSULA PATZAK

Noi credevamo [We Believed], 2012
Directed by Mario Martone

The arrival of the Garibaldi legion

Left, Francesca Inaudi
Courtesy 01 Distribution

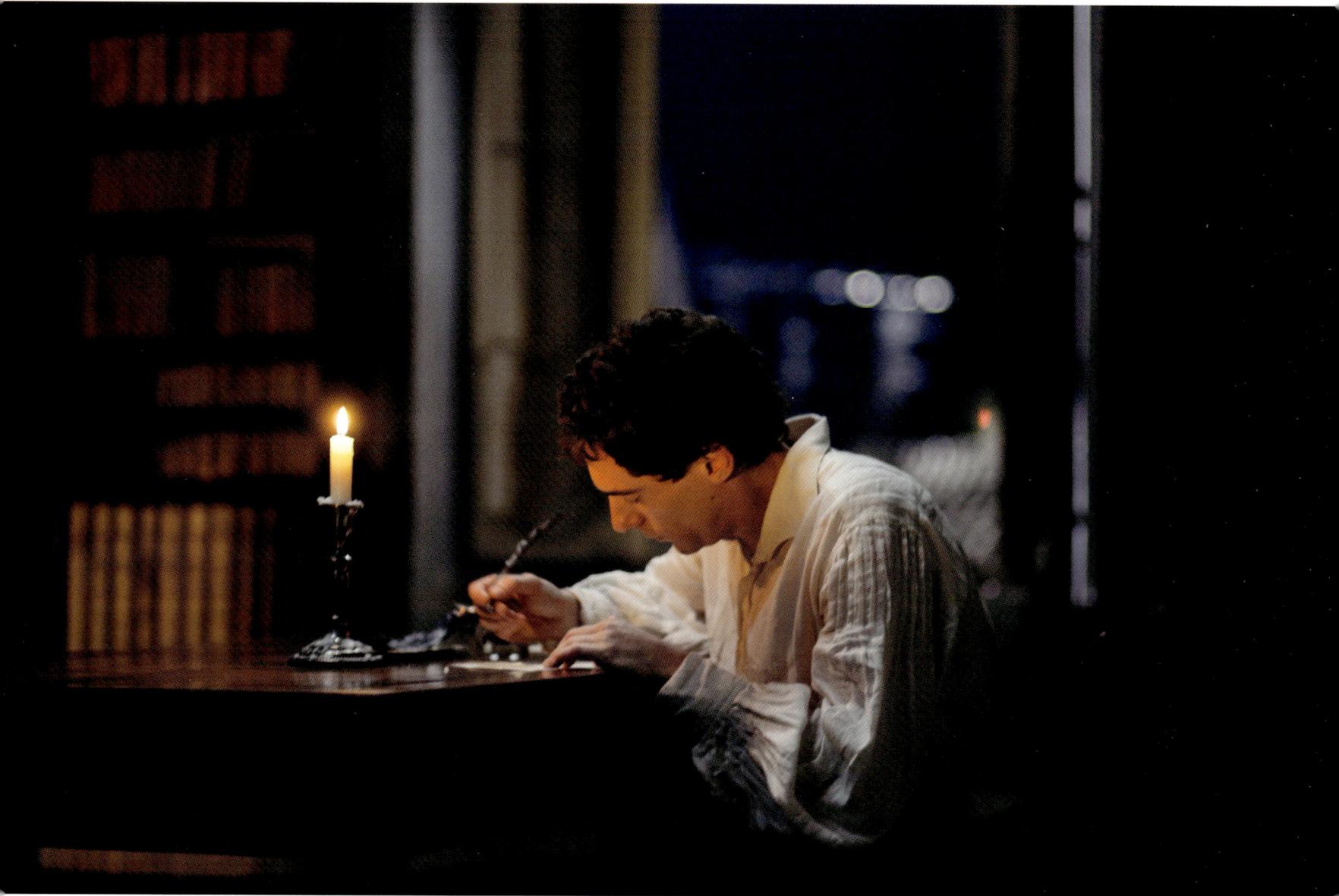

URSULA PATZAK

Il giovane favoloso [Leopardi], 2014
Directed by Mario Martone

Elio Germano
Courtesy 01 Distribution

STEFANO DE NARDIS

Coco Chanel, 2008
Directed by Christian Duguay

Courtesy Lux Vide

"I don't know if it's more of an honour or a pleasure to have a working relationship with Sartoria Tirelli – but I can tell you one thing for sure: when, as a boy, I used to sneak off to the cinema to see Visconti's Conversation Piece *rather than Fellini's* Casanova, *I never dreamed that one day I would be collaborating with the costumier. Passing through that legendary portal in the Prati district of Rome, and touching a door handle that maybe Visconti or Mangano had touched, is an experience that makes you feel part of History with a capital H. Under the watchful eyes of Dino and Luigi,* Laura and Alessandro are bringing this history into the twenty-first century, but in collaborating with us, the 'new generation' costume designers, they still make us feel part of a tradition that deserves to live on forever. Now that our work, especially for television, is a race against time, with actors always on the move and cast at the last minute – in order to 'save the show' – knowing that we can count on Tirelli's fabulous collection means that every character can become a star. As if by magic."

Stefano De Nardis

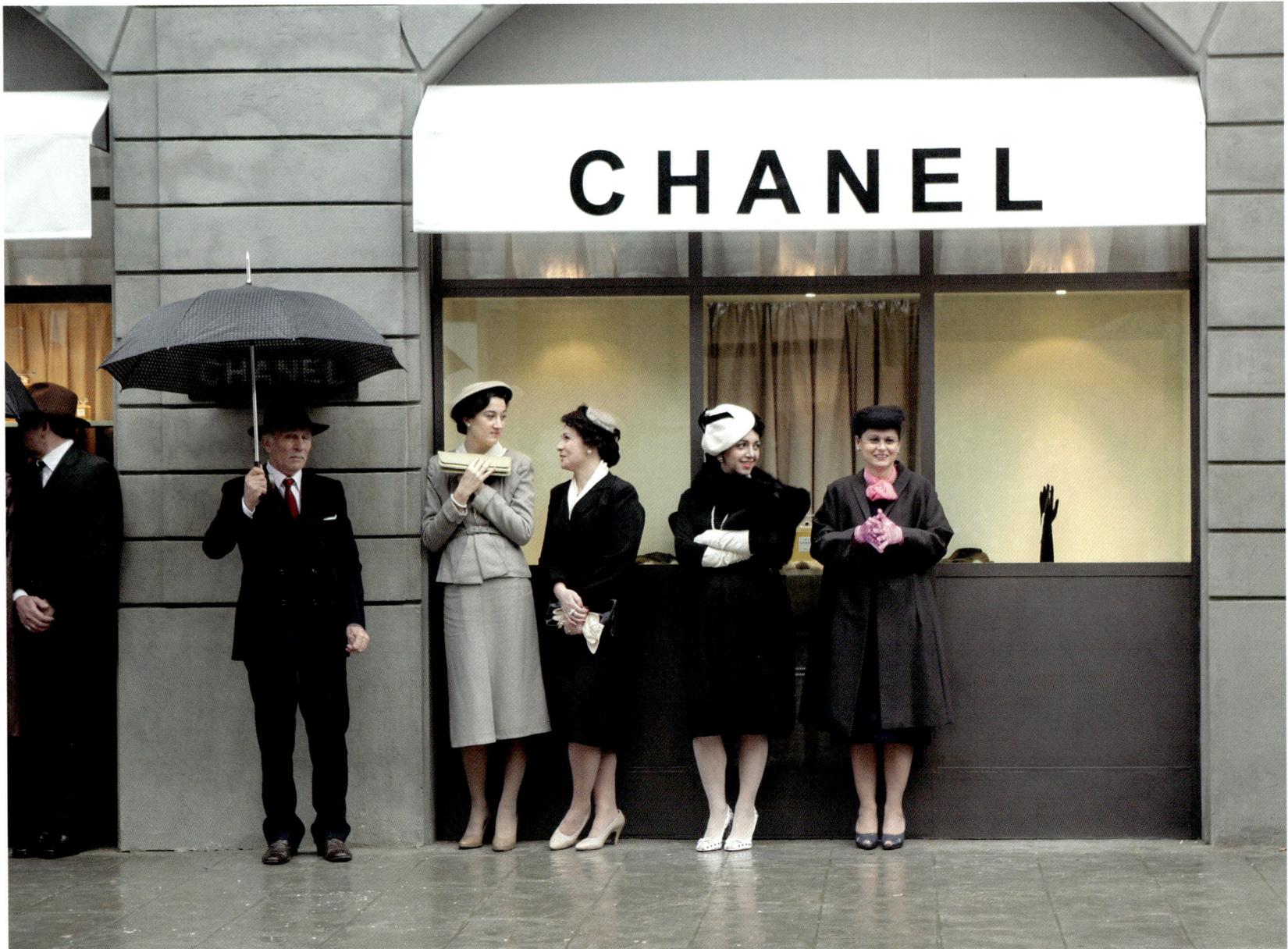

STEFANO DE NARDIS

Rodolfo Valentino – La leggenda
[Rudolph Valentino – The Legend],
2014
Directed by Alessio Inturri

Giuliana De Sio

Below, Gabriel Garko
Photos by Maurizio Torti

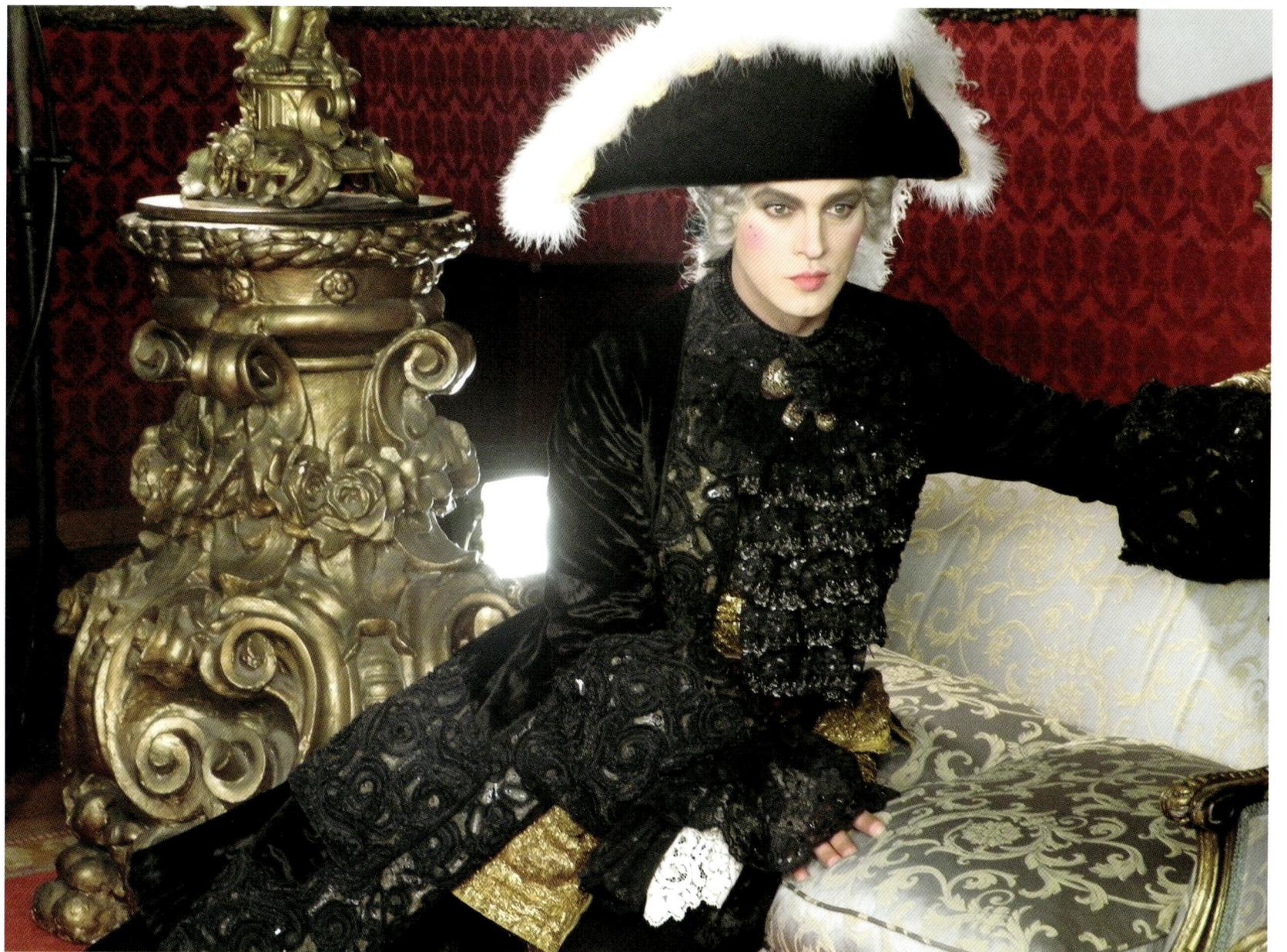

OLGA BERLUTI,
CARLO POGGIOLI

Marquise, 1997
Directed by Véra Belmont

Sophie Marceau

Below, Thierry Lhermitte
and Sophie Marceau
Courtesy Cecchi Gori Distribuzione

CARLO POGGIOLI

Miracle at St Anna, 2008
Directed by Spike Lee

Spike Lee and John Turturro
during shooting

Below, Pierfrancesco Favino
Courtesy 01 Distribution

**VARVARA AVDYUSHKO,
CARLO POGGIOLI**

Abraham Lincoln: Vampire Hunter,
2012
Directed by Timur Bekmambetov

Benjamin Walker, photo with
dedication to Roberto the cutter

Opposite

CARLO POGGIOLI

The Zero Theorem, 2013
Directed by Terry Gilliam

Matt Damon
Courtesy Moviemax

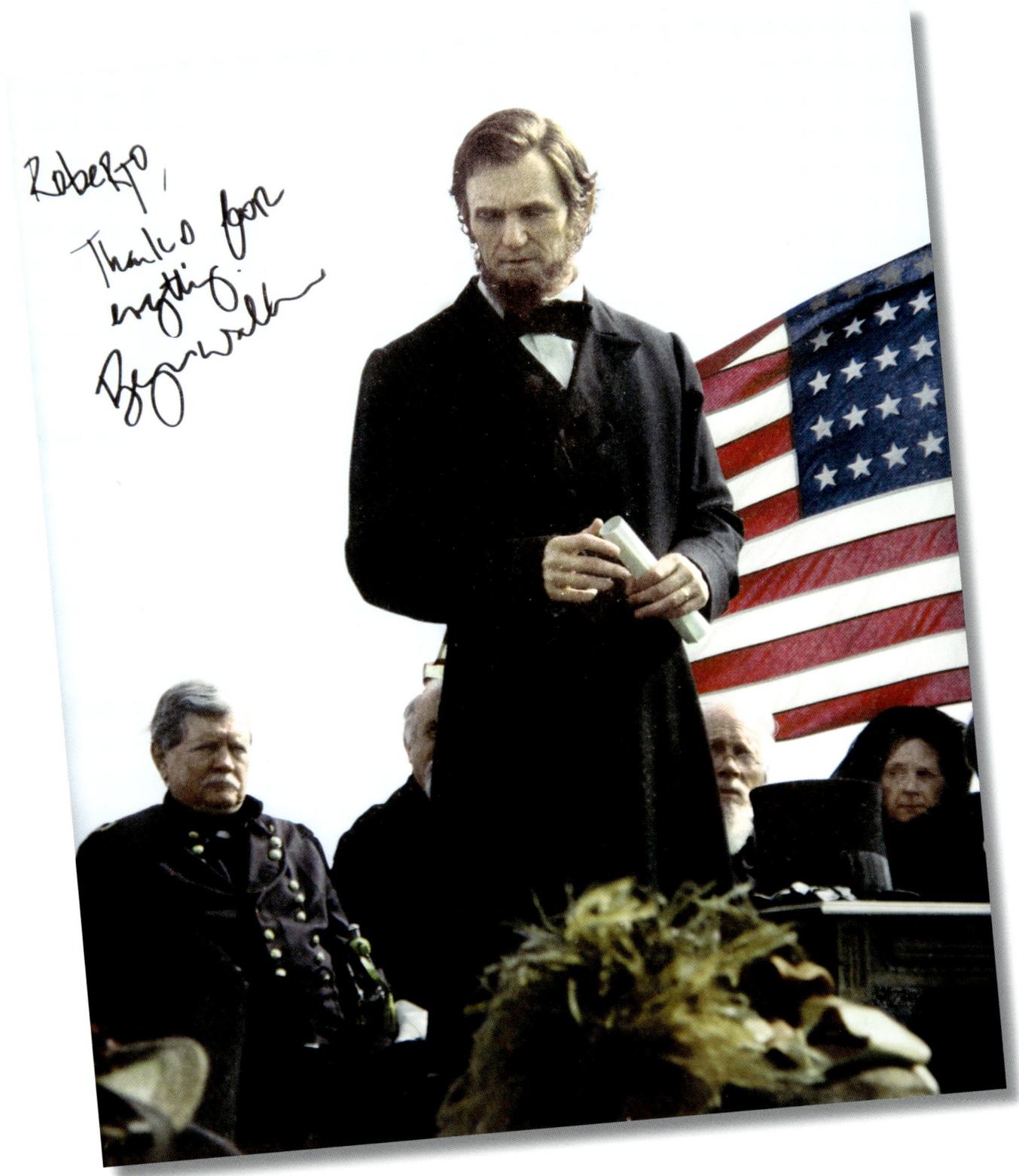

**VARVARA AVDYUSHKO,
CARLO POGGIOLI**

Abraham Lincoln: Vampire Hunter,
2012
Directed by Timur Bekmambetov

Benjamin Walker, photo with
dedication to Roberto the cutter

Opposite

CARLO POGGIOLI

The Zero Theorem, 2013
Directed by Terry Gilliam

Matt Damon
Courtesy Moviemax

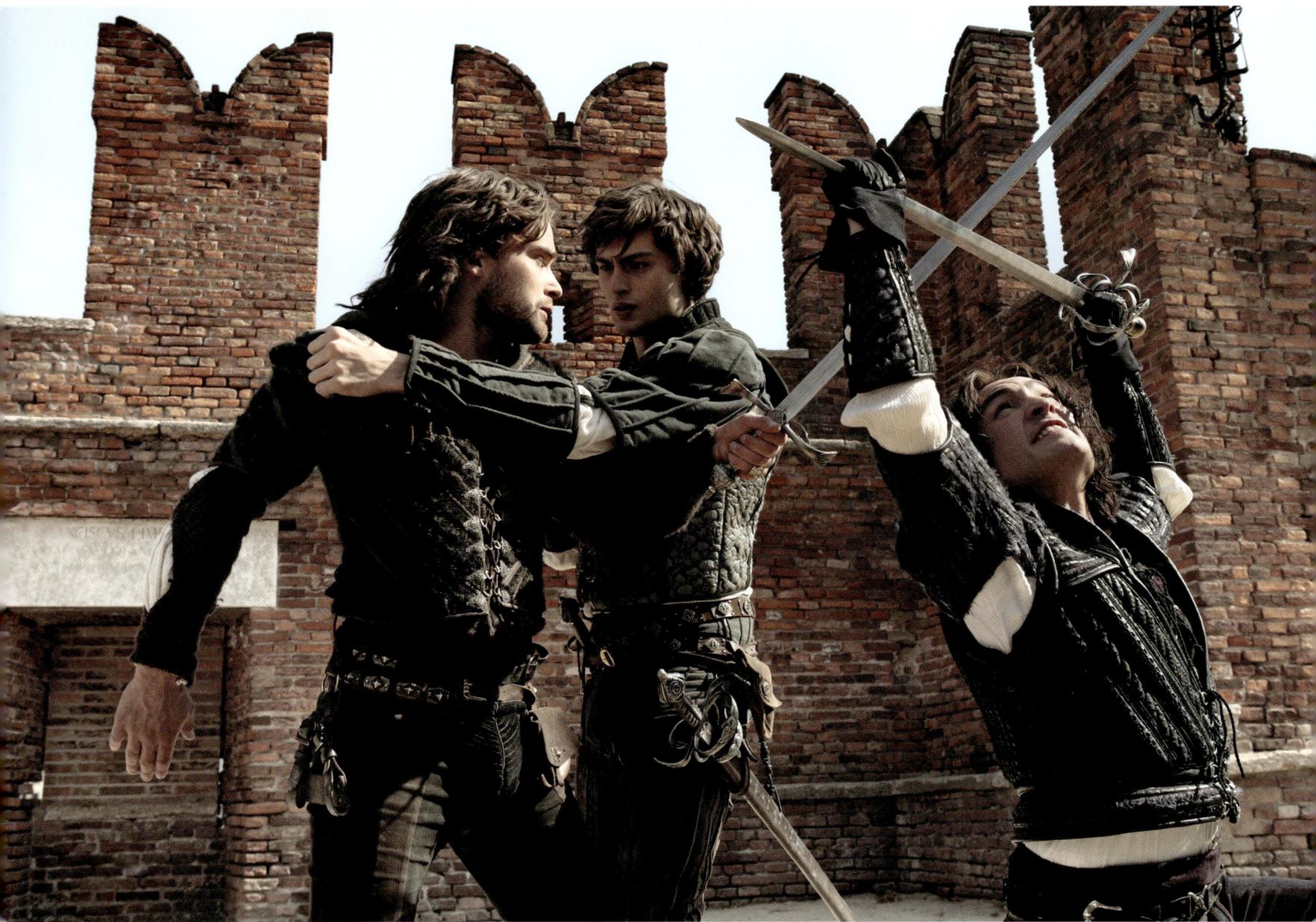

CARLO POGGIOLI

Romeo and Juliet, 2013
Directed by Carlo Carlei

Ed Westwick, Douglas Booth
and Christian Cooke

Left, Hailee Steinfeld
and Douglas Booth
Photos by Philippe Antonello

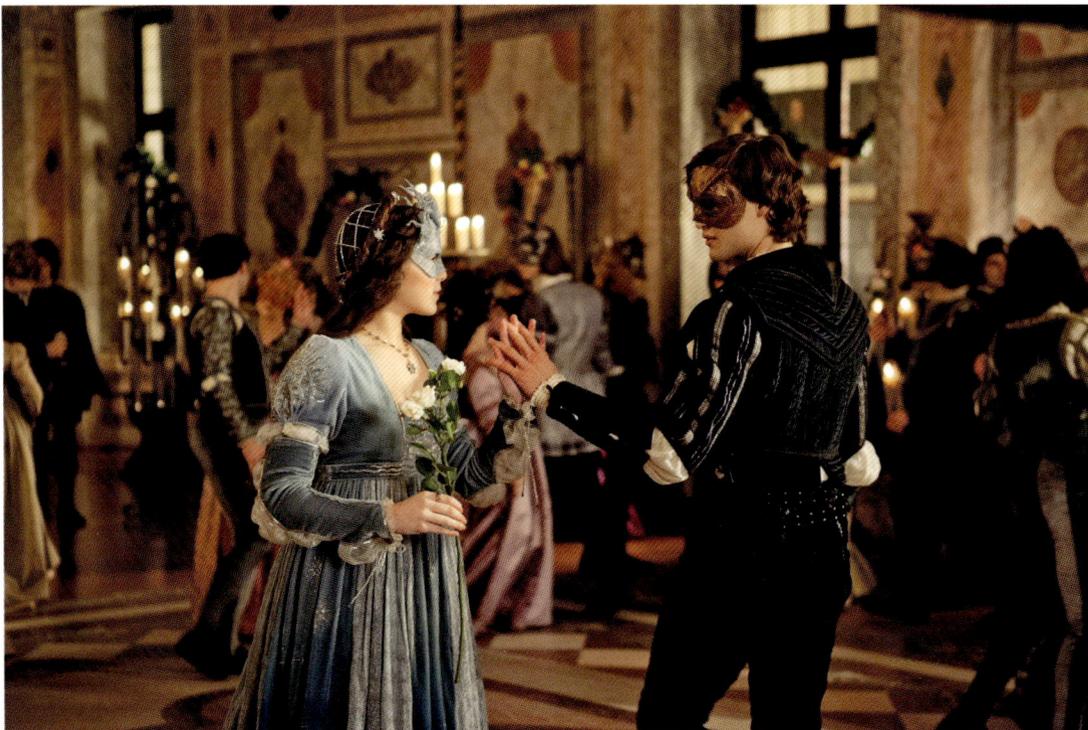

CARLO POGGIOLI

Divergent, 2014
Directed by Neil Burger

Kate Winslet

Below, Shailene Woodley
and Theo James
Courtesy of Summit Entertainment,
LLC

GABRIELLA PESCUCCI

A Midsummer Night's Dream, 1999
Directed by Michael Hoffman

Michelle Pfeiffer

Below left, Rupert Everett
and Stanley Tucci

Below right, Kevin Kline
Courtesy MEDUSA FILM S.p.A.

GABRIELLA PESCUCCI

Van Helsing, 2004
Directed by Stephen Sommers

David Wenham, Hugh Jackman
and Shuler Hensley

Below, Hugh Jackman
Courtesy UIP

GABRIELLA PESCUCCI

The Brothers Grimm, 2005
Directed by Terry Gilliam

Costume sketch for the Queen
(Monica Bellucci)

Below, Heath Ledger
and Matt Damon

Right, Monica Bellucci

Opposite, Monica Bellucci
and Heath Ledger

Below, Matt Damon
and Monica Bellucci
Courtesy Miramax Films

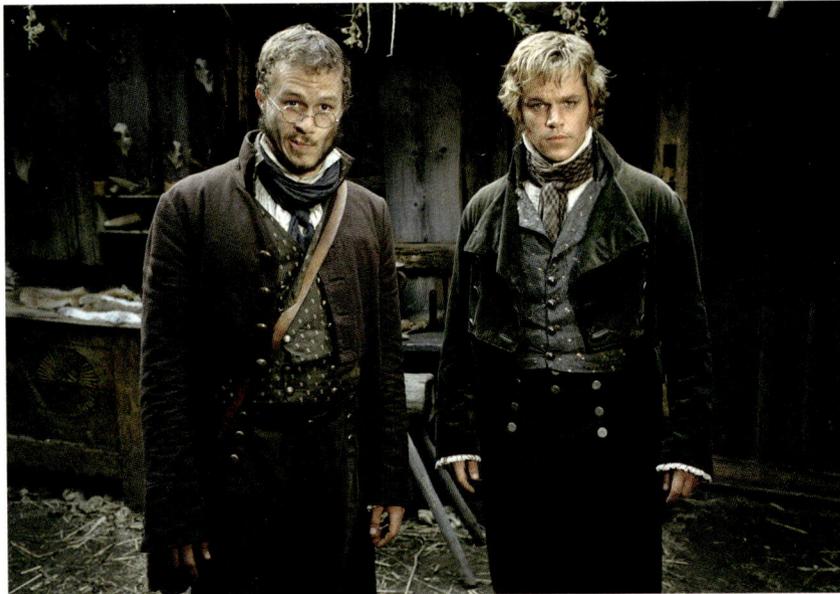

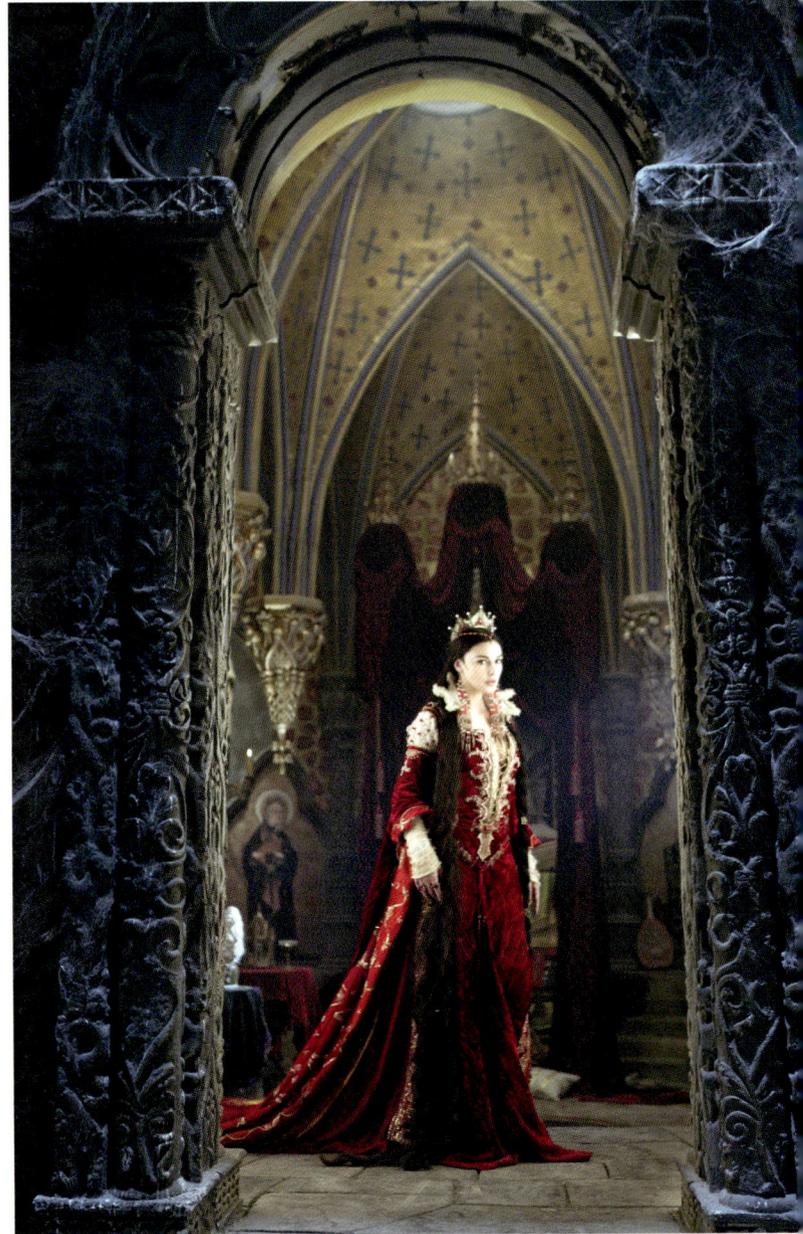

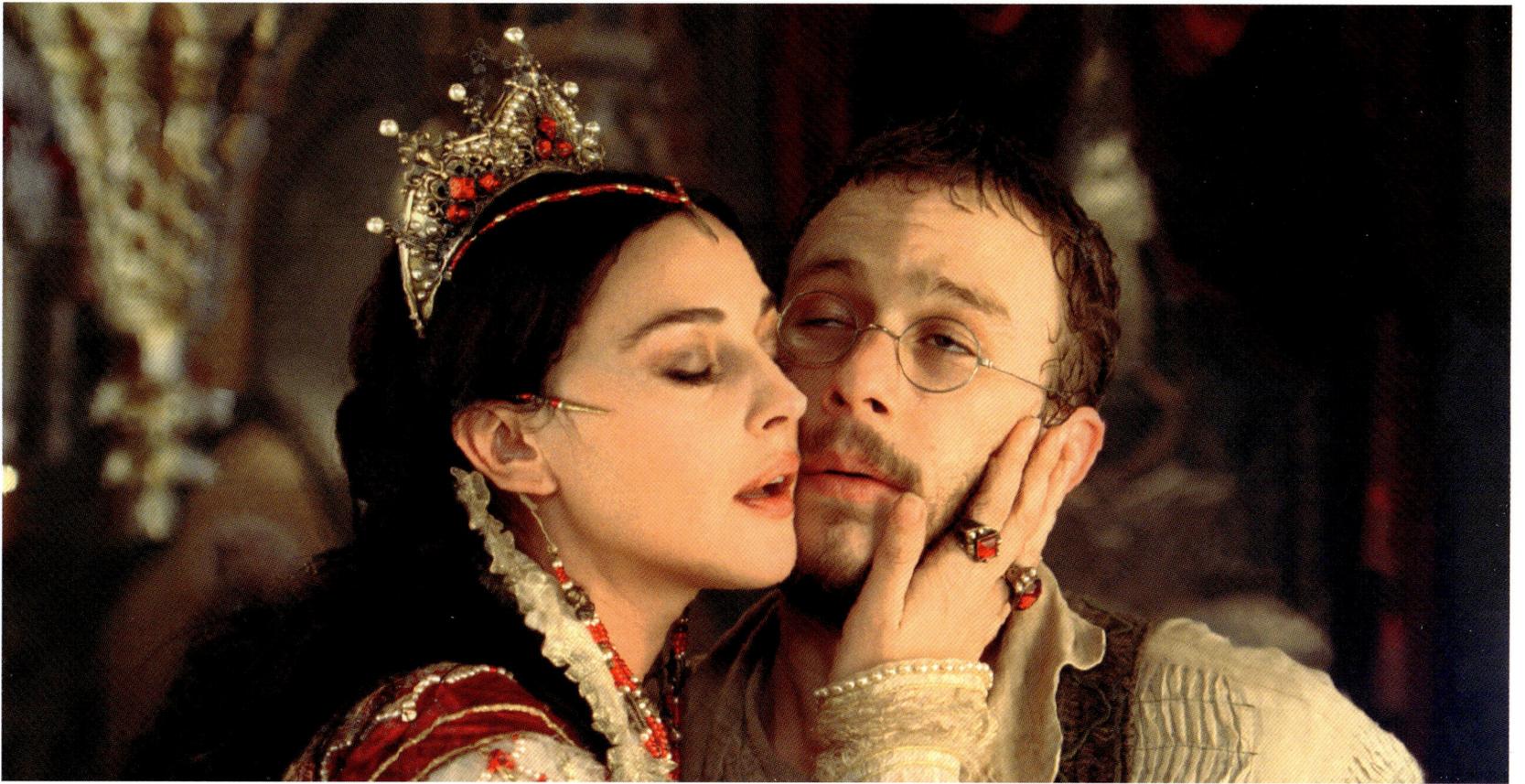

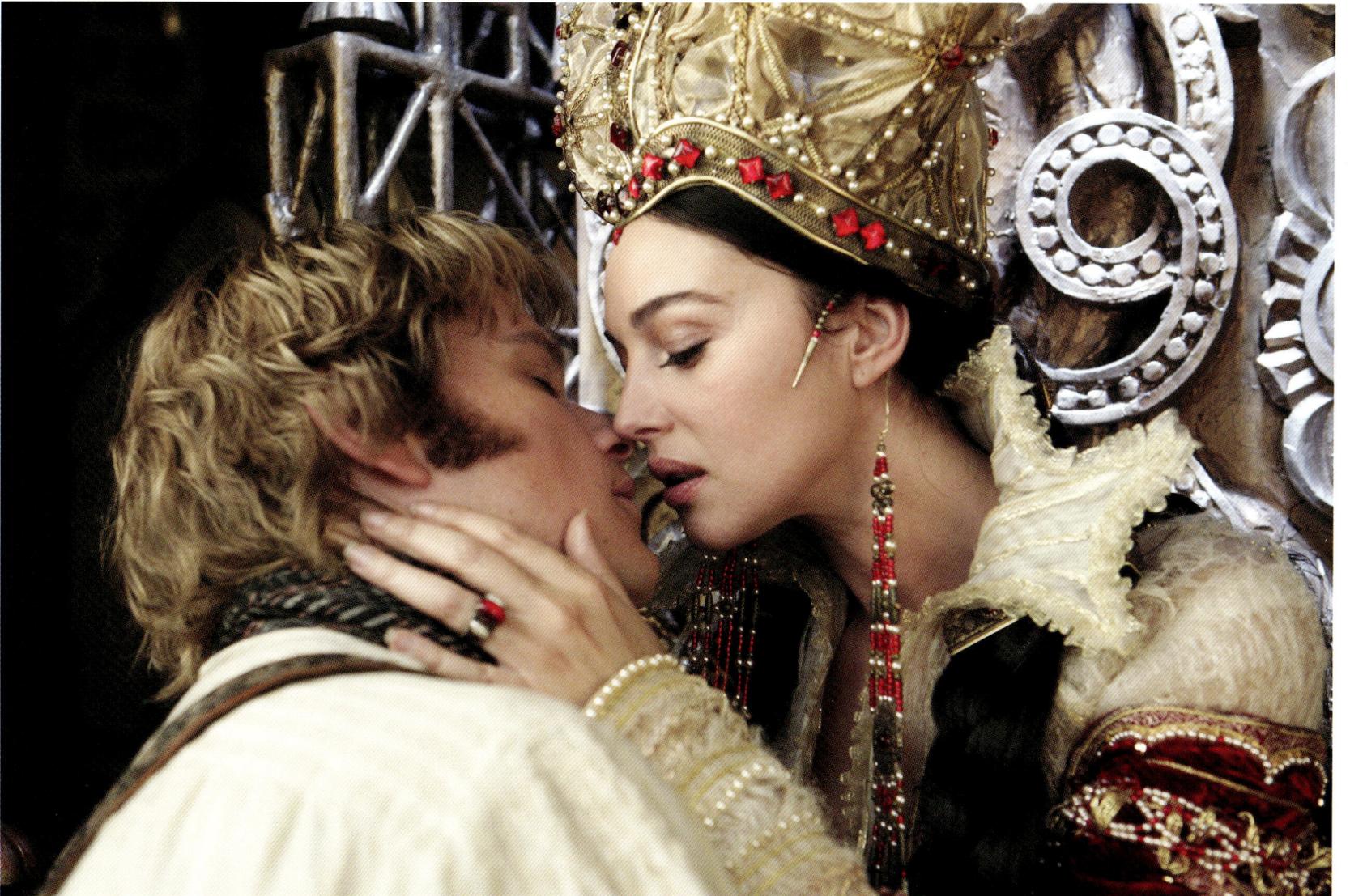

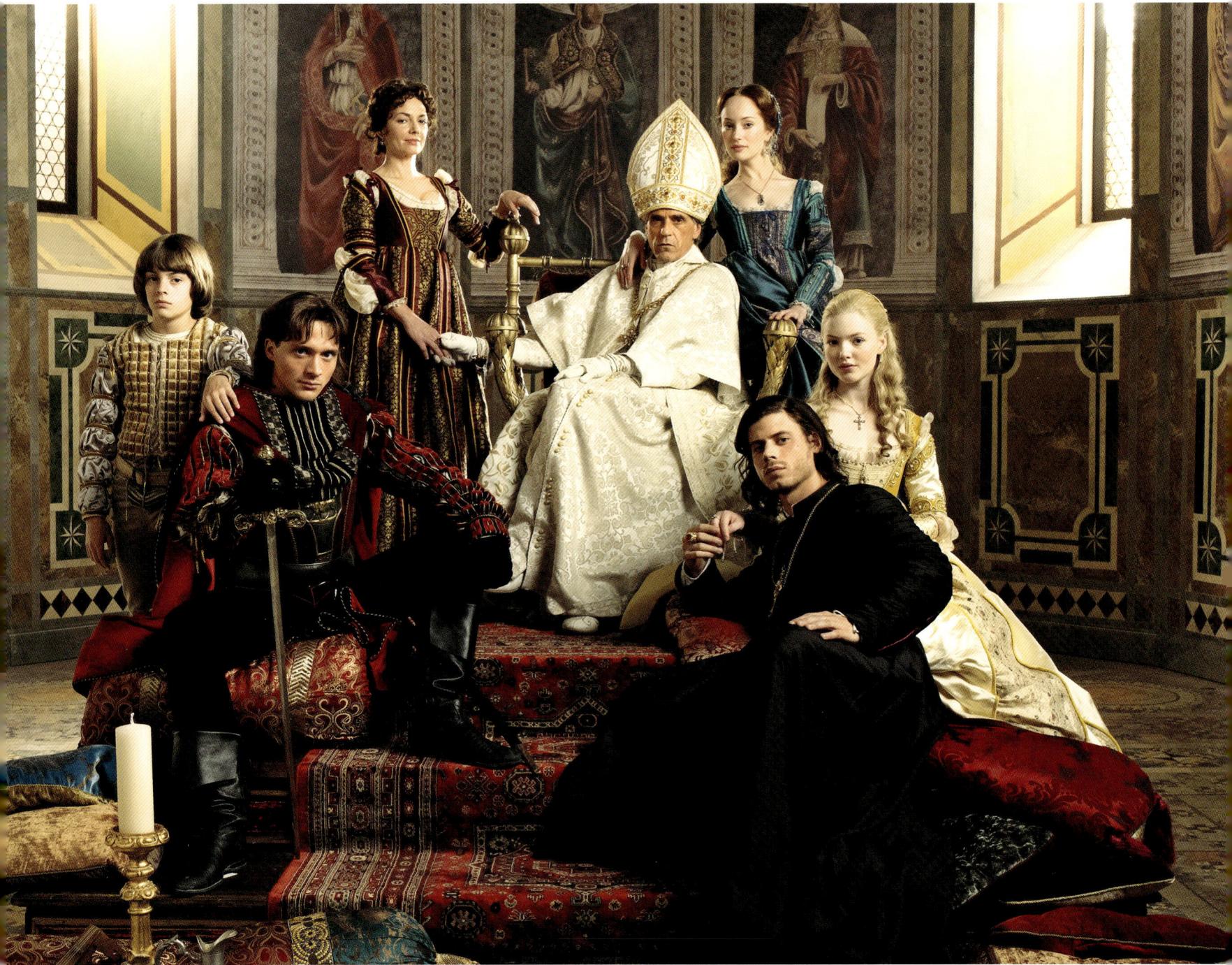

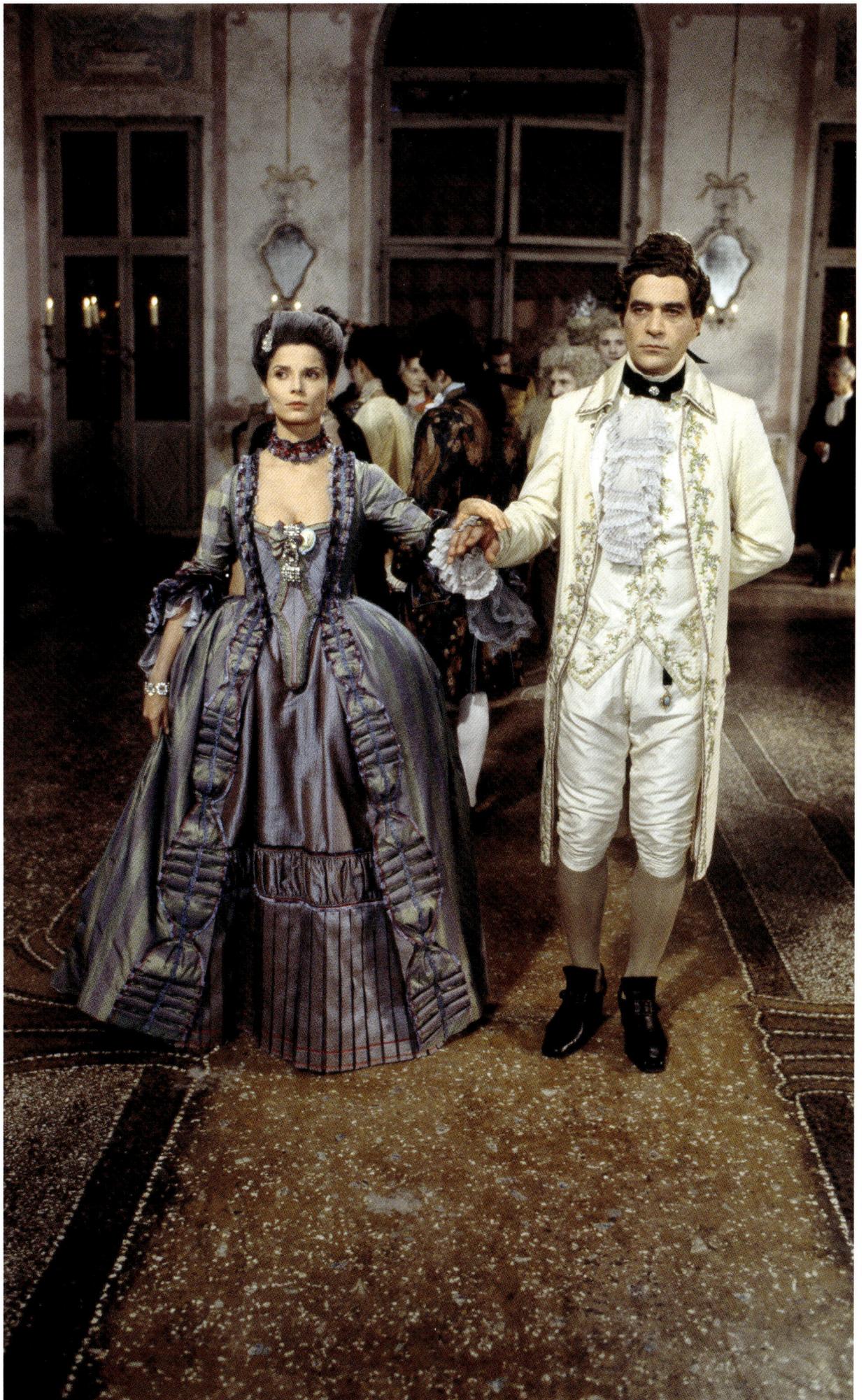

ALESSANDRO LAI

Virginia – La monaca di Monza
[The Nun of Monza], 2004
Directed by Alberto Sironi

Giovanna Mezzogiorno
Courtesy Rai Ufficio Stampa

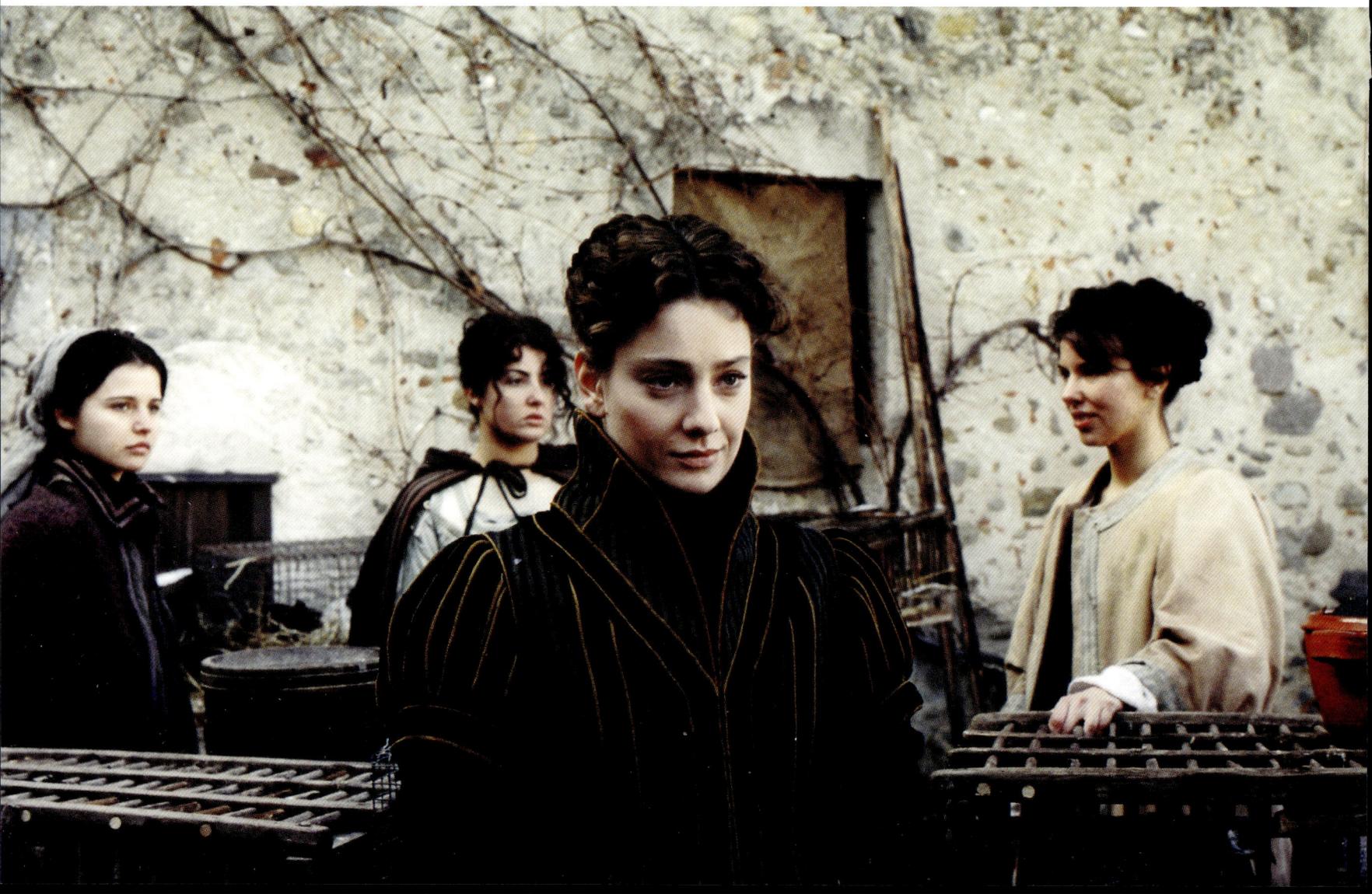

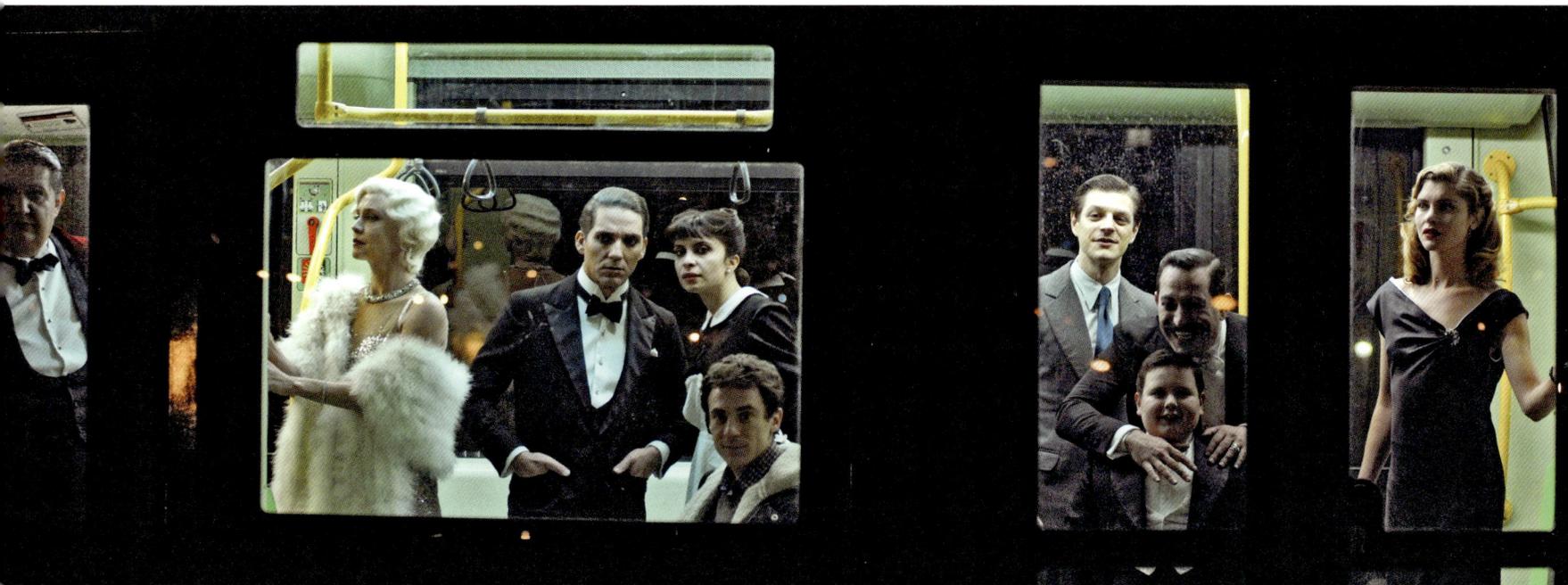

ALESSANDRO LAI

Magnifica presenza
[A Magnificent Haunting], 2012
Directed by Ferzan Ozpetek

Ambrogio Maestri, Margherita Buy,
Giuseppe Fiorello, Claudia Potenza,
Elio Germano, Andrea Bosca,
Cem Yılmaz, Matteo Savino
and Vittoria Puccini
© Romolo Eucalitto

Below, Ferzan Ozpetek with the cast
during filming
Photo by Philippe Antonello

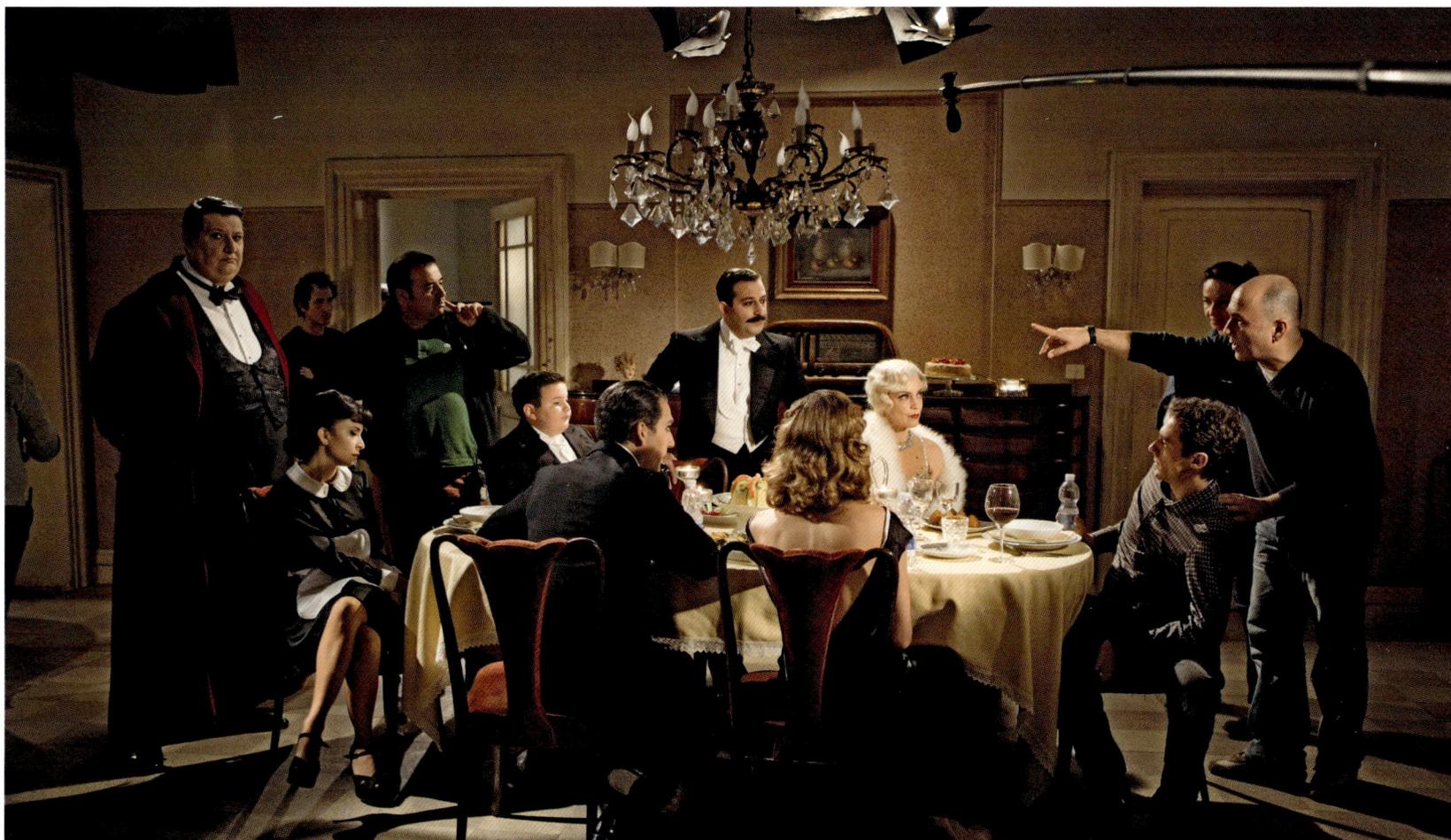

MARIANO TUFANO

La voce umana [The Human Voice],
2014
Directed by Edoardo Ponti

Sophia Loren

Opposite, Enrico Lo Verso
and Sophia Loren
Photos by Pietro Vertamy – OnOff
Picture

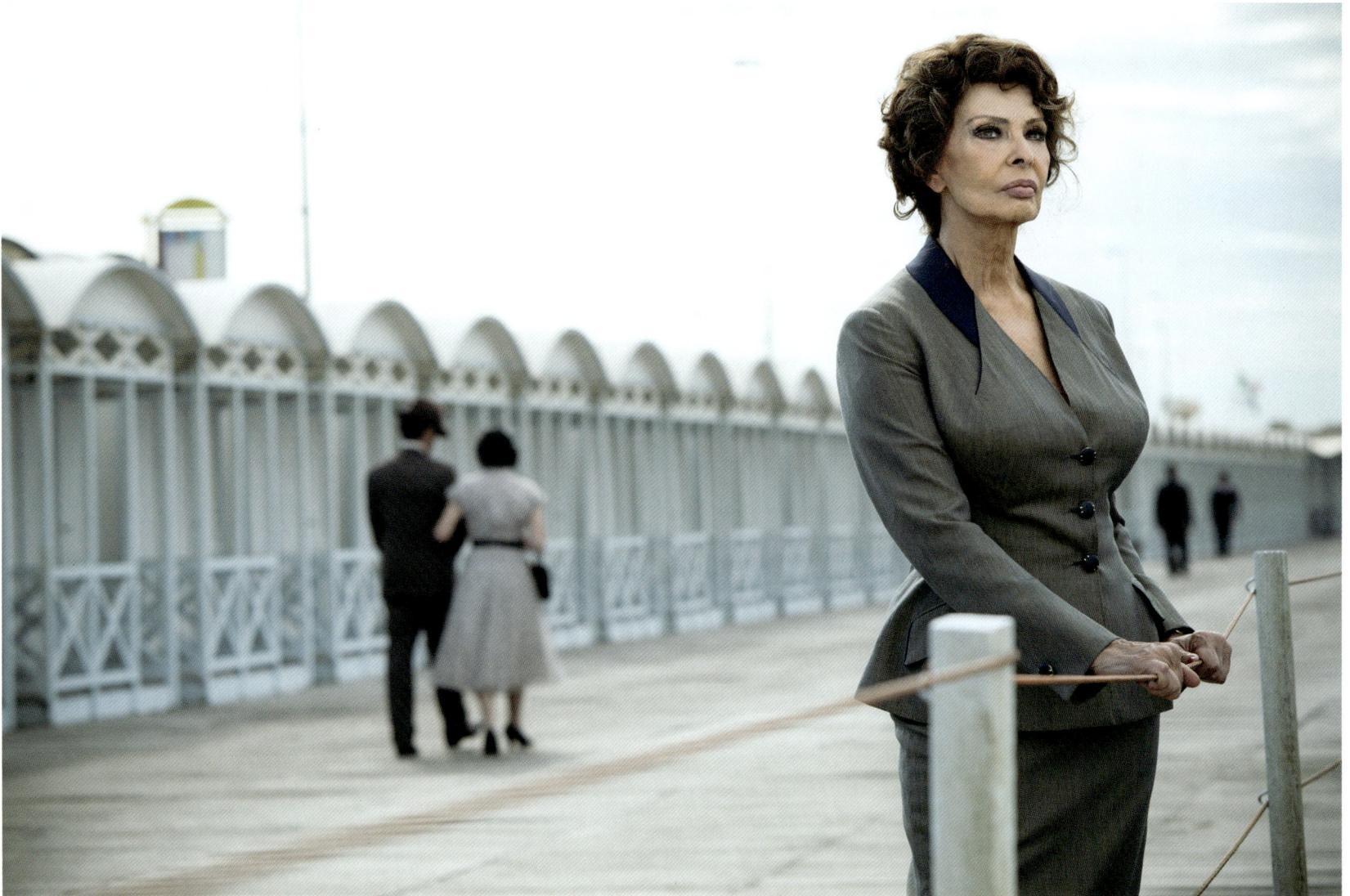

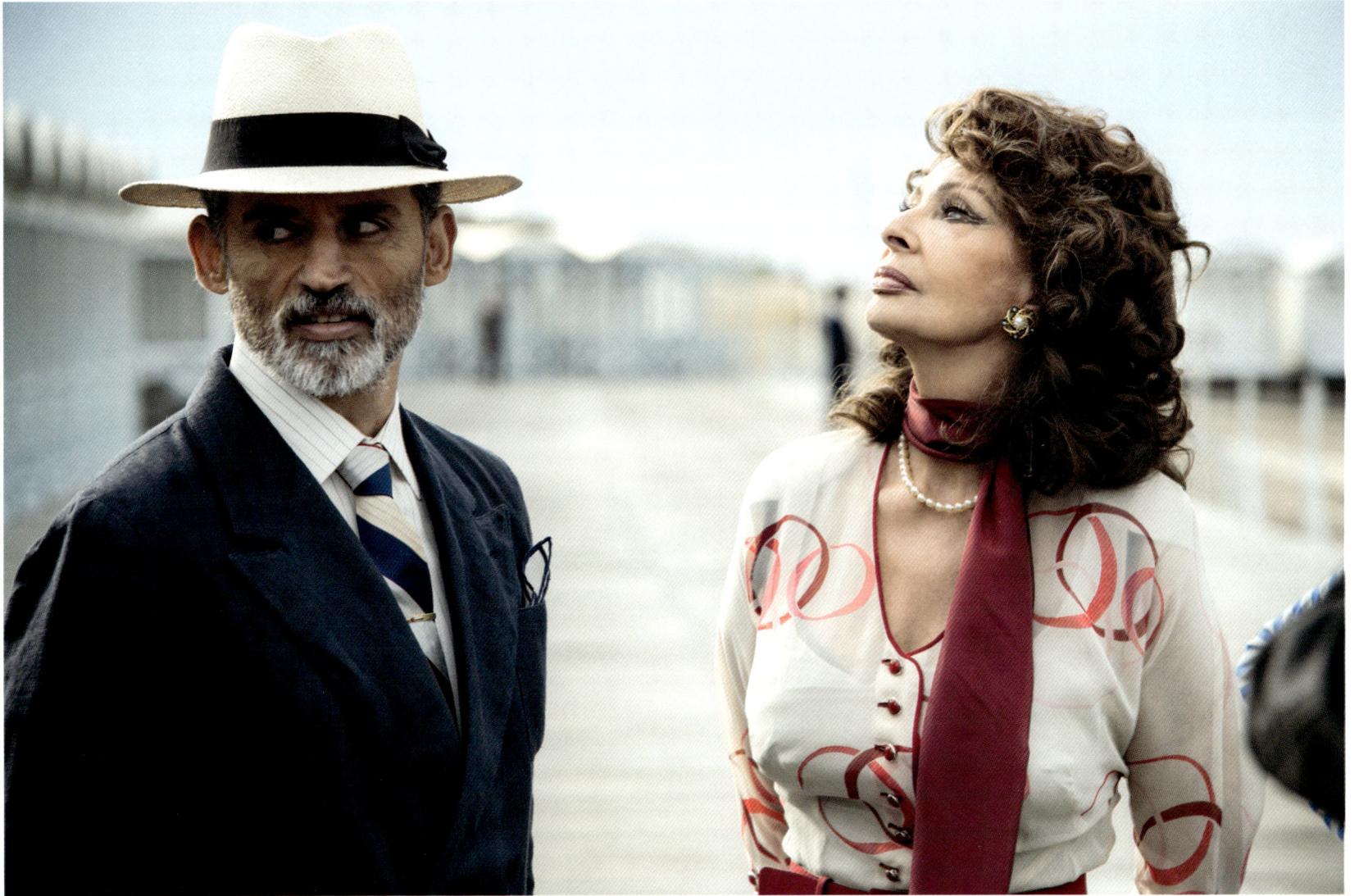

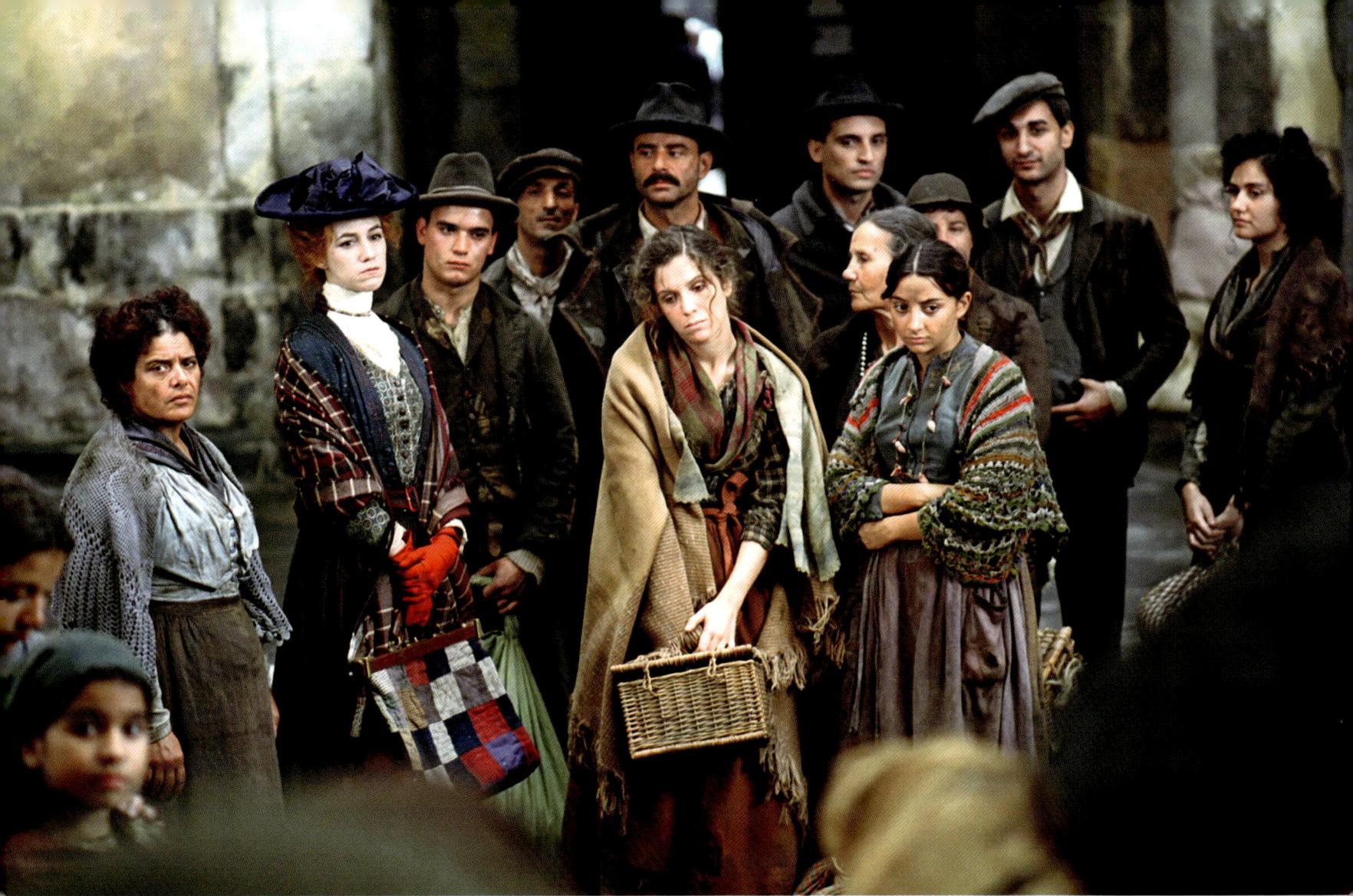

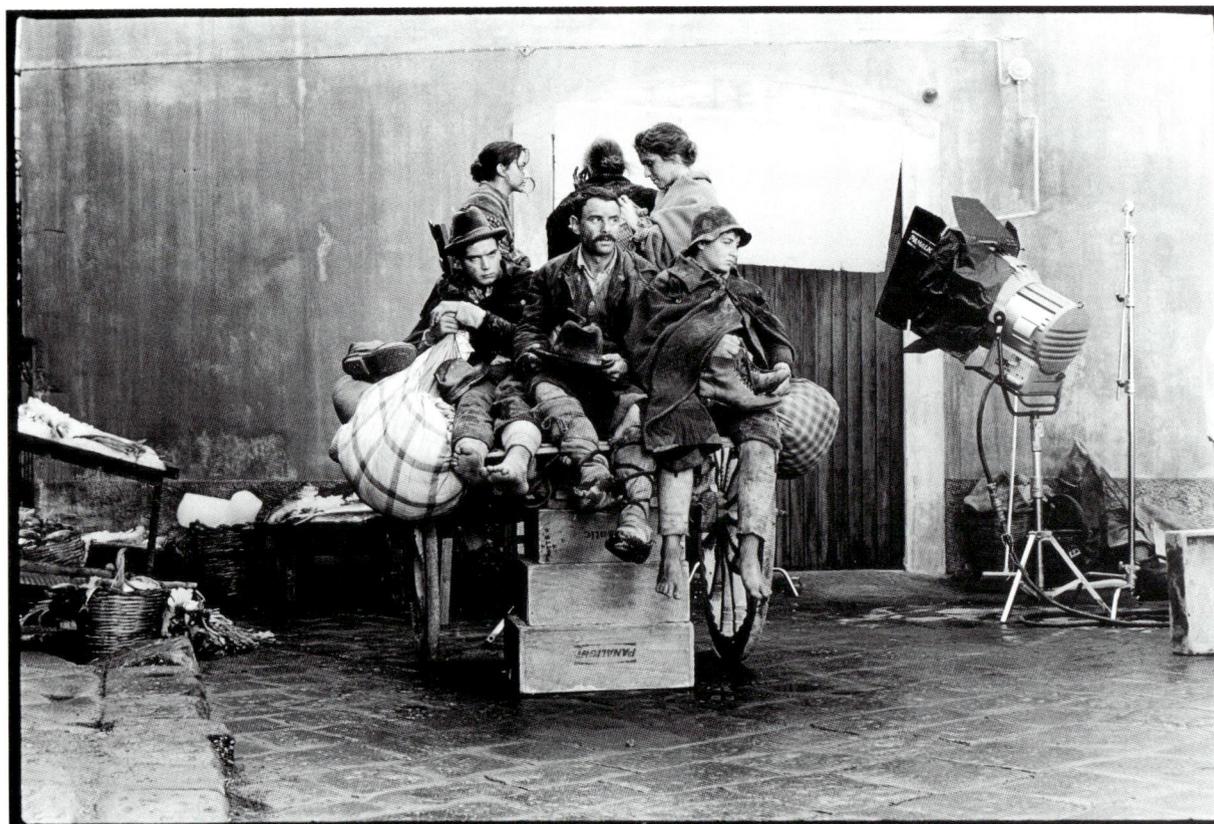

MARIANO TUFANO

Nuovomondo [Golden Door], 2006
Directed by Emanuele Crialese

Charlotte Gainsbourg, Vincenzo
Amato and Isabella Ragonese

Left, Vincenzo Amato
Courtesy 01 Distribution

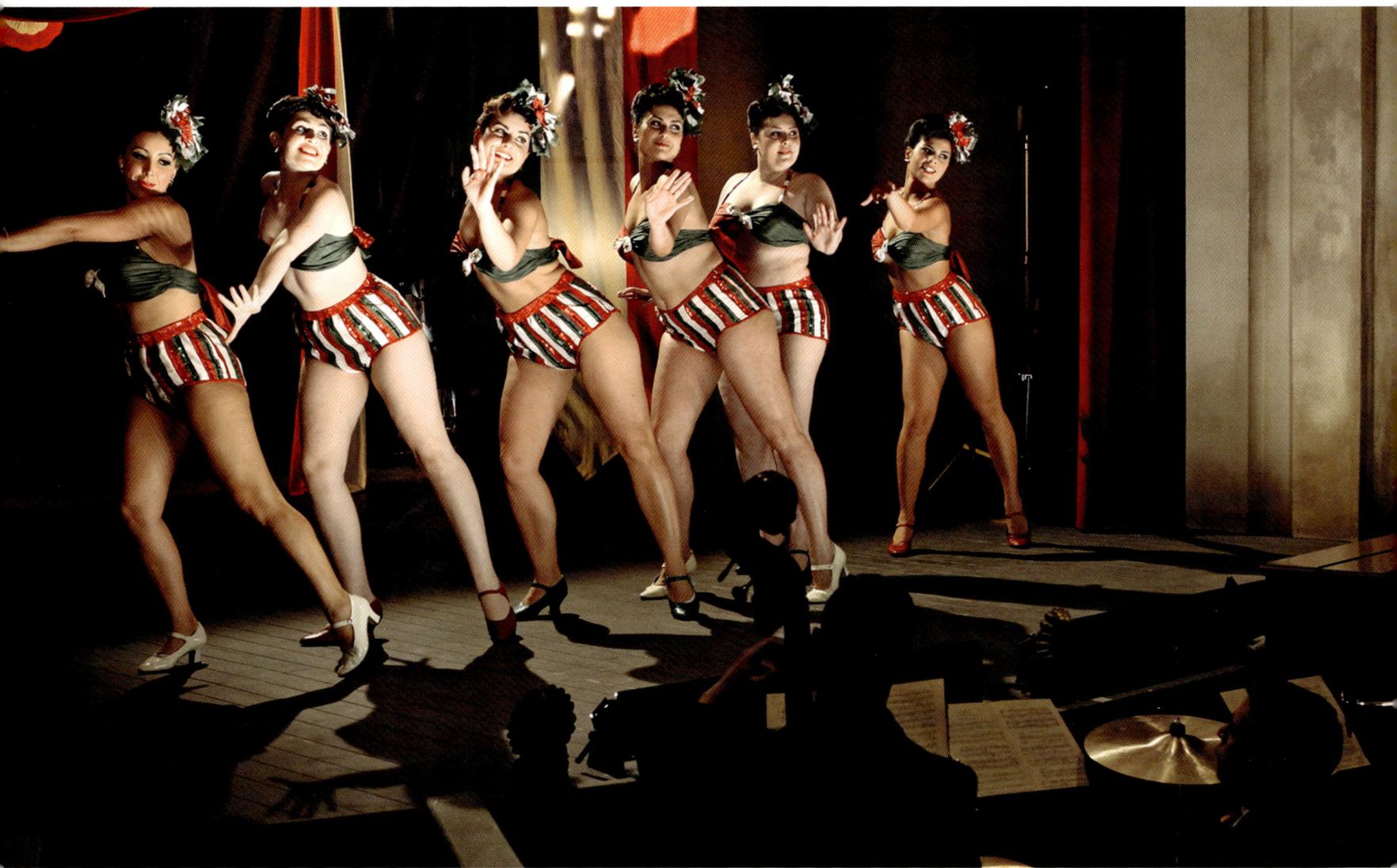

MASSIMO CANTINI PARRINI

*Che strano chiamarsi Federico
[How Strange to Be Named Federico],*
2013
Directed by Ettore Scola

The curtain raiser

Right, Ettore Scola during filming
Photos by Cristina Di Paolo Antonio

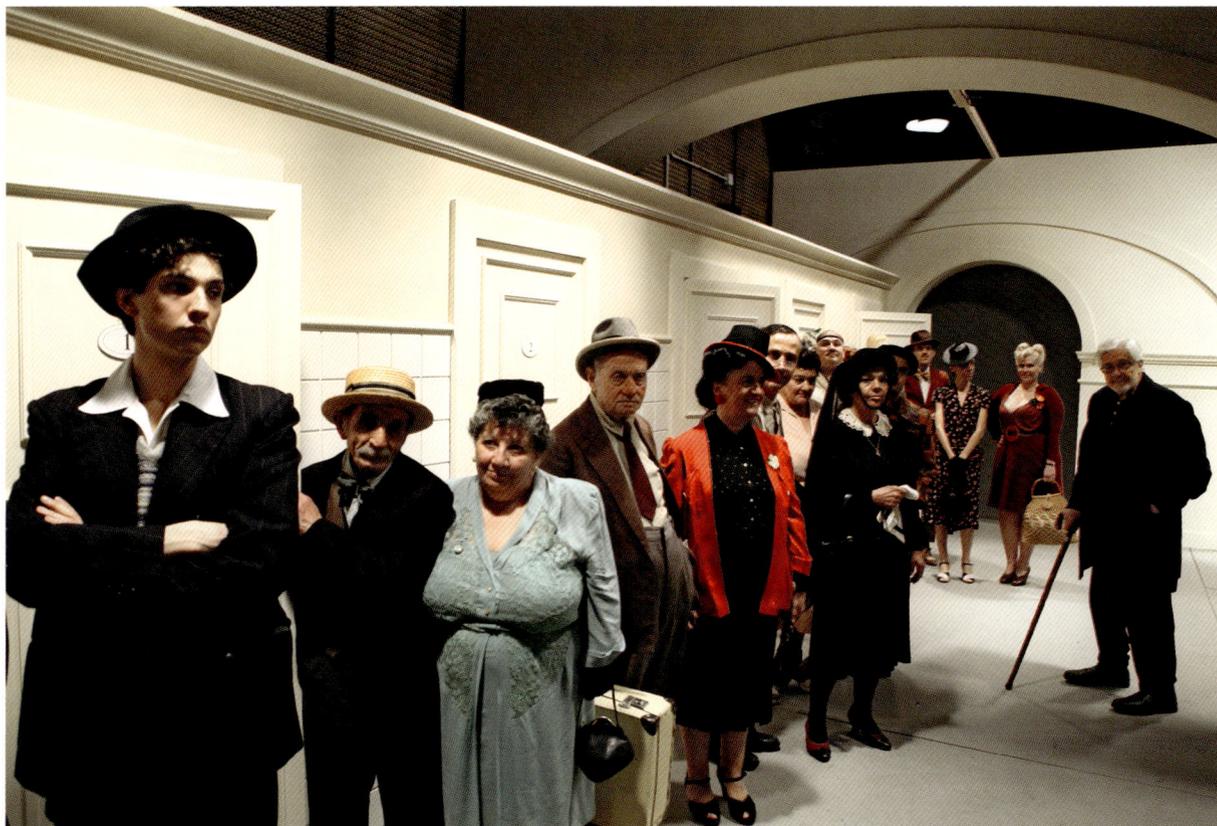

John C. Reilly and Salma Hayek

Opposite, Massimo Cantini Parrini,
Salma Hayek and Matteo Garrone
during shooting
Photos by Greta De Lazzaris

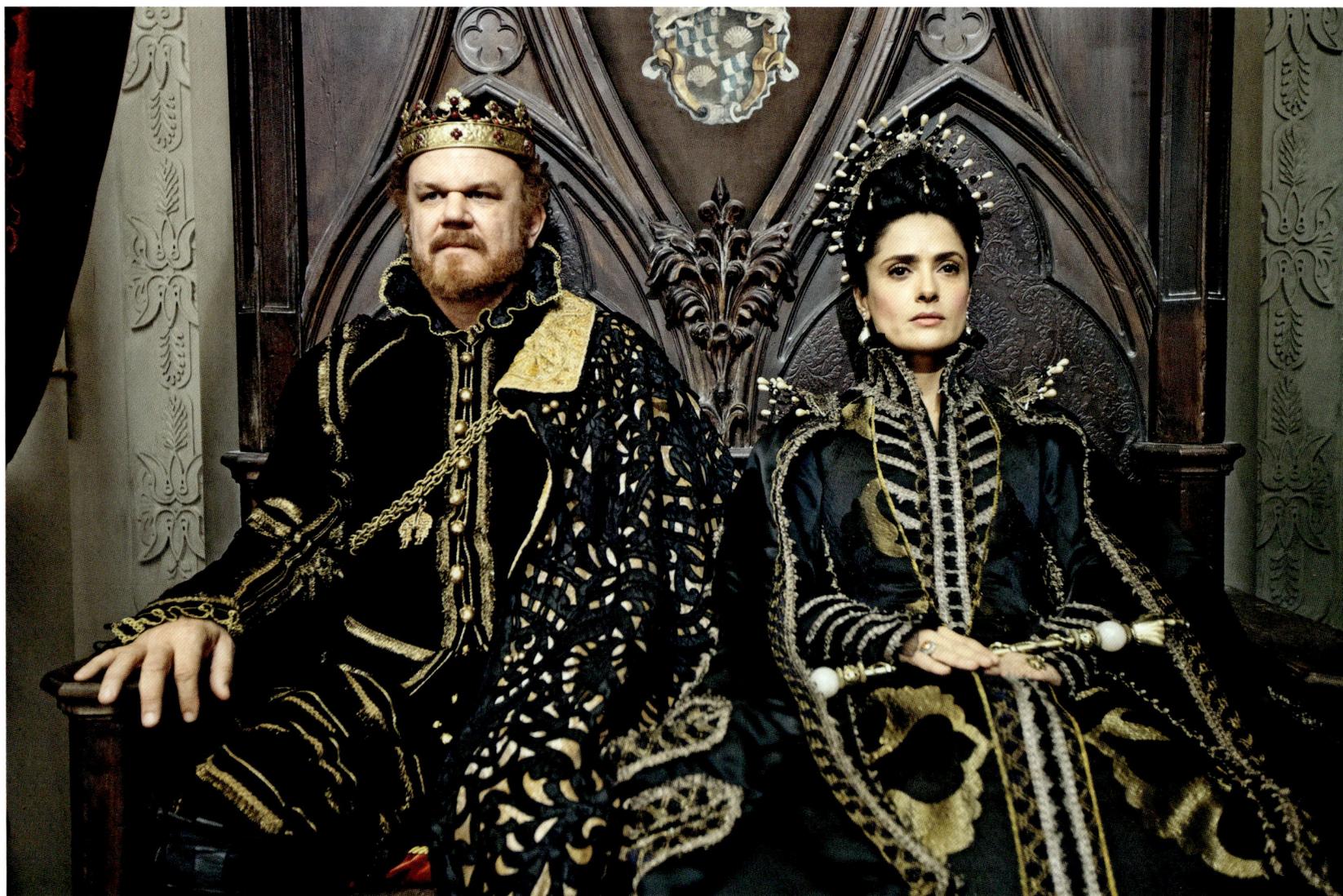

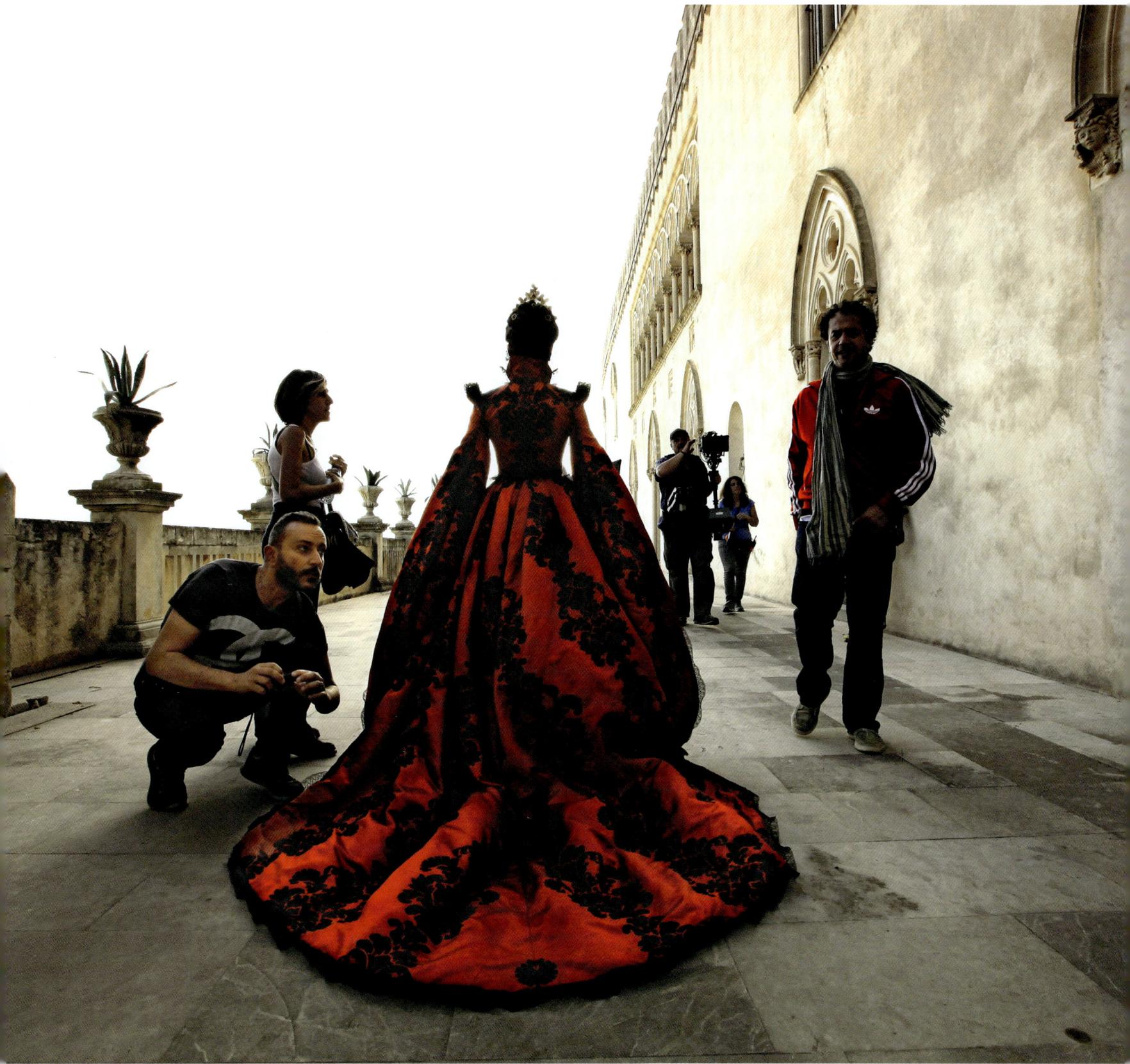

DONATIONS

A considerable portion of Umberto Tirelli's extraordinary collection consists of donations from friends, or from people who simply liked the idea that certain unappreciated, valuable family legacies should in some way bear witness to past eras. The loving preservation of clothes that were once precious, and their brief reappearance on stage, in a film or exhibition would extend their lifespan. Many treated the clothes of their ancestors like those who donate a painting to a museum in memory of the person who had admired and chosen it. Over the years the list of donors increased and this is how Tirelli remembers the first of them:

> I am now at an advantage since the fame of my "museum" has spread and people think they can sell even things of great sentimental value to Tirelli because "you know where they'll end up". Recently I have acquired from the son of a notable, a high official of the Fascist regime, all of his father's bowler hats, and, who knows, perhaps they include the one he wore for the March on Rome. I receive many extraordinary "pieces" from friends. Anne Marie Aldobrandini rifled the wardrobes of the French aristocracy for me; she gave me her 1950s trousseau by Dior and Chanel, and many of her mother Lilie Volpi's clothes. I would devote a whole room to her if my "museum" had actual premises and did not simply consist of warehouses. I would also devote a large room to Domietta del Drago, the generous patroness of my collection. Several legacies meant that Domietta's wardrobes were full of wonderful creations: 1920s Chanel, Balenciaga, Paquin, Dior. They are among my most important things and they enhanced the first fashion exhibition, organized and curated by Diana Vreeland, with my assistance, at the Metropolitan Museum of Art in New York: *The Tens, The Twenties, The Thirties: Inventive Clothes, 1909–1939*. The Chinese clothes and garments in Chinese style by the great French designers that I lent to Diana Vreeland for a historical exhibition of Oriental fashion at the Metropolitan Museum were a donation from Domietta as well. They came from the wardrobe of a Del Drago princess, but belonged to a great aunt who went to Peking at the end of the nineteenth century and took it into her head to dress like the Chinese.

Donations still continue to arrive, both from friends and admirers of Tirelli Costumi.

Recent acquisitions include: eighty dresses by Capucci, Saint Laurent and Ungaro from the Ranucci sisters; fabulous Madame Grès garments from Gloria Venturi; and the valuable and varied wardrobe of Gugi Hruska.

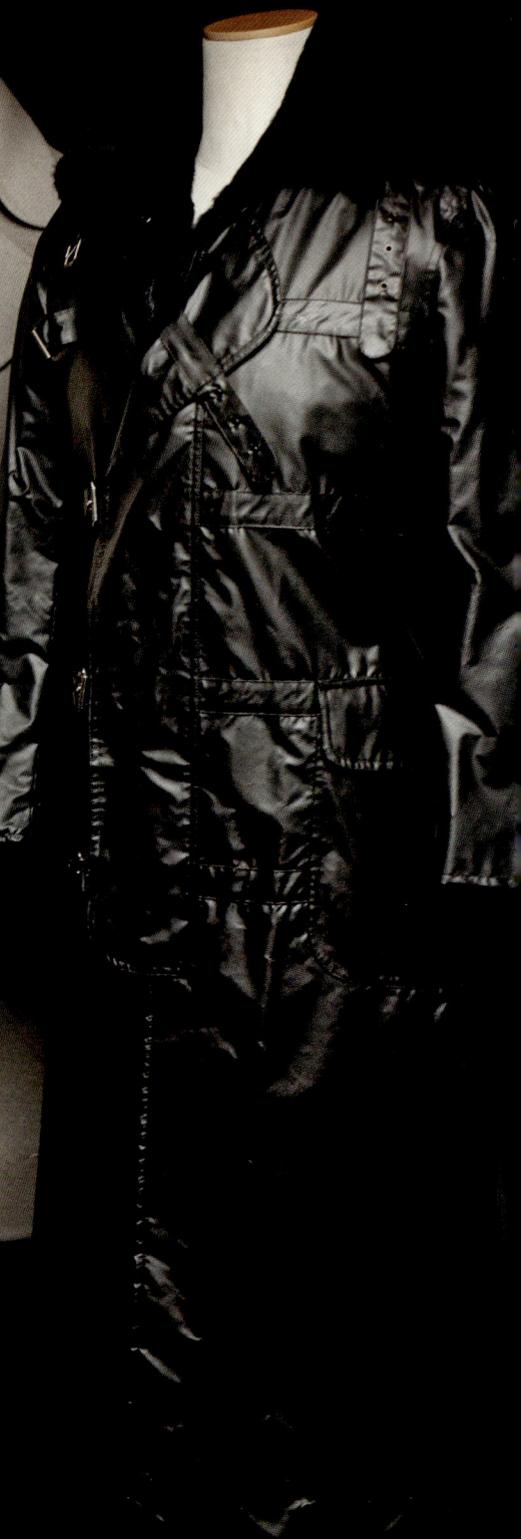

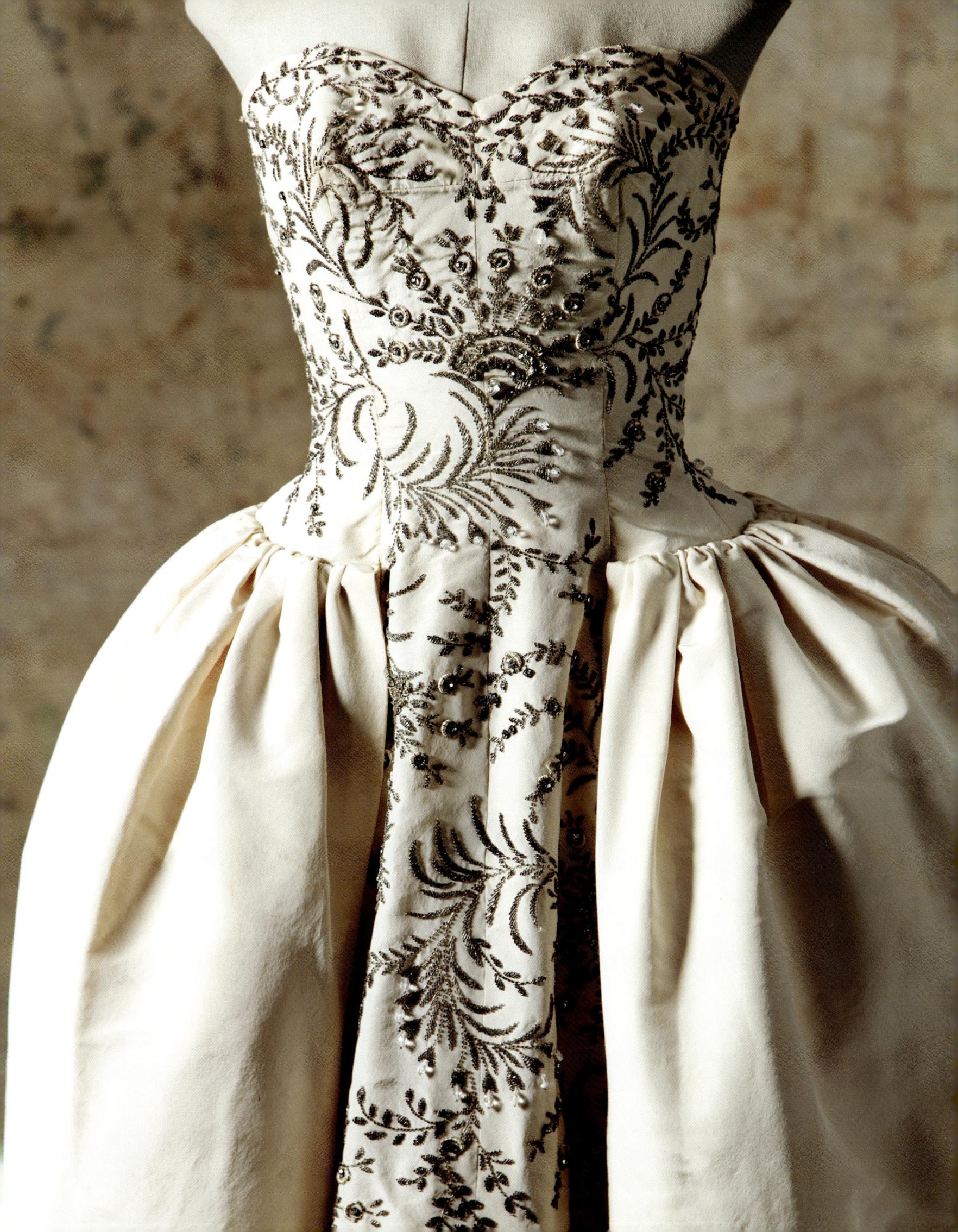

A dress (Gattinoni, 1951) that
belonged to Ingrid Bergman, from
the large donation the actress gave
to Umberto Tirelli

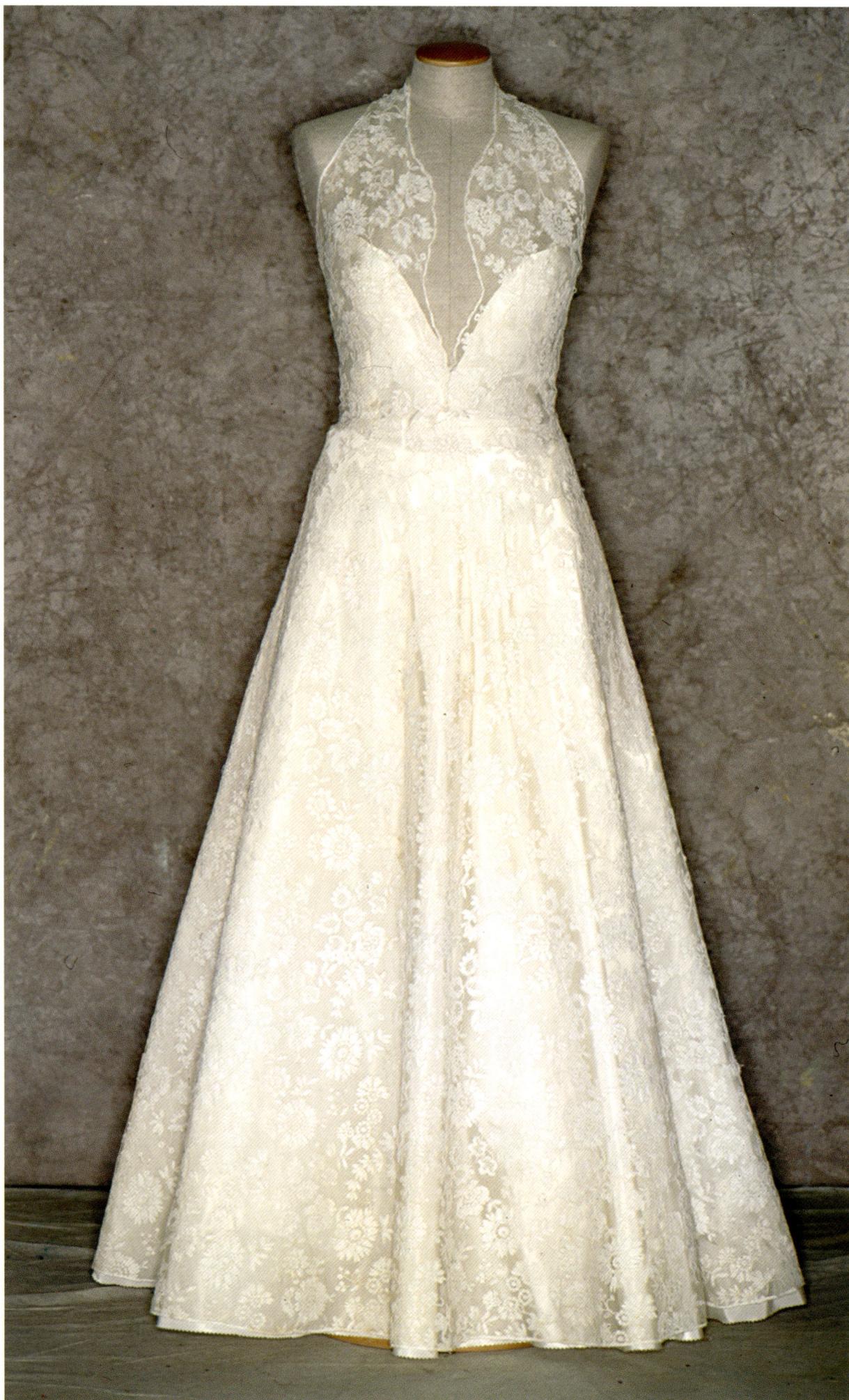

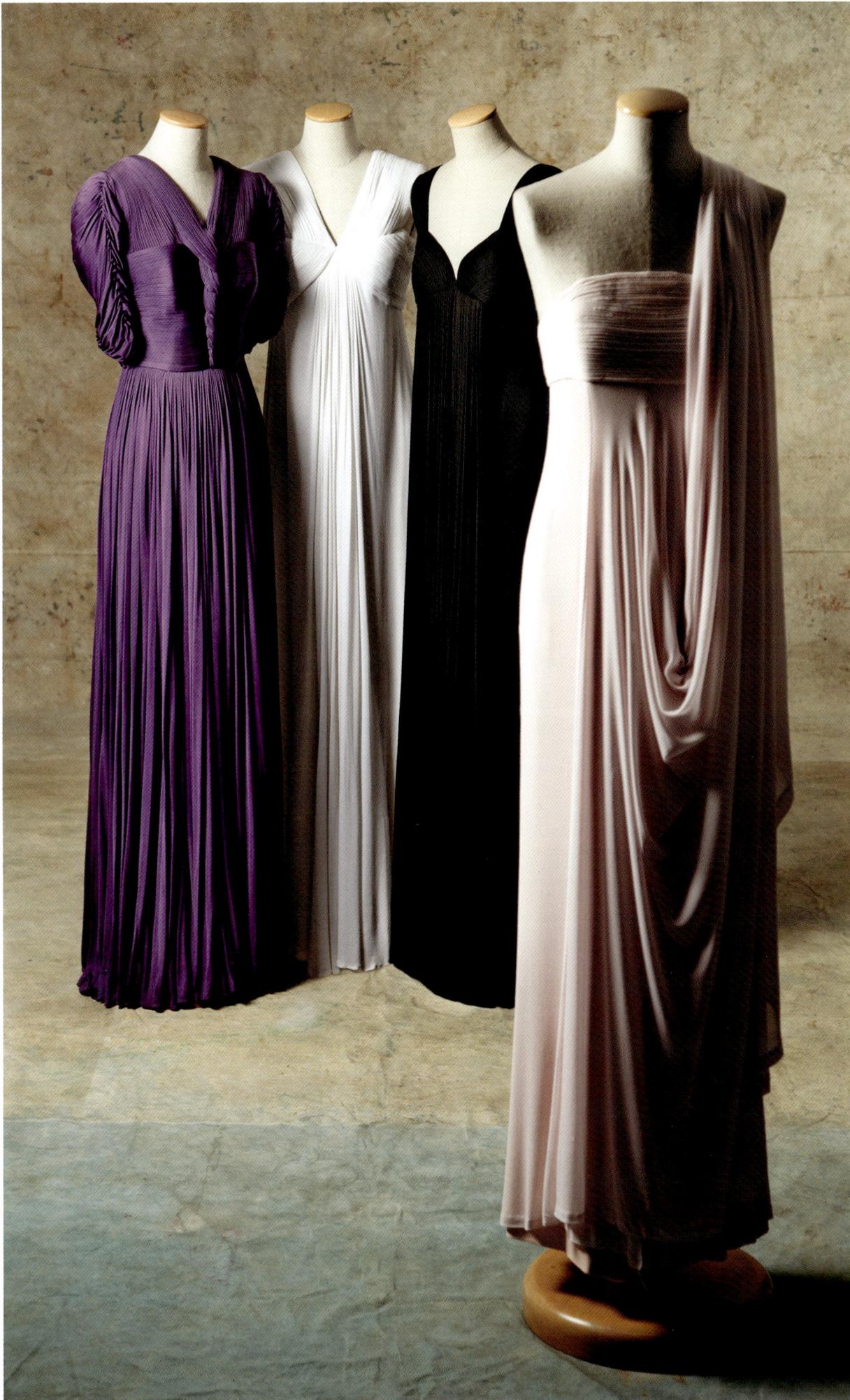

Madame Grès (1960–70)
Part of the donation from Gloria
Venturi

Opposite

Some of the costumes created by the designer Bruno Piattelli and made in his atelier for Marcello Mastroianni in the films *The Tenth Victim* directed by Elio Petri and *Casanova '70* directed by Mario Monicelli
Donated by Bruno Piattelli

Maison Jean Patou (1920): waistcoat embroidered with gold glass tubules, that belonged to Marlene Dietrich. She herself gave it to Umberto Tirelli during a dinner with Jean-Claude Brialy in Spring 1982

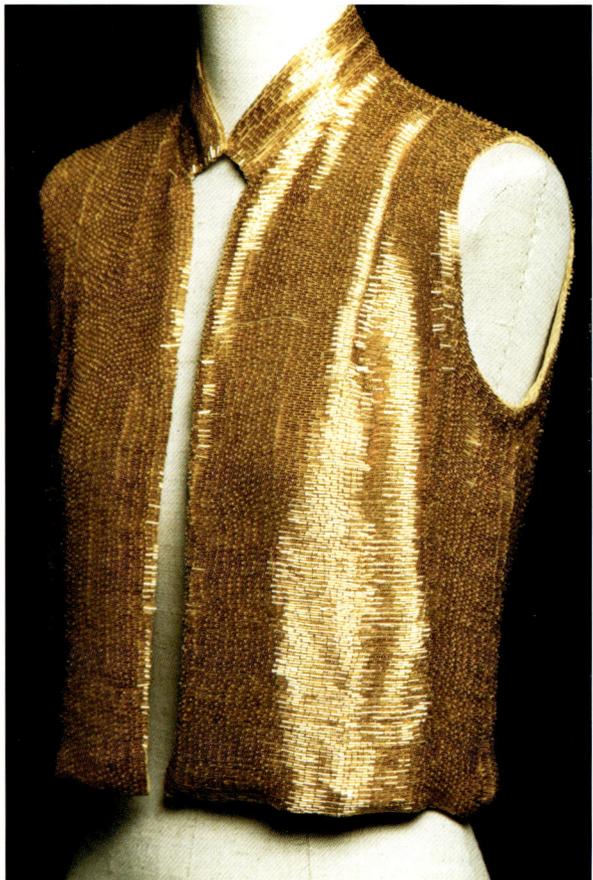

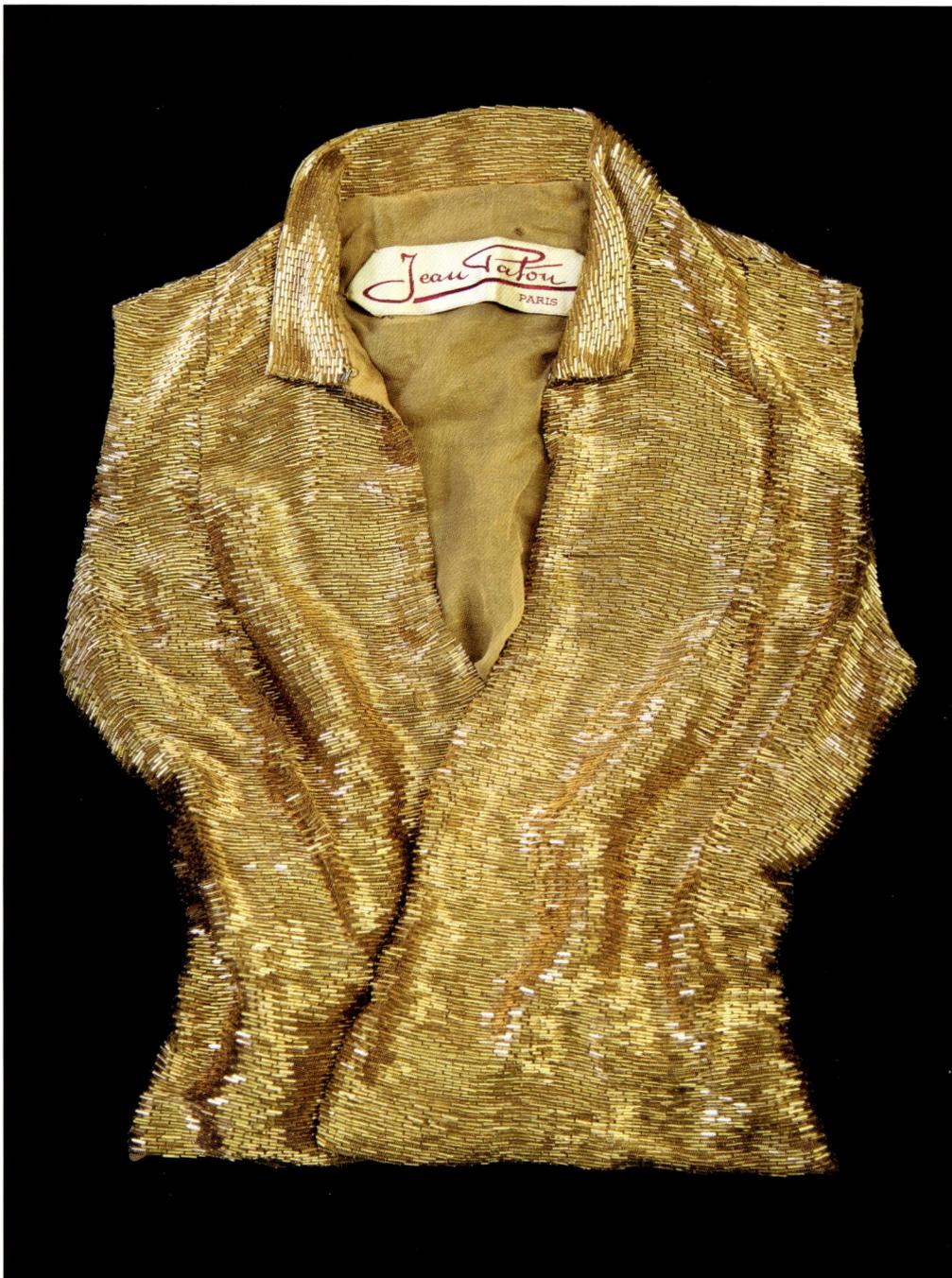

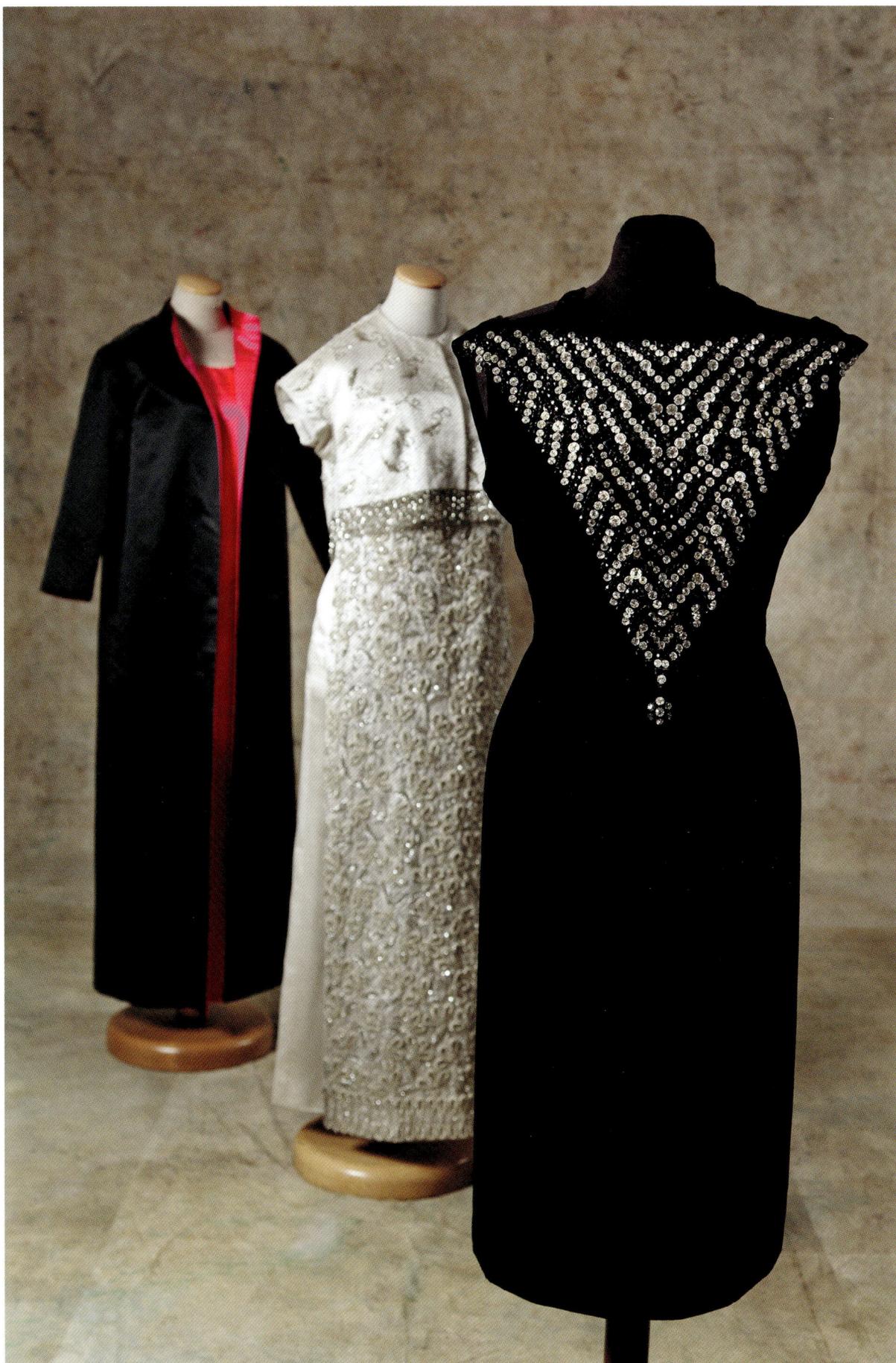

Opposite

Christian Dior (1955): dress of ivory
silk embroidered with glass tubules
and precious stones
Part of the donation from the Galvani
Fiore family

Emilio Schuberth (1970)
Donated by Maria Rosaria Natale
Serrato

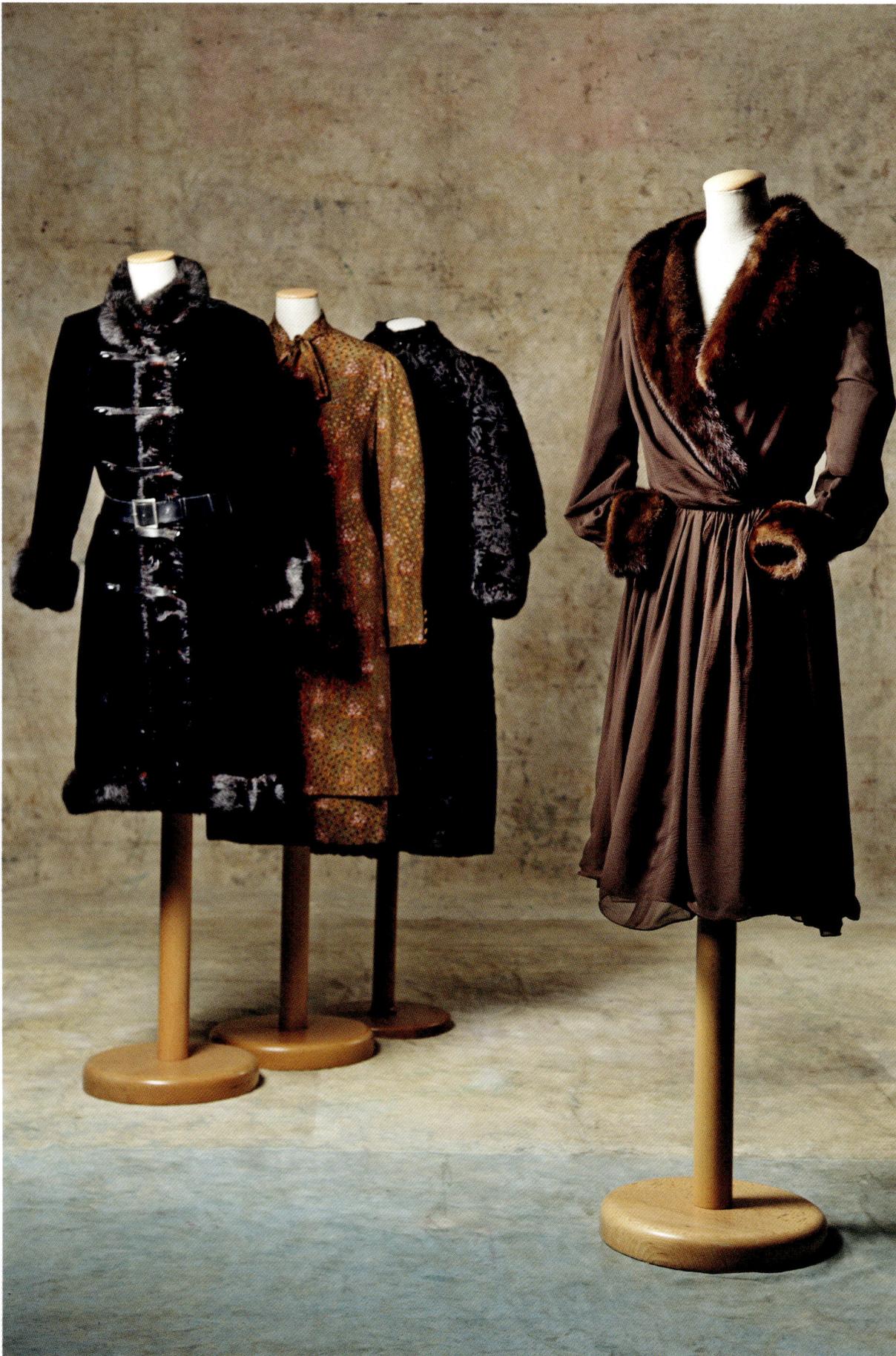

From left to right: coat with fur trimmings by De Luca; silk day dress; astrakhan fur coat by Del Frate and satin crêpe dress trimmed with mink by De Luca
Part of Silvana Mangano's wardrobe donated by Silvia d'Amico

Left, Capucci (1960): dress that belonged to Vittoria Grifoni, donated by her daughter Luisabeth; centre, Carosa (1963): dress created for Gina Lollobrigida that the actress herself gave to Umberto Tirelli; right, dress by the Neapolitan designer Buonanno (1960–70) donated by Princess Sandra Caracciolo

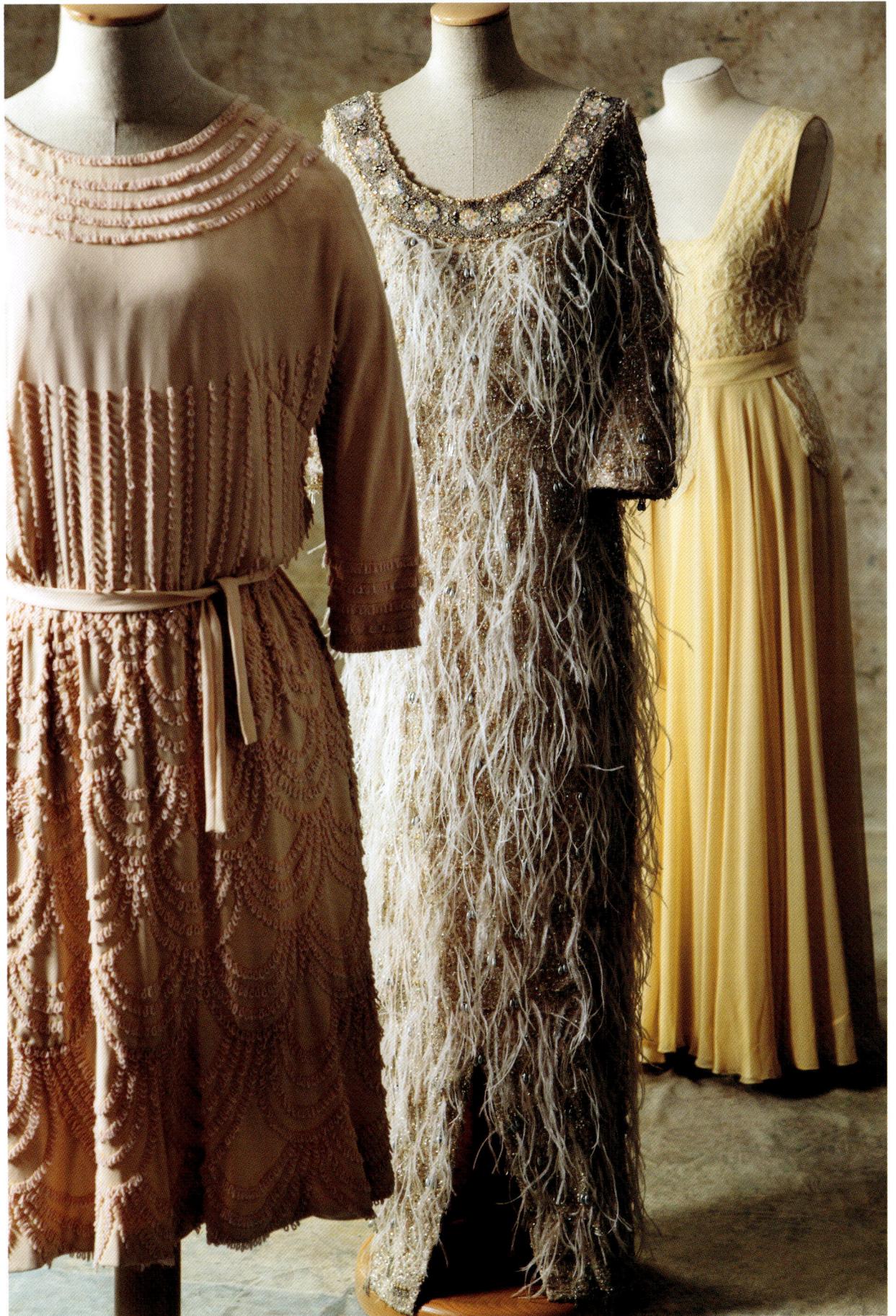

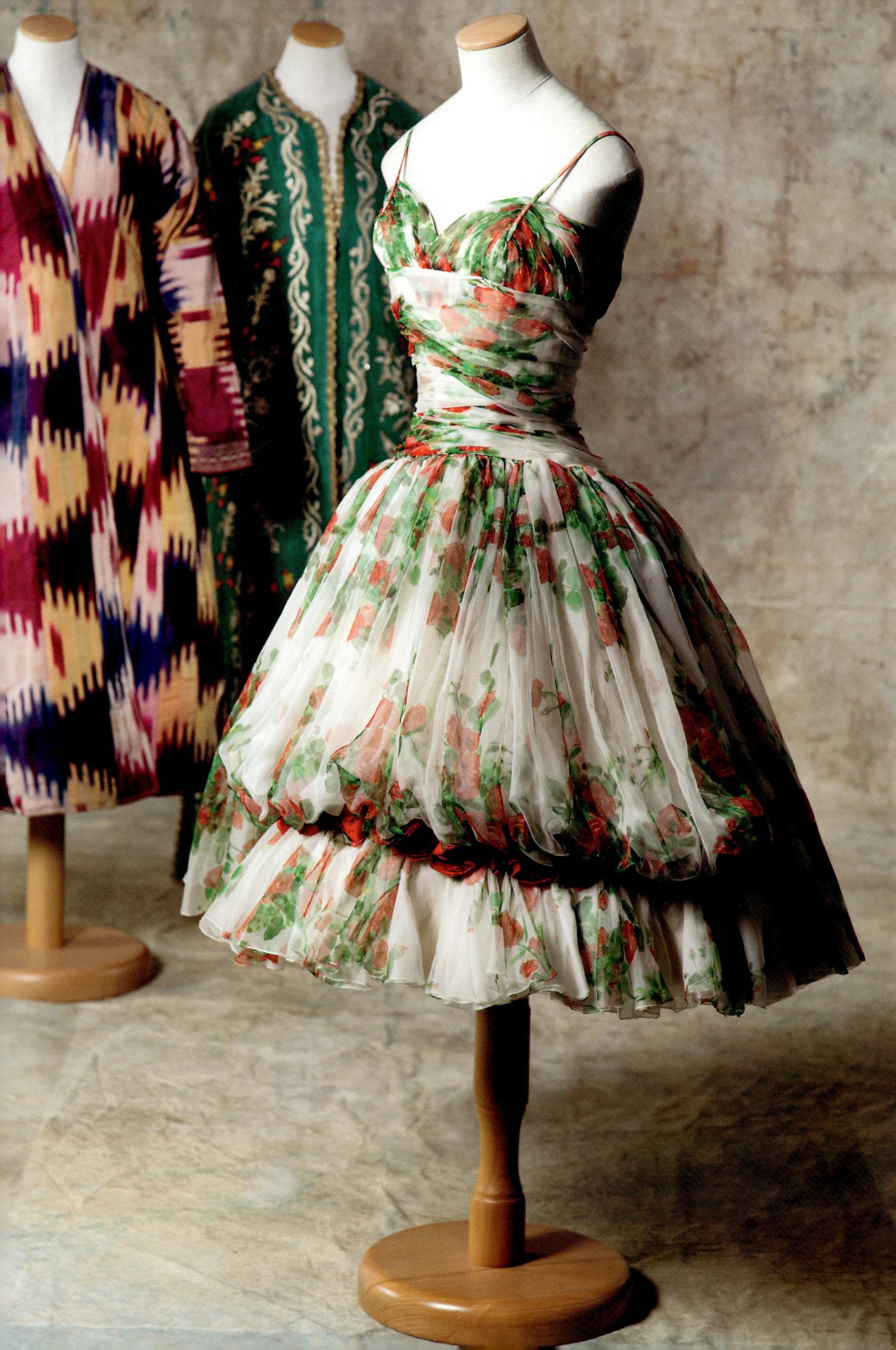

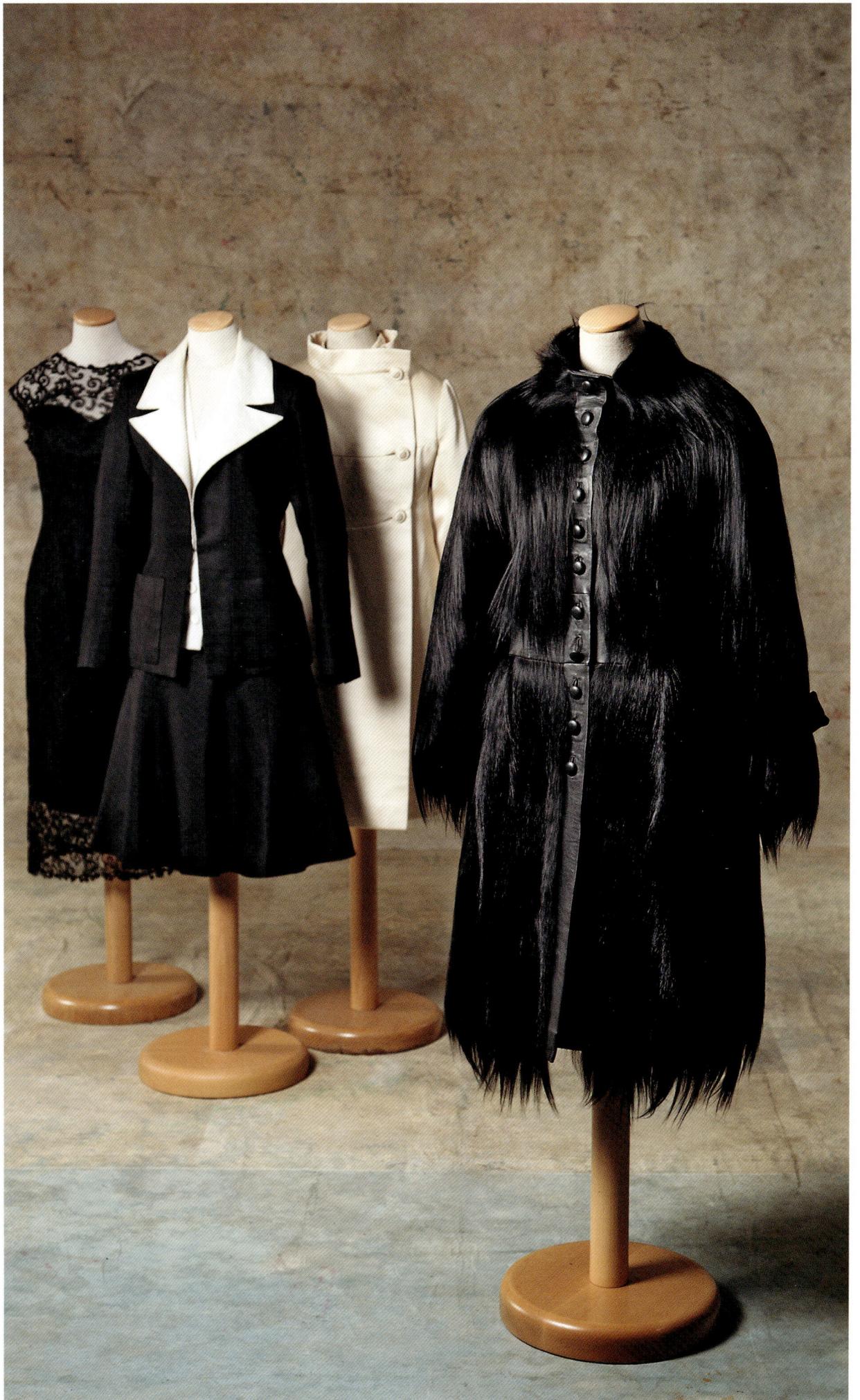

Opposite

Flowered chiffon dress (1950); in the background, two ethnically inspired coats that belonged to Gugi Hruska Part of the donation from Olimpia Hruska

Dresses by the Sorelle Botti and a monkey fur coat by Giovanni Balzani that belonged to Suso Cecchi d'Amico, donated by her children Silvia, Caterina and Masolino d'Amico

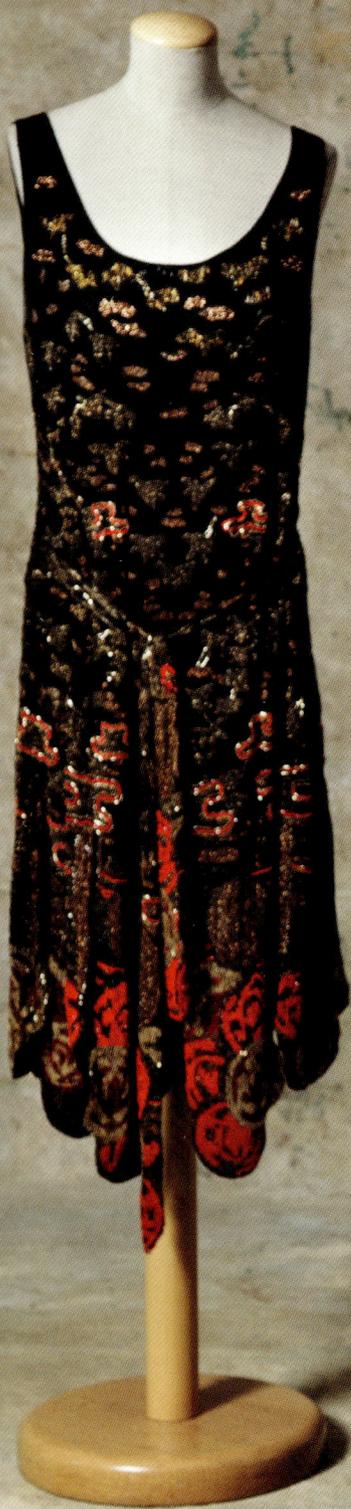

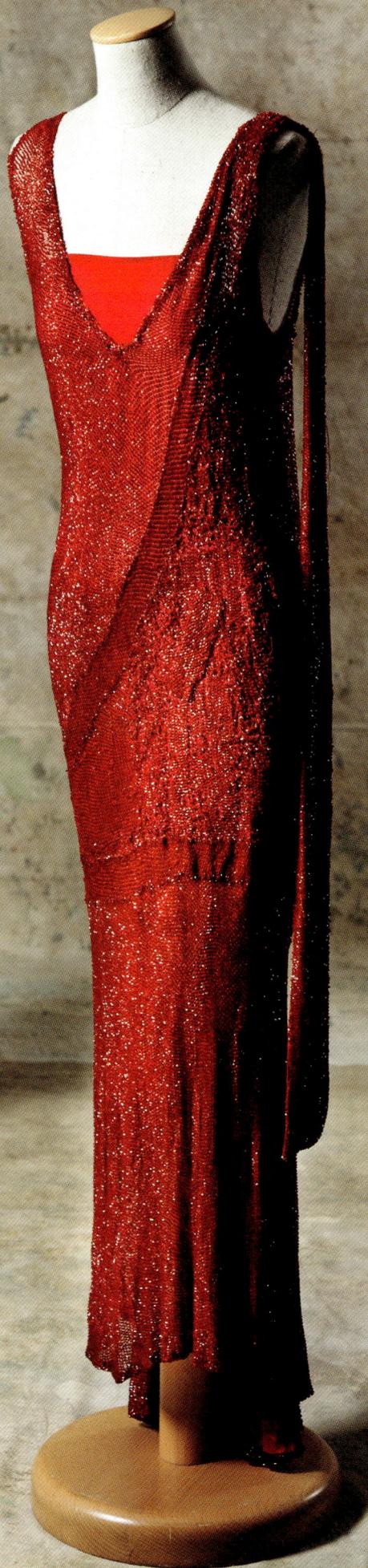

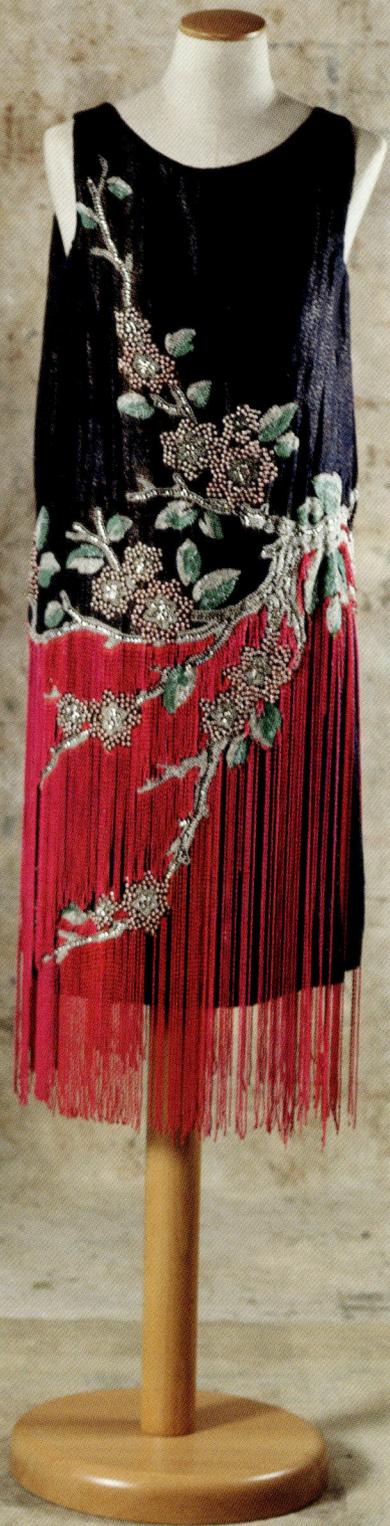

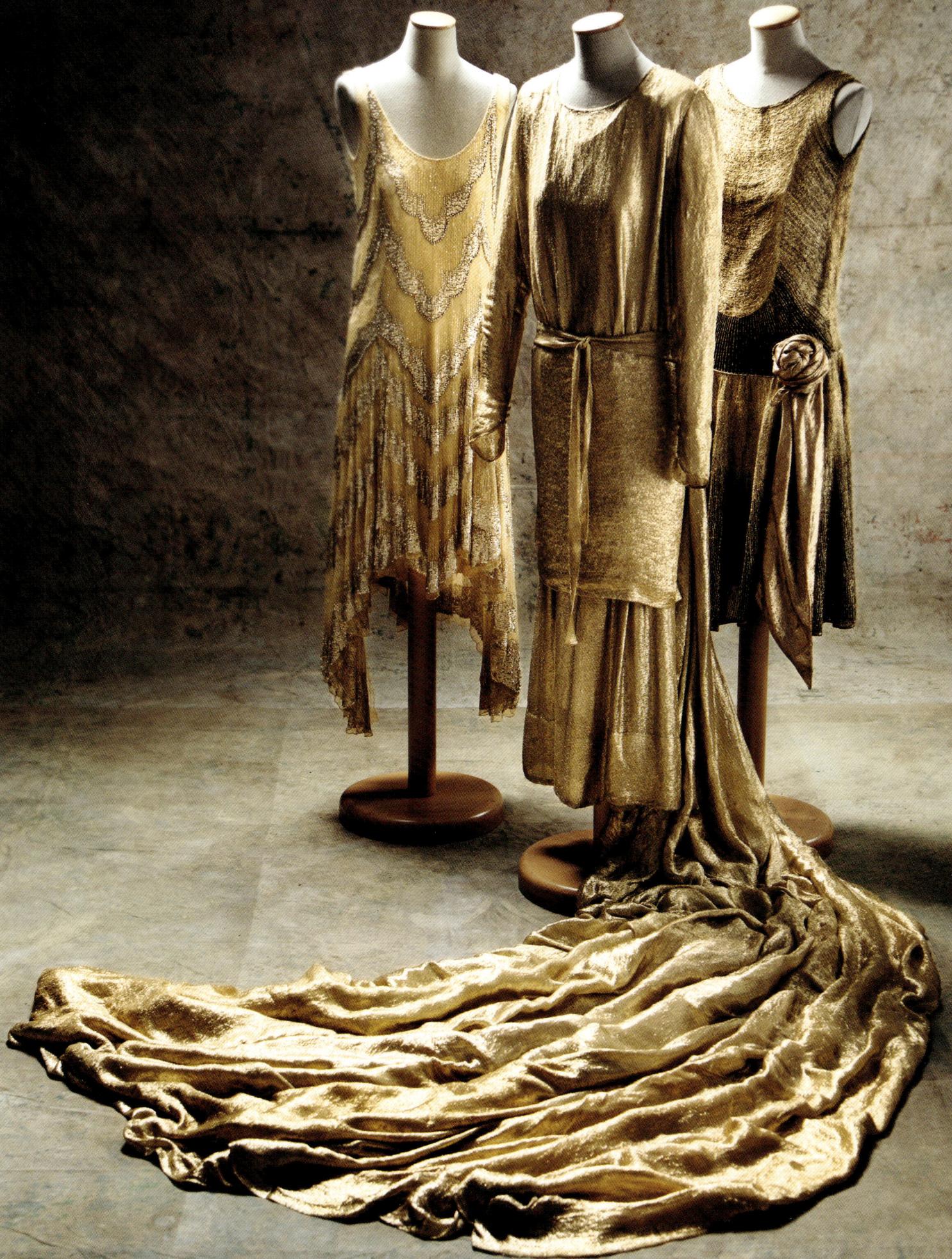

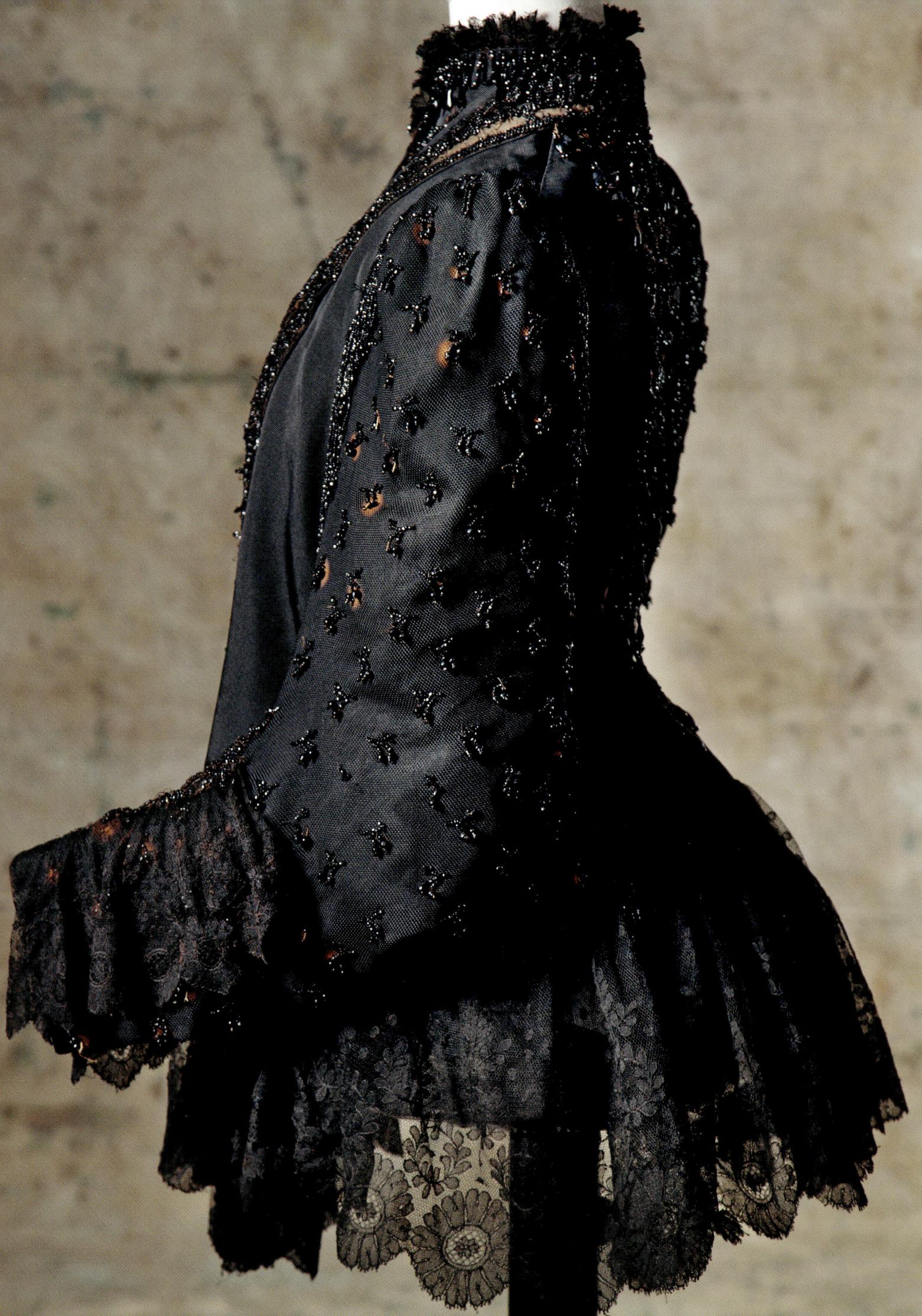

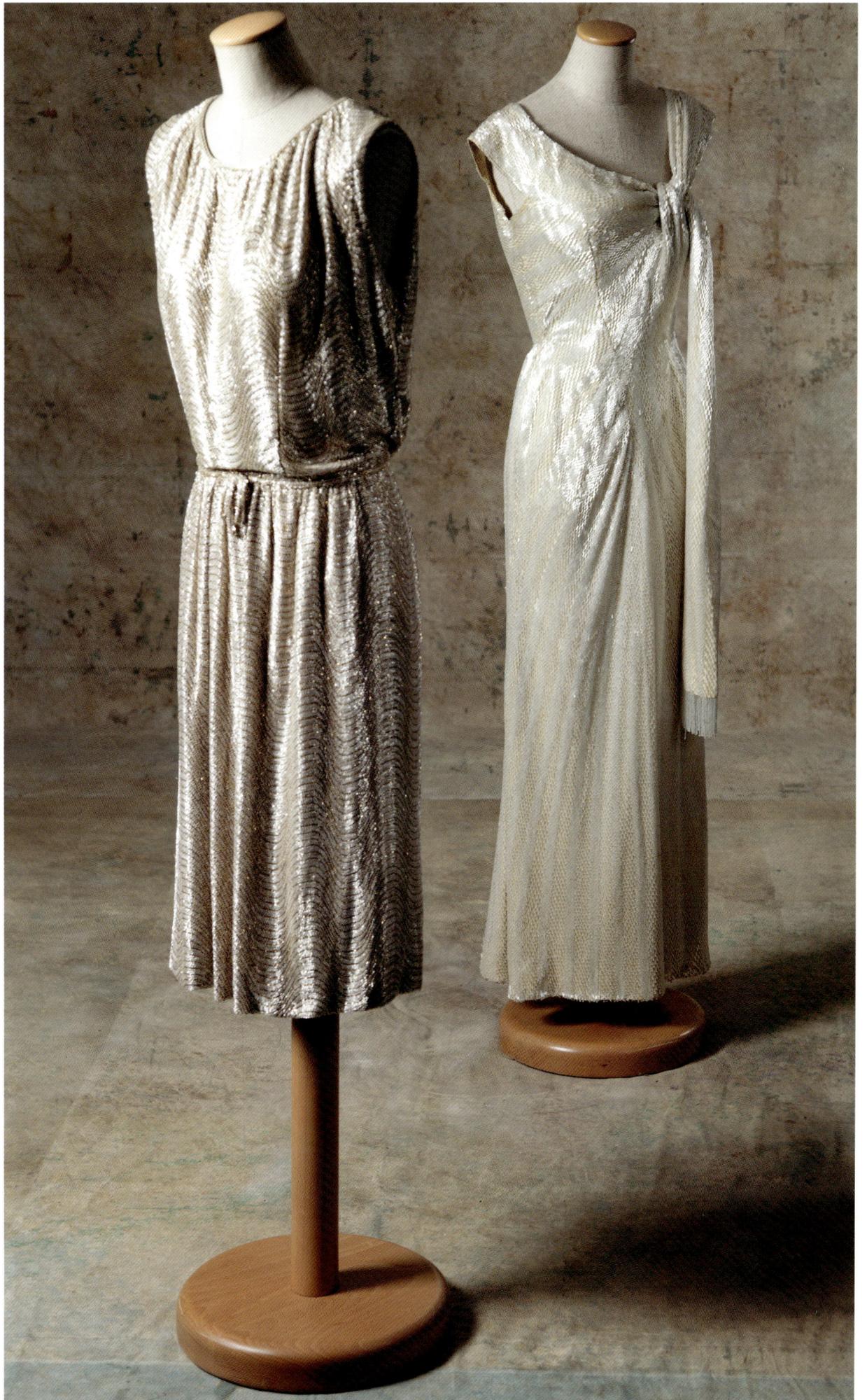

Previous pages

Chanel (1922–28): dresses that belonged to Princess Emilia Altieri, donated by her niece, Princess Domietta del Drago

Opposite

Worth (1890): black silk satin *mantelet-visite* embroidered with jet beads, black silk lace
Donated by Joelle Almagiá

In the foreground, Battilocchi (1965): dress entirely embroidered with silver glass tubules; behind, Galanti (1960): dress entirely embroidered with ice-coloured glass tubules
Part of the wardrobe of Livia de Stefani, donated by her daughter Letizia Signorini

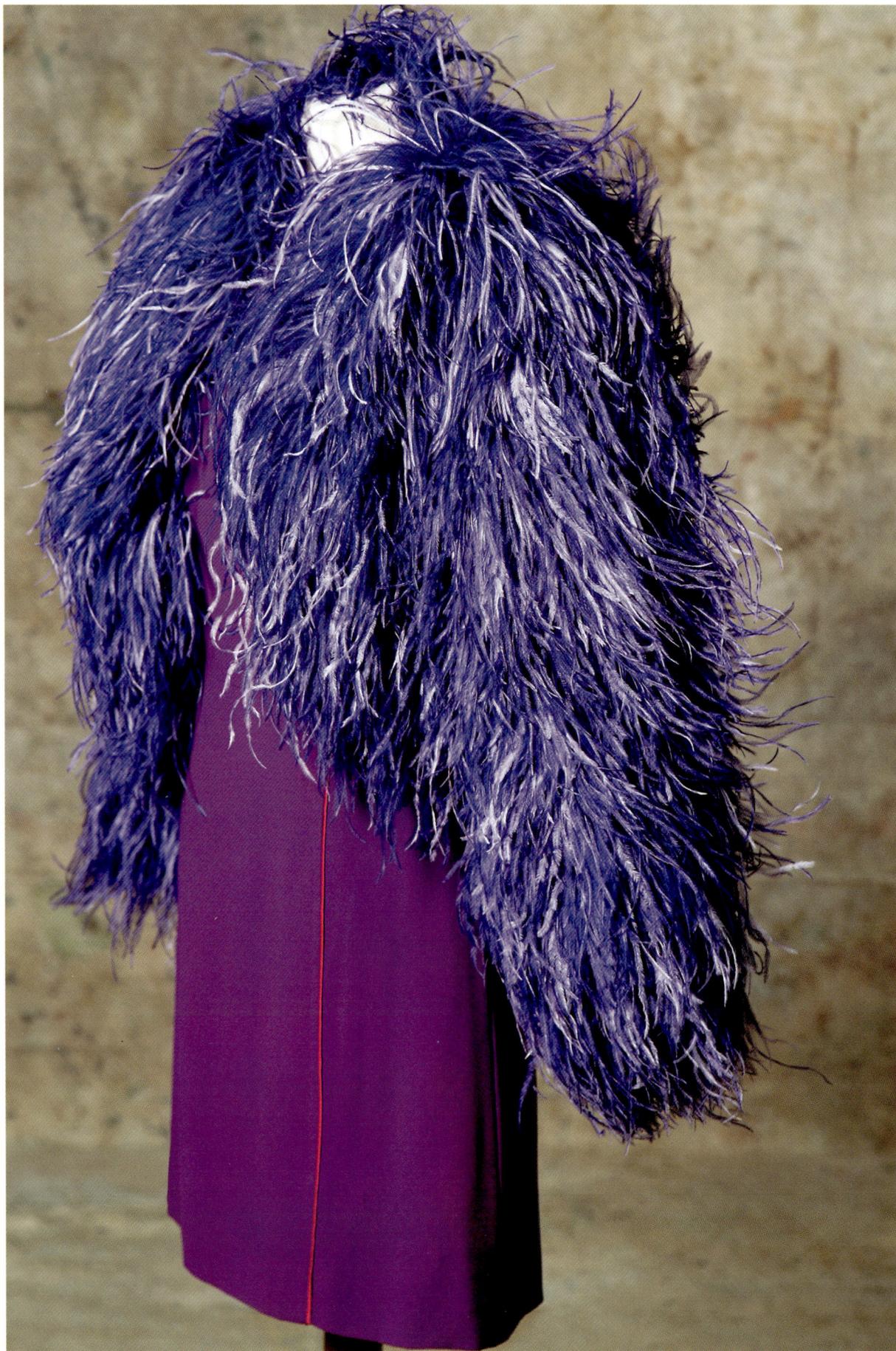

Pino Lancetti (1965): marabut bolero and satin crêpe dress
Donated by Princess Sandra Caracciolo

Opposite

Dresses (1970–80): from left, silver matelassé dress with braiding; silver matelassé dress with bead embroidery; dress entirely embroidered with black and ivory beads and sequins
Donated by Sandra Carraro

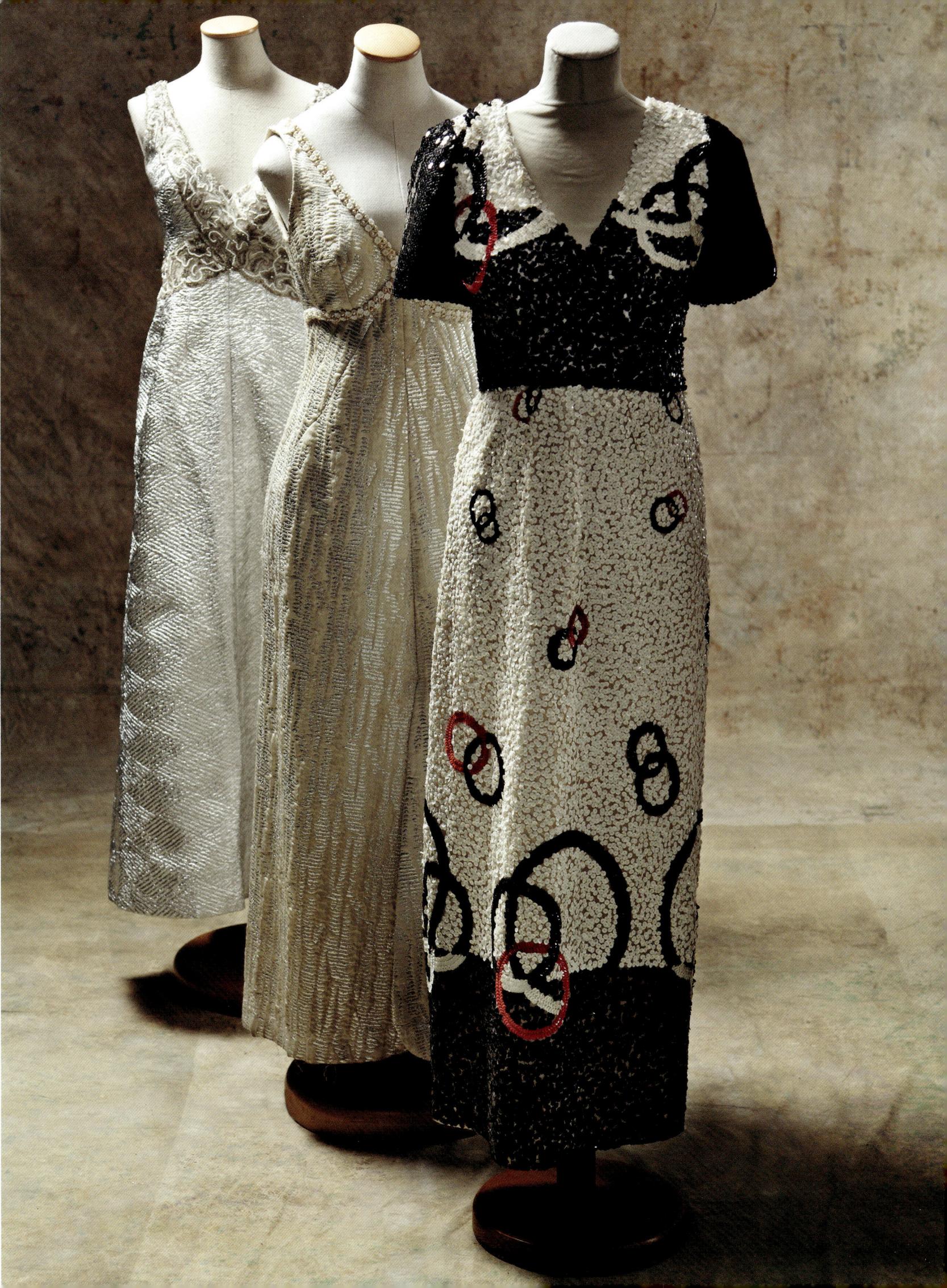

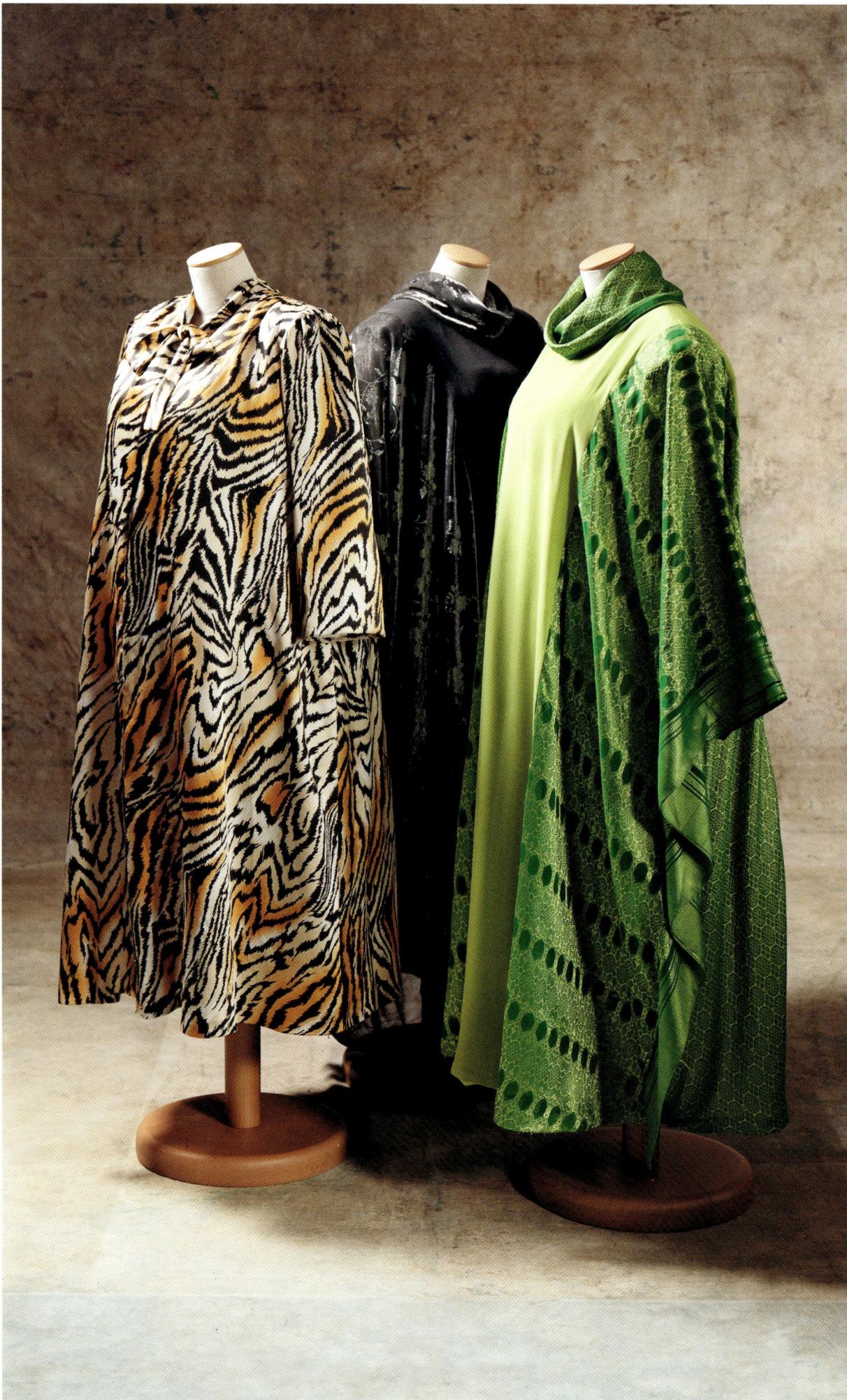

Dresses (1980–90): from left, patterned
silk dress; silk velvet dress with crêpe
de chine inserts; pale green silk
and patterned green lamé dress
Donated by Laura Betti

Opposite

From left: pink, fuchsia and maroon
lamé dress (1960); red crêpe dress with
chiffon sleeves of the same colour
(1970); suit in double black crêpe with
fur collar and braiding on the front
(Cavalli, 1970)
Part of the Barsanti donation

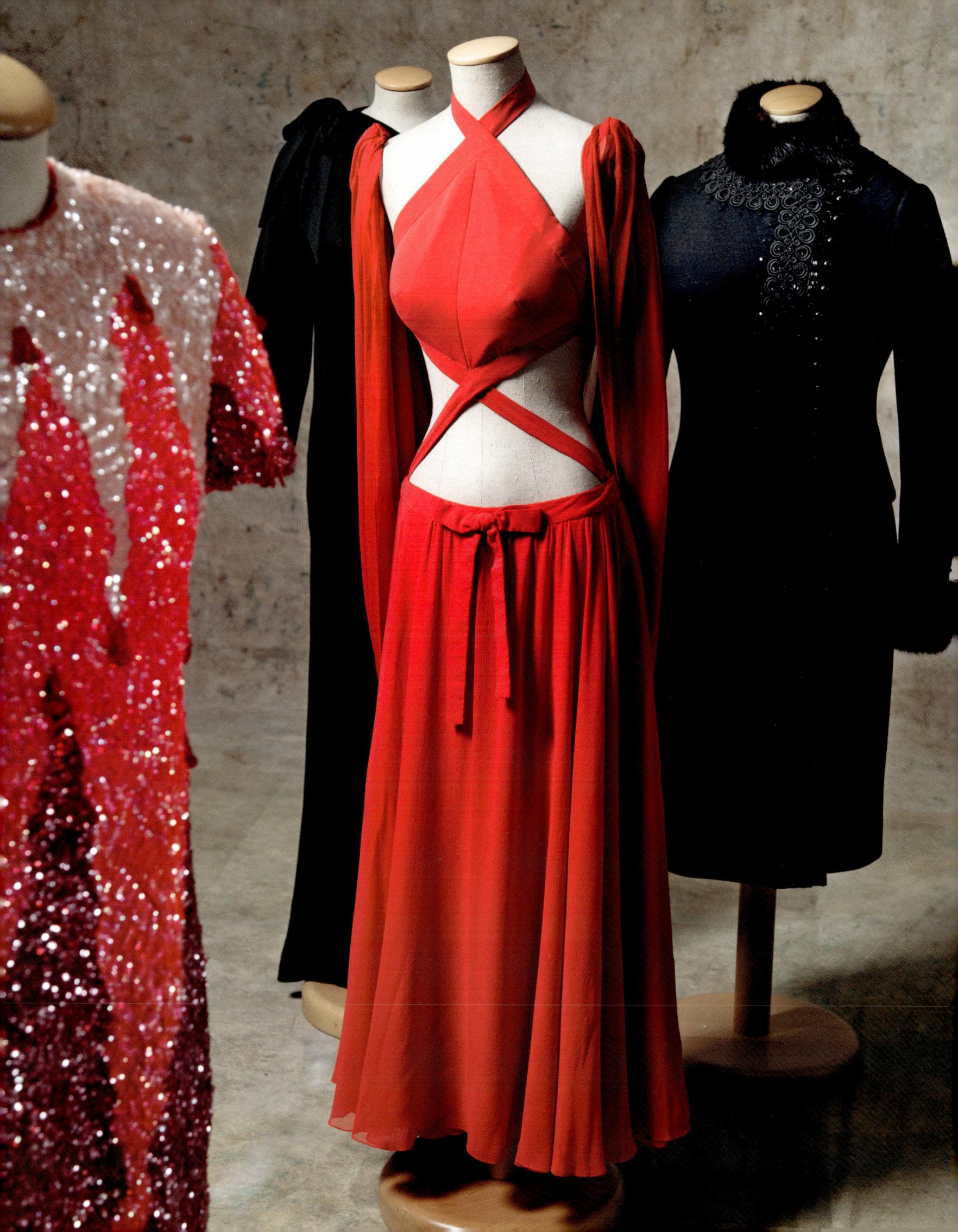

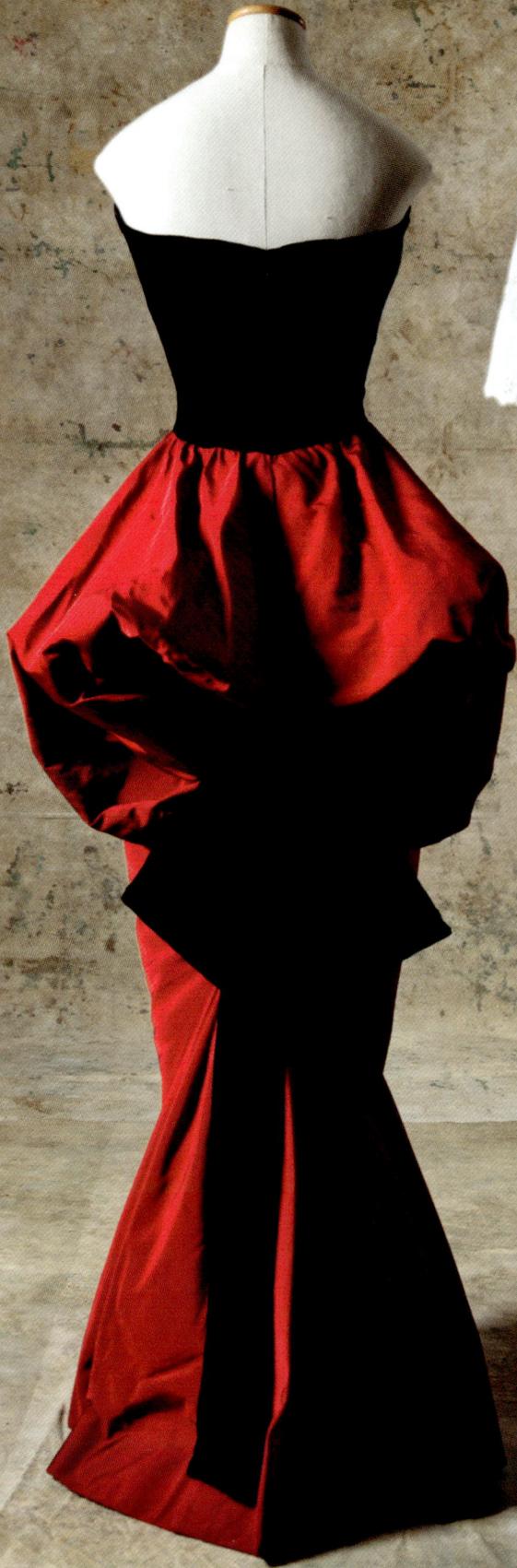

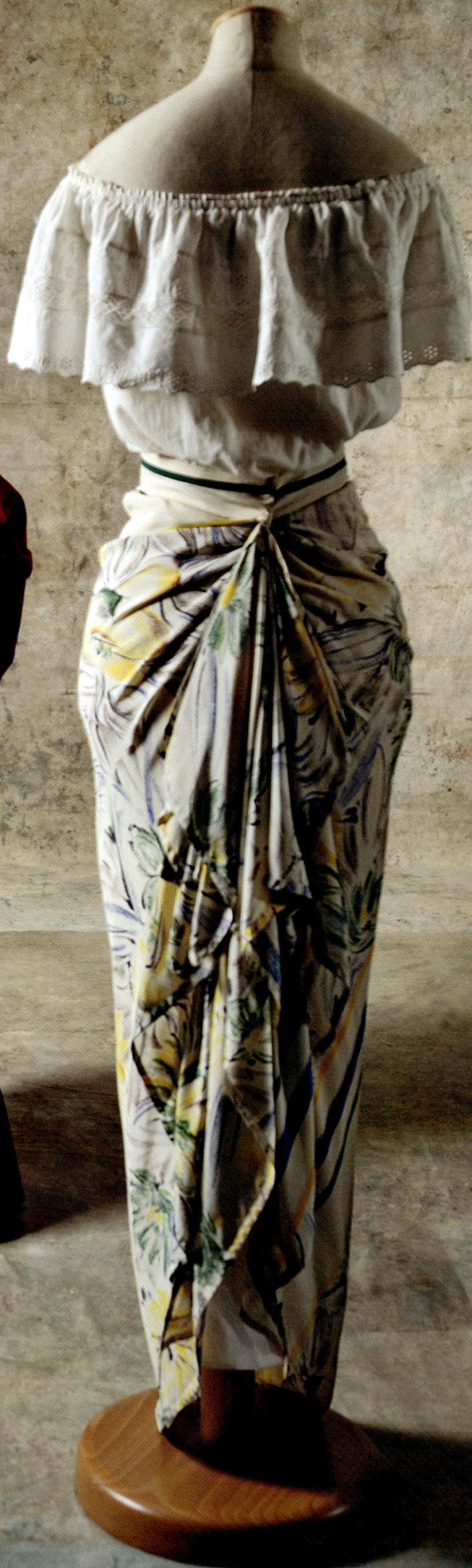

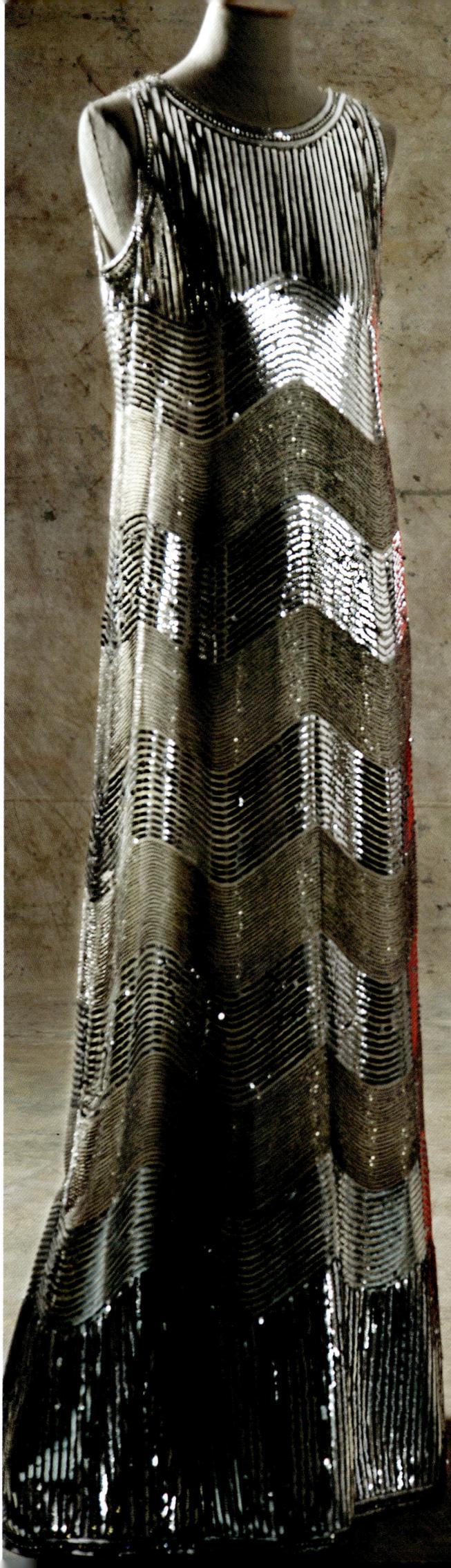

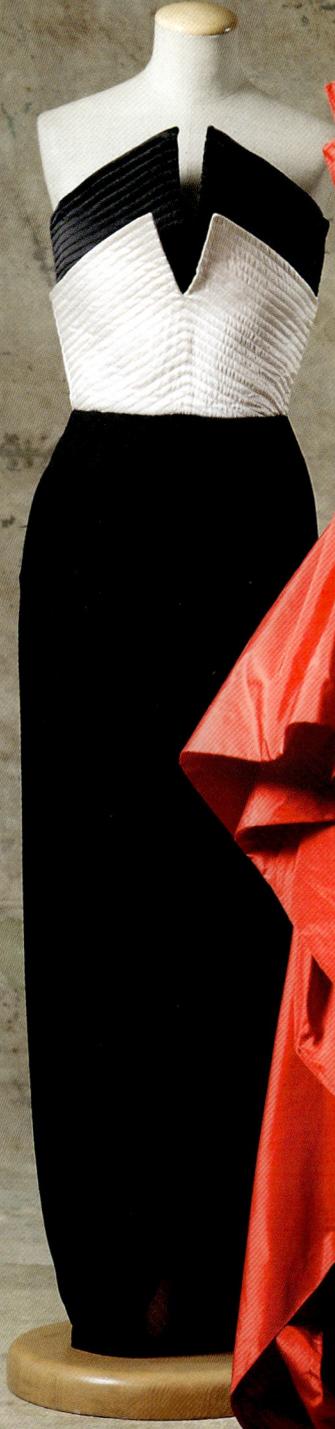

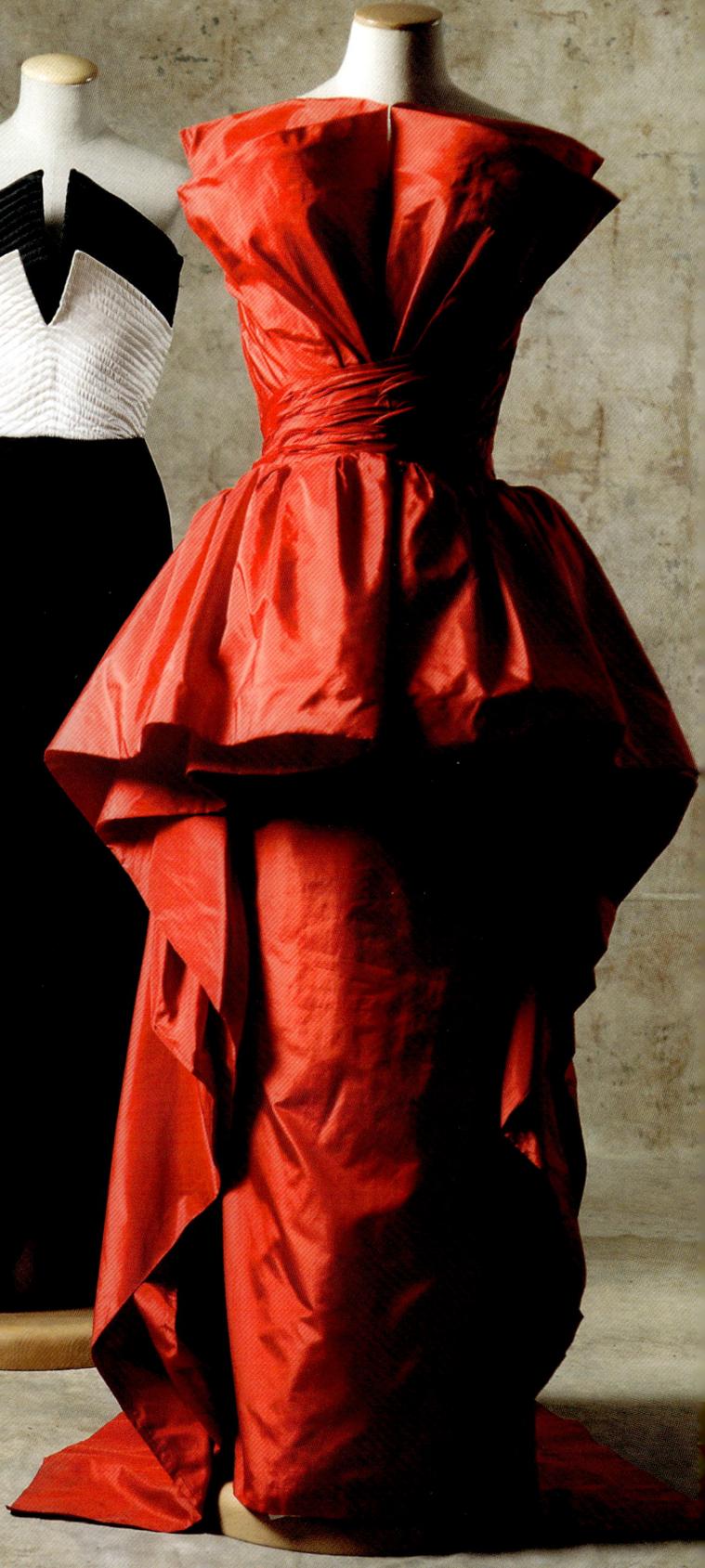

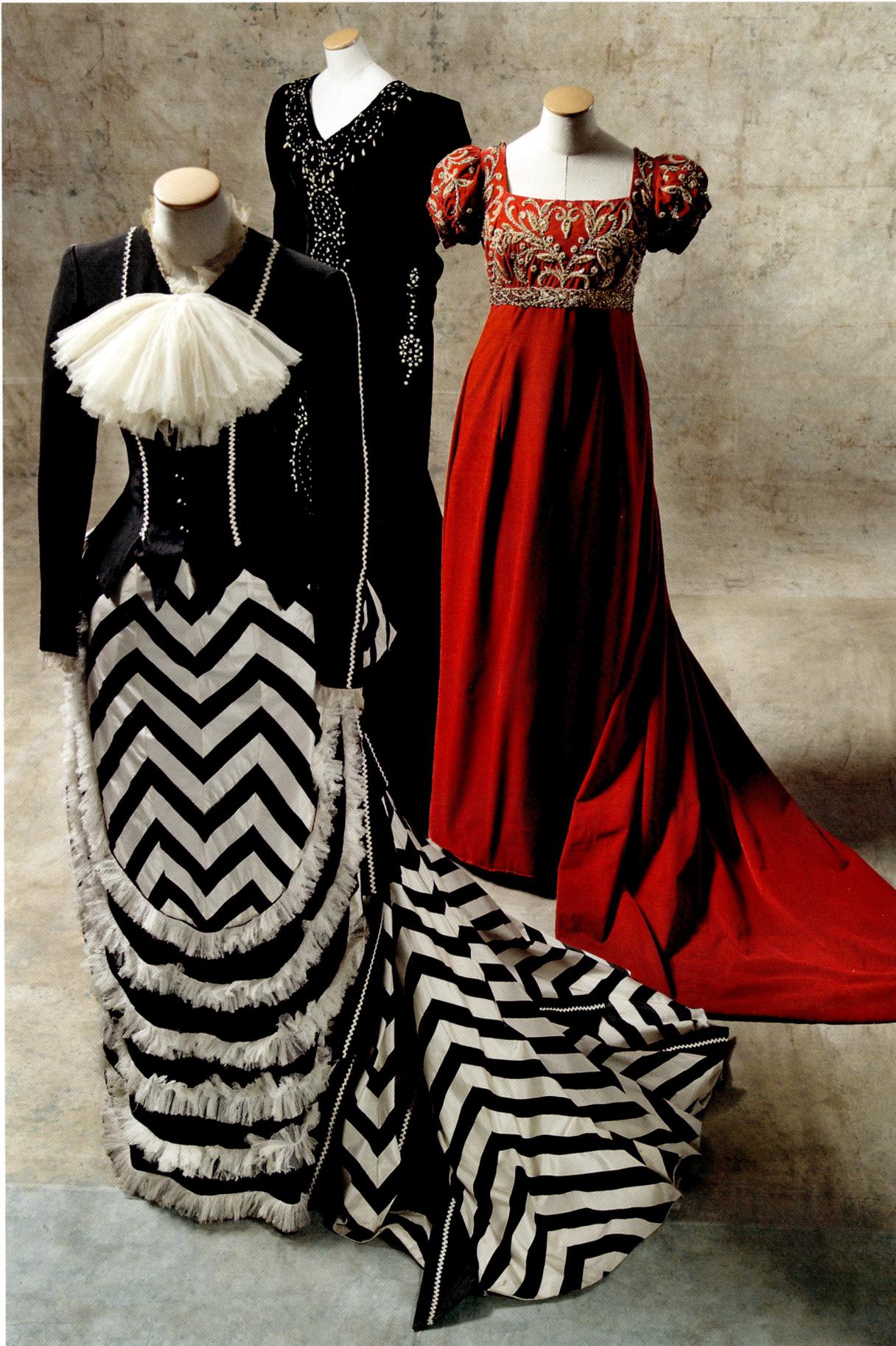

Page 298

Castillo (1956): dress with black velvet bodice and red faille skirt with large black velvet bow; Versace (1980): dress with white broderie anglaise blouse and patterned silk skirt
Donated by Elsa Martinelli

Page 299

From left: Mila Schön (1966): dress entirely embroidered with silver and black sequins; Boutique Valentino (1980s): black silk dress with ivory silk bodice finished with stitching; Chanel (1980s): red taffeta dress
Donated by Gioia Marchi Falck

From left: costume for *Adriana Lecouvreur*, consisting of a bodice in black faille and a black and white striped silk skirt, with white tulle jabot; costume for *La Gioconda*, in black velvet embroidered with white pearls; costume for *Tosca*, in red velvet embroidered with gold glass tubules
Donated by Magda Olivero

Dresses (1922–23): dress of black and silver chiffon entirely embroidered with glass tubules that belonged to Mae West; dress in black georgette embroidered with red, ivory and black beads and flower motifs
Donated by Franco Carretti

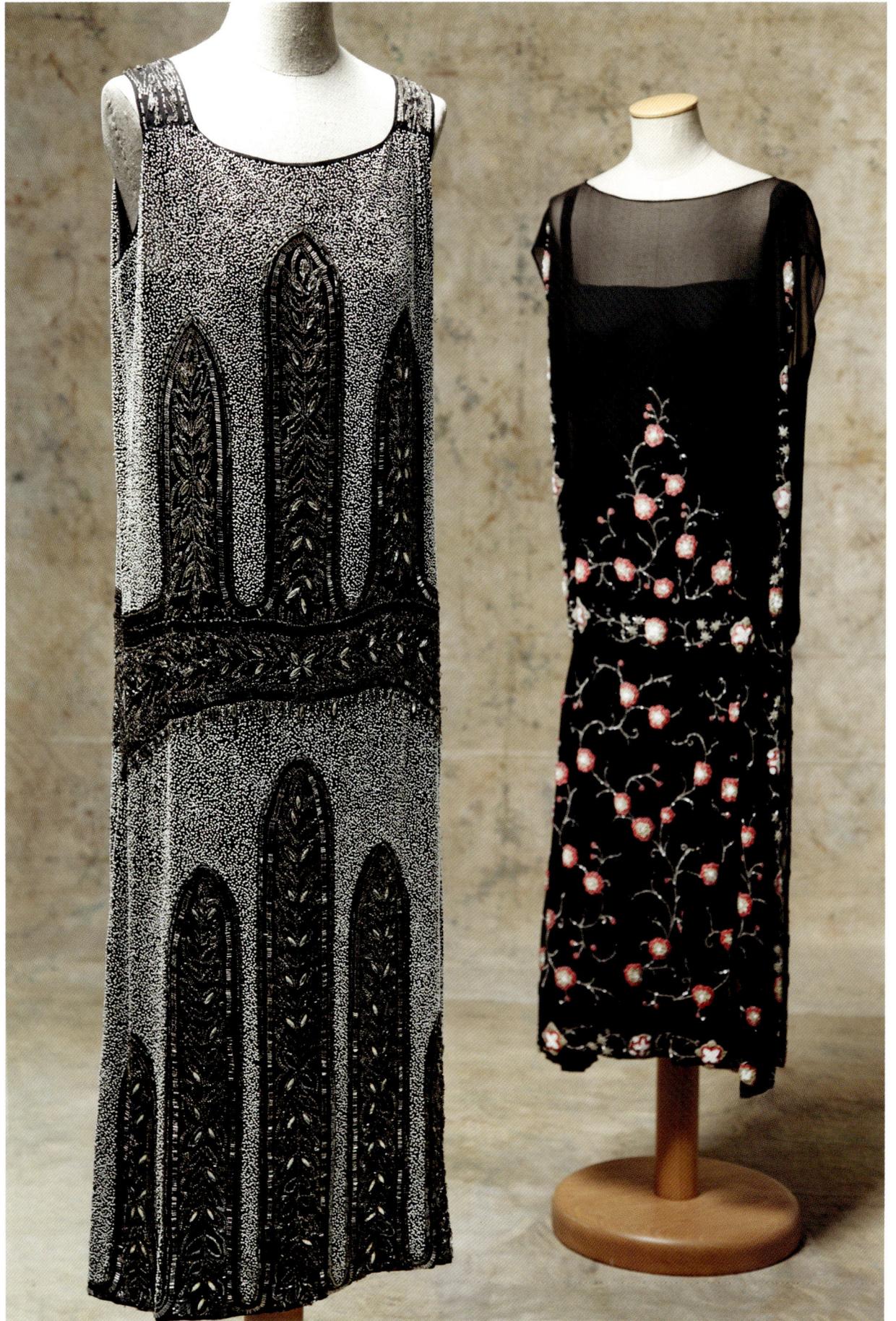

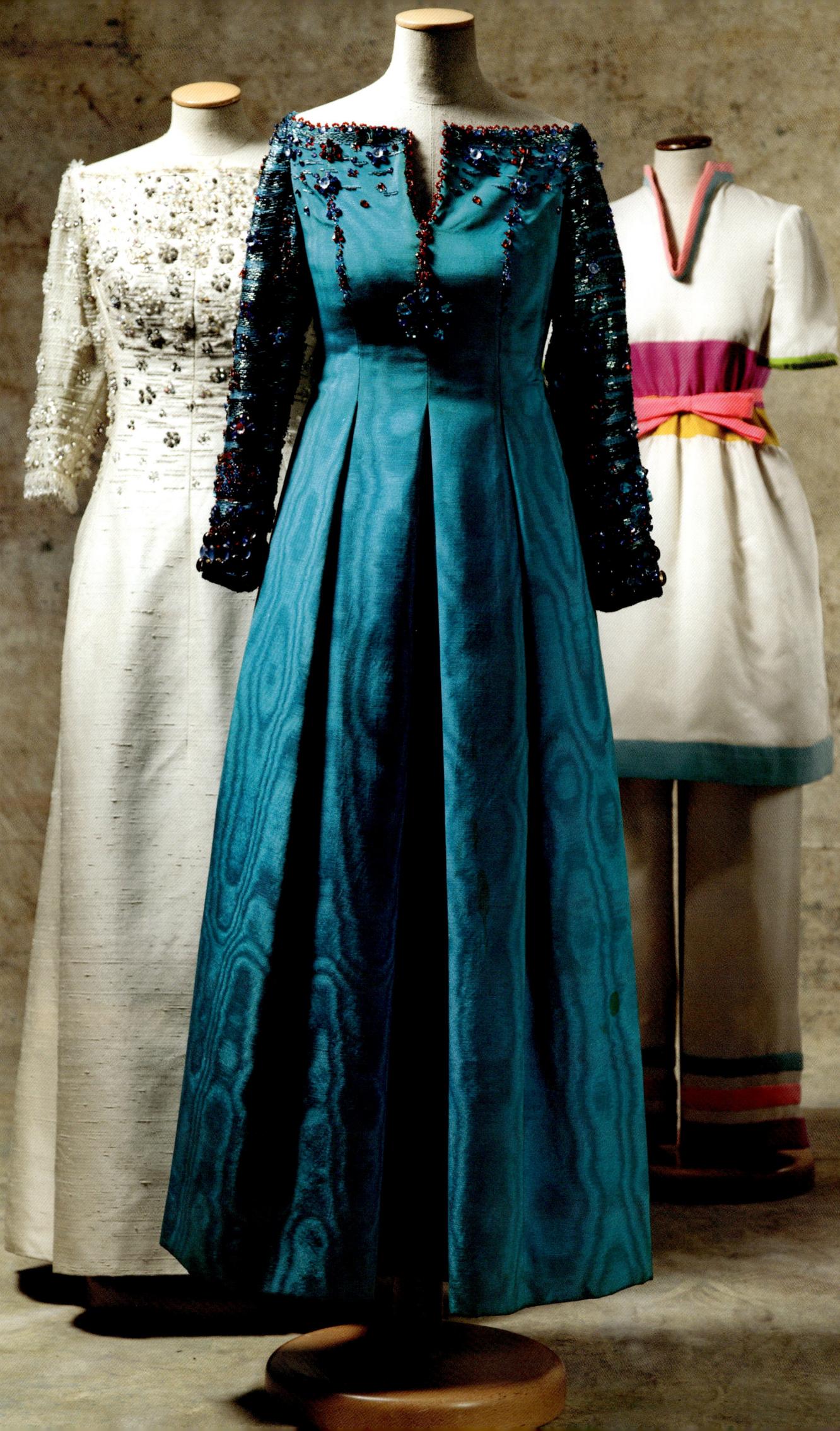

Opposite

Roberto Capucci (1960–1970): from
left, ice-coloured silk shantung dress,
embroidered with semi-precious
stones and beads; peacock green moiré
dress with jet embroidery; white
double silk trousers and jacket with
violet, pink, mustard and sky blue
inserts
Part of the donation from Georgette,
Fiamma and Raffaele Ranucci

Ceremonial shoes. Ankle boots that
belonged to Rose Kennedy, mother
of President John Fitzgerald Kennedy,
worn with her wedding dress in 1914
Donated by Franco Carretti

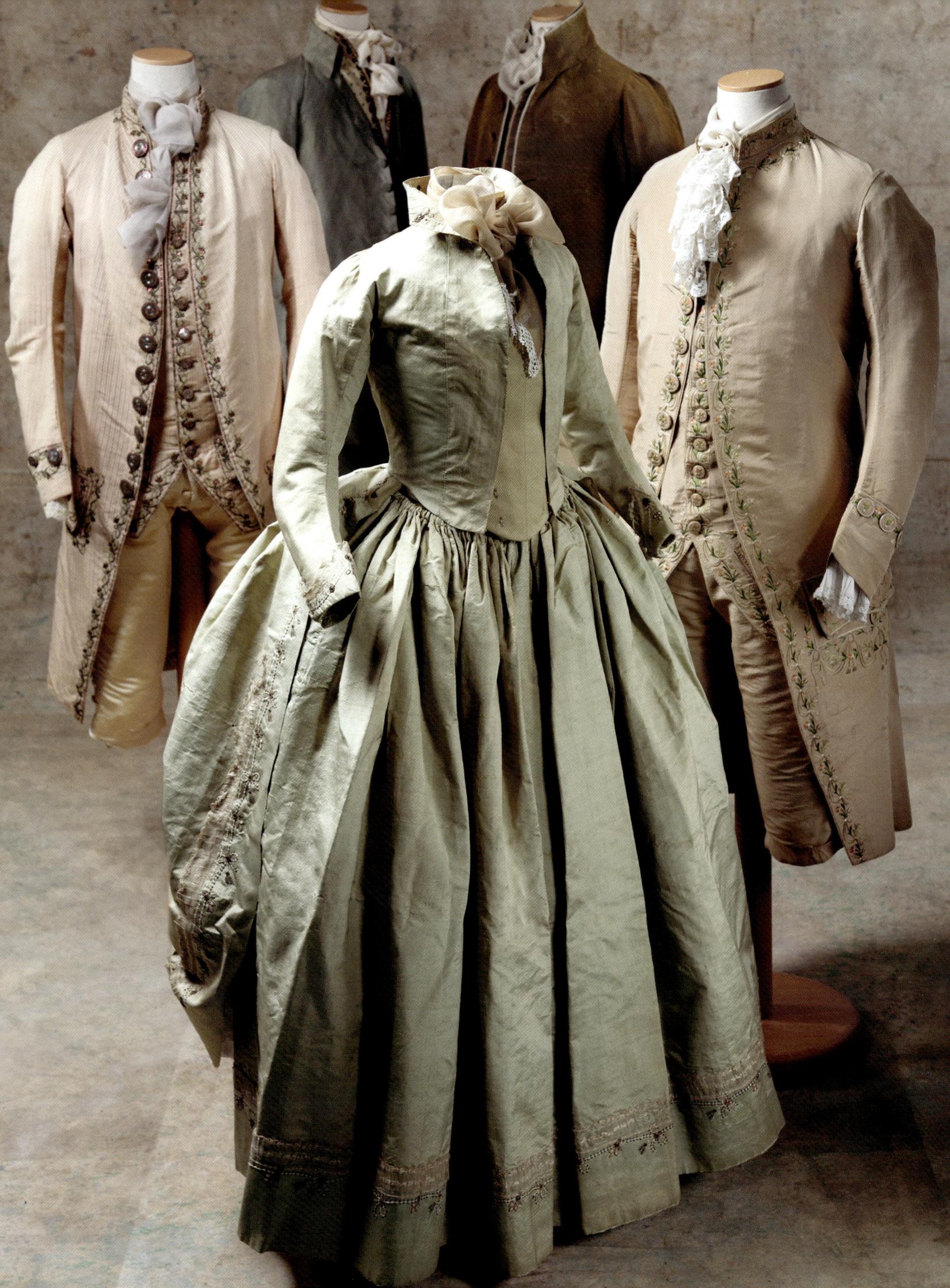

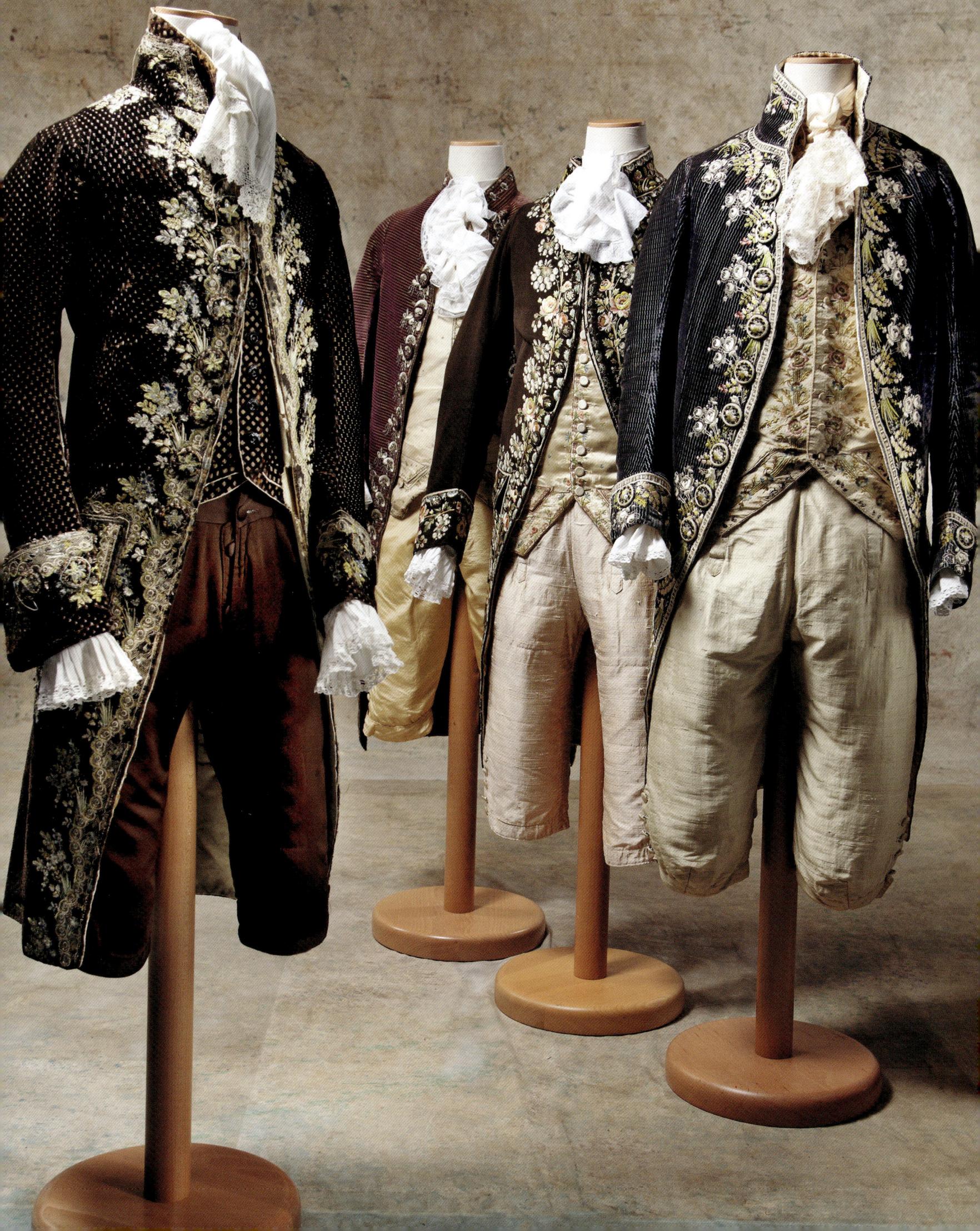

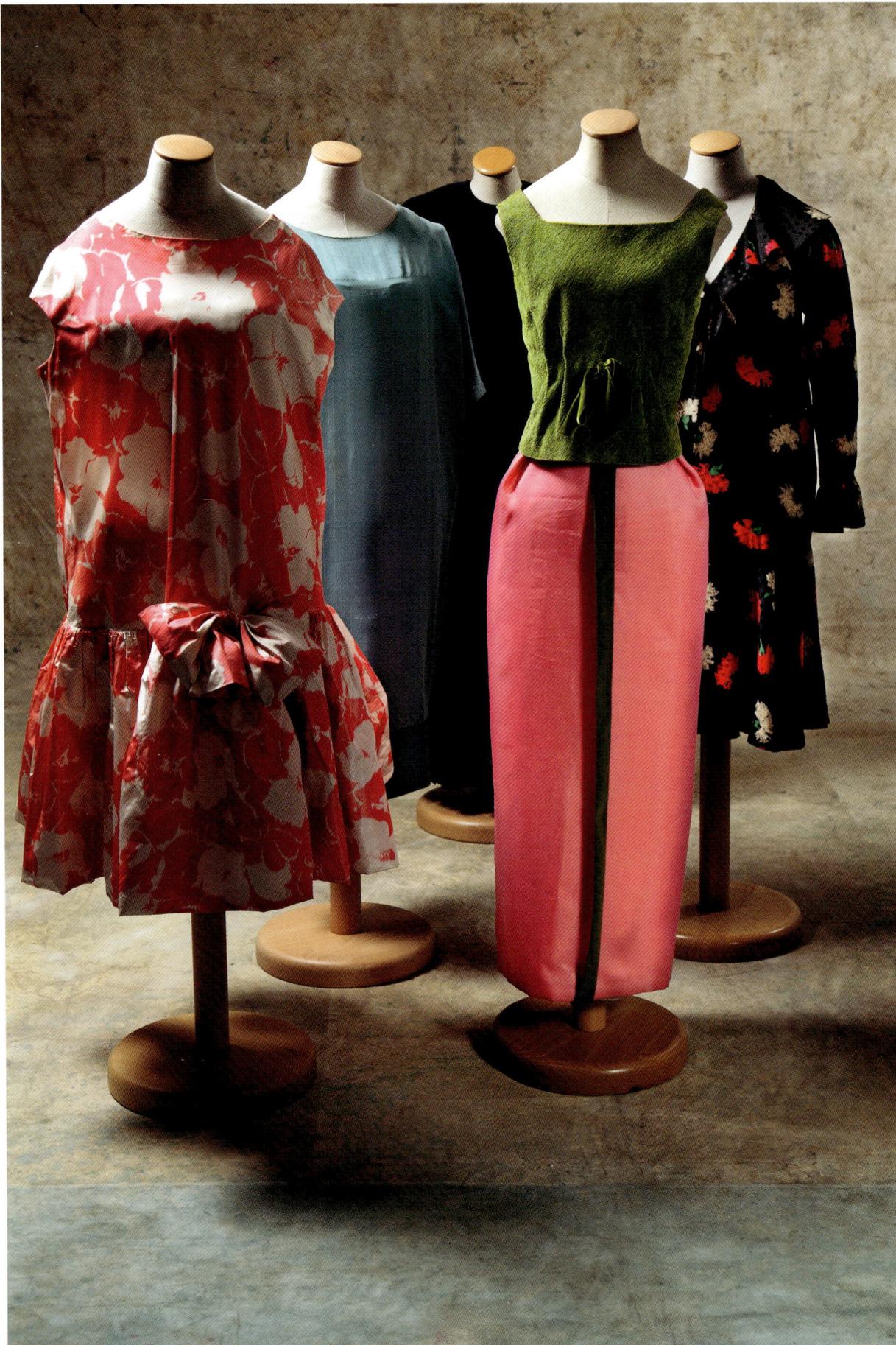

Eighteenth-century dresses from the Charles de Beistegui Collection, purchased at auction by Fabrizio Clerici, who donated them to Umberto Tirelli in 1972

From left: ivory and pink patterned silk dress (Balenciaga, 1960) that belonged to Jeanne Carola; pale blue silk shantung dress (Balenciaga, 1970) that belonged to Jeanne Carola; dark silk dress (Christian Dior, 1970) that belonged to Paola Carola; dress with worked green silk bodice and pink silk skirt (Balenciaga, 1970) that belonged to Paola Carola; patterned crêpe de chine dress (Yves Saint Laurent, 1970) that belonged to Paola Carola
Donated by Baron Paul Thorel

Paul Poiret: dress entirely embroidered
with white glass tubules, flowers
and shades of grey; cream-coloured
velvet coat embroidered with grey
glass tubule rosettes
Part of the donation from the Baroness
de Banfield

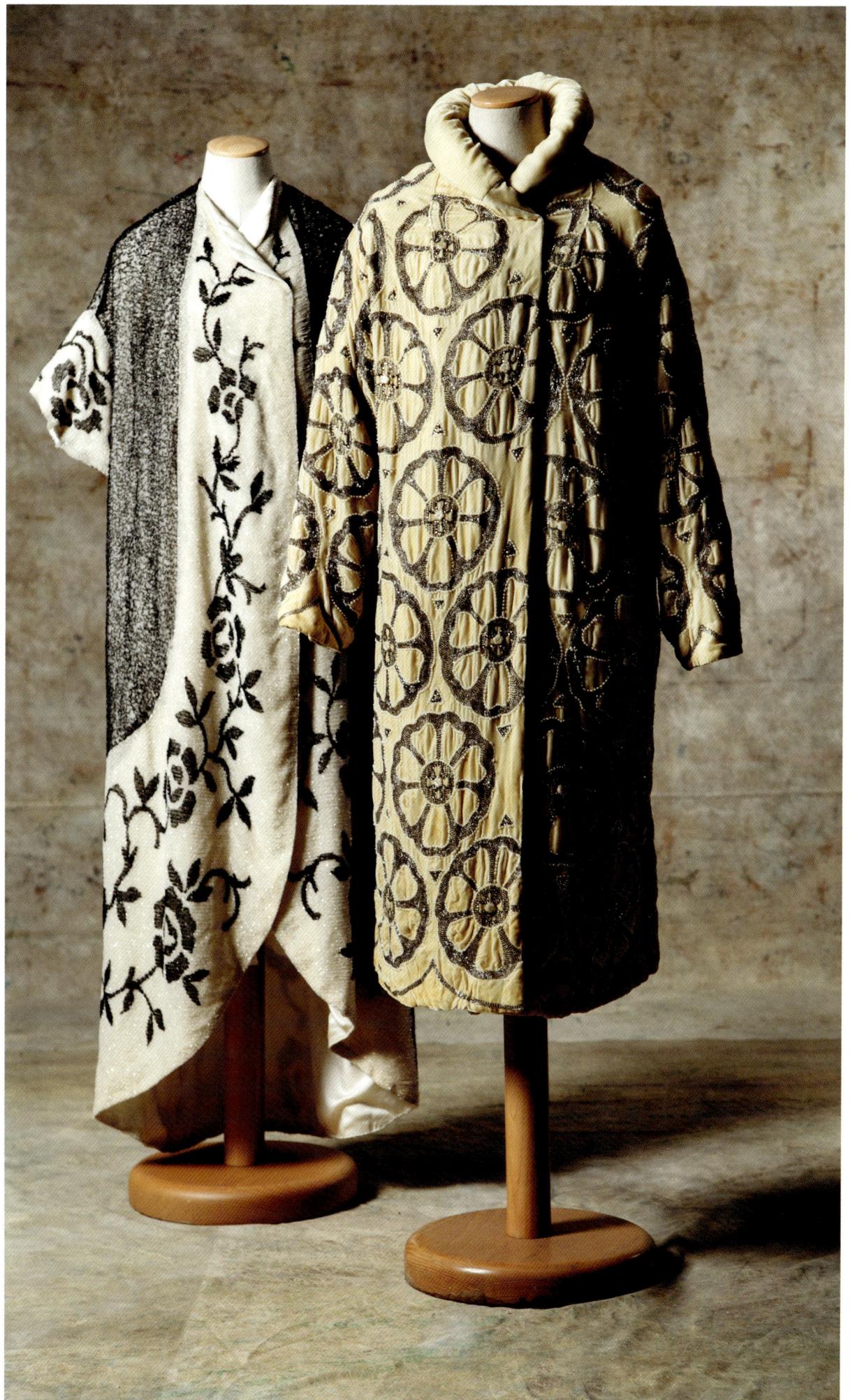

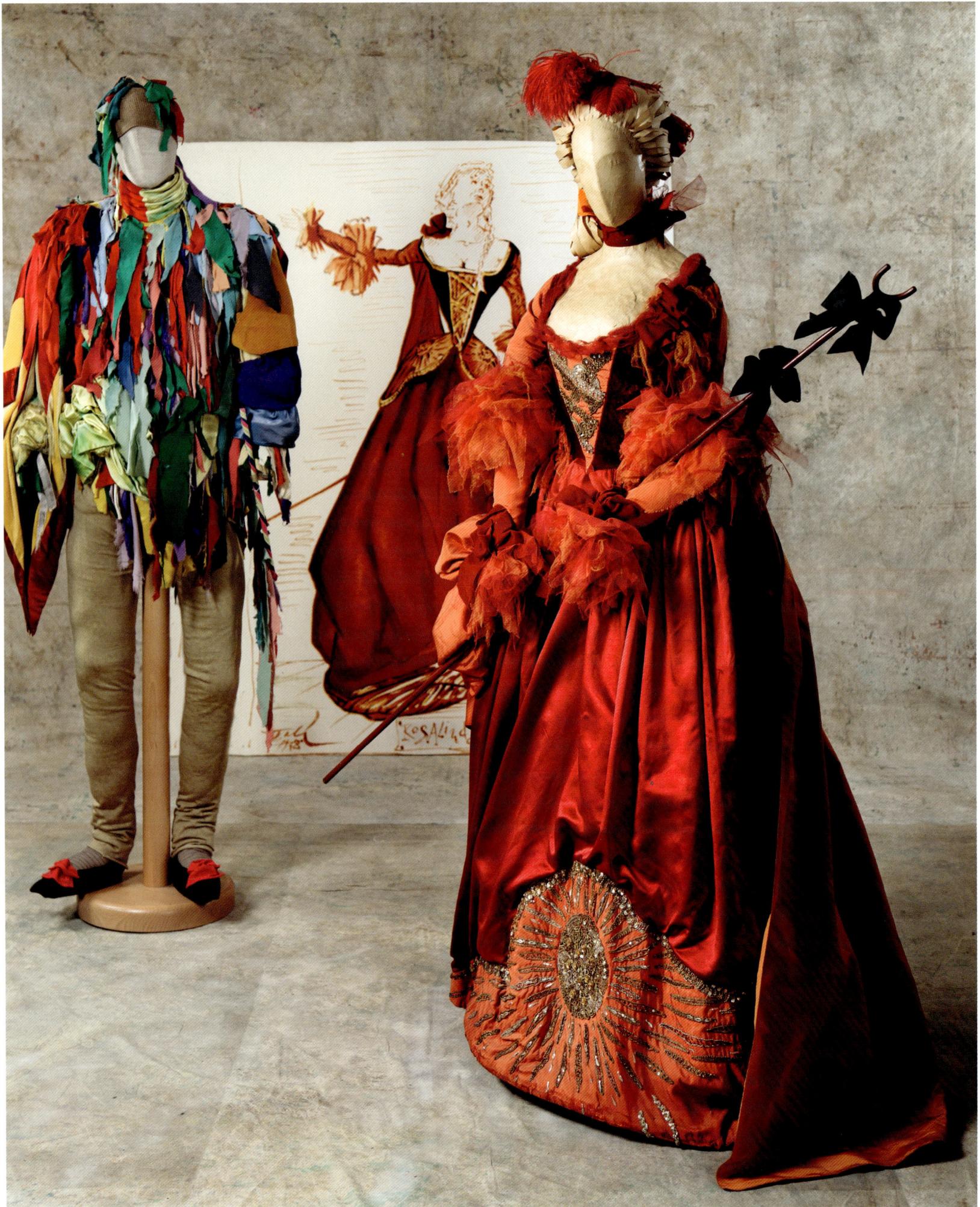

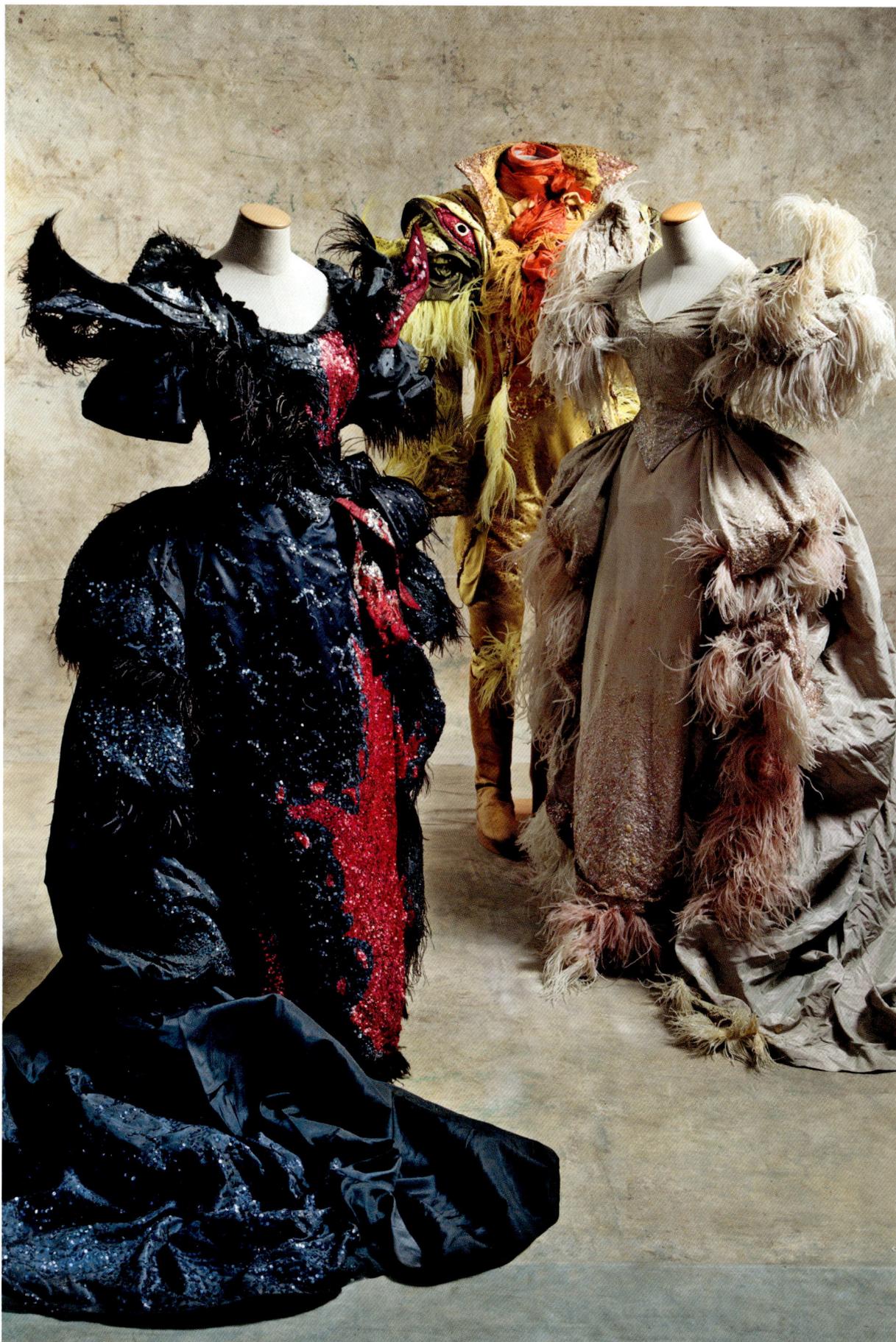

Opposite

Costumes for *As You Like It*, designed by Salvador Dalí in 1948 (in the background, an enlargement of his sketch) and made by Sartoria Marta Palmer for Luchino Visconti's theatre company. Costume for Touchstone, worn by Paolo Stoppa, with multicoloured jacket in different materials (silk, cloth, taffeta); red silk costume for Rosalind, embroidered with sequins and gold glass tubules, decorated with feathers and bows of the same colour, worn by Rina Morelli
Donated by Luchino Visconti

Costumes for *Orestes*, designed by Mario Chiari in 1949 and made by Sartoria Marta Palmer for Luchino Visconti's theatre company. From left: costume for Clytemnestra, worn by Paola Borboni, in black and red taffeta embroidered with sequins and decorated with black feathers; costume for Orestes, worn by Vittorio Gassman, in gold taffeta, embroidered with red and fuchsia sequins and decorated with multicoloured feathers; costume for Electra, worn by Rina Morelli, in dove-grey taffeta, embroidered with sequins in the same colour and decorated with feathers
Donated by Luchino Visconti

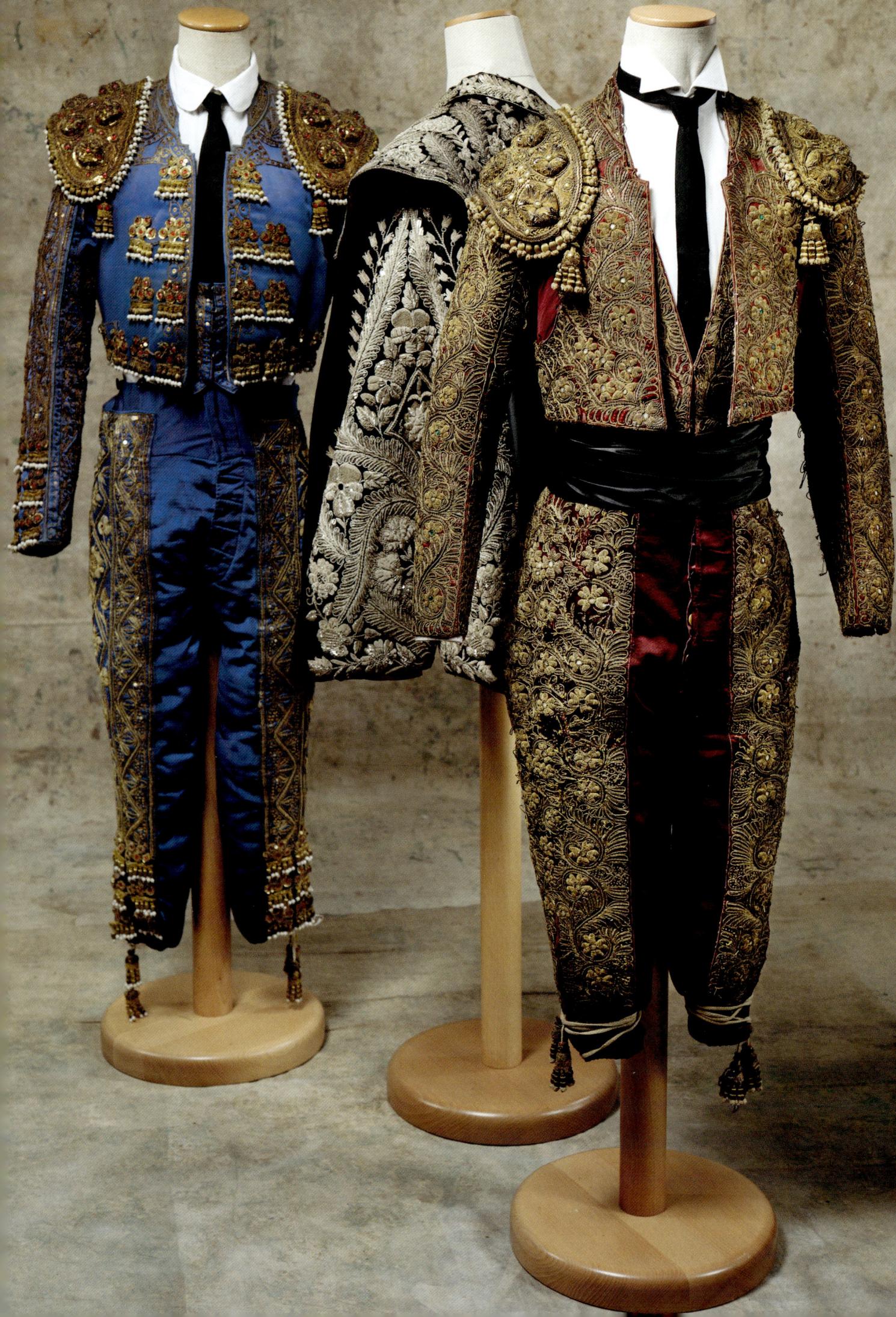

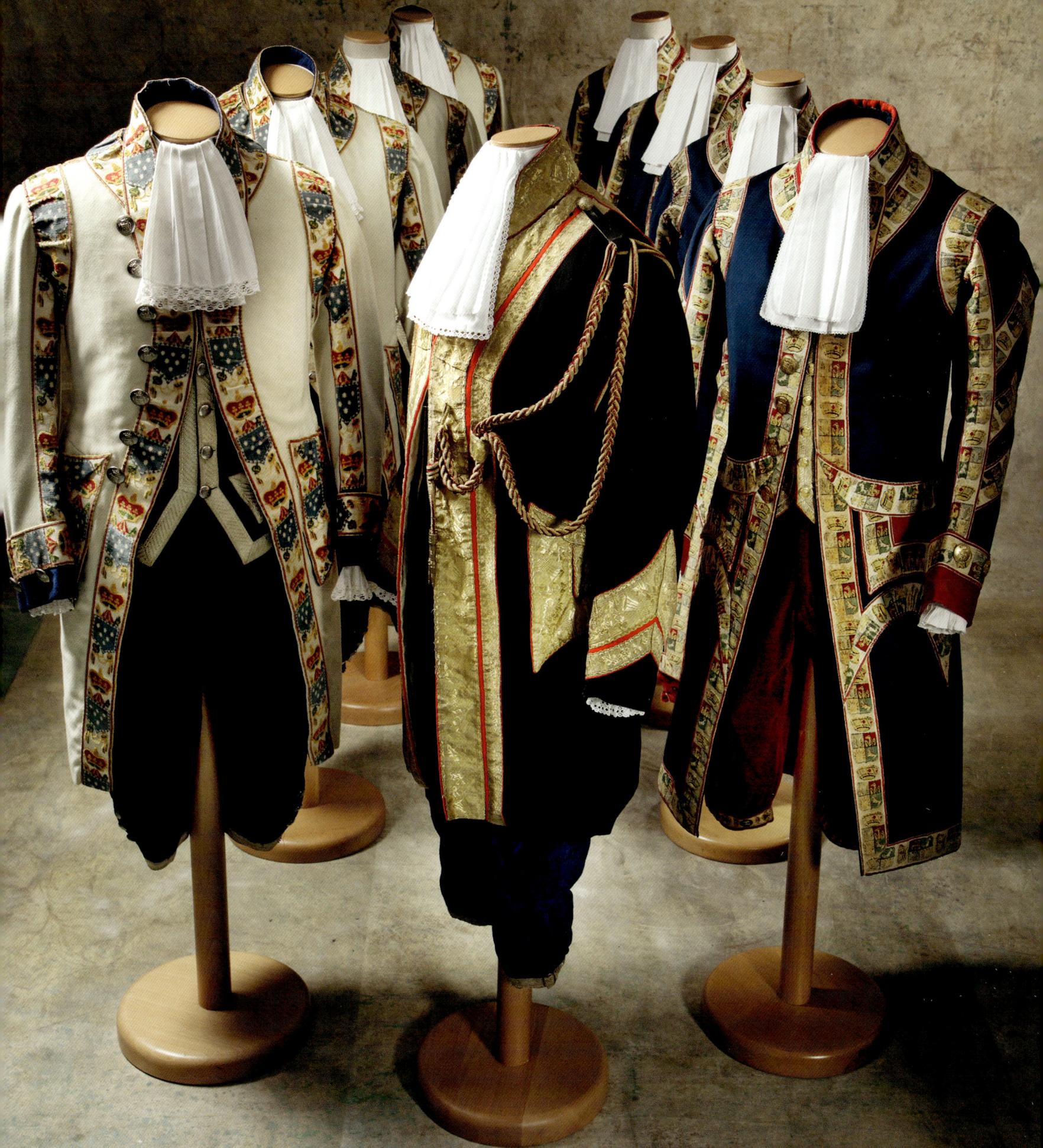

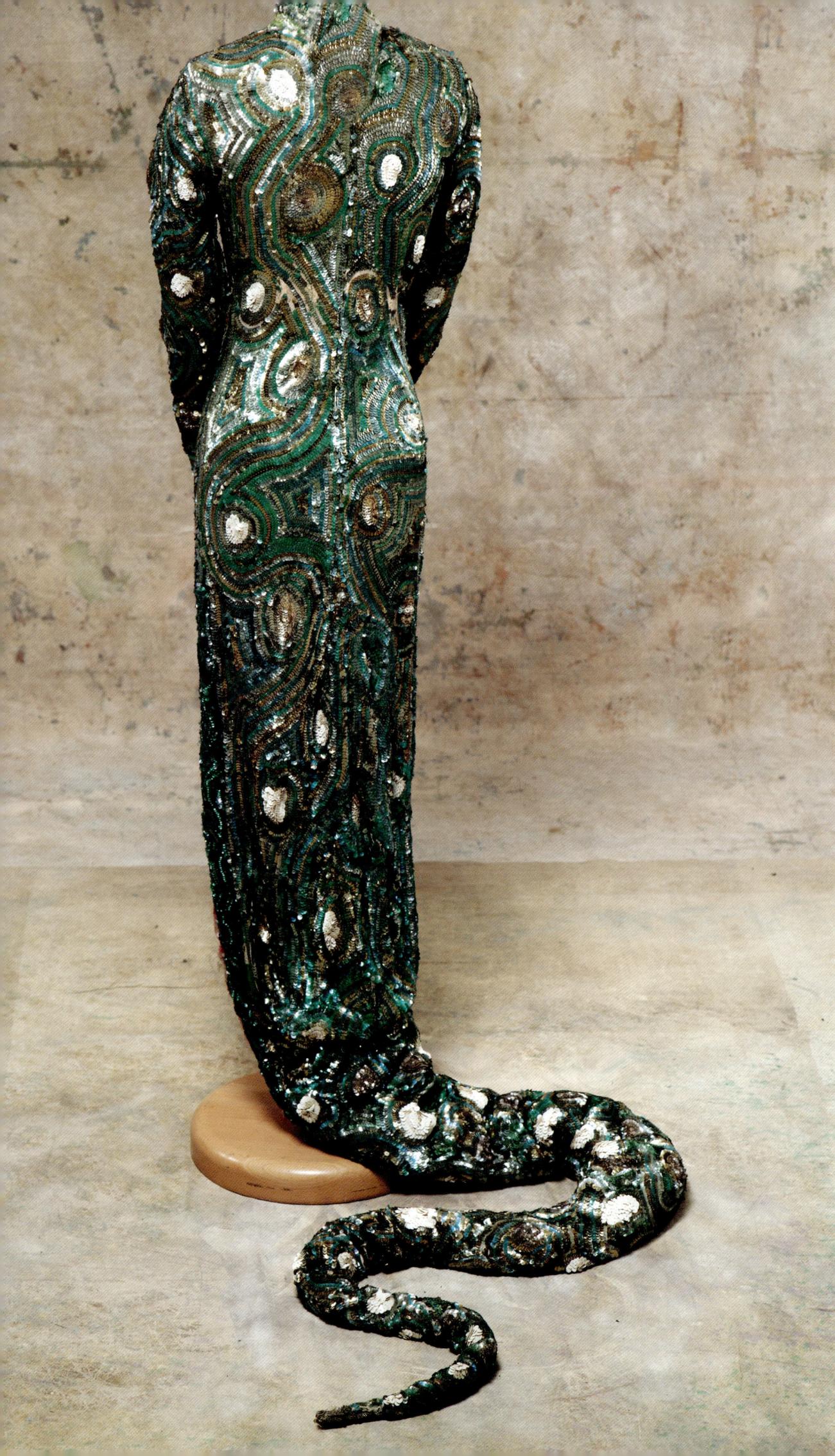

Gianni Versace Couture (1985–86): burnished metal mesh dress with bodice embroidered with tulle, lace and Swarovski crystals
Donated by Gianni Versace

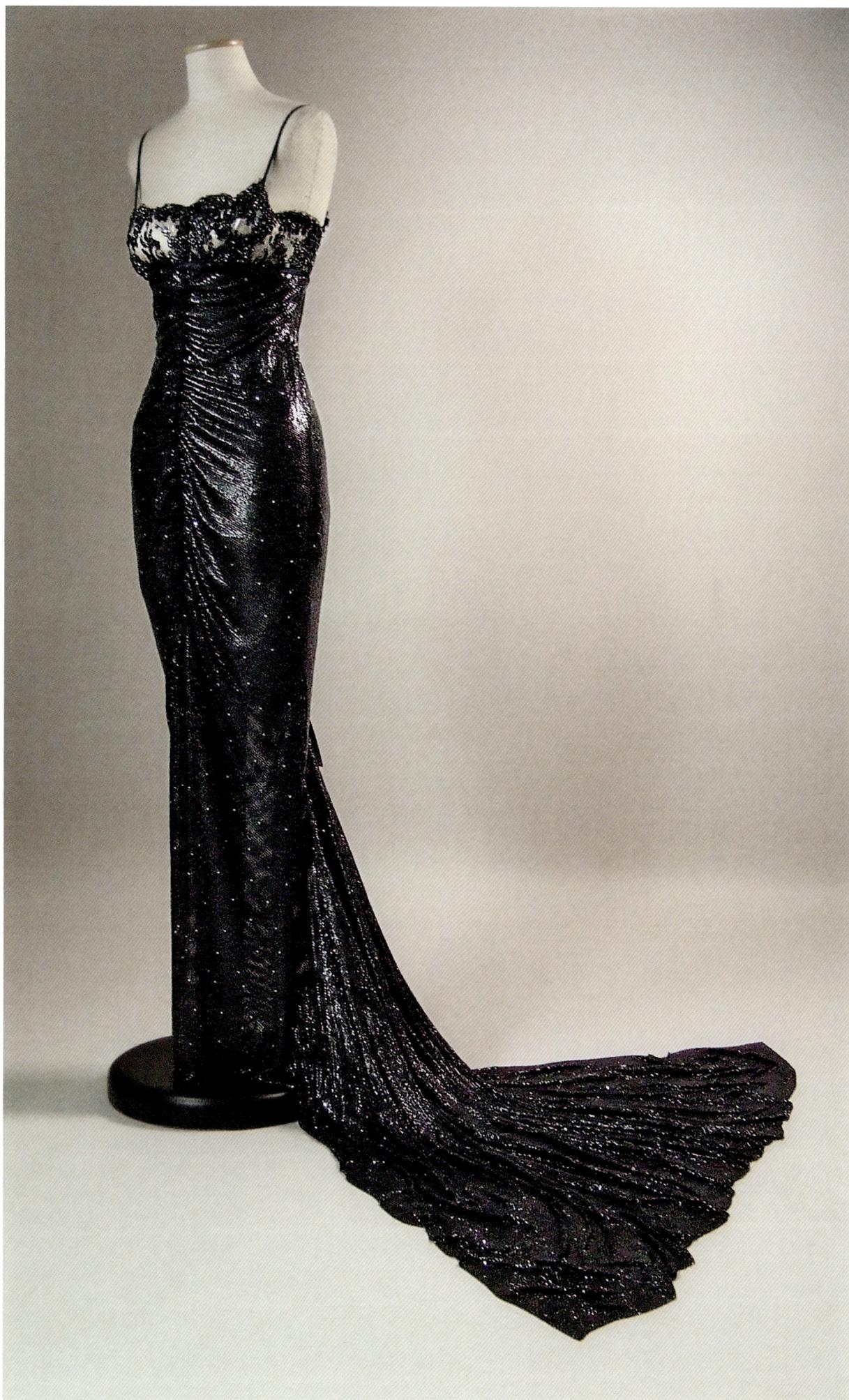

APPENDICES

by Caterina d'Amico

In reconstructing Tirelli Costumi's activity we have decided to limit ourselves to their collaborations strictly in the field of entertainment, thus excluding the countless, and at times very imporant, exhibitions and events in which they have participated. These include: the historical costumes created with Piero Tosi for the Contrada della Torre (Siena, 1976 and 2001); the reconstruction of Leonardesque clothing, also with Piero Tosi, for the exhibition *Leonardo e gli spettacoli del suo tempo* (Milan, 1983); the costumes for the historical parade preceding the Palio in Siena, created by Gabriella Pescucci; the costumes by Gabriella Pescucci for the Baroque procession and those for the final parade made with Giovanna Buzzi for the 20th Winter Olympics (Turin, 2006), and lastly the outfits devised with Giovanna Buzzi for the opening ceremony of the Paralympic Winter Games (Sochi, 2014).

We have chosen to divide Tirelli's collaborations with the world of entertainment into two sections – the first devoted to the Theatre, including drama, opera, dance and other forms of live performance; and the second devoted to Cinema, which also includes television projects and theatre productions especially created for being filmed. These two sections are structured according to quite different criteria.

For the theatre it was decided to list the projects under the names of the different costume designers, also to emphasize the continuity and development of the various collaborations. We have specified the name of the author of the theatrical works only when there is more than one with the same title. When possible, we have indicated the company, theatre, or the event within which the show was performed for the first time. We have not listed the sometimes numerous revivals.

By contrast, for cinema we have proceeded chronologically, listing the productions according to the year of the film's first general release. We felt that this would evoke for readers the contemporaneity – and hence their joint presence, at least in the Sartoria – of many famous films, such as *Death in Venice* and *Duck, You Sucker*; *Amarcord* and *Ludwig*; *Amadeus* and *Once Upon a Time in America*; *The Passion of the Christ* and *Van Helsing*.

The costumes for a film are sometimes made by a single costumier. This was, above all, the practice in the past, while nowadays there is a tendency to divide the work between various ateliers and to use a fair amount of existing material along with especially designed costumes. Therefore, we have found it opportune to mark the different kinds of collaboration with asterisks.

The following lists do not claim to be exhaustive. The reconstruction of Tirelli Costumi's activity has been difficult because the relevant documentation was often incomplete. We would like to thank all those who have helped us with their patience, their memory and the documents in their possession.

Theatre

Cristina Aceti
- *L'elisir d'amore*
Directed by Francesco Bellotto
Teatro Donizetti, Bergamo, 2009
Opera
- *Cavalleria rusticana*
Directed by Alessio Pizzech
Teatro Carlo Goldoni, Livorno,
2010
Opera
- *Pagliacci*
Directed by Alessio Pizzech
Teatro Goldoni, Livorno, 2010
Opera
- *Giulio Cesare* (George Frideric
Handel)
Directed by Alessandro Pizzech
Teatro Comunale, Ferrara, 2011
Opera

Stefano Almerighi
- *Una serata con Antonio Vivaldi*
Directed by Lorenza Codignola
Festival di Ravenna, 1986
Musical evening
- *Eugene Onegin*
Directed by Vittorio Borrelli
Teatro Comunale, Bologna, 1990
Opera
- *Luisa Miller*
Directed by Lorenzo Mariani
Teatro Comunale, Bologna, 1991
Opera

Anna Anni
- *Tosca*
Directed by Mauro Bolognini
Teatro dell'Opera, Rome, 1964
Opera
- *I puritani*
Directed by Sandro Sequi
Teatro Comunale, Bologna, 1969
Opera
- *Hommages romantiques*
(various authors)
Choreography: Milorad Miskovitch
Maggio Musicale Fiorentino, 1973
Ballet
- *Don Carlo*
Directed by Franco Zeffirelli
Teatro alla Scala, Milan, 1992
Opera
- *La bohème* (Giacomo Puccini)
Directed by Franco Zeffirelli
Teatro de la Maestranza, Seville,
1995
Opera
- *La traviata*
Directed by Luciano Alberti
Teatro del Giglio, Lucca, 1996
Opera

Gae Aulenti
- *Il barbiere di Siviglia*
(Gioachino Rossini)
Directed by Luca Ronconi
Théâtre de l'Odéon, Lyon, 1975
Opera

- *Opera*
Directed by Luca Ronconi
Opéra, Lyon, 1979
Opera
- *La donna del lago*
Directed by Gae Aulenti
Rossini Opera Festival, Pesaro, 1981
Opera
- *Il viaggio a Reims*
Directed by Luca Ronconi
Rossini Opera Festival, Pesaro, 1984
Opera

Giuseppe Avallone
- *Cavalleria rusticana*
Directed by Sebastiano Lo Monaco
Teatro Carlo Felice, Genoa, 2007
Opera

Silvia Aymonino
- *L'incoronazione di Poppea*
Directed by Pasqual Jordan
Lausitzer Opernsommer, Repten,
1998
Opera
- *Consuelo*
Directed by Franco Ripa di Meana
Teatro Rendano, Cosenza, 2001
Opera
- *L'elisir d'amore*
Directed by Saverio Marconi
Arena Sferisterio, Macerata, 2002
Opera
- *Il giuramento*
Directed by Joseph Rochlitz
Theatre Royal, Wexford, 2002
Opera
- *Simon Boccanegra*
Directed by Franco Ripa di Meana
Teatro Verdi, Trieste, 2003
Opera
- *Don Giovanni*
(Wolfgang Amadeus Mozart)
Directed by Mercedes Guillamon
Teatro Calderón, Valladolid, 2006
Opera
- *Un ballo in maschera*
Directed by Marco Gandini
Teatro Comunale, Florence, 2007
Opera
- *Trittico: Il tabarro, Suor Angelica,
Gianni Schicchi*
Directed by Luca Ronconi
Teatro alla Scala, Milan, 2008
Opera
- *Il mondo alla rovescia*
(Antonio Salieri)
Directed by Franco Ripa di Meana
Maggio Musicale Fiorentino, 2009
Opera
- *Rigoletto*
Directed by Franco Ripa di Meana
Maggio Musicale Fiorentino, 2009
Opera
- *La traviata*
Directed by Franco Ripa di Meana
Maggio Musicale Fiorentino, 2009
Opera

- *Il trovatore*
Directed by Franco Ripa di Meana
Maggio Musicale Fiorentino, 2009
Opera
- *Don Giovanni*
(Wolfgang Amadeus Mozart)
Directed by Franco Ripa di Meana
Maggio Musicale Fiorentino,
2012
Opera
- *I masnadieri*
Directed by Leo Muscato
Teatro Regio, Parma, 2013
Opera

Roberto Banci
- *La locandiera [The Mistress
of the Inn]*
Directed by Mario Bernardi
Teatro Stabile di Bolzano, 1993
Play
- *The Cherry Orchard*
Directed by Marco Bernardi
Teatro Stabile di Bolzano, 2000
Play
- *Una giornata particolare*
Directed by Marco Bernardi
Teatro Stabile di Bolzano, 2002
Play
- *A Flea in Her Ear*
Directed by Marco Bernardi
Teatro Stabile di Bolzano, 2003
Play
- *L'Alpin che torna dala guera*
Directed by Marco Bernardi
Teatro Stabile di Bolzano, 2004
Play
- *El Faina*
Directed by Marco Bernardi
Teatro Stabile di Bolzano, 2004
Play
- *La vedova scaltra [The Artful
Widow]*
Directed by Marco Bernardi
Teatro Stabile di Bolzano, 2004
Play
- *Da qui a là ci vuole 30 giorni*
Directed by Marco Bernardi
Teatro Stabile di Bolzano, 2005
Play
- *Henry IV* (William Shakespeare)
Directed by Marco Bernardi
Teatro Stabile di Bolzano, 2005
Play
- *The Dance of Death*
Directed by Marco Bernardi
Teatro Stabile di Bolzano, 2006
Play
- *La leggenda del regno dei Fanes*
Directed by Marco Bernardi
Teatro Stabile di Bolzano, 2007
Play
- *Teatro comico*
Directed by Marco Bernardi
Teatro Stabile di Bolzano, 2007
Play
- *Acciaierie*
Directed by Antonio Caldonazzi

Teatro Stabile di Bolzano, 2009
Play
• *The Seagull*
Directed by Marco Bernardi
Teatro Stabile di Bolzano, 2009
Play
• *Mrs Warren's Profession*
Directed by Marco Bernardi
Teatro Stabile di Bolzano, 2009
Play
• *The Imaginary Invalid*
Directed by Marco Bernardi
Teatro Stabile di Bolzano, 2010
Play
• *Il ritorno*
Directed by Marco Bernardi
Teatro Stabile di Bolzano, 2011
Play
• *Troades*
Directed by Marco Bernardi
Teatro Stabile di Bolzano, 2012
Play
• *The Broken Jug*
Directed by Marco Bernardi
Teatro Stabile di Bolzano, 2013
Play

Maria Baronj, Dario Cecchi
• *Ruy Blas*
Directed by Mario Ferrero
Teatro Olimpico, Vicenza, 1965
Play

Michele Barthe
• *Lucrezia Borgia*
Opéra, Montpellier, 1987
Opera

Gioia Benelli
• *Cassio governa a Cipro*
Directed by Gianni Serra
Theatre Biennale, Venice, 1974
Play

**Nathalie Bérard-Benoin,
Françoise Pace-Raybaud**
• *Dreyfus*
Directed by Daniel Benoin
Théâtre Nationale, Nice, 2014
Opera

Eugène Berman
• *Renard*
Directed by Sandro Sequi
Accademia Filarmonica Romana, 1966
Sung ballet

Paolo Bernardi
• *Fidelio*
Directed by Peter Busse
Teatro Regio, Turin, 1984
Opera
• *Otello* (Giuseppe Verdi)
Directed by Giancarlo Del Monaco
Teatro dell'Opera, Nice, 2001
Opera
• *Gli amici di Salamanca*
Directed by Franco Ripa di Meana

Teatro Comunale, Bologna, 2004
Opera

Anna Biagiotti
• *La traviata*
Directed by Gianpaolo Corti
Teatro Ventidio Basso, Ascoli Piceno, 1994
Opera
• *Die Fledermaus*
Directed by Gino Landi
Teatro Verdi, Trieste, 2000
Operetta

Ferruccio Bolognesi
• *Nina ossia La pazza per amore*
Directed by Ruggero Rimini
Teatro del Bibiena, Mantua, 1974
Opera
• *La Dafne* (Marco da Gagliano)
Directed by Ferruccio Bolognesi
Teatro Olimpico, Sabbioneta, 1978
Opera
• *Il ballo delle ingrate*
(Claudio Monteverdi)
Directed by Caterina Mattea
Teatro Olimpico, Sabbioneta, 1979
Opera
• *Il combattimento di Tancredi
e Clorinda* (Claudio Monteverdi)
Directed by Caterina Mattea
Teatro Olimpico, Sabbioneta, 1979
Opera
• *Tirsi e Clori* (Claudio Monteverdi)
Directed by Caterina Mattea
Teatro Olimpico, Sabbioneta, 1979
Ballet
• *Ballo dell'imperatore*
(Claudio Monteverdi)
Directed by Caterina Mattea
Teatro Olimpico, Sabbioneta, 1980
Madrigal
• *De la bellezza*
(Claudio Monteverdi)
Directed by Caterina Mattea
Teatro Olimpico, Sabbioneta, 1980
Madrigal
• *Aeneis* (Domenico Mazzocchi)
Directed by Gerardo Vignoli
Teatro del Bibiena, Mantua, 1981
Opera

Mariolina Bono
• *La bohème* (Giacomo Puccini)
Directed by Ugo Gregoretti
Maggio Musicale Fiorentino, 1983
Opera

Miruna Boruzescu
• *The Gambler*
Directed by Liviu Ciulei
Maggio Musicale Fiorentino, 1986
Opera
• *Adelson e Salvini*
Directed by Petrika Ionesco
Teatro Bellini, Catania, 1992
Opera

Madeleine Boyd
• *Peter Grimes*
Directed by Paul Curran
Teatro di San Carlo, Naples, 2009
Opera

Flora Brancatella
• *Don Pasquale*
Directed by Filippo Guggia
Teatro Nuovo, Udine, 1997
Opera
• *Le stanze di Mozart*
Directed by Marina Bianchi
Teatro Comunale, Florence, 1999
Opera
• *Ernani*
Directed by Grischa Asagaroff
Teatro Carlo Felice, Genoa, 2000
Opera
• *La visita meravigliosa*
Directed by Federica Santambrogi
Teatro di Fermo, 2000
Opera
• *L'ultima notte di Scolacium*
Directed by Cristina Mazzavillani Muti
Roccelletta di Borgia, 2014
Musical

**Flora Brancatella,
Gabriella Pescucci**
• *Pagliacci*
Directed by Liliana Cavani
Teatro Comunale, Bologna, 1998
Opera
• *Norma*
Directed by Daniele Abbado
Arena Sferisterio, Macerata, 2001
Opera
• *Jenufa*
Directed by Liliana Cavani
Teatro Carlo Felice, Genoa, 2003
Opera
• *Werther*
Directed by Liliana Cavani
Teatro Comunale, Bologna, 2004
Opera

Paolo Bregni
• *Widower's Houses*
Directed by Carlo Battistoni
Piccolo Teatro, Milan, 1977
Play

Bice Brichetto
• *Edipo Re* (Ruggero Leoncavallo)
Directed by Franco Guandalini
Teatro di San Carlo, Naples, 1970
Opera

Paul Brown
• *L'incoronazione di Poppea*
Directed by Graham Vick
Teatro Comunale, Bologna, 1992
Opera

Klaus Bruns
• *Tannhäuser*
Directed by Helmut Polixa

Teatro Bellini, Catania, 1994
Opera

Titta Bruson
• *L'ajo nell'imbarazzo*
Directed by Filippo Crivelli
Teatro Regio, Turin, 1984
Opera

Aldo Buti
• *La bohème* (Giacomo Puccini)
Directed by Mauro Bolognini
Teatro Petruzzelli, Bari, 1984
Opera
• *Rigoletto*
Directed by Mauro Bolognini
Arena Sferisterio, Macerata, 1985
Opera

Giovanna Buzzi
• *Cavalleria rusticana*
Directed by Gae Aulenti, Virginia
Westlake
Festival di Ravenna, 1985
Opera
• *La fanciulla del West*
Directed by Gae Aulenti, Pasquale
Dascola
Festival di Ravenna, 1985
Opera
• *Pagliacci*
Directed by Gae Aulenti, Virginia
Westlake
Festival di Ravenna, 1985
Opera
• *Rigoletto*
Directed by Gae Aulenti, Mattia Testi
Festival di Ravenna, 1985
Opera
• *La serva amorosa*
Directed by Luca Ronconi
Teatro Comunale, Gubbio, 1986
Play
• *How It Is*
Directed by Federico Tiezzi
I Magazzini, Florence, 1987
Play
• *Histoire du soldat*
Directed by Mauro Avogadro
Villa Alba, Gardone Riviera, 1987
Chamber opera
• *La fiaba dello Zar Saltan*
[The Tale of Tsar Saltan]
Directed by Luca Ronconi
Teatro Valli, Reggio Emilia, 1988
Opera
• *Hamletmachine*
Directed by Federico Tiezzi
I Magazzini, Florence, 1988
Play
• *Sogno d'un tramonto d'autunno*
(Gian Francesco Malipiero)
Directed by Mauro Avogadro
Teatro Sociale, Mantua, 1988
Opera
• *Ricciardo e Zoraide*
Directed by Luca Ronconi
Rossini Opera Festival, Pesaro, 1990

Opera
• *Anton* (Flavio Emilio Scogna)
Directed by Franco Ripa di Meana
Teatro Comunale, Florence, 1991
Opera
• *Woe from Wit*
Directed by Domenico Polidoro
Accademia Nazionale d'Arte
Drammatica, Rome, 1991
Play
• *La figlia del mago* (Lorenzo Ferrero)
Directed by Franco Ripa di Meana
Teatro Comunale, Florence, 1991
Children's opera
• *Il Paradiso* (Giovanni Giudici)
Directed by Federico Tiezzi
I Magazzini, Florence, 1991
Play
• *Pasiphae*
(Henry Millon de Montherlant)
Directed by Mauro Avogadro
Teatro Romano, Nora, 1991
Play
• *Alcassino e Nicoletta*
(Bruno Cerchio)
Directed by Mauro Avogadro
Teatro Regio, Turin, 1992
Opera
• *Endgame*
Directed by Federico Tiezzi
Centro Teatrale Bresciano, 1992
Play
• *Le Voyageur* (Denis Amiel)
Directed by Mauro Avogadro
Festival dei Due Mondi, Spoleto, 1992
Play
• *L'Arlésienne*
Directed by Mauro Avogadro
Teatro dell'Opera, Rome, 1994
Opera
• *Il cavaliere e la dama*
[The Knight and the Lady]
Directed by Mauro Avogadro
Festival Teatrale di Borgio Verezzi,
1994
Play
• *Il mondo della luna*
(Franz Joseph Haydn)
Directed by Costa-Gavras
Teatro di San Carlo, Naples, 1994
Opera
• *Porcile*
Directed by Federico Tiezzi
I Magazzini, Florence, 1994
Play
• *Moonlight*
Directed by Cherif
Centro Teatrale Bresciano, 1995
Play
• *L'onorevole Ercole Malladri*
Directed by Mauro Avogadro
Teatro Stabile di Torino, 1995
Play
• *La vita, il sogno* (Franco Loi after
Pedro Calderón de la Barca)
Directed by Andrée Ruth Shammah
Teatro Franco Parenti, Milan, 1995
Play

• *Le convenienze ed inconvenienze*
teatrali
Directed by Mauro Avogadro
Teatro Regio, Turin, 1996
Opera
• *Il corsaro*
Directed by Mauro Avogadro
Teatro Regio, Turin, 1996
Opera
• *Pelléas et Mélisande*
Directed by Mauro Avogadro
Teatro Stabile di Torino, 1996
Play
• *Tosca*
Directed by Bepi Morassi
Teatro La Fenice, Venice, 1996
Opera
• *Madama Butterfly*
Directed by Federico Tiezzi
Teatro di Messina, 1997
Opera
• *Moïse et Pharaon*
Directed by Graham Vick
Rossini Opera Festival, Pesaro, 1997
Opera
• *The Soldiers*
(Jacob Michael Reinhold Lenz)
Directed by Mauro Avogadro
Teatro Stabile di Torino, 1997
Play
• *L'assoluto naturale*
Directed by Federico Tiezzi
I Magazzini, Florence, 1998
Play
• *La sonnambula*
Directed by Mauro Avogadro
Teatro Regio, Turin, 1998
Opera
• *The Ignoramus and the Madman*
Directed by Mauro Avogadro
Teatro di Roma, 1999
Play
• *Otello* (Giuseppe Verdi)
Directed by Mario Pontiggia
Teatro Massimo, Palermo, 1999
Opera
• *Il viaggio a Reims*
Directed by Luca Ronconi
Rossini Opera Festival, Pesaro, 1999
Opera
• *The Power of Darkness*
Directed by Mauro Avogadro
Teatro Stabile di Torino, 2000
Play
• *Peter Uncino*
(Michele Serra, Marco Tutino)
Directed by Giorgio Gallione
Teatro Filarmonico, Verona, 2001
Musical theatre
• *Il trovatore*
Directed by Federico Tiezzi
Opéra, Montecarlo, 2001
Opera
• *Visita dell'uomo grigio*
(Dario Buzzolan)
Directed by Mauro Avogadro
Teatro Stabile di Torino, 2001
Play

• *Il campanello dello speziale*
Directed by Mauro Avogadro
Teatro Donizetti, Bergamo, 2002
Opera
• *Il tabarro*
Directed by Mauro Avogadro
Teatro Donizetti, Bergamo, 2002
Opera
• *Il benessere* (Franco Brusati)
Directed by Mauro Avogadro
Teatro Stabile di Torino, 2003
Play
• *Il Genio buono e il Genio cattivo*
[*The Good Genius and the Bad
Genius*]
Directed by Mauro Avogadro
Teatro Stabile di Torino, 2003
Play
• *Il barbiere di Siviglia*
(Gioachino Rossini)
Directed by Luca Ronconi
Rossini Opera Festival, Pesaro, 2005
Opera
• *I cavalieri di Ekebù*
Directed by Federico Tiezzi
Teatro Bellini, Catania, 2005
Opera
• *Die Walküre*
Directed by Federico Tiezzi
Teatro di San Carlo, Naples, 2005
Opera
• *Don Quichotte*
Directed by Federico Tiezzi
Teatro Verdi, Trieste, 2006
Opera
• *The Lady from the Sea*
Directed by Mauro Avogadro
Teatro Stabile di Torino, 2006
Play
• *La vedova allegra*
[*The Merry Widow*]
Directed by Federico Tiezzi
Teatro Verdi, Trieste, 2009
Operetta

Corrado Cagli
• *Mass* (Igor Stravinsky)
Directed by Carlo E. Crespi
Accademia Filarmonica Romana,
1975
Religious work

Francesco Calcagnini
• *Atelier Nadar*
Directed by Lorenza Codignola
Rossini Opera Festival, Pesaro, 1990
Musical evening

Milena Canonero
• *Andrea Chénier*
Directed by Otto Schenk
Staatsoper, Vienna, 1981
Opera
• *Tosca*
Directed by Luc Bondy
Metropolitan Opera House,
New York, 2009
Opera

Milena Canonero, Ambra Danon
• *Mourning Becomes Electra*
Directed by Luca Ronconi
Teatro Argentina, Rome, 1997
Play

Massimo Cantini Parrini
• *Exiles*
Directed by Massimo D'Orzi
Teatro La Cometa, Rome, 1996
Play
• *Die Fledermaus* (excerpts)
Directed by Diane Kienast
Accademia Nazionale di Santa Cecilia,
Rome, 1999
Operetta

**Alida Cappellini,
Giovanni Licheri**
• *L'italiana in Algeri*
Directed by Michele Mirabella
Teatro Bellini, Catania, 2012
Opera
• *Non è vero ma ci credo*
Directed by Michele Mirabella
Siracusa, 2012
Play
• *Die Fledermaus*
Directed by Michele Mirabella
Teatro Bellini, Catania, 2013
Operetta

Sandra Cardini
• *Tartuffe*
Directed by Carlo Cecchi
Teatro Stabile delle Marche and Teatro
Stabile di Napoli, 2007
Play
• *La belle joyeuse* (Gianfranco Fiore)
Directed by Gianfranco Fiore
Teatro Franco Parenti, Milan,
2011
Play
• *Ti ho sposato per allegria*
Directed by Piero Maccarinelli
Teatro Dozza, Novara, 2013
Play
• *The Visitor*
Directed by Valerio Binasco
Teatro Supercinema, Castellammare
di Stabia, 2013
Play

Franco Carretti
• *Del vento tra i rami del sassofrasso*
Directed by Sandro Bolchi
Teatro Bonci, Cesena, 1967
Play

Elena Carveni
• *Die Fledermaus*
Directed by Petrika Ionesco
Teatro Bellini, Catania, 1992
Operetta
• *La bohème* (Giacomo Puccini)
Directed by Lamberto Puggelli
Teatro Massimo, Palermo, 2000
Opera

Dario Cecchi, Maria Baronj
• *Ruy Blas*
Directed by Mario Ferrero
Teatro Olimpico, Vicenza, 1965
Play

Nanà Cecchi
• *The Waltz of the Dogs*
Directed by Giuseppe Patroni Griffi
Teatro Eliseo, Rome, 1978
Play
• *Così fan tutte*
Directed by Giacomo Battiato
Teatro Mercadante, Naples,
1990
Opera

**Nanà Cecchi,
Giorgio De Lullo**
• *Così fan tutte*
Directed by Giorgio De Lullo
Festival dei Due Mondi, Spoleto,
1977
Opera

Alessandro Ciammarughi
• *Falstaff* (Giuseppe Verdi)
Directed by Marco Spada
Teatro Verdi, Sassari, 2013
Opera
• *Ainadamar*
Directed by Jun Aguni
Tokyo, 2014
Opera

Deirdre Clancy
• *Prince Igor*
Directed by Andrei Serban
Covent Garden, London, 1990
Opera

Fabrizio Clerici
• *Dido and Aeneas*
Directed by Beppe Menegatti
Teatro dell'Opera, Rome, 1965
Opera

Veniero Colasanti
• *Rigoletto*
Directed by Herbert Graf
Grand Théâtre, Geneva, 1966
Opera

Enrico Colombotto Rosso
• *The Dance of Death*
Directed by Sandro Sequi
Teatro Stabile di Torino, 1969
Play

Giulio Coltellacci
• *Is There Any Hope for Sex?*
Directed by Vittorio Caprioli
Teatro Quirino, Rome, 1966
Play
• *Ciao Rudy* (in part)
Directed by Garinei e Giovannini
Teatro Sistina, Rome, 1966
Musical comedy

• *Excelsior*
Directed by Filippo Crivelli,
choreography by Ugo Dell'Ara
Maggio Musicale Fiorentino, 1968
Ballet mime
• *Mosè in Egitto*
Directed by Sandro Bolchi
Teatro di San Carlo, Naples, 1968
Opera

John Conkun
• *Un ballo in maschera*
Directed by Sonja Frisell
Teatro Comunale, Bologna, 1988
Opera

Quirino Conti
• *Tosca*
Directed by Luigi Proietti
Teatro Verdi, Pisa, 1984
Opera
• *Benvenuto Cellini*
Directed by Luigi Proietti
Teatro dell'Opera, Rome, 1995
Opera

Rita Corradini
• *L'impuro folle*
Directed by Giorgio Marini
Theatre Biennale, Venice, 1974
Play

Giuseppe Crisolini Malatesta
• *Il turco in Italia*
Directed by Sandro Sequi
Cantiere Internazionale d'Arte,
Montepulciano, 1976
Opera
• *La belle Hélène*
Directed by Sandro Sequi
Teatro Valli, Reggio Emilia, 1980
Opera
• *La gazza ladra*
Directed by Sandro Sequi
Rossini Opera Festival, Pesaro, 1980
Opera
• *L'isola disabitata*
Directed by Sandro Sequi
Accademia Filarmonica Romana, 1980
Opera
• *Mavra*
Directed by Sandro Sequi
Accademia Filarmonica Romana, 1980
Opera
• *La serva e l'ussero*
Directed by Sandro Sequi
Accademia Filarmonica Romana, 1980
Opera
• *Stella*
Directed by Sandro Sequi
Rome, 1980
Play
• *Britannicus*
Directed by Sandro Sequi
Rome, 1981
Play
• *L'elisir d'amore*
Directed by Sandro Sequi

Teatro Comunale, Modena, 1981
Opera
• *Il turco in Italia*
Directed by Sandro Sequi
Teatro Valli, Reggio Emilia, 1981
Opera
• *Mignon*
Directed by Sandro Sequi
Maggio Musicale Fiorentino, 1983
Opera
• *Rigoletto*
Directed by Sandro Sequi
Staatsoper, Vienna, 1983
Opera
• *Un ballo in maschera*
Directed by Sandro Sequi
Maggio Musicale Fiorentino,
1985
Opera
• *Il barbiere di Siviglia*
(Gioachino Rossini)
Directed by Luciano Alberti
Teatro Comunale, Genoa, 1986
Opera
• *Don Giovanni*
(Christoph Willibald Gluck)
Directed by Egon Madsen
Maggio Musicale Fiorentino, 1987
Opera
• *La grotta di Trofonio*
Directed by Sandro Sequi
Accademia Filarmonica Romana,
1987
Opera
• *Arabella*
Directed by Sandro Sequi
Teatro Bellini, Catania, 1988
Opera
• *La traviata*
Directed by Sandro Sequi
Teatro di San Carlo, Naples, 1993
Opera
• *La traviata*
Directed by Riccardo Canessa
Arena, Verona, 1999
Opera
• *La traviata*
Directed by Maurizio Di Mattia
The Japan Opera, Tokyo, 2001
Opera

Filippo Crivelli
• *Don Pasquale*
Directed by Filippo Crivelli
Teatro Massimo, Palermo, 1985
Opera

Francesco Crivellini
• *Madama Butterfly* (in part)
Directed by Franco Zeffirelli
Arena, Verona, 2004
Opera

Mariella D'Amico
• *Hamlet*
Directed by Federica Tatulli
Rome, 2010
Play

Luciano Damiani
• *The Captain from Koepenick*
Directed by Sandro Bolchi
Teatro Stabile di Trieste, 1973
Play
• *L'amore delle tre melarance*
Directed by Giorgio Strehler
Teatro alla Scala, Milan, 1974
Opera
• *The Cherry Orchard*
Directed by Giorgio Strehler
Piccolo Teatro, Milan, 1974
Play
• *Utopia* (after Aristophanes)
Directed by Luca Ronconi
Ex Cantieri della Giudecca, Venice,
1976
Play

Ambra Danon, Milena Canonero
• *Mourning Becomes Eectra*
Directed by Luca Ronconi
Teatro Argentina, Rome, 1997
Play

Cristina Darold
• *Non si sa come*
(*You Don't Know How*)
Directed by Sebastiano Lo Monaco
Siracusa, 2010
Play

Bernard Daydé
• *Salome* (Peter Maxwell Davis)
Choreography by Flemming Flindt
Copenhagen, 1978
Ballet

Hugo de Ana
• *Semiramide*
Directed by Hugo de Ana
Rossini Opera Festival, Pesaro, 1992
Opera
• *Mosè in Egitto*
Directed by Hugo de Ana
Teatro di San Carlo, Naples, 1993
Opera
• *Aida*
Directed by Hugo de Ana
Teatro de la Maestranza, Seville,
1994
Opera
• *Carmen*
Directed by Hugo de Ana
Opéra, Lille, 1994
Opera
• *Les contes d'Hoffmann*
Directed by Hugo de Ana
Teatro Filarmonico, Verona, 1994
Opera
• *Iris*
Directed by Hugo de Ana
Teatro dell'Opera, Rome, 1995
Opera
• *Norma*
Directed by Hugo de Ana
Teatro Colón, Buenos Aires, 1995
Opera

• *Samson et Dalila*
Directed by Hugo de Ana
Arena Sferisterio, Macerata, 1995
Opera
• *Turandot*
Directed by Hugo de Ana
Arena Sferisterio, Macerata, 1996
Opera
• *Il barbiere di Siviglia*
(Gioachino Rossini)
Directed by Hugo de Ana
Teatro dell'Opera, Rome, 1997
Opera
• *La fiamma*
Directed by Hugo de Ana
Teatro dell'Opera, Rome, 1997
Opera
• *Lucrezia Borgia*
Directed by Hugo de Ana
Teatro alla Scala, Milan, 1998
Opera
• *El Cid*
Directed by Hugo de Ana
Teatro de la Maestranza, Seville, 1999
Opera
• *Tosca*
Directed by Hugo de Ana
The New Israeli Opera, Tel Aviv, 1999
Opera
• *La forza del destino*
Directed by Hugo de Ana
Teatro alla Scala Milan, 2000
Opera
• *Don Carlo*
Directed by Hugo de Ana
Teatro Real, Madrid, 2001
Opera
• *Il trovatore*
Directed by Hugo de Ana
Teatro alla Scala, Milan, 2001
Opera
• *L'elisir d'amore*
Directed by Hugo de Ana
New National Theatre, Tokyo, 2002
Opera
• *Faust*
Directed by Hugo de Ana
Teatro dell'Opera, Rome, 2002
Opera
• *La traviata*
Directed by Hugo de Ana
The Japan Opera, Tokyo, 2002
Opera
• *Simon Boccanegra*
Directed by Hugo de Ana
Teatro Regio, Parma, 2004
Opera
• *Scene dal Faust di Goethe*
(Robert Schumann)
Directed by Hugo de Ana
Teatro Regio, Parma, 2007
Music drama
• *La sonnambula*
Directed by Hugo de Ana
Teatro Filarmonico, Verona, 2007
Opera
• *La favorita*
Directed by Hugo de Ana

Teatro Municipal, Santiago, 2008
Opera
• *Medea* (Luigi Cherubini)
Directed by Hugo de Ana
Teatro Regio, Turin, 2008
Opera
• *La vedova allegra*
[The Merry Widow]
Directed by Hugo de Ana
Padua, 2009
Opera
• *La bohème* (Giacomo Puccini)
Directed by Hugo de Ana
Teatro Colón, Buenos Aires,
2010
Opera
• *Senso*
Directed by Hugo de Ana
Teatro Massimo, Palermo, 2010
Opera
• *Boris Godunov*
Directed by Hugo de Ana
Teatro Municipal, Santiago, 2011
Opera
• *Ernani* (in part)
Directed by Hugo de Ana
Teatro dell'Opera, Rome, 2013
Opera

Giorgio de Chirico
• *Lauda per la Natività del Signore*
Directed by Carlo E. Crespi
Accademia Filarmonica Romana, 1975
Opera

Ortensia De Francesco
• *Una cosa rara*
Directed by Toni Servillo
Teatro La Fenice, Venice, 1999
Opera
• *Carmen*
Directed by Pappi Corsicato
Teatro di San Carlo, Naples, 2000
Opera
• *Le nozze di Figaro*
Directed by Toni Servillo
Teatro La Fenice, Venice, 2000
Opera
• *Boris Godunov*
Directed by Toni Servillo
Teatro Nacional de São Carlos,
Lisbon, 2001
Opera
• *The Seagull*
Directed by Valerio Binasco
Teatro Stabile di Roma, 2001
Play
• *Il marito disperato*
Directed by Toni Servillo
Teatro di San Carlo, Naples, 2001
Opera
• *Sabato, domenica e lunedì*
[Saturday, Sunday and Monday]
Directed by Toni Servillo
Teatri Uniti, 2002
Play
• *Ariadne auf Naxos*
Directed by Toni Servillo

Teatro Comunale, Ferrara, 2005
Opera
• *Le fausses confidences*
Directed by Toni Servillo
Teatri Uniti, 2005
Play

Giorgio De Lullo, Nanà Cecchi
• *Così fan tutte*
Directed by Giorgio De Lullo
Festival dei Due Mondi, Spoleto,
1977
Opera

Lila de Nobili
• *Hier à Andersonville*
Directed by Raymond Rouleau
Théâtre de Paris, 1966
Play
• *The Merchant of Venice*
Directed by Ettore Giannini
Teatro Stabile di Roma, 1966
Play

Zaira De Vincentiis
• *Don Giovanni*
(Wolfgang Amadeus Mozart)
Directed by Roberto De Simone
Bundestheater, Vienna, 1999
Opera
• *Il barbiere di Siviglia*
(Gioachino Rossini)
Directed by Guido Monticelli
Teatro La Fenice, Venice, 2004
Opera
• *Il Socrate immaginario*
Directed by Roberto De Simone
Teatro di San Carlo, Naples, 2005
Opera
• *La Cenerentola*
Directed by Paul Curran
Teatro Carlo Felice, Genoa, 2006
Opera
• *La Cenerentola*
Directed by Guido De Monticelli
Teatro Verdi, Trieste, 2006
Opera
• *The Kitchen*
Directed by Armando Pugliese
Accademia d'Arte Drammatica, Rome,
2007
Play
• *Lo vommaro a duello* (by Roberto
De Simone, after Pasquale Starace
and Giovanni Paisiello)
Directed by Roberto De Simone
Teatro Mercadante, Naples, 2008
Musical theatre
• *Antony and Cleopatra*
Directed by Luca De Fusco
Teatro Stabile di Napoli, 2013
Play
• *The taming of the shrew*
Directed by Andrei Konchalovsky
Teatro Stabile di Napoli, 2013
Play
• *Il sindaco del Rione Sanità*
Directed by Marco Sciaccaluga

Teatro Stabile di Napoli, 2014
Play

Lucio Diana
• *Jacob Lenz*
Directed by Lucio Diana
Teatro Comunale, Florence, 1999
Opera

Carlo Diappi
• *Don Pasquale*
Directed by Sonja Frisell
Cantiere Internazionale d'Arte,
Montepulciano, 1979
Opera
• *I contemporanei* (in part)
Directed by Marco Gagliardo
Bologna, 1980
Musical theatre
• *Delirio* (in part)
Directed by Marco Gagliardo
Rome, 1980
Musical theatre
• *Le seconde nuove musiche*
(in part)
Directed by Marco Gagliardo
Villa Cicogna, Bologna, 1980
Musical theatre
• *Le serve rivali*
Directed by Carlo Diappi
Teatro Comunale, Genoa, 1980
Opera
• *Così fan tutte*
Directed by Luca Ronconi
Teatro La Fenice, Venice, 1983
Opera
• *La prova di un'opera seria*
Directed by Pier Luigi Pizzi
Teatro La Fenice, Venice, 1983
Opera
• *Le due commedie in commedia*
Directed by Luca Ronconi
Teatro Malibran, Venice, 1984
Play
• *Fedra*
Directed by Luca Ronconi
Teatro Metastasio, Prato, 1984
Play
• *La fille de Madame Angot*
Directed by Jean-Claude Brialy
Théâtre du Châtelet, Paris, 1984
Opera
• *Mahagonny*
Directed by Pierre Constant
Théâtre du Châtelet, Paris, 1984
Musical theatre
• *The Comedy of Seduction*
Directed by Luca Ronconi
Teatro Metastasio, Prato, 1985
Play
• *Oedipus the King* (Sophocles)
Directed by Lorenzo Salveti
Teatro Olimpico, Vicenza, 1985
Play
• *L'Orfeo* (Luigi Rossi)
Directed by Luca Ronconi
Teatro alla Scala, Milan, 1985
Opera

• *Iphigénie en Tauride*
(Niccolò Piccinni)
Directed by Luca Ronconi
Teatro Petruzzelli, Bari, 1986
Opera
• *La buona moglie*
[The Good Wife]
Directed by Marco Sciaccaluga
Teatro Stabile di Genova, 1987
Play
• *Capriccio*
Directed by Luca Ronconi
Teatro Comunale, Bologna, 1987
Opera
• *L'egoista*
Directed by Marco Sciaccaluga
Teatro Stabile di Genova, 1987
Play
• *La putta onorata*
[The Honorable Maiden]
Directed by Marco Sciaccaluga
Teatro Stabile di Genova, 1987
Play
• *Un ballo in maschera*
Directed by Michael Hampe
Opernhaus, Zurich, 1988
Opera
• *Der Rosenkavalier*
Directed by Michael Hampe
Maggio Musicale Fiorentino,
1989
Opera
• *Mozart a New York*
Directed by Lutz Hochstraate
Salzburger Landestheater, 1991
Opera
• *Il pirata*
Directed by Renata Scotto
Teatro Bellini, Catania, 1993
Opera

Sergio D'Osmo
• *Ivanov*
Directed by Orazio Costa
Giovangigli
Teatro Stabile di Trieste, 1968
Play
• *Il mio Carso*
Directed by Francesco Macedonio
Teatro Stabile di Trieste, 1969
Play
• *Non si sa come*
[You Don't Know How]
Directed by José Quaglio
Teatro Stabile di Trieste, 1969–70
Play
• *Uncle Vanya*
Directed by Giulio Bosetti
Teatro Stabile di Trieste, 1970–71
Play
• *La oscienza di Zeno*
Directed by Franco Giraldi
Teatro Stabile di Trieste, 1978–79
Play
• *Das Kapital*
Directed by Franco Giraldi
Teatro Stabile di Trieste, 1981–82
Play

Nicoletta Ercole
• *Boston Marriage*
Directed by Franco Però
Teatro Stabile di Genoa, 2002
Play

Marcel Escoffier
• *Giovanna d'Arco*
Directed by Alberto Fassini
Teatro La Fenice, Venice, 1972
Opera

Marisa Fabbri
• *Giulietta e Romeo* (Nicola Vaccai)
Directed by Marisa Fabbri
Teatro Pergolesi, Jesi, 1996
Opera

Piero Faggioni
• *La fanciulla del West*
Directed by Piero Faggioni
Covent Garden, London, 1976
Opera
• *Otello* (Giuseppe Verdi)
Directed by Piero Faggioni
Bregenz Festspiele, 1981
Opera
• *Don Quichotte*
Directed by Piero Faggioni
Teatro La Fenice, Venice, 1982
Opera
• *La damnation de Faust*
Directed by Piero Faggioni
Festival Berlioz, Lyon, 1983
Opera

Gabrielle Frey
• *Tannhäuser*
Staatsoper, Vienna, 1982
Opera

Ezio Frigerio
• *King Lear*
Directed by Giorgio Strehler
Piccolo Teatro, Milan, 1972
Play
• *The Threepenny Opera*
Directed by Giorgio Strehler
Piccolo Teatro, Milan, 1973
Musical
• *Don Pasquale*
Directed by Eduardo De Filippo
Lyric Opera, Chicago, 1974
Opera
• *Romeo and Juliet* (Sergei Prokofiev)
Choreography by Rudolf Nureyev
Covent Garden, London, 1976
Ballet
• *Carmen*
Directed by Piero Faggioni
Glyndebourne Festival, 1977
Opera
• *Norma*
Directed by Piero Faggioni
Staatsoper, Vienna, 1977
Opera
• *Pelléas et Mélisande*
Directed by Gilbert Deflo

Staatsoper, Hamburg, 1977
Opera
• *Simon Boccanegra* (in part)
Directed by Giorgio Strehler
Teatro alla Scala, Milan, 1978
Opera
• *No Man's Land*
Directed by Roger Planchon
Lyon, 1979
Play
• *Wozzeck*
Directed by Liliana Cavani
Maggio Musicale Fiorentino, 1979
Opera
• *Falstaff* (Giuseppe Verdi) (in part)
Directed by Giorgio Strehler
Teatro alla Scala, Milan, 1980
Opera

Graciela Galan
• *Dracula*
Directed by Alfredo Arias
Gran Teatro, Rome, 2006
Rock opera

Marta Galvin
• *La bohème* (Giacomo Puccini)
Directed by Ken Russell
Arena Sferisterio, Macerata, 1984
Opera

Maria Antonietta Gambaro
• *L'Idiota* (Luciano Chailly)
Directed by Sandro Sequi
Teatro dell'Opera, Rome, 1970
Opera
• *Oberto conte di San Bonifacio*
Directed by Gianfranco De Bosio
Teatro Comunale, Bologna, 1972
Opera

Mario Garbuglia
• *Dal tuo al mio*
Directed by Paolo Giuranna
Teatro Valle, Rome, 1966
Play

Bruno Garofalo
• *La donna è mobile*
[The Lady is Fickle]
Directed by Eduardo De Filippo
1981
Play

Massimo Gasparon
• *Il trionfo della continenza*
considerato in Scipione Africano
Directed by Massimo Gasparon
Teatro della Fortuna, Fano, 1998
Opera
• *Artaserse*
Directed by Massimo Gasparon
Teatro Rossini, Lugo, 1999
Opera
• *Il barcheggio*
Directed by Massimo Gasparon
Teatro della Fortuna, Fano, 1999
Opera

• *Norma*
Directed by Massimo Gasparon
Teatro dell'Opera, Savona, 1999
Opera
• *I puritani*
Directed by Massimo Gasparon
Amics de s'Òpera de Maó, Minorca,
2008
Opera
• *Tosca*
Directed by Massimo Gasparon
Arena Sferisterio, Macerata, 2008
Opera
• *Ernani*
Directed by Massimo Gasparon
Fondazione Arturo Toscanini, Parma,
2009
Opera
• *Montezuma II*
Directed by Massimo Gasparon
Mexico City, 2009
Opera
• *La traviata*
Directed by Massimo Gasparon
Arena Sferisterio, Macerata, 2009
Opera
• *Juditha triumphans*
Directed by Massimo Gasparon
Korea Opera Group, Seoul Opera
House, 2010
Opera
• *Un ballo in maschera*
Directed by Massimo Gasparon
Amics de s'Òpera de Maó, Minorca,
2010
Opera
• *Rigoletto*
Directed by Massimo Gasparon
Arena Sferisterio, Macerata, 2011
Opera
• *Don Giovanni*
(Wolfgang Amadeus Mozart)
Directed by Massimo Gasparon
Amics de s'Òpera de Maó, Minorca, 2012
Opera

Claudie Gastine
• *Così fan tutte*
Directed by Filippo Crivelli
Teatro Regio, Turin, 1966
Opera
• *La bohème* (Giacomo Puccini)
Directed by Jean-Marie Simon
Lucca, 1974
Opera
• *Rigoletto*
Directed by Jean-Marie Simon
Grand Théâtre, Geneva, 1981
Opera
• *La vedova allegra*
[The Merry Widow]
Directed by Alfredo Arias
Théâtre du Châtelet, Paris, 1982
Operetta
• *Lucia di Lammermoor*
Directed by Gian Carlo Menotti
Teatro dell'Opera, Rome, 1992
Opera

• *La rondine*
Directed by Nicolas Joel
Teatro alla Scala, Milan, 1994
Opera

**Claudie Gastine,
Alberto Verso**
• *La vedova allegra*
[The Merry Widow]
Directed by Alfredo Arias
Festival dei Due Mondi, Spoleto, 1981
Operetta

Lorenzo Ghiglia
• *Francesca da Rimini* (in part)
Directed by Franco Guandalini
Teatro Regio, Turin, 1974
Opera

Mario Giorsi
• *Ghosts*
Directed by Edmo Fenoglio
1975
Play

Karel Glogr
• *Dalibor*
Directed by Jiri Menzel
Fondazione Teatro Lirico, Cagliari,
1998
Opera

Franco Grazioli
• *La signorina Julie* (Antonio Bibalo)
Teatro Verdi, Trieste, 1993
Opera

Pasquale Grossi
• *Amelia al ballo*
Directed by Gian Carlo Menotti
Montecarlo, 1976
Opera
• *Bianca e Fernando*
Directed by Sandro Sequi
Teatro Comunale, Genoa, 1978
Opera
• *Il trovatore*
Directed by Alberto Fassini
Teatro La Fenice, Venice, 1979
Opera
• *La buona figliola*
Directed by Alberto Fassini
Teatro Petruzzelli, Bari, 1980
Opera
• *Salome*
Directed by Alberto Fassini
Teatro Verdi, Trieste, 1980
Opera
• *Capuleti e Montecchi*
Directed by Giorgio Marini
Maggio Musicale Fiorentino, 1981
Opera
• *Samson et Dalila*
Directed by Alberto Fassini
Teatro Verdi, Trieste, 1981
Opera
• *Eugene Onegin*
Directed by Gian Carlo Menotti

Opéra, Paris, 1982
Opera
• *Orfeo ed Euridice*
(Christoph Willibald Gluck)
Directed by Alberto Fassini
Teatro La Fenice, Venice, 1982
Opera
• *Pelléas et Mélisande*
Directed by Gian Carlo Menotti
Teatro Comunale, Genoa, 1982
Opera
• *Manon Lescaut*
Directed by Carlo Maestrini
Teatro Regio, Turin, 1985
Opera
• *Orlando* (George Frideric Handel)
Directed by Virginio Puecher
Teatro La Fenice, Venice, 1985
Opera
• *La finta giardiniera*
Directed by Marise Flasch
Teatro Olimpico, Vicenza, 1986
Opera
• *La pietra del paragone*
Directed by Virginio Puecher
Teatro Comunale, Bologna,
1986
Opera
• *I vespri siciliani*
Directed by Luca Ronconi
Teatro Comunale, Bologna, 1986
Opera
• *Alina regina di Golconda*
Directed by Lorenza Codignola
Festival di Ravenna, 1987
Opera
• *La finta pazza*
Directed by Marise Flach
Teatro La Fenice, Venice, 1987
Opera
• *Manon*
Directed by Alberto Fassini
Teatro Comunale, Genoa, 1987
Opera
• *Una lettera d'amore*
Directed by Gianfranco Ventura
Teatro Verdi, Trieste, 1987
Opera
• *Werther*
Directed by Gianfranco Ventura
As.li.co., 1987
Opera
• *Adriana Lecouvreur*
Directed by Alberto Fassini
Teatro Comunale, Genoa, 1988
Opera
• *La Calisto*
Directed by Gerardo Vignoli
Teatro Olimpico, Vicenza, 1988
Opera
• *Paride ed Elena*
Directed by Walter Pagliaro
Teatro Olimpico, Vicenza, 1988
Opera
• *Linda di Chamounix*
Directed by Alberto Fassini
Teatro Verdi, Trieste, 1989
Opera

• *Loreley*
Directed by Alberto Fassini
Teatro Carlo Felice, Genoa, 1993
Opera
• *Werther*
Directed by Alberto Fassini
Teatro di San Carlo, Naples, 1996
Opera

Vittoria Guaita
• *Hamlet*
Directed by Gabriele Lavia
1978
Play

Franco Guandalini
• *Tosca*
Directed by Franco Guandalini
Teatro Municipale, Reggio Emilia,
1969
Opera

Peter Hall
• *La dama Boba*
Directed by Sandro Sequi
Vicenza, 1973
Play
• *Werther*
Directed by Sandro Sequi
Teatro Regio, Turin, 1973
Opera

Pet Halmen
• *Pelléas et Mélisande*
Directed by Pet Halmen
Teatro Bellini, Catania, 1995
Opera

Anne Marie Heinrech
• *La sonnambula*
Directed by Stefano Vizioli
Teatro Comunale, Treviso, 1993
Opera

Enrico Job
• *Don Giovanni*
(Wolfgang Amadeus Mozart)
Directed by Gustav Kuhn
Arena Sferisterio, Macerata,
1991
Opera

Patrick Kinmonth
• *La traviata*
Directed by Robert Carsen
Teatro La Fenice, Venice, 2004
Opera

Kevin Knight
• *I lombardi alla prima crociata*
Directed by Paul Curran
Maggio Musicale Fiorentino,
2005
Opera
• *Tannhäuser*
Directed by Paul Curran
Teatro alla Scala, Milan, 2005
Opera

Yannis Kokkos
• *Don Giovanni*
(Wolfgang Amadeus Mozart)
Directed by Yannis Kokkos
Festival of Orange, 1996
Opera

Roberto Laganà
• *Il castello del principe Barbablù*
Teatro Bellini, Catania, 1993
Opera
• *La medium*
Teatro Bellini, Catania, 1993
Opera

Karl Lagerfeld
• *At the Green Parrot*
Directed by Luca Ronconi
Teatro Stabile di Genova, 1978
Play
• *Countess Mizzie*
Directed by Luca Ronconi
Teatro Stabile di Genova, 1978
Play
• *Les contes d'Hoffmann*
Directed by Luca Ronconi
Teatro Comunale, Florence, 1980
Opera

Alessandro Lai
• *Pallido oggetto del desiderio*
Directed by Alfredo Arias
Teatro Stabile del Friuli Venezia
Giulia, 2002
Play
• *The Taming of the Shrew*
Directed by Marco Carniti
Teatro Romano, Verona, 2003
Play
• *Il trovatore*
Directed by Cristina Mazzavillani Muti
Festival di Ravenna, 2003
Opera
• *La pietra di diaspro*
Directed by Cristina Mazzavillani
Muti
Teatro dell'Opera, Rome, 2007
Opera
• *Il matrimonio inaspettato*
Directed by Andrea de Rosa
Festival di Salisburgo, 2008
Opera
• *I Promessi sposi – Opera moderna*
Directed by Michele Guardì
Stadio Meazza San Siro, Milan, 2010
Musical
• *Aida*
Directed by Ferzan Ozpetek
Maggio Musicale Fiorentino, 2011
Opera
• *Breakfast at Tiffany's*
Directed by Piero Maccarinelli
Teatro La Pergola, Florence, 2011
Play
• *Se non ci sono altre domande*
Directed by Paolo Virzì
Teatro Morlacchi, Perugia, 2011
Play

• *C come Chanel*
Directed by Roberto Piana
Teatro Comunale, Biella, 2012
Play
• *Furioso Orlando. Ballata in ariostesche rime per un cavalier narrante*
Directed by Marco Baliani
Teatro Stabile dell'Umbria / Nuovo Teatro, 2012
Play
• *Rigoletto*
Directed by Cristina Mazzavillani Muti
Festival di Ravenna, 2012
Opera
• *Sancta Susanna*
Directed by Chiara Muti
Festival di Ravenna, 2012
Opera
• *La traviata*
Directed by Ferzan Ozpetek
Teatro di San Carlo, Naples, 2012
Opera
• *Orfeo e Euridice* (Christoph Willibald Gluck)
Directed by Chiara Muti
Opéra Berlioz, Montpellier, 2013
Opera
• *Trilogia d'autunno: Verdi e Shakespeare – Macbeth / Otello / Falstaff*
Directed by Cristina Mazzavillani Muti
Festival di Ravenna, 2013
Opera
• *Faust Marlowe Burlesque*
Directed by Massimo Di Michele
Teatro Elfo Puccini, Milan, 2014
Play
• *Il vero amico [The True Friend]*
Directed by Lorenzo Lavia
Festival Teatrale di Borgio Verezzi, 2014
Play

Gabriele Lavia
• *Othello*
Directed by Gabriele Lavia
1975
Play
• *The Father*
Directed by Gabriele Lavia
1977
Play

Claude Lemaire
• *Le nozze di Figaro*
Directed by Antoine Vitez
Maggio Musicale Fiorentino, 1979
Opera

Giovanni Licheri, Alida Cappellini
• *L'italiana in Algeri*
Directed by Michele Mirabella
Teatro Bellini, Catania, 2012
Opera

• *Non è vero ma ci credo*
Directed by Michele Mirabella
Siracusa, 2012
Play
• *Die Fledermaus*
Directed by Michele Mirabella
Teatro Bellini, Catania, 2013
Operetta

Marina Luxardo
• *Demofoonte*
Directed by Cesare Lievi
Festival di Ravenna, 2009
Opera

Mino Maccari
• *Piramo e Tisbe*
(Johann Adolph Hasse)
Directed by Carlo E. Crespi
Accademia Filarmonica Romana, 1972
Opera
• *La scala di seta*
Directed by Bruno Cagli
Accademia Filarmonica Romana, 1976
Opera

Nica Magnani
• *Attila*
Directed by Flavio Ambrosini
Teatro Regio, Parma, 1983
Opera
• *Cavalleria rusticana*
Directed by Giorgio Belledi
Teatro Regio, Parma, 1986
Opera
• *Falstaff* (Antonio Salieri)
Directed by Goran Jeversfelt
Teatro Regio, Parma, 1986
Opera
• *Falstaff* (Giuseppe Verdi)
Directed by Goran Jeversfelt
Teatro Regio, Parma, 1986
Opera
• *Pagliacci*
Directed by Giorgio Belledi
Teatro Regio, Parma, 1986
Opera
• *L'elisir d'amore*
Directed by Francesca Zambella
Teatro Regio, Parma, 1988
Opera
• *La bohème* (Giacomo Puccini)
Directed by Francesca Zambella
Teatro Regio, Parma, 1989
Opera
• *Falstaff* (Giuseppe Verdi)
Directed by Mario Corradi
Opéra de Marseille, 1999
Opera

Florika Malureanu
Lucrezia Borgia
• Directed by Petrika Ionesco
Teatro La Fenice, Venice, 1984
Opera

Elena Mannini
• *Blood Wedding*
Directed by Beppe Menegatti
Estate Fiesolana, 1965
Play
• *Orlando Furioso* (Edoardo Sanguineti and Luca Ronconi after Ludovico Ariosto) (in part)
Directed by Luca Ronconi
Tour beginning in 1970
Play
• *Sono bella… ho un gran naso!* (Cristiano and Isabella)
Directed by Cristiano Censi
Nuovo Teatro delle Muse, Rome, 1969
Play
• *The Revenger's Tragedy*
Directed by Luca Ronconi
Teatro Metastasio, Prato, 1970
Play
• *Miss Julie*
Directed by Mario Missiroli
Teatro delle Arti, Rome, 1973
Play
• *The Life of Galileo*
Directed by Antonio Calenda
Teatro Stabile del Friuli Venezia Giulia / Teatro de Gli Incamminati, 2007
Play

Giacomo Manzù
• *Histoire du soldat*
Directed by Sandro Sequi, Maurice Béjart
Accademia Filarmonica Romana, 1966
Chamber opera
• *La follia di Orlando* (in part)
Choreography: Aurel Milloss
Teatro dell'Opera, Rome, 1969
Ballet
• *Tristan und Isolde*
Directed by Luigi Squarzina
Teatro La Fenice, Venice, 1971
Opera
• *Iphigénie en Tauride* (Christoph Willibald Gluck)
Directed by Sandro Sequi
Maggio Musicale Fiorentino, 1981
Opera
• *Macbeth*
Directed by Sandro Sequi
Teatro di San Carlo, Naples, 1984
Opera

Christine Marest
• *Il contrabbasso* (Valentino Bucchi)
Grand Théâtre, Bordeaux, 1981
Opera

Fiorella Mariani
• *Il barbiere di Siviglia* (Gioachino Rossini)
Directed by Sandro Sequi
Piccolo Teatro Musicale di Roma, 1965
Opera

• *La sonnambula*
Directed by Sandro Sequi
Teatro Massimo, Palermo, 1965
Opera
• *Non si sa come [You Don't Know How]*
Directed by Luigi Squarzina
Teatro Stabile di Genova, 1966
Play
• *Amelia al ballo*
Directed by Gian Carlo Menotti
Teatro dell'Opera, Rome, 1967
Opera
• *Un ballo in maschera*
Directed by Sandro Sequi
Maggio Musicale Fiorentino, 1972
Opera
• *Norma*
Directed by Sandro Sequi
Festival of Orange, 1974
Opera
• *Tosca*
Directed by Alberto Fassini
Teatro Verdi, Trieste, 1979
Opera

Lorena Marin
• *Lucia di Lammermoor*
Directed by Alfonso Romero
Teatro Rosalia Castro, La Coruña, 2013
Opera
• *Lucrezia Borgia*
Directed by Giulio Ciabatti
Teatro Verdi, Padua, 2013
Opera

Vera Marzot
• *Così è (se vi pare)*
[Right You Are (If You Think So)]
Directed by Mario Ferrero
1965
Play
• *The Wild Duck*
Directed by Luca Ronconi
Teatro Metastasio, Prato, 1977
Play
• *Sentimental Education*
Mayakovsky Company, 1977
Play
• *The Screens*
Mayakovsky Company, 1978
Play
• *Il vero amico [The True Friend]*
Directed by Gabriele Lavia
1978
Play
• *The School for Wives*
Directed by Michael Fink
1979
Play
• *The Blue Bird*
Directed by Luca Ronconi
Teatro Municipale, Reggio Emilia,
1979
Play
• *The Young Törless*
Directed by Massimo Luconi
1980
Play

• *Il ritratto di Dorian Gray*
(Franco Mannino)
Directed by Sandro Sequi
Teatro Bellini, Catania, 1981
Opera
• *La vedova scaltra*
[The Artful Widow]
Directed by Marisa Fabbri
Castiglioncello, 1981
Play
• *La traviata*
Directed by Luca Ronconi
Théâtre du Châtelet, Paris, 1985
Opera
• *Guglielmo Tell*
Directed by Luca Ronconi
Teatro alla Scala, Milan, 1988
Opera
• *Mirra*
Directed by Luca Ronconi
Teatro Stabile di Torino, 1988
Play
• *Oberon*
Directed by Luca Ronconi
Teatro alla Scala, Milan, 1989
Opera
• *Don Giovanni*
(Wolfgang Amadeus Mozart)
Directed by Luca Ronconi
Teatro Comunale, Bologna, 1990
Opera
• *Mademoiselle Molière*
(Giovanni Macchia)
Directed by Enzo Siciliano
Festival dei Due Mondi, Spoleto,
1992
Play
• *Armida* (Gioachino Rossini)
Directed by Luca Ronconi
Rossini Opera Festival, Pesaro, 1993
Opera

Barbara Mastroianni
• *The American Clock* (Arthur Miller)
Directed by Elio Petri
Teatro Stabile di Genova, 1981
Play

Ida Meo
• *La muta di Portici*
Directed by Micha van Hoecke
Festival di Ravenna, 1991
Opera

Maurizio Millenotti
• *Il turco in Italia*
Directed by Antonio Calenda
Teatro Comunale, Bologna, 1994
Opera
• *Il barbiere di Siviglia*
(Gioachino Rossini)
Directed by Marco Gandini
Garsington Opera, Oxford, 2003
Opera
• *Cavalleria rusticana*
Directed by Marco Gandini
Comitato Estate Livornese, 2004
Opera

• *Edipo XXI* (after Sophocles)
Directed by Lluís Pasqual
Teatro del Veneto, 2008
Play
• *Cactus Flower*
Directed by Guglielmo Ferro
Rome, 2008
Play
• *'Tis Pity She's a Whore*
Directed by Luca De Fusco
Teatro del Veneto, 2008
Play
• *Cavalleria rusticana*
Directed by Ermanno Olmi
Teatro La Fenice, Venice, 2009
Opera
• *L'impresario delle Smirne*
[The Impresario from Smyrna]
Directed by Luca De Fusco
Teatro Stabile di Catania, 2009
Play
• *Sàrka*
Directed by Ermanno Olmi
Teatro La Fenice, Venice, 2009
Opera
• *Falstaff* (Giuseppe Verdi)
Directed by Franco Zeffirelli
Teatro dell'Opera, Rome, 2010
Opera
• *Tosca*
Directed by Luca De Fusco
Teatro di San Carlo, Naples, 2010
Opera
• *Vestire gli ignudi [Clothe the Naked]*
Directed by Luca De Fusco
Teatro del Veneto, 2010
Play
• *Lucia di Lammermoor*
Directed by Gianni Amelio
Teatro di San Carlo, Naples, 2011
Opera
• *Turandot*
Directed by Franco Zeffirelli
Royal Opera House, Muscat, 2011
Opera
• *Il viaggio a Reims*
Directed by Marco Gandini
Maggio Musicale Fiorentino, 2011
Opera
• *Simon Boccanegra*
Directed by Adrian Noble
Teatro dell'Opera, Rome, 2012
Opera
• *Circo Equestre Sgueglia*
[Sgueglia Equestrian Circus]
Directed by Alfredo Arias
Naples, 2013
Play
• *Elektra*
Directed by Gianni Amelio
Teatro Petruzzelli, Bari, 2013
Opera
• *Falstaff* (Giuseppe Verdi)
Directed by Luca Ronconi
Teatro Petruzzelli, Bari, 2013
Opera
• *The Cherry Orchard*
Directed by Luca De Fusco

Teatro Stabile di Napoli, 2014
Play

Lucia Mirisola
• *La santa sulla scopa*
Directed by Luigi Magni
Teatro La Cometa, Rome, 1986
Play
• *La Tosca*
(by Renato Greco after Luigi Magni)
Directed by Luigi Magni
Teatro Greco, Rome, 2011
Musical comedy

Hubert Monloup
• *La forza del destino*
Directed by Jean-Claude Auvray
Grand Théâtre, Geneva, 1979
Opera
• *La Gioconda*
Directed by Jean-Claude Auvray
Grand Théâtre, Geneva, 1979
Opera
• *La grande duchesse*
Directed by Jean-Claude Auvray
Toulouse, 1979
Opera
• *Il trovatore*
Directed by Jean-Claude Auvray
Lyon, 1979
Opera
• *La Gioconda*
Directed by Nicolas Joel
Opéra, Montepellier,
1986
Opera

Maurizio Monteverde
• *Ippolito*
Directed by Sandro Bolchi
Vicenza, 1965
Play
• *Lucia di Lammermoor*
Directed by Sandro Bolchi
Teatro Comunale, Bologna,
1965
Opera
• *Antigone*
Directed by Mario Ferrero
Siracusa, 1966
Play
• *Seven from Thebes*
Directed by Giuseppe Di Martino
Siracusa, 1966
Play
• *Agamemnon*
Directed by Davide Montemurri
Vicenza, 1967
Play
• *Questo strano animale*
(Gabriel Arout after Anton Chekhov)
Directed by José Quaglio
1967
Play
• *La fiaccola sotto il moggio*
Directed by Davide Montemurri
Gardone, 1968
Play

• *Staircase*
Directed by Sandro Bolchi
Teatro Eliseo, Rome, 1968
Play
• *Life with Father*
Directed by Sandro Bolchi
1968
Play
• *Le donne* (after Aristophanes)
Directed by Mario Prosperi
Segesta, 1969
Play
• *Il berretto a sonagli*
[Cap and Bells]
Directed by Turi Ferro
Teatro Stabile di Catania, 1971
Play
• *Don't Wake the Lady*
Directed by Lucio Ardenzi
1971
Play
• *La vita che ti diedi*
[The Life I Gave You]
Directed by Mario Ferrero
1973
Play
• *The Free Trade Hotel*
Directed by Pier Antonio Barbieri
Teatro Stabile di Padova, 1974
Play
• *The Crucible*
Directed by Sandro Bolchi
Teatro Stabile di Trieste, 1974
Play
• *The Importance of Being Earnest*
Directed by Pier Antonio Barbieri
Teatro Stabile di Padova, 1975
Play
• *La vedova scaltra*
[The Artful Widow]
Directed by Pier Antonio Barbieri
Teatro Stabile di Padova, 1975
Play
• *Herodiade*
Directed by Antonio Calenda
Teatro dell'Opera, Rome, 1986
Opera

**Maurizio Monteverde,
Piero Tosi**
• *La locandiera*
[The Mistress of the Inn]
Directed by Luchino Visconti,
Giorgio De Lullo
Teatro Parioli, Rome, 1981
Play

Odette Nicoletti
• *La dama di picche*
Directed by Flavio Ambrosini
Teatro Comunale, Bologna, 1983
Opera

Chloé Obolensky
• *Death in Venice*
Directed by Deborah Warner
Teatro alla Scala, Milan, 2011
Opera

Timothy O'Brian
• *Werther*
Directed by Graham Vick
Teatro Nacional de São Carlos,
Lisbon, 2004
Opera

William Orlandi
• *La dama di picche*
Directed by Gilbert Deflo
Gran Teatre del Liceu, Barcelona,
1991
Opera

Carles Ortiz Olivan
• *Il trovatore*
Directed by Carles Ortiz Olivan
Amics de s'Òpera de Maó, Minorca,
2011
Opera

**Françoise Pace-Raybaud,
Nathalie Bérard-Benoin**
• *Dreyfus*
Directed by Daniel Benoin
Théâtre Nationale, Nice, 2014
Opera

Gianfranco Padovani
• *I rusteghi*
Directed by Luigi Squarzina
Teatro Stabile di Genova,
1969–70
Play
• *Mother Courage and Her Children*
Directed by Luigi Squarzina
Teatro Stabile di Genova, 1970
Play
• *8 Settembre*
Directed by Luigi Squarzina
Teatro Stabile di Genova, 1970–71
Play
• *Julius Caesar* (William Shakespeare)
Directed by Luigi Squarzina
Teatro Stabile di Genova, 1971
Play
• *Il Tartufo ovvero Vita amori
autocensura e morte in scena
del signor di Molière nostro
contemporaneo*
Directed by Luigi Squarzina
Teatro Stabile di Genova, 1971
Play
• *Questa sera si recita a soggetto*
[Tonight We Improvise]
Directed by Luigi Squarzina
Teatro Stabile di Genova, 1971–72
Play
• *La casa nova [The New House]*
Directed by Luigi Squarzina
Teatro Stabile di Genova, 1972–73
Play
• *The Caucasian Chalk Circle*
Directed by Luigi Squarzina
Teatro Stabile di Genova, 1973–74
Play
• *The Learned Ladies*
Directed by Luigi Squarzina

Teatro Stabile di Genova, 1977–78
Play
• *Norma*
Teatro Comunale, Genoa, 1994
Opera
• *Pagliacci*
Directed by Gianni Amelio
Teatro Carlo Felice, Genoa, 1995
Opera
• *Il tabarro*
Directed by Gianni Amelio
Teatro Carlo Felice, Genoa, 1995
Opera
• *Pagliacci*
Directed by Sebastiano Lo Monaco
Teatro Carlo Felice, Genoa, 2007
Opera

Mauro Pagano
• *Don Pasquale*
Directed by Ferruccio Soleri
Teatro Comunale, Modena, 1978
Opera
• *Il sosia*
Directed by Virginio Puecher
Piccola Scala, Milan, 1981
Opera

Ursula Patzak
• *Le nozze di Figaro*
Directed by Mario Martone
Teatro di San Carlo, Naples, 2006
Opera
• *Tosca*
Directed by Mario Martone
Centro Servizi Culturali Santa Chiara,
Trento, 2009
Opera
• *Operette Morali*
[Small Moral Works]
Directed by Mario Martone
Teatro Stabile di Torino, 2011
Play
• *Don Giovanni*
(Wolfgang Amadeus Mozart)
Directed by Mario Martone
Teatro Petruzzelli, Bari, 2012
Opera
• *Aureliano in Palmira*
Directed by Mario Martone
Rossini Opera Festival, Pesaro,
2014
Opera

Gabriella Pescucci
• *Francesca da Rimini*
Directed by Franco Guandalini
Teatro Municipale, Reggio Emilia,
1970
Opera
• *Norma*
Directed by Mauro Bolognini
Teatro alla Scala, Milan, 1972
Opera
• *Persone naturali e strafottenti*
Directed by Giuseppe Patroni Griffi
1973
Play

• *The Abdication*
Directed by Giuseppe Patroni Griffi
1977
Play
• *Le femmine puntigliose*
[The Punctilious Ladies]
Directed by Giuseppe Patroni Griffi
1978
Play
• *Manon Lescaut*
Directed by Piero Faggioni
Teatro alla Scala, Milan, 1978
Opera
• *Vita di Shakespeare*
Directed by Gabriele Lavia
1978
Play
• *Il barbiere di Siviglia*
(Gioachino Rossini)
Directed by Jean-Marie Simon
Opéra, Paris, 1982
Opera
• *Orfeo* (Claudio Monteverdi)
Directed by Claude Goretta
Aix-en-Provence Festival, 1985
Opera
• *Questa sera si recita a soggetto*
[Tonight We Improvise]
Directed by Giuseppe Patroni Griffi
Teatro Stabile del Friuli Venezia
Giulia, 1987
Play
• *Ciascuno a suo modo*
[To Each His Own]
Directed by Giuseppe Patroni Griffi
Teatro Stabile del Friuli Venezia
Giulia, 1988
Play
• *Sei personaggi in cerca d'autore*
[Six Characters in Search of an Author]
Directed by Giuseppe Patroni Griffi
Teatro Stabile del Friuli Venezia
Giulia, 1988
Play
• *Dante Symphonie*
Coreografia: Micha van Hoecke
Festival di Ravenna, 1990
Ballet
• *La traviata*
Directed by Liliana Cavani
Teatro alla Scala, Milan, 1990
Opera
• *Last Days of Humanity*
Directed by Luca Ronconi
Ex Sala Presse del Lingotto, Turin, 1990
Play
• *Cardillac*
Directed by Liliana Cavani
Teatro Comunale, Florence, 1991
Opera
• *Jenufa*
Directed by Liliana Cavani
Teatro Comunale, Florence, 1993
Opera
• *La vestale*
Directed by Liliana Cavani
Teatro alla Scala, Milan, 1993
Opera

• *La bohème* (Giacomo Puccini)
Directed by Jonathan Miller
Teatro Comunale, Florence, 1994
Opera
• *Manon Lescaut*
Directed by Gian Carlo Menotti
Teatro dell'Opera, Rome, 1994
Opera
• *Cavalleria rusticana*
Directed by Liliana Cavani
Festival di Ravenna, 1996
Opera
• *Manon Lescaut*
Directed by Liliana Cavani
Teatro alla Scala, Milan, 1998
Opera
• *La sonnambula*
Directed by Federico Tiezzi
Maggio Musicale Fiorentino, 2000
Opera
• *Don Pasquale*
Directed by Andrea De Rosa
Festival di Ravenna, 2007
Opera
• *Giulietta e Romeo*
Directed by Stefano Carrubba
Arena, Verona, 2007
Musical
• *La Betulia liberata*
Directed by Marco Gandini
Festival di Ravenna, 2010
Oratorio
• *The Game of Love and Chance*
Directed by Piero Maccarinelli
Florence, 2013
Play

**Gabriella Pescucci,
Flora Brancatella**
• *Pagliacci*
Directed by Liliana Cavani
Teatro Comunale, Bologna, 1998
Opera
• *Norma*
Directed by Daniele Abbado
Arena Sferisterio, Macerata, 2001
Opera
• *Jenufa*
Directed by Liliana Cavani
Teatro Carlo Felice, Genoa, 2003
Opera
• *Werther*
Directed by Liliana Cavani
Teatro Comunale, Bologna, 2004
Opera

**Gabriella Pescucci,
Carlo Poggioli**
• *Strange Interlude*
Directed by Luca Ronconi
Teatro Stabile di Torino, 1990
Play

Gabriella Pescucci, Piero Tosi
• *Manon Lescaut*
Directed by Luchino Visconti
Festival dei Due Mondi, Spoleto, 1973
Opera

Marco Piemontese
• *The Forest*
Directed by Brian Kulick
Classic Stage Company, New York, 2010
Play
• *Three Sisters*
Directed by Austin Pendleton
Classic Stage Company, New York, 2010
Play
• *The Cherry Orchard*
Directed by Andrei Belgrader
Classic Stage Company, New York, 2011
Play
• *Ivanov*
Directed by Austin Pendleton
Classic Stage Company, New York, 2012
Play
• *The Master Builder*
Directed by Andrei Belgrader
Brooklyn Academy of Music, 2013
Play

Pier Luigi Pizzi
• *Two Gentlemen of Verona*
Directed by Giorgio De Lullo
Teatro Romano, Verona, 1965
Play
• *Il giuoco delle parti*
[The Rules of the Game]
Directed by Giorgio De Lullo
Teatro Eliseo, Rome, 1965
Play
• *Three Sisters*
Directed by Giorgio De Lullo
Teatro Eliseo, Rome, 1965
Play
• *La Calandria*
Directed by Giorgio De Lullo
Teatro La Fenice, Venice, 1966
Play
• *Il gattopardo* (Angelo Musco)
(in part)
Directed by Luigi Squarzina
Teatro Massimo, Palermo, 1967
Opera
• *Bouvard and Pécuchet*
Directed by Luigi Squarzina
Teatro Stabile di Genova, 1968
Play
• *Medea* (Luigi Cherubini)
Directed by Alberto Fassini
Teatro La Fenice, Venice, 1968
Opera
• *Mosè*
Directed by Alberto Fassini
Teatro La Fenice, Venice, 1968
Opera
• *Belisario*
Directed by Alberto Fassini
Teatro La Fenice, Venice, 1969
Opera
• *Hedda Gabler*
Directed by Giorgio De Lullo
Teatro Carignano, Turin, 1969
Play

• *Armida* (Gioachino Rossini)
Directed by Alberto Fassini
Teatro La Fenice, Venice, 1970
Opera
• *Juditha triumphans*
Directed by Sandro Sequi
Accademia Filarmonica Romana, 1970
Opera
• *La traviata*
Directed by Mauro Bolognini
Arena, Verona, 1970
Opera
• *La traviata*
Directed by Giorgio De Lullo
Lyric Opera, Chicago, 1970
Opera
• *La bugiarda*
Directed by Giorgio De Lullo
Teatro Morlacchi, Perugia, 1971
Play
• *Il corsaro*
Directed by Alberto Fassini
Teatro La Fenice, Venice, 1971
Opera
• *Julius Caesar* (William Shakespeare)
Directed by Giorgio De Lullo
Teatro Argentina, Rome, 1971
Play
• *Il matrimonio segreto*
Directed by Sandro Sequi
Accademia Filarmonica Romana, 1971
Opera
• *Tosca*
Directed by Tito Gobbi
Lyric Opera, Chicago, 1971
Opera
• *Turandot*
Directed by Luigi Squarzina
Maggio Musicale Fiorentino, 1971
Opera
• *La bohème* (Giacomo Puccini)
Directed by Giorgio De Lullo
Lyric Opera, Chicago, 1972
Opera
• *La centaura*
Directed by Luca Ronconi
Accademia Nazionale d'Arte Drammatica, Rome, 1972
Play
• *Così e (se vi pare)*
[Right You Are (if You Think So)]
Directed by Giorgio De Lullo
Teatro Valle, Rome, 1972
Play
• *Macbeth*
Directed by Alberto Fassini
Teatro Comunale, Bologna, 1972
Opera
• *Roberto Devereux*
Directed by Alberto Fassini
Teatro La Fenice, Venice, 1972
Opera
• *Aida*
Directed by Luigi Squarzina
NHK Theatre, Tokyo, 1973
Opera

• *La dama di picche*
Directed by Alberto Fassini
Teatro Verdi, Trieste, 1973
Opera
• *Stasera Feydeau*
Directed by Giorgio De Lullo
Teatro Valle, Rome, 1973
Play
• *A Game of Chess*
Directed by Luca Ronconi
Accademia Nazionale d'Arte Drammatica, Rome, 1973
Play
• *Gianni Schicchi*
Directed by Tito Gobbi
Opernhaus, Zurigo, 1974
Opera
• *The Imaginary Invalid*
Directed by Giorgio De Lullo
Festival dei Due Mondi, Spoleto, 1974
Play
• *Simon Boccanegra*
Directed by Giorgio De Lullo
Lyric Opera, Chicago, 1974
Opera
• *Il tabarro*
Directed by Tito Gobbi
Opernhaus, Zurich, 1974
Opera
• *La traviata*
Directed by Mauro Bolognini
Teatro Comunale, Bologna, 1974
Opera
• *Trovarsi*
Directed by Giorgio De Lullo
Teatro Valle, Rome, 1974
Play
• *Antonio von Elba*
Directed by Luciano Mondolfo
Teatro Metastasio, Prato, 1975
Play
• *Carmen*
Directed by Virginio Puecher
Teatro Comunale, Bologna, 1975
Opera
• *Faust*
Directed by Luca Ronconi
Teatro Comunale, Bologna, 1975
Opera
• *Otello* (Giuseppe Verdi)
Directed by Giorgio De Lullo
Lyric Opera, Chicago, 1975
Opera
• *Otello* (Giuseppe Verdi)
Directed by Alberto Fassini
Teatro Verdi, Trieste, 1975
Opera
• *Tutto per bene [All for the Best]*
Directed by Giorgio De Lullo
Teatro Metastasio, Prato, 1975
Play
• *Cavalleria rusticana*
Directed by Luciana Novaro
Tokyo, 1976
Opera
• *Il giuoco delle parti*
[The Rules of the Game]
Directed by Giorgio De Lullo

Teatro Eliseo, Rome, 1976
Play
• *Orfeo e Euridice*
(Christoph Willibald Gluck)
Directed by Luca Ronconi
Maggio Musicale Fiorentino, 1976
Opera
• *Pagliacci*
Directed by Luciana Novaro
Tokyo, 1976
Opera
• *No Man's Land*
Directed by Giorgio De Lullo
Teatro Metastasio, Prato, 1976
Play
• *Don Giovanni*
(Wolfgang Amadeus Mozart)
Directed by Pier Luigi Pizzi
Teatro Regio, Turin, 1977
Opera
• *Enrico IV* (Luigi Pirandello)
Directed by Giorgio De Lullo
Teatro Morlacchi, Perugia, 1977
Play
• *Manon Lescaut*
Directed by Giorgio De Lullo
Lyric Opera, Chicago, 1977
Opera
Il trovatore
Directed by Luca Ronconi
Teatro Comunale, Florence, 1977
Opera
• *Aida*
Directed by Alberto Fassini
Festival di Nervi, 1978
Opera
• *Fedora*
Directed by Pier Luigi Pizzi
Teatro Comunale, Bologna, 1978
Opera
• *Gin Game*
Directed by Giorgio De Lullo
Festival dei Due Mondi, Spoleto, 1978
Play
• *Les Martyrs*
Directed by Alberto Fassini
Teatro La Fenice, Venice, 1978
Opera
• *Orlando Furioso* (Antonio Vivaldi)
Directed by Pier Luigi Pizzi
Teatro Filarmonico, Verona, 1978
Opera
• *Parisina*
Directed by Pier Luigi Pizzi
Teatro dell'Opera, Rome, 1978
Opera
• *Die Zauberflöte*
Directed by Hans Werner Henze
Staatstheater, Stuttgart, 1978
Opera
• *Come tu mi vuoi [As You Want Me]*
Directed by Susan Sontag
Teatro Carignano, Turin, 1979
Play
• *I diavoli di Loudun*
Directed by Pier Luigi Pizzi
Teatro dell'Opera, Rome, 1979
Opera

• *Diversions and Delights*
Directed by Giorgio De Lullo
Teatro Eliseo, Rome, 1979
Play
• *Twelfth Night*
Directed by Giorgio De Lullo
Teatro Eliseo, Rome, 1979
Play
• *The Seagull*
Directed by Gabriele Lavia
Teatro Bonci, Cesena, 1979
Play
• *O di uno o di nessuno*
[Either of One or No One]
Directed by Giuseppe Patroni Griffi
Piccolo Eliseo, Rome, 1979
Play
• *Porporino* (Roger Blanchard after
Nicola Antonio Porpora)
Directed by Patrick Guinaud
Aix-en-Provence Festival, 1979
Opera
• *Prima del Silenzio*
Directed by Giorgio De Lullo
Teatro Eliseo, Rome, 1979
Play
• *Das Rheingold*
Directed by Luca Ronconi
Maggio Musicale Fiorentino,
1979
Opera
• *Rigoletto*
Directed by Pier Luigi Pizzi
Teatro Verdi, Trieste, 1979
Opera
• *Les Pêcheurs de Perles*
Directed by Pier Luigi Pizzi
Teatro Comunale, Bologna,
1980
Opera
• *Semiramide*
Directed by Pier Luigi Pizzi
Aix-en-Provence Festival, 1980
Opera
• *Three Sisters*
Directed by Giorgio De Lullo
Teatro Parioli, Rome, 1980
Play
• *Ariodante*
Directed by Pier Luigi Pizzi
Piccola Scala, Milan, 1981
Opera
• *The Miser*
Directed by Giuseppe Patroni Griffi
Teatro Biondo, Palermo, 1981
Play
• *Il cardinale Lambertini*
Directed by Luigi Squarzina
Teatro Argentina, 1981
Play
• *Die Götterdämmerung*
Directed by Luca Ronconi
Maggio Musicale Fiorentino, 1981
Opera
• *La nuit et le moment*
Directed by Pier Luigi Pizzi
Teatro Asioli, Correggio, 1981
Play

• *Troilus and Cressida*
Directed by Pier Luigi Pizzi
Teatro Romano, Verona, 1981
Play
• *L'assedio di Corinto*
Directed by Pier Luigi Pizzi
Teatro Comunale, Florence, 1982
Opera
• *Oedipus at Colonus* (Sophocles)
Directed by Glauco Mauri
Teatro Raffaello Sanzio, Urbino, 1982
Play
• *Oedipus Rex* (Sophocles)
Directed by Glauco Mauri
Teatro Raffaello Sanzio, Urbino, 1982
Play
• *Macbeth*
Directed by Pier Luigi Pizzi
Théâtre du Châtelet, Paris, 1982
Opera
• *The Prince of Homburg*
Directed by Walter Pagliaro
Teatro Stabile di Genova, 1982
Play
• *Tancredi*
Directed by Pier Luigi Pizzi
Rossini Opera Festival, Pesaro, 1982
Opera
• *Betrayal*
Directed by Giuseppe Patroni Griffi
Teatro delle Arti, Rome, 1982
Play
• *Amphitryon*
Directed by Walter Pagliaro
Teatro Stabile di Genova, 1983
Play
• *La Battaglia di Legnano*
Directed by Pier Luigi Pizzi
Teatro dell'Opera, Rome, 1983
Opera
• *Hippolyte et Aricie*
Directed by Pier Luigi Pizzi
Aix-en-Provence Festival, 1983
Opera
• *Les Indes Galantes*
Directed by Pier Luigi Pizzi
Théâtre du Châtelet, Paris, 1983
Opera
• *Là ci darem la mano*
Coreography by Amedeo Amodio
Teatro delle Celebrazioni, Bologna,
1983
Ballet
• *Mosè in Egitto*
Directed by Pier Luigi Pizzi
Rossini Opera Festival, Pesaro,
1983
Opera
• *Parsifal*
Directed by Pier Luigi Pizzi
Teatro La Fenice, Venice, 1983
Opera
• *Alceste*
Directed by Pier Luigi Pizzi
Grand Théâtre, Geneva, 1984
Opera
• *Le Comte Ory*
Directed by Pier Luigi Pizzi

Rossini Opera Festival, Pesaro, 1984
Opera
• *Johannes Passion*
Directed by Pier Luigi Pizzi
Teatro La Fenice, Venice, 1984
Oratorio
• *Orfeo* (Claudio Monteverdi, Luciano Berio)
Directed by Pier Luigi Pizzi
Courtyard of Palazzo Pitti, Florence, 1984
Opera
• *Salome*
Directed by Pier Luigi Pizzi
Teatro Valli, Reggio Emilia, 1984
Opera
• *Aroldo*
Directed by Pier Luigi Pizzi
Teatro La Fenice, Venice, 1985
Opera
• *Don Carlo*
Directed by Pier Luigi Pizzi
Maggio Musicale Fiorentino, 1985
Opera
• *Der Freischütz*
Directed by Pier Luigi Pizzi
Teatro Comunale, Bologna, 1985
Opera
• *Le grand bal de la Belle Époque*
Directed by Pier Luigi Pizzi
Teatro La Fenice, Venice, 1985
Musical evening
• *Maometto II*
Directed by Pier Luigi Pizzi
Rossini Opera Festival, Pesaro, 1985
Opera
• *Il re pastore*
Directed by Pier Luigi Pizzi
Teatro Olimpico, Vicenza, 1985
Opera
• *Rinaldo*
Directed by Pier Luigi Pizzi
Teatro Valli, Reggio Emilia, 1985
Opera
• *Stiffelio*
Directed by Pier Luigi Pizzi
Teatro La Fenice, Venice, 1985
Opera
• *Bianca e Falliero*
Directed by Pier Luigi Pizzi
Rossini Opera Festival, Pesaro, 1986
Opera
• *La clemenza di Tito*
Directed by Pier Luigi Pizzi
Teatro La Fenice, Venice, 1986
Opera
• *Dido and Aeneas* (Henry Purcell)
(part of an event entitled *Nel giorno di Santa Cecilia [On St Cecilia's Day]*)
Directed by Pier Luigi Pizzi
Teatro Valli, Reggio Emilia, 1986
Opera
• *Ode on St Cecilia's Day*
(Henry Purcell) (part of an event entitled *Nel giorno di Santa Cecilia [On St Cecilia's Day]*)

Directed by Pier Luigi Pizzi
Teatro Valli, Reggio Emilia, 1986
Ode
• *I puritani*
Directed by Pier Luigi Pizzi
Teatro Petruzzelli, Bari, 1986
Opera
• *Serata Futurista [Futurist Evening]*
(various authors)
Directed by Pier Luigi Pizzi
Teatro La Fenice, Venice, 1986
Musical evening
• *Armida* (Gioachino Rossini)
Directed by Pier Luigi Pizzi
Opernhaus, Bonn, 1987
Opera
• *Il cappello di paglia di Firenze*
Directed by Pier Luigi Pizzi
Teatro Valli, Reggio Emilia, 1987
Opera
• *Lohengrin*
Directed by Pier Luigi Pizzi
Teatro La Fenice, Venice, 1987
Opera
• *La traviata*
Directed by Pier Luigi Pizzi
Opéra, Montecarlo, 1989
Opera
• *Les Danaides*
Directed by Pier Luigi Pizzi
Festival di Ravenna, 1990
Opera
• *Emma B. Vedova Giocasta*
(Alberto Savinio)
Directed by Pier Luigi Pizzi
Studio du Rondpoint, Paris, 1990
Play
• *La leggenda della città invisibile di Kitez*
Directed by Pier Luigi Pizzi
Maggio Musicale Fiorentino, 1990
Opera
• *Castor et Pollux*
Directed by Pier Luigi Pizzi
Aix-en Provence Festival, 1991
Opera
• *Samson et Dalila*
Directed by Pier Luigi Pizzi
Opéra Bastille, Paris, 1991
Opera
• *Tancredi*
Directed by Pier Luigi Pizzi
Rossini Opera Festival, Pesaro, 1991
Opera
• *Armide* (Christoph Willibald Gluck)
Directed by Pier Luigi Pizzi
Court Theatre, Versailles, 1992
Opera
• *Poliuto*
Directed by Pier Luigi Pizzi
Festival di Ravenna, 1992
Opera
• *Tancredi*
Directed by Pier Luigi Pizzi
Festspiele, Schwetzingen, 1992
Opera
• *Buovo D'Antona*
Directed by Pier Luigi Pizzi

Teatro La Fenice, Venice, 1993
Opera
• *Mosè*
Directed by Pier Luigi Pizzi
Teatro La Fenice, Venice, 1993
Opera
• *La Cenerentola*
Directed by Pier Luigi Pizzi
Opéra, Montecarlo, 1995
Opera
• *Le martyre de Saint Sébastien*
Directed by Pier Luigi Pizzi
Teatro La Fenice, Venice, 1995
Opera
• *Orfeo* (Ferdinando Bertoni)
Directed by Pier Luigi Pizzi
Opéra, Montecarlo, 1995
Opera
• *Pelléas et Mélisande*
Directed by Pier Luigi Pizzi
Teatro La Fenice, Venice, 1995
Opera
• *Armide* (Christoph Willibald Gluck)
Directed by Pier Luigi Pizzi
Teatro alla Scala, Milan, 1996
Opera
• *Les Martyrs*
Directed by Pier Luigi Pizzi
Opéra, Nancy, 1996
Opera
• *Nascita di Orfeo* (Lorenzo Ferrero)
Directed by Pier Luigi Pizzi
Teatro Filarmonico, Verona, 1996
Opera
• *Der Rosenkavalier*
Directed by Pier Luigi Pizzi
Teatro Carlo Felice, Genoa, 1996
Opera
• *Attila*
Directed by Pier Luigi Pizzi
Festival di Ravenna, 1997
Opera
• *Orfeo* (Claudio Monteverdi)
Directed by Pier Luigi Pizzi
Megaron, Athens, 1997
Opera
• *Un giorno di regno*
Directed by Pier Luigi Pizzi
Teatro Regio, Parma, 1997
Opera
• *Gli amori d'Apollo e di Dafne*
Directed by Pier Luigi Pizzi
Teatro della Fortuna, Fano, 1998
Opera
• *Dom Sébastien, roi de Portugal*
Directed by Pier Luigi Pizzi
Teatro Donizetti, Bergamo, 1998
Opera
• *Il turco in Italia*
Directed by Pier Luigi Pizzi
Opéra, Montecarlo, 1998
Opera
• *Death in Venice*
Directed by Pier Luigi Pizzi
Teatro Carlo Felice, Genoa, 1999
Opera

- *Orfeo* (Antonio Sartorio)
Directed by Pier Luigi Pizzi
Teatro della Fortuna, Fano, 1999
Opera
- *Tamerlano* (Antonio Vivaldi)
Directed by Pier Luigi Pizzi
International Istanbul Music Festival,
1999
Opera
- *Celos aun del aire matan*
Directed by Pier Luigi Pizzi
Teatro Real, Madrid, 2000
Opera
- *I due Foscari*
Directed by Pier Luigi Pizzi
Teatro dell'Opera, Rome, 2001
Opera
- *Falstaff* (Giuseppe Verdi)
Directed by Pier Luigi Pizzi
Teatro Comunale, Bologna, 2001
Opera
- *Le nozze di Teti e Peleo*
Directed by Pier Luigi Pizzi
Rossini Opera Festival, Pesaro,
2001
Opera
- *I puritani*
Directed by Pier Luigi Pizzi
Teatro Carlo Felice, Genoa, 2001
Opera
- *Il trovatore*
Directed by Pier Luigi Pizzi
Maggio Musicale Fiorentino, 2001
Opera
- *Die Zauberflöte [The Magic Flute]*
Directed by Pier Luigi Pizzi
Teatro dell'Opera, Rome, 2001
Opera
- *Euryanthe*
Directed by Pier Luigi Pizzi
Teatro Lirico, Cagliari, 2002
Opera
- *Idomeneo*
Directed by Pier Luigi Pizzi
Teatro delle Muse, Ancona, 2002
Opera
- *La pietra del paragone*
Directed by Pier Luigi Pizzi
Rossini Opera Festival, Pesaro, 2002
Opera
- *Thaïs*
Directed by Pier Luigi Pizzi
Teatro Malibran, Venice, 2002
Opera
- *Aroldo*
Directed by Pier Luigi Pizzi
Teatro Municipale, Piacenza, 2003
Opera
- *Le domino noir*
Directed by Pier Luigi Pizzi
Teatro La Fenice, Venice, 2003
Opera
- *La traviata*
Directed by Pier Luigi Pizzi
Teatro Real, Madrid, 2003
Opera
- *Les contes d'Hoffmann*
Directed by Pier Luigi Pizzi

Arena Sferisterio, Macerata, 2004
Opera
- *Hans Heiling*
Directed by Pier Luigi Pizzi
Teatro Lirico, Cagliari, 2004
Opera
- *Les pêcheurs de perles*
Directed by Pier Luigi Pizzi
Teatro Malibran, Venice, 2004
Opera
- *Un ballo in maschera*
Directed by Pier Luigi Pizzi
Piacenza Expo, 2004
Opera
- *I vespri siciliani*
Directed by Pier Luigi Pizzi
Teatro Regio, Busseto, 2004
Opera
- *Andrea Chénier*
Directed by Pier Luigi Pizzi
Arena Sferisterio, Macerata, 2005
Opera
- *Ernani*
Directed by Pier Luigi Pizzi
Teatro Filarmonico, Verona, 2005
Opera
- *Maometto II*
Directed by Pier Luigi Pizzi
Teatro La Fenice, Venice, 2005
Opera
- *Semiramide*
Directed by Pier Luigi Pizzi
Teatro dell'Opera, Rome, 2005
Opera
- *Die Zauberflöte [The Magic Flute]*
(in part)
Directed by Pier Luigi Pizzi
Arena Sferisterio, Macerata, 2006
Opera
- *Una delle ultime sere di Carnovale*
[One of the Last Nights of Carnival]
Directed by Pier Luigi Pizzi
Scuola Grande di San Giovanni
Evangelista, Venice, 2007
Play
- *Carmen*
Directed by Dante Ferretti
Arena Sferisterio, Macerata, 2008
Opera
- *Cleopatra* (Lauro Rossi)
Directed by Pier Luigi Pizzi
Arena Sferisterio, Macerata, 2008
Opera
- *Orfeo* (Claudio Monteverdi)
Directed by Pier Luigi Pizzi
Teatro Real, Madrid, 2008
Opera
- *Der Vampyr*
Directed by Pier Luigi Pizzi
Teatro Comunale di Bologna, 2008
Opera
- *La vedova allegra*
[The Merry Widow]
Directed by Pier Luigi Pizzi
Teatro alla Scala, Milan, 2008
Operetta
- *Don Giovanni*
(Wolfgang Amadeus Mozart)

Directed by Pier Luigi Pizzi
Arena Sferisterio, Macerata, 2009
Opera
- *Madama Butterfly*
Directed by Pier Luigi Pizzi
Arena Sferisterio, Macerata, 2009
Opera
- *Mozart*
(Sacha Guitry, Reynaldo Hahn)
Directed by Pier Luigi Pizzi
Festival dei Due Mondi, Spoleto,
2009
Musical comedy
- *Die Tote Stadt*
Directed by Pier Luigi Pizzi
Teatro La Fenice, Venice, 2009
Opera
- *Faust*
Directed by Pier Luigi Pizzi
Arena Sferisterio, Macerata, 2010
Opera
- *La forza del destino*
Directed by Pier Luigi Pizzi
Arena Sferisterio, Macerata, 2010
Opera
- *I lombardi alla prima Crociata*
Directed by Pier Luigi Pizzi
Arena Sferisterio, Macerata, 2010
Opera
- *Powder Her Face*
Directed by Pier Luigi Pizzi
Teatro Comunale, Bologna, 2010
Chamber opera
- *The Turn of the Screw*
Directed by Pier Luigi Pizzi
Teatro La Fenice, Venice, 2010
Opera
- *Vespro della Beata Vergine*
(Claudio Monteverdi)
Directed by Pier Luigi Pizzi
Arena Sferisterio, Macerata, 2010
Religious work
- *Così fan tutte*
Directed by Pier Luigi Pizzi
Arena Sferisterio, Macerata, 2011
Opera
- *Le nozze di Figaro*
Directed by Pier Luigi Pizzi
Teatro delle Muse, Ancona, 2011
Opera
- *Attila*
Directed by Pier Luigi Pizzi
Teatro dell'Opera, Rome, 2012
Opera
- *La battaglia di Legnano*
Directed by Pier Luigi Pizzi
Teatro Regio di Parma, 2012
Opera
- *Attila*
Directed by Pier Luigi Pizzi
Astana Opera, 2013
Opera
- *Cavalleria rusticana*
Directed by Pier Luigi Pizzi
Teatro dell'Opera, Rome, 2013
Opera
- *Maometto II*
Directed by Pier Luigi Pizzi

Teatro dell'Opera, Rome, 2013
Opera
• *Tosca*
Directed by Pier Luigi Pizzi
Teatro dell'Opera, Rome, 2013
Opera
• *Il trovatore*
Directed by Pier Luigi Pizzi
Mariinsky Theatre, St Petersburg, 2013
Opera

Stefano Poda
• *Thaïs*
Directed by Stefano Poda
Teatro Regio, Turin, 2008
Opera
• *Il concilio dei pianeti*
Directed by Stefano Poda
Sala della Ragione, Padua, 2009
Theatrical serenade
• *Così fan tutte*
Directed by Stefano Poda
Teatro Municipal di Mahon, Minorca, 2010
Opera
• *Rigoletto*
Directed by Stefano Poda
Teatro Comunale, Padua, 2010
Opera
• *Leggenda* (Alessandro Solbiati)
Directed by Stefano Poda
Teatro Regio, Turin, 2011
Opera
• *Maria Stuarda*
Directed by Stefano Poda
Opernhaus, Graz, 2012
Opera
• *Attila*
Directed by Stefano Poda
Theater St. Gallen, 2013
Opera
• *Tristan und Isolde*
Directed by Stefano Poda
Maggio Musicale Fiorentino, 2014

Carlo Poggioli
• *The Madwoman of Chaillot*
Directed by Luca Ronconi
Teatro Stabile di Torino, 1991
Play
• *Bacchides*
Directed by Ruggero Cappuccio
Teatro di Roma, 1998
Play
• *Tieste*
Directed by Ruggero Cappuccio
Teatro di Roma, 1998
Play
• *L'amico Fritz*
Directed by Marco Gandini
Teatro Bellini, Catania, 1999
Opera
• *La prova di un'opera seria*
Directed by Marco Gandini
Teatro dell'Opera, Rome, 1999
Opera

• *Falstaff* (Giuseppe Verdi)
Directed by Ruggero Cappuccio
Teatro Verdi, Busseto, 2001
Opera
• *La gazzetta*
Directed by Marco Gandini
Garsington Opera, Oxford, 2001
Opera
• *Gustavo III*
Directed by Ruggero Cappuccio
Teatro di San Carlo, Naples, 2001
Opera
• *Il ritorno di Don Calandrino*
Directed by Ruggero Cappuccio
Salzburger Festspiele, 2006
Opera
• *Il Barbiere di Siviglia*
(Gioachino Rossini)
Directed by Ruggero Cappuccio
Teatro dell'Opera, Rome, 2012
Opera

**Carlo Poggioli,
Gabriella Pescucci**
• *Strange Interlude*
Directed by Luca Ronconi
Teatro Stabile di Torino, 1990
Play

Jean-Pierre Ponnelle
• *L'occasione fa il ladro*
Directed by Jean-Pierre Ponnelle
Rossini Opera Festival, Pesaro, 1989
Opera
• *L'occasione fa il ladro*
Directed by Jean-Pierre Ponnelle
Théâtre Municipal, Lausanne, 1990
Opera

**Jean-Pierre Ponnelle,
Alberto Spiazzi**
• *L'occasione fa il ladro*
Directed by Jean-Pierre Ponnelle,
Sonja Frisell
Teatro alla Scala, Milan, 2010
Opera

Dan Potra
• *Zaide*
Directed by Graham Vick
Teatro Rosalia Castro, La Coruña, 2009
Opera
• *Clusters of Light*
Directed by Gavin Robins
Sharjah, Emirati Arabi, 2014
Operetta

Cristina Reis
• *Medea* (Luigi Cherubini)
Directed by Luís Miguel Cintra
Teatro Nacional de São Carlos, Lisbon, 2004
Opera

Jacques Reynaud
• *Verso Peer Gynt*
Directed by Luca Ronconi

Teatro di Roma, 1995
Play

Jurgen Rose
• *Parsifal*
Directed by Peter Stein
Staatsoper, Vienna, 1979
Opera

Salvatore Salzano
• *Madame De Sade*
Directed by Nadia Baldi
Salerno, 2003
Play
• *Le ultime sette parole di Caravaggio*
Directed by Ruggero Cappuccio
Teatro Bellini, Naples, 2009
Play
• *Natura viva* (Marco Betta)
Directed by Ruggero Cappuccio
Maggio Musicale Fiorentino, 2010
Opera

Pierluigi Samaritani
• *La bohème* (Giacomo Puccini)
Directed by Sandro Sequi
Teatro Comunale, Bologna, 1968
Opera
• *Maria Golovin*
Directed by Gian Carlo Menotti
Teatro Verdi, Trieste, 1969
Opera

Filippo Sanjust
• *Der Junge Lord*
Directed by Virginio Puecher
Teatro dell'Opera, Rome, 1965
Opera

Alessandro Sanquirico
(from original sketches)
• *La sonnambula*
Directed by Filippo Crivelli
Teatro Regio, Turin, 1980
Opera

Ulisse Santicchi
• *L'amore delle tre melarance*
Directed by Giulio Chazalettes
Lyric Opera, Chicago, 1976
Opera
• *L'elisir d'amore*
Directed by Giulio Chazalettes
Lyric Opera, Chicago, 1977
Opera
• *Il barbiere di Siviglia*
(Gioachino Rossini)
Directed by Giulio Chazalettes
Lyric Opera, Chicago, 1978
Opera
• *La clemenza di Tito*
Directed by Giulio Chazalettes
Teatro Bellini, Catania, 1989
Opera

Francesca Sartori
• *The Coast of Utopia*
Directed by Marco Tullio Giordana

Teatro Stabile di Torino, 2012
Play

Yvonne Sassinot de Nesle
• *Carmen*
Directed by Claude d'Anna
Teatro Regio, Turin, 1988
Opera
• *Venus* (Othmar Schoeck)
Directed by Francisco Negrini
Grand Théâtre, Geneva, 1997
Opera

Aligi Sassu
• *I vespri siciliani*
Directed by Maria Callas,
Giuseppe Di Stefano
Teatro Regio, Turin, 1973
Opera

Ferdinando Scarfiotti
• *Rigoletto*
Directed by Alberto Fassini
Civic Opera, Dallas, 1966
Opera
• *Vestire gli ignudi [Clothe the Naked]*
Directed by Giuseppe Patroni Griffi
Teatro di Roma, 1966
Play
• *La bottega del caffè*
[The Coffee Shop]
Directed by Giuseppe Patroni Griffi
Teatro Valle, Rome, 1967
Play
• *Egmont*
Directed by Luchino Visconti
Maggio Musicale Fiorentino,
1967
Play with music
• *Napoli notte e giorno*
Directed by Giuseppe Patroni Griffi
Teatro Valle, Rome, 1967
Play
• *Victor or Power to the Children*
Directed by Giuseppe Patroni Griffi
Teatro Quirino, Rome, 1969
Play

Ferdinando Scarfiotti,
Luchino Visconti
• *The Cherry Orchard*
Directed by Luchino Visconti
Teatro Stabile di Roma, 1965
Play

Alice-Maria Schlesinger
• *Der Zigeunerbaron*
Directed by Viktor Malek
Volksoper, Vienna, 1977
Operetta
• *Der Zarewitsch*
Directed by Auer Theussl
Volksoper, Vienna, 1978
Operetta

Christian Schmidt
• *Lohengrin*
Directed by Claus Guth

Teatro alla Scala, Milan, 2012
Opera

Renata Schussheim
• *Eugene Onegin*
Opéra, Lille, 1997
Opera
• *Lady Macbeth of the Mtsensk
District*
Directed by Sergio Renan
Old and New Montecarlo, Monaco,
2000
Opera

Walter Schwab
• *Pariser Leben*
Directed by Herbert Prikopa
Volksoper, Vienna, 1980
Opera

Michael Scott
• *La bohème* (Giacomo Puccini)
Directed by Giancarlo Del Monaco
Teatro Comunale, Bologna, 1982
Opera

Karin Seydtle
• *Rigoletto*
Vlaamse Opera, Antwerp, 1997
Opera

Cynthia Sleiter
• *The Tempest*
Directed by Adriano Dallea
Teatro dell'Opera, Rome, 1985
Play

Alberto Spiazzi
• *Farinelli. Estasi in canto*
Directed by Anna Cuocolo
Museo Strumenti Musicali, Rome, 2002
Musical evening
• *La traviata*
Directed by Franco Zeffirelli
Teatro Verdi, Busseto, 2002
Opera
• *Norma*
Directed by Paolo Miccichè
The Washington Opera, 2003
Opera
• *Norma* (in part)
Directed by Paolo Miccichè
Teatro Carlo Felice, Genoa, 2005
Opera
• *I vespri siciliani*
Directed by Paolo Miccichè
The Washington Opera, 2005
Opera
• *Nabucco*
Directed by Joseph Rochlitz
Masada, 2010
Opera
• *Le nozze di Figaro*
Directed by Luca Verdone
Teatro Bellini, Catania, 2012
Opera
• *Un ballo in maschera*
Directed by Luca Verdone

Teatro Bellini, Catania, 2012
Opera

Alberto Spiazzi,
Jean-Pierre Ponnelle
• *L'occasione fa il ladro*
Directed by Jean-Pierre Ponnelle,
Sonja Frisell
Teatro alla Scala, Milan, 2010
Opera

Alberto Spiazzi, Piero Tosi
• *La bohème* (Giacomo Puccini)
Directed by Franco Zeffirelli
Teatro alla Scala, Milan, 2000
Opera

Luisa Spinatelli
• *La forza del destino*
Teatro Bellini, Catania, 1992
Opera
• *Madame Sans-Gêne*
(Umberto Giordano)
Directed by Lamberto Puggelli
Teatro Bellini, Catania, 1997
Opera

Franca Squarciapino
• *Les contes d'Hoffmann*
Directed by Virginio Puecher
Strasbourg, 1979
Opera
• *The Storm*
Directed by Giorgio Strehler
Piccolo Teatro, Milan, 1980
Play
• *Le nozze di Figaro* (in part)
Directed by Giorgio Strehler
Teatro alla Scala, Milan, 1981
Opera
• *Ernani*
Directed by Luca Ronconi
Teatro alla Scala, Milan, 1982
Opera
• *Elektra*
Directed by Nuria Espert
Théâtre Royal de la Monnaie, Brussels,
1988
Opera
• *Jean de la Lune* (Marcel Achard)
Directed by Colette Brosset and
Robert Déhry
Théâtre de Carouge, Geneva,
1990
Play
• *Carmen*
Directed by Nuria Espert
Royal Opera House, London,
1991
Opera
• *Il turco in Italia*
Opéra, Lille, 1992
Opera

Silvia Strahammer
• *Gasparone*
Volksoper, Vienna, 1980
Operetta

Cristian Taraborrelli
• *Maria di Rohan*
Directed by Giorgio Barberio Corsetti
Grand Théâtre, Geneva, 2001
Opera

Luigi Tessoni
• *Otello* (Giuseppe Verdi)
Directed by Alberto Fassini
Teatro Regio, Parma, 1982
Opera

Carla Teti
• *Sigismondo* (in part)
Directed by Damiano Michieletto
Rossini Opera Festival, Pesaro, 2010
Opera

Fabio Toblini
• *Béatrice et Bénédict*
Directed by Chris Mattaliano
Manhattan School of Music,
New York City, 2003
Opera

Carlo Tomassi
• *The Changeling*
Directed by Luca Ronconi
Courtyard of Palazzo Ducale, Urbino,
1966
Play
• *Il barbiere di Siviglia*
(Gioachino Rossini)
Directed by Virginio Puecher
Teatro Comunale, Genoa, 1968
Opera

Carl Toms
• *Faust*
Directed by Ken Russell
Staatsoper, Vienna, 1985
Opera

Piero Tosi
• *L'idiota* (by Angelo Dellagiacoma
after Fyodor Dostoyevsky)
Directed by Aldo Trionfo
Teatro Pergolesi, Jesi, 1978
Play
• *La traviata*
Directed by Mauro Bolognini
Arena Sferisterio, Macerata, 1984
Opera
• *La vedova allegra*
[The Merry Widow]
Directed by Mauro Bolognini
Teatro di San Carlo, Naples, 1985
Operetta
• *Don Carlo*
Directed by Mauro Bolognini
Teatro La Fenice, Venice, 1991
Opera
• *La bohème* (Giacomo Puccini)
Directed by Franco Zeffirelli
Teatro dell'Opera, Rome, 1992
Opera
• *Il matrimonio segreto*
Directed by Quirino Conti

Festival dei Due Mondi, Spoleto, 2013
Opera

Piero Tosi, Maurizio Monteverde
• *La locandiera [The Mistress
of the Inn]*
Directed by Luchino Visconti,
Giorgio De Lullo
Teatro Parioli, Rome, 1981
Play

Piero Tosi, Gabriella Pescucci
• *Manon Lescaut*
Directed by Luchino Visconti
Festival dei Due Mondi, Spoleto,
1973
Opera

Piero Tosi, Alberto Spiazzi
• *La bohème* (Giacomo Puccini)
Directed by Franco Zeffirelli
Teatro alla Scala, Milan, 2000
Opera

Françoise Tournafond
• *Les contes d'Hoffmann*
Directed by Alfredo Arias
Teatro alla Scala, Milan, 1995
Opera
• *La dame de Chez Maxim*
Directed by Alfredo Arias
Teatro Stabile di Genova, 1998
Play

Sergio Tramonti
• *Don Giovanni*
(Wolfgang Amadeus Mozart)
Directed by Mario Martone
Teatro di San Carlo, Naples, 2002
Opera

Mariano Tufano
• *Romeo and Juliet*
Directed by Giuseppe Marini
Rome, 2010
Play
• *La ciociara*
Directed by Roberta Torre
Teatro Bellini, Naples, 2011
Play
• *Richard III*
Directed by Alessandro Gassman
Rome, 2012
Play

Sven Use
• *La Cenerentola*
Directed by Guy Joosten
Vlaamse Opera, Antwerp, 1990
Opera
• *Parsifal*
Directed by Joris Bultink
Vlaamse Opera, Antwerp, 1992
Opera

Franca Valeri
• *Rigoletto*
Directed by Franca Valeri

Associazione Maria Battistini, 1982
Opera
• *La traviata*
Directed by Franca Valeri
Associazione Maria Battistini, 1982
Opera
• *Un ballo in maschera*
Directed by Franca Valeri
Associazione Maria Battistini, 1983
Opera

Thibault van Craenenbroeck
• *L'elisir d'amore*
Directed by Rolan Villazon
Festspielhaus und Festspiele,
Baden-Baden, 2012
Opera
• *Don Giovanni*
(Wolfgang Amadeus Mozart)
Directed by Stéphane Braunschweig
Théâtre des Champs-Élysées, Paris, 2013
Opera

Rob Van der Vorst
• *Die Fledermaus*
Vlaamse Opera, Antwerp,
1994
Operetta

José-Manuel Vàzquez
• *Bianca e Fernando*
Directed by René Terrasson
Teatro Bellini, Catania, 1991
Opera

Fanny Vergnes
• *Parsifal*
Directed by Alfred Wopmann
Festival of Orange, 1979
Opera
• *Turandot*
Directed by Alfred Wopmann
Festival of Orange, 1979
Opera
• *Der fliegende Holländer*
Directed by Helse Thoma
Festival of Orange, 1980
Opera
• *Rigoletto*
Directed by Leif Soderstrom
Festival of Orange, 1980
Opera
• *Il trovatore*
Directed by Giancarlo Del Monaco
Festival of Orange, 1981
Opera
• *Die Zauberflöte*
Directed by Alfred Wopmann
Festival of Orange, 1981
Opera
• *Romeo and Juliet*
Directed by Marie-Claire Valène
Festival of Angers, 1983
Play
• *Le Cid*
Directed by Marie-Claire Valène
Festival of Angers, 1984
Play

• *La Glorieuse Jeunesse du Cid*
(Guillén de Castro)
Directed by Marie-Claire Valène
Festival of Angers, 1984
Play
• *The Crucible*
Directed by Marie-Claire Valène
Festival of Angers, 1987
Play

Gianni Versace
• *Dionisio*
Choreography by Maurice Béjart
Teatro alla Scala, Milan, 1984
Ballet
• *Don Pasquale*
Directed by Antonello Madau Diaz
Teatro alla Scala, Milan, 1984
Opera
• *Souvenir de Léningrad*
Choreography by Maurice Béjart
Théatre de Beaulieu, Lausanne,
1987
Ballet

Alberto Verso
• *Anima nera [Black Soul]*
Directed by Giorgio De Lullo
Teatro Parioli, Rome, 1981
Play
• *Gianni Schicchi*
Directed by Mario Monicelli
Maggio Musicale Fiorentino,
1983
Opera
• *Suor Angelica*
Directed by Franco Piavoli
Maggio Musicale Fiorentino, 1983
Opera
• *Il tabarro*
Directed by Ermanno Olmi
Maggio Musicale Fiorentino, 1983
Opera
• *La favorita*
Directed by Walter Pagliaro
Teatro Comunale, Bologna,
2002
Opera
• *Alceste*
Directed by Liliana Cavani
Teatro Regio, Parma, 2005
Opera
• *Macbeth*
Directed by Liliana Cavani
Teatro Regio, Parma, 2006
Opera

Laura Viani
• *Adina*
Directed by Cesare Scarton
Teatro Flavio Vespasiano, Rieti,
2012
Opera
• *Gianni Schicchi*
Directed by Cesare Scarton
Accademia Nazionale di Santa Cecilia,
Rome, 2012
Opera

• *L'heure espagnole*
Directed by Cesare Scarton
Accademia Nazionale di Santa Cecilia,
Rome, 2012
Opera

**Luchino Visconti,
Ferdinando Scarfiotti**
• *The Cherry Orchard*
Directed by Luchino Visconti
Teatro Stabile di Roma, 1965
Play

Catherine Voeffray
• *Die Entführung aus dem Serail*
Directed by Eike Gramss
Maggio Musicale Fiorentino, 2002
Opera

Titus Vossberg
• *Uncle Vanya*
Directed by Edmo Fenoglio
Teatro Stabile di Catania,
1965–66
Play
• *I viceré*
Directed by Franco Enriquez
Teatro Stabile di Catania,
1969–70
Play
• *La vita che ti diedi*
[The Life I Gave You]
Directed by Mario Landi
Teatro Stabile di Catania, 1970–71
Play

Georges Wakhévitch
• *La chanson de Fortunio*
Grand Théâtre, Bordeaux, 1983
Opera

Monika von Zallinger
• *Der Bettelstudent*
Directed by Monika Wiesler
Volksoper, Vienna, 1990
Operetta

Franco Zeffirelli
• *La città morta [The Dead City]*
(Gabriele d'Annunzio)
Directed by Franco Zeffirelli, 1977
Play

Francesco Zito
• *Lucia di Lammermoor*
Directed by Franca Valeri
Associazione Maria Battistini, 1983
Opera
• *Tosca*
Directed by Franca Valeri
Associazione Maria Battistini, 1983
Opera
• *La traviata*
Directed by Franca Valeri
Associazione Maria Battistini, 1983
Opera
• *Cavalleria Rusticana*
Directed by Franca Valeri

Associazione Maria Battistini, 1984
Opera
• *La bohème* (Giacomo Puccini)
Directed by Franca Valeri
Associazione Maria Battistini, 1984
Opera
• *Ernani*
Directed by Franca Valeri
Associazione Maria Battistini, 1984
Opera
• *Pagliacci*
Directed by Franca Valeri
Associazione Maria Battistini, 1984
Opera
• *Laurianna* (Augusto de Oliveira
Machado)
Directed by Mauro Avogadro
Teatro Nacional de São Carlos,
Lisbon, 2006
Opera
• *Franca Florio regina di Palermo*
Directed by Luciano Cannito
Teatro Massimo, Palermo, 2007
Ballet
• *La bohème* (Giacomo Puccini)
Directed by Marco Pontiggia
Maggio Musicale Fiorentino, 2008
Opera
• *Cavalleria rusticana*
Directed by Marco Pontiggia
Maggio Musicale Fiorentino, 2008
Opera
• *Tosca*
Directed by Marco Pontiggia
Maggio Musicale Fiorentino, 2008
Opera
• *I vespri siciliani*
Directed by Marco Pontiggia
Maggio Musicale Fiorentino, 2008
Opera

"by Tirelli Costumi"
• *La Calandria*
Directed by Antonio Pierfederici
Rondò di Bacco, 1972
Play

Cinema

Note
The costumes for the films listed were created by Tirelli Costumi. Only some of the costumes for the films accompanied by an* were created by Tirelli Costumi.
Tirelli Costumi did not create new costumes but hired them out for films accompanied by two**.

1965

• *Il compagno Don Camillo [Don Camillo in Moscow]*
Costumes: Danda Ortona
Directed by Luigi Comencini
• *David Copperfield* – Rai TV series
Costumes: Pier Luigi Pizzi
Directed by Anton Giulio Majano
• *Scaramouche* – Rai TV series
Costumes: Danilo Donati
Directed by Daniele D'Anza
• *Tra vestiti che ballano* – Theatre for TV
Costumes: Maria Teresa Stella
Directed by Giacomo Colli
• *Una vergine per il principe [A Maiden for a Prince]*
Costumes: Pier Luigi Pizzi
Directed by Pasquale Festa Campanile

1966

• *L'Arcidiavolo [The Devil in Love]*
Costumes: Danda Ortona / Maurizio Chiari
Directed by Ettore Scola
• *El Greco*
Costumes: Danilo Donati
Directed by Luciano Salce
• *Hotel Paradiso*
Costumes: Jacques Dupont
Directed by Peter Glenville
• *Madamigella di Maupin [Mademoiselle de Maupin]*
Costumes: Danilo Donati
Directed by Mauro Bolognini
• *Orestea* – Theatre for TV
Costumes: Maurizio Monteverde
Directed by Mario Ferrero
• *Le piacevoli notti*
Costumes: Pier Luigi Pizzi
Directed by Pasquale Festa Campanile
• *La strega in amore [The Witch in Love]*
Costumes: Pier Luigi Pizzi
Directed by Damiano Damiani

1967

• *1898: Processo a don Albertario* – Rai TV film
Costumes: Mario Giorsi
Directed by Leandro Castellani
• *Abramo Lincoln. Cronaca di un delitto* – Rai TV series
Costumes: Veniero Colasanti
Directed by Daniele D'Anza
• *Arabella*
Costumes: Piero Tosi
Directed by Mauro Bolognini
• *Caravaggio* – Rai TV series
Costumes: Veniero Colasanti
Directed by Silverio Blasi
• *C'era una volta… [More than a Miracle]**
Costumes: Giulio Coltellacci
Directed by Francesco Rosi
• *Che cosa sono le nuvole? [What Are The Clouds?]* (episode of *Capriccio all'Italiana [Caprice Italian Style]*)

Costumes: Jurgen Henze
Directed by Pier Paolo Pasolini
• *Leocadia* – Theatre for TV
Costumes: Pier Luigi Pizzi
Directed by Mario Ferrero
• *Il Novelliere 2* – Rai TV series
Costumes: Maurizio Monteverde
Directed by Daniele D'Anza
• *La traviata*
Costumes: Maurizio Monteverde
Directed by Mario Lanfranchi

1968

• *Addio, giovinezza!* – Rai TV series
Costumes: Pier Luigi Pizzi
Directed by Antonello Falqui
• *Barbarella*
Costumes: Giulio Coltellacci
Directed by Roger Vadim
• *Caio Gracco* – Rai TV film
Costumes: Pier Luigi Pizzi
Directed by Piero Schivazappa
• *Il caso Dreyfus* – Rai TV series
Costumes: Vera Marzot
Directed by Leandro Castellani
• *The Charge of the Light Brigade*
Costumes: Lila de Nobili / David Walker
Directed by Tony Richardson
• *Felicita Colombo* – Rai TV series
Costumes: Pier Luigi Pizzi
Directed by Antonello Falqui
• *Mayerling*
Costumes: Marcel Escoffier
Directed by Terence Young
• *Le mie prigioni* – Rai TV series
Costumes: Veniero Colasanti
Directed by Sandro Bolchi
• *Non cantare, spara!* – Rai TV series
Costumes: Maurizio Monteverde
Directed by Daniele D'Anza
• *La vedova allegra [The Merry Widow]* – Rai TV film
Costumes: Giulio Coltellacci
Directed by Antonello Falqui

1969

• *La caduta degli dei [The Damned]**
Costumes: Piero Tosi / Vera Marzot
Directed by Luchino Visconti
• *Eleonora Duse* – Rai TV series
Costumes: Pier Luigi Pizzi
Directed by Flaminio Bollini
• *I fratelli Karamazov* – Rai TV series
Costumes: Ezio Frigerio
Directed by Sandro Bolchi
• *H2S*
Costumes: Franco Carretti
Directed by Roberto Faenza
• *Medea*
Costumes: Piero Tosi
Directed by Pier Paolo Pasolini
• *Nell'anno del Signore [In the Year of Our Lord]*
Costumes: Lucia Mirisola
Directed by Luigi Magni
• *La parigina* – Theatre for TV
Costumes: Maurizio Monteverde
Directed by Davide Montemurri

• *Le regine di Francia* – Theatre for TV
Costumes: Maria Teresa Stella
Directed by Marcello Sartarelli
• *La resa dei conti. Dal Gran Consiglio al processo di Verona* – TV series
Costumes: Vera Marzot
Directed by Marco Leto
• *Vivi o preferibilmente morti [Alive or Preferably Dead]*
Costumes: Danda Ortona
Directed by Duccio Tessari

1970

• *Il berretto a sonagli [Cap and Bells]* – Theatre for TV
Costumes: Vera Marzot
Directed by Edmo Fenoglio
• *Brancaleone alle crociate [Brancaleone at the Crusades]**
Costumes: Mario Garbuglia / Ugo Pericoli
Directed by Mario Monicelli
• *I cannibali [The Cannibals]*
Costumes: Ezio Frigerio
Directed by Liliana Cavani
• *Il conformista [The Conformist]*
Costumes: Gitt Magrini
Directed by Bernardo Bertolucci
• *I demoni* – Rai TV series
Costumes: Maurizio Monteverde
Directed by Sandro Bolchi
• *Elisabetta d'Inghilterra* – Rai TV film
Costumes: Vera Marzot
Directed by Edmo Fenoglio
• *La fine dei Borboni* – Rai TV series
Costumes: Veniero Colasanti
Directed by Alessandro Blasetti
• *Indagine su un cittadino al di sopra di ogni sospetto [Investigation of a Citizen Above Suspicion]**
Costumes: Franco Carretti
Directed by Elio Petri
• *Peau d'Âne* (*Donkey Skin*)
Costumes: Gitt Magrini
Directed by Jacques Demy
• *Promise at Dawn*
Costumes: Theoni V. Aldredge
Directed by Jules Dassin

1971

• *Addio, fratello crudele ['Tis Pity She's a Whore]*
Costumes: Gabriella Pescucci
Directed by Giuseppe Patroni Griffi
• *Arsenio Lupin* – TV series
Costumes: Gabriele Mayer
Directed by Marcello Baldi and others
• *Bubù*
Costumes: Piero Tosi
Directed by Mauro Bolognini
• *Les deux anglaises et le continent [Two English Girls]*
Costumes: Gitt Magrini
Directed by François Truffaut
• *E le stelle stanno a guardare* – Rai TV series

Costumes: Maria Teresa Stella
Directed by Anton Giulio Majano
• *L'ereditiera* – Theatre for TV
Costumes: Vera Marzot
Directed by Edmo Fenoglio
• *Er Più – Storia d'amore e di coltello*
Costumes: Enrico Sabbatini
Directed by Sergio Corbucci
• *Giù la testa [Duck, You Sucker]*
Costumes: Franco Carretti
Directed by Sergio Leone
• *Morte a Venezia [Death in Venice]*
Costumes: Piero Tosi
Directed by Luchino Visconti
• *Les papiers d'Aspern [The Aspern Papers]* – Theatre for TV
Costumes: Jean-Marie Simon
Directed by Raymond Rouleau
• *Scipione detto anche l'Africano [Scipio the African]*
Costumes: Lucia Mirisola
Directed by Luigi Magni
• *La signora dalle camelie* – Theatre for TV
Costumes: Pier Luigi Pizzi
Directed by Vittorio Cottafavi

1972
• *Il carteggio Aspern [The Aspern Papers]* – Theatre for TV
Costumes: Vera Marzot
Directed by Sandro Sequi
• *Finalmente… le mille e una notte*
Costumes: Wayne Finkelman
Directed by Antonio Margheriti
• *Il matrimonio di Figaro* – Theatre for TV
Costumes: Giovanna La Placa
Directed by Sandro Sequi
• *Nostra Dea*
Costumes: Maurizio Monteverde
Directed by Silverio Blasi
• *L'ospite [The Guest]*
Costumes: Fiorella Mariani
Directed by Liliana Cavani
• *Paulina 1880*
Costumes: Claudie Gastine
Directed by Jean-Louis Bertuccelli
• *Pulp*
Costumes: Gitt Magrini
Directed by Mike Hodges
• *Roma*
Costumes: Danilo Donati
Directed by Federico Fellini
• *Sorelle Materassi* – TV series
Costumes: Piero Tosi / Vera Marzot
Directed by Mario Ferrero

1973
• *Amarcord**
Costumes: Danilo Donati
Directed by Federico Fellini
• *La colonna infame [The Infamous Column]*
Costumes: Vera Marzot
Directed by Nelo Risi
• *La Duchesse d'Avila*
Costumes: Bernard Daydé
Directed by Philippe Ducrest

• *Goldoni e le sue sedici commedie nuove* – Theatre for TV
Costumes: Maria Teresa Stella
Directed by Sandro Sequi
• *Ludwig**
Costumes: Piero Tosi
Directed by Luchino Visconti
• *Il mio nome è nessuno [My Name Is Nobody]*
Costumes: Vera Marzot
Directed by Tonino Valerii
• *Le monache di Sant'Arcangelo*
Costumes: Wayne Finkelman
Directed by Domenico Paolella
• *Paolo il caldo [The Sensual Man]*
Costumes: Gabriella Pescucci
Directed by Marco Vicario
• *Poil de carotte [Carrot Head]*
Costumes: Gitt Magrini
Directed by Henri Graziani
• *La rosa rossa [The Red Rose]*
Costumes: Danda Ortona
Directed by Franco Giraldi
• *Storia di una monaca di clausura [Story of a Cloistered Nun]*
Costumes: Wayne Finkelman
Directed by Domenico Paolella
• *La Tosca*
Costumes: Lucia Mirisola
Directed by Luigi Magni

1974
• *Anna Karenina* – Rai TV series
Costumes: Maurizio Monteverde
Directed by Sandro Bolchi
• *Il commissario De Vincenzi 1* – Rai TV series
Costumes: Maurizio Monteverde
Directed by Mario Ferrero
• *Daisy Miller*
Costumes: John Furniss / Mariolina Bono
Directed by Peter Bogdanovich
• *Fatti di gente per bene*
Costumes: Gabriella Pescucci
Directed by Mauro Bolognini
• *The Great Gatsby***
Costumes: Theoni V. Aldredge (Academy Award for Best Costume Design)
Directed by Jack Clayton
• *Gruppo di famiglia in un interno [Conversation Piece]**
Costumes: Piero Tosi / Vera Marzot
Directed by Luchino Visconti
• *L'Invenzione di Morel [Morel's Invention]*
Costumes: Gitt Magrini
Directed by Emidio Greco
• *Milarepa*
Costumes: Jean-Marie Simon
Directed by Liliana Cavani
• *Mio Dio, come sono caduta in basso! [Till Marriage Do Us Part]*
Costumes: Dante Ferretti
Directed by Luigi Comencini
• *Philo Vance* – Rai TV series
Costumes: Adriana Berselli

Directed by Marco Leto
• *Il portiere di notte [The Night Porter]**
Costumes: Piero Tosi
Directed by Liliana Cavani

1975
• *L'amico delle donne* – Theatre for TV
Costumes: Maurizio Monteverde
Directed by Davide Montemurri
• *Lu curaggiu de nu pumpiero napulitano* – Theatre for TV
Costumes: Raimonda Gaetani
Directed by Eduardo De Filippo
• *Divina creatura [The Divine Nymph]*
Costumes: Gabriella Pescucci
Directed by Giuseppe Patroni Griffi
• *Un genio, due compari, un pollo [A Genius, Two Partners and a Dupe]*
Costumes: Franco Carretti
Directed by Damiano Damiani
• *Mondo candido*
Costumes: Franco Carretti
Directed by Gualtiero Jacopetti
• *Li nepute de lu sinneco* – Theatre for TV
Costumes: Raimonda Gaetani
Directed by Eduardo De Filippo
• *Orlando Furioso* – Rai TV series
Costumes: Pier Luigi Pizzi
Directed by Luca Ronconi
• *Per le antiche scale [Down the Ancient Staircase]**
Costumes: Piero Tosi
Directed by Mauro Bolognini
• *La prima volta, sull'erba [The First Time on the Grass]*
Costumes: Mariolina Bono
Directed by Gianluigi Calderone
• *Ritratto di signora* – Rai TV series
Costumes: Maria Teresa Stella
Directed by Sandro Sequi
• *'Na santarella* – Theatre for TV
Costumes: Raimonda Gaetani
Directed by Eduardo De Filippo
• *'O tuono 'e marzo* – Theatre for TV
Costumes: Raimonda Gaetani
Directed by Eduardo De Filippo
• *Uomo e galantuomo [Man and Gentleman]* – Theatre for TV
Costumes: Raimonda Gaetani
Directed by Eduardo De Filippo

1976
• *Abramo Lincoln in Illinois*
Costumes: Vera Carotenuto
Directed by Sandro Sequi
• *L'arte della commedia* – Theatre for TV
Costumes: Raimonda Gaetani
Directed by Eduardo De Filippo
• *Bettina* (adaptation of *La putta onorata – La buona moglie*) – Theatre for TV
Costumes: Giovanna La Placa
Directed by Luca Ronconi

• *Bluff – Storia di truffe e di imbroglioni [The Con Artists]*
Costumes: Wayne Finkelman
Directed by Sergio Corbucci
• *Il Casanova di Federico Fellini [Fellini's Casanova]**
Costumes: Danilo Donati
(Academy Award for Best Costume Design)
Directed by Federico Fellini
• *L'eredità Ferramonti [The Inheritance]*
Costumes: Gabriella Pescucci
Directed by Mauro Bolognini
• *Gli esami non finiscono mai* – Theatre for TV
Costumes: Raimonda Gaetani
Directed by Eduardo De Filippo
• *L'innocente [The Innocent]*
Costumes: Piero Tosi
Directed by Luchino Visconti
• *Majakovskij* – TV series
Costumes: Vera Marzot
Directed by Alberto Negrin
• *Novecento [1900]**
Costumes: Gitt Magrini
Directed by Bernardo Bertolucci
• *Salon Kitty**
Costumes: Ugo Pericoli / Jost Jacob
Directed by Tinto Brass
• *Scandalo [Scandal]**
Costumes: Gitt Magrini
Directed by Salvatore Samperi

1977
• *Al di là del bene e del male [Beyond Good and Evil]**
Costumes: Piero Tosi
Directed by Liliana Cavani
• *Castigo* – TV series
Costumes: Maria Baronj
Directed by Anton Giulio Majano
• *Il commissario De Vincenzi 2* – Rai TV series
Costumes: Maurizio Monteverde
Directed by Mario Ferrero
• *Il gabbiano [The Seagull]* – Rai TV film
Costumes: Gabriella Pescucci
Directed by Marco Bellocchio
• *In nome del Papa Re**
Costumes: Lucia Mirisola
Directed by Luigi Magni
• *Ligabue* – Rai TV series
Costumes: Franco Carretti
Directed by Salvatore Nocita
• *Moglieamante [Wifelover]**
Costumes: Luca Sabatelli
Directed by Marco Vicario
• *Natale in casa Cupiello [Christmas at the Cupiello's]** – Theatre for TV
Costumes: Raimonda Gaetani / Clelia Gonzales
Directed by Eduardo De Filippo
• *La villa* – Rai TV series
Costumes: Maria Teresa Stella
Directed by Ottavio Spadaro

1978
• *Gennareniello* – Theatre for TV
Costumes: Raimonda Gaetani / Clelia Gonzales
Directed by Eduardo De Filippo
• *In memoria di una signora amica [In Memory of a Lady Friend]* – Theatre for TV
Costumes: Maurizio Monteverde
Directed by Mario Ferrero
• *Le mani sporche* – Rai TV film
Costumes: Barbara Mastroianni
Directed by Elio Petri
• *Quei figuri di tanti anni fa* – Theatre for TV
Costumes: Raimonda Gaetani / Clelia Gonzales
Directed by Eduardo De Filippo
• *Ritratto di borghesia in nero [Nest of Vipers]**
Costumes: Wayne Finkelman
Directed by Tonino Cervi

1979
• *Il '98* – Rai TV series
Costumes: Maurizio Monteverde
Directed by Sandro Bolchi
• *Don Giovanni***
Costumes: Annalisa Nasalli Rocca / François de Pouilly
Directed by Joseph Losey
• *La giacca verde* – Rai TV film
Costumes: Danda Ortona
Directed by Franco Giraldi
• *Il malato immaginario [Hypochondriac]*
Costumes: Piero Tosi
Directed by Tonino Cervi
• *Tre ore dopo le nozze* – Rai TV film
Costumes: Vera Marzot
Directed by Ugo Gregoretti

1980
• *Arrivano i bersaglieri**
Costumes: Lucia Mirisola
Directed by Luigi Magni
• *Arsène Lupin Joue et Perd* – TV series
Costumes: Jacques Fonteray
Directed by Alexandre Astruc
• *La Banquière [The Lady Banker]***
Costumes: Jacques Fonteray
Directed by Francis Girod
• *La città delle donne [The City of Women]*
Costumes: Gabriella Pescucci
Directed by Federico Fellini
• *The Elephant Man***
Costumes: Patricia Norris
Directed by David Lynch
• *O Megalèxandros [Alexander the Great]***
Costumes: Giorgos Ziakas
Directed by Theo Angelopoulos
• *Nijinsky**
Costumes: Alan Barrett
Directed by Herbert Ross
• *Orient Express* – TV series

Costumes: Jost Jacob
Directed by Daniele D'Anza
• *La tela del ragno* – TV series
Costumes: Maurizio Monteverde
Directed by Mario Ferrero
• *La Velia* – TV series
Costumes: Maurizio Monteverde
Directed by Mario Ferrero

1981
• *La brace dei Biassoli* – Rai TV series
Costumes: Maria Teresa Stella
Directed by Giovanni Fago
• *Chanel Solitaire***
Costumes: Rosine Delamare
Directed by George Kaczender
• *Chariots of Fire***
Costumes: Milena Canonero
(Academy Award for Best Costume Design)
Directed by Hugh Hudson
• *La clemenza di Tito* – Filmed opera
Costumes: Pet Halmen
Directed by Jean Pierre-Ponnelle
• *The Tyrant's Heart*
Costumes: Danda Ortona
Directed by Miklós Jancsó
• *Passione d'amore [Passion of Love]*
Costumes: Gabriella Pescucci
Directed by Ettore Scola
• *La pelle [The Skin]**
Costumes: Piero Tosi / Ugo Pericoli
Directed by Liliana Cavani
• *Priest of Love*
Costumes: Anthony Powell
Directed by Christopher Miles
• *Le rose di Danzica* – TV series
Costumes: Adriana Berselli
Directed by Alberto Bevilacqua
• *Les secrets de la princesse de Cadignan*** – TV film
Costumes: Jacques Fonteray
Directed by Jacques Deray
• *Il sogno dell'altro* (episode of *I giochi del diavolo*) – Rai TV film
Costumes: Danda Ortona
Directed by Giovanna Gagliardo
• *La storia vera della signora delle camelie [The Lady of the Camellias]*
Costumes: Piero Tosi
Directed by Mauro Bolognini
• *Il Turno [The Turn]**
Costumes: Lucia Mirisola
Directed by Tonino Cervi

1982
• *Il caso Murri* – TV series
Costumes: Maurizio Monteverde
Directed by Mario Ferrero
• *Il Conte Tacchia [Count Tacchia]***
Costumes: Raimonda Gaetani
Directed by Sergio Corbucci
• *Delitto di stato* – Rai TV series
Costumes: Maria Teresa Stella
Directed by Gianfranco De Bosio
• *Elle voit des nains partout!*
Costumes: Fanny Vergnes
Directed by Jean-Claude Sussfeld

• *John Gabriel Borkman* – Theatre for TV
Costumes: Vera Marzot
Directed by Luca Ronconi
• *Monsignore [Monsignor]***
Costumes: Theoni V. Aldredge
Directed by Frank Perry
• *Il mondo nuovo*
[That Night in Varennes]
Costumes: Gabriella Pescucci
Directed by Ettore Scola
• *Verdi** – Rai TV series
Costumes: Maria De Matteis
Directed by Renato Castellani

1983
• *Danton**
Costumes: Yvonne Sassinot de Nesle
Directed by Andrzej Wajda
• *Don Camillo*
Costumes: Vera Marzot
Directed by Terence Hill
• *E la nave va [And the Ship Sails On]**
Costumes: Maurizio Millenotti
Directed by Federico Fellini
• *The Hunger***
Costumes: Milena Canonero
Directed by Tony Scott
• *La traviata*
Costumes: Piero Tosi
Directed by Franco Zeffirelli
• *Tre anni* – TV series
Costumes: Franca Zucchelli
Directed by Salvatore Nocita
• *La vigna di uve nere** – Rai TV film
Costumes: Maurizio Monteverde
Directed by Sandro Bolchi

1984
• *Amadeus**
Costumes: Theodor Pištěk (Academy Award for Best Costume Design)
Directed by Miloš Forman
• *Un amour de Swann [Swann in Love]**
Costumes: Yvonne Sassinot de Nesle
Directed by Volker Schlöndorff
• *Le avventure di Jean-Jacques Rousseau*** – Rai TV series
Costumes: Clara Mezzanotte
Directed by Umberto Silva
• *Le bon roi Dagobert [Dagobert]*
Costumes: Gabriella Pescucci
Directed by Dino Risi
• *Carmen***
Costumes: Gino Persico
Directed by Francesco Rosi
• *Claretta**
Costumes: Ezio Altieri
Directed by Pasquale Squitieri
• *The Cotton Club***
Costumes: Milena Canonero
Directed by Francis Ford Coppola
• *Cristoforo Colombo** – Rai TV series
Costumes: Maria De Matteis
Directed by Alberto Lattuada
• *Once Upon a Time in America*
Costumes: Gabriella Pescucci
Directed by Sergio Leone

1985
• *Arthur the King*** – TV film
Costumes: Phyllis Dalton
Directed by Clive Donner
• *The Berlin Affair**
Costumes: Alberto Verso
Directed by Liliana Cavani
• *The Bride**
Costumes: Shirley Russell
Directed by Franc Roddam
• *I due prigionieri** – Rai TV film
Costumes: Alberto Verso
Directed by Anton Giulio Majano
• *Esclave et Pharaon* – TV film
Costumes: Fanny Vergnes
Directed by Patrick Meunier
• *Out of Africa***
Costumes: Milena Canonero
Directed by Sydney Pollack
• *Tender is the Night*** – BBC series
Costumes: Barbara Kidd
Directed by Robert Knights
• *Teresa Raquin* – Rai TV series
Costumes: Carlo Diappi
Directed by Giancarlo Cobelli

1986
• *Anastasia: The Mystery of Anna***
Costumes: Jane Robinson
Directed by Marvin J. Chomsky
• *La contessina Mitzi* – Rai TV film
Costumes: Carlo Diappi
Directed by Antonio and Andrea Frazzi
• *The Mission***
Costumes: Enrico Sabbatini
Directed by Roland Joffé
• *Il nome della rosa [The Name of the Rose]*
Costumes: Gabriella Pescucci
Directed by Jean-Jacques Annaud
• *Otello**
Costumes: Anna Anni / Maurizio Millenotti
Directed by Franco Zeffirelli

1987
• *Casanova*** – TV film
Costumes: Yvonne Blake
Directed by Simon Langton
• *La Famiglia [The Family]*
Costumes: Gabriella Pescucci
Directed by Ettore Scola
• *Dancers (Giselle)***
Costumes: Adriana Spadaro / Anna Anni / Enrico Serafini
Directed by Herbert Ross
• *Intervista [Interview]***
Costumes: Danilo Donati
Directed by Federico Fellini
• *Oci Ciornie [Dark Eyes]**
Costumes: Carlo Diappi
Directed by Nikita Mikhalkov
• *Lo scialo** – Rai TV series
Costumes: Vittoria Guaita
Directed by Franco Rossi
• *Secondo Ponzio Pilato**
Costumes: Lucia Mirisola
Directed by Luigi Magni

• *The Sicilian**
Costumes: Wayne Finkelman
Directed by Michael Cimino

1988
• *The Adventures of Baron Münchausen*
Costumes: Gabriella Pescucci
Directed by Terry Gilliam
• *Chéri* – Rai TV film
Costumes: Carlo Diappi
Directed by Enzo Muzii
• *Chouans!**
Costumes: Yvonne Sassinot de Nesle
Directed by Philippe de Broca
• *Il giovane Toscanini [The Young Toscanini]**
Costumes: Tom Rand
Directed by Franco Zeffirelli
• *Haunted Summer*
Costumes: Gabriella Pescucci
Directed by Ivan Passer
• *La romana** – TV series
Costumes: Alberto Verso
Directed by Giuseppe Patroni Griffi
• *Il treno di Lenin*** – TV series
Costumes: Monica Bauert
Directed by Damiano Damiani

1989
• *La bottega dell'orefice [The Jeweller's Shop]***
Costumes: Nadia Vitali
Directed by Michael Anderson
• *Champagne Charlie*** – TV film
Costumes: Cerf
Directed by Allan Eastman
• *Le chemin de Damas* – TV film
Costumes: Fanny Vergnes
Directed by Ludovic Segarra
• *Hiver 1954, l'Abbé Pierre***
Costumes: Brigitte Demouzon
Directed by Denis Amar
• *Obbligo di giocare – Zugzwang***
Costumes: Stefania Benelli
Directed by Daniele Cesarano
• *I Promessi sposi [The Betrothed]* – Rai TV series
Costumes: Maurizio Monteverde
Directed by Salvatore Nocita
• *Quel treno per Vienna** – TV film
Costumes: Vittoria Guaita
Directed by Duccio Tessari
• *'O Re**
Costumes: Lucia Mirisola
Directed by Luigi Magni
• *La Revolution Française** – TV series
Costumes: Catherine Leterrier
Directed by Robert Enrico and Richard T. Heffron
• *Splendor*
Costumes: Gabriella Pescucci
Directed by Ettore Scola
• *Tolérance***
Costumes: Dominique Borg
Directed by Pierre-Henry Salfati

• *Torrents of Spring**
Costumes: Theodor Pištěk / Sibylle Ulsamer
Directed by Jerzy Skolimowski
• *Valmont**
Costumes: Theodor Pištěk
Directed by Miloš Forman

1990
• *L'Avaro [The Miser]*
Costumes: Alberto Verso
Directed by Tonino Cervi
• *Cyrano de Bergerac**
Costumes: Franca Squarciapino
(Academy Award for Best Costume Design)
Directed by Jean-Paul Rappeneau
• *Dames galantes**
Costumes: Jacques Fonteray
Directed by Jean-Charles Tacchella
• *Frankenstein Unbound***
Costumes: Franca Zucchelli
Directed by Roger Corman
• *The Godfather: Part III***
Costumes: Milena Canonero
Directed by Francis Ford Coppola
• *Mio caro dottor Gräsler*
*[My Dear Dr Gräsler]***
Costumes: Milena Canonero
Directed by Roberto Faenza
• *A Season of Giants***
Costumes: Maurizio Monteverde
Directed by Jerry London
• *La putain du roi*
*[The King's Whore]***
Costumes: Carlo Diappi
Directed by Axel Corti

1991
• *Caccia alla vedova*
Costumes: Carlo Diappi
Directed by Giorgio Ferrara
• *Gioco perverso***
Costumes: Mariolina Bono
Directed by Italo Moscati
• *Grand Isle***
Costumes: Martin Pakledinaz
Directed by Mary Lambert
• *Lucky Luke**
Costumes: Vera Marzot
Directed by Terence Hill
• *Marcellino pane e vino*
*[Miracle of Marcelino]***
Costumes: Carolina Ferrara
Directed by Luigi Comencini
• *La valle di pietra*
*[The Valley of Stone]***
Costumes: Simonetta Leoncini
Directed by Maurizio Zaccaro

1992
• *1492: Conquest of Paradise***
(in part)
Costumes: Charles Knode
Directed by Ridley Scott
• *L'Atlantide**
Costumes: Maurizio Millenotti
Directed by Bob Swaim

• *Indochine*
Costumes: Gabriella Pescucci
Directed by Régis Wargnier
• *Mouche*** (unfinished)
Costumes: Jacques Fonteray
Directed by Marcel Carné
• *Oro [Zoloto]***
Costumes: Fiorenza Cipolloni
Directed by Fabio Bonzi

1993
• *The Age of Innocence*
Costumes: Gabriella Pescucci
(Academy Award for Best Costume Design)
Directed by Martin Scorsese
• *Il giovane Mussolini*** – Rai TV series
Costumes: Mariolina Bono
Directed by Gian Luigi Calderone
• *Justinien Trouvé***
Costumes: Pierre-Yves Gayraud
Directed by Christian Fechner
• *Louis, enfant roi***
Costumes: Franca Squarciapino
Directed by Roger Planchon
• *Per amore, solo per amore*
[For Love, Only for Love]
Costumes: Gabriella Pescucci
Directed by Giovanni Veronesi
• *Il segreto del bosco vecchio*
[The Secret of the Old Woods]
Costumes: Maurizio Millenotti
Directed by Ermanno Olmi
• *Storia di una capinera [Sparrow]*
Costumes: Piero Tosi
Directed by Franco Zeffirelli

1994
• *Con gli occhi chiusi*
*[With Eyes Closed]**
Costumes: Paola Marchesin
Directed by Francesca Archibugi
• *La famiglia Ricordi** – Rai TV series
Costumes: Aldo Buti
Directed by Mauro Bolognini
• *Farinelli***
Costumes: Olga Berluti / Anne De Laugardière
Directed by Gérard Corbiau
• *Immortal Beloved**
Costumes: Maurizio Millenotti
Directed by Bernard Rose
• *Inside the Vatican* – TV series
Costumes: Fanny Vergnes
Directed by John McGreevy
• *Interview with the Vampire:*
*The Vampire Chronicles***
Costumes: Sandy Powell
Directed by Neil Jordan
• *La nuit et le moment*
[The Night and the Moment]
Costumes: Gabriella Pescucci
Directed by Anna Maria Tatò
• *OcchioPinocchio***
Costumes: Maurizio Millenotti
Directed by Francesco Nuti

• *Only You***
Costumes: Milena Canonero
Directed by Norman Jewison
• *The Road to Wellville***
Costumes: Penny Rose
Directed by Alan Parker
• *Scarlett*** – TV series
Costumes: Marit Allen
Directed by John Erman

1995
• *Braveheart***
Costumes: Charles Knode
Directed by Mel Gibson
• *Les Misérables***
Costumes: Dominique Borg
Directed by Claude Lelouch
• *Rob Roy***
Costumes: Sandy Powell
Directed by Michael Caton-Jones
• *The Scarlet Letter*
Costumes: Gabriella Pescucci
Directed by Roland Joffé
• *La Vie de Marianne*** – TV film
Costumes: Caroline de Vivaise
Directed by Benoît Jacquot

1996
• *3**
Costumes: Nicoletta Ercole
Directed by Christian De Sica
• *The Adventures of Pinocchio*
Costumes: Maurizio Millenotti
Directed by Steve Barron
• *Albergo Roma*
Costumes: Gabriella Pescucci
Directed by Ugo Chiti
• *Beaumarchais, l'Insolent**
Costumes: Sylvie de Segonzac
Directed by Édouard Molinaro
• *The Crucible***
Costumes: Bob Crowley
Directed by Nicholas Hytner
• *L'élève***
Costumes: Yvonne Sassinot de Nesle
Directed by Olivier Schatzky
• *The English Patient**
Costumes: Ann Roth (Academy Award for Best Costume Design)
Directed by Anthony Minghella
• *Evita**
Costumes: Penny Rose
Directed by Alan Parker
• *In Love and War**
Costumes: Penny Rose
Directed by Richard Attenborough
• *Hamlet**
Costumes: Alexandra Byrne
Directed by Kenneth Branagh
• *Jane Eyre***
Costumes: Jenny Beavan
Directed by Franco Zeffirelli
• *Nostromo*** – TV series (in part)
Costumes: Danilo Donati
Directed by Alastair Reid
• *Rasputin*** – HBO film
Costumes: Natasha Landau
Directed by Uli Edel

1997

• *Amistad**
Costumes: Ruth E. Carter
Directed by Steven Spielberg
• *Anna Karenina**
Costumes: Maurizio Millenotti
Directed by Bernard Rose
• *La femme de chambre du Titanic*
*[The Chambermaid on the Titanic]***
Costumes: Franca Squarciapino
Directed by Bigas Luna
• *Kull the Conqueror***
Costumes: Thomas Casterline
Directed by John Nicolella
• *Marquise**
Costumes: Olga Berluti / Carlo
Poggioli
Directed by Véra Belmont
• *Raggio di sole* – TV film
Costumes: Fanny Vergnes
Directed by Georg Brintrup
• *Titanic***
Costumes: Deborah Lynn Scott
(Academy Award for Best Costume
Design)
Directed by James Cameron
• *La tregua [The Truce]**
Costumes: Alberto Verso
Directed by Francesco Rosi
• *Il viaggio della sposa*
*[The Bride's Journey]**
Costumes: Maurizio Millenotti
Directed by Sergio Rubini
• *The Wings of the Dove***
Costumes: Sandy Powell
Directed by Iain Softley

1998

• *The Barber of Siberia***
Costumes: Natasha Ivanova
Directed by Nikita Mikhalkov
• *Le Comte de Monte-Cristo*
*[The Count of Monte-Cristo]** –
TV series
Costumes: Jean-Philippe Abril
Directed by Josée Dayan
• *Cousin Bette*
Costumes: Gabriella Pescucci
Directed by Des McAnuf
• *Dangerous Beauty*
Costumes: Gabriella Pescucci
Directed by Marshall Herskovitz
• *Elizabeth***
Costumes: Alexandra Byrne
Directed by Shekhar Kapur
• *Ever After – A Cinderella Story**
Costumes: Jenny Beavan
Directed by Andy Tennant
• *La leggenda del pianista sull'oceano*
[The Legend of 1900]
Costumes: Maurizio Millenotti
Directed by Giuseppe Tornatore
• *The Man in the Iron Mask***
Costumes: James Acheson
Directed by Randall Wallace
• *Il mio West [Gunslinger's Revenge]**
Costumes: Maurizio Millenotti
Directed by Giovanni Veronesi

• *Les Misérables*
Costumes: Gabriella Pescucci
Directed by Bille August
• *L'ultimo capodanno**
Costumes: Maurizio Millenotti
Directed by Marco Risi

1999

• *La Balia [The Nanny]**
Costumes: Sergio Ballo
Directed by Marco Bellocchio
• *Balzac*** – TV series
Costumes: Jean-Philippe Abril
Directed by Josée Dayan
• *Caraibi* – TV series
Costumes: Rosanna Andreoni
Directed by Lamberto Bava
• *Ferdinando e Carolina*
*[Ferdinando and Carolina]**
Costumes: Gino Persico
Directed by Lina Wertmüller
• *Harem Suare**
Costumes: Alfonsina Lettieri
Directed by Ferzan Ozpetek
• *An Ideal Husband***
Costumes: Caroline Harris
Directed by Oliver Parker
• *Joan of Arc** – TV series
Costumes: John Hay
Directed by Christian Duguay
• *Il Mattatore. Corso accelerato di*
piccole verità – TV variety show
Costumes: Giovanna Buzzi
Directed by Vittorio Gassman
• *A Midsummer Night's Dream*
Costumes: Gabriella Pescucci
Directed by Michael Hoffman
• *Plunkett & Macleane***
Costumes: Janty Yates
Directed by Jake Scott
• *Sofies Verden [Sophie's World]***
Costumes: Else Lund – Torkil Ranum
Directed by Erik Gustavson
• *The Talented Mr. Ripley**
Costumes: Ann Roth
Directed by Anthony Minghella
• *Un tè con Mussolini [Tea with*
*Mussolini]**
Costumes: Anna Anni / Alberto
Spiazzi
Directed by Franco Zeffirelli
• *Le temps retrouvé [Time Regained]*
Costumes: Gabriella Pescucci
Directed by Raúl Ruiz
• *Titus**
Costumes: Milena Canonero
Directed by Julie Taymor
• *Wanted***
Costumes: Uli Fessler
Directed by Harald Sicheritz
• *Wild Wild West***
Costumes: Deborah Lynn Scott
Directed by Barry Sonnenfeld

2000

• *Arabian Nights** – TV film
Costumes: Maurizio Millenotti
Directed by Steve Barron

• *Canone inverso [Making Love]**
Costumes: Alfonsina Lettieri
Directed by Ricky Tognazzi
• *Le destinées sentimentales***
Costumes: Anais Romand
Directed by Olivier Assayas
• *Il furto del Tesoro di San Pietro*** –
Rai TV series
Costumes: Alberto Verso
Directed by Alberto Sironi
• *Jason and the Argonauts** – TV film
Costumes: Carlo Poggioli
Directed by Nick Willing
• *Lourdes*** – Rai TV series
Costumes: Paola Marchesin
Directed by Lodovico Gasparini
• *Malèna**
Costumes: Maurizio Millenotti
Directed by Giuseppe Tornatore
• *The Man who Killed Don Quixote*
(unfinished and documented in *Lost in*
La Mancha by Keith Fulton, 2002)
Costumes: Gabriella Pescucci
Directed by Terry Gilliam
• *Marlene***
Costumes: Ute Hofinger
Directed by Joseph Vilsmaier
• *Les Misérables** – TV series
Costumes: Jean-Philippe Abril
Directed by Josée Dayan
• *Nora***
Costumes: Consolata Boyle
Directed by Pat Murphy
• *Padre Pio – Tra cielo e terra*** – Rai
TV series
Costumes: Paola Marchesin
Directed by Giulio Base
• *Palavra e Utopia [Word and Utopia]***
Costumes: Isabel Branco
Directed by Manoel de Oliveira
• *The Patriot**
Costumes: Deborah Lynn Scott
Directed by Roland Emmerich
• *Rosa e Cornelia*
*[Rosa and Cornelia]**
Costumes: Alessandro Lai
Directed by Giorgio Treves
• *Sud Side Stori**
Costumes: Alessandro Lai
Directed by Roberta Torre
• *Vatel**
Costumes: Yvonne Sassinot de Nesle
Directed by Roland Joffé

2001

• *The Affair of the Necklace***
Costumes: Milena Canonero
Directed by Charles Shyer
• *The Cat's Meow***
Costumes: Caroline de Vivaise
Directed by Peter Bogdanovich
• *Concorrenza sleale*
*[Unfair Competition]***
Costumes: Odette Nicoletti
Directed by Ettore Scola
• *Cuore*** – TV series
Costumes: Elena Del Guerra
Directed by Maurizio Zaccaro

• *The Emperor's New Clothes**
Costumes: Sergio Ballo
Directed by Alan Taylor
• *Harry Potter and the Philosopher's Stone***
Costumes: Judianna Makovsky
Directed by Chris Columbus
• *Just Visiting***
Costumes: Penny Rose
Directed by Jean-Marie Poiré
• *Il Mestiere delle armi [The Profession of Arms]**
Costumes: Francesca Sartori
Directed by Ermanno Olmi
• *The Mists of Avalon** – TV film
Costumes: Carlo Poggioli
Directed by Uli Edel
• *Moulin Rouge!***
Costumes: Catherine Martin
(Academy Award for Best Costume Design)
Directed by Baz Luhrmann
• *The Musketeer***
Costumes: Raymond Hughes
Directed by Peter Hyams
• *MythQuest*** – TV series
Costumes: Catherine McComb
Various directors
• *Le pacte des loups [Brotherhood of the Wolf]***
Costumes: Dominique Borg
Directed by Christophe Gans
• *Piccolo mondo antico** – TV film
Costumes: Maurizio Millenotti
Directed by Cinzia Th. Torrini
• *La terre d'Outremer*** – TV film
Costumes: Francesca Sartori
Directed by Dominique Girard
• *Tra due mondi*
Costumes: Alessandro Lai
Directed by Fabio Conversi

2002
• *Callas Forever**
Costumes: Anna Anni / Alberto Spiazzi
Directed by Franco Zeffirelli
• *Confessions of an Ugly Stepsister*** – TV film
Costumes: Penny Rose
Directed by Gavin Millar
• *The Count of Monte Cristo***
Costumes: Tom Rand
Directed by Kevin Reynolds
• *Le frère du guerrier***
Costumes: Yvonne Sassinot de Nesle
Directed by Pierre Jolivet
• *Gangs of New York***
Costumes: Sandy Powell
Directed by Martin Scorsese
• *Il giovane Casanova*** – TV film
Costumes: Anne de Laugardière
Directed by Giacomo Battiato
• *I Am Dina***
Costumes: Dominique Borg
Directed by Ole Bornedal
• *The Importance of Being Earnest**
Costumes: Maurizio Millenotti
Directed by Oliver Parker

• *Napoléon*** – TV series
Costumes: Pierre-Jean Larroque
Directed by Yves Simoneau
• *Prendimi l'anima [The Soul Keeper]**
Costumes: Francesca Sartori
Directed by Roberto Faenza
• *San Francesco*** – TV series
Costumes: Sergio Ballo
Directed by Michele Soavi
• *Sant'Antonio di Padova*** – TV film
Costumes: Maurizio Basile
Directed by Umberto Marino
• *Senso '45*
Costumes: Alessandro Lai
Directed by Tinto Brass
• *Stranded** – TV film
Costumes: Alfonsina Lettieri
Directed by Charles Beeson
• *Un viaggio chiamato amore [A Journey Called Love]***
Costumes: Elena Mannini
Directed by Michele Placido

2003
• *Angels in America** – HBO series
Costumes: Ann Roth
Directed by Mike Nichols
• *Bon Voyage**
Costumes: Catherine Leterrier
Directed by Jean-Paul Rappeneau
• *Carmen***
Costumes: Yvonne Blake
Directed by Vicente Aranda
• *Cold Mountain**
Costumes: Ann Roth / Carlo Poggioli
Directed by Anthony Minghella
• *Fanfan la Tulipe [Fan-Fan the Tulip]***
Costumes: Olivier Bériot
Directed by Gérard Krawczyk
• *The Haunted Mansion***
Costumes: Mona May
Directed by Rob Minkoff
• *Luther***
Costumes: Ulla Gothe
Directed by Eric Till
• *Marcinelle*** – Rai TV series
Costumes: Mariolina Bono
Directed by Antonio and Andrea Frazzi
• *Monsieur N.***
Costumes: Carine Sarfati
Directed by Antoine de Caunes
• *Perdutoamor [Lost Love]*
Costumes: Gabriella Pescucci / Flora Brancatella
Directed by Franco Battiato
• *Pirates of the Caribbean 1: The Curse of the Black Pearl***
Costumes: Penny Rose
Directed by Gore Verbinski
• *Il quaderno della spesa [Household Accounts]*
Costumes: Alessandro Lai
Directed by Tonino Cervi
• *The Roman Spring of Mrs. Stone** – TV film
Costumes: Dona Granata
Directed by Robert Allan Ackerman

• *Seabiscuit***
Costumes: Judianna Makovsky
Directed by Gary Ross
• *Il segreto di Thomas*** – TV series
Costumes: Anne de Laugardière
Directed by Giacomo Battiato
• *Shanghai Knights***
Costumes: Anna Sheppard
Directed by David Dobkin
• *Song for a Raggy Boy***
Costumes: Allison Byrne
Directed by Aisling Walsh
• *Soraya*** – TV series
Costumes: Elisabetta Montaldo
Directed by Lodovico Gasparini
• *Timeline***
Costumes: Jenny Beavan
Directed by Richard Donner
• *Volpone*** – TV film
Costumes: Olivier Bériot
Directed by Frédéric Auburtin

2004
• *L'eretico – Un gesto di coraggio***
Costumes: Alfonsina Lettieri
Directed by Piero Maria Benfatti
• *Around the World in 80 Days***
Costumes: Anna Sheppard
Directed by Frank Coraci
• *A Good Woman***
Costumes: John Bloomfield
Directed by Mike Barker
• *Guardiani delle nuvole**
Costumes: Alfonsina Lettieri
Directed by Luciano Odorisio
• *Head in the Clouds***
Costumes: Mario Davignon
Directed by Jean Duigan
• *King Arthur***
Costumes: Penny Rose
Directed by Antoine Fuqua
• *The Libertine***
Costumes: Dean Yam Straalem
Directed by Laurence Dunmore
• *O Milagre segundo Salomé***
Costumes: Isabel Branco
Directed by Mário Barroso
• *Nouvelle-France***
Costumes: François Barbeau
Directed by Jean Beaudin
• *The Passion of the Christ**
Costumes: Maurizio Millenotti
Directed by Mel Gibson
• *Renzo e Lucia* – TV series
Costumes: Alessandro Lai
Directed by Francesca Archibugi
• *Rita da Cascia*** – TV series
Costumes: Enrica Biscossi
Directed by Giorgio Capitani
• *Secret Passage*
Costumes: Gabriella Pescucci
Directed by Ademir Kenović
• *Il sorriso dell'ultima notte**
Costumes: Salvatore Salzano
Directed by Ruggero Cappuccio
• *Stage Beauty***
Costumes: Tim Hatley
Directed by Richard Eyre

- *Taranus – Empire**
Alberto Spiazzi
Directed by Kim Manners
- *La terra del ritorno** – TV series
Costumes: Alfonsina Lettieri /
Maurizio Millenotti
Directed by Jerry Ciccoritti
- *Trilogy: To Livadi pou dakryzei
[The Weeping Meadow]***
Costumes: Ioulia Stavridou
Directed by Theo Angelopoulos
- *Van Helsing*
Costumes: Gabriella Pescucci
Directed by Stephen Sommers
- *Vaniglia e cioccolato
[Vanilla and Chocolate]**
Costumes: Alessandro Lai
Directed by Ciro Ippolito
- *The Village**
Costumes: Ann Roth
Directed by M. Night Shyamalan
- *Virginia – La monaca di Monza* – TV
film
Costumes: Alessandro Lai
Directed by Alberto Sironi

2005
- *Alcide De Gasperi* – TV series
Costumes: Alessandro Lai
Directed by Liliana Cavani
- *The Brothers Grimm*
Costumes: Gabriella Pescucci
Directed by Terry Gilliam
- *Callas e Onassis** – TV series
Costumes: Elisabetta Montaldo
Directed by Giorgio Capitani
- *Casanova***
Costumes: Jenny Beavan
Directed by Lars Hallström
- *Charlie and the Chocolate
Factory***
Costumes: Gabriella Pescucci
Directed by Tim Burton
- *Il cuore nel pozzo*** – TV series
Costumes: Mariolina Bono
Directed by Alberto Negrin
- *Elizabeth I*** – TV series
Costumes: Mike O'Neill
Directed by Tom Hooper
- *The Fine Art of Love: Mine Ha-Ha**
Costumes: Carlo Poggioli
Directed by John Irvin
- *Gabrielle***
Costumes: Caroline de Vivaise
Directed by Patrice Chéreau
- *Galilée ou L'amour de Dieu*** – TV
film
Costumes: Bernadette Villard
Directed by Jean-Daniel Verhaeghe
- *The Greatest Game Ever Played***
Costumes: Renée April
Directed by Bill Paxton
- *Il ne faut jurer… de rien!**
Costumes: Anne Brault
Directed by Eric Civanyan
- *Kingdom of Heaven***
Costumes: Janty Yates
Directed by Ridley Scott

- *The League of Gentlemen's
Apocalypse***
Costumes: Yves Barre
Directed by Steve Bendelack
- *Meucci – L'italiano che inventò il
telefono** – TV series
Costumes: Paolo Scalabrino
Directed by Fabrizio Costa
- *La Passione di Giosuè l'Ebreo
[The Passion of Joshua the Jew]***
Costumes: Grazia Colombini
Directed by Pasquale Scimeca
- *Pope John Paul II*** – TV series
Costumes: Enrica Biscossi
Directed by John Kent Harrison
- *Raul – Diritto di uccidere
[Raul: the Right to Kill]***
Costumes: Alberto Verso
Directed by Andrea Bolognini
- *La tigre e la neve
[The Tiger and the Snow]***
Costumes: Louise Stjernsward
Directed by Roberto Benigni
- *"V" for Vendetta***
Costumes: Sammy Sheldon
Directed by James McTeigue

2006
- *Alatriste**
Costumes: Francesca Sartori
Directed by Augustín Díaz Yanes
- *Amazing Grace***
Costumes: Jenny Beaven
Directed by Michael Apted
- *Assunta Spina** – TV series
Costumes: Elena Del Guerra
Directed by Riccardo Milani
- *Les brigades du Tigre
[Tiger Brigades]***
Costumes: Pierre-Jean Larroque
Directed by Jérôme Cornuau
- *La contessa di Castiglione* – TV film
Costumes: Nicoletta Ercole
Directed by Josée Dayan
- *The Da Vinci Code**
Costumes: Daniel Orlandi
Directed by Ron Howard
- *Eragon***
Costumes: Carlo Poggioli
Directed by Stefen Fangmeier
- *Fade to Black***
Costumes: Louise Stjernsward
Directed by Oliver Parker
- *Figli strappati* – TV series
Costumes: Alessandro Lai / Rosanna
Andreoni
Directed by Massimo Spano
- *The Fountain**
Costumes: Renée April
Directed by Darren Aronofsky
- *Gino Bartali – L'intramontabile** –
TV series
Costumes: Mariolina Bono
Directed by Alberto Negrin
- *Giovanni Falcone, l'uomo che sfidò
Cosa Nostra*** – TV series
Costumes: Mariolina Bono
Directed by Andrea and Antonio Frazzi

- *Goya's Ghosts***
Costumes: Yvonne Blake
Directed by Miloš Forman
- *The Holiday***
Costumes: Marlene Stewart
Directed by Nancy Meyers
- *L'inchiesta [The Inquiry]*** –
TV series
Costumes: Carlo Poggioli
Directed by Giulio Base
- *Marie Antoinette**
Costumes: Milena Canonero
(Academy Award for Best Costume
Design)
Directed by Sofia Coppola
- *Marie-Antoinette*** – TV film
Costumes: Sylvie de Segonzac
Directed by Francis Leclerc
and Yves Simoneau
- *N (Io e Napoleone)
[Napoleon and Me]**
Costumes: Maurizio Millenotti
Directed by Paolo Virzì
- *The Nativity Story**
Costumes: Maurizio Millenotti
Directed by Catherine Hardwicke
- *Nuovomondo [Golden Door]*
Costumes: Mariano Tufano
Directed by Emanuele Crialese
- *Papa Luciani – Il sorriso di Dio*** –
TV series
Costumes: Enrica Biscossi
Directed by Giorgio Capitani
- *Pirates of the Caribbean 2:
Dead Man's Chest***
Costumes: Penny Rose
Directed by Gore Verbinski
- *Quijote**
Costumes: Ortensia De Francesco
Directed by Mimmo Paladino
- *Il regista di matrimoni
[The Wedding Director]**
Costumes: Sergio Ballo
Directed by Marco Bellocchio
- *La Sacra Famiglia** – TV film
Costumes: Alberto Spiazzi
Directed by Raffaele Mertes
- *Le Temps des Secrets*** – TV film
Costumes: Sophie Dussaud
Directed by Thierry Chabert
- *Tirante el Blanco***
Costumes: Yvonne Blake
Directed by Vicente Aranda
- *Tristan & Isolde**
Costumes: Maurizio Millenotti
Directed by Kevin Reynolds

2007
- *2061***
Costumes: Nicoletta Ercole
Directed by Carlo Vanzina
- *L'Amaro caso della baronessa
di Carini* – TV series
Costumes: Enrico Serafini
Directed by Umberto Marino
- *L'amore e la guerra** – TV series
Costumes: Marina Roberti
Directed by Giacomo Campiotti

• *Angel***
Costumes: Pascaline Chavanne
Directed by François Ozon
• *Beowulf*
Costumes: Gabriella Pescucci
Directed by Robert Zemeckis
• *Chiara e Francesco*** – Rai TV series
Costumes: Enrica Biscossi
Directed by Fabrizio Costa
• *I demoni di San Pietroburgo [The Demons of St. Petersburg]***
Costumes: Elisabetta Montaldo
Directed by Giuliano Montaldo
• *Dombais et Fils*** – TV series
Costumes: Anne Brault
Directed by Laurent Jaoui
• *Il Dono dei Magi*** (short)
Costumes: Carolina Olcese
Directed by Gianni Quaranta
• *Eravamo solo mille** – Rai TV series
Costumes: Maurizio Millenotti
Directed by Stefano Reali
• *Elizabeth: the Golden Age***
Costumes: Alexandra Byrne
(Academy Award for Best Costume Design)
Directed by Shekar Kapur
• *Giuseppe Moscati*** – TV series
Costumes: Marina Roberti
Directed by Giacomo Campiotti
• *Guerra e Pace (War and Peace)*** – TV series
Costumes: Enrica Biscossi
Directed by Robert Dornhelm
• *Hannibal Rising***
Costumes: Anna B. Sheppard
Directed by Peter Webber
• *Northanger Abbey*** – TV film
Costumes: Grania Preston
Directed by Jon Jones
• *Ripopolare la Reggia [Peopling the Palaces at Venaria Reale]*** – film-installation
Costumes: Gianluca Sbicca / Simone Valsecchi
Directed by Peter Greenway
• *Silk**
Costumes: Carlo Poggioli
Directed by François Girard
• *Teresa, el cuerpo de Cristo***
Costumes: Eiko Ishioka
Directed by Ray Loriga
• *The Tudors*** – TV series
Costumes: Joan Bergin
Directed by Charles McDougall and others
• *L'ultimo dei Corleonesi*** – TV film
Costumes: Mariolina Bono
Directed by Alberto Negrin
• *I Viceré** – Tv series and film
Costumes: Milena Canonero
Directed by Roberto Faenza
• *Virgin Territory***
Costumes: Roberto Cavalli
Directed by David Leland

2008
• *1 1/2 Ritter – Auf der Suche nach der hinreißenden Herzelinde***
Costumes: Mirjam Muschel / Gabriela Reumer
Directed by Til Schweiger, Torsten Künstler, Christof Wahl
• *Artemisia Sanchez** – TV series
Costumes: Nicoletta Ercole / Flora Brancatella
Directed by Ambrogio Lo Giudice
• *L'Aviatore*** – TV film
Costumes: Valter Azzini
Directed by Carlo Carlei
• *Brideshead Revisited***
Costumes: Eimar Ni Mhaoldomhnaigh
Directed by Julian Jarrold
• *Buddenbrooks*
Costumes: Barbara Baum
Directed by Heinrich Breloer
• *Carnera* – TV series and film
Costumes: Massimo Cantini Parrini / Silvia Nebiolo
Directed by Renzo Martinelli
• *The Chronicles of Narnia: Prince Caspian***
Costumes: Isis Mussenden
Directed by Andrew Adamson
• *Coco Chanel** – Rai TV series
Costumes: Stefano De Nardis
Directed by Christian Duguay
• *Il Commissario De Luca*** – Rai TV series
Costumes: Mariolina Bono
Directed by Antonio Frazzi
• *Il cosmo sul comò***
Costumes: Valeria Campo
Directed by Marcello Cesena
• *Don Zeno – L'uomo di Nomadelfia*** – TV series
Costumes: Paola Marchesin
Directed by Gianluigi Calderone
• *The Duchess***
Costumes: Michael O'Connor
(Academy Award for Best Costume Design)
Directed by Saul Dibb
• *Figaro*** – TV film
Costumes: Dominique Borg
Directed by Jacques Weber
• *John Adams*** – TV series
Costumes: Donna Zakowska
Directed by Tom Hooper
• *Lezione 21 [Lecture 21]*
Costumes: Carlo Poggioli
Directed by Alessandro Baricco
• *Manolete***
Costumes: Sonia Grande
Directed by Menno Meyjes
• *Miracle at St. Anna**
Costumes: Carlo Poggioli
Directed by Spike Lee
• *Il papà di Giovanna [Giovanna's Father]***
Costumes: Mario Carlini / Francesco Crivellini
Directed by Pupi Avati

• *Parlami d'amore [Speak to Me of Love]***
Costumes: Maurizio Millenotti
Directed by Silvio Muccino
• *Pinocchio*** – Rai TV series
Costumes: Enrica Biscossi
Directed by Alberto Sironi
• *Trilogy II: I Skoni tou Hronou [The Dust of Time]***
Costumes: Francesca Sartori
Directed by Theo Angelopoulos
• *Rebecca, la prima moglie*** – Rai TV series
Costumes: Valter Azzini
Directed by Riccardo Milani
• *Il Sangue e la Rosa*** – TV series
Costumes: Stefano Cioncolini
Directed by Salvatore Samperi
• *Sanguepazzo [Wild Blood]***
Costumes: Anna Maria Barbera
Directed by Marco Tullio Giordana
• *Si può fare [It Can Be Done]***
Costumes: Maurizio Millenotti
Directed by Giulio Manfredonia

2009
• *Angels & Demons***
Costumes: Daniel Orlandi
Directed by Ron Howard
• *Assassin's Creed: Lineage***
Costumes: Mario Davignon
Directed by Yves Simoneau
• *Bakhita. La santa africana*** – Rai TV series
Costumes: Marina Roberti
Directed by Giacomo Campiotti
• *Barbarossa*
Costumes: Massimo Cantini Parrini
Directed by Renzo Martinelli
• *Coco Chanel & Igor Stravinsky***
Costumes: Chattoune / Fab
Directed by Jan Kounen
• *Chéri***
Costumes: Consolata Boyle
Directed by Stephen Frears
• *David Copperfield*** – Rai TV series
Costumes: Francesca Brunori
Directed by Ambrogio Lo Giudice
• *Demain dès l'aube***
Costumes: Pierre-Yves Gayraud
Directed by Denis Dercourt
• *Doc West*** – TV film
Costumes: Lahli Poore-Ericson / Gianni Viti
Directed by Giulio Base / Terence Hill
• *Giacomo Puccini*** – Rai TV series
Costumes: Enrica Biscossi
Directed by Giorgio Capitani
• *Inglourious Basterds***
Costumes: Anna B. Sheppard
Directed by Quentin Tarantino
• *Io, Don Giovanni (I, Don Giovanni)***
Costumes: Birgit Hutter
Directed by Carlos Saura

- *Italians***
Costumes: Gemma Mascagni
Directed by Giovanni Veronesi
- *Kaamelott 6*** – TV series
Costumes: Anne-Gaelle Daval
Directed by Alexandre Astier
- *Louis XV, Le Soleil Noir***
Costumes: Valerie Adda
Directed by Thierry Binisti
- *Miacarabefana.it*** – TV film
Costumes: Valter Azzini
Directed by Lodovico Gasparini
- *Nine***
Costumes: Colleen Atwood
Directed by Rob Marshall
- *The Nutcracker* in 3D**
Costumes: Louise Stjernsward
Directed by Andrei Konchalovsky
- *Un'offerta per la festa*** – short
Costumes: Andrea Cavalletto
Directed by Fabio Mollo
- *Omaggio a Roma*
*[Tribute to Rome]*** – short
Costumes: Maurizio Millenotti
Directed by Franco Zeffirelli
- *Pope Joan*
Costumes: Esther Walz
Directed by Sonke Wortmann
- *Questione di cuore*
*[A Question of the Heart]***
Costumes: Alessandro Lai
Directed by Francesca Archibugi
- *L'ultimo re [The Last King]***
Costumes: Sandra Cardini
Directed by Aurelio Grimaldi
- *L'uomo nero**
Costumes: Maurizio Millenotti
Directed by Sergio Rubini
- *Vincere [Win]***
Costumes: Sergio Ballo
Directed by Marco Bellocchio
- *Vivaldi, il prete rosso*** – TV film
Costumes: Franca Squarciapino /
Alessandra Torella
Directed by Liana Marabini

2010
- *Alice in Wonderland***
Costumes: Colleen Atwood
(Academy Award for Best Costume
Design)
Directed by Tim Burton
- *Anton Chekhov's The Duel***
Costumes: Sergio Ballo
Directed by Dover Koshashvili
- *La Banda dei Babbi Natale*
*[The Santa Claus Gang]***
Costumes: Bettina Pontiggia
Directed by Paolo Genovese
- *Barney's Version***
Costumes: Nicoletta Massone
Directed by Richard J. Lewis
- *Chateaubriand*** – TV film
Costumes: Anne Brault
Directed by Pierre Aknine
- *Filumena Marturano** – Theatre for TV
Costumes: Giovanni Ciacci
Directed by Massimo Ranieri

- *La Leggenda del bandito*
*e del campione***
Costumes: Valter Azzini
Directed by Lodovico Gasparini
- *Letters to Juliet***
Costumes: Nicoletta Ercole
Directed by Gary Winick
- *Mine vaganti [Loose Cannons]**
Costumes: Alessandro Lai
Directed by Ferzan Ozpetek
- *Noi credevamo [We Believed]***
Costumes: Ursula Patzak
Directed by Mario Martone
- *La Passione [The Passion]***
Costumes: Francesca Sartori
Directed by Carlo Mazzacurati
- *Il peccato e la vergogna 1*** – TV
series
Costumes: Stefano De Nardis
Directed by Luigi Parisi / Alessio
Inturri
- *The Pillars of the Earth*** – TV
series
Costumes: Mario Davignon
Directed by Sergio Mimica-Gezzan
- *La prima cosa bella [The First
Beautiful Thing]***
Costumes: Gabriella Pescucci
Directed by Paolo Virzì
- *La princesse de Montpensier***
Costumes: Caroline de Vivaise
Directed by Bertrand Tavernier
- *La Rafle [The Round Up]***
Costumes: Pierre-Jean Larroque
Directed by Rose Bosch
- *Rigoletto*** – Opera for TV
Costumes: Sergio Ballo
Directed by Marco Bellocchio
- *Robin Hood***
Costumes: Janty Yates
Directed by Ridley Scott
- *Sant'Agostino*** – TV series
Costumes: Stefano De Nardis
Directed by Christian Duguay
- *Lo Scandalo della Banca Romana***
– Rai TV series
Costumes: Alfonsina Lettieri
Directed by Stefano Reali
- *La scomparsa di Patò***
Costumes: Paola Marchesini
Directed by Rocco Mortelliti
- *La Señora 3*** – TV series
Costumes: Pepe Reyes
Various directors
- *Terra Ribelle 1*** – TV series
Costumes: Enrico Serafini
Directed by Cinzia Th. Torrini
- *La vita è una cosa meravigliosa***
Costumes: Daniela Ciancio
Directed by Carlo Vanzina
- *Wolfman**
Costumes: Milena Canonero
Directed by Joe Johnston

2011
- *À la rechérche du temps perdu***
Costumes: Dominique Borg
Directed by Nina Companeez

- *Amici miei – Come tutto ebbe inizio
[My Friends – How It All Began]**
Costumes: Alfonsina Lettieri
Directed by Neri Parenti
- *The Borgias 1** – TV series
Costumes: Gabriella Pescucci
Directed by Neil Jordan and others
- *Camelot*** – TV series
Costumes: Joan Bergin
Directed by Ciaran Donnelly
and others
- *Cenerentola [Cinderella]** – Rai TV
series
Costumes: Maurizio Millenotti
Directed by Christian Duguay
- *Eroi per caso** – TV series
Costumes: Alessandro Lai
Directed by Alberto Sironi
- *Games of Thrones 1*** – HBO series
Costumes: Michele Clapton
Various directors
- *Il generale Della Rovere*** – Rai TV
series
Costumes: Valter Azzini
Directed by Carlo Carlei
- *Ghost Rider – Spirit of Vengeance***
Costumes: Bojana Nikitovic
Directed by Mark Neveldine / Brian
Taylor
- *Gottes Machtige Dienerin***
Costumes: Mirjam Muschel
Directed by Markus Rosenmuller
- *Hugo***
Costumes: Sandy Powell
Directed by Martin Scorsese
- *Louis XVI, l'homme qui ne voulait
pas être roi***
Costumes: Valerie Adda
Directed by Thierry Binisti
- *Manon Lescaut*** – TV film
Costumes: Florence Sadaune
Directed by Gabriel Aghion
- *The Novel***
Costumes: Mariano Tufano
Directed by Paolo Licata
- *Pirates of the Caribbean 4:
On Stranger Tides***
Costumes: Penny Rose
Directed by Rob Marshall
- *I primi della lista [The First on the List]***
Costumes: Andrea Cavalletto
Directed by Roan Johnson
- *The Rite**
Costumes: Carlo Poggioli
Directed by Mikael Håfström
- *Rossella*** – TV series
Costumes: Liliana Sotira
Directed by Gianni Lepre
- *Season of the Witch***
Costumes: Carlo Poggioli
Directed by Dominic Sena
- *Sherlock Holmes 2: A Game
of Shadows***
Costumes: Jenny Beavan
Directed by Guy Ritchie
- *Three Muskeeters***
Costumes: Pierre-Yves Gayraud
Directed by Paul W.S. Anderson

2012
- *Abraham Lincoln: Vampire Hunter**
Costumes: Varvara Avdyushko /
Carlo Poggioli
Directed by Timur Bekmambetov
- *Anna Karenina***
Costumes: Jacqueline Durran
(Academy Award for Best Costume
Design)
Directed by Joe Wright
- *Appartamento ad Atene*
[*Apartment in Athens*]
Costumes: Alessandro Lai
Directed by Ruggero Dipaola
- *Au Nom d'Athènes***
Costumes: Vincent Dumas
Directed by Fabrice Hourlier
- *Bel Ami***
Costumes: Odile Dicks-Mireaux
Directed by Declan Donnellan / Nick
Ormerod
- *Belle du Seigneur***
Costumes: Magdalena Labuz
Directed by Glenio Bonder
- *The Borgias 2** – TV series
Costumes: Gabriella Pescucci
Directed by Neil Jordan and others
- *La Certosa di Parma [The
Charterhouse of Parma]*** – TV series
Costumes: Florence Emir
Directed by Cinzia Th. Torrini
- *Cesari Mori – Il prefetto di ferro*** –
TV series
Costumes: Valter Azzini
Directed by Gianni Lepre
- *Cloud Atlas***
Costumes: Kym Barrett / Pierre-Yves
Gayraud
Directed by Tom Tykwer, Andy
and Lana Wachowski
- *Confession d'un Enfant du siècle***
Costumes: Esther Walz
Directed by Sylvie Verheyde
- *Copper** – TV series
Costumes: Delphine White
Various directors
- *Dark Shadows***
Costumes: Colleen Atwood
Directed by Tim Burton
- *Games of Thrones 2*** – HBO series
Costumes: Michele Clapton
Various directors
- *Il generale dei briganti** – TV series
Costumes: Mariano Tufano
Directed by Paolo Poeti
- *Inquisitio** – TV series
Costumes: Florence Clamond
Directed by Nicolas Cuche
- *L'Isola dell'Angelo Caduto
[The Island of the Fallen Angel]***
Costumes: Olivia Bellini
Directed by Carlo Lucarelli
- *John Carter***
Costumes: Mayes C. Rubeo
Directed by Andrew Stanton
- *Ludwig II***
Costumes: Gerhard Gollnhofer
Directed by Marie Noelle / Peter Sehr

- *Magnifica Presenza
[Magnificent Presence]*
Costumes: Alessandro Lai
Directed by Ferzan Opzetek
- *Merlin***
Costumes: Nathalie Chesnais
Directed by Stéphane Kappes
- *Les Misérables**
Costumes: Paco Delgado
Directed by Tom Hooper
- *Né con te né senza di te*** – Rai TV
series
Costumes: Stefano De Nardis /
Claudio Manzi
Directed by Vincenzo Terracciano
- *The Raven**
Costumes: Carlo Poggioli
Directed by James McTeigue
- *Snow White and the Huntsman***
Costumes: Colleen Atwood
Directed by Rupert Sanders
- *Terra Ribelle 2*** – TV series
Costumes: Francesca Brunori
Directed by Ambrogio Logiudice
- *Toledo*** – TV series
Costumes: Bina Daigeler
Various directors
- *World Without End*** – TV series
Costumes: Mario Davignon
Directed by Michael Caton-Jones
- *The Wholly Family*** – short
Costumes: Gabriella Pescucci /
Massimo Cantini Parrini
Directed by Terry Gilliam

2013
- *September Eleven 1683**
Costumes: Massimo Cantini Parrini
Directed by Renzo Martinelli
- *Anna Karenina*** – TV series
Costumes: Enrica Biscossi
Directed by Christian Duguay
- *Baciamo le mani – Palermo
New York 1958*** – TV series
Costumes: Stefano De Nardis
Directed by Eros Puglielli
- *The Borgias 3** – TV series
Costumes: Gabriella Pescucci
Directed by Neil Jordan and others
- *Che strano chiamarsi Federico
[How Strange to Be Called Federico]***
Costumes: Massimo Cantini Parrini
Directed by Ettore Scola
- *Ci vuole un gran fisico***
Costumes: Rossano Marchi
Directed by Sophie Chiarello
- *Copper 2*** – TV series
Costumes: Delphine White
Various directors
- *Dancing on the Edge*** – TV series
Costumes: Lindsay Pugh
Directed by Stephen Poliakoff
- *Da Vinci's Demons 1*** – TV series
Costumes: Annie Symons
Directed by David S. Goyer
and others
- *Une femme dans la Révolution*** –
TV series

Costumes: Florence Clamon
Directed by Jean Daniel Verhaeghe
- *Game of Thrones 3*** – HBO series
Costumes: Michele Clapton
Various directors
- *Gilded Lilys*** – TV film
Costumes: Ellen Mirojnick
Directed by Brian Kirk
- *Libertador***
Costumes: Sonia Grande
Directed by Alberto Arvelo
- *Un matrimonio***
Costumes: Francesco Crivellini
Directed by Pupi Avati
- *La migliore offerta
[The Best Offer]**
Costumes: Maurizio Millenotti
Directed by Giuseppe Tornatore
- *Passione Sinistra [Sinister Passion]*
Costumes: Massimo Cantini Parrini
Directed by Marco Ponti
- *Pupetta – Il coraggio e la passione***
– TV series
Costumes: Stefano De Nardis /
Johanna Bronner
Directed by Luciano Odorisio
- *Romeo e Giulietta
[Romeo and Juliet]* – TV series
Costumes: Alessandro Lai
Directed by Riccardo Donna
- *Romeo and Juliet**
Costumes: Carlo Poggioli
Directed by Carlo Carlei
- *Sleepy Hollow*** – TV series
Costumes: Kristin M. Burke
Directed by Ken Olin and others
- *Something Good***
Costumes: Milena Canonero
Directed by Luca Barbareschi
- *Trilussa – Storia d'amore e di poesia**
– Rai TV series
Costumes: Valter Azzini
Directed by Lodovico Gasparini
- *Vikings 1*** – TV series
Costumes: Joan Bergin
Directed by Johan Renck and others
- *The Zero Theorem**
Costumes: Carlo Poggioli
Directed by Terry Gilliam

2014
- *A testa alta. I martiri di Fiesole*** –
TV film
Costumes: Paola Marchesin
Directed by Maurizio Zaccaro
- *Anita B.***
Costumes: Anna Lombardi
Directed by Roberto Faenza
- *Gli anni spezzati*** – Rai TV series
Costumes: Francesca Brunori
Directed by Graziano Diana
- *Caserta Palace Dream*** – short
Costumes: Carlo Poggioli
Directed by James McTeigue
- *Da Vinci's Demons 2*** –
TV series
Costumes: Trisha Biggar
Various directors

- *Divergent**
Costumes: Carlo Poggioli
Directed by Neil Burger
- *Eliza Graves**
Costumes: Thomas Olàh
Directed by Brad Anderson
- *Furore – Il vento della speranza*** –
TV series
Costumes: Stefano De Nardis / Laura
Giustini
Directed by Alessio Inturri
- *Game of Thrones 4*** – HBO series
Costumes: Michele Clapton
Various directors
- *La gente che sta bene***
Costumes: Eva Coen
Directed by Francesco Patierno
- *Il giovane favoloso [Leopardi]***
Costumes: Ursula Patzak
Directed by Mario Martone
- *Grace of Monaco***
Costumes: Gigi Lepage
Directed by Olivier Dahan
- *Grand Budapest Hotel***
Costumes: Milena Canonero
Directed by Wes Anderson
- *A Little Chaos***
Costumes: Joan Bergin
Directed by Alan Rickman
- *Magic in the Moonlight***
Costumes: Sonia Grande
Directed by Woody Allen
- *Maleficent***
Costumes: Anna B. Sheppard
Directed by Robert Stromberg
- *Mister Ignis** – Rai TV series
Costumes: Massimo Cantini Parrini
Directed by Luciano Manuzzi
- *Il peccato e la vergogna 2*** – TV series
Costumes: Stefano De Nardis /
Giovanni Paris
Directed by Luigi Parisi / Alessio
Inturri
- *Penny Dreadful** – TV series
Costumes: Gabriella Pescucci
Various directors
- *Il Pretore***
Costumes: Laura Costantini
Directed by Giulio Base
- *Reign 2*** – TV series
Costumes: Meredith Markworth
Pollack
Various directors
- *Rodolfo Valentino – La leggenda** –
TV series
Costumes: Stefano De Nardis /
Claudio Manzi
Directed by Alessio Inturri
- *I Segreti di Borgo Larici*** – TV
series
Costumes: Maurizio Basile
Directed by Alessandro Capone
- *La Trattativa [The Negotiation]*
Costumes: Massimo Cantini Parrini
Directed by Sabina Guzzanti
- *La voce umana [The Human Voice]*
Costumes: Mariano Tufano
Directed by Edoardo Ponti

- *Vikings 2*** – TV series
Costumes: Joan Bergin
Directed by Johan Renck and others
- *Vinodentro**
Costumes: Alessandro Lai
Directed by Ferdinando Vicentini
Orgnani
- *Winter's Tale***
Costumes: Michael Kaplan
Directed by Akiva Goldsman

In production
- *Antonia***
Costumes: Ursula Patzak
Directed by Ferdinando Cito
Filomarino
- *Black Sails 2*** – TV series
Costumes: Tim Aslan
Directed by Sam Miller and others
- *Cinderella***
Costumes: Sandy Powell
Directed by Kenneth Branagh
- *Clavius*
Costumes: Maurizio Millenotti
Directed by Kevin Reynolds
- *Crimson Peak***
Costumes: Kate Hawley
Directed by Guillermo del Toro
- *Exodus: Gods and Kings***
Costumes: Janty Yates
Directed by Ridley Scott
- *La giovinezza [Youth]***
Costumes: Carlo Poggioli
Directed by Paolo Sorrentino
- *Into the Woods***
Costumes: Colleen Atwood
Directed by Rob Marshall
- *The Man From U.N.C.L.E***
Costumes: Johanna Johnston
Directed by Guy Ritchie
- *L'onore e il rispetto 4*** – TV series
Costumes: Stefano De Nardis /
Giovanni Paris
Directed by Alessio Inturri / Luigi
Parisi
- *Il racconto dei racconti
[Tale of Tales]*
Costumes: Massimo Cantini Parrini
Directed by Matteo Garrone
- *Warcraft – Conflagration***
Costumes: Mayes C. Rubeo
Directed by Duncan Jones